THE AMERICAN INSTITUTE
OF IRANIAN STUDIES

The American Institute of Iranian Studies

Half a Century of Foundational Research

EDITED BY ERICA EHRENBERG

EISENBRAUNS | University Park, Pennsylvania

This work was made possible with the support of the American Institute of Iranian Studies

Library of Congress Cataloging-in-Publication Data

Names: Ehrenberg, Erica, editor.
Title: The American Institute of Iranian Studies : half a century of foundational research / edited by Erica Ehrenberg.
Description: University Park, Pennsylvania : Eisenbrauns, [2025] | Includes bibliographical references and index.
Summary: "Explores the history and development of Iranian Studies in the U.S., highlighting the American Institute of Iranian Studies' role in advancing research. Essays cover the Institute's founding, the rise of Iranian Studies in universities and museums, and the growth of various disciplines within the field"—Provided by publisher.
Identifiers: LCCN 2025004429 | ISBN 9781646023073 (hardback)
Subjects: LCSH: American Institute of Iranian Studies—History. | Iran—Study and teaching—United States—History. | Iran—Civilization—Study and teaching—United States—History.
Classification: LCC DS271.9.U6 A44 2025
LC record available at https://lccn.loc.gov/2025004429

Copyright © 2025 The Pennsylvania State University
All rights reserved
Printed in the United States of America
Published by The Pennsylvania State University Press,
University Park, PA 16802–1003

Eisenbrauns is an imprint of The Pennsylvania State University Press.

The Pennsylvania State University Press is a member of the Association of University Presses.

It is the policy of The Pennsylvania State University Press to use acid-free paper. Publications on uncoated stock satisfy the minimum requirements of American National Standard for Information Sciences—Permanence of Paper for Printed Library Material, ANSI Z39.48–1992.

To Franklin D. Lewis

in loving memory

CONTENTS

List of Illustrations .. ix
Acknowledgments .. xi

INTRODUCTION ... 1
Erica Ehrenberg

CHAPTER 1. Brief Overview of the American Institute of Iranian Studies .. 5
Erica Ehrenberg

CHAPTER 2. A View from Tehran: Reflections on the Memories of the Early Days ... 10
Keyvan Tabari

CHAPTER 3. The Tehran Center, 1977–79 14
Stephen C. Fairbanks

CHAPTER 4. The American Institute of Iranian Studies in the Twenty-First Century ... 25
Erica Ehrenberg

CHAPTER 5. The Council of American Overseas Research Centers 42
Richard L. Spees

CHAPTER 6. The Formative Decades of Iranian Studies in North America: An Overview ... 46
Ahmad Ashraf

CHAPTER 7. The *Encyclopaedia Iranica* and *A History of Persian Literature* ... 60
Elton L. Daniel (based on a draft by Ehsan Yarshater)

CHAPTER 8. The University of Pennsylvania Museum in Iran 69
Christopher P. Thornton, Alessandro Pezzati, and Holly Pittman

CHAPTER 9. The Persian Expedition: The Past and Present of the
Oriental Institute's Early Work in Iran 86
Matthew W. Stolper

CHAPTER 10. Iranian Art (of the Islamic Period) in American
Museums: A Brief History ... 118
Linda Komaroff

CHAPTER 11. Exhibiting Iran in the United States: Iranian Studies
and Museum Exhibitions .. 141
Shiva Balaghi

CHAPTER 12. Some American Contributors to Iranian Studies
Born Before 1900 ... 164
D. T. Potts

CHAPTER 13. The Study of Ancient Iran in the United States:
A History Focusing on Art and Material Culture 201
Judith A. Lerner

CHAPTER 14. Sasanian Art Historical and Archaeological Studies
in the United States, 1960–2010 216
Prudence O. Harper

CHAPTER 15. The Nomad Period in Iranian History from the
Seljukids Through the Timurids: North American Contributions to
the Field, 1980–2010 .. 232
Beatrice Forbes Manz

CHAPTER 16. Development of Persian Language Studies in the
United States ... 256
Franklin D. Lewis

CHAPTER 17. Persianate Islamic Studies in American Universities 282
Carl W. Ernst

CHAPTER 18. First- and Second-Generation Iranian Americans 301
Mehdi Bozorgmehr

List of Contributors .. 331
Index .. 335

ILLUSTRATIONS

Figures
3.1. Tehran Center, 1979 15
8.1. Erich Schmidt surveying at Tepe Hissar, northeastern Iran, 1931 74
8.2. Carleton S. Coon's excavations at a cave in Mazandaran Province, Iran, 1949 76
8.3. R. H. Dyson Jr. and Froelich Rainey at Hasanlu Tepe, Iran, 1970 77
8.4. Holly Pittman with Akram Gholami, Simin Piran, and Yousef Madjidzadeh at Konar Sandal, southeastern Iran, 2005 79
9.1. Persepolis terrace during 1936 excavations and plan of terrace, as excavated by the Oriental Institute, 1939 89
9.2. Tall-e Bākun A (partially excavated) and Tall-e Bākun B (unexcavated) in 1935, and Eṣṭakr in 1936 91
9.3. The Kaʻba-ye Zardušt at Naqš-e Rostam in 1939 92
9.4. George G. Cameron examining the trilingual inscription of Shapur I 93
9.5. Tablets from the Persepolis Fortification Archive 103
9.6. OCHRE presentation of Fortification tablet with Elamite text 104
10.1. Pair of life-sized carved princely figures, late twelfth to early thirteenth century 125
10.2. Khusraw at the castle of Shirin, from a manuscript of *Khusraw and Shirin* by Nizami, Iran, early fifteenth century, Timurid period 127
10.3. Coronation Carpet (detail), Iran, ca. 1520–30, Safavid period 129
11.1. Helen Keller and Arthur Upham Pope at the Exhibition of Persian Art, New York, 1940 142
11.2. Installation view of "Royal Persian Paintings: The Qajar Epoch, 1785–1925" 146
11.3. Shirin Neshat, *Offered Eyes*, 1993 153
13.1. Gur-e Dokhtar, Buzpar, Fars Province, Iran 203

13.2. Photographic plate showing Achaemenid cylinder seal impressions, nos. 819–23 207
13.3. Vessel with two zebu, 2600–2350 BCE (Early Dynastic II–III), probably from the Persian Gulf region, Tarut Island (al-Rafiah) 210

Tables
6.1. Distribution of North American Scholars in Iran by Fields of Research, 1969–78 52
6.2. Estimate of the Number of North American Scholars, Selected Years, 1969–77 53
6.3. Five Quantitative Indices of the State of Iranian Studies in North America, 1976–77 and 1986–87 56
8.1. Collections Relating to Iran in the Penn Museum Archives 70
8.2. Artifact Collections from Iran in the Penn Museum 71

ACKNOWLEDGMENTS

The American Institute of Iranian Studies would like to recognize the long-standing and unstinting support of the Council of American Overseas Research Centers (CAORC), which made the publication of this volume possible. We thank our institutional members and the individuals who contributed to this book, many of whom are our trustees. To the peer reviewers who read the manuscript and provided insightful critique leading to valuable improvements, we extend our gratitude. At Penn State University Press, we are indebted to former director Patrick Alexander, acquisitions editor for the Eisenbrauns imprint Maria Metzler, editorial assistant Emily Lovett, and managing editor Alex Ramos for their significant input, ministration, and patience in seeing this project to completion. And to editor Blake A. Jurgens, we offer our appreciation for numerous stylistic refinements from which the volume benefitted.

Introduction

Erica Ehrenberg

THIS VOLUME GERMINATES from a workshop convened in 2010 by the American Institute of Iranian Studies on the history and development of Iranian studies in the United States. The workshop's aim was to examine the impetus behind scholarly undertakings in the United States concerning the Iranian and Persian cultural spheres and to document the birth and growth of various fields of Iranistics in American institutions. The Institute is central to this narrative, being one of the earliest organizational ventures to promote the study of Iranian and Persian civilizations in the United States and forge ties between Iranian and American scholars. The purview of the Institute is vast. It covers Iranology (the study of Iranian peoples and cultures throughout history) both within and beyond the modern-day country of Iran. It also covers the study of population groups speaking various forms of Persian in Iran (Farsi), Tajikistan (Tajiki), Afghanistan (Dari), and even farther afield as a second language. The purview of the Institute also includes localized, Persian-speaking minorities in Iraq, Turkey, Azerbaijan, Turkmenistan, Uzbekistan, western China, Pakistan, India, and the Persian Gulf region. The Persian language continues to be a cultural force beyond the boundaries of modern Iran, with classical Persian and "Persianate" forms of cultural expression remaining a key to the understanding of history, literature, and the arts for a large swath of eastern Islam stretching from the Arabian Peninsula eastward through Central Asia, and from the Caucasus southward through South Asia. Another major group of Persian speakers includes those living in the Iranian diaspora, a demographic well represented in the United States. The majority of speakers at the workshop comprised the Institute's trustees, who are professors and curators at American universities and museums with dedicated Iranian and Persian programs or collections. Speakers were invited to present papers on the development of Iranian studies in their institutions, in their particular fields of study, or in the United States in general.

While the disciplines addressed in the papers in this volume do not begin to cover the full range of the greater field of Iranian studies, they represent

traditional fields of inquiry—archaeology, art history, history, language, religion—that have benefited from direct access to materials in Iran, as is in keeping with the primary purpose of the Institute's grant program of facilitating in-country research in Iran. In the decade since the Institute's workshop was held, it has become difficult for American fellows to obtain research visas to travel to Iran. In response, the Institute has been enabling fellowship travel to other countries and regions where relevant resources are housed, including elsewhere in the Middle East, Central and South Asia, and Europe. This broadening of geographical breadth has been accompanied by an expansion of areas of study in tandem with evolving research foci in American universities and institutions. A few examples of the variety of topics more recently being pursued in other countries, particularly at archival repositories, are financial sanctions, the oil industry, Iranian cinema, the Iran-Iraq War, and Iranian diplomatic missions to Europe.

The opening articles of this volume introduce the American Institute of Iranian Studies, including its founding, history, and programs both stateside, as related by Erica Ehrenberg, and in Iran, as related by both Keyvan Tabari, who recounts the establishment of the Institute's Tehran Center, and Stephen C. Fairbanks, who narrates the events at the Tehran Center during the tumultuous period of the 1979 Revolution. The Institute's role in fostering American research abroad is situated in the larger network of American overseas research centers by Richard L. Spees, who profiles the Council of American Overseas Research Centers in Washington, DC, of which the Institute is a founding member.

Expanding the view outward to Iranian studies in general, Ahmad Ashraf outlines the emergence and first century of Iranian studies as an academic endeavor in American universities. Elton L. Daniel delineates two seminal Iranological research compendia—the *Encyclopaedia Iranica* and *A History of Persian Literature*—founded by Ehsan Yarshater, whose name is synonymous with Iranian studies worldwide and who served as a Life Trustee of the Institute. Two universities famed for archaeological research—the University of Pennsylvania and the University of Chicago—funded early twentieth-century expeditions to Iran, as encapsulated, respectively, in the chapter jointly authored by Christopher P. Thornton, Alessandro Pezzati, and Holly Pittman and by the contribution of Matthew W. Stolper. It was out of these expeditions that excavated antiquities (subject to different laws than today) entered the Penn Museum and the Oriental Institute Museum of Chicago (recently renamed the Institute for the Study of Ancient Cultures Museum). Even earlier in the late nineteenth century, American museums began acquiring Islamic art from Iran, as discussed by Linda Komaroff. In recent decades,

museums have also turned attention to exhibiting modern and contemporary art from Iran, as documented by Shiva Balaghi.

Prior to institutional involvement in Iranian archaeology, individual scholars, explorers, and missionaries planted the seeds for the growth of Iranology in the United States. D. T. Potts summarizes biographies of nineteenth-century researchers of ancient Iran, while Judith A. Lerner traces the story of researchers of ancient Iran into the twentieth century. Other chapters offer case histories of various fields of Iranian studies that have been traditional strongholds of Institute-sponsored research. In the discipline of art history, scholarship of the Sasanian period is surveyed by Prudence O. Harper. In the field of history, Beatrice Forbes Manz chronicles investigations into the Nomad period (Seljukids through Timurids). In the discipline of philology, Franklin D. Lewis explores the motivations behind the growth of Persian language studies in the United States. In the field of religion, the contribution of Iranological perspectives to Islamic studies and Religious studies programs in higher education is treated by Carl W. Ernst. Finally, in a sociological study that was funded by the Institute, Mehdi Bozorgmehr reviews scholarship on the Iranian diaspora in the United States.

The gap in time between the 2010 presentation of the papers in this volume and their publication is a consequence not only of the general overcommitment of its authors but also the prolonged illness and untimely passing of the Institute's dear colleague and long-serving president, Franklin D. Lewis, who was to have served as a coeditor for this volume. Although he was unable to fulfill this role, his legacy permeates the project and is reflected in its conception and spirit. Lewis's astonishing breadth and depth of knowledge as well as his magnanimity as a scholar of Persian language and literature are legendary. His warmth and kindness are best captured in the memorial statement by Paul Losensky, Professor Emeritus of Persian Literature and Literary History at Indiana University and long-serving member of the Institute (as overseas director, trustee, and advisor): "Frank was a gentleman in every sense of the word. Unfailingly polite, he spoke with quiet, measured deliberation, yet his keen wit and ready smile quickly dispelled any suspicion of aloofness. He wore his learning lightly and radiated good will to all. We have lost not only a talented scholar but a humane and gentle soul." It is with this sentiment that we dedicate this volume to Frank Lewis.

The trustees who serve on the Institute's board, and the advisors who lend it support, form the backbone of the Institute and constitute a brain trust of Iranian studies. Over the years, trustees and advisors have been instrumental in all aspects of the Institute's functioning from its founding to the expansion of its programs and its connections with institutions in the United States and

overseas. Trustees undertake a range of tasks such as sitting on committees, including the Roth Committee that awards the Lois Roth Persian Translation Prize and the Program Committee that selects annual research fellows. None of their labors are remunerated; trusteeships and advisory roles have always been assumed on a volunteer basis. Theirs is a labor of love not only for the Institute itself but for the furtherance of Iranian studies in America.

Erica Ehrenberg
Director, American Institute of Iranian Studies

CHAPTER 1

Brief Overview of the American Institute of Iranian Studies

Erica Ehrenberg

THE WORK OF ENVISIONING, supporting, and running the American Institute of Iranian Studies (AIIrS) has been an act of dedication and devotion on the part of its many trustees, who have served AIIrS uncompensated in various roles, some of them for decades. Recognizing the need for support of Iranian studies in the United States as well as the difficulties inherent in finding it and in making inroads into the Iranian academic system, a number of American scholars began discussing in the early 1960s the need for an organization specifically devoted to the promotion of Iranian studies and facilitating research in Iran. Out of these conversations, AIIrS was born and incorporated as was its Tehran Center, which operated from 1969 to 1980. All that AIIrS has achieved from its first moments until now stands as a testament to the aspirations and efforts of its trustees. What follows here is a timeline of the formation of AIIrS and the center in Tehran until the closing of the latter. A separate chapter in this volume describes the endeavors of AIIrS in recent years following the resumption of exchange programs with Iran.

At the annual meeting of the American Oriental Society in 1964, a committee was organized to investigate the possibilities of founding an American Institute of Iranian Studies in Tehran modeled after the American centers in Cairo, New Delhi, and Istanbul along with the French, German, and British centers in Iran. An interim meeting was convened at the annual American Oriental Society conference in Chicago in 1965 to report on the progress of such efforts. As a result of this meeting, a new committee was formed in March 1967 at the American Oriental Society conference in New Haven and was instructed to carry out the preparatory work for the founding of the Institute. This committee, chaired by Robert Dyson (Pennsylvania) and consisting of Richard N. Frye (Harvard), J. C. Hurewitz (Columbia), Charles Wilkinson (emeritus, Metropolitan Museum of Art), and Ehsan Yarshater (Columbia), met in New York in April 1967 and again in May of that year. The committee

designated a member to consult legal counsel for framing articles of constitution and for registering the projected Institute as a tax-exempt educational agency.

The committee also decided to seek the participation of leading American institutions of higher learning and museums. It outlined two basic purposes of the proposed new Institute. First: "To facilitate and to promote the advancement of knowledge and understanding of Iran through studies in the U.S. and Iran, primarily by American scholars but with the specific aim of promoting joint research whenever possible with Iranian colleagues. Such purposes shall be facilitated by the provision of facilities and information to qualified scholars and students, both American and Iranian, and by encouraging the publication of the results of their studies." Second: "To establish a center in Tehran, with accommodations and library, for use by American scholars researching in Iran; hold lectures and related activities; maintain relations with Iranian universities, museums, educational and cultural institutions, and pertinent government agencies; assist Iranian scholars wishing to research in the U.S.; facilitate study in Iran by American graduate students and scholars."

With its *raison d'être* established, the committee pursued funding and approval from Iran for the development of a center in Tehran. Over the ensuing years of formation, financial assistance and support was sought from, among other groups, the United States Department of State, the Embassy of the United States of America in Iran, the Fulbright Commission, the Offices of the Shah of Iran, the Iran-America Society, the National Foundation of the Arts and the Humanities, and the Ford Foundation. In July 1967, committee members Hurewitz and Yarshater held meetings in the office of the Iranian Cultural Attaché in Tehran with Richard Arndt (cultural attaché, American Embassy), Sterlyn B. Steele (Director, Iran-American Society), and Lois Roth (deputy to the Cultural Affairs Officer, American Embassy) about potential collaborations, the setting up of a center in Tehran, and the nature of the center's mandate and the role of its director.

Subsequent to another organizational meeting in October 1967, the newly named American Institute of Iranian Studies filed a certificate of incorporation with the State of Delaware on December 28, 1967. The first formal organizational meeting of AIIrS was held in New York in February 1968, with the principal business being to adopt the by-laws that had been drawn up by the organizing committee. By the end of 1968, AIIrS had received tax-exempt classification as a nonprofit organization from the IRS. Meanwhile in Iran, Keyvan Tabari, Director General for International Relations of The Ministry of Science and Higher Education, assisted in gaining permission for the founding of a center there from the Ministry of Foreign Affairs, the Ministry of Science and Higher Education, the Ministry of Culture and Art, and the

Ministry of Justice. By June 1969, AIIrS had obtained approval in principle from the Iranian government for the establishment of a center, which opened in Tehran in September 1969 under the directorship of William Sumner at 102 Khiaban Ghaani, four blocks south of Tehran University. The new center had the accommodation capacity for up to four scholars in addition to the director.

In the spring of 1970, a legal representative was retained in Tehran to assist with registering AIIrS as a nonprofit institution in Iran with the Companies Registration Office in Tehran and with advising on Iranian reporting requirements and tax law, the hiring of locals and importation of equipment, charging for the hostel rooms in the Tehran Center, and obtaining requisite permissions from governmental ministries and permits from the Police Department. Official notice of the registration of AIIrS was published in the Iranian Government Newspaper on August 12, 1970. This was the final step in gaining compete legal recognition for the Institute to operate in Iran. Not long afterward in October 1972, the Tehran Center moved to new quarters at 9 Khiaban Moshtaq, which offered more ample accommodations.

After almost a decade of successful operations, including supporting and facilitating American and Iranian researchers, assisting archaeological excavation teams, holding lectures, developing a library of scholarly books and journals, building relations with Iranian academics and institutions, and running hostel services for visiting scholars, the Center began to encounter a darkening political landscape. The soaring rate of inflation in Iran in 1978 took a large toll on the finances of the Center. In May and June 1978, AIIrS president K. Allin Luther went to Tehran to speak with American Embassy officials. The bank fires of November 5, 1978 resulted in a loss of cash in the AIIrS bank accounts. An emergency grant from the National Endowment for the Humanities helped make up for these losses, but correspondent banking arrangements became illegal, making the transfers of funds impossible, and all US dollar funds were repatriated. The Center remained open through the February Revolution but was effectively closed in autumn 1979, though in spring 1980 there were still American scholars and Institute members traveling back and forth between the United States and Iran. The loss of a grant renewal from the United States International Communications Agency (USICA) in spring 1980 was partially alleviated by a one-time emergency grant from the Ford Foundation, which allowed for some basic operations to continue. The Center was being maintained by a single local staff member in the autumn of 1980 until the Center and other AIIrS property were seized in December of that year.

While waiting to see how events would unfold in Iran, the trustees of AIIrS worked over the next few years with its funders to reconfigure the activities of the Institute so that it could continue to carry out its mandate of promoting Iranian studies without the benefit of the Tehran Center or access to resources

in Iran. AIIrS funding was redirected to sponsor scholarly work, including bibliographic studies and dissertation research, that was being conducted domestically. AIIrS president William L. Hanaway was present at a June 1981 meeting at the Smithsonian Institute with the heads of ten other American overseas research centers (AORCs) to discuss the state and future prospects of the various overseas centers, provide general publicity about the centers and their importance, exchange operational, administrative, and fund-raising information, share scholarship and research information, provide a continuing voice in government and foundations in support of the centers, assist in the foundation of new centers, and lay the groundwork for the formation of the Council of American Overseas Research Centers (CAORC), of which AIIrS is a founding member.

Directors of the Tehran Center

William M. Sumner, 1969–71
Edward W. Davis, 1971–72
Jerome W. Clinton, 1972–74
David J. Peterson, 1974–75
Colin R. MacKinnon, 1975–77
Stephen C. Fairbanks, 1977–79

Presidents of AIIrS

Robert H. Dyson Jr., Chairman of the Organizing Committee, Founding President, through 1969
Marvin Zonis, 1970–71
T. Cuyler Young Jr., 1971–77
K. Allin Luther, 1977–79
William L. Hanaway, 1979–84
Edith Porada, 1984–87
Robert H. Dyson Jr., 1987–90
Marilyn R. Waldman, 1990–93
Brian Spooner, 1993–96
Michael E. Bonine, 1996–99
Prudence O. Harper, 1999–2002
Franklin D. Lewis, 2002–12
Beatrice Manz, 2012–16
Franklin D. Lewis, 2016–20

Anne Betteridge, 2020–

Charter Institutional Members of AIIrS

Archaeological Institute of America
Boston Museum of Fine Arts
Bryn Mawr College
Cleveland Museum of Art
Columbia University
Harvard University
Institute of Fine Arts, New York University
The Metropolitan Museum of Art
Princeton University
University of California, Berkeley
University of California, Los Angeles
University of Chicago—Oriental Institute
University of Michigan
University of Pennsylvania—University Museum
University of Pittsburgh
University of Texas, Austin
University of Utah
University of Virginia

CHAPTER 2

A View from Tehran: Reflections on the Memories of the Early Days

Keyvan Tabari

IN 1969 I MADE A SMALL CONTRIBUTION to the establishment of the American Institute of Iranian Studies by helping to open its offices in Tehran. At the time, I was the Director General of International Relations at Iran's Ministry of Science and Higher Education. In that capacity, I had a professional relationship with the cultural officers of foreign embassies to Tehran. My relationship was deeper with the American cultural attaché Richard Arndt. We had both received our PhDs from Columbia and were active members of the small alumni association of that university in Tehran. Furthermore, Richard and his wife Lois had become fairly close personal friends of mine and my American wife, who, like Lois, was also a Columbia graduate. So when Richard called me one day in 1969 and asked to have lunch, it was not unusual.

What made this lunch noteworthy was the message that Richard was carrying for me. I vividly remember the restaurant where we ate. It was on Kucheh Rasht, an alley just south of Shah Reza Avenue. Named Rasht 39 after its address, this self-consciously simple venue, modest in decor in the midst of the pretentiously opulent eateries in Tehran, had gained a reputation among the city's culturally hip. A few even compared it with the far more famous Café Naderi, where a generation earlier the most acclaimed writer Sadegh Hedayat (Ṣādeq Hedāyat) held court.

How times had changed! The new generation was sometimes accused of being uncritically Americanized. Sadegh Hedayat looked to Paris as his Mecca. On this day, Richard Arndt looked me in the eye and gave me his trademark grin. Then he said, "I have a message for you from Jay Hurewitz." Professor Hurewitz wanted me to help facilitate the process of approving the application for opening AIIrS offices in Tehran. While the diplomatic demarche (Arndt's words) would be made at the Ministry of Foreign Affairs, such matters were then referred to where I worked for decision. Let me just say that I fulfilled Professor Hurewitz's request.

More interesting than the details of that process is the story of my connection to Professor Hurewitz. He was, after all, a central figure in the formation

of AIIrS, and I was instrumental in the formation of another related organization, the Society for Iranian Studies (SIS), now known as the Association for Iranian Studies (AIS). Our connection thus bridged two distinctly different environments for Iranian studies in the United States at that time.

Professor Hurewitz was my dissertation advisor at Columbia. While he had many other Iranian students, I was one of his first. It was Professor Hurewitz who had practically recruited me into the field of Iranian studies. I had entered Columbia to study international law, organization, and politics. Even at my oral exams, those constituted my major fields; Middle East politics was only my minor.

I never took a course on Iran while at Columbia. A course exclusively about Iran was not even offered in the social sciences at Columbia or at my undergraduate school, Duke University. Yet I chose to write my dissertation on Iranian-American relations at the encouragement of Professor Hurewitz. It was when I began preparing for my oral examinations at Columbia in the early 1960s that, so as to meet the requirements of my minor, I started reading several of the books on Iran that were popular among American academics. I recall Professor Hurewitz asking me at the examinations to name some of them. After listening to my response, he then asked, "How is it that you don't mention the book *Mission for My Country* by Mohammed Reza Shah Pahlavi?" My reason was that I considered that book to be more a work of public relations than accurate information on conditions in Iran. In this, I was showing my bias. I was not just a student; I was a student activist. My political activism was hardly as pronounced as that of some other Iranian students, but I was now reading about Iranian politics as much as anyone, and because I was a member of the governing board of the Iranian Student Organization in the United States, I had the special access of a participant observer. We could read Persian publications written by the opposition to the Iranian regime unavailable to our professors. The converse of our potentially greater insight was, of course, a potentially greater difficulty for us to maintain scholarly detachment. We were eager for change rather than focused on understanding what might have appeared as a stable status quo to an interested American observer.

The Communist Tudeh Party's analysis of current events in Iran printed in their European-based journals and periodicals especially provided us with a perspective we could not find in Western publications. After the Khomeini-led unrest of the early 1960s was suppressed in Iran, we continued to receive his group's underground publications, which shed light on his increasingly significant influence. I reported on Khomeini's movement as early as 1965 in one of the first American conferences on Iranian studies held at Johns Hopkins University. An article based on that report has impressed some as showing

foresight, but only after the 1979 Islamic Revolution had transpired. At the aforementioned 1965 conference, it was one of my copanelists and fellow students, Marvin Zonis, who talked captivatingly about his work on the Iranian elite—a subject of much attention at the time. But soon this group of elites would vanish unexpectedly.

Professor Hurewitz was on sabbatical at the time of the conference and busy with research on yet another pillar of Iranian stability: its military. He called me to his temporary office at the Council on Foreign Relations and asked me to read the draft of his chapter on Iran in his forthcoming book on the military in the Middle East. I felt flattered. My comments were respectfully timid. The one that stood out was my objection to his characterization of Mohammed Reza Shah Pahlavi's rule as "constitutional absolutism." I merely said it looked like a contradiction in terms. "Constitutionalism" to an Iranian was literally "conditionality" (*mašrutiyat*). Professor Hurewitz smiled enigmatically; he did not offer another response that day. He could have argued that he meant that constitutional constraints defined the scope of the Shah's absolutism—this was how the Shah might have seen his rule.[1] Retrospectively, I think that our different understandings of Professor Hurewitz's phrase, "constitutional absolutism" at that time pointed out the two different provenances of AIIrS and SIS. I say this because I was present at the creation of that other entity.

It took place in a cottage in Cape Cod in the summer of 1967. There were five or six of us gathered there. Two of us were students from Harvard, one of us was from Yale, and the rest of us from Columbia. We were friends. We were also student activists, leaders of the US branch of the Iranian student movement, and publishers and writers of this movement's more serious journals (*Pendar* in English and, more importantly, *Maktab* in Persian). There in that cottage, we laid the foundations for an organization that became SIS. Unlike AIIrS, this was not to be an association of institutions but of individuals. We were all Iranians, and our discussions were in Persian.

I left the field soon thereafter, having taught briefly in the United States and Tehran, but some of the founders of SIS rose to be prominent scholars of Iranian studies. In the beginning, however, there was no faculty member among us. Indeed, at the time there were hardly any Iranians on the faculties of humanities at American universities, at least not in the social sciences. There were only a few Iranians in departments of languages and literature.

This is, of course, the story of the early days. Things have changed dramatically at SIS/AIS. The change has been no less dramatic at AIIrS, whose roster of trustees now includes Iranian-American scholars. One more converging development needs to be mentioned here. Those of us who founded SIS eventually proved to have more or less the same values as the founders

of AIIrS. We never became members of communist parties or the Khomeini movement. Indeed, most of us found ways to work with the slowly changing monarchical regime in Iran, myself included. In the critical parlance of today, we were "secular humanist liberals" who had been Americanized by the intellectual and political culture of our American universities and, as such, were not compatible with the real opposition to the Shah. The enigmatic Professor Hurewitz likely suspected this all along.

Note
1. I have dealt with this subject in Tabari, "Rule of Law and the Politics of Reform," and Tabari, "Musaddiq's Conception of Constitutionalism."

Bibliography
Tabari, Keyvan. "Musaddiq's Conception of Constitutionalism Based on His Arguments Before the Court That Tried Him in 1953." Iranian.com, September 14, 2006. https://www.iranian.com/Tabari/2006/September/Constitutionalism/index.html.
———. "The Rule of Law and the Politics of Reform in Post-Revolutionary Iran." Pages 113–37 in *Constitutionalism and Political Reconstruction*. Edited by S. A. Arjomand. Leiden: Brill, 2007.

CHAPTER 3

The Tehran Center, 1977–79

Stephen C. Fairbanks

DURING THE FIRST of its final two years, the Tehran Center of the American Institute of Iranian Studies was a thriving hub for scholars of many nationalities conducting research on Iran. The Center was even looking forward to future expansion, but its prospects quickly changed as the Iranian Revolution closed in. By late 1978, it was becoming increasingly difficult for the Center to continue to serve researchers studying Iran. The prevailing insecurity and disapproval of American entities following the 1979 Revolution outweighed the hard efforts of those in America and Tehran who endeavored to keep it operational in the new Islamic Republic.

But through the summer of 1978, the Tehran Center was able to facilitate the research activities of archaeological teams, professors, and graduate researchers in a wide range of Iranian studies. As it had since its beginning, the Center helped to obtain research permits, make connections with government offices, and provide temporary housing for visiting scholars. Its expansion appeared likely as business and government entities in America increased their financial support, seeing the Institute's potential to promote Iran-US cultural relations and perhaps help scholars understand the dramatic events taking place in Iran.

The Institute sought to revitalize the Tehran Center during those years and to ensure its survival in the Islamic Republic, but after the 1979 Revolution the Center could no longer obtain research permits, despite its efforts to establish good relations with the government. In the wake of the November 1979 takeover of the American Embassy, the Center's library and furnishings were seized, effectively halting further prospects for the Center's activities.

The Tehran Center was located on Moshtaq Street off Kakh (now Felestin) Street, a block below Shahreza (renamed Enqelab) Avenue, a location that often put it in the midst of the turmoil of 1978 and 1979 (fig. 3.1). Its large house, rented from a former senator then in his nineties, had a lovely garden dominated by a huge persimmon tree and housed on its main floor the Center's office, a library, and a dining room that was the scene of daily lunchtime gatherings of visiting scholars and local guests. The second floor housed the

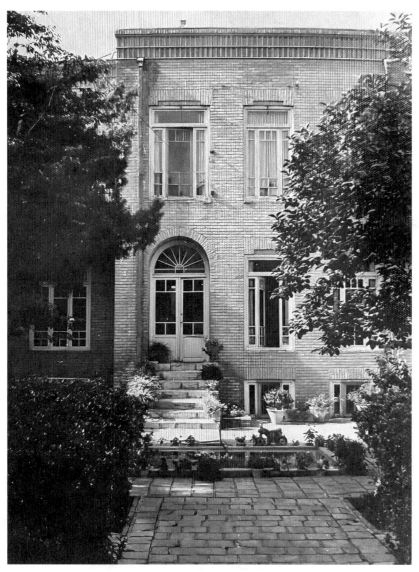

FIGURE 3.1. The Tehran Center of the American Institute of Iranian Studies in 1978, with its garden and small pool (*howz*). Photo: Stephen C. Fairbanks.

director's quarters with a large living room that doubled as the venue for public lectures. Across the street was the Center's hostel with three rooms for visiting scholars.

My tenure as director began promisingly in July 1977, when outgoing director Colin MacKinnon and his wife Shokoufeh organized a welcoming party for me and my wife Dolores, who was to serve as the Center's librarian, and our two daughters. American and Canadian Ambassadors William Sullivan and James George, American cultural attaché William DeMyer, and numerous Institute-affiliated scholars attended.

The Center assisted American-led archaeological digs in 1977 and 1978, the last year for such activities by Americans. The late Professor Helene Kantor from the University of Chicago's Oriental Institute conducted her thirteenth year of field research on pre- and protohistoric life at Chogha Mish in Khuzestan. William Sumner of Ohio State University (and later the Oriental Institute) led the fifth season of excavations at Tal-e Malyan (ancient Anshan) north of Shiraz, a project cosponsored by the University of Pennsylvania and Ohio State University that involved researchers from several American universities. Their excavations of temples, ordinary houses, and a rich variety of objects and cuneiform texts documented Sumerian contacts with Elam and Anshan. Judith Berman from the City University of New York surveyed prehistoric sites in the Khorramabad Valley in search of data on changes in land use and settlement.

Other archaeological research in 1978 included a study of Pliocene and Pleistocene tar and asphaltite deposits in Khuzestan by Douglas Lay from the University of North Carolina and William Farrand, Richard Redding, and Douglas Elmore from the University of Michigan. In explorations that they planned to continue in subsequent seasons, they uncovered fossil deposits at Mamatain near Ram Hormuz and at Mordeh Fil near Izeh. They also excavated tar deposits Iat Deh Loran near the Iraqi border and surveyed asphalt deposits in other areas of Khuzestan and Fars provinces. Louis Levine of the Royal Ontario Museum in the summer of 1978 directed the second season of a multistage, interdisciplinary exploration of the archaeological history of the Mahidasht and Kermanshah valleys near Kermanshah that focused on the Neolithic, Chalcolithic, Iron Age, and Parthian periods. Expedition members from universities in Canada, England, Israel, and Italy as well as sixteen students from universities in the United States, Canada, the United Kingdom, and Iran participated that summer.

Several social scientists with Institute affiliations carried out research in Iran in 1978. Janet Bauer, a Stanford PhD candidate, studied women village migrants in south Tehran and their adjustments to urban life, while Ann Fioretta from California State University researched traditional woven handicrafts

in the Isfahan area. Harvard PhD candidate Rafique Keshavjee studied religious thought in Isma'ili villages in Khorasan, and Sally Weisskopf studied birth customs and infant caretaking in the Shiraz area for her Harvard PhD dissertation. Beatrice F. Manz examined manuscripts at the Tehran University, Senate, Majles, Melli, and Malek libraries (the latter despite stirrings of unrest in the Tehran bazaar) for her Harvard dissertation on the position of nomads in the Timurid army and administration.

Other social scientists affiliated with the Tehran Center in 1978 included Jerrold Green, whose research for a University of Chicago dissertation on communications and social change put him in a good position to undertake an eyewitness study of the unfolding revolution; Arizona's Ludwig Adamec, who collected information for new volumes of his Gazetteer of Iran; Victoria Rowe Holbrook, who researched classical Persian poetry and vocal music at the Iranian Academy of Arts and Sciences and the National Conservatory of Iran; Eric Hooglund, who researched village economies in southern Iran; and Mary E. Hegland, who studied the social organization of rural credit in Fars. University of California, Los Angeles Professor Nikki Keddie gathered research material on Qashqais during the summer of 1978, and Ottoman historian Halil Inalcik, at that time with the University of Chicago, spent July in Tehran and Tabriz studying Persian links in Ottoman institutional history and researching the history of the Iranian silk economy.

Also in 1978 Brian Spooner, as the principal investigator of the Turan Program of Integrated Ecological Research and Management, was continuing his desertification research south of Shahrud. The program, which had begun in 1975, involved several Iranian scientific institutions, UNESCO, and researchers in a variety of disciplines from American, Iranian, and European universities. Carried out under the auspices of Iran's Ministry of the Environment, the program aimed to develop strategies to maximize sustainable production and optimal living standards in the more arid and economically marginal parts of the country. At the Turan Biosphere Reserve, Dr. Spooner was joined by other University of Pennsylvania researchers, including Chris Hamlin (then Institute treasurer), who collected data on the usage of vegetation by pastoralists, Lee Horne, who worked on an ethno-archaeological study of small scale settlement, and A. Andre Nyerges, who carried out a feasibility study on the interaction between range vegetation and domesticated animals.

During the relative calm in Tehran that lasted into the summer of 1978, Institute-affiliated scholars were active in several international Iranian studies events. At the August 1977 Shiraz Arts Festival, William Beeman was involved in the staging of traditional dramatic *ta'ziyeh* performances. In Hamadan in October 1977, the late Tehran University historian and bibliographer Iraj Afshar organized a conference on Seljuk and Mongol history, at which

K. Allin Luther, Richard Bulliet, Roy Mottahedeh, and I gave papers along with numerous international scholars, among them A. K. S. Lambton, Bertold Spuler, Wilferd Madelung and Bert Fragner. I also spoke on the state of Iranian studies in America at the Eighth Congress of Iranian Studies, a large international gathering of scholars in many disciplines organized by Iraj Afshar and held at Kerman University in September 1978. Roger Savory, a trustee of the Institute, spoke on Persian language teaching in Canada at the Society of Professors of Persian Language and Literature in Tehran in February 1978.

The Center maintained good relations with other foreign research centers and scholars in Tehran, most notably the British Institute for Persian Studies and its director David Stronach. It also coordinated with members of the French Institute (Institut Français de Recherche en Iran), headed by Charles-Henri de Fouchécour and later by Bernard Hourcade. In the months following the revolution, the Japanese anthropologist Morio Ono, director of Japan's Cultural Center in Tehran, was also a frequent visitor to the Center.

One of the Tehran Center's functions was to stage public lectures by Institute-affiliated researchers. In 1978, Janet Bauer and Annabelle Sreberny presented on traditional women and modernization in Iran, Rafique Keshavjee discussed Khorasani Isma'ili communities, and Soheila Shashahani from the New School of Social Research talked about women of the Mamasani tribe. Andrew Lins of the Winterthur Museum explained current laboratory techniques in monument restoration, describing the perils of hydrostatic pressures on Islamic-period structures. By September 1978, however, deteriorating security in Tehran prevented additional lectures from being organized, and one scheduled for that month by William Sumner on excavations at Malyan had to be canceled.

Through 1977 and most of 1978, life at the Tehran Center continued unaffected by the unrest in various parts of the country, which was sporadically brought to the Center's attention. When viewed in retrospect, early signs of unrest in Tehran gave no indication of the direction in which events were heading. When I arrived in July 1977, having been away from Tehran for five years, I was struck by the frequency of street arguments that led, unlike in the past, to public bouts that bystanders did not attempt to quell, as had been usual before. Shortly after I arrived that summer, an Iranian friend informed me that life in the capital had become tense and chaotic as never before, while students in Shiraz told me that in the current atmosphere they felt as if they were at sea. Any such criticism of life in Iran would never have been expressed to me, an American, in the past times I had lived in Iran. In September of that year, the director of the Goethe Institute, where I spoke on some aspects of Seljuk history, told me about the unprecedented gatherings outside the city of students eager to hear the works of heretofore banned poets. As early as the

fall of 1977, at a gathering I hosted at the Center for professors from Tehran University's history department, the topic of conversation quickly turned to the attitudes of the students, who had recently returned for the fall semester. The professors expressed concern that they had never seen the students so tense, unruly, and uninterested in their classes, and they were puzzled that the students seemed unable to articulate any particular demands.

By the summer of 1978, occasional disturbances in Tehran, against a background of repetitive demonstrations and violence in provincial cities, prompted me as an *ex officio* member of the Fulbright board in Tehran to advise US Embassy officials to suspend bringing a new crop of professors and their families to Iran that fall. The American Embassy cultural officials dismissed this as a needlessly pessimistic assessment, and the professors subsequently arrived at their posts in various cities only to be forced to leave within a few months.

Nonetheless, the Center itself did not appear threatened, and it was confident enough about its future that at the end of summer it published a greatly improved version of its periodic newsletter, which reported on current research projects. Staff at the Iran-America Society helped redesign the newsletter as a replacement for an older mimeographed version. It turned out to be the last edition, however, as deteriorating security was rapidly bringing research activities by American scholars to an end.

By September only a few Institute-affiliated scholars remained in the country, and no new projects were underway. One of the remaining few was Jerry Green, who turned his observations of the growing unrest into his University of Chicago PhD dissertation and subsequent book. Following major incidents in Tehran (most notably the September 8 Jaleh Square massacre), by October 1978 the Tehran Center was often in the midst of disturbances as students fled from the streets surrounding Tehran University. On several occasions, we opened the garden doors to students trying to escape the pervasive tear gas. The imposition of martial law with strict evening curfews did little to halt the demonstrations, while daily electrical blackouts and strikes at essential service providers, ranging from the postal service to television broadcast and Iran Air, made daily life increasingly difficult. A strike at the Ministry of Culture caused the cancelation of a major archaeology symposium scheduled for November in Tehran, to which many archaeologists affiliated with the Institute had been invited.

On November 5, the widespread burnings of banks, theaters, and liquor stores engulfed the area around the Tehran Center. The major streets of Shahreza and Pahlavi were devoid of traffic for most of the day as young men filled the streets and set what they could on fire, unimpeded by any police or military presence. The intersection at Pahlavi was flooded with alcohol from

smashed wine, whisky, and beer bottles from the large corner liquor store there. Every bank in the area of the Center was destroyed as determined young men attacked safes with crowbars and set records on fire. The Institute subsequently could no longer access its own account in the neighborhood bank.

Overseas journalists seeking assistance in covering the events in Tehran would stop by the Center. I accompanied Joseph Kraft in visits to Tehran University that November as he sought to report on the bloodshed there for a series he wrote for the *New Yorker*. The BBC's Andrew Whitley was a frequent visitor and, following the revolution, so was Elaine Sciolino, then with *Newsweek*.

The disturbances that autumn had the effect initially of improving the Center's prospects for raising funds, which the Institute needed in the face of Iran's rising inflation. Several American companies, hoping to continue to operate in Iran, understood that the Institute could promote Iranian-US cultural relations and facilitate academic efforts to understand the changes that were rapidly taking place. In a highly unusual effort, Ambassador William Sullivan wrote a letter asking eighty-five companies to consider contributing to the Center's financial well-being. I made follow-up visits to several of them, sometimes accompanied by Lee Horne, to discuss unfolding political developments and to explain the importance of the Institute's role in Iranian studies. Many of these companies responded favorably with sizable pledges toward the creation of an endowment fund. But while several did follow through with generous contributions most others stalled in order to determine if it would be possible for them to do business in Iran at all.

As the deteriorating situation undermined fundraising efforts with American businesses in Tehran, the Institute's president, University of Michigan's Professor K. Allin Luther, was working to find new sources of support, since funding from institutional members represented only a small part of the overall budget. In pursuit of federal assistance, Luther held meetings with State Department desk officers and sought modest grants from the International Communications Agency (ICA), which the Carter administration had established earlier in 1978 to replace the United States Information Agency, and from the National Endowment for the Humanities. Luther's appeals in Washington continued through the summer not only because of cumbersome bureaucratic procedures but also because officials in Tehran and Washington wanted reassurance that the Institute would be able to function and that researchers would be permitted to come to Iran.

Considering the uncertainty about what kind of governance structure would emerge in the post-Pahlavi era, the Institute's executive committee agreed it would be preferable to try to keep the Tehran Center in place during the impending turmoil. They judged it would be easier to adapt to changing

circumstances on the spot than to depart and then reestablish a center once the dust settled. During the transitional phase of the Iranian Revolution, the Institute could provide valuable help to member institutions and the Library of Congress in the purchase of books and periodicals on current developments for their libraries. The anti-Americanism occasionally seen in the weeks before the 1979 Revolution that February looked like it would only be a transitory phenomenon that would not continue.

Luther remained optimistic that Americans and other foreigners would be able to continue to do research in Iran after the revolution. In a January 28, 1979, memorandum to the Institute's executive committee, he indicated that he saw favorable prospects for textual studies in history, religion, and literature for the Islamic period. Further, he wrote that Iran's intrinsically interesting culture and society as well as its strategic position in the Persian Gulf would continue to excite interest not just for Iran specialists; general social scientists, he asserted, would also be broadly interested in Iran as a laboratory of social and cultural change.

Following a three-month stay in America starting January 15, 1979, where I settled my family in Ann Arbor and spoke on events in Iran at college campuses in the eastern United States and Canada, I returned to Tehran in April. The streets were relatively calm, but there was a prevailing uneasiness that had culminated during the February revolution. From time to time, that calm would suddenly be interrupted by sporadic gunfire, and there would be daily clashes between Islamists and secular leftists in the area of Tehran University.

The previously underground leftists, ranging from the Mojahedin-e Khalq and Fedayan to the Tudeh communists, now participated openly in marches and demonstrations. They contributed noticeably to the anti-American sentiments that were emerging at the same time among the pro-Khomeinists. The communists were selling booklets on the sidewalks in front of the university. One such booklet, which was on supposed American spy posts in the city, charged that the Institute was one such post, but the address given for the Institute was incorrect.

Among the few visiting scholars during that summer, Allin Luther came to assess the situation of the Tehran Center. Together we visited Iraj Afshar and some notable clerics as well as relevant officials at the Ministry of Foreign Affairs. Chris Hamlin and Brian Spooner came on their way out to Turan and, later, on their way back from India. Other scholars present that summer were Nikki Keddie, Marvin Zonis, and Lois Beck. But such visits became rarer and rarer, and very few Iranian visitors stopped by the Center as the new administration became increasingly anti-American, with the Iranian media offering daily warnings about foreign agents and spies. My spirits were often lifted by some of the directors of other Iranian studies institutes in town, including

David Stronach of the British Institute, Morio Ono of Japan's Cultural Center, and Bernard Hourcade of the French Institute.

I needed to learn what sort of official permission the new government was prepared to grant for the archaeologists and researchers who needed to resume their work in Iran, but I was frustrated in my efforts to learn anything definitive from the Ministry of Culture, the Ministry of Foreign Affairs, and the Archaeology Center. There were frequent personnel changes, and I could not obtain a commitment guaranteeing permission for foreign research scholars. Numerous officials sought to assure me that work in libraries and other relatively safe venues in Tehran would likely be permissible, but they did not know about the actual issuing of permits or even whether visas would be obtainable.

There was general agreement that archaeological field permits that year would not be issued to any foreigners and not just Americans. That was because there were no effective security forces in the provinces, and the greatest danger for both native Iranian and foreign archaeologists was the prevalence of armed, illegal excavators. Much to the disappointment of several American archaeologists who needed to complete dissertation research and other projects based on artifacts at the Iran Bastan Museum, the museum had been sealed to prevent theft during those unsettled times. It was becoming apparent that not much was going to be decided under the interim government of Prime Minister Bazargan, and these uncertainties had a negative effect on our various efforts to secure funding.

I set about acquiring resources for the libraries of several of the Institute's members and the Library of Congress, trying to collect as much material on the Iranian Revolution as possible, including a vast outpouring of books, pamphlets, cassette tapes, and even wall posters. I went to dealers near Tehran University and in the bazaar and visited small publishers and presses, managing to get discounts with several of them. From there, I began to assemble packages for shipment, initially to the University of Michigan and the Library of Congress. In July, I returned to America and joined the efforts to obtain modest support from ICA in Washington, which ICA was generally positive to provide.

For my final stay at the Institute's Tehran Center, I arrived on August 13, having missed by only a few hours the considerable clashes in the neighborhood of the Institute during the previous evening. Demonstrations along Shahreza and Kakh in protest of the closures earlier in the week of *Ayandegan* and other newspapers had turned into violent clashes, leaving over three hundred hospitalized. Political parties and meetings were becoming banned, and opposition leaders had gone into hiding. Streets were crowded with protestors, and there was frequent gunfire. There was a standoff between government supporters and the Mojahedin-e Khalq, whose headquarters were at the

Pahlavi Foundation building on the former Pahlavi Avenue not far from the Center. The prevailing insecurity led me to consider changing the location of the Tehran Center, which in any case had become increasingly decrepit with physical problems ranging from falling plaster to tangled and antiquated electrical circuits. It was apparent that if the Institute were to continue, a more suitable building in better structural condition would be needed.

The summer of 1979 offered plenty of real estate opportunities to obtain a property that would provide greater security. The landlord of the Institute's hostel, which was the ground floor of a two-story building across the street, offered to rent out the whole building to us, but it was not in very good condition. The most attractive opportunity was the entire second floor of a well-located building near Ferdowsi Circle and behind Leon's Grill Room (one of our favorite restaurants that had gone out of business). It had sufficient space for offices, several hostel rooms, a library, a garden, and a parking lot. It would have served us well. But the rising level of insecurity in Tehran in the summer of 1979 eventually led me to conclude that we should remain where we were. I decided to abandon negotiations for the Ferdowsi building and to work instead to improve our facilities on Moshtaq. An additional reason not to enter into a new rent agreement elsewhere was that the Institute still was experiencing major budgetary uncertainty, since there had been no news about the expected grant from the ICA (which did not arrive until August 28).

In exchange for the landlord's forgiveness of a couple of month's rent, I set about to do renovations. Several walls were replastered, crumbling ceilings replaced, a large colony of mice hauled away, and electrical connections rewired. In its final months, the Tehran Center looked better than it had in years.

With my family in Michigan and unable to return to Iran, since schools for foreign children had been closed in Tehran, I informed the Institute's board that I would have to leave my position as director. Since the building had been repaired and there was very little further that I could do, I prepared to return to the United States on October 5. In consideration of the increasing instability on the streets and perceptible anti-Americanism, friends at the American Embassy offered to house the Institute's library for safekeeping. I declined, sensing that the Center would probably be a safer place. I hired a part-time office assistant to look after the Center along with the housekeeper until a new director could be identified.

At the Institute's annual meeting held at the Middle East Studies Association conference in Salt Lake City on November 10, a few days after the takeover of the American Embassy in Tehran, I recommended that the Tehran Center be closed. The situation in Tehran and the lack of an embassy made it seem no longer justifiable to maintain the Center under a new director. Nonetheless, in subsequent months the search for a new director continued.

On the evening of November 14, I received a frantic telephone call from the Center's housekeeper Mahmud, who reported that the office assistant had made off with a truckload of belongings from the Center. The housekeeper reported the loss to the local revolutionary *komiteh*, which located the office assistant, seized all of the Institute's property, and returned it to the Institute's courtyard before posting a guard at the door. In early December 1980, representatives of the Bonyad-e Mostaz'afan (the Foundation of the Oppressed) entered the Center and removed the library and furnishings. With that, William Hanaway Jr., the Institute's president since November 1979, informed the board that there was no longer any point in keeping the house.

Despite the unceasingly dismal state of relations between Iran and the United States, and the impossibility so far of reopening the Center in Tehran, maintaining a center in Tehran has always been the fundamental purpose of the American Institute of Iranian Studies. While continuing to promote Iranian studies in the United States and supporting students and scholars in the field, the Institute has retained its corporate formalities and maintained its institutional base for the eventual day that relations between the two countries improve and scholars from the United States can return to Iran.

CHAPTER 4

The American Institute of Iranian Studies in the Twenty-First Century

Erica Ehrenberg

FROM THE TURN of the twenty-first century to the present, the American Institute of Iranian Studies (hereafter AIIrS) has developed and tailored its programmatic offerings in order to ensure the continuity of its mission—the promotion of Iranian studies and the facilitation of research by scholars in its various disciplines. In its pursuits, AIIrS coordinates closely with its university and museum members and with the Council of American Overseas Research Centers (CAORC) in Washington, DC, of which AIIrS is a founding member. The majority of AIIrS's funding comes in the form of grants received by and channeled through CAORC and dedicated to the operations of American overseas centers across the globe, currently twenty-six in number. AIIrS also receives occasional grants from foundations and annual dues from its member institutions. It has benefited from the advice and cooperation of the Permanent Mission of the Islamic Republic of Iran to the United Nations regarding opportunities for American scholars of Iranian studies to pursue research in Iran.

During periods when study visas are available to US citizens, AIIrS awards grants for language training and research in Iran. When visas are not readily obtainable, AIIrS awards grants for research in countries with resources relevant to the topic at hand. Supplementing its fellowship activities, AIIrS underwrites conferences and other projects consistent with its aims. Through its board—a brain-trust of scholars across all disciplines of Iranian studies at universities and museums around the country—AIIrS serves as a platform for advocacy of the field nationally.

After two decades of circumscribing its activities to projects within the United States following the closure of its center in Tehran in 1979, AIIrS reestablished academic ties with Iran in the late 1990s. The resumption of American study in Iran was heralded in 1998, when the possibility of resumed contact presented itself under the auspices of the Dialogue of Civilizations initiative advanced by then-Iranian President Mohammad Khatami and formalized by the General Assembly, which adopted a resolution proclaiming the United Nations Year of Dialogue among Civilizations. In response, AIIrS officers William L. Hanaway and Brian

Spooner worked with the Permanent Mission of the Islamic Republic of Iran to the United Nations to develop a language training session in Iran for Americans, forwarding a primary goal of AIIrS—namely, the support of Persian language instruction in native-speaking environments to ensure that young American scholars in the field might acquire requisite proficiency to conduct advanced research. During the summer of that same year, AIIrS selected nine graduate students for a summer of intensive study in Iran. Local costs in Tehran were covered by the Iranian Ministry of Culture and Higher Education, and international travel was covered by the United States Information Agency. While in Iran, the students also conducted research relevant to their doctoral dissertations. Owing to the success of this pilot program, AIIrS began awarding grants for individual graduate students in various disciplines of Iranian studies to undertake language training in Tehran at the International Center for Persian Studies / Dehkhoda Institute of the University of Tehran. In 2014, a new partnership program for graduate-level Persian language training was initiated with the Saʿdi Foundation in Tehran.

AIIrS subsequently instituted a longer-term grant for senior American scholars of Iranian studies to pursue research in Iran. Having a significant amount of time in Iran allowed these scholars to familiarize themselves (and consequently the American academic community) with research facilities and resources in Iran that had not been available to Americans for many years. These senior fellows also assisted the AIIrS graduate student fellows enrolled in the language program at the Dehkhoda Institute. The first holders of this post were Paul Losensky and then James D. Clark, who held the tenure for successive years and later designed the AIIrS Persian language program in Tajikistan.

With the research landscape in Iran once again ascertainable, AIIrS formulated a short-term research grant for senior scholars requesting a few weeks of support to consult resources in Iran as a component of a larger research topic. With this new line of grants in operation, AIIrS also developed a reciprocal grant for senior Iranian scholars to pursue specific lines of research in the United States for up to one month. Many of these grant awards were facilitated by AIIrS trustees, whose home universities and museums served as host institutions for the scholars. Traveling in both directions, Iranian and American scholars gained exposure to human, archival, and museum resources; research and institutional trends; disciplinary approaches; and the configuration of Iranian studies as a field in the United States and Iran respectively.

When student visas for Iran became difficult to obtain with increasing tensions between the United States and Iran as the first decade of the millennium progressed, AIIrS was determined that Persian language training for American graduate students in a native-speaking environment would not cease, as it had during the 1980s and '90s. It looked to Tajikistan, where it had operated an incipient program in 1992 that could not continue thereafter as a result of

the ensuing civil war in that country. In 2006 AIIrS was invited by CAORC to apply for funds to establish a summer program for Persian language studies in Tajikistan as part of the larger Critical Languages Scholarship program being developed by various American overseas research centers in numerous countries. Under the aegis of AIIrS Overseas Director James Clark and with backing from the Embassy of Tajikistan in Washington, DC and the Academy of Sciences of the Republic of Tajikistan, AIIrS established a program of intensive training in beginning, intermediate, and advanced standard Persian (in Arabic script) and introductory Tajik Persian (in Cyrillic script). Stationed in Dushanbe, Clark hired faculty from Tajikistan and Iran; held language pedagogy workshops with instructors from Tajikistan, Russia, and the United States; devised curricula, syllabi, and cultural programs; and contracted classroom space and apartments for students and faculty. The Tajikistan program, accommodating about fifteen students each summer, ran through 2012.

Research topics that have been supported by AIIrS since travel grants were reinstated have swept the interdisciplinary range of Iranian studies in many fields of the humanities and social sciences, including language and literature, ancient and modern history, archaeology, art and architectural history, political sciences, philosophy, religion, sociology, and anthropology. Subjects investigated by American AIIrS fellows include:

Political Science
 Persianate kingship, Hanafi law, and Muslim political ideology in the medieval period
 Russo-Caucasian political protest in northern Iran, 1915–22
 Comparative study of French, Russian, and Iranian Revolutions
 Urban consumer capitalism and cultural practices under Mohammed Reza Shah
 Electoral processes in Iran, Egypt, Burma, and the Philippines
 Financial sanctions in the Persian Gulf from the late nineteenth century to the present
 Oil workers in Abadan in the early twentieth century
 Influence of the Anglo-Iranian Oil Company in Iran in the early twentieth-century

Sociology
 Female *Javānmardī* in the premodern Persianate world
 Modernization, individualization, and aging in the Islamic Republic
 Rural development in Iran
 Social security and welfare in Iran
 Adoption in Iran

Ethnicity in Iran
Human genetics research in Iran under the Pahlavi dynasty
Primary schooling in Iran
Iranian diaspora in the United States

Religion and Philosophy
Canonization of al-Bukhārī and Muslim
Eleventh-century Fatimid Ismaʿili missionary al-Muʾayyad fi-al-Din Shirazi
Khorasanian Sufi saint Ahmad-i Jām (1049–1141) and his descendants
Religious identity in Rumi's *Masnavi*
Zoroastrian *Rivāyats* from the late fifteenth to late eighteenth centuries
Umma and identity in early Muslim Iran
History of rational processes in Muslim scholarly culture
Reception history of Mullah Husain Vaʾez Kashefi's *Rowzat al-Shohada*
Ismaili Tradition in Central Asia
Persianate Sufism
Shiʿi jurisprudence and theology
Women's participation in the Shiʿi community of remembrance
Theoretical and ideological debates among Iran's Shiʿite thinkers
Role of philosophy in religious education in Iran

History
Historical biography of Fatima
Political patronage in early modern Iran (Safavid dynasty, 1501–1722)
Safavid involvement in seventeenth-century Eurasia
Political authority in post-Safavid Iran and relations with the Caspian and Caucasus
Historiography and diplomatic history of the Afsharid era
Eighteenth-century diplomatic relations between Iran and the Ottoman Empire
Eighteenth-century Punjab and the legitimization of power
Islamic populism in Qajar Iran
Role of British consuls in the strategic and economic interests in Iran, 1889–1921
Role of Iranian women in the Constitutional Revolution
History of Iranian press and media

Literature
Sasanian wisdom texts
Portrayals of the Bahram Gur period in literature
Literary dimensions in historiographic discourses of the Middle Ages

Persian poetic forms as conduits for the Sufi tradition of the medieval Persianate world
Akhlaq advice literature
Urban and architectural poetry of the Safavid period
Links between political and literary history in Iran during the reign of Tahmasb I
Nineteenth-century Persian poet and scholar Mirza Ghalib
Despair and irony in *Mantiq al-Tayr* (Conference of the Birds)
Shahrāshūb and urban subjectivity in the early modern Persianate world
Persianate literature of South Asia

Archaeology, Architecture, and Art History
Early Bronze Age trade and sociopolitical organization in northeastern Iran
Bronze and Iron Age materials in the Iran National Museum
Sasanian seals and bullae in the Iran National Museum
Archaeology and nationalism in the Middle East, 1919–39
Medieval Buyid silks
Sixteenth-century Persian book arts
Timurid manuscript tradition in sixteenth-century Eurasia
Role of Safavid carpets in mediating space in the early modern Islamic world
Visual and material history of Italian-Iranian diplomatic exchange in the Safavid period
Seventeenth-century Persian painting and the Armenian community of New Julfa
The art of paper marbling in the Islamic world
The innovations of the Qajar calligrapher Mirza Muhammad Reza Kalhor (1829–1892)
Qajar photography
Images of modernity in Iranian visual culture during the rule of Reza Shah
Public images of Fatima
The Central Martyrs' Museum in Tehran: grave photographs and funerary objects
Visual culture of war in Iran
Modernity, national identity, and monuments in twentieth-century Iran
Contemporary Iranian women artists
International Iranian art market
City of Tehran: past, present and future

Ethnomusicology
Role of music in relation to Iranian-American concepts of identity
Role of music in the arena of identity in postrevolutionary Iran

Subjects treated by Iranian fellows of AIIrS who traveled to the United States include:

Religion
Dialogue between Islam and Christianity
Ruzbihan Baqli and mysticism in the twelfth-century

Language, Literature, and Translation
Comparative syntax of Old Iranian and Classical Greek
Comparative verbal system of the Baluchi language
Semantic approaches to compilation of a Persian language thesaurus
Popularity of Rumi in the United States
Links between literature and psychology in Saʿdi's *Gulistan*
New edition of Sadeq Hedayat's *The Blind Owl*
Persian translation of books 7 and 8 of Plato's *Republic*
English translation of a Syriac essay by Paul the Persian to King Khosrow Anushirwan
English translation of Ahmad Ghazali's *Sawanih* and of the poetry of Jalal-e Tabib
English translation of Borhan al-Din Mohaqqeq Termezi's *Maʿaref* from circa 1232 to 1240

Archaeology, Architecture, and Art History
Macrobotanical material from excavations in Tall-e Mushki, Jari and Bakun
Activities and Projects of the Centre of Achaemenid Studies
Persepolis Fortification tablets
Persian lusterware of the Ilkhanid period
The shrine of Sheykh Safi in Ardabil
Indo-Iranian painting
Digital anthology of masterworks of Persian calligraphy
Architectural education in Iran

Culture
Women's movements in Iran
Cultural and intellectual trends in contemporary Iran

In addition to supporting individual fellows, AIIrS has assisted scholarly organizations as well, helping them realize academic conferences in various countries. As with the fellowship program, the purpose of the conference grants has been to support research in Iranian studies and offer opportunities for the exchange of ideas and scholarship among scholars from different

countries. Organizations with which AIIrS has partnered in convening conferences include:

> Association for Iranian Studies (AIS): biennial conferences in London, 2006; Toronto, 2008; Los Angeles, 2010; Montreal, 2014
> Association for the Study of Persianate Societies (ASPS): biennial conferences in Lahore, 2009; Sarajevo, 2013; Tbilisi, 2018; Yerevan, 2023
> Iran Heritage Foundation and British Museum: conference on the poetic mastery of Jalal al-Din Rumi, London, 2007
> International Society for Iranian Culture: conference on the promotion of Persian language in North America in honor of Professor Mahdavi Damghani, New York City, 2012
> Symposia Iranica: biennial conferences 2017, 2019
> Middle East Studies Association (MESA): panel on linguistic and cultural exchange in the wider Persianate cultural sphere, Washington, DC, 2008; panel on conducting research in Iran, Boston, 2016; panel on museum collections of Persian art, Washington, DC, 2017
> American Society of Overseas Research (ASOR): annual conference panels on recent excavations in Iran
> Textile Museum: symposium on classical Persian carpet fragments, Washington, DC, 2006
> Metropolitan Museum of Art: workshop for Iranian-American artists, New York City, 2011
> Yale University: Iranian Studies Initiative workshop and speakers' series, New Haven, 2012
> Columbia University: conference on the history of Islamic studies in North America, 2013; university seminars on Iran; ongoing
> Asian American Writers' Workshop presentation "Shahnameh, Order, and Myth," New York City, 2014
> University of Santa Barbara: Iranian Studies Initiative conference on family and marriage in contemporary Iran, 2017
> Archaeological Legacy Institute: Archeology Channel Film Festival, Oregon, 2017
> University of North Carolina at Chapel Hill: symposium on revisiting discourses of love, sex and desire in modern Iran and diaspora, 2019
> University of Nebraska at Omaha: roundtables on contemporary Iran, 2018, 2019, 2021, 2023

AIIrS has also collaborated with its fellow American overseas research centers on a variety of projects from individual fellow support to conferences and exhibitions. These projects have drawn jointly on the human and financial

resources of: American Institute of Indian Studies (AIIS), American Institute of Pakistan Studies (AIPS), and American Institute of Afghanistan Studies (AIAS).

With its grants for academic research and programs reestablished, AIIrS expanded its bailiwick to encompass cultural projects, especially in the realm of the visual arts. In 2004, AIIrS subsidized the United Nations exhibition of a display of photographs of the city and fortress of Bam, which was cosponsored by the Iranian Ministry of Culture and Islamic Guidance, the Permanent Representative of the Islamic Republic of Iran to the United Nations, the Iranian Academy of Arts, and the International Society for Iranian Culture (based in New York City). The exhibit then moved to the Library of Congress, where it was also subsidized by AIIrS and accompanied a conference organized by an AIIrS fellow that traced Bam's historical evolution.

Support for museum exhibitions showcasing Iranian art has become an increasingly larger component of AIIrS's endeavor to bring Persian culture to the general public. Numerous undertakings by the Metropolitan Museum of Art in New York City have received financial underwriting from AIIrS. In 2011, AIIrS helped celebrate the reopening of the galleries of Islamic art at the Metropolitan Museum through a grant allowing for an expanded program of gallery talks and public lectures about the new permanent exhibition. Funding from AIIrS also enabled the Metropolitan Museum to undertake significant research on Iranian material for exhibitions on the first millennium BCE (2014) and the Seljuk period (2015) as well as on inscriptions on Persian objects in the permanent collection, all of which were published on the Metropolitan Museum's web-based museum catalog.

In 2013, AIIrS partnered with the Asia Society in New York City toward the realization of the exhibition there on Iranian modern art that showcased works by luminary artists in the three decades leading up to the Islamic Revolution. Aside from exhibition support, AIIrS underwrote a number of public programs, including a symposium on the Shiraz Arts Festival, a film series on Iran's New Wave Cinema of the 1960s and '70s, and panel discussions on Iranian visual arts of the modern and contemporary periods. Also in 2013, AIIrS lent support to the Freer Gallery of Art / Arthur M. Sackler Gallery in Washington, DC, for educational materials related to the "Cyrus Cylinder" exhibition there. In the US Midwest, AIIrS made an exhibition grant to the Oriental Institute of the University of Chicago for their exhibition (2020–21) of the photographic prints of Qajar photographer Antoin Sevrugin. On the West Coast, AIIrS supported several public programs at the Los Angeles County Museum of Art, including an exhibition (2012) of work by the contemporary Iranian artist Siamak Filizadeh as well as several lectures on Islamic and contemporary Iranian art.

In its efforts to promote further the visual culture of Iran, AIIrS funded the "virtual museum" website of the Grey Art Gallery of New York University, highlighting the gallery's collection of modern and contemporary Iranian art, the largest and one of the most important collections outside of Iran. Beyond museum walls, both real and virtual, AIIrS has also celebrated the practice of Iranian and Persian culture by partnering in with another New York City–based nonprofit organization, the Persian Arts Festival, to present multiarts evenings in honor of Nowruz.

On occasion, AIIrS has provided partial subventions to realize the publication of scholarly works in the field. It effectuated the 2003 publication of the Festschrift for William Sumner, entitled *Yeki bud, yeki nabud: Essays on the Archaeology of Iran in Honor of William M. Sumner*, which was edited by Naomi F. Miller and Kamyar Abdi and published in association with the University of Pennsylvania Museum of Archaeology and Anthropology. Sumner served as the first AIIrS Resident Director in Tehran from 1969 to 1971 after the establishment of the Tehran Center. The essays in this volume address manifold aspects of his research in Iranian archaeology. An AIIrS subvention provided in 2007 facilitated the publication of *Vaqaaʿi-yi musaafirat* (1888), a travelogue written in Persian by Mir Laiq Ali Khan—known as Salar Jang II (1861–1889)—who was the prime minister to the Nizam of Hyderabad. This book was published by the Nashr-e Tarikh Press in Tehran as a collaboration between scholars in the United States (Omar Khalidi and Sunil Sharma) and Iran (Mansoureh Ettehadieh and Pamela Karimi). Only a few copies of the travelogue were lithographed and distributed privately when it appeared in 1888. The lithographed text is riddled with typographical errors, and sometimes even the order of the entries is confused. As a result, scholars had felt the need for a modern edition of the text. A publication subvention was awarded to Syracuse University Press in 2020 to publish *Iranian Women and Gender in the Iran-Iraq War* (Mateo Mohammad Farzaneh), presenting never-before-seen historical documents and photographs that offer a detailed account of women and their participation in the war. And in 2021, a grant was made to Mazda for a facsimile edition by Gregory Maxwell Bruce of a major work of Persian wisdom literature, *Nigāristān* (1334–35) by Muʿīn al-Dīn Juvainī, which is among the earliest imitations of Saʿdī's *Gulistān* and may be the first self-conscious imitation of Saʿdī's influential work. *Nigāristān* offers unique insights into the literary, social, and political culture of late Ilkhanid Iran in the months before the sudden dissolution of the empire. It is also an important work for historians of Persian literature, since it appears to have served as a bridge between the form and style of the *Gulistān* and later innovations by Jāmī and Vāʿiẓ Kāshifī at the Timurid court in Herat. Blending its support for the written word and visual culture, AIIrS subvented the 2013 publication

distributed by W. W. Norton of Hamid Rahmanian's illustrated *Shahnama* with a text adapted by Ahmad Sadri. The images presented in this work are composed of thousands of iconographical elements and motifs from hundreds of historical Persian miniatures and illuminations dating from the fifteenth to mid-nineteenth centuries from Iran, Mughal India, and the Ottoman Empire. An accompanying website explores the process of creation of the images and renders the illustrations accessible to all.

Beyond supporting occasional publications, AIIrS recognizes outstanding translations of literary works from Persian to English under the auspices of its Lois Roth Translation Prize. The prize was established in memory of Lois Roth, whose interest in and affection for Iran and Iranian culture dates back to the late 1960s, when she lived and worked in Iran as deputy to the Cultural Affairs Officer at the American Embassy and as Director of the Iran America Society. At that time, Lois Roth was one of a group of persons that helped initiate and encourage the founding of the American Institute of Iranian Studies. After her death in 1986, the Lois Roth Foundation was created. Since 1999, the Lois Roth Foundation has included, among many contributions to international programs, funding for the Lois Roth Persian Translation Prize juried by the American Institute of Iranian Studies. Following is a list of awarded works:

2000: Iraj Pezeshkzad, *My Uncle Napoleon*, trans. Dick Davis (Washington, DC: Mage, 1996)

2001: Farid al-Din Attar, *The Conference of the Birds*, trans. Afkham Darbandi and Dick Davis (Harmondsworth: Penguin, 1984)
The publication in 1987 of the translation of Attar's Conference of the Birds by Afkham Darbandi and Dick Davis was a watershed moment in the long history of Persian and English literary relations. English-speaking scholars and poets have labored since the eighteenth century to bring the richness, variety, and lyric beauty of Persian poetry into their own language. While there have been a few qualified successes, such as Gertrude Bell's rendering of Hafez, the one unquestioned triumph until now has been FitzGerald's remarkable recasting of randomly composed quatrains into the *Ruba'iyyat of Omar Khayyam*—a work that gained so eminent a place in English letters that it forced a reevaluation of the poet in his native land. Attar was a greater poet than Khayyam, and his *Conference* is an unquestioned masterpiece of the Sufi poetic tradition. The fluency, elegance, and precision of Darbandi and Davis's translation belies its foreign origins and makes it appear rather as a remarkable native innovation—a vivid and moving anthology of Sufi stories that has miraculously blossomed from the pen of an English poet. In short, it merits comparison with the best

translations from languages more familiar and better studied than Persian, such as Heaney's *Beowulf* or Fagles's *Odyssey* and *Iliad*. Despite a minimum of publicity, their *Conference* was quickly recognized by students of Persian literature as a masterwork and promises to serve for many years as the new standard by which translations from Persian will be judged.

2002: Ferdowsi, ***In the Dragon's Claws: The Story of Rostam and Esfandiyar,*** **trans. Jerome W. Clinton. (Washington, DC: Mage, 1999)**
This blank verse translation of the Rostam and Esfandyar story from Ferdowsi's *Shahnama* brings the noble and deceptively simple voice of Ferdowsi into English. Epic is no longer our medium, as we do not think in those ways, and the voices of epic are alien voices for us. To make such grandeur speak to us naturally and persuasively is almost impossibly hard. Jerry Clinton brought this seemingly insurmountable task off with great panache in his first translation from the *Shahnama* (his version of Sohrab and Rostam). When it appeared, it was clearly the finest verse translation of Ferdowsi in existence. In his version of the Esfandyar story, he has raised the bar even higher and written a superlatively fine version—faithful, moving, and beautiful with a stark nobility that matches Ferdowsi's own.

2003: Sadriddin Aini, ***The Sands of Oxus: Boyhood Reminiscences of Sadriddin Aini,*** **trans. John Perry and Rachel Lehr (Costa Mesa, CA: Mazda, 1998)**
Sadriddin Aini was the most significant and influential twentieth-century Tajik author, and his childhood autobiography is an enthralling book that not only provides us with a moving account of the author's childhood in late nineteenth and early twentieth-century Tajikistan but also describes in vivid detail a traditional way of life that was shortly to disappear forever. In this dual focus, Aini's richly evocative memoirs are comparable both to Gorki's (by which they were influenced, as Aini acknowledged) and to those of major Iranian Persian authors such as Jamalzadeh and Kasravi. John Perry and Rachel Lehr's translation is a delight to read; it is beautifully fluent and persuasive, and it constantly strikes a felicitous balance between evoking the distance of much of the material from the modern Anglophone world and employing clear, strong, and idiomatic English.

2004: Nizami, ***The Haft Paykar: A Medieval Persian Romance,*** **trans. Julie Meisami (Oxford: Oxford University Press, 1995)**
Nizami's *Haft Paykar*, the concluding narrative of his *Khamsa*, is one of those masterpieces of Persian poetry that was previously available to Anglophone readers only in summaries and prose paraphrases. What Julie Meisami brings

to this project is a surprising combination of rigorous academic apparatus and linguist inventiveness. At a moment when one of the biggest issues in theory of translation is the question of how much to domesticate the work—where to find the balance between writing fluently in English and retaining the strangeness of the original—she has found a way to combine the rough edge of a scholar's rigor (keeping the word *paykar* as an English transliteration, for instance, noting that it can be translated as seven images, seven portraits, seven beauties or seven planets in inconspicuous scholarly notes at the end of the book) with a colloquial and direct readable verse form that draws in the reader. Her bold decision to write in tetrameter—a rapid meter we associate in English with folkloric narrative—combines compression, readability, and speed. Even those who regard it an experiment acknowledge these finer qualities, which opens up new vistas of possibility for future translators.

2005: Rumi, *The Masnavi, Book 1*, trans. Jawid Mojaddedi (Oxford: Oxford University Press, 2003)
Rumi is a best-selling poet in the United States, whose work has reached English readers often through translations that present polished excerpts from his *Masnavi*, one of the most widely read poems in the Muslim world. Such selections typically excerpt the stories from the fabric of the work and fail to show the lineaments that thread one story to the next. Now English speakers are at a moment when a translation of the entire masterpiece, expressed in accessible contemporary language for a wider readership, is a desirable next step. This is a daunting task that requires a commitment of heroic patience and intellectual persistence. Jawid Mojaddedi has taken that step with the first volume of his projected complete verse translation. We honor him for his success in a timely contribution to English letters. There are translations that introduce new voices to us, and others that make the voices we had thought familiar seem new. New generations need new translations of the classics, and we feel that we now have the voice of Rumi's *Masnavi* in the idiom of today, one that can take its place alongside modern translations of Ferdowsi, Dante, and Homer. Making Rumi available to us in his complexity and his discursive, conversational persona is a great and lasting contribution, and we would be pleased if this award confirms Mojaddedi in the commitment to translate the remaining five books of this great mystical-didactic poem.

2006: Simin Behbahani, *A Cup of Sin: Selected Poems*, trans. Farzaneh Milani and Kaveh Safa (Syracuse: Syracuse University Press, 1999)
In *A Cup of Sin*, Farzaneh Milani and Kaveh Safa introduce a distinctive and often compelling poetic voice to English-speaking readers. Simin Behbahani, Iran's most celebrated living poet, writes courageously and incisively—

a compelling female voice that does not flinch from poetic, personal, or political engagement. Behbehani's poetry is grounded in the fixed forms and traditional versification of the Persian literary heritage but is modern in its themes and speech rhythms as well as thoughtfully innovative in its adaptation and expansion of prosodic conventions. A poet much concerned with form and metrics like Behbehani presents an immense challenge for translation, but Milani and Safa have pioneered the path to a convincing English idiom. Unlike Farrokhzad or Sepehri, whose poems were more readily portable to an "international" lyric idiom (one thinks here of the relative mobility across European language boundaries of poets like Lorca, Paz, Celan, Rilke, or Milosz), Behbehani's mode of lyricism is rooted in its Persian-ness, more particularly in the *ghazal* form. Milani and Safa's approach to translating the modern Persian *ghazal* is exciting, and the engaging explication and analysis (including an autobiographical essay by Behbehani herself) creates a contextual framework for new readers to approach the poems of this talented yet, at least to English readers, almost unknown poet. Given the sizeable proportions of Behbehani's still expanding *oeuvre*, the translators' careful culling of the poems to present in translation is to be much commended. The informative discussion of translation considerations and practices in Safa's afterword will provide food for thought for future translators, as it also deepens our appreciation of the notable achievement of *A Cup of Sin*.

2008: Shahrokh Meskoob, *Translating the Garden*, trans. Mohammad Ghanoonparvar (Austin, TX: University of Texas Press, 2001)

The late Shahrokh Meskoob's *Dialogue in the Garden* (*Goftogu dar bāgh*, originally published in Tehran in 1992), provides us with a meandering conversation between a young man (Shahrokh) and his Uncle Farhad. While the reader might be tempted to assume Meskoob has written a straightforward autobiography, the pathways of their dialogue take them into universal themes of change and stability, youth and experience, and tradition confronted by new ways. Like the Persian miniatures they analyze, the work piles on rich detail, looping around and around itself so that even in a tight space one feels overwhelmed. And like the inner spirituality of contemporary abstract art, which Uncle Farhad wants his nephew to appreciate, the way toward this inner connection is not always clear. In its dynamic progression of conversation, which sometimes takes a bewildering structure and can appear to lack direction, Meskoob's short work unveils traditional Persian culture and contemporary Iranian feelings, especially the feelings of Iranians separated from their country, their garden. Mohammad Ghanoonparvar's choice of this author and work for translation is daring, presenting English readers with an original and unique voice whose name was, however, previously unknown to

non-Persian speakers. Furthermore, the task of translating a novella that consists almost entirely of a conversation, and a highly literary and philosophical conversation at that, presents the peculiar and difficult challenge of striking a believable register and idiom for the dialogue. The freshness and lucidity of the translation is testimony to the translator's skill and his long-standing commitment to sharing the artistry of modern Iranian authors with a wider audience. But this is only the second half of *Dialogue in the Garden*. In the first half, the translator has given a gift to all those who would attempt literary translation. Here he records his personal reflections, his own dynamic progression through Meskoob's work, reflecting English off the Persian and back again. In this process, Ghanoonparvar reveals the dynamic poesis of original creativity that constitutes true translation. We see the translator struggling to hold himself in check, to respect the author and transpose that author's sensibility into the target language. With its two balanced parts, *Dialogue in the Garden* is self-reflective on many levels, and it sets before us a multivalenced portrait of Iranian-ness, of exile and transposition, of the craft and art of translation, and of recovery of the prelapsarian, preexilic state.

2010: Forugh Farrokhzad, *Sin: Selected Poems of Forugh Farrokhzad*, trans. Sholeh Wolpe (Fayetteville, AR: University of Arkansas Press, 2008)

Some great poets never find their perfect match in a translator who can render them as an essential poet in a new language. In the case of European masterworks, the process of translation frequently assumes the characteristic of a collective project, one to which many different hands—or voices—contribute over time and help refine. In the case of poets working in non-Western languages, this is not so often the case, and a single anthology in translation is all to which a poet can aspire. Rarely do we encounter a contemporary Persian poet with the rich and multiple translation history that Forugh Farrokhzad has enjoyed. Her best poems place her squarely within the pantheon of the foremost poets of world-literature writing in the twentieth century. Now, in Sholeh Wolpe's recent selection of Farrokhzad's poems, we find English versions fully in tune with the vibrant idioms of contemporary American poetry. An outstanding translation often creates the possibility for a fresh encounter with an oft-read original text. In Wolpe's vital translation, a musical and compelling English version that draws readers along and captures a sense of the exquisitely balanced pacing of Farrokhzad's language and the immediacy and authenticity of her voice, readers find themselves experiencing Forugh's Persian poems with new eyes. Wolpe's *Sin* is a convincing poetic translation, one that should help Farrokhzad claim her rightful place in the international canon of poetry. And we hope it will open the door in broader

poetry circles for fresh translations of other modern and classical Persian poets.

2012: Fakhraddin Gorgani, *Vis and Ramin*, trans. Dick Davis (Washington, DC: Mage, 2008; New York: Penguin, 2009)
In recent years, the crop of translations of both modern and premodern Persian works of literature has been particularly rich. Among these, Dick Davis's translation of *Vis and Ramin* stands out for the contribution it makes to the history of modern English letters, rendering the Persian text into charming, fluid, and suspenseful rhyming verse, a virtuosic narrative feat smoothly sustained throughout its nearly five hundred pages. With an erudite yet very elegant introduction, Davis sets the work solidly in dialogue with the Greek novels of late antiquity and with the medieval romances of Europe, paving the way for this unique Parthian romance (in Gorgani's eleventh-century retelling) to assume its rightful place in the canon of world literature and in the wider literary curriculum. Davis's translation, beginning with the story proper, is informed by the latest scholarship, yet it presents the reader—even those Anglophone readers who may not have the habit of reading long narrative poems in verse—with an engagingly attractive and deceptively simple language that draws us magnetically onward into the thick of the plot with its unexpected twists and turns. The publication of excerpts of Davis's translation of *Vis and Ramin* in *The Hudson Review* and in *The New Criterion*, and its adoption into the Penguin Classics series, demonstrate how this most prolific of contemporary translators is helping to win anew a wider appreciation and public readership for works of Persian literature in English.

2014: Hafez, *Hafez: Translations and Interpretations of the Ghazals*, trans. Geoffery Squires (Oxford, OH: Miami University Press, 2014)
Since Sir William Jones first made the attempt to set in English the "orient pearls at random strung" of Hafez, the most canonical of Persian lyric poets, dozens of translators have attempted English translations and versions of Hafez, but few have succeeded. Squires's *Hafez* captures the energy and depth of this fourteenth-century poet in contemporary English without archaisms or predetermined interpretation. It displays a supple and at times even exhilarating handling of language and form. The integration of annotations and commentary provide the uninitiated reader with the right balance of background information and a personal, lyrical encounter with the raw poem. Squires's intimate familiarity with the poems, and the clarity and crispness of the diction he employs, almost makes Hafez a contemporary writer but does so without obscuring from today's reader the chronological and cultural differences as well as the unique qualities of the fixed-form *ghazal* he practiced.

2016: Ahmad Shamlu, *Born upon the Dark Spear: Selected Poems of Ahmad Shamlu,* **trans. Jason Bahbak Mohaghegh (New York: Contra Mundum, 2015)**
Known for his voice of resilient defiance and political dissent, Shamlu is one of the most prominent literary figures in twentieth-century Iran, evidenced by his nomination for a Nobel Prize in Literature in 1984. While previous translations of Shamlu's work have been limited in scope, leaving his poetry relatively unknown in the English-speaking world, *Born upon the Dark Spear* showcases seventy-eight poems from throughout his career, honoring his use of poetry to respond to the political tyranny and social upheaval he observed in his country. Mohaghegh's translation is noteworthy not only for its groundbreaking collection of poems but also for its exceptional quality. *Born upon the Dark Spear* expertly captures the tone and spirit of Shamlu's poetry, enabling readers to engage with it not only as a piece of history but also as an ever-relevant commentary on an individual's response to inequality, oppression, and indifference.

2021: Iraj Pezeshkzad, *Hafez in Love,* **trans. Patricia J. Higgins and Pouneh Shabani-Jadidi (Syracuse: Syracuse University Press, 2021)**
Iraj Pezeshkzad (b. 1928) is one of Iran's most popular novelists and the author of the social satire of modern Iranian manners entitled *My Uncle Napoleon* (translated by Dick Davis, winner of the first Roth Prize for Literary Translation from Persian). Pezeshkzad's 2004 historical fiction, *Hāfez-e nā-shenide pand,* now available in an elegant English translation by Pouneh Shabani-Jadidi and Patricia Higgins as *Hafez in Love,* is set in mid-fourteenth-century Shiraz and depicts the intellectual and political atmosphere of the city during the period following the collapse of the Il Khanid empire through two principal characters: the famous lyrical poet Hafez (d. 1392) and the notorious political satirist 'Obayd-e Zakani (d. ca. 1371). With a light-hearted and almost comic mood, the novel follows these familiar figures through imagined encounters with family members, other poets, and the religious and political leaders of the day. And, of course, the cat. *Hafez in Love* is an excellent example of two important rules of translation—accuracy and readability—achieving a fine balance between the narrative prose, the dialogue, and the frequent quotations of classical Persian poetry. In this literary work, one senses a manner of storytelling quite distinctive from the usual norms of American novels, yet this distinctiveness in no way impedes comprehension or enjoyment of the text. Appendices provide the reader with a glossary of the significant names and terms occurring in the book as well as the Persian first lines for all the poems quoted—a thoughtful touch for those who wish to consult the original. The publication of this book does even more to advance the study and appreciation of Hafez among Anglophone audiences, following the footsteps of two anthologies of Hafez in translation, *Faces of Love*

by Dick Davis (Mage, 2012) and Geoffrey Squires's *Hafez* (Miami University Press, 2014—winner of the Roth Prize of that year), along with Dominic Brookshaw's *Hafiz and His Contemporaries* (Bloomsbury, 2019) and M. R. Ghanoonparvar's translation of *In the Valley of the Friend*, by Shahrokh Meskoob (Syracuse University Press, 2019). With such a welcome array of new studies and translations now available, it is hoped that Hafez—and Pezeshkzad—may look forward to a revitalized interest in the English-speaking world.

2023: Sadeq Hedayat, *Blind Owl*, trans. Sassan Tabatabai (New York: Penguin Classics, 2022).
The original novella, *Buf-e kur*, first appeared in 1936 in a small run of privately circulated copies and was then published in Iran in 1941. A landmark work in the history of modern Persian literature, its author Sadeq Hedayat (1903–1951) was a pioneering Persian writer and translator who was prolific in his production of novels and short stories among other writings. Banned and censored at various times, the novella's story is told in the first-person voice with a mix of fragmentary recollections of an opium addict and the stream of consciousness thoughts of a troubled man caught between traditional and modern life in Iran. Tabatabai's new translation lucidly captures the appropriate tone of the text with the use of the most apt idiomatic expressions along with an evocative representation of an important era in Iran's cultural history. Tabatabai's expertise as a translator of Persian poetry into English comes through in his dramatic translation of Hedayat's novella, conveying the author's unique narrative style. Publication in the Penguin Classics series is a prestigious achievement for the translator and ensures a wide circulation for Hedayat's important work.

Along with its fellowships for individual scholars and support of conferences, exhibitions, and publications, AIIrS strives to advance the field of Iranian studies on a national level. It has lent its human resources to the International Institute for Education (IIE), which has been mandated to sponsor educational exchanges between the United States and abroad. When still operating out of its Tehran Center, AIIrS assisted the IIE in vetting candidates for its Fulbright grants. AIIrS's own consortium of member universities and museums continues to grow, and each institution has a voice on the AIIrS board through its trustee representative. Through this network, including trustees-at-large from institutions that are not members, AIIrS keeps abreast of developments in the field and has convened trustee conferences to take its pulse and make recommendations. In previous years, AIIrS held a roundtable discussion on academic exchange between Iran and the United States, conference panels on conducting research in Iran and on Iranian art in US museums, and a workshop on Iranian studies in the United States, of which this present volume is the outcome.

CHAPTER 5

The Council of American Overseas Research Centers

Richard L. Spees

THE COUNCIL OF American Overseas Research Centers (CAORC) serves as a federation of the American overseas research centers, which are independent organizations located around the globe that provide essential host country support for American scholars working in foreign countries primarily in the arts, humanities, and greater social sciences. American overseas research centers are little-known outside academic and foreign policy circles. Nevertheless, they play an important role in promoting international scholarship and creating links between the scholarly communities in the United States and the countries in which they are located. The American Institute of Iranian Studies (AIIrS) was a founding member of CAORC.

Before CAORC was founded, there were a number of independent research centers dedicated to supporting American scholars conducting work overseas in the fields of the social sciences, humanities, and cultural heritage. Some of these centers were over a century old, such as the American School of Classical Studies at Athens, which was founded in 1881. Others were founded after World War II, when the United States expanded its diplomatic and scholarly reach throughout the world. Still other centers were created in response to the needs of US scholars and institutions to conduct research in specific host countries, such as AIIrS, which was founded in 1967.

The growing complexity of international research was increasing the need for the services of the centers; however, lack of support from private and US governmental sources was beginning to threaten their work. In February 1978, after a few years of informal discussions between the centers on areas of joint concerns, the Smithsonian Institution and the American Academy of Arts and Sciences (AAAS) convened a meeting at Dumbarton Oaks that was supported by the Andrew W. Mellon Foundation. AAAS organized a study of the contributions of and problems faced by the centers. The resulting report, "Corners of a Foreign Field," edited by Robert (Bob) McCormack Adams, stated, "American overseas advanced research centers represent a geographically wide-flung

net of institutions affiliated with or operated by an American parent organization but situated in foreign countries, where they provide essential research support to American scholars. They girdle the globe from America to Europe and Asia. Their contribution to our understanding of their host countries and the United States has been enormous. They are priceless extensions of our institutions of learning." The report recommended that a planning committee begin work on the design of a cooperative association among the centers.

Subsequent meetings of the planning committee expanded on the original work. At the same time that the academic community was considering ways for the centers to collaborate, the Smithsonian Institution, which had its own history of sponsoring international education and research programs, asked Alice Ilchman, a former Assistant Secretary of State and then-president of Sarah Lawrence College, to review the Smithsonian's international programs and report on the prospects for long-term funding for the centers and the appropriate role of the Smithsonian in supporting and strengthening the centers. AAAS and the Smithsonian held a workshop with representatives of ten of the centers, along with several private foundations and government agencies, to explore potential future funding sources, consider ideas for new program opportunities that could strengthen the centers, and discuss the structure and role of a continuing organization. In the fall of 1981, after Ilchman's report was submitted to the Secretary of the Smithsonian, CAORC was established. William Hanaway and Brian Spooner, who both served as president of AIIrS, were among the original founders of CAORC.

The Smithsonian provided space for CAORC upon its founding in 1981 under the tenure of Secretary S. Dillon Ripley. Initially, CAORC was unincorporated and fairly informal with a budget of only $12,000. The purpose of CAORC was to raise the general level of funding for all the centers by increasing their visibility through publicizing their activities in a brochure and newsletters and by developing a mailing list.

Gradually, the needs of the centers demanded a more robust response from CAORC. Federal funding for international exchange programs was threatened. Reporting, auditing, and technical requirements of organizations that received federal grants became more complex and time-consuming. Many of the smaller centers simply did not have the capacity to manage the administration and legal requirements. Additional centers were created, with some needing technical assistance to get off the ground. The informal organization was not meeting all the needs of the centers.

In 1986, after Bob Adams became Secretary of the Smithsonian, CAORC began full-time operations and hired Dr. Mary Ellen Lane as Executive Director. Dr. Lane had recently returned from Egypt, where she served on the staff

of the American Research Center in Egypt (ARCE). Under her full-time leadership, CAORC took a larger role in its interactions with the federal government. It also began to expand its own programs and increase the funding levels for CAORC itself.

Over time, CAORC has greatly broadened its programs and support for the centers. In 1991, Lane testified before Congress when it was considering the reauthorization of the Higher Education Act and calling for Department of Education funding for the centers. In 1992, Congress enacted Section 610 of the Higher Education Act, which funds administrative and programmatic activities for the centers out of the Title VI programs at the Department of Education.

At that time, fellowship program funding for the centers was administered by the United States Information Agency (USIA) and routed through CAORC for distribution to the centers. In 1999, Congress passed legislation that disbanded USIA and placed the cultural exchange programs in the State Department under the Undersecretary of State for Public Diplomacy and Public Affairs. In 2006, the State Department asked CAORC to design and implement language programs at the centers through the newly established National Security Language Initiative (NSLI). This language program would later be known as the Critical Language Scholarship Program, which CAORC continued to implement through 2012, including the collaboration with AIIrS to conduct intensive Persian language programs in Tajikistan. Other federal funding sources for programs conducted with the centers have included the National Endowment for the Humanities, the Institute of Museum and Library Services, and the Library of Congress.

CAORC has also successfully developed collaborative programs funded by the Andrew W. Mellon Foundation, the Carnegie Corporation of New York, the Ford Foundation, the Getty Foundation, UNESCO, the J. M. Kaplan Fund, the International Alliance for the Protection of Heritage in Conflict Areas (ALIPH), and the Institute for International Exchange's Fulbright Scholar Program in West Africa. The most recent critical program that CAORC has undertaken is the Andrew W. Mellon Fellowship Program for At-Risk Afghan Scholars and Artists. Scholars in Afghanistan who faced persecution have been evacuated and supported in third countries. This is just a sample of the programs that CAORC has implemented or is currently administering.

CAORC is committed to supporting the overseas research centers in promoting advanced research, particularly in the humanities and social sciences, with a focus on the conservation and recording of cultural heritage, the

understanding and interpretation of modern societies, and intensive foreign language training. CAORC fosters research projects across national boundaries, encourages collaborative research as well as programmatic and administrative coherence among member centers, and works to expand their resource base and service capacity. CAORC responds to centers' concerns and problems and serves as a liaison among the centers, the federal government, and the foundation world.

CHAPTER 6

The Formative Decades of Iranian Studies in North America: An Overview

Ahmad Ashraf

IRANIAN STUDIES began in North America at the turn of the twentieth century and has undergone four phases of development. First came the advent of Old Iranian studies by students of philology and ancient religions from 1890 through the 1920s. Also in this period a number of museums developed an interest in collecting Iranian artifacts. The second phase began with the activities of archaeologists and art historians in the 1930s. The third phase was marked by the beginning of interest in modern Persian language and literature during World War II and the Cold War era of the 1940s and '50s. And, finally, the period from the early 1960s on has witnessed a rapid expansion and diversification of Iranian studies and a growing interest in the field by anthropologists, political scientists, historians, and students of Islamic studies.

The First Phase: The 1890s Through the 1920s

Iranian studies was introduced to American academic circles in the last decade of the nineteenth century by Abraham Valentine Williams Jackson of Columbia University, who may justifiably be regarded as the founder of Indo-Iranian studies in North America.[1] Jackson studied Sanskrit at Columbia College in 1879 and later studied comparative Avestan philology with Karl Geldner in Germany. He almost single-handedly directed and manned the Department of Indo-Iranian Languages (later a subdivision of the Department of Ancient and Oriental Languages) at Columbia University for some forty-six years. In addition, Jackson's interest in comparative philology, carried on by his student Louis H. Gray, ultimately led to the creation of the Department of Linguistics at Columbia. Jackson is perhaps best known for his *Zoroaster: The Prophet of Ancient Iran*.[2] Equally significant are Jackson's *An Avesta Grammar in Comparison with Sanskrit*,[3] and his *Avesta Reader: First Series*.[4] The Columbia University Catalogues for the years of his tenure show that year after year Jackson

carried a heavy course load, always teaching at least one course each in Avestan, Pahlavi, Sanskrit, Indo-Iranian history, and religion.[5]

The University of Pennsylvania was the next institution of higher education that introduced Iranian studies in North America. Roland Kent, a leading Indo-European linguist, began to teach at the University of Pennsylvania in the 1920s.[6] His work *Old Persian: Grammar, Text, and Lexicon* became the standard reference work for students of the language.[7]

During the same period, the interest in Iranian artifacts, particularly carpets, was growing among a number of collectors. In 1905, Charles Lang Freer donated his collection of art to the Smithsonian Institution in Washington, DC, together with funds for a museum building. This collection included a wide range of oriental art and a handsome smattering of Iranian objects. It was also during this period that the Metropolitan Museum of Art in New York City began to acquire its core collection of Iranian artifacts. During the interwar period, the Islamic collection of the Metropolitan Museum continued to grow. As a measure of its importance, its first curator, M. Dimand, was appointed in 1923 and published the first handbook on Islamic art in English based primarily on the Metropolitan Museum's own collection.[8]

The Second Phase: The 1930s

This period witnessed the development of interest at a number of North American universities, museums, and institutes in Iranian archaeology and art history. The rise of Reza Shah and his promotion of Iran's pre-Islamic heritage was an important factor. The Antiquities Law of 1930 terminated a long French monopoly of excavations and opened up new opportunities to North American archaeologists and art historians to enter the field.

The excavation of Persepolis was initiated in 1931 by Professor James Henry Breasted, director of the Oriental Institute of the University of Chicago (now known as the Institute for the Study of Ancient Cultures, West Asia & North Africa), and the field activities of the expedition were overseen by Professor Ernst Herzfeld of the University of Berlin.[9] Erich Schmidt of the University Museum of the University of Pennsylvania joined the Philadelphia Museum of Art in 1931–33 to excavate at Rayy, and he later worked with the Boston Museum of Fine Arts in 1934–36 to excavate at Damghan. The University Museum also sent Fredrick Wulsin to Astrabad for excavations.[10] The Metropolitan Museum expedition, led by Joseph Upton, excavated the late Sasanian levels of Qasr-i Abu Nasr near Shiraz in 1932–35. Further, C. K. Wilkinson, Joseph Upton, and William Hauser led the Metropolitan Museum's expedition to Nishapur in

1935–40. In 1937, the University Museum and the Museum of Fine Arts in Boston joined the Oriental Institute as cosponsors of the Persepolis excavations, where Schmidt had taken over as of 1935. The expedition ended in the fall of 1939 after the outbreak of World War II. Furthermore, in this period historians George Cameron and Albert Olmstead and linguist Martin Sprengling were active in ancient Iranian studies at the University of Chicago. In 1933, M. Aga-Oghlu took the first chair in Islamic Art at the University of Michigan. This chair, when vacated in 1938, was filled by Richard Ettinghausen from Frankfurt.[11] In the mid-1930s, Mehmet Semsar began to offer the first courses on the living Persian language at Princeton University.

For much of the above period, Arthur Upham Pope was the central figure in the promotion of Iranian studies in this country.[12] Pope organized the First International Congress on Persian Art in Philadelphia in 1926. The second conference was held in London in 1931 and the third in Leningrad in 1935. In April 1930, Pope founded and directed the American Institute for Persian Art and Archaeology in New York City. Later, the name of the institute was changed to the Iranian Institute and then finally to the Asia Institute. In 1966, the Asia Institute was moved to Shiraz, where it "was transformed into the department of languages of Shiraz University."[13] The first issue of the *Bulletin of the American Institute for Persian Art and Archaeology* appeared in July 1931 and the last issue (vol. 6, nos. 1–4) came out in December 1946. "Beginning in 1934 another phase of the Institute's development had begun, brought about by the rise of Nazi Germany. Richard Ettinghausen and Leo Bronstein were the first refugees who joined the Institute (Gustave von Grunebaum and Bernhard Geiger among others were to join later)."[14] Further, Arthur Pope's monumental six-volume work, *A Survey of Persian Art*, which was published in 1938, represented a landmark achievement in the field of Iranian art history.[15]

The Third Phase: The 1940s and '50s

At the outbreak of World War II, "there were very few Americans who knew [the Middle East] at all well: missionaries, archaeologists, research scholars, oil men, and a scattering of businessmen, such as tobacco buyers in Turkey."[16] The war "naturally introduced a sudden urgency into American perception of the Middle East" and Iran.[17] Responding to the exigencies of the war, Pope mobilized the resources of the Iranian Institute and founded, under the umbrella of the Asia Institute, the School of Asiatic Studies in 1940. The School of Asiatic Studies offered the first integrated program in North America of Iranian culture and civilization as well as Persian languages.[18] Another manifestation of the new American awareness of the Middle East was a conference entitled

"The Near East: Problems and Prospects," held at the University of Chicago in June 1942. Faced with a need for regional specialists in different fields, the government turned to the universities for help. Intensive Arabic, Persian, and Turkish language training was among the most important contributions of the universities to the war effort.[19] This ad hoc mobilization of resources in the course of the war helped transform the attitudes of many, both within the government and at the universities, toward the study of the Middle East and Iran. As a contemporary observer put it, "It was strongly impressed upon the minds, not only of officials of government, but also of the university faculties, that a reservoir of trained personnel must be created by continuing and expanding these programs leading toward professional work in the field of international relations in the post war era, so that never again would the United States be caught critically short of the personnel necessary for the expanded operations of government agencies."[20]

One of the earliest integrated language and culture-area courses of study focusing on Iran was included in the Program in Oriental Civilizations that was established and developed at the University of Michigan in the 1930s. It offered courses on the Persian language as well as Iranian culture and civilization in the 1940s in order to meet the wartime needs of government agencies. Later, Richard N. Frye's appointment as Professor of Iranian History and Languages at Harvard University in 1948 was another indication of the new recognition granted to the study of Iran.[21] Meanwhile, Princeton's interdepartmental program in Near Eastern studies was inaugurated in the fall of 1947 with the late T. Cuyler Young offering courses on contemporary Persian language. In the 1950s, the study of Iran became a well-established part of the University of Michigan's overall program on the Near East and North Africa; George Cameron covered ancient Iranian history, and Oleg Grabar covered Iranian art in his art history courses. The pace of development, however, was not the same at all universities, and there were occasional reversals at some institutions. At Columbia, for example, after the professorships of the linguists and Iranists Williams Jackson and Louis Gray, Iranian studies declined and was revived only after the federal government became active in the field. At the University of Chicago in the 1950s, Iranian studies was represented by the field of archaeology.

The Fourth Phase: The 1960s and '70s

A more broadly based development of Iranian studies in North America effectively began in the late 1950s and '60s with the formation of centers for Middle Eastern studies and departments of Near Eastern languages and literatures at

various universities, some of which represented a reactivation of moribund programs. The stimulus came from the federal government through the enactment of Title VI of the National Defense Education Act of 1958 (presently the Foreign Language and Area Studies Program of Title VI of the Higher Education Act of 1965, as amended), which provided funds for scholarships and research grants in Persian. As a result of these activities in the 1960s and '70s, Iranian studies became a part of academic programs at a sizable number of North American universities (table 6.3). In 1958, the Aga Khan Professorship of Iranian Studies was established at Harvard University, upon which Richard Frye was appointed to the chair. In 1959, the Hagop Kevorkian Chair of Iranian Studies was established at Columbia University, with Ehsan Yarshater assuming the chair in 1960. In 1960, W. B. Henning, a noted scholar of Old and Middle Iranian, joined the University of California, Berkeley. He played a prominent role in establishing Berkeley as an important center of Iranian studies in North America.

This period was marked by the growing interest of a variety of disciplines in the social sciences and humanities in Iranian studies, including anthropology, political science, history, religion and, to a lesser extent, economics and sociology. The disciplines of archaeology, art history, linguistics, and Persian language and literature, which had developed an interest in Iranian studies in the earlier periods, continued to flourish in the 1960s and '70s. The Iranian Revolution led to the proliferation of works on Iranian political processes, particularly those concerned with the Iranian Revolution itself and militant Islam. The abundant works on the Iranian Revolution represent the efforts of scholars from a variety of disciplines, including political science, history, anthropology, economics, and sociology. Studies on Shi'i Islam introduced in the 1960s and '70s became particularly popular after the Islamic Revolution. One index of the rise of interest in Iranian studies in the aftermath of the Iranian Revolution is the sheer number of publications (over 450 titles) produced on Iran in English between 1980 and 1988. The number of titles published during this period exceeds the number of titles published in the previous decades combined.

As the above overview clearly shows, Iranian studies in North America underwent a major expansion and substantive development in the 1960s and '70s due to a new awareness of the significance of area studies, the rapid socioeconomic development of Iran, and friendly relations between Iran and the United States. These factors facilitated fieldwork, made available research funds and scholarships to scholars and students in the field, and set the stage for the establishment of a number of organizations and professional associations to promote the study of Iran. Chief among these are the American Institute of

Iranian Studies (AIIrS), the Society for Iranian Studies (now known as the Association for Iranian Studies), and the Center for Iranian Studies at Columbia University, all of which began their activities in the late 1960s.

American Institute of Iranian Studies

Preliminary discussions concerning the establishment of the AIIrS took place in a meeting convened by Ehsan Yarshater at Harvard University in 1966. AIIrS was formally established in 1967 by a number of universities, museums, and institutes of art and archaeology, including: the Archaeological Institute of America, the Boston Museum of Fine Arts, Bryn Mawr College, the Cleveland Museum of Art, Columbia University, Harvard University, the Institute of Fine Arts of New York University, the Metropolitan Museum of Art, Princeton University, University of Arizona, University of California, Berkeley, University of California, Los Angeles, University of Chicago, University of Michigan, University of Pennsylvania and its University Museum, University of Pittsburgh, University of Texas at Austin, University of Utah, and University of Virginia.

Following the pattern of the previously established American Research Center in Egypt and the American Research Institute of Turkey, AIIrS set as its goal the task of facilitating research on the host country, in this case Iran, by both North American and Iranian scholars. To this end, it began to undertake a variety of programs, both in Iran and the United States, that have aided established scholars in their research, encouraged communication and collaboration between American and Iranian scholars, and greatly facilitated research undertakings by young scholars in Iran.

The American Institute of Iranian Studies Tehran Center

AIIrS opened its Center in Tehran in the fall of 1969.[22] William Sumner, E. W. Davis, Jerome Clinton, David Peterson, Colin MacKinnon, and Stephen Fairbanks served successively as directors of the Tehran Center during the period from 1969 to 1980.[23] The Center operated successfully until the fall of 1978—that is, a few months before the collapse of the Pahlavi regime and the final victory of the Iranian Revolution. In the fall of 1980 during the hostage crisis, the Center was obliged to close. The Tehran Center served as the official liaison between North American scholars and Iranian counterparts. Frequent seminars and lecture programs allowed the Center to develop close ties with the universities and research institutes in Iran as well as with individual

TABLE 6.1. Distribution of North American Scholars in Iran by Fields of Research, 1969–78

Discipline	Number	Percent
Archaeology and art history	58	26.1
Cultural anthropology[b]	53	23.8
Other social sciences[c]	37	16.7
History	26	11.7
Linguistics, language and literature	25	11.3
Islamic studies	11	4.9
Other fields or unidentified[d]	12	5.4
Total	222[a]	100

[a]These figures are likely to be underestimated due to the missing issues of the *Tehran Center Newsletter* for the following years: no. 2, 1970; no. 2, 1971; no. 3, 1974; and nos. 2–3, 1975.
[b]Including 7 cases of ethnomusicology and musicology.
[c]Including 11 educationists, 9 political scientists, 6 demographers, 4 sociologists, 4 geographers, and 3 economists.
[d]Including 7 ethnozoologists, palaeobotanists, and scholars in related areas; 1 bibliographer; 1 nutritionist; 1 expert in community medicine; and 2 unidentified.
Source: "Directory of Research in Progress," *Tehran Center Newsletter*, various issues (1969–78), unpublished.

Iranian scholars. In addition, the Center's building contained a basic research library and offered temporary accommodations to visiting scholars, and its newsletter enjoyed a wide readership among interested scholars. During the years of its operation, the Tehran Center served some 250 North American scholars and doctoral candidates who traveled to Iran to carry out research. A review of the "Directory of Research in Progress," presented in the successive issues of AIIrS's *Tehran Center Newsletter* shows a steady growth in the number of scholars over this time. Of a total of 222 scholars in the field, over one-fourth were archaeologists, another one-fourth were cultural anthropologists, nearly 17 percent came from other social science disciplines (such as political science, geography, sociology, demography, education, and economics), about 12 percent were historians, approximately 11 percent were linguists or specialists in Persian language and literature, about 5 percent were in Islamic studies, and about 5 percent came from other fields.

In this period, the North American contribution to the development of archaeology and art history of Iran underwent a phenomenal growth. As Cuyler Young Jr. pointed out, "The increase in activity in Iranian archaeology which began toward the end of the 1950s is so remarkable that it can only be described as an intellectual and scholarly explosion. More field work was done

by more scholars between 1958 and 1978 than had been undertaken in all the years between 1884 and 1958."[24]

North American scholars representing such major museums and institutes as the University Museum (Philadelphia), the Metropolitan Museum of Art, the Royal Ontario Museum, the Smithsonian Institution, the Cleveland Museum, and the Oriental Institute (Chicago) were active in excavations and surveys, and these museums expanded their collections at an ever-increasing rate. For example, in pre-Median archaeology nearly one-half of sixty-four excavations and one-third of thirty-three significant surveys conducted during the 1960s and '70s were directed by North American archaeologists.[25] The 1970s witnessed a rapid expansion of North American interest in anthropological work in Iran. Of some eighty anthropologists working on Iranian cases, about forty-five were North Americans, twenty-two Europeans, seven Iranians, and the remaining nine from other countries. During this period, American anthropologists played a major part in broadening the scope of the anthropology of Iran from tribal studies to a variety of social and cultural subjects such as religion, marriage and the family, health, and women among other topics. These developments, along with considerable contributions of British, Swedish and French anthropologists, led to the elevation of Iranian case studies to the main stock of anthropological knowledge.[26]

Table 6.2 presents the steady growth in the number of North American scholars conducting research in Iran during the period from 1969 to 1977. The number of scholars residing in Iran increased from twenty-seven persons in 1969 to forty-three persons in 1977. The actual number of scholars for the years

TABLE 6.2. Estimate of the Number of North American Scholars, Selected Years, 1969–77

Discipline	1969	1971	1973	1975	1977
Archaeology and Art History	2	2	10	14	12
Cultural Anthropology	8	7	12	12	12
Other Social Sciences	4	4	7	10	5
History	4	1	9	1	5
Linguistics, Language and Literature	6	2	8	5	4
Islamic Studies	2	2	1	1	3
Others	1	—	3	3	2
Total	**27**	**17[a]**	**50**	**46[a]**	**43**

[a]Figures for these years are underestimates of the actual number of individuals due to the unavailability of the following issues of the Tehran Center Newsletter to the author: no. 2, 1971, and nos. 2–3, 1975.

Source: "Directory of Research in Progress," *Tehran Center Newsletter*, various issues, 1969–1977, unpublished.

1971 and 1975 is likely to be greater than the one reported in the table due to information missing from the Center's files for 1971 and 1975. The number for 1978 declined due to the revolutionary situation, during which only six scholars were reported to be in Iran.

North Americans were prominently represented in different scholarly and research activities compared to scholars from other countries. For example, of the twenty archaeological sites excavated by Western teams in 1971–72, eight were being excavated by North Americans, four by the British, three by the French, two by Germans, and one each by Italian, Belgian, and Japanese teams. In the Fourth Annual Symposium of Archaeological Research in Iran held in Tehran in November 1975, ten North American directors of expeditions of the previous years attended and gave papers on the results of their work. Also well attended by North American scholars was the International Congress of Mithraic Studies held in Tehran at the National University in September 1975, in which twelve scholars affiliated with AIIrS participated. In the First International Iranian Festival of Popular Traditions held in Isfahan in October 1977, twenty-two American scholars read papers. In the Symposium on Government and Administrative Institutions in Iran from Early Islam until the Mongol Invasion, sponsored by Iran's Anjoman-e Tarikh (Historical Society), held in Hamadan in October 1977, six North Americans participated and read papers.

The Society for Iranian Studies

Now known as the Association for Iranian Studies (AIS), the Society for Iranian Studies (SIS) was founded in the fall of 1967 in a meeting at Yale University by a small group of young scholars of Iran, mostly in the social science disciplines at several major American universities.[27] The main objective of SIS, as set forth in its constitution, was "to encourage the study of Iranian culture and society, including history, language, literature, social, economic, and political problems of Iran."[28] The purposes of SIS, as described by its founders, were to encourage research on Iran, organize academic conferences and forums for presentation of scholarly works, facilitate understanding and collaboration between Iranian and non-Iranian scholars, and generate interest in Iranian studies in academic communities. SIS took a major step toward achieving its goals in 1968 with the publication of the first issue of its journal, *Iranian Studies*, under the editorship of Ali Banuazizi. His active leadership over the following fourteen years helped transform *Iranian Studies* into the leading journal for the study of modern Iranian culture, politics, and society.

Columbia Center for Iranian Studies

A particularly significant development for the field was the founding of the Center for Iranian Studies at Columbia University by Ehsan Yarshater in 1968. The Center sponsors research, lectures, colloquia, occasional performances and exhibitions, and publications, including the *Encyclopaedia Iranica*.[29] In 1983, Yarshater additionally established the Persian Heritage Foundation to support research in Iranian studies and the publication of the *Encyclopaedia Iranica*, Persian Heritage Series, Persian Studies Series, Translation of Modern Persian Literature Series, Persian Art Series, Persian Text Series, and the Yarshater Lectures (given by scholars in the United States and abroad).

Five quantitative indices have been constructed here for the purpose of evaluating early trends in the field of Iranian studies in American universities. The reference years are 1976–77 (preceding Iran's Revolution) and 1986–87 (a decade later). The indices are: (1) number of courses taught on Iran, (2) number of courses taught on the Middle East that devoted 20 percent or more time to Iran, (3) number of students enrolled in Persian-language courses, (4) number of faculty specializing primarily in one or another area of Iranian studies, and (5) number of PhD candidates in the area of Iranian studies. The figures presented in table 6.3 are not complete due to the lack of response to the study questionnaire on the part of four institutions and missing data in some completed questionnaires. It should also be noted that even with fully completed questionnaires, the figures would still underestimate the actual quantities in question. The underestimation is due to a number of factors, including the fact that courses on Iran were offered in a number of universities not included in table 6.3 (e.g., Auburn University, Boston College, Brown University, University of California, Santa Barbara, University of Connecticut, Dartmouth College, Duke University, George Washington University, Johns Hopkins University, University of Minnesota, Rice University, University of Wisconsin–Madison), that many additional Iranists were dispersed in other colleges and universities throughout North America, and that students working on dissertations related to Iranian studies were enrolled in institutions not included in the survey. As shown in table 6.3, in the 1986–87 academic year 190 courses were offered on Iran. Of these, the majority were courses on Persian language and literature as well as Iranian history. An additional 222 courses on the Middle East, which devoted 20 percent or more of their coverage to Iran, were taught. Of these, the majority were courses on history, political science, and Islamic studies. The enrollment of students in Persian-language courses at all levels was 490, the number of faculty who specialized primarily in some

TABLE 6.3. Five Quantitative Indices of the State of Iranian Studies in North America, 1976–77 and 1986–87

	Courses on Iran				Persian Enrollment		Faculty Iranian Stud.		PhD Candidates	
Universities	20%[b]		100%							
	76–77	86–87	76–77	86–87	76–77	86–87	76–77	86–87	76–77	86–87
Arizona	4	4	10	10	45	98	7	8	6	6
Berkeley[a]	8	9	9	20	29	35	7	7	5	4
Chicago[a]	18	18	30	32	20	12	7	7	5	6
Columbia	10	14	?	?	16	12	6	8	4	14
Harvard	6	14	?	9	17	5	7	9	?	4
Illinois[a]	8	8	?	6	22	13	5	5	?	1
Michigan	8	8	?	11	31	37	7	8	?	4
New York	12	14	8	8	35	32	4	7	12	15
Ohio State[a]	?	5	?	9	?	12	2	3	?	2
Pennsylvania	8	10	25	29	35	19	11	14	9	8
Princeton	8	9	8	9	27	7	4	4	1	3
Texas	16	18	24	23	40	25	5	5	11	6
Toronto	6	8	?	8	12	28	7	9	?	2
UCLA[a]	18	18	10	10	12	28	8	10	5	8
Utah[a]	19	14	18	11	119	57	7	4	2	3
Virginia	2	6	2	4	0	36	2	3	0	1
Washington[a]	6	10	10	12	14	25	1	2	0	1
Yale	1	3	6	11	0	9	3	6	2	3
Total	158	190	160	222	474	490	100	119	62	91

[a] Quarter system
[b] Number of courses taught on the Middle East devoting 20 percent or more to Iran

aspects of Iranian studies was 119, and there were ninety-one active PhD candidates in the field of Iranian studies.

The number of courses on Iran taught in the surveyed institutions increased from 158 to 190 during the ten-year period. The figures remained unchanged for five universities (Arizona, Chicago, Illinois, Michigan, and UCLA), declined at Utah, and increased in the remaining twelve universities. The number of faculty in Iranian studies rose from 100 to 119 over this period. Again, while this number remained unchanged for five universities, it decreased at Utah and increased in the remaining twelve institutions. The number of students enrolled in Persian language courses increased slightly during this period from 474 to 490. At Arizona, with the highest rate of increase and an unusually large

number (98) of students enrolled in Persian-language courses, most of the students hailed from the Persian Gulf states. There are also increases in the enrollment figures for Persian courses at universities located in the main centers of concentration of Iranian immigrants, including the University of California, Berkeley, the University of Toronto, UCLA, and the University of Washington, Seattle. Conversely, enrollment in Persian courses declined in such leading universities as Chicago, Columbia, Harvard, Princeton, and Texas.

As a result of the political changes wrought by the Iranian Revolution in 1979, Iranian studies in North America was faced with a number of pressing problems and challenges. First, the political situation in Iran rendered impossible any significant research in Iran by scholars from North America. This affected archaeological excavations and the social sciences most severely, but the humanities also suffered. Second, the lack of opportunities for research in Iran adversely affected the number of graduate students entering almost all fields of Iranian studies. On the positive side, the Iranian Revolution demonstrated the ever-increasing importance of Iran in the Middle East and in world politics. Knowledge of Iran and the Persian language became increasingly relevant for political purposes.

Another factor that positively influenced the field was the changing composition and social ecology of the field of Iranian studies in North America as a large Iranian community took shape in the United States and Canada, with individual communities concentrated mainly in Los Angeles (including Orange County), San Jose (including the Bay Area), San Diego, Houston (including neighboring cities), Greater New York, Washington, DC (including neighboring areas), Boston, Chicago, Vancouver, Toronto, and Montreal. Aside from its relatively large size, the Iranian community distinguished itself when compared to other recent immigrants to North America, in that the majority of its arriving members were relatively well educated and included a disproportionate number of professionals and a sizable number of émigré scholars who populated the various fields of Iranian studies. While American students became less inclined to pursue Iranian studies, more students of Iranian origin were attracted to the field. In many cases, such students constituted the majority of those enrolled in Persian language courses. Many Iranians living in North America became keenly interested in preserving and promoting their cultural heritage, as they wanted their children to be exposed to the various aspects of such heritage, particularly in the context of their postsecondary education. The Iranian diaspora communities in North America also became an important focus of research by anthropologists, sociologists, and other social scientists.[30]

Notes

This chapter is a revised version of a paper presented at the American Institute of Iranian Studies conference on Iranian Studies in North America held at the Arthur M. Sackler Gallery, Smithsonian Institution, Washington, DC, January 26–28, 1989.

1. For more on Jackson, see D. T. Potts in this volume.
2. A. V. W. Jackson, *Zoroaster*.
3. A. V. W. Jackson, *Phonology, Inflection, Word-Formation*.
4. A. V. W. Jackson, *Avesta Reader*.
5. This section is based on Bishop, "North American Contribution." For more on Jackson, see the chapter by D. T. Potts in this volume.
6. For more on Kent, see D. T. Potts in this volume.
7. Kent, *Old Persian*.
8. Dimand, *Handbook of Mohammedan Decorative Arts*. Linda Komaroff in this volume treats the development of collections of Islamic art in American museums.
9. The Persepolis expedition is discussed in full by Matthew W. Stolper in this volume.
10. For more on the University of Pennsylvania Museum excavations, see Christopher P. Thornton, Alessandro Pezzati, and Holly Pittman in this volume.
11. See Linda Komaroff in this volume for more on Ettinghausen.
12. Pope is further discussed in this volume by Linda Komaroff, Shiva Balaghi, and Judith A. Lerner.
13. Frye, "Preface," xi.
14. Frye, "Preface," ix.
15. Pope and Ackerman, *Survey of Persian Art*. For more on Pope, see, the articles by Linda Komaroff, Shiva Balaghi, and Judith A. Lerner in this volume.
16. Wilber, *Adventures in the Middle East*, 101.
17. Winder, "Four Decades," 42.
18. Frye, "Institute in War-Time," 5.
19. Winder, "Four Decades," 42.
20. As quoted in Winder, "Four Decades," 43.
21. Frye is further discussed by Judith A. Lerner in this volume.
22. See Keyvan Tabari in this volume for a recounting of the founding of the AIIrS Tehran Center.
23. Stephen Fairbanks in this volume provides a narrative of the final years of the Tehran Center.
24. Young, "Archeology," 284.
25. Young, "Archeology," 283–84.
26. Spooner, "Anthropology."
27. See Keyvan Tabari, in this volume, for personal recollections on the founding of SIS/AIS.
28. Bishop, "By Way of Introduction," 2.
29. The *Encyclopaedia Iranica* is addressed by Daniel Elton in this volume.
30. For one such study, see the Mehdi Bozorgmehr in this volume.

Bibliography

Bishop, D. "By Way of Introduction." *Iranian Studies* 1.1 (1967): 2–3.

———. "North American Contribution to the Study of the Old and Middle Iranian Languages." Unpublished paper prepared for the American Institute of Iranian Studies, 1977.

Dimand, M. S. *A Handbook of Mohammedan Decorative Arts.* New York: Metropolitan Museum of Art, 1930.

Frye, Richard N. "The Institute in War-Time." *Bulletin of the Iranian Institute* 6.1–4 (1946): 1–10.

———. "Preface." *Bulletin of the Asia Institute* 1 (1987): ix–xi.

Jackson, A. V. W. *Avesta Grammar in Comparison with Sanskrit.* Part 1. Stuttgart: Kohlhammer, 1892.

———. *Avesta Reader, First Series: Texts, Notes and Vocabulary.* Stuttgart: Kohlhammer, 1893.

———. *Zoroaster: The Prophet of Ancient Iran.* New York: Macmillan, 1899.

Kent, Roland G. *Old Persian: Grammar, Texts, Lexicon.* New Haven: American Oriental Society, 1950.

Pope, Arthur Upham, and Phyllis Ackerman, eds. *A Survey of Persian Art from Prehistoric Times to the Present.* 6 vols. London: Oxford University Press, 1938–39.

Spooner, B. "Anthropology." *Encyclopaedia Iranica.* Last updated August 5, 2011. http://www.iranicaonline.org/articles/anthropology-social-and-cultural-in-iran-and-afghanistan.

Wilber, Donald Newton. *Adventures in the Middle East, Excursions and Incursions.* Princeton: Darwin, 1986.

Winder, R. Bayly. "Four Decades of Middle Eastern Study." *Middle East Journal* 41.1 (1987): 40–63.

Young, T. C. "Archeology i. Pre-Median: History and Method of Research." *Encyclopaedia Iranica.* Last updated August 11, 2011. http://www.iranicaonline.org/articles/archeology-i.

CHAPTER 7

The *Encyclopaedia Iranica* and *A History of Persian Literature*

Elton L. Daniel (based on a draft by Ehsan Yarshater)

Encyclopaedia Iranica

The induction of the concept of area studies into the American curriculum after 1945 made geography the primary criterion for organizing multidisciplinary university programs. Subsequently, departments of oriental studies were transformed into area studies programs in which Arabic, Central Asian, Turkish, Indian, and Iranian studies emerged as independent fields of study. It was in this context that the *Encyclopaedia Iranica* (*EIr*) was conceived in the early 1970s as a printed reference work combining the concept of a modern national encyclopedia, such as the *Encyclopaedia Britannica* and the *Encyclopaedia Judaica*, with that of an academic handbook, such as *Der Neue Pauly* and the *Encyclopaedia of Islam*. The goal was twofold: to provide the general public with access to knowledge about the Iranian lands and civilization and to offer the small and widely dispersed scholarly community of Iranian studies specialists a platform for the publication of research outside highly specialized and hard-to-access journals.

A Multidisciplinary Approach to Iranian Studies

As of May 2023, the *Encyclopaedia Iranica* project at Columbia University had produced over 7,800 entries in print, including multipart articles and cross-references, as well as approximately 1,800 additional entries that have not yet been printed but are available online. These entries constitute the backbone of a detailed and lucid account of the civilization of Iranian lands, including Iran, Afghanistan, Tajikistan, Kurdistan, Baluchistan, the Pathan areas of Pakistan, parts of Uzbekistan, and the Caucasus from prehistory to the present. The comprehensive coverage necessitates a multidisciplinary approach that takes into account a wide range of disciplines from anthropology, ethnography, archaeology, art history, economics, and geography to Islamic history, linguistics, literature, religion, philosophy, mysticism, folklore, history of science

and medicine, political science, international relations, diplomatic history, and botany and zoology. Accordingly, the *EIr* caters to a diverse audience of scholars and students as well as to nonspecialists interested in the various branches of Iranian studies. The meticulous research and high caliber of the authors, the generous but carefully selected use of primary sources, and the provision of extensive bibliographies have made the *EIr* an indispensable reference work for research and teaching in the humanities.

The print version of *EIr*, most recently published by Brill, continues to follow the traditional text format with articles arranged in alphabetical order (up to entry "Kokand Khanate"). An electronic version of *EIr*, the *Encyclopaedia Iranica Online*, has been developed and made available in open access by Brill (at http://referenceworks.brillonline.com/browse/encyclopaedia-iranica-online). The print and online encyclopedias share much in terms of content, but they should be regarded as related but separate publications. Although the online version was originally intended to be a readily available and easily searchable duplicate of the printed *EIr*, it also provided the project—no longer bound by the alphabetical order—with the freedom to commission and publish entries from A to Z guided by the availability of scholars and the significance to users. The online version of *EIr* has transformed the resource into a dynamic digital database with tremendous potential for future growth and development. Its advantages include the ability to provide greater access to the *EIr* for a global audience, the ability to update entries in real time without having to wait for supplement volumes or printed corrigenda, and the ability to supplement entries with more illustrations as well as high quality audio-visual material (it currently offers over a hundred music clips to supplement various articles).

History of the Project

In the early 1970s when planning for the *EIr* began at the Center for Iranian Studies of Columbia University, it was envisioned only in terms of a printed encyclopedia. In 1982, the first fascicle of volume 1 of the *EIr* appeared in print, and fascicle 3 of volume 17 was published in January 2023. In 1996, the first version of the *EIr*'s website was created to ensure the project's web presence and to provide free online access to already published entries. In early 2002, *EIr* adopted a new approach that focuses on the digital publication of entries commissioned according to significance of topic as opposed to alphabetical order.

Sources of Support

The Iranian Plan Organization (*Sāzmān-e Barnāma*), a government agency supervising Iran's development activities, funded *EIr* from 1974 until January

1979, when financing was abruptly terminated with the advent of the Islamic Revolution in Iran and the resulting political upheavals. To have aborted the *EIr* at that stage would have meant not only writing off the considerable investment in time, effort, and capital already made over a period of nearly five years but, far more significantly, would have also entailed abandoning an incredibly valuable project serving a genuine need and filling a conspicuous gap in the range of available reference works. An application was therefore submitted to the National Endowment for the Humanities (NEH) in the midst of the Iranian hostage crisis. Nonetheless, despite the awkward timing of the application, the editor's argument concerning the significance of the project and the need for it to be sustained prevailed, and an NEH Chairman's Emergency Grant came to the rescue of the *EIr* until 1980, when an application to the NEH for a three-year continuation of the project was approved. Through that and subsequent grants to Columbia University, NEH supported the *EIr* continuously until September 2016.

In 1990, the not-for-profit Encyclopaedia Iranica Foundation was established to guarantee the project's long-term viability. The Foundation raised funds to meet the *EIr*'s matching fund requirements and other financial needs. By 2016, the Encyclopaedia Iranica Foundation had become the third most important source of funding for the project after the generous and continuous support of both Columbia University and the NEH.

There have been a number of other important donors to the project. The Getty Grant Program, known for its support of art historical and archaeological projects, awarded a substantial three-year grant to the *EIr* in 1990. In 1997, the Encyclopaedia Iranica Project was honored when, as a recognition of the its contribution to academia, the American Council of Learned Societies endorsed the project and in turn recommended to the International Union of Academies that it follow suit and grant its patronage to the project "on the basis of its proven publication record, its usefulness to several scholarly communities, and the high quality of its entries." Since 2002, the Union has supported the project as well.

The Iranian-American community remained a strong source of private support for the *EIr*. Some recent demographic statistics place the number of Iranian-Americans individuals at about one million. The majority have a college degree or higher. Second- and third-generation Iranian-Americans are becoming increasingly interested in the project both as readers and as supporters. Several years ago, as part of the strategy for raising contributions for matching funds, a group of volunteer supporters of the *Encyclopaedia Iranica* was assembled and organized as "Friends of the Encyclopaedia" to help identify and contact likely donors for the project. Benefit galas, which have also proved to be a successful fundraising approach, have been held in New York

City, Washington, DC, Miami, Houston, Los Angeles, San Francisco, Toronto, Geneva, and Dubai.

In 2018, in response to an appeal from Ehsan Yarshater, the founding editor of the *EIr*, the Persian Heritage Foundation, a private charitable organization, agreed to provide the funding needed to create the Ehsan Yarshater Center for Iranian Studies at Columbia University, with its primary mission being the continuation of the *EIr* project. Since 2018, the Yarshater Center has used the bulk of the funding provided by this endowment, along with gifts from individual donors and grants from the International Union of Academies, to produce the *EIr*.

However, the Encyclopaedia Iranica Foundation opted to suspend its funding for the project in 2018 and terminated its relationship with Columbia University in April 2019. After four years of litigation between Columbia University and the Encyclopaedia Iranica Foundation, the parties announced a settlement in June 2023 under which the project at Columbia would be ended and transferred to another institution to "be selected and announced in the coming months." Columbia had previously canceled its publication contracts with Brill, and all work in progress was suspended. As of January 2024, no new host institution has been named, and publication has not resumed.

Editorial Policies

Until the publication project was terminated at Columbia, the production of content for the *EIr* was guided by an advisory board consisting of eminent scholars from countries where Iranian studies flourish. In addition, consulting editors from major international academic institutions represented each discipline of Iranian studies and regularly reviewed the relevant subject lists of *EIr* entries to make recommendations regarding entry topics, lengths, and authors. The majority of entries were written in English, but the *EIr* also received entries written in Persian, French, German, Russian, and Italian and occasionally in other languages. These non-English entries were assigned to outside translators once they were approved. The Editor-in-Chief assigned each article to an appropriate project editor depending on the subject. Apart from checking the accuracy and adequacy of research, the project editors also ensured that each article achieved a desired measure of harmony in terms of style and format with the other entries in the *EIr*. The editors also systematized the bibliographies of different articles and brought their rendering of foreign terms and proper names in line with the *EIr*'s scheme of transcription. At the same time, editors also attempted to verify the proper organization of the material in the entries. Each of the entries contributed to *EIr* were reviewed by more than one editor before publication.

A History of Persian Literature

In the 1990s, the idea was conceived for a new project—a comprehensive and detailed history of Persian literature. The initial scheme naturally took note of previous endeavors, both in Iran and abroad, in this respect. Hermann Ethé's pioneering survey of the subject ("Neupersische Litteratur" in volume 2 of *Grundriss der iranischen Philologie*) was published in 1904, and E. G. Browne's far more extensive *A Literary History of Persia*, with ample discussion of the political and cultural background of each period, appeared in four successive volumes between 1902 and 1924. The English translation of Jan Rypka's *History of Iranian Literature*, written in collaboration with other scholars, came out in 1968. Iranian scholars had also made a number of significant contributions throughout the twentieth century to different aspects of Persian literary history. These include B. Foruzānfar's *Sokhan va sokhanvarān* (On poetry and poets, 1929–33), M.-T. Bahār's three-volume *Sabk-shenāsi* (Varieties of style in prose, 1942), and a number of monographs on individual poets and writers. The most truly monumental achievement of the century on this subject has been Dh. Safā's wide-ranging and meticulously researched *Tārikh-e adabiyyāt dar Irān* (History of literature in Iran), which was published in five volumes and eight parts from 1953 to 1979. It is a study of Persian poetry and prose vis-à-vis the political, social, religious, and cultural contexts embedding their literary production from the rise of Islam to almost the middle of the eighteenth century. Nevertheless, it cannot be said that Persian literature has received the attention it merits, bearing in mind that it has been the jewel in the crown of Persian culture in its widest sense and the standard-bearer of aesthetic and cultural norms of the literature of the eastern regions of the Islamic world since the twelfth century. It profoundly influenced the literatures of Ottoman Turkey, Muslim India, and Turkic Central Asia, which in turn inspired Goethe, Emerson, Matthew Arnold, and Jorge Luis Borges among others. It was also praised by William Jones, Rabindranath Tagore, E. M. Forster, and many other writers. Persian literature remained a major model for literature until the nineteenth century, when European influence began to challenge Persian literary and cultural influence and succeeded in replacing it. Whereas Persian art and architecture (and more recently Persian film) have been extensively written about and for varied audiences, Persian literature has largely remained the exclusive domain of specialists. It is only in the past few years that the poems of Rumi have drawn to themselves the kind of popular attention enjoyed by Omar Khayyam in the nineteenth century.

A History of Persian Literature has been planned as a richly documented work and a fresh critical approach written by prominent scholars in the field. The plan for the series projects a total of twenty volumes, including two

companion volumes, two anthology volumes, and a general index. As of 2023, nine of the volumes have been published by I. B. Tauris, all of which have been funded by the Persian Heritage Foundation and prepared under the auspices of the Columbia Center for Iranian Studies. Following the termination of the *Encyclopaedia Iranica* project, however, the Yarshater Center at Columbia was closed and its endowment funding was returned to the Persian Heritage Foundation. Subsequently, the Persian Heritage Foundation concluded an agreement to create a new Yarshater Center for the Study of Iranian Literary Traditions at the University of California, Los Angeles, with the continuation and completion of the *A History of Persian Literature* series as part of its core mission.

The projected set of volume titles (subject to change), with a brief description of those already published, is as follows:

Volume 1: *General Introduction to Persian Literature*, edited by J. T. P de Bruijn
An introduction to Persian literature's long and rich history that examines themes and subjects that are common to many fields of Persian literary study: prosody, literary theory, rhetoric, poetic imagery, genres, influences, manuscripts and copying, printing and publishing, libraries and librarianship.

Volume 2: *Persian Lyric Poetry in the Classical Era, 800–1500: Ghazals, Panegyrics and Quatrains*, edited by Ehsan Yarshater
An extensive study of some major genres of Persian poetry from the first centuries after the rise of Islam to the end of the Timurid era and the inauguration of Safavid rule. The authors explore the development of poetic genres from the panegyric (*qasida*) to short lyrical poems (*ghazal*) and the quatrains (*robā'i*), tracing the stylistic evolution of Persian poetry and the vital role of these poetic forms within the rich landscape of Persian literature.

Volume 3: *Persian Narrative Poetry in the Classical Era, 800–1500: Romantic and Didactic Genres*, edited by Mohsen Ashtiany
Introduces masterpieces of Persian poetry from these seven centuries and their reception throughout the Persianate world. The first two chapters of this volume recount the literary history of the entire period, focusing on didactic and romantic narratives. The central chapters take a closer look at the towering figure of the poet Nezāmi Ganjavi. The final chapter takes the reader to a wider landscape tracing the footsteps of Alexander across the globe, offering insights to the cultural preoccupations refracted in so many versions past and present.

Volume 4: *Heroic Epic: The Shahnameh and Its Legacy*

Volume 5: *Persian Prose,* **edited by Bo Utas**
Offers a broad survey of Persian prose from biographical, historiographical, and didactic prose to scientific manuals and popular prose fiction with analysis of the rhetorical devices and conventions used by each work.

Volume 6: *Religious and Mystical Literature*

Volume 7: *Persian Poetry, 1500–1900: From the Safavids to the Dawn of the Constitutional Movement*

Volume 8: *Persian Poetry in the Indian Subcontinent: Divans, Biographical Anthologies and Literary Criticism*

Volume 9: *Persian Literature from Outside Iran: The Indian Subcontinent, Anatolia, Central Asia, and in Judeo-Persian,* **edited by John R. Perry**
New Persian literature was written and read in India even before it became firmly established in cities such as Isfahan on the Iranian plateau. Over the course of a millennium (ca. 900–1900 CE), Persian established itself as a contact vernacular and an international literary language from Sarajevo to Madras, with Persian poetry serving as a universal cultural cachet for both Muslim and non-Muslim literati. This volume contributes to the scholarship of the Persianate world with the aid of the abundant material (notably in Tajik, Uzbek, and Russian) long neglected by Western scholars and the perspectives of a new generation on this complex and important aspect of Persian literature.

Volume 10: *Persian Historiography,* **edited by Charles Melville**
An overview of Persian literature's long and rich tradition of historical writing from its origins in the Samanid period to modern times, highlighting its various genres and the central themes and ideas that inform historical writing, such as the ethical and exemplary value of history and its connections to political power. It includes chapters on the writing of history in Persian in the Ottoman Empire, Central Asia, Afghanistan, and the Indian subcontinent.

Volume 11: *Literature of the Early Twentieth Century: From the Constitutional Period to Reza Shah,* **edited by Ali-Asghar Seyed-Gohrab**
Pays special attention to the development during this turbulent period of politically engaged poetry; of genres of fiction such as the novel and short story; of satirical literature, drama, journalism, and children's literature; and of themes such as gender relations and nationalism.

Volume 12: *Modern Persian Poetry, 1940 to the Present: Iran, Afghanistan, and Tajikistan*

Volume 13: *Modern Fiction and Drama*

Volume 14: *Biographies of the Poets and Writers of the Classical Period*

Volume 15: *Biographies of the Poets and Writers of the Modern Period; Literary Terms*

Volume 16: *General Index*

Volume 17. Companion Volume 1: *The Literature of Pre-Islamic Iran,* **edited by Ronald E. Emmerick and Maria Macuch**
The main object of this companion volume is to provide an overview of the most important extant literary sources in the Old and Middle Iranian languages—the languages of the Achaemenid, Parthian, and Sasanian periods culminating in the rich Middle Persian sources, which fed directly into the language of the later great Persian poets.

Volume 18. Companion Volume 2: *Oral Literature of Iranian Languages: Kurdish, Pashto, Balochi, Ossetic, Persian and Tajik,* **edited by Philip G. Kreyenbroek and Ulrich Marzolph**
This volume treats of Kurdish, Pashto, Baloch, and Ossetic literature, which at least until the twentieth century is basically an oral literature. Chapters on Persian and Tajik oral literatures are also included. Since other Iranian dialects—such as Lori, Gilaki, Māzandarāni, Tāti, Tāleshi, Yaghnābi, the dialects of the Zoroastrian and Jewish communities of Iran, and many less significant dialects—do not possess oral literatures comparable in size to the literature of the languages discussed in this volume, they have not been taken into account.

Volume 19. Anthology Volume 1: *A Selection of Persian Poems in English Translation*

Volume 20. Anthology Volume 2: *A Selection of Persian Prose in English Translation*

The inclusion of a volume on Persian historiography is justified by the fact that Persian histories, like the biographical accounts of mystics or poets, often exploit the same stylistic and literary features and the same kinds of figures of

speech that are encountered in Persian poetry and *belles-lettres* with the skillful use of balanced cadences, rhyme, varieties of metaphor and hyperbole, and an abundance of embellishing devices. This was considered to impart a literary dimension to the prose, enhance its aesthetic effect, and impress the reader with the literary prowess of the author. The study of Persian historiography should therefore be regarded as a component of any comprehensive study of Persian literary prose and the analysis of its changing styles and contours. Moreover, in premodern times "literature" was defined more broadly than it is today and often included historiography.

As is evident from the title and description of the abovementioned volumes, *A History of Persian Literature*'s approach is neither uniformly chronological nor entirely thematic. On the one hand, to understand a literary genre requires tracing its course chronologically; on the other hand, images, themes, and motifs have lives of their own and need to be studied not only diachronically but also synchronically. *A History of Persian Literature* therefore employs a combination of the two approaches to achieve an all-inclusive treatment. Generous space has been given to modern poetry, fiction, and drama in order to place them in the wider context of Persian literary studies and criticism.

CHAPTER 8

The University of Pennsylvania Museum in Iran

Christopher P. Thornton, Alessandro Pezzati, and Holly Pittman

WHEN THE FRENCH MONOPOLY on archaeological excavations in Iran ended in 1927, one of the first American institutions to leap at this new opportunity was the University of Pennsylvania Museum of Anthropology and Archaeology in Philadelphia (then called "The University Museum"). A venerable institution that had been excavating in Egypt, the Levant, and Mesopotamia since the late nineteenth century, the University of Pennsylvania Museum (UPM) was always looking for opportunities to expand its research interests and collections. In fact, the accessibility of Iran to non-French excavators was due in no small part to the work of UPM curator Frederick Wulsin and his wife Susanne, who were sent to Tehran in 1930 by then-director Horace Jayne to negotiate a contract between the UPM and the Iranian government for archaeological explorations in Iran.[1] It was to be the start of one of the most fruitful institutional collaborations in the history of Near Eastern archaeology—one that continues to this day.

In this paper, we have sought to present a "timeline" of the UPM's involvement with Iran. Our primary source of information was the archives of the UPM. Established in 1981 to care for and provide access to the UPM's administrative and scientific records, the archives houses over half a million images, thousands of plans and drawings, and over two thousand linear feet of textual records. These include records of the UPM's administrative departments (e.g., Director's Office, Education Department, Exhibits Department) and of the many expeditions the UPM has sent out all over the world, to sites such as Nippur, Iraq; Tikal, Guatemala; and Rojdi, India.

Although not the focus of our paper, it should be remembered that the UPM is one of the world's foremost repositories for archaeological and anthropological collections from Iran, the vast majority of which was scientifically collected. It is indisputable that the UPM holds one of the largest collections of excavated Iranian artifacts outside of Tehran. Unfortunately, most of this

TABLE 8.1 Collections relating to Iran in the Penn Museum Archives

Frederick Wulsin	Tureng Tepe, 1931	Correspondence, field notes, maps and drawings, photographs
Erich Schmidt	Tepe Hissar, 1931–32	Correspondence, field notes, maps and drawings, photographs, motion picture films
	Rayy (incl. Cheshmeh Ali, etc.), 1934–37	Correspondence, photographs, some field notes
	Persepolis, 1934–39	Correspondence, some photographs
	Luristan Valley, 1934–38	Correspondence, some photographs
	Aerial Survey, 1935–37	Correspondence, some photographs
Carleton Coon	Cave excavations, 1949–51	Correspondence, field notes, photographs, motion picture film
Robert Dyson	Hasanlu Project, 1956–77	Correspondence, field notes, maps and drawings, photographs
	Dinkha Tepe, 1966–68	Correspondence, field notes, maps and drawings, photographs
	Tepe Hissar, 1975–76	Correspondence, field notes, maps and drawings, photographs
William Sumner	Tal-e Malyan, 1971–78	Correspondence, field notes, maps and drawings, photographs
Elizabeth Carter	Tal-e Malyan, 1971–78	Correspondence, field notes, maps and drawings, photographs
Warden Family	Iran, 1935–38	Motion picture films
Watson Kintner	Iran, 1963	Motion picture films
Edward Austin Waters	Syria, Iraq, Iran, 1931	Photographs

material remains unstudied or unpublished. The variety and size of the collections (dating from the Paleolithic to Late Islamic periods and geographically covering all areas of Iran) as well as their corresponding documentation in the archives provide an immense number of possible thesis topics, dissertations, and research projects. For many students of Iranian culture and civilization, the artifact and archival collections in the UPM provide an excellent resource for the study of this critical region between the Middle East, South Asia, and Central Asia.

TABLE 8.2. Artifact Collections from Iran in the Penn Museum

Location	Number of Registered Objects[a]	Location	Number of Registered Objects[a]
Agrab	16	Kundur	45
Ali Kosh	4	Kur River Valley	8
Aliabad Kishmar	31	Luristan Province	3
Amlash	76	Malyan	647
Amlash Area	2	Marlik	23
Ardebil	20	Mir Vali	24
Azerbaijan	3	Muman	5
Bakun	223	Murteza Gerd	50
Bastam	29	Nishapur	6
Belt	18	Pisdeli	16
Belt Cave	2006	Qabr Sheykhan	329
Bisitun	2405	Qaleh Sam	10
Chal Tarkhan	8	Rayy	1523
Chandar	9	Rhages (Rayy)	8
Cheka Sabz	292	Ruba-I Kuchek	9
Cheshmeh Ali	1560	Rud-I Biyaban #2	14
Choga Zanbil	2	Sabz	39
Dalma	27	Sakkisabad	10
Damghan	6	Sang-I Chakhmaq	35
Damghan Citadel	2	Sarab	2
Dinkha	873	Saveh	4
Farukhabad	13	Shafiabad I	27
Firuzabad	75	Shafiabad II	20
Ganj Dareh	8	Shahdad	17
Gawra	4	Shahr-I Qumis	6
Geoy	525	Shahr-I Sokhta	59
Ghuloman	10	Shahrud	8
Giyan	5	Sharafabad	124
Hajji Firuz	363	Siabid	4
Hamadan	10	Sialk	3
Hasanlu	4376	Solduz Valley	16
Hissar	2984	Sultanabad	9
Hotu	207	Surkh Dum	166
Isfahan	12	Susa	250
Istakhr	126	Tamtama	67
Jing	109	Teheran	20
Kamterlan	183	Tepe Seavan	10
Kara Tepe	25	Tureng	248
Kermanshah	2	Zagheh	9
Khorvine	10	Zenjan	3
Khunik	11	Ziwiye	20

[a]The number of Registered Objects sometimes refers to groups of artifacts (e.g., a bag of sherds from one context).

The Early Years

As stated above, the UPM was actively involved in the abrogation of the French monopoly on archaeological excavations in Iran through the Wulsins and Arthur Upham Pope, an advisor to the Museum on Persian art. Frederick Wulsin had achieved renown in the early 1920s with a famous expedition through China and inner Asia made with his first wife Janet and sponsored by the National Geographic Society.[2] Thus, Horace Jayne saw him as intrepid and savvy enough to represent the UPM's interests in Persia. At the time, Jayne and the UPM were engaged in a "land grab" tussle with the Oriental Institute in Chicago (recently renamed the Institute for the Study of Ancient Cultures, West Asia & North Africa) and its director James Henry Breasted, who leveraged Rockefeller money to secure rights to some of the prime archaeological sites in the Near East.[3] When it became clear that the great German Iranologist Ernst Herzfeld was encouraging the Iranians to grant the University of Chicago permission to excavate the site of Persepolis, the UPM was encouraged by Wulsin to ask for rights to excavate the nearby Achaemenid city of Istakhr (which the UPM eventually excavated under Erich Schmidt beginning in 1934) and the Parthian city of Hecatompylos, thought to be the site of Tepe Hissar near Damghan (excavated by Schmidt in 1931–32; see below). Although Wulsin had done much of the groundwork, he was not interested in tackling large sites such as Istakhr or Hissar. Instead, Wulsin had his sights set on a different prize.

In the 1840s, a hoard of gold, marble, and bronze objects was found near the city of Astrabad (modern-day Gorgan) in northeastern Persia and was presented to the Shah for safekeeping.[4] The Astrabad Treasure, as it was called, was mostly ignored by scholars until the early twentieth century, when the great orientalist Michael Rostovtzeff noted parallels between the iconography on the objects found in the hoard and Sumerian iconography from Mesopotamian sites.[5] With most archaeologists squabbling over access to a few choice sites in southern and western Iran, Wulsin saw an opportunity for the UPM further to the northeast, and he quickly secured the rights to excavate a large site called Tokhmakh Tepe just north of the modern city of Astrabad. However, he quickly changed his plans:

> I wrote you last from Bender Shah near Asterabad. Since then I have been able to see a lot more of that region, and have found that Tureng Tepe, where the famous Sumerian treasure was found in 1841 … is a splendid site, small but with very deep strata and easy to work, very much better in every way than Tokhmakh Tepe which had been granted to us. So I have come back to town to get the permit changed to read for

Tureng Tepe. The authorities agreed willingly and I expect to go back to Asterabad in a couple of days.[6]

The excavations at Tureng Tepe, jointly funded by the UPM and the Kansas City Museum (now the Nelson-Atkins Museum of Fine Arts), were the first by an American expedition anywhere in Iran. They lasted only one season but produced a number of exciting finds.[7] The Wulsins' field notes and records have remained mostly unpublished and unstudied until recently,[8] but they contain a wealth of information on the Bronze Age of northeastern Iran. Sadly, the Great Depression dried up Wulsin's funds, and the UPM's expedition to Tureng Tepe was never continued. Wulsin resigned in anger as the Curator of Anthropology of the UPM in May 1932, and he passed the baton over to a young and brilliant archaeologist who would truly launch American involvement in Iranian archaeology.

The story of how Erich F. Schmidt became one of the most celebrated field archaeologists in the Middle East—including his stint in the German army in World War I, his escape from the Siberian Gulag on foot, his PhD studies at Columbia with the great Franz Boas, and his field training in the American Southwest with A. V. Kidder—reads like a fictional Hollywood script.[9] For the purposes of this paper, it is enough simply to note that Pope recommended Schmidt to Jayne as an excellent field archaeologist who could lead the UPM's efforts in Persia, and he was right. Schmidt brought to Near Eastern archaeology an appreciation for both stratigraphy and anthropology—two aspects heretofore lacking—and he combined rigorous field methods with meticulous note-taking (fig. 8.1). If he can be faulted for anything, it is only for undertaking too much. He began at Tepe Hissar near Damghan, where in two long seasons (1931–32) he uncovered a stunning array of artifacts and established the archaeological sequence of prehistoric northeastern Iran that is still used today.[10] It was at Hissar that Schmidt met his first wife, Mary-Helen, the daughter of a wealthy Philadelphian supporter of the UPM who had decided to take his family on a world tour. With Mary-Helen's financial and political support, Schmidt secured funds from a number of wealthy socialites—most notably Mrs. William Boyce Thompson,[11] whose collection of Hissar artifacts is currently housed at the American Museum of Natural History in New York City—to fund his excavations in Iran. Most importantly, Mary-Helen bought him a biplane, appropriately named "The Friend of Iran," that would play a critical role in his future endeavors.

After completing two seasons at Tepe Hissar, Schmidt moved to the medieval city of Rayy just outside of Tehran, where he excavated a number of prehistoric sites (e.g., Cheshmeh Ali, Murteza Gerd) as well as key areas of Rayy itself.[12] At the same time, Schmidt became involved with two other major

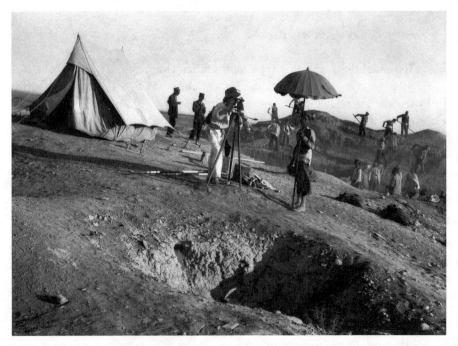

FIGURE 8.1. Erich Schmidt surveying at Tepe Hissar, northeastern Iran, 1931. Courtesy of the Penn Museum, image #82776.

projects through the Oriental Institute at Chicago and the UPM. The Holmes expedition to Luristan (1934–35, 1938–39) provided the first systematic excavation of sites containing the famous "Luristan bronzes," which had been turning up in the antiquities market for decades.[13] After Herzfeld was removed from the Persepolis excavations by the Iranian government,[14] Schmidt was selected to be the new director, a task he carried out from 1934 to 1939. Most amazingly, Schmidt was able to direct all three projects simultaneously thanks to "The Friend of Iran," which he also employed to carry out the first systematic aerial surveys of major Iranian sites.[15] Although officially an affiliate of the Oriental Institute at this point,[16] Schmidt continued to receive support from the UPM and corresponded regularly with Horace Jayne.[17]

Sadly, growing tensions between the Allied powers and the German-sympathizing Shah, and America's increasing focus on the escalating war effort, led to the cessation of archaeological work in the Middle East for almost a decade. By the late 1930s, Schmidt's beloved wife had died in childbirth, his relationship with his funders had all but dried up, and his chances of getting a job in America as a German-American were bleak. Instead, he spent the rest of his days at the Oriental Institute, completing four stunning volumes about

the Persepolis excavations. Unfortunately, the other sites (including Hissar, Cheshmeh Ali, Rayy, Murteza Gerd, and Istakhr) have only been partially published and provide great opportunities for future research.

The final person who figures into the story of the early years of the UPM's involvement in Iranian archaeology is the incomparable Carleton S. Coon, who left Harvard soon after World War II to teach at the University of Pennsylvania and serve as a curator of the UPM. Coon carried out a number of cave excavations in Iran and Afghanistan between 1949 and 1951 with the support of then-director Froelich Rainey. Coon's excavations at Bisitun, Tamtama, Khunik, and the Hotu/Belt (Kamarband) Caves, though remaining largely unpublished, provided the first stratigraphic chronology from the Mousterian to the Neolithic periods in Iran.[18] Coon was also the first scholar to introduce radiocarbon dating to Iranian archaeology, which was a notable achievement. However, perhaps his greatest contribution to the UPM's legacy of Iranian archaeology is that he created a position for an assistant curator at the museum that was subsequently filled by a bright, young scholar from Harvard by the name of Robert H. Dyson Jr. (fig.).

The Dyson Years

The history of American archaeology in Iran could be written in three parts— "Before Dyson," the "Dyson Years," and "After Dyson"—because no other American scholar has so profoundly changed the scale and scientific rigor of excavations in Iran before or since. Robert H. Dyson Jr. received his theoretical education at Harvard under Lauriston Ward and his field training at Jericho under Kathleen Kenyon.[19] Both experiences proved useful for his PhD research in 1954 at Susa, where he excavated the first stratigraphic *sondage* under Roman Ghirshman. Having accepted the UPM position that same year (before finishing his dissertation), Dyson was encouraged by Froelich Rainey to find a site in Iran where he could establish a new post–World War II presence for the museum. Dyson carried out a rather perfunctory survey of northern Iran in 1956 that produced little other than a sherd collection for the UPM but provided Dyson the insight to go to northwestern Iran to find Neolithic sites comparable to what Robert Braidwood's team from the Oriental Institute of Chicago was excavating in northeastern Iraq.[20]

In 1956, Dyson began excavations at the mound of Hasanlu Tepe outside Urmia, a site more famous for its well-preserved Iron Age remains than for any possible Neolithic occupation, which is buried under twenty-seven meters of archaeological deposit (fig. 8.3). Relevant for this paper, the Hasanlu Project (1956–77) of the UPM served as an important training ground for an entire

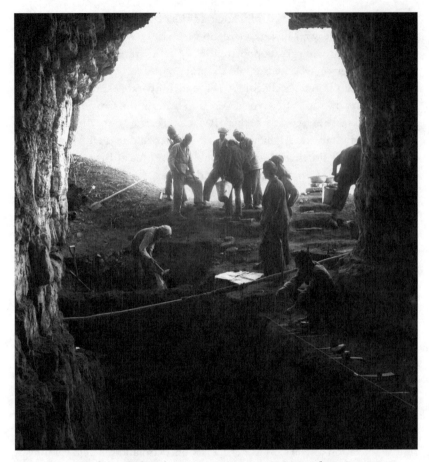

FIGURE 8.2. Carleton S. Coon's excavations at a cave in Mazandaran Province, northeastern Iran, 1949. Courtesy of the Penn Museum, image #43747.

generation of American archaeologists, many of whom went on to conduct their own excavations at Iranian sites using the "Dyson method." Dyson and his numerous students not only established stratigraphic and historic chronologies of northwestern Iran, but they also aligned the pre- and protohistory of Iran to both absolute and relative timelines still relevant today.[21]

Of course, Bob Dyson's contributions to Iranian archaeology went well beyond the Hasanlu Project. He was a founding member of the American Institute of Iranian Studies and helped to establish its Center in Tehran in the late 1960s. In the 1970s, he expanded his excavation interests to include Tal-e Malyan in Fars (a project founded by his former student, William Sumner) and Tepe Hissar in Damghan, thereby increasing knowledge about the

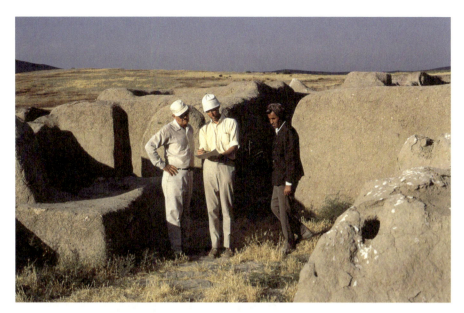

FIGURE 8.3. R. H. Dyson Jr. and Penn Museum Director Froelich Rainey at Hasanlu Tepe, northwestern Iran, 1970. Courtesy of the Penn Museum, image #302563.

stratigraphic sequences of south-central and northeastern Iran, respectively. As president of the Archaeological Institute of America (1977–80) and director of the UPM (1982–94), Dyson encouraged American scholars to continue working with Iranian collections despite the Islamic Revolution, which effectively ended Western involvement in Iranian field excavations for two decades.

In addition to the scores of students who came to the UPM in order to study and work with Dyson, he also brought to the museum two people who would have a profound effect upon the UPM's relationship with Iranian scholarship. The first was Brian Spooner, a social anthropologist and expert on the Baluchis of southeastern Iran, who had been the assistant director of the British Institute of Persian Studies in Tehran for most of the 1960s. Spooner was hired in 1968 as assistant curator of ethnology at the UPM, and he quickly established himself as one of America's leading scholars on the modern peoples and cultures of the Persianate lands.[22] In addition to his sociolinguistic work on Baluchis of Iran, Pakistan, and Afghanistan, Spooner along with his students began one of the most expansive ethno-archaeological and ethno-ecological projects ever attempted: the Turan Program of northeastern Iran.[23] Although cut short by the Islamic Revolution, the Turan Program was groundbreaking

for its focus on the interplay of built spaces with the ever-changing landscape and how this shifting relationship affects human behavior.

The other major figure brought to the UPM by Dyson was the so-called "Father of Iranian Archaeology," Ezatollah Negahban. After receiving his MA at the Oriental Institute at Chicago, Negahban had returned to Iran in 1955 and entered the faculty of the University of Tehran, where he trained two generations of Iranian archaeologists and founded the Institute of Archaeology.[24] He made a name for himself in the early 1960s at the excavations of the elite burials at Marlik Tepe in Gilan before beginning a thirteen-year excavation project at the important Elamite site of Haft Tepe in 1965. In the 1970s, Negahban began a large-scale project on the Qazvin Plain as a way to train Iranian students in excavation methods. Sadly, Negahban's defiance of the Shah during the Islamic Revolution led to a near-fatal run-in with SAVAK (the Bureau for Intelligence and Security of the State), and it seemed that all of Negahban's knowledge and unpublished excavations would be lost. Dyson and others rallied behind their friend and colleague, and in 1980 Negahban and his family fled to the United States, where he was given a visiting curator position at the UPM. It was in Philadelphia that Negahban completed his final publication of the Haft Tepe (1991) and Marlik (1996) excavations, and he produced a number of important articles on his work in the Qazvin Plain and other regions.[25] Negahban remained a major figure in Iranian archaeology at the UPM until his retirement in 2001.

The University of Pennsylvania Museum Today

Although Brian Spooner has since retired as professor and curator of Near Eastern ethnology, he still remains one of the UPM's most senior scholars on Iran. A number of other scholars at the UPM work on Iranian collections and unpublished excavations. Professor emerita Renata Holod and her students (e.g., Leslee Michelsen) have spent considerable time studying the collections held in the UPM from the Islamic site of Rayy.[26] Deborah Olszewski, a scholar of the Upper Paleolithic, is continuing the work she began with the late Harold Dibble to complete the study and publication of Carleton Coon's Paleolithic cave excavations,[27] while Michael Gregg and Christopher Thornton work on the Mesolithic and Neolithic occupations of Hotu and Belt.[28] Ayse Gürsan-Salzmann has furthered the publication of much of Schmidt's excavations at Tepe Hissar,[29] while Timothy Matney's postdoctoral research on Schmidt's excavations at Cheshmeh Ali is coming to fruition.[30] For much of the 1980s and '90s, the Museum Applied Science Center for Archaeology (MASCA) at the UPM was a foremost center for the study of Iranian craft

technologies, most notably metals and glass.[31] There, Naomi Miller and her students instituted a study of the botanical remains from a number of Iranian sites,[32] while Janet Monge and her students conducted a forensic study of a number of the skeletons brought back to the UPM from Iranian expeditions.[33] Although the main Hasanlu publication remains unwritten, a plethora of scholars have contributed their talents to the massive collection of artifacts from that site and related sites in the vicinity.[34] Forthcoming publications by Michael Danti on Period IV, by visiting researcher Stephan Kroll on Period III, and by Danti and UPM consulting scholar Megan Cifarelli on Period II will add considerably to this corpus.

In the late 1990s during a period of *détente* between Iran and the United States, a number of UPM scholars returned to Iran to seek new collaborations and fieldwork. In 2000 Holly Pittman, one of the curators of the Near East Section at the UPM and professor of art history, was asked by Professor Yousef Madjidzadeh of the University of Tehran (a former student of Negahban's) to become codirector of his excavations at the new Bronze Age site of Konar Sandal near Jiroft, whence thousands of carved chlorite vessels with elaborate iconography had flooded the antiquities market since the 1990s.[35] Pittman and a small cadre of University of Pennsylvania students were able to excavate at Konar Sandal for two seasons (2004 and 2005), and Pittman returned in 2008 to study the glyptic material (fig. 8.4).[36] Her work with the seals and sealings

FIGURE 8.4. Holly Pittman with Akram Gholami, Simin Piran, and Yousef Madjidzadeh at Konar Sandal, southeastern Iran, 2005. Courtesy of the Penn Museum.

from Konar Sandal has completely rewritten our understanding of the Early Bronze Age of southeastern Iran and surrounding regions, and it has placed Jiroft in the ranks of other major urban centers of the third millennium. UPM consulting scholar Christopher Thornton, a former student of Dyson and Pittman's, studied museum collections at the UPM and in Iran from 2005 to 2009 while completing his dissertation on Tepe Hissar.[37] Beginning in 2011, Kyle Olson began to reevaluate the Tureng Tepe collections, starting with the figurines and moving on to the entire assemblage curated at UPM.[38] This research led to a PhD thesis focused on the trade relations and political geography of northeastern Iran during the third millennium BCE. Ancillary to this research, Olson began to reconstruct the history of American-Iranian heritage diplomacy that is embedded in the archive's records,[39] research which is ongoing.

The University of Pennsylvania Museum has been deeply committed to the study and preservation of Iranian cultural heritage since 1930 and continues to be involved with Iranian studies courtesy of its extensive collections and well-curated archives. There are many opportunities for original research projects using these collections, and the concentration of affiliated scholars fluent in the art, archaeology, and anthropology of Iran at the UPM is unparalleled in the United States. The legacy of Wulsin and Schmidt, Coon and Dyson, and all those who followed is alive and well in Philadelphia. We encourage all scholars to visit the museum and work with the collections, so that future generations of students will benefit from continuing scholarship on the rich and diverse heritage of Iran.

Notes

Thanks to Erica Ehrenberg and the AIIrS for inviting us to submit a paper on the Penn Museum's history in Iran. Katherine Blanchard, Keeper of the Near East Section at the UPM, provided the list of collections (table 8.2), while a number of UPM Archives staff and volunteers helped to put together the archives list (table 8.1). Gregory Tentler carried out much of the archival research on Wulsin, Schmidt, and Coon, and without his careful notes this paper could not have been written.

1. Unpublished Jayne letters, UPM Archives.
2. Cabot, *Vanished Kingdoms*.
3. Unpublished Jayne letters, UPM Archive.
4. De Bode, "On a Recently Opened Tumulus."
5. Rostovtzeff, "Sumerian Treasure of Astrabad."
6. Frederick R. Wulsin, Letter to Horace Jayne, May 19, 1931, UPM Archives.
7. Wulsin, *Excavations at Tureng Tepe*, and Wulsin, "Early Cultures of Astarabad."
8. Olson "Figurines and Identity," and Olson and Thornton, "Tureng Tepe."
9. Haines, "Erich F. Schmidt."
10. Schmidt, *Tepe Hissar Excavations 1931*; Schmidt, *Excavations at Tepe Hissar*; and Gürsan-Salzmann, *Exploring Iran*.
11. Mrs. Thompson had already funded Schmidt's work in Arizona for the American Museum of Natural History in the 1920s.

12. Schmidt, "Persian Expedition"; Schmidt, "Rayy Research"; and Matney, "Re-Excavating Cheshmeh-Ali."
13. Schmidt, van Loon, and Curvers, *Holmes Expeditions to Luristan.*
14. Mousavi, "Ernst Herzfeld."
15. Schmidt, *Flights over Ancient Cities.*
16. Schmidt moved to the OI in 1939.
17. Unpublished letters in UPM Archives.
18. Coon, *Cave Explorations in Iran*; Coon, *Seven Caves*; and Olszewski and Dibble, *Paleolithic Prehistory.*
19. Dyson, "Introduction."
20. Braidwood et al., *Prehistoric Archeology Along the Zagros Flanks.*
21. See Voigt and Dyson, "Chronology of Iran."
22. E.g., Spooner, *City and River in Iran,* and Spooner, "Anthropology, Social and Cultural."
23. Spooner and Horne, "Cultural and Ecological Perspectives"; Martin, "Making a Living in Turan"; and Horne, *Village Spaces.*
24. Kamyar Abdi, unpublished obituary of Negahban.
25. For example, Negahban, "Clay Human Figurines of Zaghe."
26. For example, Holod "What's in a Name?"
27. For example, Dibble, "Mousterian Industry," and Olszewski and Dibble, *Paleolithic Prehistory.*
28. Gregg and Thornton, "Preliminary Analysis."
29. Gürsan-Salzmann, *New Chronology.*
30. Matney et al., *Cheshmeh Ali.*
31. See, for example, Pigott, "Development of Metal Production," and McGovern, Fleming, and Swann, "Beads."
32. Miller, "Archaeobotany in Iran."
33. Selinsky, "Death a Necessary End," and Monge and McCarthy, "Life of Violence."
34. Winter, *Decorated Breastplate*; Muscarella, *Catalogue of Ivories*; Voigt, *Hajji Firuz Tepe*; Rubinson, "Mid-Second Millennium Tomb"; De Schauensee, "Horse Gear from Hasanlu"; De Schauensee, *Peoples and Crafts*; Marcus, *Emblems of Identity and Prestige*; Danti, *Ilkhanid Heartland*; Danti, *Hasanlu*; and Pizzorno, "Dinkha Tepe Revisited."
35. Madjidzadeh, *Jiroft*; Madjidzadeh and Pittman, "Excavations at Konar Sandal."
36. Pittman, "Complete Corpus of Glyptic Art"; Pittman "Art of the Bronze Age"; and Pittman, "Bronze Age Interaction."
37. Thornton, Gürsan-Salzmann, and Dyson, "Tepe Hissar and the Fourth Millennium"; Thornton, "Tappeh Sang-e Chakhmaq"; Dyson and Thornton, "Shir-i Shian"; Vahdati Nasab et al., "Late Neolithic Site of Rashak III."
38. Olson "Figurines and Identity," and Olson and Thornton, "Tureng Tepe."
39. Olson "Heritage Diplomacy and US-Iran Relations."

Bibliography

Braidwood, Linda S., Robert J. Braidwood, Bruce Howe, Charles A. Reed, and Patty Jo Watson. *Prehistoric Archeology Along the Zagros Flanks.* Oriental Institute Publications 105. Chicago: University of Chicago Press, 1983.

Cabot, Mabel H. *Vanished Kingdoms: A Woman Explorer in Tibet, China and Mongolia, 1921–1925.* New York: Aperture, 2005.

Coon, Carleton S. *Cave Explorations in Iran 1949*. University Museum Monograph 5. Philadelphia: University of Pennsylvania Museum, 1951.

———. *The Seven Caves*. New York: Knopf, 1957.

Danti, Michael D. *Hasanlu V: The Late Bronze and Iron I Periods*. Hasanlu Excavation Reports 3. University Museum Monograph 137. Philadelphia: University of Pennsylvania Museum, 2013.

———. *The Ilkhanid Heartland: Hasanlu Tepe (Iran) Period I*. Hasanlu Excavation Reports 2. University Museum Monograph 120. Philadelphia: University of Pennsylvania Museum, 2004.

De Bode, C. A. "On a Recently Opened Tumulus in the Neighbourhood of Asterabad, Forming Part of Ancient Hyrcania, and the Country of the Parthians." *Archaeologia* 30 (1844): 248–55.

De Schauensee, Maude. "Horse Gear from Hasanlu." *Expedition* 31.2–3 (1989): 37–52.

———, ed. *Peoples and Crafts in Period IVB at Hasanlu, Iran*. Hasanlu Special Studies 4. University Museum Monograph 132. Philadelphia: University of Pennsylvania Museum, 2011.

Dibble, Harold L. "The Mousterian industry from Bisitun Cave (Iran)." *Paléorient* 18 (1984): 23–34.

Dyson, Robert H., Jr. "Introduction." Pages xxv–xxviii in *Hajji Firuz Tepe, Iran: The Neolithic Settlement*. Edited by Mary M. Voigt. Hasanlu Excavation Reports 1. University Museum Monograph 50. Philadelphia: The University Museum, 1983.

Dyson, Robert H., Jr., and Christopher P. Thornton. "Shir-i Shian and the Fifth Millennium Sequence of Northern Iran." *Iran* 47 (2009): 1–22.

Gregg, Michael W., and Christopher P. Thornton. "A Preliminary Analysis of the Prehistoric Pottery from Coon's Excavations of Hotu and Belt Caves in Northern Iran: Implications for Future Research into the Emergence of Village Life in Western Central Asia." *International Journal of the Humanities* 19.3 (2012): 56–94.

Gürsan-Salzmann, Ayse. *Exploring Iran: The Photography of Erich F. Schmidt, 1930–1940*. Philadelphia: University of Pennsylvania Museum, 2007.

———. *The New Chronology of the Bronze Age Settlement of Tepe Hissar, Iran*. University Museum Monograph 142. Philadelphia: University of Pennsylvania Museum, 2016.

Haines, Richard C. "Erich F. Schmidt: September 13, 1897–October 3, 1964." *Journal of Near Eastern Studies* 24.3 (1965): 145–48.

Holod, Renata. "What's in a Name? Signature or Keeping Count? On Craft Practices at Rayy." Pages 215–27 in *The Seljuqs and Their Successors: Art, Culture and History*. Edited by Sheila R. Canby, Deniz Beyazit, and Martina Rugiadi. Edinburgh: Edinburgh University Press, 2020.

Horne, Lee. *Village Spaces: Settlement and Society in Northeastern Iran*. Washington, DC: Smithsonian Institution, 1994.

Madjidzadeh, Yousef. *Jiroft: The Earliest Oriental Civilization*. Tehran: Ministry of Culture and Islamic Guidance, 2003.

Madjidzadeh, Yousef, and Holly Pittman. "Excavations at Konar Sandal in the Region of Jiroft in the Halil Basin: First Preliminary Report (2002–2008)." *Iran* 46 (2008): 69–105.

Marcus, Michelle I. *Emblems of Identity and Prestige: The Seals and Sealings from Hasanlu, Iran*. Hasanlu Special Studies 3. University Museum Monograph 84. Philadelphia: University of Pennsylvania Museum, 1996.

Martin, Mary. "Making a Living in Turan: Animals, Land, and Wages." *Expedition* 22.4 (1980): 29–35.
Matney, Timothy. "Re-Excavating Cheshmeh-Ali." *Expedition* 37.2 (1995): 26–32.
Matney, Timothy, Hassan Fazeli Nashli, Holly Pittman, and Christopher P. Thornton, eds. *Cheshmeh Ali: A Neolithic and Chalcolithic Site in North-Central Iran*. Philadelphia: University of Pennsylvania Museum Monographs, forthcoming.
McGovern, Patrick E., Stuart J. Fleming, and Charles P. Swann. "The Beads from Tomb B10a b27 at Dinkha Tepe and the Beginnings of Glassmaking in the Ancient Near East." *American Journal of Archaeology* 95.3 (1991): 395–402.
Miller, Naomi F. "Archaeobotany in Iran: Past and Future." Pages 9–16 in *Yeki Bud, Yeki Nabud: Essays on the Archaeology of Iran in Honor of William M. Sumner*. Edited by Naomi F. Miller and Kamyar Abdi. Cotsen Institute of Archaeology at UCLA Monograph 48. Los Angeles: Cotsen Institute of Archaeology, 2003.
Monge, Janet, and Colleen McCarthy. "A Life of Violence: When Warfare and Interpersonal Violence Intertwine at Hasanlu, Period IVB." Pages 183–94 in *Peoples and Crafts in Period IVB at Hasanlu, Iran*. Edited by M. de Schauensee. Hasanlu Special Studies 4. University Museum Monograph 132. Philadelphia: University of Pennsylvania Museum, 2011.
Mousavi, Ali. "Ernst Herzfeld, Politics, and Antiquities Legislation in Iran." Pages 445–75 in *Ernst Herzfeld and the Development of Near Eastern Studies, 1900–1950*. Edited by Ann C. Gunter and Stefan R. Hauser. Leiden: Brill, 2004.
Muscarella, Oscar White. *The Catalogue of Ivories from Hasanlu, Iran*. Hasanlu Special Studies 2. University Museum Monograph 40. Philadelphia: University of Pennsylvania Museum, 1980.
Negahban, Ezatollah O. "Clay Human Figurines of Zaghe." *Iranica Antiqua* 19 (1984): 1–20.
———. *Excavations at Haft Tepe, Iran*. University Museum Monograph 70. Philadelphia: University of Pennsylvania Museum, 1991.
———. *Marlik: The Complete Excavation Report*. 2 vols. University Museum Monograph 87. Philadelphia: University of Pennsylvania Museum, 1996.
Olson, Kyle G. "Figurines and Identity in Bronze Age Iran: An Analysis of Adornment, Context, and Use at Tureng Tepe." *Archäologische Mitteilungen aus Iran und Turan* 49 (2017): 123–47.
———. "Heritage Diplomacy and US-Iran Relations: The Case of the Iranian Antiquities Bill of 1930." Pages 57–72 in *American-Iranian Dialogues: An International History from Constitution to White Revolution*. Edited by Michael K. Shannon. New York: Bloomsbury, 2021.
Olson, Kyle G., and Christopher P. Thornton. "Tureng Tepe, a Bronze Age Center in Northeastern Iran Revisited (The Wulsin Excavations, 1931)." *Iran* 59.1 (2021): 4–35.
Olszewski, Deborah I., and Harold L. Dibble, eds. *The Paleolithic Prehistory of the Zagros-Taurus*. University Museum Monograph 83. Philadelphia: University of Pennsylvania Museum, 1993.
Pigott, Vincent C. "The Development of Metal Production on the Iranian Plateau: An Archaeometallurgical Perspective." Pages 73–106 in *The Archaeometallurgy of the Asian Old World*. Edited by Vincent C. Pigott. MASCA Research Papers in Science and Archaeology 16. University Museum Symposium Series 7. University Museum Monograph 89. Philadelphia: University of Pennsylvania Museum, 1999.

Pittman, Holly. "Art of the Bronze Age in Iran: A New Chapter from Konar Sandal." Pages 89–110 in *Sepehr Majd: Essays on the Archaeology of the Iranian World and Beyond in Honor of Dr. Youssef Madajidzadeh*. Edited by Sajjad Alibaigi, Mohammadresa Miri, and Holly Pittman. Tehran: The Centre for the Great Islamic Encyclopedia Centre for Iranian and Islamic Studies, 2021.

———. "Bronze Age Interaction on the Iranian Plateau. From Kerman to the Oxus through Seals." Pages 267–89 in *The Iranian Plateau During the Bronze Age: Developments of Urbanisation, Production and Trade*. Edited by Jan-Waalke Meyer, Emmanuella Vila, Marjan Mashkour, Michèle Casanova, and Régis Vallat. Lyon: Maison de l'Orient et de la Méditerranee-Jean Pouilloux, 2019.

———. "The Complete Corpus of Glyptic Art from Konar Sandal South and Konar Sandal North." In *Corpus of Inscriptions and Seals of the Indus* series. Edited by Asko Parpola. Helsinki: University of Helsinki Press, forthcoming.

Pizzorno, Gabriel H. "Dinkha Tepe Revisited: A Critical Evaluation and Stratigraphic Analysis of the Hasanlu Project Excavations." PhD diss., University of Pennsylvania, 2011.

Rostovtzeff, M. "The Sumerian Treasure of Astrabad." *Journal of Egyptian Archaeology* 6 (1920): 4–27.

Rubinson, Karen S. "A Mid-Second Millennium Tomb at Dinkha Tepe." *American Journal of Archaeology* 95.3 (1991): 373–94.

Schmidt, Erich F. *Excavations at Tepe Hissar: Damghan*. Philadelphia: The University Museum, 1937.

———. *Flights over Ancient Cities of Iran*. Special Publication of the Oriental Institute of the University of Chicago. Chicago: University of Chicago Press, 1940.

———. "The Persian Expedition." *University Museum Bulletin* 5.5 (1935): 41–49.

———. "Rayy Research." *University Museum Bulletin* 6.3 (1936): 79–87.

———. *Tepe Hissar Excavations 1931*. The Museum Journal 23.4. Philadelphia: The University Museum, 1933.

Schmidt, Erich F., Maurits N. van Loon, and Hans H. Curvers. *The Holmes Expeditions to Luristan*. Oriental Institute Communications 21. Chicago: University of Chicago Press, 1989.

Selinsky, Page. "Death a Necessary End: Perspectives on Paleodemography and Aging from Hasanlu, Iran." PhD diss., University of Pennsylvania, 2009.

Spooner, Brian. "Anthropology, Social and Cultural, in Iran and Afghanistan." *Encyclopaedia Iranica*. Last updated August 11, 2011. https://www.iranicaonline.org/articles/anthropology-social-and-cultural-in-iran-and-afghanistan.

———. *City and River in Iran: Urbanization and Irrigation of the Iranian Plateau*. New Haven: Society for Iranian Cultural and Social Studies, 1974.

Spooner, Brian, and Lee Horne. "Cultural and Ecological Perspectives from the Turan Program, Iran." *Expedition* 22.4 (1980): 4–10.

Thornton, Christopher P. "Tappeh Sang-e Chakhmaq: A New Look." Pages 241–55 in *The Neolithisation of Iran: The Formation of New Societies*. BANEA Publication Series 3. Edited by Roger Mathews and Hassan Fazeli Nashl. London: Oxbow, 2013.

Thornton, Christopher P., Ayse Gürsan-Salzmann, and Robert H. Dyson Jr. "Tepe Hissar and the Fourth Millennium of Northeastern Iran." Pages 131–44 in *Ancient Iran and its Neighbours*. Edited by Cameron A. Petrie. London: Oxbow, 2013.

Vahdati Nasab, Hassan, Christopher P. Thornton, S. M. Mousavi Kouhpar, N. Sykes, and R. Naderi. "Late Neolithic Site of Rashak III Rock Shelter, Mazandaran,

Iran." Pages 272–83 in *The Neolithisation of Iran*. Edited by R. Matthews ad H. Fazeli Nashli. London: Oxbow, 2013.

Voigt, Mary M. *Hajji Firuz Tepe, Iran: The Neolithic Settlement*. Hasanlu Excavation Reports 1. University Museum Monograph 50. Philadelphia: The University Museum, 1983.

Voigt, Mary M., and Robert H. Dyson Jr. "The Chronology of Iran, ca. 8000–2000." Pages 122–78 in *Chronologies in Old World Archaeology*. Edited by Robert W. Erich. Chicago: University of Chicago Press, 1992.

Winter, Irene. J. *A Decorated Breastplate from Hasanlu, Iran*. Hasanlu Special Studies 1. University Museum Monograph 39. Philadelphia: The University Museum, 1980.

Wulsin, Frederick R. "The Early Cultures of Astarabad (Turang Tepe)." Pages 163–67 in vol. 1 of *A Survey of Persian Art from Prehistoric Times to the Present*. Edited by Arthur Upham Pope and Phyllis Ackerman. London: Oxford University Press, 1938.

———. *Excavations at Tureng Tepe, Near Asterabad*. Vol. 2 of *Supplement to the Bulletin of the American Institute for Persian Art and Archaeology*. New York: American Institute for Persian Art and Archaeology, 1932.

CHAPTER 9

The Persian Expedition: The Past and Present of the Oriental Institute's Early Work in Iran

Matthew W. Stolper

THE UNIVERSITY OF CHICAGO WAS founded in 1893 as a research university, and its Oriental Institute (now known as the Institute for the Study of Ancient Cultures, West Asia & North Africa) was founded in 1919 as a vehicle for research on many parts of one big topic. James Henry Breasted (1865–1935), the Oriental Institute's founding director, stated that by the early twentieth century, scientists had developed the basis for understanding the physical origins of modern man, and historians had developed the basis for understanding the documented history of civilization. Bridging the gap between these two approaches to understanding the human career could only be done by studying the emergence and early histories of the societies of the ancient Near East. Bridging that gap was "the greatest task of the humanist today."[1] The mission of the Oriental Institute was to be carried out by a combination of archaeological field expeditions and a home staff of philologists and historians.

The historical assumption behind Breasted's vision—a single arc of civilization that rose in the East and passed to the West—is not a given in the academy today, even if it is far from extinct in society at large. The stirring terms in which Breasted expressed his vision now seem quaint, if not even worse. The political and economic conditions that made it possible for him to enact his vision are long gone. Nevertheless, the coherence of the underlying concept abides. The consequences of the Oriental Institute's original purpose and the results of its first twenty hectic years continue to shape its research and publication agendas to the present day, including some of its research and publication on ancient Iran.

During the 1920s, the Oriental Institute carried out a series of large-scale, long-term archaeological projects in Egypt and around the entire arc of the "fertile crescent," the term Breasted had coined to designate the areas where the oldest complex literate societies of Western Asia had arisen. As these pieces of the plan went into place, Breasted and his colleagues paid increasing attention to opportunities for research in what he called "the highland zone"

adjoining the Fertile Crescent. The eastern territory of the highland zone became accessible to his ambitions when the French monopoly on archaeological excavation in Iran, in effect since 1897, ended in 1927.

Ernst Herzfeld (1879–1948), professor of oriental studies at the University of Berlin,[2] had been one of the advisers who shaped the new Iranian antiquities law that went into effect in early 1931.[3] By then, the bleak conditions of the Great Depression had dampened even Breasted's soaring hopes, so he asked Herzfeld to apply on the Oriental Institute's behalf only for an option on a concession to begin archaeological work at Persepolis. Herzfeld obtained not an option but an actual concession. Breasted obtained funding from Mrs. William H. Moore, though she chose to remain anonymous at the time,[4] and the Persian Expedition of the Oriental Institute began to excavate under Herzfeld's direction in the spring of 1931.[5]

The Oriental Institute's research in and on ancient Iran falls into three periods: interwar (1931–39), postwar (1945–79), and postrevolutionary (1979 to the present). These periods are bounded by political and economic conditions, but they are also marked by changing intellectual, methodological, legal, and ethical conditions that affected American academic research in general, the mission and structure of the Oriental Institute as a whole, and the Oriental Institute's research on ancient Iran in particular. The results of the Persian Expedition of the Oriental Institute during its eight short years in the field affected later work most obviously in the form of publications produced decades after the original excavations, which finally became available in much different intellectual environments than those surrounding the excavations themselves. The effects also appear less obviously in research agendas that were sometimes motivated by the discrepancies between the intellectual basis of older work and later assumptions or methods.

Interwar (1931–39)

The focus of the Persian Expedition in the interwar period was the great terrace of Takt-e Jamšid, also known Persepolis (as it was called in Greek) and Pārsa (as it was called in Old Persian). Darius I had begun to build the complex of palaces, ceremonial buildings, and structures housing support facilities in about 518 BCE. Darius's Achaemenid successors had completed, extended, maintained, and renovated the complex, and Alexander III of Macedon had sacked and destroyed it in 330 BCE.

The ruins were one of the focal points of the European rediscovery of Near Eastern antiquity. The cyclopean masonry of the terrace, the columns that stood over the debris on the terrace, and the royal tombs cut into the face of the

Kuh-e Raḥmat above the terrace had attracted the notice of European travelers since Odoric of Pordenone in the fourteenth century and Pietro della Valle in the seventeenth. Engelbert Kaempfer and Cornelis De Bruijn produced accurate drawings of the ruins in the late seventeenth and early eighteenth centuries. In the late eighteenth century, Carsten Niebuhr made accurate copies of Achaemenid trilingual inscriptions visible on the standing ruins, copies which were the basis for the first steps in the decipherment of the cuneiform scripts at the beginning of the nineteenth century.[6] Sasanian and Qajar magnates, as well as Western travelers, had added inscriptions and carved graffiti on the exposed ruins, and some had taken away pieces of architectural ornament for reuse in buildings nearby or for display in cabinets of curiosities abroad. Some probed the debris,[7] but before 1931 no serious attempt had been made to excavate the site.

In the views of Breasted and Herzfeld, the Achaemenid Persian Empire was the final synthesis of ancient Near Eastern civilizations, the hinge that connected the mission of the Oriental Institute to the established history of Western civilization. In Iran, even before the nationalistic climate of the early Pahlavi regime, Persepolis was the emblem of continuity with a triumphant past.[8] Ernst Herzfeld had passionately urged the excavation and conservation of Persepolis as one of the foremost desiderata of ancient Near Eastern studies.[9] By the end of the last season of the Oriental Institute's work ten years later, the structures on the terrace had been cleared. Almost the entire plan of Persepolis as it is seen today is the result of these excavations (fig. 9.1). Extended clearance and restoration, continuing to the present, builds on this work.[10]

The early results of the excavation were spectacular. As Herzfeld foresaw, the rubble accumulated during and after the destruction of the site preserved an array of architectural relief sculptures in nearly perfect condition and in undisturbed arrangement. The Apadana reliefs that Herzfeld cleared in 1932 became the foremost corpus of Achaemenid monumental art. As Herzfeld's architect Friedrich Krefter (1898–1995) recognized, undisturbed foundation deposits were to be found under the buried corners of the Apadana. In 1933, they yielded gold and silver tablets with trilingual inscriptions of Darius I. No one had anticipated that tens of thousands of Achaemenid administrative records on clay tablets and fragments would be unearthed in a salient of the fortification wall around the site.

The discoveries at Persepolis, like those of the other great interwar archaeological projects in Mesopotamia and Egypt, became international news reported in the *Illustrated London News*, the *Times* of London, the *New York Times*, *Time* magazine, *Scientific American*, and newspapers in Chicago and Berlin.[11] The site became a destination for a new class of European travelers for whom the modern automobile made the Middle East accessible.[12] Persepolis

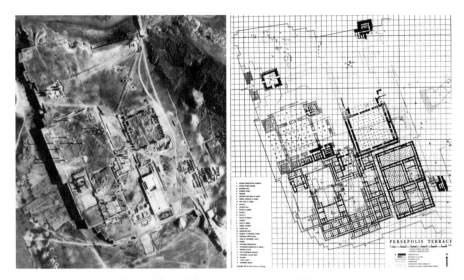

FIGURE 9.1. Persepolis terrace. Left, Persepolis terrace during 1936 excavations. Right, plan of terrace as excavated by Oriental Institute, 1939. Courtesy of the Institute for the Study of Ancient Cultures of the University of Chicago.

was glamorous and "a public relation man's dream," as John A. Wilson, Breasted's successor as director of the Oriental Institute put it.

In 1934, however, the Persian Expedition passed through a crisis. The new Iranian antiquities law included provisions for the division of finds between foreign institutions sponsoring excavations and the archaeological and antiquities services of Iran. Iranian ministries held that both the Oriental Institute's original concession of 1930 (which had been limited to clearance, restoration, and preservation) and the revision of the concession in late 1931 (which authorized archaeological explorations within a ten-kilometer radius around Persepolis) exempted discoveries at Persepolis from such division.[13] Breasted, Herzfeld, and the American diplomats in Iran acting on behalf of the Oriental Institute insisted otherwise, demanding what they considered to be an equitable return for their efforts, expenses, expertise, and success. After months of tense negotiations, reluctant Persian ministries conceded, and a first division took place in December 1934.[14]

Herzfeld, however, fell victim to the negotiations. He was a man of vast knowledge and strong opinion. He was a student and heir of a generation of German academic giants, men who considered it imperative to know every fact and command every skill within their fields and to extend the boundaries of their fields.[15] Like some of his masters, he had a knack for creating enmity among rivals and colleagues alike, but unlike some of them his circumstances

were not immune from the consequences. He had strained relations both with his teachers, including Friedrich Delitzsch and Eduard Meyer, and with his academic colleagues.[16] He had strained relations with contemporaries in Tehran, including André Godard, the director of the new Iranian National Museum in Tehran, and Arthur Upham Pope, the founding director of the American Institute for Persian Art and Archaeology.[17] He had strained relations with members of his own team, including Krefter after the discovery of the gold and silver foundation tablets. It would be a gross understatement to say that his relationship with his team member Alexander Langsdorff (1898–1946) was also strained. Langsdorff, a participant in the Beer-Hall Putsch of 1923 and a committed Nazi party member after 1933, submitted denunciations of Herzfeld to Iranian and German authorities.[18] By 1934, in spite of his earlier position of privilege and access as an advisor, Herzfeld had strained relations with agencies of the Pahlavi government.[19] He had strained relations with supporters including Breasted himself, others at the University of Chicago, and American academic colleagues.[20] When he was accused of sending antiquities out of the country illegally—a charge that he denied and that seems in modern perspective to have been a pretext—the government of Iran told the Oriental Institute that although he would not be declared *persona non grata*, he must be relieved of his post at the head of the Persian Expedition. The Oriental Institute complied. Later, Herzfeld was forced out of his post at the University of Berlin, his vulnerability under the racial laws of the Nazi regime compounded by his acerbic personality.[21]

Friedrich Krefter took over direction of the Persepolis excavations during the 1934 season, which was cosponsored with the Oriental Institute by the Boston Museum of Fine Arts and the University of Pennsylvania Museum. These institutions also sponsored excavations at Rayy that began in 1934 under the direction of Erich F. Schmidt (1897–1964). Schmidt, whom Oriental Institute director John A. Wilson later remembered as "a meticulous craftsman . . . a curious combination of the methodical German worker and the highly emotional romantic," had been codirector of the Oriental Institute's excavation at Alishar Hüyük in Turkey during the 1920s, and at the beginning of 1935 the Oriental Institute appointed him to direct the Persian Expedition.

Both before and after this crisis, the work of the Persian Expedition was not confined to the palaces and monumental art that represented what Breasted called "the full noonday of Persian civilized development."[22] In keeping with the stated mission of the Oriental Institute, Breasted and Herzfeld aimed to document the long prehistoric and historic context in which the Persian Empire arose and passed away, leaving Persepolis as its testament. The Persian Expedition worked at three other sites within the ten-kilometer radius around Persepolis that was authorized by the revised concession of 1931.

FIGURE 9.2. Tall-e Bākun and Eṣṭakr. Left, Tall-e Bākun A, partially excavated, and B, unexcavated, in 1935. Right, Eṣṭakr in 1936. Courtesy of the Institute for the Study of Ancient Cultures of the University of Chicago.

At Tall-e Bākun, a few hundred meters south of the Persepolis terrace, two well-preserved Neolithic and Chalcolithic settlements were excavated, both under Herzfeld's oversight and under Schmidt's (fig 9.2).

At Naqš-e Rostam, about five kilometers north-northwest of the terrace, Schmidt's team recorded the Achaemenid royal tombs with detailed photographs and plans. Herzfeld began to excavate buildings of Achaemenid, Hellenistic, Sasanian, and early Islamic date in a mounded site at the foot of the Achaemenid royal tombs, efforts that were later continued by Schmidt. Under Schmidt's direction, excavation of the Achaemenid structure facing the tombs, called the Ka'aba-ye Zardušt, revealed the great inscriptions in Parthian, Middle Persian, and Greek telling the deeds of Shapur I. These inscriptions, which their first editor called "the greatest historical inscriptions found since Behistun," were accompanied by a contemporary Middle Persian inscription of the priest Kartir (figs. 9.3 and 9.4).[23] Schmidt's team made detailed photographs of the vestiges of a second-millennium BCE Elamite relief and of the Sasanian reliefs near the Achaemenid tombs.

At Eṣṭakr (Takt-e Ṭā'ūs), about five kilometers north-northeast of Persepolis, Herzfeld and Schmidt recorded the early Islamic mosque and excavated Abbassid and early Islamic structures and pits, but they failed to find the Sasanian city known from historical records or the Achaemenid city that they believed must lie beneath it.[24]

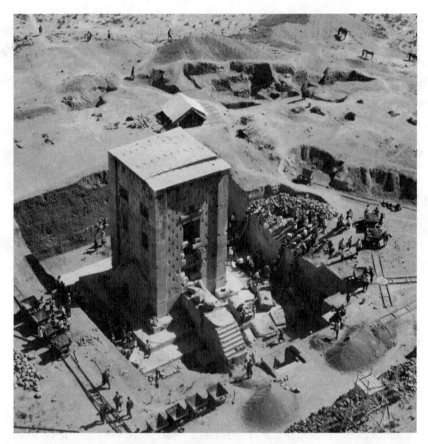

FIGURE 9.3. The Kaʻaba-ye Zardušt at Naqš-e Rostam in 1939. Courtesy of the Institute for the Study of Ancient Cultures of the University of Chicago.

Indeed, this series of tests and excavations failed to achieve its prime goal: to establish the ceramic sequence of Fars from prehistoric times through the Early Islamic period, as a baseline for wider exploration of ancient Iran. Schmidt nevertheless pursued this goal by other means. With financial support from his wife, Mary Ellen Warden Schmidt, he bought an airplane, christened it "The Friend of Iran," threaded the maze of permissions and political connections needed to bring the plane into Iran and fly it there, and created an Aeronautical Department of the Persian Expedition.[25]

Schmidt and photographer Boris Dubensky (1899–1984) carried out a series of aerial reconnaissances of western and northern Iran between 1935 and 1937. The plane touched down at many sites to collect sherds and record ground-based observations—"ground truth" in today's droll phrase. This was

FIGURE 9.4. George G. Cameron examines the trilingual inscription of Shapur I. Courtesy of the Institute for the Study of Ancient Cultures of the University of Chicago.

meant to be the beginning of a comprehensive survey and sampling of archaeological sites in Iran and eventually, Schmidt hoped, in all the archaeological areas of the Middle East. Around Persepolis itself, Schmidt carried out a detailed aerial survey that recorded about four hundred sites in the Marvdašt, expecting to be able to collect ground data from each in order to establish the entire settlement history of the Persepolis area.[26]

Schmidt had already carried out surveys and soundings in Luristan that were sponsored by the Rayy Expedition of the University of Pennsylvania Museum and the Boston Museum of Fine Arts. In 1938, the Oriental Institute's Persian Expedition—its season abbreviated by thin funding during the second trough of the Great Depression—joined the survey and Schmidt's season of excavation at the Iron Age sanctuary of Surkh Dum-i Luri.

In the late 1930s, the Chicago archaeologists were finding Iran to be an inhospitable place. By 1939, the Oriental Institute's deteriorating relations with Iranian authorities led John A. Wilson to give notice that the Persian Expedition would end. The final season of the excavation at Persepolis took place under the ominous conditions that followed the German occupation of the Sudetenland. By the time Schmidt left Persepolis in October 1939, the invasion of Poland had begun World War II. The United States was not yet a combatant, but the war ended all Oriental Institute fieldwork for the duration.

Breasted had inaugurated the Oriental Institute with the claim that "with sufficient funds and an adequate personnel, it will be possible in the next twenty-five or thirty years, or, let us say, within a generation, to clear up the leading ancient cities of Western Asia and to recover and preserve for future study the vast body of human records which they contain."[27] When World War II interrupted the execution of this program, a short generation had elapsed. In those twenty years, the Oriental Institute's fieldwork in Egypt, Palestine, Syria, Turkey, Iraq, and Iran resembled the agenda of a national research organization and not of a mere university institute. The complement of the Persepolis excavations resembled the crew of an eighteenth-century warship more than the staff of a late twentieth-century excavation: "The staff regularly includes ... a chauffeur ... a mason ... restorers ... a carpenter with his helpers ... garage hands, a gardener, electrician's helpers, guards at the four entrances, night patrols, a cook and servants.... The Persepolis digging crew fluctuates from two hundred to five hundred men."[28]

The amount of raw data accumulated by these excavations was staggering, and the preliminary announcements promised transformative results, but the reality behind what Breasted described as "efficient and scientific field expeditions ... associated with the home staff of philologists and historians"[29] was not balanced. Fifteen years after the interruption of large-scale fieldwork, as a

later Director of the Oriental Institute remarked in his annual report, "the printer [was] still catching up with the spade."[30]

Brief reports of the Persian Expedition's work, from a few paragraphs to a few pages, appeared regularly in the *American Journal of Semitic Languages and Literatures*, the house organ of the Oriental Institute and the University of Chicago's Department of Oriental Languages,[31] and in *Archiv für Orientforschung*.[32] These discharged an academic duty but included few illustrations and no detail, so they lacked the impact and even the archaeological value of contemporary newspaper and magazine notices. When World War II broke out, only a single substantial preliminary report was available, published by the Oriental Institute in a series intended (again in Breasted's words), "to keep the general reader informed of Institute activities ... *popular* in style, written in simple non-technical language, and plentifully illustrated ... to bring out the main *facts* developed by field work."[33]

Schmidt's preface to this report summarized Herzfeld's work on the terrace but did not describe or illustrate it. As the report's title indicates, Schmidt focused on the main area of the terrace explored under his own direction (i.e., the Treasury), but he also gave extensive accounts of work at Naqš-e Rostam, Tall-e Bākun A and B, and Eṣṭaḵr as well as summaries of his aerial survey of the Marvdašt.[34]

When Herzfeld had been relieved of his command, the Oriental Institute announced that it was "retaining him without field duties to publish the results of his successful campaigns at Persepolis and the neighboring sites," and that an Oriental Institute Communication was in preparation with chapters on some of Herzfeld's major discoveries. It was to treat the prehistoric settlement at Tall-i Bākun A, the Apadana stairway reliefs, and Naqš-e Rostam.[35] The reader is allowed to suppose that Herzfeld was preparing the work, but Krefter remembered it as his task.[36] It was never completed.

Herzfeld lectured on Persepolis at the Royal Asiatic Society in 1933.[37] His Schweich Lectures at Oxford in 1934 barely touched on Persepolis,[38] but his Lowell Lectures in Boston in 1936 discussed the architecture of the areas he had cleared, and the publication included fine illustrations of some of the reliefs he had uncovered as well as of the post-Alexander "frātadāra temple" (now generally called the "Frataraka temple complex") that he had partially excavated a few hundred meters northwest of the terrace.[39] In 1938, he published many of the Achaemenid inscriptions from Persepolis, both newly excavated and long-known items.[40]

By 1936, Herzfeld was safe with a professorship at the Institute for Advanced Studies in Princeton, where he remained until 1944. His relationship with the Oriental Institute had turned icy. Bitter about his treatment, an unhappy survivor of cultures and courtesies that had ceased to exist, he was deaf to calls for

help with final publications.[41] The only Oriental Institute publication of work done specifically under Herzfeld's direction was the final report on the 1932 season at the Chalcolithic site of Tall-i Bākun A, which was published soon after the United States had entered the war.[42]

The "home staff" of philologists began to report on some of the Persepolis texts with exemplary speed, venturing first observations without full comprehension. The Assyriologist Arno Poebel (1881–1958), the editor of the *Chicago Assyrian Dictionary*, organized a team to work on the Persepolis Fortification tablets and published two prompt articles on their chronology,[43] the latter soon corrected by junior members of his team, George Cameron (1905–1979)[44] and Richard Hallock (1906–1980).[45] Especially remarkable for detail and promptness (though now all but forgotten) were the extensive reports that Martin Sprengling (1878–1959) published about the Sasanian inscriptions on the Kaʿaba-ye Zardušt: two on the Middle Persian version of the Shapur inscription cleared in 1936,[46] one on the Kartir inscription, and three on the Shapur trilingual cleared in 1939.[47]

The most imposing of the Persian Expedition's early publications, however, was not the outcome of excavation or philology. It was the sumptuous folio publication of photographs made by the Aeronautical Department, which included aerial imagery not only of Persepolis and its surroundings but also of sites, buildings, and environments of northeastern, northwestern, and west central Iran.[48]

Postwar

This is where the work of the Persian Expedition stood when the war disrupted every aspect of American life. At the end of World War II, the prosperity and political reach of the United States were even greater than they had been after World War I, but the conditions of 1945 did not foster the ongoing work of the Oriental Institute in the way that the conditions of 1919 had favored its creation. As American universities and research underwent deep changes in the postwar period, the very existence of the Oriental Institute was in a precarious position until a new administrative and financial relationship with the University of Chicago was forged in 1956.

The clarion tones with which Breasted had trumpeted the creation of the Oriental Institute to serve the highest purposes of humanistic study were very different from the anxious but sturdy terms in which the new director Carl Kraeling (1897–1966) characterized its ongoing status:

> Research institutes, properly understood, are means for the concentration of effort in special fields, particularly on the frontiers of knowledge.

In the natural sciences, in medicine, and in the social sciences they are today playing a momentous role.... Through the agencies of industry and government they are in effect remaking the circumstances of national and individual life.

In the field of humane letters, where they began, institutes are anything but numerous and, lacking national and industrial affiliation, relatively less powerful.... The existence of an Oriental Institute at the University of Chicago implies ... that the ancient cultures of the Near East are worthy of special attention as the record of man's earliest attempts to organize human life on a comprehensive scale, to unfold its higher potential, and to give it a cosmic frame of reference.[49]

During these years in the institutional wilderness, even before the resumption of its archaeological work in Iran, the Oriental Institute continued to publish the results of the Persian Expedition. George Cameron treated the smaller of the Achaemenid Elamite administrative archives (the Persepolis Treasury Archive) in an Oriental Institute Publication monograph in 1948.[50] It drew enthusiastic attention from philologists of Old Iranian but not so much from Assyriologists and other ancient Near Eastern specialists.

Erich Schmidt had joined the "home staff" as a regular member of the University of Chicago faculty, and the first two volumes of his final presentation of the excavation itself appeared in the Oriental Institute Publication series in 1953 and 1957. The third volume, substantially complete when Schmidt died in 1964, appeared posthumously.[51] In 1939, Schmidt had promised not to postpone the final publications but also not to rush them.[52] Their contents were hampered by the lack of information from Herzfeld, but drawings and photographs were published with sumptuous quality in large format.[53]

Some of the results of Herzfeld's work finally came into print long after Herzfeld's death, albeit still without the Oriental Institute's direct participation, when Friedrich Krefter, the last survivor of the original Persian Expedition, published detailed observations on the architecture of the terrace along with suggested reconstructions of the buildings.[54]

Far less grand was Martin Sprengling's final version of the Shapur and Kartir inscriptions from Naqš-e Rostam.[55] This work was published not in the fine letterpress form of the Oriental Institute Publication series but as a Roneotype facsimile of a typescript. The parentage of this orphan of the publishing storm is barely acknowledged on the title page with the phrase "Prepared and distributed at the Oriental Institute, University of Chicago." Antipathy to Sprengling's pro-German views had forced his resignation as editor of the *American Journal of Semitic Languages and Literatures* in 1940.[56] Citing an article by Albert T. Olmstead, who had been dead for five years, Sprengling's

preface hints broadly at ongoing intramural professional hostility that must have contributed to this embarrassing treatment of one of the Persian Expedition's greatest discoveries.[57]

The resumption of Oriental Institute fieldwork in Iran was hesitant. In 1948–49, Donald McCown, a veteran of the prewar Persian Expedition, conducted a season of survey in the Ram Hormuz plain and excavation of fifth-millennium BCE deposits at Tall-e Ghazir (now called Geser).[58] After that, surveys and excavations did not resume until 1959, and they were not a continuation of the prewar work of the Persian Expedition. The emphasis was now on prehistory and southwestern Iran, the Zagros valleys that were part of "the hilly flanks of the fertile crescent" (Robert J. Braidwood's adaptation of Breasted's coinage) and the plains of Khuzestan.[59] However distant they were from Breasted's methods, conceptual frameworks, and expressions, and however much their attachment to social and natural sciences departed from Breasted's announcement of a mission rooted in the humanities, these projects still served the Oriental Institute's original mission, finding in the earliest periods of settled life in western Iran the antecedents of the social and technical developments at the root of the civilizations of Western Asia.

In the Oriental Institute's *Annual Reports* for these years of renewed fieldwork, the unpublished balance of the Persian Expedition's prewar results is inconspicuous. It sometimes figures under the rubric "Enterprises Nearing Completion."

An important part of the unpublished balance consisted of texts in several languages. Herzfeld and others had published many of the Achaemenid royal inscriptions from Persepolis soon after they were discovered. Cameron and Schmidt had made their photographs and notes available to Roland G. Kent for use in his edition of the entire corpus of the Old Persian versions of royal inscriptions.[60] Kent's publication stood for decades as the definitive edition of the Old Persian corpus, to such an extent that it was sometimes perceived as a definitive publication of all the Achaemenid royal inscriptions from Persepolis.[61] Schmidt's final publications included high-quality photographs of all the versions (Old Persian, Elamite, and Babylonian) accompanied by Cameron's translations. By the time these volumes came out, no separate synoptic edition of the royal inscriptions was evidently thought to be needed, and none has yet been published.[62] The long pre-Achaemenid Elamite inscription on a bronze plaque excavated in the Treasury resisted comprehension, and no full edition has been published.[63] After conservation at the Oriental Institute in 1940, the plaque was sent to Iranian embassy in 1942 for return to Iran.

The tens of thousands of tablets of the Persepolis Fortification Archive discovered in 1933 had been on loan to Chicago since 1936, but the war had broken up the team that Poebel had assigned to study them. From the time

that Hallock returned to Chicago from service with US Naval Intelligence in 1947 until his death in 1980, he worked in isolation on the immense Elamite component of the Fortification Archive.

Hallock faced a daunting task. The Elamite language was a poorly understood isolate. The cuneiform script of the tablets was an idiosyncratic variant of Mesopotamian cuneiform. The Iranian vocabulary transcribed in Elamite form was unparalleled in extant sources that were dominated by royal inscriptions and religious texts. Only one other text of this kind had been published before, and it was an incomprehensible and useless point of comparison.[64] And as administrative records of beer and wine, flour and barley, the texts were unexciting. Breasted suggested as much only days after he received Herzfeld's telegram announcing the find with the words "Hundreds probably thousands business tablets Elamite discovered on terrace" (March 4, 1933). And further, in a telegram dated March 8, 1933: "This is a demonstration that the Persepolis Terrace contains cuneiform tablets and gives us just ground for hoping, or even expecting, that tablet documents from the State Archives of the Persian Kings are still lying under the rubbish of the Terrace. *If so, a new period in the history of the East has begun.* Even these *business* tablets should contribute essentially to a full understanding of the Elamite language."[65]

Every aspect of the Persepolis Fortification Archive required fundamental work, for which "the wonderful Hallock"[66] was well suited. He was exact, disciplined, perspicacious, and indefatigable even by the standards of obsessive cuneiformists. His wartime work in cryptography had sharpened his ability to organize masses of detail and find patterned information flows. His magisterial edition of 2,083 Elamite Fortification documents, organized in thirty formal and functional categories that reflect the ancient flow of information and the structure of the ancient institutions that produced the archive, was accompanied by a sketch of Achaemenid Elamite grammar and a compendious lexicon of Achaemenid Elamite.[67]

Like Cameron's earlier work on the Treasury tablets, Hallock's work on the Fortification tablets had its first impact not on cuneiformists but on Iranists. Soon after, a few historians of the Achaemenid Empire and its contact with the Greek world recognized the significance of the Fortification corpus. An early and influential representative was David Lewis of Oxford, a classical historian and epigrapher who credited Hallock with "having opened whole new areas by his published work."[68] Hallock's work began to transform the study of Achaemenid Persian languages, institutions, society, religion, and geography to a degree that exceeded Breasted's hopes for more glamorous texts and in ways that continue today.

The work of Raymond A. Bowman (1903–1979) on another unparalleled corpus from Persepolis was less fortunate. His treatment of the inked Aramaic

texts on more than two hundred stone mortars, pestles, and other implements that had been discovered in the Treasury received scathing reviews and met with general rejection of its main interpretations.[69]

Postrevolutionary

After the Iranian Revolution, the Oriental Institute's publication of Persian Expedition's backlog continued at stately pace. It was now in the hands of scholars cut off both from Iran and from living memory of the excavations. In 1968, four years after Erich Schmidt's death, Maurits van Loon (1923–2006) had announced that "steps have been taken to process for publication his meticulous records of his work in Luristan, Rayy, Istakhr and Tall-i Bakun."[70] He added that his own presentation of the Holmes Expeditions to Luristan under Schmidt's direction, including the 1938 season that occupied the Persepolis field staff, was already in draft form. The final form appeared in 1989.[71]

Tall-i Bākun was a greater problem. Most of the excavated materials and records from Schmidt's excavation of Bākun B were lost to submarine attack in the Caribbean in 1942. Nevertheless, Abbas Alizadeh reexcavated both mounds,[72] and he finished the publication as the foundation for a study of state formation in Fars,[73] fulfilling the aims of the original excavators in terms that they would scarcely have recognized. George Miles published coins from the Eṣṭakr excavations,[74] and Donald Whitcomb teased a detailed plan of the early Islamic city from Schmidt's aerial photographs, but publication of the Persian Expedition's work at Eṣṭakr remains to be completed.[75]

Hallock's pioneering work of 1969 recognized that identifying the seal impressions on the Persepolis Fortification tablets was essential to interpreting the contents of the texts and understanding the structure of the archive.[76] Margaret Cool Root began work on this corpus in 1979 and continued in a sustained collaboration with her student Mark B. Garrison, culminating in the publication of more than 1,160 seals impressed on the 2,083 tablets that Hallock had published.[77] The drawings, which were often based on the collation of many partial impressions of a single seal on irregular tablet surfaces, along with the photographs of exemplars and the accompanying discussion present a corpus of Achaemenid art that is unparalleled for its iconographic range and stylistic variation, dated with unparalleled precision by the associated texts, and embedded in a social and political context documented with unparalleled detail. As an artistic corpus, it exceeds Albert T. Olmstead's prediction that it would make available "a whole new museum to present Achaemenid art."[78] It is arguably as rich in implications as the reliefs that Herzfeld revealed. Because the seal impressions represent specific behaviors of ancient

individuals, it is also a trove of administrative information. It is also part of a much larger corpus of impressions on Elamite, Aramaic, and uninscribed Fortification tablets—one of the largest coherent bodies of imagery from anywhere in the ancient world—now being documented by the Persepolis Fortification Archive Project at the Oriental Institute.

Present and Future

A legal crisis sparked the formation of the current Persepolis Fortification Archive Project. US federal courts awarded large monetary judgments against the Islamic Republic of Iran to survivors and families of victims of bombings that took place in Beirut in 1983 and in Jerusalem in 1997. The judgments entitled the plaintiffs to take property belonging to Iran up to the amount of the awards, totaling more than 3 billion US dollars. With few ordinary commercial assets of the Islamic Republic being vulnerable to seizure, in 2004 the plaintiffs sought possession of the Fortification tablets held at the Oriental Institute on long-term loan from Iran.[79] Whether the nature of the tablets as cultural and intellectual property rather than commercial assets protected them from this claim became a matter for litigation in federal courts in 2005. In 2018, the Supreme Court of the United States ruled against the plaintiffs and hence, by implication, in favor of the Oriental Institute and the Islamic Republic of Iran, but it did so without addressing this broader question.[80]

The fact that the tablets were loaned to the University of Chicago is remarkable in itself. The Iranian antiquities law that was in effect when they were discovered and that remained in effect until 1972 provided for a division of excavated finds between the host country and the institutions that sponsored the excavations.[81] In that respect, it resembled the law drawn up in the 1920s under Gertrude Bell's aegis to govern archaeology in Iraq. In Iran and Iraq it became a common practice to treat cuneiform tablets as individual objects, with some being allotted to the national museum and others to the excavators. Groups of tablets that were associated with each other by find-spot and by contents could be divided in this way, as were the Persepolis Treasury tablets excavated between 1936 and 1938. But in the division negotiated in 1934, the first tablets found at Persepolis, the Fortification tablets, were not divided.

From the strain, anger, and bitterness of the 1934 negotiations, the result was an extraordinary act of trust. A unique find from the foremost ancient site in Iran, a site charged with particular ideological importance by an assertively nationalistic regime, was loaned to an American research institution, and it was loaned all together and not broken up into many constituents. Because this loan was an early example of relationships that have become essential to

modern work on cultural heritage materials, whether research, publication, or museum display, the legal dispute over the Fortification tablets has wide implications.[82]

What was loaned to the Oriental Institute was not many distinct Persepolis Fortification tablets but rather the single Persepolis Fortification Archive, a coherent assemblage of several components (fig. 9.5). As Herzfeld cabled Breasted in 1933, the largest number of the tablets and fragments are documents bearing cuneiform texts in the Elamite language and bearing the impressions of one or more cylinder seals or stamp seals; there are not just hundreds or thousands of them, but tens of thousands. As Herzfeld told the Royal Asiatic Society in 1933,[83] a few (at least 840) have texts in Aramaic script and language incised with a stylus or written in ink with a pen, brush, or stylus, all of them with impressions of seals. Many others (about 4,000 to 6,000, perhaps 20 percent of the find) have no texts but do have impressions of one or more seals, sometimes of the same seals that appear on Aramaic or Elamite tablets but more often not. Herzfeld recognized a unique Phrygian text in 1933, and there are also unique items with texts in Greek, Old Persian, and Babylonian, and one or more in Demotic Egyptian.[84]

These classes of documents are components of one archive, records produced and stored by a single administrative organization in the time of Darius I. They fit together as parts of a system through which information flowed that has been structured in a way that speaks to their social and institutional environment. Their greatest value depends on the connections among them—that is, on the Persepolis Fortification Archive's combination of complexity and integrity.

At the same time, these components are the topics of distinct modern academic fields, hence they would ordinarily have been parceled out among cuneiformists, Semitic epigraphers, and art historians, each of them analyzing and discussing these artifacts in different terms for partially different audiences. The problem they pose was and is that responding to the Archive's complexity requires the components to be treated by specialists, but maintaining the Archive's integrity requires keeping the components connected.

A coherent program of study was not formalized when the Fortification tablets first came to Chicago. They were parceled out, but the results were not integrated. After Hallock finished the manuscript of his magnum opus, he continued to read Elamite Fortification documents. He compiled draft editions of about 2,500 more documents before he died; they have remained unpublished, but since the middle of the 1980s they have circulated widely in *samizdat*. Bowman worked on the Aramaic Fortification texts for decades, making careful autographed copies and draft editions with a glossary of more than five hundred of these texts before he died. The manuscript left at his death

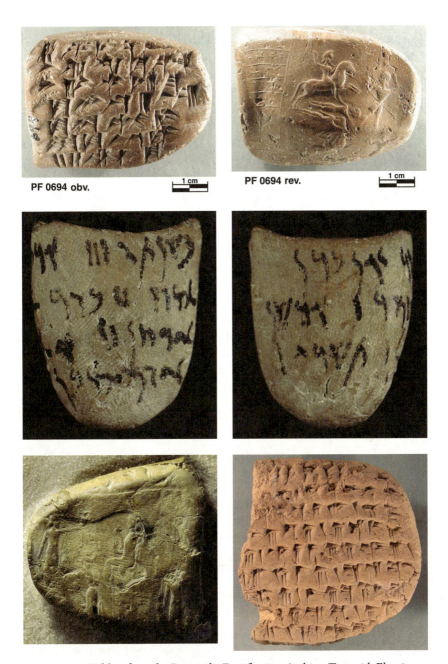

FIGURE 9.5. Tablets from the Persepolis Fortification Archive. Top, with Elamite text obverse and impression of heirloom seal, mentioning "Cyrus of Anzan," reverse; middle, with Aramaic text obverse and reverse; bottom left, impression of seal with presentation scene on uninscribed tablet; bottom right, obverse of tablet with Old Persian text. Courtesy of the Persepolis Fortification Archive Project at the Institute for the Study of Ancient Cultures of the University of Chicago.

(very soon after Hallock's) shows that he had little contact with Hallock and limited understanding of what Hallock had accomplished.[85] Helene Kantor began to organize the corpus of seal impressions on all classes of Fortification tablets, including the uninscribed tablets, relying especially on photographs made under a grant from the Works Progress Administration in 1940–41, but she set this work aside.

The priorities of the Persepolis Fortification Archive Project active at the Oriental Institute since 2005 have been to enable future research by making useful records of as much of the archive as possible and to enable current research by distributing useful records quickly and continuously. The records include legible images of all categories of documents made with several electronic techniques. They also include cataloging, editorial, and analytical information compiled by specialists in Elamite, Aramaic, and Achaemenid glyptic, all of which has been organized and published in electronic form. By the end of 2015, editions or high-quality images of about 11,500 Elamite, Aramaic, and uninscribed and miscellaneous Fortification tablets were available through three online applications: InscriptiFact based at the University of Southern California;[86] OCHRE (the On-Line Cultural and Historical Research Environment) based at the Oriental Institute (fig. 9.6);[87] and Achemenet based

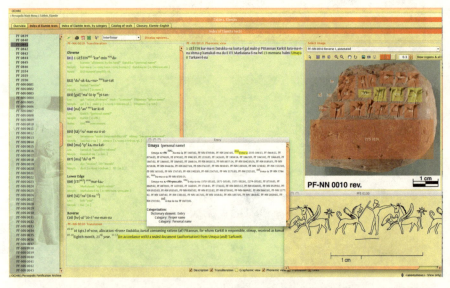

FIGURE 9.6. OCHRE presentation of Fortification tablet with Elamite text displaying transliteration, interlinear parse, click-through glossary, translation, photograph with sign-values marked and linked to transliteration, and collated seal drawing. Courtesy of the Persepolis Fortification Archive Project at the Institute for the Study of Ancient Cultures of the University of Chicago.

in at the Maison d'Archéologie et Ethnologie of Paris Nanterre University.[88] Among the items currently being published in this way are the 2,500 previously unpublished Elamite documents recorded by Hallock, the 530 previously unpublished Aramaic documents recorded by Bowman, and thousands of previously unrecorded items. More Fortification documents are made public at frequent intervals.[89]

Eventual publication of these artifacts in conventional book form is intended, but the electronic versions make working drafts of the documents available without the delays involved in preparation of books. More importantly, they also preserve the integrity of the Archive by presenting all components together in compatible forms at the same sites. They also offer a growing array of electronic tools that will make it possible to examine, search, compare, and connect the documents and the classes of documents in ways that books do not easily permit.[90] Legal circumstances permitting, at least ten thousand Persepolis Fortification tablets and fragments will be published in this way, effectively discharging this outstanding item of the Persian Expedition's agenda.

The Center for Middle Eastern Landscapes (CAMEL) at the Oriental Institute is dealing with another outstanding item: the legacy of the Aeronautical Department. The images published in 1940 on the 119 plates of Schmidt's *Flights Over Ancient Cities of Iran* were a selection from about one thousand aerial photographs. CAMEL has digitized and cataloged all of Schmidt's photographs and his flight paths as well as georeferenced selections of the collection that refer to major sites. As the printer continues to catch up with the spade (to respond to Kraeling's dry remark about publication), the computer overtakes the airplane.

When the Persian Expedition began its work more than ninety years ago, Persepolis was a picturesque ruin. Eight years later, as the Expedition came to an end, it was an imposing historical, cultural, and artistic monument with few equals in the world. What the Expedition recovered and preserved for future study (in Breasted's phrase) includes the palaces and tombs of Achaemenid kings, the homes of villagers who occupied the Marvdašt thousands of years before the Achaemenids arose, and reliefs and inscriptions of Sasanian kings who attached themselves to the Achaemenid legacy five hundred years after Alexander destroyed Persepolis. It includes the words of kings, but also the words of the clerks who saw to feeding the kings. It includes the art of kings, but also the art of the society that sustained the kings. Ninety years on, most of the results (with some of the lacunae noted above) have been or are being ordered, analyzed, and made public. After three generations of scholars have engaged with them, building on the erudition of the first excavators with new methods and new technologies, the Persian Expedition's results are still

yielding new facts and new ways of investigating and comprehending ancient realities. The Persian Expedition is dead and gone. The Persian Expedition is alive and well.

Notes
1. Breasted, *Oriental Institute*, 2.
2. Renger, "Ernst Herzfeld in Context"; Nagel, "Ernst E. Herzfeld."
3. "Persien"; Mousavi, "Ernst Herzfeld," 452–65; Helwing and Rahemipour, *Tehran 50*, 37–45.
4. Kawami, "Ernst Herzfeld," 191n47; Mousavi, "Ernst Herzfeld," 469; Byron, *Road to Oxiana*, 58.
5. Mousavi, "Persepolis in Retrospect," 224–25; Mousavi, *Persepolis*, 161–63; and Goode, *Negotiating for the Past*, 140–49, describe the competition in Tehran between Herzfeld and Arthur Upham Pope and the competition in America between the Oriental Institute and the University Museum that led to this outcome. The detailed discussion of the personalities and events by Majd, *Great American Plunder*, 29–132, construed from a perspective that is hostile to almost all of the parties involved, takes little interest in archaeology as such but provides extensive excerpts of contemporary records in the archives of the US Department of State. Breasted's various accounts, written in the interests of the Oriental Institute, understandably ignored these matters.
6. Sancisi-Weerdenburg and Drijvers, *Through Travellers' Eyes*, 95–122.
7. Stolze and Andreas, *Persepolis*; Weld-Blundell, "Persepolis," 527–59; at Naqš-e Rostam, Curzon, *Persia and the Persian Question*, 2:144. Mousavi, "Persepolis in Retrospect," 213–22, and especially Mousavi, *Persepolis*, 73–154, survey commemoration and exploration at Persepolis from Sasanian through Qajar times, drawing on both Persian and European sources.
8. Mousavi, *Persepolis*, 156–58; Helwing and Rahemipour, *Tehran 50*, 35–37.
9. Herzfeld, "Rapport sur l'état actuel," submitted to the governor of Fars in 1924; see Mousavi, "Persepolis in Retrospect," 222, and Mousavi, *Persepolis*, 159–60.
10. Mousavi, "Persepolis in Retrospect," 235–45, and Mousavi, *Persepolis*, 193–219, describe excavation, restoration, and preservation on and around the terrace after the end of the Persian Expedition.
11. References appear in "Oriental Institute Archeological Report on the Near East," published quarterly in the *American Journal of Semitic Languages and Literatures* and in annual surveys of Near Eastern archaeology in *Archiv für Orientforschung*.
12. Byron, *Road to Oxiana*, 159–68; Schwarzenbach, *Winter in Vorderasien*, 161–72; Schwarzenbach, *Tod in Persien*, 47–58; Rahemipour, "Archäologen, Philologen, Literaten"; Samsami, "Ausgraben und Erinnern."
13. Mousavi, *Persepolis*, 163; Majd, *Great American Plunder*, 128, 139–42.
14. The negotiations and the settlement are detailed by Majd, *Great American Plunder*, 139–93, and Goode, *Negotiating for the Past*, 155–65, summarized by Helwing and Rahemipour, *Tehran 50*, 57–59.
15. Gerold Walser, "Zum Gedenken," 11; von Bruch, "Ernst Herzfeld"; Hauser, "History, Races and Orientalism."
16. Renger, "Ernst Herzfeld in Context," 570–72.
17. For example, Mousavi, "Ernst Herzfeld," 462–62, 468–69.

18. Renger, "Ernst Herzfeld in Context," 575, cites Mahrad, "Intrigen während der NS-Zeit" (with critical remarks); Helwing, "Alexander Langsdorff in Persien." Krefter's difficulties with Herzfeld, recorded in his unpublished diary (Goode, *Negotiating for the Past*, 160; Mousavi, *Persepolis*, 180), are absent from his reminiscence on the occasion of Herzfeld's centenary, see Krefter, "Mit Ernst Herzfeld."

19. Majd, *Great American Plunder*, 146, 149–50, 160, 198; Mousavi, *Persepolis*, 182.

20. In a letter to George Cameron, the usually mild Roland Kent greeted the news of Herzfeld's death in 1948 with harsh remarks, adding *de mortuis nil nisi verum*. Cf. Walter Adams, Katherine Smith, and others quoted in Gunter and Hauser, "Ernst Herzfeld and Near Eastern Studies," 32. Even now, modern scholars often treat Herzfeld pitilessly, even if they are of narrower competence and lesser stature.

21. Balcer, "Erich Friedrich Schmidt," 164–65; Gunter and Hauser, "Ernst Herzfeld and Near Eastern Studies," 28–31; Renger, "Ernst Herzfeld in Context," 575–76; Mousavi, "Ernst Herzfeld," 465–70; Mousavi, *Persepolis*, 180–84.

22. Breasted, *Oriental Institute*, 316.

23. Sprengling, "Shahpuhr I," 341. Later, with only a little more restraint, Sprengling said the inscriptions ranked as "greater than the *Monumentum Ancyranum* of Augustus and not far behind the great Bīsītun inscription of Darius I." See Sprengling, *Third Century Iran*, iii.

24. Whitcomb, "City of Istakhr."

25. Breasted anticipated this development when he made aerial photographs of the pyramids during the founding expedition of the Institute in 1919; see Breasted, *Oriental Institute*, 39; Emberling and Teeter, "First Expedition of the Oriental Institute," 52–54. On the politics of Schmidt's airplane, see Majd, *Great American Plunder*, 224–25, and Goode, *Negotiating for the Past*, 168–70, 173, 175–76, 178, 182.

26. Schmidt, *Treasury of Persepolis*, 130–39; Balcer, "Erich Friedrich Schmidt," 161.

27. Breasted, *Oriental Institute of the University of Chicago*, 44.

28. Schmidt, *Treasury of Persepolis*, xii.

29. Breasted, *Oriental Institute*, 2.

30. Kraeling, "Oriental Institute [1955]," 5.

31. Debevoise, "Oriental Institute Archaeological Report on the Near East: 1932–33," 199–200; Cameron, "Oriental Institute Archaeological Report on the Near East: First Quarter, 1934," 271–72; Engberg, "Oriental Institute Archaeological Report on the Near East: First Quarter 1935," 273–76; Dubberstein, "Oriental Institute Archeological Report on the Near East: Second Quarter, 1935," 70; Allen, "Oriental Institute Archaeological Report on the Near East: Fourth Quarter, 1935," 213–14; Hardy, "Oriental Institute Archaeological Report on the Near East: First Quarter, 1936," 274; Parker, "Oriental Institute Archaeological Report on the Near East: Second Quarter, 1936," 70; Dubberstein *apud* Hughes, Engberg, and Dubberstein, "Oriental Institute Archeological Report on the Near East: Third Quarter, 1937," 107–8; Schmidt *apud* Hughes, Tushingham, and Dubberstein, "Oriental Institute Archaeological Report on the Near East: Third Quarter, 1938," 109; McCown *apud* Hughes et al., "Oriental Institute Archeological Report on the Near East: Second Quarter, 1939," 437; Schmidt *apud* Hughes et al., "Oriental Institute Archeological Report," 193–94.

32. See "Persien"; "Persepolis [1933]"; "Persepolis [1934]"; "Persepolis [1937]"; "Persepolis [1939]"; "Naqš-i-Rustam" in *Archiv für Orientforschung*.

33. Breasted, *Oriental Institute*, 429.

34. Schmidt, *Treasury of Persepolis*.

35. Engberg, "Oriental Institute Archaeological Report on the Near East: First Quarter 1935," 273–76.
36. Krefter, "Mit Ernst Herzfeld," 25.
37. "Persepolis [1934]."
38. Herzfeld, *Archaeological History of Iran*.
39. Herzfeld, *Iran in the Ancient East*; Schmidt, *Structures, Reliefs, Inscriptions*, 56; Wiesehöfer, *Dunklen Jahrhunderte*, 70–79.
40. Herzfeld, *Altpersische Inschriften*.
41. Balcer, "Erich Friedrich Schmidt," 167; Mousavi, *Persepolis*, 187–88; Ettinghausen, "Ernst Herzfeld," 600–601.
42. Langsdorff and McCown, *Tall-i-Bakun A*.
43. Poebel, "Old Persian and Elamite Months"; Poebel, "King of the Persepolis Tablets."
44. Cameron, "Darius' Daughter."
45. Hallock, "Darius I."
46. Sprengling, "Zur Parsīk-Inschrift"; Sprengling, "New Pahlavi Inscription."
47. Sprengling, "Kartīr"; Sprengling, "From Kartīr to Shahpuhr I"; Sprengling, "Shahpuhr I."
48. Schmidt, *Flights over Ancient Cities*. Schmidt also made his aerial photographs available to the US Army Air Corps and the Office of Strategic Services during World War II (Goode, *Negotiating for the Past*, 182).
49. Kraeling, "Oriental Institute [1960]," 3, revised and enlarged from Kraeling, "Oriental Institute [1955]," 3, repeated without attribution in *Annual Reports* of the Oriental Institute after Kraeling's death (Kraeling, "Oriental Institute [1963]"; Kraeling, "Oriental Institute [1968]"), and quoted by Johnson, "Introduction," 3–4.
50. Cameron, *Persepolis Treasury Tablets*, amended by Hallock, "New Light from Persepolis," and supplemented after Cameron's departure to the University of Michigan by Cameron, "Persepolis Treasury Tablets Old and New," and Cameron, "New Tablets from the Persepolis Treasury."
51. Elizabeth Hauser in Schmidt, *Royal Tombs and Other Monuments*, vii.
52. Balcer, "Erich Friedrich Schmidt," 170.
53. Fit for presentation to Queen Elizabeth II as the finest emblem of the University of Chicago's scholarly publication; see Haines, "Erich F. Schmidt," 147; Mousavi, "Persepolis in Retrospect," 234–35.
54. Krefter, *Persepolis Rekonstruktionen*. In 1967, at the instance of the Deutsches Archäologisches Institut Tehran Abteilung and the German foreign ministry, Krefter made a fastidious scale model of his reconstructions of the buildings on the terrace; it was presented to the Shah in connection with his coronation and later destroyed; see Mousavi, *Persepolis*, 199–201.
55. Sprengling, *Third Century Iran*, 195.
56. Biggs, "Hebraica," 6.
57. Sprengling may also have been referring to Wilhelm Eilers's unpublished readings of inscriptions, made when he visited the site shortly after the discovery in 1939, at Schmidt's invitation (Helwing, "Wilhelm Eilers," 79.) For modern editions, see Back, *Die sassanidischen Staatsinschriften*.
58. Perkins, "Archaeological News," 54; Caldwell, "Ghazir, Tall-e"; and Alizadeh, *Excavations and Surveys in the Ram Hormuz Region*.

59. On the first incarnation of the Iranian Prehistoric Project, under Robert J. Braidwood (1907–2003) at Asiab, Sarab, and Ali Khosh, see Braidwood, "Iranian Prehistoric Project, 1959–1960," and Braidwood, Howe, and Reed, "Iranian Prehistoric Project." On the long series of excavations at Chogha Mish and Chogha Bonut under Pinhas Delougaz (1906–1975) and Helene Kantor (1919–1993), see Delougaz and Kantor, *First Five Seasons of Excavations*; Alizadeh, *Excavations at the Prehistoric Mound of Chogha Bonut*; and Alizadeh, *Development of a Prehistoric Regional Center*. On the Khuzestan survey of Robert McC. Adams, from which many projects carried out by other institutions proceeded, see Adams, "Agriculture and Urban Life." The Sasanian city of Gunde Shapur was surveyed by Adams and mapped and tested by Donald Hansen (1931–2007); the Oriental Institute obtained a permit, but the intended excavation did not take place (Adams, "Archaeological Reconnaissance," and Whitcomb, "Iranian Cities").

60. Kent, *Old Persian*.

61. For example, see Balcer, "Erich Friedrich Schmidt," 163.

62. Gene Gragg and Matthew Stolper developed an experimental online presentation of all three versions of the Achaemenid royal inscriptions from Persepolis in a form that allowed text-by-text and section-by-section comparison among the versions as well as lexical searches of glossaries of each of the languages. It was presented on the Oriental Institute's website in 1998 and suspended in 2010.

63. Cameron *apud* Erich F. Schmidt, *Contents of the Treasury*, 64–65 and pls. 27–28; Henkelman, *Other Gods Who Are*, 314–15; Basello, "From Susa to Persepolis."

64. Herzfeld had actually discovered and photographed a fragment of a sealed Achaemenid Elamite administrative tablet at Persepolis in 1932 (Jones and Yie, "From the Persepolis Fortification Archive Project," 3). It could not have been interpreted before the discoveries of the Fortification Archive in 1933 and the Treasury Archive in 1936 made comparable material available. Neither Herzfeld nor his successors mentioned it.

65. Breasted (writing from Cairo) to Henri Frankfort (in Iraq), March 8, 1933. In a letter to Herzfeld written on the same day, his confidence was unqualified: "It is now assured that our Persepolis campaign means a new chapter in the history of modern knowledge of the Ancient East." I am indebted to John Larson, former archivist of the Oriental Institute, for knowledge of these documents.

66. Gershevitch, "Alloglottography of Old Persian," 155n71.

67. Hallock, *Persepolis Fortification Tablets*.

68. D. Lewis, *Sparta and Persia*, i, 4–13.

69. Bowman, *Aramaic Ritual Texts from Persepolis*.

70. van Loon, "Enterprises Nearing Completion," 23.

71. Schmidt, van Loon, and Curvers, *Holmes Expeditions to Luristan*.

72. Alizadeh et al., "Iranian Prehistoric Project."

73. Alizadeh, *Origins of State Organizations*.

74. Miles, *Excavation Coins*.

75. Whitcomb, "City of Istakhr," and Whitcomb, "Iranian Cities," 91–92.

76. Cf. Hallock, "Use of Seals."

77. Garrison and Root, *Images of the Heroic Encounter*; Garrison and Root, *Images of the Human Activity*; and Garrison and Root, *Images of Animals*.

78. Olmstead, *History of the Persian Empire*, 178.

79. Blair, "Paying with the Past."
80. Stolper, "Persepolis Fortification Archive Project [2019]," 139.
81. Mousavi, "Ernst Herzfeld," 471n68.
82. Heath and Schwarz, "Legal Threats."
83. "Persepolis [1934]"; "Recent Discoveries at Persepolis," 231–32.
84. Briant, Henkelman, and Stolper, *L'archive des Fortifications de Persépolis*; Stolper, "Persepolis Fortification Archive Project [2007]"; Stolper and Tavernier, "From the Persepolis Fortification Archive Project," 1; Azzoni et al., "From the Persepolis Fortification Archive Project," 7.
85. Azzoni, "Bowman MS."
86. The InscriptiFact Digital Library was discontinued in August 2022; pending its revival in a new venue, images remain available at https://digitallibrary.usc.edu/Archive/InscriptiFact---an-image-database-of-inscriptions-and-artifacts-2A3BF1OL6PW.
87. See http://ochre.lib.uchicago.edu/.
88. See http://www.achemenet.com/fr/tree/?/sources-textuelles/textes-par-langues-et-ecritures/elamite/archives-des-fortifications-de-persepolis/tablettes-des-fortifications-de-persepolis#set.
89. The Persepolis Fortification Archive Project has received timely and generous support, even during straitened times, from the Andrew W. Mellon Foundation, the Farhang Foundation, the Getty Foundation, the Iran Heritage Foundation, the National Endowment for the Humanities, the National Geographic Society Committee for Research and Exploration, the PARSA Community Foundation, the Roshan Foundation, the University of Chicago Women's Board, the Friends of the Persepolis Fortification Archive Project, and many private donors and organizations.
90. Stolper, "Persepolis Fortification Archive Project [2007]"; Stolper, "Persepolis Fortification Archive Project [2008]"; Stolper, "Persepolis Fortification Archive Project [2009]"; and Stolper, "Persepolis Fortification Archive Project [2010]."

Bibliography

Adams, Robert McC. "Agriculture and Urban Life in Early Southwestern Iran." *Science* 136 (1962): 109–22.

———. "Archaeological Reconnaissance at Gundeshapur." *Oriental Institute 1962–1963 Annual Report* (1963): 14.

Alizadeh, Abbas. *The Development of a Prehistoric Regional Center in Lowland Susiana, Southwestern Iran: Final Report on the Last Six Seasons of Excavations, 1972–1978*. Vol. 2 of *Chogha Mish*. Oriental Institute Publications 130. Chicago: Oriental Institute of the University of Chicago, 2008.

———. *Excavations and Surveys in the Ram Hormuz Region, Southwestern Iran*. Oriental Institute Publications 140. Chicago: Oriental Institute of the University of Chicago, 2014.

———. *Excavations at the Prehistoric Mound of Chogha Bonut, Khuzestan, Iran. Seasons 1976/77, 1977/78 and 1996*. Oriental Institute Publications 120. Chicago: Oriental Institute of the University of Chicago, 2003.

———. *The Origins of State Organizations in Prehistoric Highland Fars, Southern Iran. Excavations at Tall-e Bakun*. Oriental Institute Publications 128. Chicago: Oriental Institute of the University of Chicago, 2006.

Alizadeh, Abbas, and Matthew W. Stolper. "The Past and Present of the OI's Work in Iran." Pages 274–303 in *Discovering New Pasts: The OI at 100*. Edited by Theo van den Hout. Chicago: Oriental Institute of the University of Chicago, 2019.

Alizadeh, Abbas, Mohsen Zeidi, Alireza Askari, Lili Niakan, and Ali Atabaki. "Iranian Prehistoric Project." *Oriental Institute 2003–2004 Annual Report* (2004): 94–105.

Allen, Francis O. "The Oriental Institute Archaeological Report on the Near East: Fourth Quarter, 1935." *American Journal of Semitic Languages and Literatures* 52 (1936): 201–14.

Azzoni, Annalisa. "The Bowman MS and the Aramaic Tablets." Pages 253–74 in *L'archive des Fortifications de Persépolis: État des questions et perspectives de recherches*. Edited by Pierre Briant, Wouter F. M. Henkelman, and Matthew W. Stolper. Persika 12. Paris: Boccard, 2008.

Azzoni, Annalisa, Christina Chandler, Erin Daly, Mark B. Garrison, Jan Johnson, and Brian Muhs. "From the Persepolis Fortification Archive Project, 7: A Demotic Tablet or Two in the Persepolis Fortification Archive." *ARTA: Achaemenid Research on Texts and Archaeology* 2019.003. http://www.achemenet.com/pdf/arta/ARTA_2019_003_Azzoni.pdf.

Back, Michael. *Die sassanidischen Staatsinschriften*. Acta Iranica 18. Leiden: Brill; Tehran: Bibliothèque Pahlavi, 1978.

Balcer, Jack Martin. "Erich Friedrich Schmidt, 13 September 1897–3 October 1964." Pages 147–72 in *Through Travellers' Eyes: European Travellers on the Iranian Monuments*. Edited by Heleen Sancisi-Weerdenburg and Jan Willem Drijvers. Achaemenid History 7. Leiden: Nederlands Instituut voor het Nabije Oosten, 1991.

Basello, Gian Pietro. "From Susa to Persepolis: The Pseudo-Sealing of the Persepolis Bronze Plaque." Pages 249–64 in *Susa and Elam: Archaeological, Philological, Historical and Geographical Perspectives*. Edited by Katrien de Graef and Jan Tavernier. Mémoires de la Délégation en Perse 58. Leiden: Brill, 2013.

Biggs, Robert D. "Hebraica, American Journal of Semitic Languages and Literatures, Journal of Near Eastern Studies, 1884–1984." *Journal of Near Eastern Studies* 43 (1984): 1–8.

Blair, Gwenda. "Paying With the Past." *Chicago* 57.12 (2008): 90–95, 110–13. http://www.chicagomag.com/Chicago-Magazine/December-2008/Paying-with-the-Past/.

Bowman, Raymond A. *Aramaic Ritual Texts from Persepolis*. Oriental Institute Publications 91. Chicago: University of Chicago Press, 1970.

Braidwood, Robert J. "The Iranian Prehistoric Project, 1959–1960." *Iranica Antiqua* 1 (1961): 3–7.

Braidwood, Robert J., Bruce Howe, and Charles Reed. "The Iranian Prehistoric Project." *Science* 133 (1961): 2008–10.

Breasted, James Henry. *The Oriental Institute*. The University of Chicago Survey 12. Chicago: University of Chicago Press, 1933.

———. *The Oriental Institute of the University of Chicago: A Beginning and a Program*. Oriental Institute Communications 1. Chicago: University of Chicago Press, 1922.

Briant, Pierre, Wouter F. M. Henkelman, and Matthew W. Stolper, eds. *L'archive des Fortifications de Persépolis: État des questions et perspectives de recherches*. Persika 12. Paris: Boccard, 2008.

Bruch, Rüdiger von. "Ernst Herzfeld in an Academic Context: The Historical Sciences of Culture at the University of Berlin During the Weimar Republic (1919–1933)." Pages 477–504 in *Ernst Herzfeld and the Development of Near Eastern Studies, 1900–1950*. Edited by Ann C. Gunter and Stefan R. Hauser. Leiden: Brill, 2005.

Byron, Robert. *The Road to Oxiana*. London: Macmillan, 1937.

Caldwell, Joseph. "Ghazir, Tall-e." *Reallexikon der Assyriologie und Vorderasiatischen Archäologie* 3 (1969): 348–55.

Cameron, George G. "Darius' Daughter and the Persepolis Inscriptions." *Journal of Near Eastern Studies* 1 (1942): 214–18.

———. "New Tablets from the Persepolis Treasury." *Journal of Near Eastern Studies* 24 (1965): 167–92.

———. "The Oriental Institute Archaeological Report on the Near East: First Quarter, 1934." *American Journal of Semitic Languages and Literatures* 50 (1934): 251–72.

———. *Persepolis Treasury Tablets*. Oriental Institute Publications 65. Chicago: University of Chicago Press, 1948.

———. "Persepolis Treasury Tablets Old and New." *Journal of Near Eastern Studies* 17 (1958): 161–76.

Curzon, George N. *Persia and the Persian Question*. 2 vols. London: Longmans, Green, 1892.

Debevoise, Nielson. "The Oriental Institute Archaeological Report on the Near East: 1932–33." *American Journal of Semitic Languages and Literatures* 50 (1934): 182–200.

Delougaz, Pinhas, and Helene J. Kantor. *The First Five Seasons of Excavations, 1961–1971*. Vol. 1 of *Chogha Mish*. Edited by Abbas Alizadeh. Oriental Institute Publications 101. Chicago: Oriental Institute of the University of Chicago, 1995.

Dubberstein, Waldo H. "The Oriental Institute Archeological Report on the Near East: Second Quarter, 1935." *American Journal of Semitic Languages and Literatures* 52 (1935): 50–72.

Emberling, Geoff, and Emily Teeter. "The First Expedition of the Oriental Institute, 1919–1920." Pages 31–84 in *Pioneers to the Past: American Archaeologists in the Middle East, 1919–1920*. Edited by Geoff Emberling. Oriental Institute Museum Publications 30. Chicago: Oriental Institute of the University of Chicago, 2010.

Engberg, Robert M. "The Oriental Institute Archaeological Report on the Near East: First Quarter 1935." *American Journal of Semitic Languages and Literatures* 51 (1935): 252–77.

Ettinghausen, Elizabeth S. "Ernst Herzfeld: Reminiscences and Revelations." Pages 582–615 in *Ernst Herzfeld and the Development of Near Eastern Studies, 1900–1950*. Edited by Ann C. Gunter and Stefan R. Hauser. Leiden: Brill, 2005.

Garrison, Mark B., and Margaret Cool Root. *Images of Animals, Geometric and Abstract Designs*. Vol. 3 of *Seals on the Persepolis Fortification Tablets*. Oriental Institute Publications. Chicago: Oriental Institute of the University of Chicago, forthcoming.

———. *Images of the Heroic Encounter*. Vol. 1 of *Seals on the Persepolis Fortification Tablets*. Oriental Institute Publications 117. Chicago: Oriental Institute of the University of Chicago, 2001.

———. *Images of the Human Activity*. Vol. 2 of *Seals on the Persepolis Fortification Tablets*. Oriental Institute Publications 117. Chicago: Oriental Institute of the University of Chicago, forthcoming.

Gershevitch, Ilya. "The Alloglottography of Old Persian." *Transactions of the Philological Society* (1979): 114–89.
Goode, James F. *Negotiating for the Past. Archaeology, Nationalism, and Diplomacy in the Middle East, 1919–1941.* Austin: University of Texas Press, 2007.
Gunter, Ann C., and Stefan R. Hauser, eds. "Ernst Herzfeld and Near Eastern Studies, 1900–1950." Pages 3–44 in *Ernst Herzfeld and the Development of Near Eastern Studies, 1900–1950.* Edited by Ann C. Gunter and Stefan R. Hauser. Leiden: Brill, 2005.
———, eds. *Ernst Herzfeld and the Development of Near Eastern Studies, 1900–1950.* Leiden: Brill, 2005.
Haines, Richard. "Erich F. Schmidt. September 13, 1897–October 3, 1964." *Journal of Near Eastern Studies* 24 (1965): 145–47.
Hallock, Richard T. "Darius I, the King of the Persepolis Tablets." *Journal of Near Eastern Studies* 1 (1942): 230–32.
———. "New Light from Persepolis." *Journal of Near Eastern Studies* 9 (1950): 237–52.
———. *Persepolis Fortification Tablets.* Oriental Institute Publications 92. Chicago: University of Chicago Press, 1969.
———. "The Use of Seals on the Persepolis Fortification Tablets." Pages 127–33 in *Seals and Sealings in the Ancient Near East.* Edited by McGuire Gibson and Robert D. Biggs. Bibliotheca Mesopotamica 6. Malibu, CA: Undena, 1977.
Hardy, Robert S. "The Oriental Institute Archaeological Report on the Near East: First Quarter, 1936." *American Journal of Semitic Languages and Literatures* 52 (1936): 257–76.
Hauser, Stefan R. "History, Races and Orientalism: Eduard Meyer, the Organization of Oriental Research, and Ernst Herzfeld's Intellectual Heritage." Pages 505–59 in *Ernst Herzfeld and the Development of Near Eastern Studies, 1900–1950.* Edited by Ann C. Gunter and Stefan R. Hauser. Leiden: Brill, 2005.
Heath, Sebastian, and Glenn M. Schwartz. "Legal Threats to Cultural Exchange of Archaeological Materials." *American Journal of Archaeology* 113 (2009): 459–62.
Helwing, Barbara, "Alexander Langsdorff in Persien." Pages 62–63 in *Tehran 50: Ein halbes Jahrhundert deutsche Archäologen in Iran.* Edited by Barbara Helwing and Patricia Rahemipour. Archäologie in Iran und Turan 11. Darmstadt: von Zabern, 2011.
———. "Wilhelm Eilers." Pages 77–79 in *Tehran 50: Ein halbes Jahrhundert deutsche Archäologen in Iran.* Edited by Barbara Helwing and Patricia Rahemipour. Archäologie in Iran und Turan 11. Darmstadt: von Zabern, 2011.
Helwing, Barbara, and Patricia Rahemipour, eds. *Tehran 50: Ein halbes Jahrhundert deutsche Archäologen in Iran.* Archäologie in Iran und Turan 11. Darmstadt: von Zabern, 2011.
Henkelman, Wouter F. M. *The Other Gods Who Are: Studies in Elamite-Iranian Acculturation Based on the Persepolis Fortification Texts.* Achaemenid History 14. Leiden: Nederlands Instituut voor het Nabije Oosten, 2008.
Herzfeld, Ernst E. *Altpersische Inschriften.* Archaeologische Mitteilungen aus Iran Ergänzungsband 1. Berlin: Reimer, 1938.
———. *Archaeological History of Iran: The Schweich Lectures of the British Academy 1934.* London: Oxford University Press for the British Academy, 1934.
———. *Iran in the Ancient East: Archaeological Studies Presented in the Lowell Lectures at Boston.* London: Oxford University Press, 1941.

---. "Rapport sur l'état actuel des ruines de Persépolis et propositions pour leur conservation." *Archaeologische Mitteilungen aus Iran* 1 (1930): 17–40 (French), 3–24 (Persian).

Hole, Frank, ed. *The Archaeology of Western Iran: Settlement and Society from Prehistory to the Islamic Conquest*. Smithsonian Series in Archaeological Inquiry. Washington, DC: Smithsonian Institution, 1987.

Hughes, George R., D. K. Andrews, Waldo H. Dubberstein, Henry Field, and Eugene Prostov. "The Oriental Institute Archeological Report on the Near East: Fourth Quarter, 1939." *American Journal of Semitic Languages and Literatures* 57 (1940): 188–96.

Hughes, George R., Robert M. Engberg, and Waldo H. Dubberstein. "The Oriental Institute Archeological Report on the Near East: Third Quarter, 1937." *American Journal of Semitic Languages and Literatures* 55 (1938): 97–112.

Hughes, George R., A. Douglas Tushingham, and Waldo H. Dubberstein. "The Oriental Institute Archeological Report on the Near East: Third Quarter, 1938." *American Journal of Semitic Languages and Literatures* 56 (1939): 95–112.

Hughes, George R., A. Douglas Tushingham, D. E. McCown, Henry Field, and Eugene Prostov. "The Oriental Institute Archeological Report on the Near East: Second Quarter, 1939." *American Journal of Semitic Languages and Literatures* 56 (1939): 423–42.

Johnson, Janet. "Introduction: To the Members and Friends of the Oriental Institute." *Oriental Institute 1984–1985 Annual Report* (1985): 1–6.

Jones, Charles E., and Seunghee Yie. "From the Persepolis Fortification Archive Project, 3: The First Administrative Document Discovered at Persepolis: PT 1971–1." *ARTA: Achaemenid Research on Texts and Archaeology* 2011.003. http://www.achemenet.com/document/2011.003-Jones&Yie.pdf.

Kawami, Trudy S. "Ernst Herzfeld, Kuh-e Khwaja, and the Study of Parthian Art." Pages 181–214 in *Ernst Herzfeld and the Development of Near Eastern Studies, 1900–1950*. Edited by Ann C. Gunter and Stefan R. Hauser. Leiden: Brill, 2005.

Kent, Roland G. *Old Persian: Grammar, Texts, Lexicon*. 2nd rev. ed. American Oriental Series 33. New Haven: American Oriental Society, 1953.

Kraeling, Carl H. "The Oriental Institute." *Oriental Institute* [= Annual Report for 1954–55] (1955): 3–6.

---. "The Oriental Institute." *Annual Report of the Oriental Institute, 1959–60* (1960): 3–6.

---. "The Oriental Institute." *Annual Report of the Oriental Institute, 1962–63* (1963): 1–4.

---. "The Oriental Institute." *Annual Report of the Oriental Institute, 1967–68* (1968): 1–3.

Krefter, Friedrich. "Mit Ernst Herzfeld in Pasargadae und Persepolis 1928 und 1931–1934." *Archaeologische Mitteilungen aus Iran* 12 (1979): 13–25.

---. *Persepolis Rekonstruktionen*. Teheraner Forschungen 3. Berlin: Mann, 1971.

Langsdorff, Alexander, and Donald E. McCown. *Tall-i-Bakun A: Season of 1932*. Oriental Institute Publications 59. Chicago: University of Chicago Press, 1942.

Lewis, David M. *Sparta and Persia*. Cincinnati Classical Studies 1. Leiden: Brill, 1977.

Loon, Maurits van. "Enterprises Nearing Completion: The Iranian Expeditions." *Annual Report of the Oriental Institute, 1967–68* (1968): 22–23.

Mahrad, Ahman. "Intrigen während der NS-Zeit gegen deutsche Orientalisten jüdischen Glaubens." *Hannoversche Studien über den Mittleren Osten* 28 (1999): 31–38.
Majd, Mohammad Gholi. *The Great American Plunder of Persia's Antiquities, 1925–1941*. Lanham, MD: University Press of America, 2003.
Miles, George C. *Excavation Coins from the Persepolis Region*. Numismatic Notes and Monographs 143. New York: American Numismatic Society, 1959.
Mousavi, Ali. "Ernst Herzfeld, Politics, and Antiquities Legislation in Iran." Pages 445–75 in *Ernst Herzfeld and the Development of Near Eastern Studies, 1900–1950*. Edited by Ann C. Gunter and Stefan R. Hauser. Leiden: Brill, 2005.
———. *Persepolis: Discovery and Afterlife of a World Wonder*. Berlin: de Gruyter, 2012.
———. "Persepolis in Retrospect: Histories of Discovery and Archaeological Exploration at the Ruins of Ancient Parseh." *Ars Orientalis* 32 (2002): 209–51.
Nagel, Alexander. "Ernst E. Herzfeld." Pages 58–59 in *Tehran 50: Ein halbes Jahrhundert deutsche Archäologen in Iran*. Edited by Barbara Helwing and Patricia Rahemipour. Archäologie in Iran und Turan 11. Darmstadt: von Zabern, 2011.
"Naqš-i-Rustam." *Archiv für Orientforschung* 14 (1944): 228–30.
Olmstead, Albert Ten Eyck. *History of the Persian Empire*. Chicago: University of Chicago Press, 1948.
Parker, Richard A. "The Oriental Institute Archaeological Report on the Near East: Second Quarter, 1936." *American Journal of Semitic Languages and Literatures* 53 (1936): 52–72.
Perkins, Ann, ed. "Archaeological News: The Near East." *American Journal of Archaeology* 53 (1949): 53–57.
"Persepolis." *Archiv für Orientforschung* 8 (1933): 82–84, 332–34.
"Persepolis." *Archiv für Orientforschung* 9 (1934): 224–25.
"Persepolis." *Archiv für Orientforschung* 11 (1937): 266.
"Persepolis." *Archiv für Orientforschung* 12 (1939): 175–76.
"Persien." *Archiv für Orientforschung* 7 (1932): 64–65.
Poebel, Arno. "The King of the Persepolis Tablets, the Nineteenth Year of Artaxerxes I." *American Journal of Semitic Languages and Literatures* 56 (1939): 301–4.
———. "The Names and the Order of the Old Persian and Elamite Months During the Achaemenian Period." *American Journal of Semitic Languages and Literatures* 55 (1938): 130–41.
Rahemipour, Patricia, "Archäologen, Philologen, Literaten." Pages 65–66 in *Tehran 50: Ein halbes Jahrhundert deutsche Archäologen in Iran*. Edited by Barbara Helwing and Patricia Rahemipour. Archäologie in Iran und Turan 11. Darmstadt: von Zabern, 2011.
"Recent Discoveries at Persepolis." *Journal of the Royal Asiatic Society* 66 (1934): 226–32.
Renger, Johannes. "Ernst Herzfeld in Context: Gleanings from His Personnel File and Other Sources." Pages 561–82 in *Ernst Herzfeld and the Development of Near Eastern Studies, 1900–1950*. Edited by Ann C. Gunter and Stefan R. Hauser. Leiden: Brill, 2005.
Samsami, Behrang. "'Ausgraben und Erinnern': Der Iran-Aufenthalt der Schweizer Schriftstellerin und Journalistin Annemarie Schwarzenbach im Frühjahr 1934." Pages 68–72 in *Tehran 50: Ein halbes Jahrhundert deutsche Archäologen in Iran*.

Edited by Barbara Helwing and Patricia Rahemipour. Archäologie in Iran und Turan 11. Darmstadt: von Zabern, 2011.

Sancisi-Weerdenburg, Heleen, and Jan Willem Drijvers, eds. *Through Travellers' Eyes: European Travellers on the Iranian Monuments.* Achaemenid History 7. Leiden: Nederlands Instituut voor het Nabije Oosten, 1991.

Schmidt, Erich F. *Contents of the Treasury and Other Discoveries.* Vol. 2 of *Persepolis.* Oriental Institute Publications 69. Chicago: University of Chicago Press, 1957.

———. *Flights over Ancient Cities of Iran.* Special Publication of the Oriental Institute of the University of Chicago. Chicago: University of Chicago Press, 1940.

———. *The Royal Tombs and Other Monuments.* Vol. 3 of *Persepolis.* Oriental Institute Publications 70. Chicago: University of Chicago Press, 1970.

———. *Structures, Reliefs, Inscriptions.* Vol. 1 of *Persepolis.* Oriental Institute Publications 68. Chicago: University of Chicago Press, 1953.

———. *The Treasury of Persepolis and Other Discoveries in the Homeland of the Achaemenians.* Oriental Institute Communications 21. Chicago: University of Chicago Press, 1939.

Schmidt, Erich F., Maurits N. van Loon, and Hans H. Curvers. *The Holmes Expeditions to Luristan.* Oriental Institute Publications 108. Chicago: Oriental Institute of the University of Chicago, 1989.

Schwarzenbach, Annemarie. *Tod in Persien.* Basel: Lenos, 1995.

———. *Winter in Vorderasien: Tagebuch einer Reise.* Zürich: Rascher, 1934. Repr., Basel: Lenos, 2002.

Sprengling, Martin. "From Kartīr to Shahpuhr I." *American Journal of Semitic Languages and Literature* 57 (1940): 330–40.

———. "Kartīr, Founder of Sasanian Zoroastrianism." *American Journal of Semitic Languages and Literatures* 57 (1940): 197–228.

———. "A New Pahlavi Inscription." *American Journal of Semitic Languages and Literatures* 53 (1937): 126–44.

———. "Shahpuhr I, the Great, on the Kaabah of Zoroaster (KZ)." *American Journal of Semitic Languages and Literatures* 57 (1940): 341–420.

———. *Third Century Iran, Sapor and Kartir.* Chicago: Oriental Institute of the University of Chicago, 1953.

———. "Zur Parsik-Inschrift an der 'Kaaba des Zoroaster.'" *Zeitschrift der Deutschen Morgenländischen Gesellschaft* 91 (1937): 652–72.

Stolper, Matthew W. "The Oriental Institute and the Persepolis Fortification Archive." Pages xxxvii–lix in *Die Verwaltung im Achämenidenreich—Imperiale Muster und Strukturen / The Administration of the Achaemenid Empire. Tracing the Imperial Signature.* Edited by Bruno Jacobs, Wouter F. M. Henkelman, and Matthew W. Stolper. Classica et Orientalia 17. Wiesbaden: Harrassowitz, 2017.

———. "Persepolis Fortification Archive Project." *Oriental Institute 2006–2007 Annual Report* (2007): 92–103.

———. "The Persepolis Fortification Archive Project." *Oriental Institute 2007–2008 Annual Report* (2008): 110–15.

———. "Persepolis Fortification Archive Project." *Oriental Institute 2008–2009 Annual Report* (2009): 104–11.

———. "Persepolis Fortification Archive Project." *Oriental Institute 2009–2010 Annual Report* (2010): 83–91.

———. "Persepolis Fortification Archive Project." *Oriental Institute 2017–2018 Annual Report 2017–2018* (2019): 139–44.

Stolper, Matthew W., and Jan Tavernier. "From the Persepolis Fortification Archive Project, 1: An Old Persian Administrative Tablet from the Persepolis Fortification." *ARTA: Achaemenid Research on Texts and Archaeology* 2007.001. http://www.achemenet.com/document/2007.001-Stolper-Tavernier.pdf.

Stolze, F., and F. C. Andreas. *Persepolis: Die achaemenidischen und sasanidischen Denkmäler und Inschriften von Persepolis, Istakhr, Pasargadae, Shâpûr*. Berlin: Asher, 1882.

Walser, Gerold. "Zum Gedenken an Ernst Herzfeld (1879–1948)." *Archaeologische Mitteilungen aus Iran* 12 (1979): 9–12.

Weld-Blundell, Herbert. "Persepolis." Pages 537–59 in vol. 2 of *Transactions of the Ninth International Congress of Orientalists (Held in London, 5th to 12th September 1892)*. Edited by E. D. Morgan. London: Committee of the Congress, 1893.

Whitcomb, Donald E. "The City of Istakhr and the Marvdasht Plain." Pages 363–70 in *Akten des VII. Internationalen Kongresses für Iranische Kunst und Archäologie, München 7.–10. September 1976*. Archaeologische Mitteilungen aus Iran Ergänzungsband 6. Berlin: Reimer, 1979.

———. "Iranian Cities of the Sasanian and Early Islamic Periods." *Oriental Institute Annual Report 2003–2004* (2004): 90–94.

Wiesehöfer, Josef. *Die "dunklen Jahrhunderte" der Persis: Untersuchungen zu Geschichte und Kultur von Fārs in frühhellenistischer Zeit (330–140 v. Chr.)*. Zetemata 90. Munich: Beck, 1994.

CHAPTER 10

Iranian Art (of the Islamic Period) in American Museums: A Brief History

Linda Komaroff

THE PHENOMENON OF COLLECTING has only in more recent years been recognized as a vital part of the historiography of the field of Islamic art, of which Iranian art is one subset.[1] In a museum context, Iranian art has introduced generations of Americans to a key aspect of Iranian civilization, whether referred to with the geographically and chronologically expansive term "Persian" or subsumed under headings such as oriental, Mohammedan, or Islamic. The story of Iranian art in American museums is closely bound up with the history of museums, private collections, excavations (commercial and otherwise), and scholarship, as will be delineated in this essay.[2]

From its inception in the second half of the nineteenth century, the art museum in America was intended as a place for the enhancement and diffusion of knowledge of a broad spectrum of humankind's cultural accomplishments, as reflected in museum charters and realized through collections, exhibitions, publications, and interpretive programs. From the very beginning, Iranian art was part of the museum pantheon.[3] A significant proportion of artworks have entered American museums as gifts, and the same holds true for works of Iranian art. The history of collecting Iranian art is closely tied to the history of the academic study of Islamic and Iranian art, including the allied field of archaeology, and its maturation as a scholarly discipline. The collection and study of Iranian art have developed a reciprocal relationship: what was collected helped to drive initially commercial excavations in Iran and influenced what was studied, and what was excavated and studied helped to drive what was collected. What follows will consider the history of museum collections and exhibitions of Iranian art regarding private collecting, archaeology, and the growth of scholarship.

The great popularity of Iranian art in American collections may be traced to a variety of factors, not the least of which is availability of artworks. Comparatively large numbers of high quality objects are preserved from medieval and early modern Iran.[4] In the late nineteenth and early twentieth centuries, commercial and clandestine excavations at various sites in Iran produced vast

quantities of material, especially ceramics.[5] Most significantly, in contrast to Egypt and Turkey, where national museums began to be founded in the nineteenth century, such collections were only formed in Iran in the 1930s, which seems to have allowed for greater forbearance in the enactment and enforcement of laws preventing the export of cultural patrimony.[6]

Setting the Stage

At the time the first art museums were established in the 1870s—for example, the Boston Museum of Fine Arts and the Metropolitan Museum of Art (1870), the Philadelphia Museum of Art (founded as the Pennsylvania Museum and School of Industrial Art in 1876), and the Art Institute of Chicago (1879)—Nasir al-Din Shah (r. 1848–96) was just past the halfway point in his reign, and Iranian art perhaps was best known in America through works displayed and disseminated at the 1876 Centennial Exhibition in Philadelphia.[7] Of further note were the carpets decorating the great mansions of the newly inaugurated "Gilded Age."[8] The Centennial Exposition not only introduced collectors, such as the Metropolitan Museum's future donor H. O. Havemeyer (1847–1907), to "Oriental" art,[9] but a number of examples of Iranian art subsequently acquired by the Philadelphia Museum of Art may have come through the exposition.[10] Edward C. Moore (1827–91), a silversmith and chief designer at Tiffany & Co., who bequeathed to the Metropolitan Museum in 1891 a large collection of Islamic art, which included a number of important examples of Iranian glazed ceramics and inlaid metalwork, would have been actively collecting in the last decades of the nineteenth century.[11] Denman W. Ross (1853–1935), an artist and lecturer on theory of design at Harvard University, was an avid and eclectic collector of the late nineteenth century and donated over ten thousand works of art to the Museum of Fine Arts, among which were many key examples of "Oriental" art. His gifts to the museum, on whose board he served from 1895 until his death, included Iranian textiles, carpets, and several pages from fourteenth- and fifteenth-century manuscripts of the *Shahnama*, most notably the Great Mongol *Shahnama*.[12] Henry Walters (1848–1931), who inherited his father William's fortune and interest in art, began to collect seriously and broadly in the closing years of the nineteenth century.[13] Many of the objects acquired by the younger Walters, in particular examples of Islamic art, came from the dealer Dikran Kelekian, under whose influence he purchased Iranian illustrated and illuminated manuscripts, pottery and tiles, carpets and textiles, and arms and armor.[14] He bequeathed an encyclopedic collection of twenty-two thousand objects to the city of Baltimore in 1931 through what was first called the Walters Art Gallery and is now known as the Walters Art Museum.[15]

During this same period and in a similar though more focused vein, Charles Lang Freer (1854–1919) amassed a vast collection of Asian art, which he bestowed to the United States as part of the Smithsonian Institution. He also provided funds for the construction of the Freer Gallery of Art, which opened to the public in 1923. Many of Freer's Iranian acquisitions, mainly reflecting his interest in Islamic ceramics, seem to belong to the last years of his life, while the most significant works were acquired only after his death with funds provided by his bequest.[16]

Several art dealers also played a decisive part in this formative period of collecting, most of whom often seemed to wear simultaneously several hats, including that of the scholar, the collector, and the archaeologist as well as that of the businessman. Such overt intersection and intertwining of commerce and scholarship should not necessarily be judged by the academic criteria and ethical standards of our own time, although it must be factored into any discussion of this important moment in collecting.[17]

Along with Hagop Kevorkian (1872–1962), Dikran Kelekian (1868–1951) was one of these multifaceted and influential dealers and one of several Armenians in the trade from Kaysari, Turkey. Kelekian even added a diplomatic component to his versatile professional portfolio. He seems to have first come to America to serve as the commissioner for the Persian pavilion at the 1893 Columbian Exposition in Chicago, where he met and began relationships with several important American collectors, some of whose collections subsequently were bequeathed to museums.[18] Kelekian's connection to Iran (he had a special interest in its pottery) is further demonstrated by his appointment in 1902 as the Persian consul in New York. Two years later, he served as the Imperial Persian commissioner general at the Louisiana Purchase Exposition in St. Louis, where he exhibited one hundred of his objects in the Persian pavilion.[19] The dealer's concern for promoting Iranian ceramics as an art form is demonstrated through his 1909 and 1910 publications on this material, through which he transformed himself from a mere entrepreneur to a collector and scholar.[20] This goal was perhaps fully realized with the long-term exhibition of his ceramics collection at the Victoria and Albert Museum.[21] Both Kelekian and Kevorkian conducted commercial excavations in Iran giving them direct access to material for their clients and collections. Kevorkian excavated at Rayy south of Tehran, the finds from which became an important source for satisfying the new appetite in Islamic ceramics beginning in the late nineteenth century.[22] As there was no comprehensive regulation of archaeological work in Iran until 1930, the site of Rayy, which had been ravaged by commercial diggers for decades, was only excavated in a studied manner from 1934 to 1936 by Erich Schmidt.[23] Ultimately, the results of Schmidt's fieldwork would help to contextualize the cultural milieu and suggest a provenance for some of the many medieval Iranian ceramics in museum collections.[24]

Excavations at Nishapur in northeastern Iran, undertaken by the Metropolitan Museum from 1935 to 1940 with a final season in 1947, would have a far deeper impact on collecting and scholarship. The excavations corroborated what was known from historical accounts—namely, that Nishapur was a great political, commercial, and cultural center from the ninth through the early thirteenth centuries. Among the wealth of objects unearthed there, which were divided between the Metropolitan Museum and the National Museum of Iran, the ceramic finds were among the most abundant and significant.[25] For the ninth through tenth centuries, they demonstrate the coeval production of a remarkable variety of types and styles of slip-painted and glazed earthenware, with decoration ranging from colorful figural designs to austere calligraphy. The excavations also helped to document the introduction by the beginning of the eleventh century of a new ceramic body, so-called fritware or stone-paste ware.[26] Nishapur pottery acquired on the art market is very well represented in American collections, including the Metropolitan Museum.[27] In 1960, the establishment of the Archaeological Research Center of Iran would put a halt to commercial excavations and foreign concessions, but the preceding decades (especially the 1920s through the 1940s) formed a remarkable period of growth in collections of Iranian art in the United States, both public and private.[28] It also saw a corresponding expansion of related scholarship.

Arthur Upham Pope (1881–1969) played a key role in these developments. Pope's life and career have been the subject of scholarly discussion concerning the historiography of collecting and the broader field of Iranian art.[29] Pope seems largely to have been self-educated in the history of art, and he began his career in art as a consultant, following a brief and abortive stint as an academic.[30] By the early 1920s, he was appointed Advisory Curator of Mohammedan Art to the Chicago Art Institute and an advisor in Persian Art to the Pennsylvania Museum, which later became the Philadelphia Museum of Art.[31] He also played an advisory role at the Boston Museum of Fine Arts that included selling the museum a large group of ceramics acquired in Iran.[32] Pope first visited Iran in 1925, where his ideas on Persian art, particularly as it related to the greatness of Iranian civilization, struck a resonant chord with the newly installed Pahlavi regime under Reza Shah (r. 1925–41) and its own nationalist agenda.[33] Pope soon was appointed Special Commissioner for Persia by the Iranian government and was placed in charge of designing the Persian pavilion for the Sesquicentennial International Exposition held in Philadelphia in 1926, which was notable for its reduced scale model of the seventeenth-century Masjid-i Shah (Shah Mosque) in Isfahan.[34] An overabundance of objects solicited from collectors and dealers led to another exhibition in late 1926 at the Pennsylvania (Philadelphia) Museum of Art, which also included loans from six American museums.[35]

The twin Philadelphia exhibitions were perhaps only a rehearsal for the great Persian exhibition of 1931 at Burlington House, London, which remarkably brought together more than two thousand works ranging from prehistoric times through the Islamic period, among them loans from eleven American museums as well as several private collections.[36] This time, the exhibition included a thirty-foot, reduced-scale replica of the monumental entrance portal of the Masjid-i Shah rendered in painted cloth and stucco.[37] Probably more spectacle than scholarship, the exhibition left a lasting impact on the field of Iranian art, especially through the multivolume *Survey of Persian Art* published several years later.[38] Pope attempted to re-create the scope of the London exhibition and some of its lavishness in New York City in 1940 with his exhibition entitled "Six Thousand Years of Persian Art," which included some twenty-eight hundred works drawn from American museums, collectors, and galleries.[39] While many of the works of art gathered for the Philadelphia exhibitions and especially for the London and New York extravaganzas were still either in private collections or with dealers, these work subsequently entered American museum collections.[40] Whatever were his shortcomings, particularly when viewed in relation to ensuing standards of scholarship and professional codes of behavior, Pope's activities during the years between the two World Wars created an interest in and an appetite for Iranian art that was to continue to impact American museum collections, exhibitions, and their audiences into the following decades.[41]

The Next Generation

Among the US-based dealers who catered to the American market for Iranian art in the middle decades of the twentieth century, perhaps Nasli Heeramaneck (1902–1971) was the most prolific. Born in Bombay, India, in 1927 he immigrated to New York, where he set up shop. As with members of the preceding generation of dealers like Kevorkian and Kelekian, Heeramaneck presented himself not as a purveyor of art but rather as a knowledgeable connoisseur and collector.[42] Heeramaneck did in fact amass several important collections of Indian, ancient Near Eastern, and Islamic art, though each of them was available for sale en masse. The last two collections, now housed at the Los Angeles County Museum of Art, were composed predominately of Iranian art.[43]

In the decades following World War II in America, Richard Ettinghausen (1906–1979) was the single most influential scholar whose work straddled the museum world and academia. German born and educated with a PhD from the University of Frankfurt in Islamic history and art history, Ettinghausen's

interests in Iranian art seem to have crystalized following his immigration in 1934 to the United States, where he briefly joined Pope's staff at the Institute of Iranian Art and Archaeology in New York.[44] In 1944, Ettinghausen was appointed to the Near Eastern Department at the Freer Gallery of Art, and in 1961 he was made the chief curator of that institution. During twenty-three years at the Freer, he helped to build the collection into one of the finest holdings of Islamic art anywhere, and many of his most notable acquisitions were in the area of Iranian art.[45] He was also closely involved with the Islamic component of the exhibition "7,000 Years of Iranian Art," which opened in Washington, DC in 1964 and subsequently traveled throughout the United States.[46]

In 1969, Ettinghausen became Consultative Chairman of the Islamic Department of the Metropolitan Museum of Art. There, he was instrumental in installing the Islamic collection in a new and larger space, which opened in 1975. These galleries were groundbreaking for their innovative display methods and their well-construed arrangement.[47] Galleries devoted to the Nishapur excavations, Saljuq art, and Timurid and Safavid arts highlighted the important contributions of Greater Iran within the overall framework of Islamic art.[48] Under Ettinghausen, in 1970 the Metropolitan Museum received the extraordinary gift from museum trustee Arthur Houghton of seventy-six pages from the now notorious Tahmasp (formerly known as Houghton) *Shahnama*.[49] Through his connoisseurship, innovative installation approach, and his publications dealing directly with the physical work of art, its meaning, style, and provenance, Ettinghausen helped to set a new standard for the modern American museum collection of Islamic art.

Late Twentieth and Early Twenty-First Centuries

Several major exhibitions in America in the late twentieth and early twenty-first centuries, all of which were international loans shows concentrating on a particular dynasty, helped to advance the field and to redirect or refocus collecting patterns. These shows also introduced a new generation to Iranian art. The "Wonders of the Age" exhibition in 1979–80, which was organized by the Fogg Museum at Harvard University (now Harvard Art Museum) with the British Library and the National Gallery of Art, Washington, DC, brought together some of the greatest examples of early Safavid manuscript illustration.[50] The groundbreaking 1989–90 "Timur and the Princely Vision" exhibition, which was co-organized by the Los Angeles County Museum of Art and the Arthur M. Sackler Gallery, Washington, DC, examined Timurid cultural patronage above and beyond the well-known hallmarks of manuscript illustration.[51] The 1998–99 exhibition "Royal Persian Paintings" organized by

the Brooklyn Museum was devoted to the monumental and life-size painting of the Qajar dynasty.[52] Co-organized by the Metropolitan Museum and the Los Angeles County Museum of Art in 2002–3, "The Legacy of Genghis Khan" exhibition explored the important artistic developments that occurred in the Iranian world as a result of the Mongol invasions.[53] Returning again to the early Safavid dynasty, the 2003–4 exhibition "Hunt for Paradise," which was co-organized by the Asia Society, New York, and Museo Poldi Pezzoli, Milan, expanded the scope of inquiry beyond manuscript illustration to include a broader range of courtly art.[54] Mention can also be made of "Falnama: The Book of Omens," a 2009 exhibition focusing on a type of illustrated divination text largely associated with the Safavid dynasty that was organized by the Arthur M. Sackler Gallery.[55] Finally, the 2016 exhibition "Court and Cosmos: The Great Age of the Seljuqs" at the Metropolitan Museum of Art was devoted in part to the Great Seljuqs of Iran.[56]

With collections literally from coast to coast and extending beyond the contiguous forty-eight states to Hawaii, America is an excellent resource for Iranian art of the Islamic era. Only a few museum collections, however, would on their own provide a comprehensive view of Iranian art in all media. For most of these collections, the preponderance of material predates the cataclysmic Mongol invasions of the late twelfth and early thirteenth centuries, testifying not merely to the prosperity and creativity of this earlier period but also to the sheer destructive force of the Mongols that covered much of the Iranian world like volcanic ash, preserving what lay beneath for the avaricious excavators of the late nineteenth and early twentieth centuries.[57] American museum collections are therefore rich in the art of Iranian objects, including ceramics and tiles, metalwork, glass, textiles, jewelry, stone, and stucco. The arts of the Ilkhanid, Timurid, Safavid, and Qajar dynasties, to which can be added the arts of the book and carpets, are less ubiquitous. What follows is a short, preliminary guide to the major museum collections of Islamic art, several of which have already been noted, with emphasis placed on those institutions with the most significant holdings of Iranian material.[58]

Institutional Collections

The Metropolitan Museum of Art, New York City

By far the largest and most comprehensive collection of Iranian art is that of the Metropolitan Museum, the origins of which were already briefly discussed.[59] While this is a collection that represents the entire breadth of Islamic art, the newly reconfigured galleries, which opened in late 2011, serve to highlight

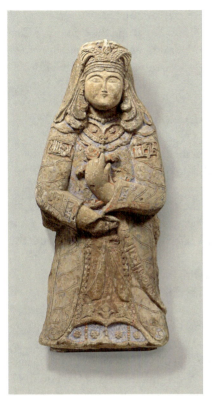 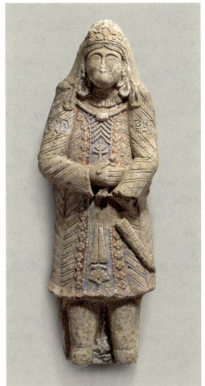

FIGURE 10.1. Pair of Figures, Iran or Afghanistan, late twelfth or early thirteenth century. (a) Stucco; incised, painted, gilt, H. 119.4 cm. Cora Timken Burnett Collection of Persian Miniatures and Other Persian Art Objects, Bequest of Cora Timken Burnett, 1956 (57.51.18); (b) Painted stucco, H. 144.8 cm. Gift of Mr. and Mrs. Lester Wolfe, 1967 (67.119). The Metropolitan Museum of Art, New York.

the sheer size and scope of the museum's Iranian holdings.[60] Even by the generous standards of other American museums, the Metropolitan Museum's collection excels in the period from about the tenth through the early thirteenth centuries as well as in the arts of the Safavid dynasty (1501–1732). The earlier holdings encompass the material excavated at Nishapur (noted above) as well as a number of remarkable objects contemporaneous to or allied with the Nishapur finds.[61] These holdings also include a large number of high-quality luster and *mina'i* ceramics, a pair of nearly life-size carved and painted princely figures, and key examples of luxury metalwork (fig. 10.1).[62] In terms of the Safavid material, pride of place belongs to the museum's manuscript paintings and carpets. Among the former, as previously noted, are seventy-six pages from the Tahmasp *Shahnama* (ca. 1525–35) as well as a large group of single-page

album paintings from the seventeenth century.[63] Among the latter are several "named" carpets such as the Anhalt Medallion Carpet and the Emperor's Carpet, with its intricate design of animals and flowers, as well as other unnamed but equally remarkable carpets, including those from the collection of Benjamin Altman.[64]

Freer Gallery of Art and Arthur M. Sackler Gallery, Washington, DC

Though less comprehensive and considerably smaller than the collection of the Metropolitan Museum, the combined holdings in Islamic art of the Freer and Sackler Galleries perhaps proportionally include a greater number of masterpieces.[65] In Iranian art, the collection excels in the arts of the book, ceramics, and metalwork, and while the core collection initially formed by Freer was rich in these media, the greatest examples came to the collection only after the museum opened to the public in 1923.[66] Moreover, the collection of manuscript illustrations was greatly enhanced with the acquisition of the Vever Collection by the Sackler Gallery in 1986.[67] The finest examples of glazed pottery, especially *mina'i* and lusterware, and metalwork again belong to the period from about the tenth through early thirteenth centuries and include the petite *mina'i* vessel known as the Freer Beaker, a luster dish with mermaid dated 1210, and an inlaid brass pen case dated 1210–11, all of which have become cornerstones in the study of these mediums. Concerning the arts of the book, the quantity, quality, and rarity of the complete manuscripts, detached paintings, drawings, and single-page paintings make this a singular American resource for the history of Persian painting from the fourteenth through seventeenth centuries, a prime example being the sixteenth-century so-called Freer Jami manuscript. The Freer Gallery's early fifteenth-century manuscript of Nizami's *Khusraw and Shirin* can also be singled out, along with eight pages from the Great Mongol *Shahnama* in the Sackler Gallery (fig. 10.2).[68]

Los Angeles County Museum of Art

The largest encyclopedic art museum in the western United States, the Los Angeles County Museum of Art (LACMA) had already started collecting works of Iranian art before it separated from the Museum of Natural History and moved to its present location in 1965. Among these first acquisitions were the museum's two great sixteenth-century carpets—one of the two well-known Ardabil Carpets dated from 1539–40 and the contemporaneous so-called Coronation Carpet—both of which were gifted by J. Paul Getty.[69] LACMA first began to collect Iranian art in a serious and systematic manner in 1973 with the purchase of the Nasli M. Heeramaneck Collection of Islamic

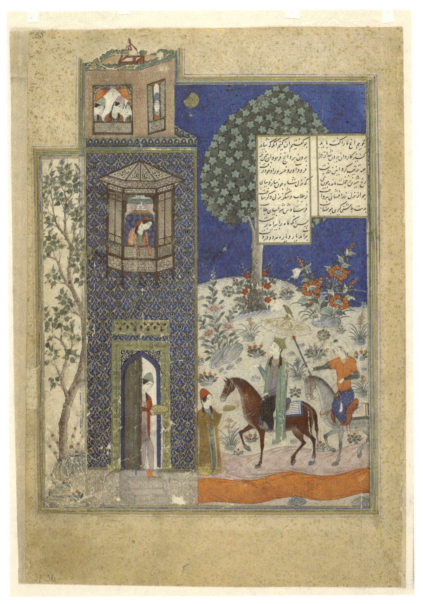

FIGURE 10.2. Khusraw at the castle of Shirin, from a manuscript of *Khusraw and Shirin* by Nizami. Iran, early fifteenth century, Timurid period. Ink, opaque watercolor, and gold on paper, 25.7 × 18.4 cm. National Museum of Asian Art, Smithsonian Institution, Freer Collection, Purchase—Charles Lang Freer Endowment, F1931.36.

art.[70] In 2002, LACMA made a similar large-scale acquisition with the Madina Collection of Islamic Art, which, although not predominantly Iranian, contained a number of exceptional examples.[71] Other purchases and gifts alongside the acquisition of a considerable body of contemporary Middle Eastern and especially Iranian art have made this a substantial and comprehensive collection.[72] In addition to the two sixteenth-century carpets just mentioned, the collection is notable for its pottery and tilework (fig. 10.3).[73] Although the collection was assembled primarily from the second half of the twentieth century onward, many of its Iranian works have an exceptional provenance; a number of them, including the two carpets, initially passed through the hands of key collectors and dealers in the late nineteenth and first half of the twentieth century or were shown in exhibitions of that period.[74]

Brooklyn Museum of Art

Founded in 1895 as an encyclopedic museum, the Brooklyn Museum acquired some of its first examples of Iranian art, mainly pottery, in the opening years of the twentieth century. The Brooklyn Museum hosted its own exhibition of Persian art in 1931, which comprised works from its collection, and especially loans from neighboring museums, as well as works from dealers and private collectors. In contrast to the nearly contemporaneous London exhibition, the Brooklyn show was intended "to demonstrate Persian art from an ethnological and educational standpoint."[75] The Iranian art that constitutes the bulk of the museum's Islamic collection is a particularly rich resource for the periods of the Zand and Qajar dynasties, including paintings, architectural decoration, and photography.[76]

Museum of Fine Arts, Boston

The origins of the Museum of Fine Arts and initial gifts of Iranian art from Denman Ross have already been noted above, as was Pope's influential role in the acquisition of a group of Iranian ceramics. In addition to ceramics, the collection is significant for its manuscript painting.[77]

Harvard Art Museum, Cambridge

The Harvard Art Museum's collection is an even greater resource than the Museum of Fine Art in Boston for the arts of the book in Iran. The exceptional collection, shaped in part by Stuart Cary Welch (1928–2008), who served in various curatorial capacities from 1956 to 1995, is notable for its drawings as well as its paintings, especially Safavid works from the important donation of John Goelet

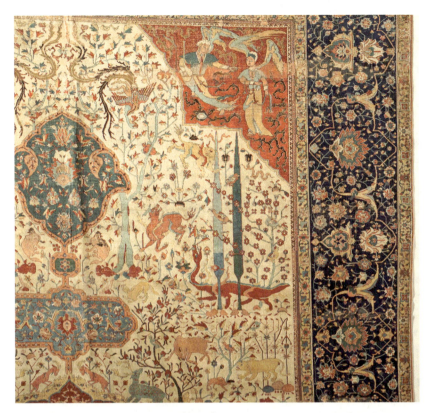

FIGURE 10.3. Coronation Carpet (detail), Iran, ca. 1520–30, Safavid period. Knotted pile in wool on a cotton foundation, 701 × 365.76 cm. Los Angeles County Museum of Art, Gift of J. Paul Getty (49.8). Photo © 2012 Museum Associates / LACMA.

in 1958. This collection was augmented further in 2002 with the gift of over fifty paintings and drawings from the Norma Jean Calderwood Collection.[78]

Philadelphia Museum of Art

As already mentioned, the Philadelphia Museum began acquiring Iranian art very soon after its founding in 1876. In spite of its early start, the collection remains small, uneven in quality, and largely focused on ceramics and textiles.

Walters Art Museum, Baltimore

The specific circumstances of this museum's founding and the origins of its Islamic collection has already been noted. Its Iranian material, which

is strongest in the areas of the book arts and ceramics, is of a high quality overall.[79]

Detroit Institute of Arts

Founded in 1885, the Detroit Institute of Arts began seriously to acquire Islamic art during the directorship of William Valentiner (from 1924 to 1945), when the museum started to build its collections in an encyclopedic manner. In 1929, Valentiner recruited the art historian Mehmet Ağa-Oğlu (1896–1949) from Istanbul to serve as one of the first curators in America specializing in Islamic art.[80] The following year, Ağa-Oğlu organized a show entitled "A Loan Exhibition of Mohammedan Decorative Arts," which, in spite of its title, was largely composed of Iranian material, including more than two hundred paintings belonging to the Belgian dealer Georges Demotte, from whom the Detroit Institute of Arts likely acquired a page from the Great Mongol *Shahnama* in 1935.[81] Along with several seventeenth-century single-page paintings, the collection is notable for its ceramics.

Art Institute of Chicago

The Art Institute of Chicago, founded in 1879, holds a small collection of Islamic art predominantly from Iran and largely comprising ceramics, the first examples of which were given to the museum between 1913 and 1919.[82] As noted above, Pope was appointed as an advisory curator in 1925 with a portfolio and funds for expanding the collection.[83] During Pope's decade-long affiliation with the Art Institute, he acquired around three hundred examples of Iranian art on the museum's behalf, often directly from Iran.[84]

Cleveland Museum of Art

The Cleveland Museum of Art, which opened to the public in 1916, includes among its earliest acquisitions two Sultanabad-type bowls.[85] It has a small but significant collection of Islamic art, which is rich in Iranian material, including a number of fine examples of ceramics, inlaid metalwork, textiles, and manuscript illustrations.[86]

Doris Duke Foundation for Islamic Art, Honolulu

Also known as Shangri La, the Islamic art collection of Doris Duke (1912–1993) is housed in her former home in Diamond Head. As part of an extended trip to the Middle East in 1938, she visited Isfahan and was smitten by the tile

revetment of the city's mosques and palaces. Working with and through Pope, who had helped to arrange her trip, Duke acquired both historical and newly commissioned Safavid-style tiles to decorate the home she was then planning in Honolulu.[87] The collection is today most notable for these tiles, including a large Ilkhanid group possibly from the palace at Takht-i Suleiman, and especially a nearly complete luster mihrab dated 1265.[88]

Conclusions

As this preliminary account suggests, the early history of Iranian art in American museums is part of a larger intriguing story involving the development and growth of museums, the predilections of private collectors, the adventures of commercial excavators and archaeologists, and the endeavors of a remarkable group of curators, scholars, and dealers. Looking backward to this formative period, the unique figure of Arthur Upham Pope continues to dominate the narrative, just as he did in the decades between the World Wars. In the latter half of the twentieth century, heightened professional standards laid the ground more firmly for collection building and exhibition development centered on issues of scholarship, authenticity, and connoisseurship. As for Iranian art and the twenty-first-century museum, the digitalization of collections and databases as well as their accessibility through the Internet have provided a wealth of shared information as never before. What remains to be seen is how new technology will be engaged, along with the objects themselves, to produce the next generation's "survey" of Iranian art.[89]

Notes

1. Vernoit, *Discovering Islamic Art*; also see *Ars Orientalis* 30 (2000) for a series of essays on collections and perceptions of Islamic art. In terms of the historiography of Islamic art in general, see a special volume of *Journal of Art Historiography* 6 (2012) edited by Moya Carey and Margaret S. Graves.

2. Although early collectors traveled outside the United States, where they saw exhibitions and museum collections or made purchases from dealers abroad, this essay will restrict itself to collecting activities in America.

3. On museums in America, see Einreinhofer, *American Art Museum*; also, more generally, see Alexander and Alexander, *Museums in Motion*. The first Iranian object acquired by a museum seems to be a twelfth or thirteenth-century bronze mirror with paired sphinxes (72.4482), presented to the Boston Museum of Fine Arts in 1872.

4. For the medieval period, see Grabar, "Visual Arts," and especially Ettinghausen, "Flowering of Seljuk Art."

5. For a rather polemical account of excavations in early twentieth-century Iran and the American connection, see Majd, *Great American Plunder*.

6. See Masuya, "Persian Tiles," especially with regard to a royal edict of 1876 to prevent Iranian religious buildings from being stripped of their tiles and furnishings,

which evidently did not prevent the subsequent export of carpets from the Ardabil Shrine, among other things.

7. Gross and Snyder, *Philadelphia's 1876 Centennial Exhibition*.

8. See Erdmann, *Seven Hundred Years*, 89. For photographs of such carpets *in situ* in great American homes, see Lewis, Turner, and McQuillon, *Opulent Interiors*. Also see Bacharach and Bierman, *Warp and Weft of Islam*, 53–57, for early collections in America, focusing on the Northwest.

9. Frelinghuysen et al., *Splendid Legacy*, 129.

10. These probably include a Qajar ax (1876–1596), which was sold to the museum by a certain Colonel H. B. Sanford, who was the British commissioner to the Centennial Exposition. Other objects that might have come through the exposition are those purchased from Caspar Clarke in 1877, including two seventeenth-century Safavid luster vases (1877–120 and 1877–121), an eighteenth-century glass bottle (1877–99), and a Qajar helmet and shield (1877–90 and 1877–91). I am grateful to Yael Rice for her kind assistance in this regard.

11. He does not appear to have traveled to the Middle East but likely bought from European sources. See "Edward C. Moore Collection"; Jenkins-Madina, "Collecting the 'Orient,'" 76–80; Ekhtiar et al., *Masterpieces*, 2–3, and cat. nos. 76, 87, 132, 157, and 160.

12. His first gift of Iranian art to the Museum of Fine Arts seems to have been in 1893, a possibly Qajar-era textile (93.983), followed in 1898 by a Safavid silk fragment (98.963). For these objects, and for the Great Mongol Shahnama page known as "Alexander Fights the Habash Monster" (30.105), a page from a late Timurid Shahnama (19.778), and a fine Safavid "Polonaise" carpet (17.603), see the Museum of the Fine Arts website. See Coomaraswamy, "Early Arabic and Persian Paintings," for several Injuid paintings given in the 1920s. On the general details of his life and career, see Frank, *Denman Ross*. I am grateful to Sheila Blair and Jonathan Bloom for bringing this collector to my attention. As an interesting sidebar, one of Denman Ross's students at Harvard, Harvey Wetzel, bequeathed to Harvard's Fogg Museum (now Harvard Art Museum) in 1919 its first Iranian manuscript illustration, another page from the Great Mongol Shahnama (1919.130), see Simpson, *Arab and Persian Painting*, 12.

13. See Johnston, *William and Henry Walters*.

14. About 1,200 works in all; see Simpson, "Gallant Era," 99.

15. See Johnston, *William and Henry Walters*.

16. See Lawton and Merrill, *Freer*, especially 78; for the specific terms of Freer's bequest, see Smithsonian Institution, *Material Papers*. Freer had a particular interest in ceramics; for some of the Iranian acquisitions, see Atil, *Ceramics*, cat. nos. 21, 24, 31–34, 38, 43, 49, 54, 68, 69, 71–77, 89–90, 92, 94–101.

17. See Jenkins-Madina, "Collecting the 'Orient.'"

18. Jenkins-Madina, "Collecting the 'Orient,'" 72; also see Simpson, "Gallant Era," 91.

19. Jenkins-Madina "Collecting the 'Orient,'" 74–75.

20. Kelekian, *Kelekian Collection*. Kevorkian also had a reputation well beyond that of dealer or even later a donor. In "New Rubaiyat of Omar Discovered in Ancient Volume," *New York Times*, April 12, 1914, Kevorkian is given the title of "Dr." and is referred to as a "Persian archaeologist." A short piece in *American Art News* 9.34 (August 19, 1911), discussing the excavations in Iran that were then shedding light on the "real art of the Mohammedan Orient," concludes: "It is to the systematic exploration of the

last five years or so of M. H. Kevorkian that we owe the opportunity to see collectively more than sufficient to survey the whole period."

21. The exhibition extended from 1910 until after Kelekian's death in 1951. See Jenkins-Madina "Collecting the 'Orient,'" 76. Many of these objects ended up in public collections, such as a Safavid luster dish with leafy tree at LACMA; see Komaroff, *Islamic Art*, fig. 52.

22. Jenkins-Madina "Collecting the 'Orient,'" 73 (fig. 2); also, see "To Display Rare Ceramics," *New York Times*, February 27, 1910, by special cable to the *Times* from London announcing Kevorkian's immanent arrival in New York with ceramics from his collection recently excavated at Rayy, all of them fragments "put together by native expert workmen." For a more academic discussion of the finds from Rayy, see Treptow and Whitcomb, *Daily Life Ornamented*, especially 9.

23. See Majd, *Great American Plunder*, especially 106–10. The excavations were conducted initially under the auspices of the University Museum of Philadelphia and the Boston Museum of Fine Arts and are discussed also by Christopher P. Thornton, Alessandro Pezzati, and Holly Pittman in this volume. Also see Treptow and Whitcomb, *Daily Life Ornamented*.

24. In contrast to the large numbers of wares excavated at Rayy, only a single kiln was uncovered there by Schmidt in his first season. See Treptow and Whitcomb, *Daily Life Ornamented*, especially 48, for the kiln and reference to the unpublished excavation report.

25. See Wilkinson, *Nishapur: Pottery*. But also see Wilkinson, *Nishapur: Some Early Islamic Buildings*, for some of the remarkable stucco panels and wall paintings. For the metalwork, see Allan, *Nishapur: Metalwork*.

26. See Wilkinson, *Nishapur: Pottery*.

27. For example, see Ekhtiar et al., *Masterpieces*, cat. no. 67.

28. Ettinghausen, in his review of the 1940 exhibition "Six Thousand Years of Persian Art," noted the very large number of exhibitions and events related to Iranian art that occurred during the 1930s. On the burgeoning taste for Iranian art in this period, also see Overton, "From Pahlavi Isfahan," 67–68.

29. Though not without its biases, the most exhaustive study is still Gluck and Siver, *Surveyors of Persian Art*. For a perhaps more realistic assessment, see Muscarella, "Pope and the Bitter Fanatic." See as well Kadoi, "Arthur Upham Pope." Also see Kadoi, *Arthur Upham Pope and a New Survey*, a collection of papers from a 2010 symposium with the same title held at the Art Institute of Chicago. Finally, see Rizvi, "Art History and the Nation."

30. See Gluck and Siver, *Surveyors of Persian Art*, 67, in reference to the well-known scandal involving Pope's involvement with his student and later wife, Phyllis Ackerman.

31. Gluck and Siver, *Surveyors of Persian Art*, 22 and 155, with reference to his acquisitions on behalf of the Philadelphia Museum. Also see Kadoi, "Arthur Upham Pope."

32. The sale occurred in 1931. See McWilliams, "Collecting by the Book," 232, 234, 237, and figs. 9–10; the related citations reference MFA archives.

33. See Rizvi, "Art History and the Nation." At the time of Pope's visit in spring 1925, Reza Khan had yet to take the official title "Shah," which he did on December 15 that year.

34. See Gluck and Siver, *Surveyors of Persian Art*, 119.

35. See Pope, "Special Persian Exhibition."

36. On the significance and reception of the exhibition, see Wood, "Great Symphony of Pure Form," and Robinson, "Burlington House Exhibition," 185.

37. Gluck and Siver, *Surveyors of Persian Art*, 8–9.

38. Wood, "Great Symphony of Pure Form," and Robinson, "Burlington House Exhibition." But also see Meyer Shapiro's astute review of *A Survey of Persian Art*, in which he pinpoints one of the main problems with the work, which is its failure to justify and explain a transcendent notion of "Persian" art without regard to time, space, culture, and ethnicity.

39. The quantity of objects, mainly dating to the Islamic era, would seem to attest to the popularity of Iranian art in America at this time. See Ackerman, *Guide to the Exhibition*, but especially see the thoughtful review by Ettinghausen, "Six Thousand Years."

40. Among the most extraordinary acquisitions that may be connected to Pope, and perhaps on more than one level, is the mihrab from the Imami Madrasa, in the Metropolitan Museum of Art since 1939. See Carboni and Masuya, *Persian Tiles*, 36, for what is generally know about the circumstances under which the mihrab first came to America, to Philadelphia, and eventually entered the collection of the New York Museum.

41. For Pope's legacy as a purveyor of art and the ongoing work of sorting out the authentic from the modern, see Overton, "From Pahlavi Isfahan." An interesting contemporary counterbalance to Pope's career would be that of Mehmet Ağa-Oğlu after his arrival in America in 1929; see Simavi, "Mehmet Ağa-Oğlu."

42. See Pal, *Islamic Art*, 7–8.

43. The Islamic collection was acquired in 1973; see Pal, *Islamic Art*. His ancient Near Eastern collection came to LACMA in 1976; see Moorey et al., *Ancient Bronzes*. LACMA also purchased an Indian collection from Heeramaneck in 1969.

44. During his time in New York, Ettinghausen also contributed to the *Survey of Persian Art* then in progress; see Soucek, "Richard Ettinghausen." On his early career before his immigration first briefly to England and then the United States, and for an important assessment of his scholarship and contributions to the field, see Hillenbrand, "Richard Ettinghausen."

45. Among the Iranian works acquired during Ettinghausen's tenure, one of the most notable is the sixteenth-century illustrated manuscript of the *Haft Awrang* of Jami' made for the Safavid prince Ibrahim Mirza. On Ettinghausen's relationship to the acquisition and early study of this manuscript, see Simpson, *Sultan Ibrahim Mirza's Haft Awrang*, 365.

46. See Porada and Ettinghausen, *7000 Years*. The exhibition traveled to the Denver Art Museum; Nelson-Atkins Gallery, Kansas City; the Museum of Fine Arts, Houston; the Cleveland Museum of Art; the Boston Museum of Fine Arts; the California Palace of the Legion of Honor, San Francisco; and the Los Angeles County Museum of Art. With some five hundred objects from the collection of Mohsen Foroughi, brother of the Iranian ambassador to the United States, and another two hundred works from the Iran Bastan Museum, Tehran, the exhibition had its own political dimension both from the perspective of the Pahlavi regime and the Johnson administration.

47. For an interesting but also somewhat self-serving review of the galleries, see Oleg Grabar, "Art of the Object."

48. See the Metropolitan Museum of Art, *Notes on Islamic Art*, a 1975 companion booklet for the Metropolitan Museum's then newly opened galleries for a floor plan and list of the Iranian galleries (cat. nos. 4a–c, 5, 6, and 7).

49. For the most recent discussion of this manuscript and its unfortunate dismemberment in 1970, see Gross, *Rogues Gallery*, 362–264.

50. See Welch, *Wonders of the Age*.
51. See Lentz and Lowry, *Timur and the Princely Vision*.
52. See Diba and Ekhtiar, *Royal Persian Painting*.
53. See Komaroff and Carboni, *Legacy of Genghis Khan*.
54. See Thompson and Canby, *Hunt for Paradise*.
55. See Farhad and Bağci, *Falnama*.
56. Canby et al., *Court and Cosmos*.
57. See Ettinghausen, "Flowering of Seljuk Art," for the period 1050–1225; see also Grabar, "Visual Arts," 626.
58. Omitted from this list are the Dallas Museum of Art and the Museum of Fine Arts, Houston, both of which exhibit Iranian art from collections on long-term loan: the Keir Collection in Dallas, and rotating works from the al-Sabah Collection, Dar al-Athar al-Islamiyyah, Kuwait, and the Hossein Afshar Collection of Persian Art in Houston. For the last of these, see Froom, *Bestowing Beauty*.
59. For more a complete account of the Department of Islamic art and its collections, see Ekhtiar et al., *Masterpieces*, 2–19.
60. These account for about 60 percent of the Islamic collection. With a little over twelve thousand objects in the collection, the size of the Iranian holdings would hover above the seven thousand mark. See Ekhtiar et al., *Masterpieces*, fig. 27, for a plan of the galleries, which are organized by dynasty and region, and 16–17, for a brief discussion of the Iranian material and its display.
61. While there have been a number of publications over the years highlighting the Islamic collection or focusing on specific media, the reader is here referred to Ekhtiar et al., *Masterpieces*, where additional references may be found.
62. Ekhtiar et al., *Masterpieces*, e.g., cat. nos. 4–5, 62–63, 85.
63. Ekhtiar et al., *Masterpieces*, cat. nos. 138 A–G, 145–48, 152–53.
64. Ekhtiar et al., *Masterpieces*, cat. nos. 180–83.
65. The Islamic collection of the Freer and Sackler Galleries numbers over twenty-two hundred works of art.
66. On the Freer and Sackler, see, for example, Lawton and Lentz, *Beyond the Legacy*, especially 19–115. The Freer's collection of Islamic art is generally well known, but for the lesser known Sackler see Farhad, "Arts of the Islamic World at the Sackler."
67. For this particular key acquisition, see Lowry and Nemazee, *Jeweler's Eye*.
68. For these works of art see, respectively Atil, *Ceramics*, cat. no. 44; Atil, Chase, and Jett, *Islamic Metalwork*, cat. no. 14; Simpson, *Sultan Ibrahim Mirza's Haft Awrang*; Gray, *Persian Painting*, 54–55; and Lowry and Nemazee, *Jeweler's Eye*, cat. nos. 7–14.
69. Given in 1953 and 1949, respectively.
70. Largely comprised of works of art from the Iranian world, see Pal, *Islamic Art*.
71. See Komaroff, *Beauty and Identity*, cat. nos. 16, 18, 21, 42, 74, 76, 79, 81, 84, 85, 86, 94, and 128.
72. The total number of works is approximately two thousand.
73. Most notably, the large upper section of a luster mihrab of the fourteenth century and a seventeenth-century spandrel from the Hasht Behesht palace in Isfahan; see Komaroff, *Islamic Art*, frontispiece and fig. 50.
74. For example, the Ardabil Carpet was purchased by the American collector Charles Tyson Yerkes in the late 1890s; the Coronation Carpet was used at the 1902 coronation of Britain's Edward VII, through the arrangement of Joseph Duveen; two important *mina'i* vessels, a large jug and a dish dated from 1187, along with a *lajvardina*

bottle were among the objects included in the volume pertaining to pottery in volume 5 of Pope and Ackerman, *Survey of Persian Art*, pls. 676, 684, 687, where they are listed, respectively, as belonging to the dealers Rabenou, and Parish-Watson and the collector Allan Balch. Two large Timurid jars bear exhibition labels for the 1910 Munich exhibition of Islamic art; the jars were then the property of the dealer Kirkor Minassian; see Dercon, Krempel, and Shalem, *Future of Tradition*, cat. no. 16.

75. From a press release dated February 24, 1931, the full text of which is available at http://www.brooklynmuseum.org/opencollection/exhibitions/702/Exhibition _of_Persian_Art. This interest in ethnology today is still reflected in the museum's extensive though not comprehensive collection of Islamic art of about 1,450 objects. Also see Brooklyn Museum, *Exhibition of Persian Art*.

76. For example, see Diba and Ekhtiar, *Royal Persian Painting*, cat. nos. 29 A–G, 47, 71, and 83.

77. A number of these works are reproduced in Weinstein, *Ink, Silk, and Gold*.

78. See Schroeder, *Persian Miniatures*; more significantly see Simpson, *Arab and Persian Painting*. For the Calderwood gift, see, for example, Simpson, "Illustrated Shahnama."

79. For example, see Simpson, "Gallant Era."

80. See Simavi "Mehmet Ağa-Oğlu."

81. Simavi "Mehmet Ağa-Oğlu."

82. These initially may have been acquired through the 1893 Columbian Exposition; see Kadoi, "Pope and Chicago," for a brief history of the collection. Among the earliest such gifts is an interesting luster tile with double arched niches (1917.221).

83. Kadoi, "Pope and Chicago."

84. Kadoi, "Pope and Chicago," 66. Pope's legacy in Chicago, as elsewhere, is perhaps somewhat mixed. A so-called fifteenth-century tile mosaic window grill, visible in a 1934 photograph of the Islamic galleries at the Art Institute (see Kadoi, "Pope and Chicago," fig. 6), which Pope gave to the museum in 1931, seems to belong to the twentieth-century group of tiles discussed in Overton, "From Pahlavi Isfahan," especially 64, where it is clear that Pope was already familiar with the skilled workmanship of tile restorers by 1931.

85. Both are very fine examples (1915.589; 1915.591). Several other examples of Iranian pottery were accessioned in 1915 and in the years immediately following.

86. There is no single publication on the Islamic collection, which is at present most accessible through the museum's collections online at https://www.clevelandart .org/art/collection/search.

87. See Overton, "From Pahlavi Isfahan," especially 75. Also see Mellins and Albrecht, *Doris Duke's Shangri La*.

88. See Littlefield, *Doris Duke's Shangri La*, especially 19.

89. One possibility is to use digital images and records to reconstruct some of the manuscripts and architectural facades literally torn apart for the sake of collecting Iranian art.

Bibliography

Ackerman, Phyllis. *Guide to the Exhibition of Persian Art*. New York: The Iranian Institute, 1940.

Alexander, Edward Porter, and Mary Alexander. *Museums in Motion: An Introduction to the History and Functions of Museums*. Lanham, MD: AltaMira, 2008.

Allan, James W. *Nishapur: Metalwork of the Early Islamic Period*. New York: Metropolitan Museum of Art, 1982.
Atıl, Esin. *Ceramics from the World of Islam*. Washington, DC: Freer Gallery of Art and the Smithsonian Institution, 1973.
Atıl, Esin, W. T. Chase, and Paul Jett. *Islamic Metalwork in the Freer Gallery of Art*. Washington, DC: Freer Gallery of Art and the Smithsonian Institution, 1985.
Bacharach, Jere L., and Irene Bierman, eds. *The Warp and Weft of Islam: Oriental Carpets and Weavings from Pacific Northwest Collections*. Seattle: University of Washington Press, 1978.
Brooklyn Museum. *Exhibition of Persian Art and its Reaction on the Modern World: Museum and Loan Collections and Special Exhibits of Schools and Manufacturers Illustrating Persian Inspiration, March 16 to May 24, 1931*. New York: The Brooklyn Museum of Art, 1931.
Canby, Sheila R., Deniz Beyazit, Martina Rugiadi, and A. C. S. Peacock. *Court and Cosmos: The Great Age of the Seljuqs*. New York: Metropolitan Museum of Art, 2016.
Carboni, Stefano, and Tomoko Masuya. *Persian Tiles*. New York: Metropolitan Museum of Art, 1993.
Carey, Moya, and Margaret S. Graves, eds. *Journal of Art Historiography 6* (2012). https://arthistoriography.wordpress.com/number-6-june-2012-2/.
Coomaraswamy, Ananda. "Early Arabic and Persian Paintings: Mainly Recent Acquisitions." *Museum of Fine Arts Bulletin* 21.126 (1923): 49–53.
Dercon, Chris, León Krempel, and Avinoam Shalem, eds. *The Future of Tradition, the Tradition of Future: 100 Years After the Exhibition Masterpieces of Muhammadan Art*. Munich: Prestel, 2010.
Diba, Layla S., and Maryam Ekhtiar, eds. *Royal Persian Painting: The Qajar Epoch, 1785–1925*. New York: Brooklyn Museum of Art; London: I. B. Tauris, 1998.
"The Edward C. Moore Collection." *Collector* 3.13 (May 1, 1892): 199–201.
Einreinhofer, Nancy. *The American Art Museum: Elitism and Democracy*. Leicester: Leicester University Press, 1997.
Ekhtiar, Maryam, Priscilla P. Soucek, Sheila R. Canby, and Navina Najat Haidar, eds. *Masterpieces from the Department of Islamic Art in The Metropolitan Museum of Art*. New York: Metropolitan Museum of Art, 2011.
Erdmann, Kurt. *Seven Hundred Years of Oriental Carpets*. Berkeley: University of California Press, 1970.
Ettinghausen, Richard. "The Flowering of Seljuk Art." *Metropolitan Museum Journal* 3 (1970): 113–31.
———. "'Six Thousand Years of Persian Art': The Exhibition of Iranian Art, New York 1940." *Ars Islamica* 7 (1940): 106–17.
Farhad, Massumeh. "Arts of the Islamic World at the Sackler." *Oriental Art* 43.3 (1997): 42–47.
Farhad, Massumeh, and Serpil Bağci. *Falnama: The Book of Omens*. Washington, DC: Arthur M. Sackler Gallery and the Smithsonian Institution, 2009.
Frank, Marie. *Denman Ross and American Design Theory*. Lebanon, NH: University Press of New England, 2011.
Frelinghuysen, Alice Cooney, Gary Tinterow, Susan Alyson Stein, Gretchen Wold, and Julia Meech. *Splendid Legacy: The Havemeyer Collection*. New York: Metropolitan Museum of Art, 1993.

Froom, Aimée, ed. *Bestowing Beauty: Masterpieces from Persian Lands—Selections from the Hossein Afshar Collection*. Houston: Museum of Fine Arts, 2019.
Gluck, Jay, and Noël Siver. *Surveyors of Persian Art: A Documentary Biography of Arthur Upham Pope and Phyllis Ackerman*. Costa Mesa, CA: Mazda, 1996.
Grabar, Oleg. "An Art of the Object." *Artforum* 14 (1976): 36–43.
———. "The Visual Arts, 1050–1350." Pages 626–58 in *The Saljuq and Mongol Periods*. Vol. 5 of *The Cambridge History of Iran*. Edited by J. A. Boyle. Cambridge: Cambridge University Press, 1986.
Gray, Basil. *Persian Painting*. Lausanne: Skira, 1961.
Gross, Linda P., and Theresa R. Snyder. *Philadelphia's 1876 Centennial Exhibition*. Charleston, SC: Arcadia, 2005.
Gross, Michael. *Rogues Gallery: The Secret Story of the Lust, Lies, Greed, and Betrayals That Made the Metropolitan Museum of Art*. New York: Broadway, 2010.
Hillenbrand, Robert. "Richard Ettinghausen and the Iconography of Islamic Art." Pages 171–81 in *Discovering Islamic Art: Scholars, Collectors and Collections, 1850–1950*. Edited by Stephen Vernoit. London: I. B. Tauris, 2000.
Jenkins-Madina, Marilyn. "Collecting the 'Orient' at the Met: Early Tastemakers in America." *Ars Orientalis* 30 (2000): 69–90.
Johnston, William R. *William and Henry Walters: The Reticent Collectors*. Baltimore: Johns Hopkins University Press, 1999.
Kadoi, Yuka, ed. *Arthur Upham Pope and a New Survey of Persian Art*. Leiden: Brill, forthcoming.
———. "Arthur Upham Pope and His 'Research Methods in Muhammadan Art': Persian Carpets." *Journal of Art Historiography* 6 (2012). https://arthistoriography.files.wordpress.com/2012/05/kadoi.pdf.
———. "Pope and Chicago: The Emergence of a Persian Art Collection." *Hali* 165 (2010): 64–67.
Kelekian, Dikran Khan. *The Kelekian Collection of Persian and Analogous Potteries*. Paris: Clarke, 1910.
———. *The Potteries of Persia*. Paris: Clarke, 1909.
Komaroff, Linda. *Beauty and Identity: Islamic Art from the Los Angeles County Museum of Art*. Los Angeles: Los Angeles County Museum of Art; New Haven: Yale University Press, 2016.
———. *Islamic Art at the Los Angeles County Museum of Art*. Los Angeles: Los Angeles County Museum of Art, 2005.
Komaroff, Linda, and Stefano Carboni, eds. *The Legacy of Genghis Khan: Courtly Art and Culture in Western Asia, 1256–1353*. New York: The Metropolitan Museum of Art; New Haven: Yale University Press, 2002.
Lawton, Thomas, and Thomas W. Lentz. *Beyond the Legacy: Anniversary Acquisitions for the Freer Gallery of Art and the Arthur M. Sackler Gallery*. Washington, DC: Smithsonian Institution, 1998.
Lawton, Thomas, and Linda Merrill. *Freer: A Legacy of Art*. Washington, DC: Freer Gallery of Art and the Smithsonian Institution, 1993.
Lentz, Thomas W., and Glenn D. Lowry. *Timur and the Princely Vision, Persian Art and Culture in the Fifteenth Century*. Los Angeles: Los Angeles County Museum of Art, 1989.
Lewis, Arnold, James Turner, and Steven McQuillon. *The Opulent Interiors of the Gilded Age*. New York: Dover, 1987.

Littlefield, Sharon. *Doris Duke's Shangri La*. Honolulu, HI: Honolulu Academy of Arts, 2002.
Lowry, Glenn D., and Susan Nemazee. *A Jeweler's Eye, Islamic Arts of the Book from the Vever Collection*. Washington, DC: Arthur M. Sackler Gallery and the Smithsonian Institution, 1988.
Majd, Mohammad Gholi. *The Great American Plunder of Persia's Antiquities: 1925–1941*. Lanham, MD: University Press of America, 2003.
Masuya, Tomoko. "Persian Tiles on European Walls: Collecting Ilkhanid Tiles in Nineteenth-Century Europe." *Ars Orientalis* 30 (2000): 39–54.
McWilliams, Mary, ed. "Collecting by the Book: The Shaping of Private and Public Collections." *Muqarnas* 20 (2003): 235–52.
———. *In Harmony: The Norma Jean Calderwood Collection of Islamic Art*. Cambridge: Harvard Art Museums, 2013.
Mellins, Thomas and Donald Albrecht, eds. *Doris Duke's Shangri La: A House in Paradise*. New York: Skira Rizzoli, 2012.
The Metropolitan Museum of Art. *Notes on Islamic Art in its Historical Setting*. New York: Metropolitan Museum of Art, 1975.
Moorey, P. R. S., Emma C. Bunker, Edith Porada, and Glenn Markoe. *Ancient Bronzes, Ceramics and Seals: The Nasli M. Heermaneck Collection of Ancient Near Eastern, Central Asiatic, and European Art*. Los Angeles: Los Angeles County Museum of Art, 1981.
Muscarella, Oscar White. "The Pope and the Bitter Fanatic." Pages 5–12 in *The Iranian World: Essays on Iranian Art and Archaeology Presented to Ezat O. Negahban*. Edited by Abbas Alizadeh, Yousef Majidzadeh, and Sadegh Malek Shahmirzadi. Tehran: Iran University Press, 1999.
Overton, Keelan. "From Pahlavi Isfahan to Pacific Shangri La: Reviving, Restoring, and Reinventing Safavid Aesthetics, c. 1920–40." *West 86th: A Journal of Decorative Arts, Design History, and Material Culture* 19.1 (2012): 61–87.
Pal, Patrapaditya. *Islamic Art: The Nasli M. Heeramaneck Collection*. Los Angeles: Los Angeles County Museum of Art, 1973.
Pope, Arthur Upham. "Special Persian Exhibition." *Pennsylvania Museum Bulletin* 22.107 (1926): 245–51.
Pope, Arthur Upham, and Phyllis Ackerman, eds. *A Survey of Persian Art from Prehistoric Times to the Present*. 6 vols. London: Oxford University Press, 1938–39.
Porada, Edith, and Richard Ettinghausen, eds. *7000 Years of Iranian Art*. Washington, DC: Smithsonian Institution, 1964.
Rizvi, Kishwar. "Art History and the Nation: Arthur Upham Pope and the Discourse on 'Persian Art' in the Early Twentieth Century." *Muqarnas* 24 (2007): 45–65.
Robinson, B. W. "The Burlington House Exhibition of 1931: A Milestone in Islamic Art History." Pages 147–55 in *Discovering Islamic Art: Scholars, Collectors, and Collections, 1850–1950*. Edited by Stephen Vernoit. London: I. B. Tauris, 2000.
Schroeder, Eric. *Persian Miniatures in the Fogg Museum of Art*. Cambridge: Harvard University Press, 1942.
Shapiro, Meyer. Review of *A Survey of Persian Art: From Prehistoric Times to the Present*, by Arthur Upham Pope and Phyllis Ackerman. *The Art Bulletin* 23.1 (1941): 82–86.
Simavi, Zeynep. "Mehmet Ağa-Oğlu and the Formation of the Field of Islamic Art in the United States." *Journal of Art Historiography* 6 (2012). https://arthistoriography.files.wordpress.com/2012/06/simavi.pdf.

Simpson, Marianna Shreve. *Arab and Persian Painting in the Fogg Museum*. Cambridge: Fogg Art Museum, 1980.

———. "'A Gallant Era': Henry Walters, Islamic Art, and the Kelekian Connection." *Ars Orientalis* 30 (2000): 91–112.

———. "The Illustrated *Shahnama* in Sixteenth-Century Shiraz." Pages 77–113 in *In Harmony: The Calderwood Collection of Islamic Art at the Harvard University Art Museums*. Edited by Mary McWilliams. Cambridge: Harvard Art Museums, 2013.

———. *Sultan Ibrahim Mirza's Haft Awrang: A Princely Manuscript from Sixteenth-Century Iran*. Washington, DC: Freer Gallery of Art and the Smithsonian Institution; New Haven: Yale University Press, 1997.

Smithsonian Institution. *Material Papers Relating to the Freer Gift and Bequest*. Publication 2958. Washington, DC: Smithsonian Institution, 1928.

Soucek, Priscilla P. "Richard Ettinghausen." *Encyclopaedia Iranica*. Last updated January 20, 2012. http://www.iranicaonline.org/articles/ettinghausen.

Thompson, Jon and Sheila Canby, eds. *Hunt for Paradise: Court Arts of Safavid Iran, 1501–1576*. Milan: Skira, 2003.

Treptow, Tanya, and Donald Whitcomb. *Daily Life Ornamented: The Medieval Persian City of Rayy*. Chicago: Oriental Institute of the University of Chicago, 2007.

Vernoit, Stephen, ed. *Discovering Islamic Art: Scholars, Collectors and Collections, 1850–1950*. London: I. B. Tauris, 2000.

Weinstein, Laura. *Ink, Silk, and Gold: Islamic Art from the Museum of Fine Arts, Boston*. Boston: Museum of Fine Arts, 2015.

Welch, Stuart Cary. *Wonders of the Age: Masterpieces of Early Safavid Painting, 1501–1576*. Cambridge: Fogg Art Museum, 1979.

Wilkinson, Charles K. *Nishapur: Pottery of the Early Islamic Period*. New York: Metropolitan Museum of Art, 1973.

———. *Nishapur: Some Early Islamic Buildings and Their Decoration*. New York: Metropolitan Museum of Art, 1986.

Wood, Barry. "'A Great Symphony of Pure Form': The 1931 International Exhibition of Persian Art and its Influence." *Ars Orientalis* 30 (2000): 113–30.

CHAPTER 11

Exhibiting Iran in the United States: Iranian Studies and Museum Exhibitions

Shiva Balaghi

ELEANOR ROOSEVELT WROTE THE FOLLOWING in her regular, nationally syndicated newspaper column on June 3, 1940 after visiting the exhibition "Six Thousand Years of Persian Art."[1]

> I went to the Persian Art Exhibit at 51st Street and Fifth Ave. It is impossible to describe to you what it is like. If you have not seen it, I can only urge you to go at once. Everything is so beautiful that you can spend hours in any one of the rooms. The important thing is the realization that here is an art which has survived through 6,000 years of invasion, war, tyranny, prosperity and power. Here is the real proof that the spirit as expressed through the arts transcends all material things. These priceless treasures from the Iranian civilization are gathered from collections all over this country and may never again be seen by the public, so do not miss this opportunity.

At that time, Manhattan's Union Club Building was filled with some 2,800 paintings, statues, carpets, manuscripts, pottery, and other Iranian objects then valued at over ten million dollars. *Time* magazine reported, "The ringmaster of this gigantic art circus was a talkative, six-foot, grey-thatched former philosophy professor named Arthur Upham Pope."[2]

A foundational figure in the field of Iranian art history, Pope was born in a small Rhode Island town called Phenix. His interest in Iranian art was stimulated by childhood visits to Boston to his favorite aunts' home, whose floors were covered with Persian rugs. "I looked at those rugs and it was like a call to the pulpit," he recalled.[3] After studying philosophy at Brown University, Pope went on to teach at the University of California, Berkeley where he scandalously married a student named Phyllis Ackerman. Together, they edited and wrote much of *A Survey of Persian Art*, which appeared in six volumes consisting of 2,817 pages with 1,482 plates and weighing some fifty-five pounds.[4] In the early years of his career, Richard Ettinghausen worked with Pope on this

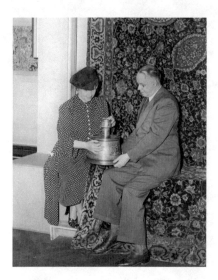

FIGURE 11.1. Helen Keller and Arthur Upham Pope at the Exhibition of Persian Art, New York, 1940. Courtesy of the Penn Museum, image #21954.

massive undertaking.[5] Published by the University of Oxford Press, the survey featured the work of seventy-two scholars from sixteen nations and took over twelve years to complete.[6]

"In the history of Near Eastern studies the decade of 1930–40 will probably live as the period of exhibitions, especially of those of Iranian art, in nearly all parts of the world," wrote Ettinghausen in his review of Pope's 1940 exhibition in New York. "There were the large Persian exhibitions in London (1931), Cairo (1934), Leningrad (1935), Paris (1938), and the smaller ones in Detroit (1930), Toledo, O., Brooklyn, N.Y., Warsaw (1935), Zurich (1936), San Francisco (1937), and Baltimore (1940)." The exhibit "Six Thousand Years of Persian Art," Ettinghausen conjectured, may be the last one for a long time and "deserves special consideration as one more great effort to display the artistic treasures that a pivotal country in the East produced during its long and eventful history."[7]

The 1930s, observed the art historian Robert Hillenbrand, were "a magical decade in the art history of Iran.... In a scant ten years, or so it seemed to an astonished world, an entire art historical industry had sprung up out of the blue—all focused on a subject largely neglected by earlier scholarship—namely Islamic Iran."[8] And Arthur Pope, an entrepreneurial scholar whose interest in Iranian art "just missed being an obsession,"[9] was the central figure in this magical decade of exhibitions. The 1940 exhibition was not just a record of Iranian art but also of the formative years of American interest in Iranian art. Everything in the show, noted the New York Times, was owned in the United States and Canada; all 2,800 objects had been borrowed from

thirty-six museums and sixty private collections.[10] Among the finer objects on display, Ettinghausen observed, were pages from an early Qu'ran "belonging to Mr. Minassian, [which] were remarkable for a special, perhaps East Persian, variation of tenth-century Kufic."[11] In addition to selections from the important collection of Kirkor Minassian, Pope's exhibit featured works borrowed from Hagop Kevorkian, Mrs. John D. Rockefeller, the Demotte Gallery, the Textile Museum in Washington, DC, Dumbarton Oaks, and the Boston Museum of Fine Arts. The exhibit, in effect, mapped some of the most important collections of Iranian art extant in America at the time. Together with Pope's *Survey*, it laid the foundations for the study of Iranian art in the United States for several decades. Pope had essentially helped create the field of Iranian art history. As scholar John Shapley observed in his review of the *Survey*, "Here is a vast body of entirely new material, another esthetic world, an uncharted sea. Here is a fresh diet for esthetic contemplation, an undulled stimulus to collecting and a virgin field of study." The objects Pope exhibited and wrote about, the discursive paradigms he helped formulate for discussing Iranian art, the temporal scope within which he framed his studies, and the scholars whose work he enabled and featured all helped define the field of Iranian art history. As Shapely wrote, "The primary goal of the 'survey' was to summarize what was known about Persian art. But it has gone far beyond a summary of achieved knowledge. In chapter after chapter it represents not merely an addition to knowledge but *the creation of knowledge* where little or none had hitherto existed."[12] Art historian Sheila Blair observed that "the monumental *Survey of Persian Art*, published in six volumes in 1938–39, basically stopped with the 17th century. Of its 2,817 pages, a mere six were devoted to the subject of Iranian painting after the Safavids."[13] Among the legacies of the magical decade of Iranian art, whose apex were Pope's 1940 exhibit and his "monumental survey," was the neglect of the history of contemporary and modern Iranian art. It would take another six decades before scholars of Iranian studies in the United States focused serious attention on the arts produced in the eighteenth century onward.

In this article, I frame the history of American museum exhibitions featuring Iranian art from the Qajar era to the present as generative moments. Museum exhibitions both reflect and stimulate a level of popular interest; they can help develop and support certain areas of academic study. As Arjun Appardurai and Carol A. Breckenridge argued, "Museums are deeply located in cultural history, on the one hand, and are therefore also critical places for the politics *of* history, on the other."[14] The Iranian art objects that Western museumgoers were able to see and scholars were able to study increased in the 1930s because of political changes within Iran by Reza Shah that linked a certain narrative of modern nationalism with ancient heritage.[15]

The exhibition of Iranian art in American museums in the past decades is embedded in broader scholarly and political contexts. Scholar Melani McAlister has characterized "cultural exchange as an instrument of international relations."[16] The magical decade of the 1930s was enabled, in large part, by close relations between the Iranian government and key figures in the exhibition and study of Iranian art. In contrast, more recent Iranian art exhibitions mounted in American museums have taken shape at a time when the United States and Iran severed official diplomatic relations. The American public's encounter with Iranian art, then, is mediated in part by political affairs of state. Given that so few Americans have visited Iran itself since 1979, museums exhibitions as a form of visual representation can help shape broader perspectives on Iranian culture. The status of Iranian objects as art per se was underlined by the very fact that they were collected, ordered, studied, categorized, and exhibited in museums.[17] In the 1930s, carpets, textiles, ancient silver objects, pottery, and illuminated manuscripts came to acquire the status of art, art that could be exhibited in museums, written about in scholarly books, and taught at leading universities. Only relatively later did objects from the Qajar era to the present receive similar attention as subjects of museum exhibitions and scholarship.

Tracing Modernity: Iranian Art Exhibitions in New York Museums

In the fall of 1998, Holland Cotter, the Pulitzer Prize–winning art critic for the *New York Times*, highlighted a Zand era painting hung in what he dubbed "a dazzling" exhibit at the Brooklyn Museum of Art. "The standout," he wrote, "is a large picture, once owned by Andy Warhol, of a couple locked in a steamy (for Persian art at least) embrace. Their clothing has been loosened, their limbs are intertwined. The woman salutes her importunate lover with a wine glass as he fondles her breast. But her attention is elsewhere. She stares confidingly out at the viewer as if extending an invitation to join the fun." In the exhibition catalog, art historian and curator Dr. Layla Diba explained, "The directness of the woman's gaze, the informality of the lovers' pose, and the warm palette all contribute to the sense of intimacy created between the viewer and the painting."[18] The notations on this single painting attributed to Muhammad Sadiq (ca. 1770–80) are revealing.

From the time Diba joined the Brooklyn Museum of Art as the Hagop Kevorkian Curator of Islamic Art in 1990, she began to lay the groundwork for this exhibition. In 1987, Dr. Sheila Canby, then a curator at the museum, had organized a symposium on "Art and Culture of Nineteenth-Century Iran."

On that occasion, a checklist of the museum's Qajar holdings was produced by Maryam Ekhtiar. Through the early 1990s, Diba undertook a major project of gathering information on Qajar works of art held in hundreds of institutions and private collections across the world. The quest confirmed the feasibility of a major exhibition but also provided a stunning record of the provenance of these art works, most of which had not received serious consideration by art historians at that time. In 1995, with support from the National Endowment for the Humanities, Diba convened an interdisciplinary symposium on "Historical and Cultural Issues of the Post-Safavid and Qajar Periods." From its very inception, then, the exhibition was organized as a scholarly investigation, an interdisciplinary dialogue centered on a visual archive that was painstakingly gathered and meticulously researched.

By the 1990s, Diba had acquired a singular knowledge of Qajar art through her work as the founding curator of the Negarestan Museum in Tehran (1975–78) and in the course of writing her dissertation at New York University's Institute of Fine Arts on the relationship between lacquer work and painting. The years of preparation unveiled interesting bits of information. Surely Cotter's infatuation with the flirtatious Zand painting was heightened by the knowledge that the picture had once belonged to Warhol. Diba's own attentiveness to the female gaze in the Zand picture may have been enhanced by her discussions with Afsaneh Najmabadi, an influential scholar of gender studies in Iran who participated in the symposia associated with the exhibition and contributed an essay to its catalog.

At their best, art exhibitions excite, inspire, and inform those who stroll through a museum's galleries. "Royal Persian Paintings: The Qajar Epoch, 1785–1925" was, as Cotter so aptly perceived, a "once in a lifetime show" (fig. 11.2). He wrote, "Many shows flatter audiences by telling them what they already know; this one does the opposite."[19] And if it upset conventional notions of Iranian art, "The Qajar Epoch" also offered new "ways of seeing."[20] Its interpretive approach to Iran's "long nineteenth century" stimulated new approaches in scholarship. In her groundbreaking book, *Women with Mustaches and Men Without Beards: Gender and Sexual Anxieties of Iranian Modernity*, Najmabadi wrote, "The exhibition and the many symposia organized around it did more than give me an appreciation of Qajar art. I came to realize what a critical and powerfully rich source art historical resources provide for understanding a society's history and culture."[21]

As the Qajar exhibition traveled to the Armand Hammer Museum in Los Angeles, an academic symposium was organized at UCLA as well. Nikki Keddie, an eminent scholar of Iranian history, wrote studies on Qajar history illuminating the significance of the Tobacco Rebellion and of Jamal al-Din Al-Afghani. Invited to participate in the conference marking the Los Angeles

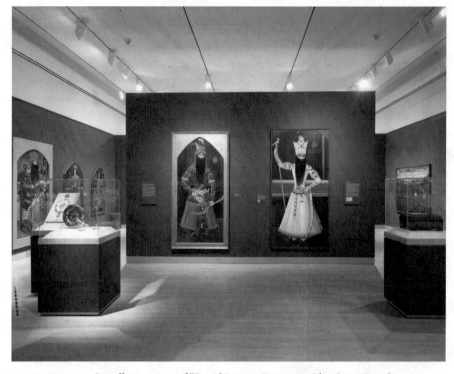

FIGURE 11.2. Installation view of "Royal Persian Paintings: The Qajar Epoch, 1785–1925." Brooklyn Museum Libraries and Archives. Records of the Department of Asian Art. "Royal Persian Paintings: The Qajar Epoch, 1785–1925," October 13, 1998–January 14, 1999. Installation view.

show, Keddie decided to prepare a compact history of the period. The resulting book, *Qajar Iran and the Rise of Reza Khan*, provides a historical overview of a critical era of Iranian history.[22]

In July 1999, the exhibition "Royal Persian Paintings" opened at the Brunei Gallery of the School of Oriental and African Studies at the University of London. A series of academic programs were organized around the London venue, the highlight of which was a four day conference in September on "The Qajar Epoch: Culture, Art and Architecture." That gathering brought together two generations of scholars of Qajar Iran from Iran, Europe, and the United States, facilitating critically important scholarly networks across time and space.

In 2001, the journal *Iranian Studies* published a special issue dedicated to scholarship that had been enhanced or generated by the exhibition. Invited by Diba to reflect on the significance of Qajar art, the late great Islamic art historian Oleg Grabar wrote, "The search for ... modernity in Iran seems to be

the most fascinating aspect of Qajar art. In this sense, it can be seen in parallel with many other traditions as illustrating a major nineteenth century feature, the need to be modern, the impossibility of returning to the past, without having necessarily found one's full authenticity. This quest is universal and never ends."[23]

Beyond the scholastic occasions it provided, "The Qajar Epoch" exhibition, particularly as hung in the Brooklyn Museum of Art, was quite simply a beautiful display. Seeing art in a museum is experiential, and the curatorial staff who hung the show seemed particularly mindful of the viewer's experience of seeing the art. As art historian Sheila Blair observed when she visited the exhibition, "It was the art that carried the day: viewers at the Qajar show were smiling and happy. The exhibition showed that Qajar art is fun."[24] Layla Diba credits part of the success of the show with the decision by the Brooklyn Museum of Art to devote its greatest galleries for the exhibition. "The scale of the show made an impact," she explains. "The space allotted for the exhibition, the large size of many of the works these made an impact. This affected the show's visual impact and made it memorable."[25]

From the informative timeline of Iranian history to the richly detailed wall text, the show used art to convey a sense of history. For American audiences, who at the time had had little interaction with Iran for two decades, the exhibit filled an important gap in the visual narrative of Iran. Red walls served as a rich background for paintings of 'Abbas Mirza battling the Russians, providing a much more hospitable setting than the fairly tired galleries in which they are normally exhibited at the State Hermitage Museum in Saint Petersburg. And to see Abu Turab Ghaffari's precise watercolors in person was to appreciate the detail of his superb hand at work. Even someone familiar with *taziyeh* would have been struck by the rich pictorial narrative of the Battle of Karbala *pardeh* by 'Abdallah Musavvar (d. 1931).[26]

It was Peter Chelkowski, known for his groundbreaking scholarship on *taziyeh*, who wrote about piety and popular art for the exhibition's catalog.[27] Chelkowski elaborated on this theme in *Staging a Revolution: The Art of Persuasion in the Islamic Republic of Iran*, a 1999 book he coauthored with Hamid Dabashi of Columbia University.[28] The highly original book argued that "a reading of the constellation of revolutionary images is indispensable in comprehending the more compelling question of how public sentiments and collectively held symbolics are used to mobilize a people for radical and revolutionary purposes."[29] The authors showed how posters, graffiti, banknotes and stamps could serve as an archive for studying the mobilization of visual culture during the 1979 Revolution, the establishment of the subsequent Islamic regime, and the Iran-Iraq War (1980–88). In the wake of the publication of the book in fall 2000, Chelkowski met with me, then working as the

Associate Director of the Kevorkian Center at New York University; Timothy Mitchell, the Center's Director; and Lynn Gumpert, the Director of the Grey Gallery at NYU. He proposed an exhibition of Iranian photographs at the Grey, reminding us of the great interest Abby Weed Grey had in contemporary Iranian art.

Abby Weed Grey first visited Iran in 1960 on a trip she took to Asia and the Middle East; she intended to seek out artists and add to her art collection.[30] Her time in Tehran "coincided with the second national biennial of modern art, which was on view at the Golestan Palace in Tehran, and which she described as an 'eye-opener.'"[31] Grey would return to Iran in June 1961 for an exhibition of Minnesotan artists she had organized at the Iran-America Society. Her host in Tehran insisted that she visit an exhibition of contemporary art mounted in the foyer of the Bank Saderat building. The exhibition had been organized by an artists' group known as Contemporary Artists—Marcos Grigorian, Sirak Melkanin, Bijan Saffari, Sohrab Sepehri, Manuchehr Shaybani, and Parviz Tanavoli.[32] Grey and Tanavoli struck up a conversation that day that would lead to a decades' long friendship. Tanavoli introduced Grey to some of the leading artists working in Iran in the 1960s and '70s. Over the course of subsequent visits to Iran, Grey visited the young artists' studios, observing shifts in their work, seeing Iran through their eyes, and building her collection. Back in Minnesota, she began to collect works by Siah Armajani, then a student at Macalester College, where his uncle Yahya taught history.

In 1962, Grey helped arrange for Tanavoli to be invited for a residency at the Minneapolis School of Art. "To alleviate my loneliness and ease my transition during a severe, snowy winter," Tanavoli explained, "Mrs. Grey had arranged for a room for me in [Siah] Armajani's house." A close friendship developed between the two artists, and Tanavoli helped Armajani keep apace of artistic developments in Iran. The artist Marcos Grigorian, who had been living in New York, also moved to Minneapolis around this time. He opened the Universal Galleries. Grey's home and Grigorian's gallery became centers for Iranian art in Minneapolis. In 1963, the Universal Galleries mounted an exhibition that included works by Grigorian, Zenderoudi, Armajani, and Tanavoli.[33]

When he returned to Tehran in 1964, Tanavoli convened a seminar on contemporary Iranian art in the new headquarters of the Iran-America Society. The seminar focused on two topics—the artistic treasures of the past and the links between contemporary Iranian art and global art on the one hand and historic Iranian art forms on the other. In the seminar, he introduced the work of Siah Armajani to participants in the Iranian art scene. The Grey collection, then, serves as an important window into cultural ties between the United States and Iran. Through Grey's diaries and collection, we learn that Iranian diasporic artists and those living and working in Iran were in intimate contact.

Their work was featured together in exhibitions in both Iran and the United States.

Over the course of two decades, Grey went on to collect over two hundred works of contemporary and modern art by some of Iran's leading artists—Sohrab Sepehri, Behjat Sadr, Monir Farmanfarmaian, Mansour Ghandriz, Marcos Grigorian, and Faramarz Pilaram. Her collection of Armajani's work represents the early stages of his work, revealing his deeply philosophical and poetic approach to making art. Her collection of Tanavoli's work is singular, representing nearly eighty works from jewelry to ceramics, lithographs to paintings, and, of course, sculpture. Through her close friendship with Peter Chelkowski, Grey developed confidence that New York University should be the ultimate home of her collection. She donated most of her artwork and funds for the establishment of the Grey Art Gallery to NYU. The Grey Art Gallery held its inaugural exhibit in 1975. Abby Weed Grey passed away in June 1983. While some pieces of Iranian art from her collection were displayed throughout NYU's buildings, most remained in storage underneath Washington Square in lower Manhattan until Peter Chelkowski raised the possibility of exhibiting Iranian art at the Grey Art Gallery.

"Between Word and Image: Modern Iranian Visual Culture" opened on September 18, 2002.[34] The exhibit brought together some one hundred works of art that were divided into three discrete but interrelated aspects of Iranian art from the 1960s and '70s. Working with Lynn Gumpert, the Director of the Grey Art Gallery, curator Fereshteh Daftari selected approximately thirty paintings, sculptures and works on paper from the gallery's extensive collection of modern and contemporary Iranian art. Another section of the exhibition featured iconic photographs of the 1979 Revolution by Magnum photographer Abbas, and the final section featured revolutionary posters, some of which were made by Iran's leading artists like Nicky Nodjoumi and Morteza Momayez.

As a university museum, the Grey Art Gallery works closely with NYU's faculty to organize academic and public programs around each of its exhibits. "Between Word and Image" was accompanied by a series of programs in collaboration with other New York institutions, including artist talks, musical performances, and a film series. Two symposia highlighted Iranian visual culture and political posters from Iranian and Latino contexts. A collection of related essays, *Picturing Iran: Art, Society and Revolution*, was published in 2002;[35] an Arabic edition appeared in Lebanon in 2006.

The question of modernity in Iranian art, of which Oleg Grabar had written in relation to the Brooklyn Museum's Qajar exhibition, was explored further in the publications and programs surrounding "Between Word and Image." The construction of modernity in Iran entailed seeking out new ways in which the

arts could engage social and political concerns.[36] In one of my essays for *Picturing Iran*, I argued against the facile narrative that contemporary Iranian cultural history was a tension between tradition and modernity, that Iranian artists created a hybrid art that wedded European (modern) form with local (traditional) content; an examination of Iranian modern art, I argued, might well expand our understanding of modernity itself.[37] The art historian and curator Fereshteh Daftari also contributed a seminal essay to the book titled "Another Modernism: An Iranian Perspective."[38] In his review of the show for the *New York Times*, Holland Cotter also focused on its presentation of Iranian modernity.[39]

The exhibit became one of the most popular shows of non-Western art in the history of the Grey Art Gallery. The opening was so crowded that viewers poured into Washington Square and stayed for hours. An incredibly diverse group of Iranian-Americans gathered in the gallery's small spaces, each talking passionately about the work. Abbas's photographs, in particular, provoked viewers to recall their own memories of the Revolution. Marcel Proust wrote that photographs were an instrument of memory; for Susan Sontag, they were an invention of memory. In an extensive review of the show, Babak Ebrahamian wrote, "For anyone who has lived through the revolution, this exhibit acts as a reminder of the early days of the uprising, the overthrow, and the replacement of the old regime with the new one. Each work echoes a moment of this pre-/post-section of history."[40] For some of its viewers, "Between Word and Image" confirmed the importance of visual culture in better understanding Iranian history.

Subsequently, the Grey Art Gallery has continued to showcase Iranian art. With a grant from the American Institute of Iranian Studies, the Grey Art Gallery created an online database in 2008 of its entire collection of Iranian art.[41] It has also organized more exhibitions featuring Iranian art, including "Modern Iranian Art: Selections from the Abby Weed Grey Collection" in 2013, "Global/Local 1960–2015: Six Artists from Iran" in 2016, and "Modernisms: Iranian, Turkish, and Indian Highlights from NYU's Abby Weed Grey Collection" in 2019.[42]

Some of the artworks on view at the Grey Art Gallery in 2002 were again featured in "Iran Modern," a major exhibition at New York's Asia Society that opened in September 2013. Curated by Fereshteh Daftari and Layla Diba, the exhibit included one hundred works from the 1950s through the 1970s by twenty-six artists. The curators organized the art into four thematic clusters—saqqakhaneh, abstraction, calligraphic modernism, and political art. The first of these demonstrated that the modernity propagated in the Pahlavi era did not look only to the West as inspiration; it was also rooted in a particular articulation of Iran's ancient past and folk culture. Iranian artists reshaped

that cultural heritage in their own distinct ways as they forged an art that was liberated from Iranian academicism and drew inspiration from vernacular culture in both form and content. And the final thematic grouping of artworks showed that modernity in this time period was also marked by social dislocations, economic inequality, and political closures. The exhibition catalog and a series of programs organized by the Asia Society throughout the fall of 2013 contextualized the art on view within the broader cultural context of the 1960s and '70s. Two symposia focused on the Shiraz Art Festival and on art and discourse in Iran, bringing together scholars, curators, and artists for important conversations about art and social change in a critical era of Iranian history. Collectively, these three museum exhibitions helped extend and expand the temporal and thematic scope of the arts within the field of Iranian studies in the United States.

Irangeles: Iranian-American and Iranian Art in Los Angeles Museums

The University of California, Los Angeles has been at the forefront of highlighting Iranian diasporic art. In 1994, the Fowler Museum at UCLA hosted two shows, "Irangeles: Iranians in Los Angeles," and "Labyrinth of Exile." "Irangeles" was accompanied by the publication of a significant book by the same title. Edited by Ron Kelley and Jonathan Friedlander, it featured photographs and significant essays by scholars like Mehdi Bozorgmehr, Nayereh Tohidi, and Hamid Naficy.[43] The exhibit confirmed a great interest in the study of Iranian exilic communities; in 1998, Mehdi Bozorgmehr edited a special issue of *Iranian Studies* devoted to Iranian Americans.[44] Subsequently, Naficy's groundbreaking book, *An Accented Cinema: Exilic and Diasporic Filmmaking*, highlighted the work of significant Iranian-American filmmakers like Amir Naderi.[45] Naficy's body of work has done much to advance theories of diasporic cultural production, draw attention to some of Iran's leading filmmakers who live and work in the United States, and legitimize the study of Iranian-American communities altogether.

That same year, the Fowler mounted a small show titled "Labyrinth of Exile" that proved to be historic, since it was among the first public exhibitions of Shirin Neshat's photographs. At the time, Neshat was in the midst of creating her photograph series "Unveiling" and "Women of Allah."[46] The Neshat photographs on display were deeply embedded in Iranian motifs— both Islamic and secular. "It's very important that those photographs are understood in the context in which they were made," she explained.

It was a time in my life when I really felt I needed a connection to my family, my country. When I started to make this work, it was just done for myself. I felt this incredible urge. I don't know where it came from because I hadn't touched art for a long time. There was something dormant in me, a more philosophical inclination, that was awakened. The work cannot be looked at outside of the context of me, my return to Iran, my return to art, my introduction to photography. The photographs are about me finding my way through the cultural iconography, through the artistic form. It was a very dense moment."[47]

The 1994 group exhibition at the Fowler offered a glimpse of Neshat working through this dense moment (fig. 11.3).

This exhibition also showed the complex layers and distorted lenses through which Neshat's art would be seen. A *Los Angeles Times* critic wrote a review of both "Irangeles" and "Labyrinth of Exile," ending it with two brief paragraphs on Neshat's photographs. "In a fractioned second," he wrote, "this startling image informs Western viewers that their chances of understanding such a traditional Muslim woman are next to nil. She has been raised as a model of rectitude and told to be ashamed of her body as a sinkhole of temptation. Yet recently the leaders of her people have told her to take up arms and fight like a man."[48] From the earliest exhibitions of her work, then, dissonance accompanied acclaim in the reception of Neshat's work.

"When I saw the reviews of the first show," Neshat recalls, "I saw how misunderstood this work would be and yet I had to go through the process. That notion of the translation of the idea became a problem. The iconography was overtly political. They are difficult images to analyze. In the end I stopped it altogether because I thought it was a dangerous way to go about exploring the issues. I needed to move on."[49] The early exhibitions of Neshat's work showed how acclaim and misrecognition are often woven together in the critical reception of Iranian-American artists.

In the summer of 2010, the Fowler Museum revisited the Iranian-American community through the lens of photography. "Document: Iranian-Americans in L.A." was organized by Amy Malek, then a doctoral student in anthropology at UCLA. Together with four Iranian-American photographers, Malek created a visual narrative of the lives of thirty-nine second-generation Iranian-Americans. "Document," noted a blogger on the *Los Angeles Times* website, "marks the emergence of a sense of Iranian American identity, even as it threatens to explode any attempt to actually define it. This tension between the desire for unity and the inherent diversity of any community is something every marginalized group confronts as it seeks recognition in the mainstream."[50] The exhibition also showed how younger scholars of Iranian diasporic studies were

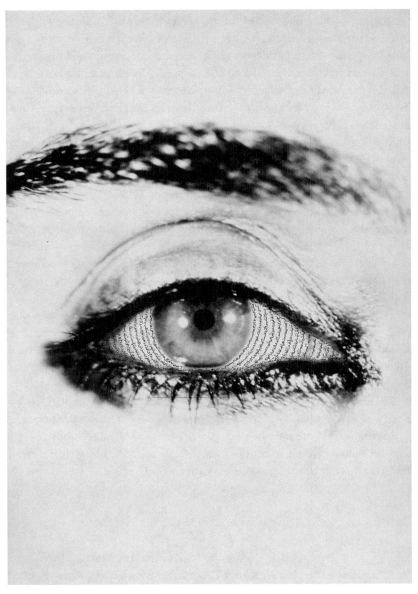

FIGURE 11.3. Shirin Neshat, *Offered Eyes*, 1993. RC print and ink, 101.6 × 152.4 cm. © Shirin Neshat. Courtesy of the artist and Gladstone Gallery. Photo: Plauto.

extending and enhancing the field through creative and insightful approaches to scholarship and cultural organizing.

Meanwhile, the Los Angeles County Museum of Art (LACMA) has been steadily growing its collection of contemporary Iranian art under the guidance of Dr. Linda Komaroff, who has been curator of Islamic Art there since 1995. Initially, Komaroff's acquisitions were limited to photography and print media, and she was creative in integrating contemporary Iranian art into Islamic art galleries or mounting installations in unused spaces within the museum. A 2018 exhibition, "In the Field of Empty Days: The Intersection of Past and Present in Iranian Art," was in some sense a culmination of Komaroff's curatorial vision. Some 125 works of art were displayed in galleries taking on an entire level of the Broad Contemporary Art Museum on LACMA's campus. Nearly half of the exhibition was drawn from the museum's permanent collection. The relationship between past and present, the interplay between history and myth, and the artistic appropriation of history are the overarching themes threaded throughout. Iconic historic figures—kings and heroes, saints and martyrs— are reimagined into something altogether new by artists like Siamak Filizadeh, Afsoon Afsoonagain, Shoja Azari, and Siah Armajani. All of the subheadings of the exhibition were named after books or films on time travel. "I am attracted to the evanescent but constant nature of time," Komaroff explained, "the future becomes the present which becomes the past whether in a matter of nanoseconds or eons. I appreciate when artists play with time, disrupting the cycle and spinning the chronometer. And so much of artistic manipulation of time is nonetheless of the moment. The visual merging of past and present today may appear to the future viewers merely as the blurred edges of old and older."[51]

Komaroff borrowed the exhibition title—"In the Fields of Empty Days"— from a poem by Mehdi Akhavan-e Sales written in the wake of Mossadeq's overthrow. It spoke to her, she explains, "of our paradoxical relationship with the past—do we embrace it or flee from it?" History casts a long shadow over Iran, one that has been redrawn so evocatively by its artists.

Politics and Exhibiting Iranian Art in the United States

In the spring of 2006, Nicky Nodjoumi took me to visit Ardeshir Mohassess in the small apartment in New York City's Greenwich Village, where he lived and worked for more than three decades. Mohassess's diminishing health was evident but so was his blistering spirit. He flipped through piles to show me proudly various articles written about his recent exhibition at the Homa Gallery in Tehran. For an artist who lived so much of his life in exile to be embraced by the art world in his home country was clearly moving. In 2008,

Shirin Neshat and Nicky Nodjoumi curated a major retrospective of Mohassess's work at the Asia Society. The opening of "Ardeshir Mohassess: Art and Satire in Iran" was filled with leading art historians and scholars of Iran, a testament to the importance of the occasion. Mohassess studied political science at the University of Tehran before making a career as an illustrator. As an artist, Mohassess was at once everywhere and barely seen. His drawings were published in *Kayhan*, Iran's leading daily, and in the *New York Times*. He influenced some of Iran's most notable artists. His art was included in the first Tehran Biennale in 1958 and in a group show at the Louvre in 1974. And yet, to many his name was unknown—perhaps because he lived much of his adult life in quiet exile in the United States and because Parkinson's disease limited his mobility for nearly twenty-five years. In the 1970s, Mohassess's drawings poked fun at the Shah's liberalizing modernization program, and he created some of the iconic images of the Iranian Revolution that overthrew the monarchy. He soon turned his keen eye on the Islamic Republic.

The exhibit at the Asia Society represented a rich tapestry of images from three decades of Iran's history. Mohassess's drawings not only told a story of Iran's present but wove together pictorial tropes from her past. The result of years of hard work by a group of scholars and artists determined to collect and protect Mohassess's drawings and papers, the exhibit was also a manifestation of a collective effort to preserve an important archive for Iranian studies. Some might think of Mohassess a political artist; he was rather an artist of politics. "One can never change anything by art," he once said. "The only thing that one can say is that artists in each period of history leave a record so that people in the future will know about their time."[52]

If artists can depict a record of their time, "Iran Inside Out" will surely stand as a notable moment in Iranian exhibitions in the United States. The curators Sam Bardaouil and Till Fellrath intended to curate a show of Iranian art that would mark the thirtieth anniversary of the 1979 Revolution and open near the 2009 Iranian Presidential elections.[53] No one could have predicted that by the time the exhibit opened at the Chelsea Museum of Art on June 26, 2009, that Iran would be in the midst of its largest uprising since 1979. Viewers waited patiently in long lines to enter the museum, to see works by Iranian artists. "The artists got a voice," explained Fellrath. "Visitors left the exhibition with a true sense ... of connection on a humanitarian level." As one of the artists in the show, Darius Yaktai, explained to a reporter, "It's been very hard to paint, lately. It feels like painting doesn't change the world. What's happening now is going to enter into everyone's studio."[54] Hung over three floors of the museum, "Iran Inside Out" featured over two hundred works by fifty-six Iranian artists, interrogating the relationship between "homeland and diaspora." Bardaouil explained, "Most of the artists in the show had never been

exhibited side by side before, especially those from the inside and the outside. So in a way the show created a sense of unintended unity that multiplied into symbolism due to the political context, the timing of the show."[55] It is one of the caveats of organizing Iranian art exhibitions in the United States. Even if one does not intend to curate a political show, even if the artists do not intend to create political work, the larger political context hangs in the air and can frame the reception of the art on view.

"An Iranian Moment"

Some analysts called it the Persian Spring. Through a historic confluence in the spring of 2015, three American museums held major monographic exhibitions of Iranian art simultaneously.[56] The Davis Museum at Wellesley organized a six-decade retrospective of the work of sculptor Parviz Tanavoli. A show of Monir Shahroudy Farmanfarmaian's mosaic mirror works and line drawings traveled from Serralves in Portugal to the Guggenheim Museum in New York. And Shirin Neshat's photographs and video installations were exhibited at the Hirshhorn Museum and Sculpture Garden in Washington, DC. In the *Boston Globe*, the art critic Sebastian Smee wrote, "An Iranian moment? It almost feels like it."[57]

As museum audiences were taking in all this Iranian art, another historic turn of events was unfolding in the diplomatic arena—the P5+1 negotiations to curb Iran's nuclear program was taking place in Vienna. The parallel stories of diplomatic and artistic exchange between the United States and Iran are intertwined in fascinating ways. Tanavoli, Farmanfarmaian, and Neshat are all artists who lived and made art in the interstitial spaces of Iran's relations with the United States, spaces that have expanded and retracted intermittently since the end of World War II. As one of the curators of the Tanavoli exhibit, I often checked in with him in the weeks leading up to the show. One night over the phone, he told me in a quiet voice, "The doors have finally opened." Just before his opening, I walked with him through the galleries of the Davis, which were filled with his sculptures, drawings, and paintings. He spoke again of how his art was inspired by Persian poetry and folk art but imbued with a pop sensibility, an inflection from the time he spent living in the United States in the 1960s. I asked him to expand on his comment about doors opening. "With the background I had in the US," Tanavoli said, "I expected that the doors would never close on me, because from a very young stage in my career, I had shows in the States. I created a lot of my work in the United States. I taught at the Minnesota College of Art and Design. I had a following in the

public in the United States. I was known there. Then, all of a sudden, with the Iranian Revolution and the war and the hostage crisis, they closed all the doors. Relations between the two countries were tarnished, and I couldn't continue. I lost all my connections. I went into the dark." The Davis exhibit was his first solo US museum exhibition in nearly four decades.

Monir Shahroudy Farmanfarmaian first arrived in the United States by boat in 1944. She studied at Cornell and the Parsons School of Design. For a time, she worked as a fashion illustrator, designing the famous Persian violet logo for Bonwit Teller department stores. Monir tapped into New York City's lively cultural circles, interacting with Jackson Pollock, Willem de Kooning, Joan Mitchell, and Mark Rothko. Returning to Iran in 1957, she rediscovered the country with renewed vigor, finding inspiration in its tribal arts and rugged landscapes. As her close friend Frank Stella explained, Monir's art combined "the measured geometry" of Western abstraction with the underlying concepts and designs of Islamic architecture.[58] In Islamic cosmology, each geometric shape has a symbolic value. For Monir, the hexagon became a resonant shape with which she could create infinite possibilities. Monir told me that as a young artist in New York, she would often pass the construction site long Central Park on her evening strolls, watching the Guggenheim Museum being built. Decades later, at the age of ninety-two, she would become the first Iranian artist to receive a solo exhibition at the museum.

At the Hirshhorn, the convergence of history and art became the curatorial impulse for Shirin Neshat's exhibition, "Facing History." Alongside Neshat's art, the museum exhibited archival photographs and news footage that the artist used as source material for her films, photographs, and video installations. "I am so proud, as a woman artist, to be taking up so much space at the Hirshhorn," Neshat told viewers at the opening. As she completed her remarks, I looked over at crowds of museumgoers and watched as a father holding his young daughter's hand carefully showed her the historical materials relating to the 1953 coup in Iran, a US-led action that overthrew the democratically elected government of Prime Minister Mossadegh. The exhibition offered an artistic interjection on the troubled histories of Iran's relations with the United States.

By July 2015, it seemed a new chapter was being opened that troubled history. President Obama announced that a comprehensive deal had been reached with Iran. "Our differences are real and the difficult history between our nations cannot be ignored," he said, "but it is possible to change." After decades of retrenchment, there was a sense that political and cultural flows between the two countries were shifting, that for Iran's artists the doors may be opening once again.

Public Art and Art's Publics

On February 20, 2019, Siah Armajani's seminal work "Bridge over Tree" was unveiled at the Brooklyn Bridge Park. Originally shown in a Minneapolis public park in 1970, the sculpture's installation in New York City coincided with the opening of the exhibition "Siah Armajani: Follow This Line," which had traveled from the Walker Art Center in Minneapolis to the Metropolitan Museum of Art. Curated by Clare Davis and Victoria Sung, the monumental exhibition covered six decades of Armajani's artistic career. When I visited "Bridge over Tree" in May 2019, several children were playing in the sculptural installation. They would enter the covered bridge on one side, climb over the tree, and jump with glee out of the other side. They were experiencing the work exactly as the artist intended—becoming aware of what came before it and what came after, what was below it and what was above. Rather than creating a myth of the artist, he believed public art should serve the common good. That people often recall Armajani's art without knowing his name is not incidental. "Public art is not about self but others," he explained in one of our conversations.

Many will remember Mohammad Ali lighting the Armajani designed caldron at the 1996 Atlanta Olympics. Passersby have often stood at the iron gates he inscribed with the poetry of Walt Whitman and Frank O'Hara in Battery Park City, experiencing the way his installation frames a view of Ellis Island. Armajani's gate was part of a major collaboration he undertook with the architect Cesar Pelli, artist Scott Burton, and landscape artist M. Paul Friedberg at the World Financial Center Plaza in 1986, turning the Hudson waterfront into one of the most popular public spaces in New York City. Hikers along the trail at Cheekwood Botanical Gardens in Nashville probably wouldn't know it was Armajani who created the "Glass Bridge" they crossed. Drawing on his lived experiences in Iran as a young man and decades of life as an immigrant in the United States, Armajani incorporated poetry, philosophy, and architecture from both countries into his artistic expression and philosophy on public art. As he told Calvin Tomkins in the *New Yorker* in 1990, "Art by itself cannot bring about social changes. But art in concert with other forces can make a difference. We can be citizens with something to offer besides self-analysis. We can be part of society."[59]

Exhibiting art often stimulates an entire ecology of knowledge production.[60] The museum produces scholarly publications with related essays and documentation. Art critics write about the art and the artists in newspapers and magazines. Scholars are triggered to extend their research into new directions. Professors integrate the art into their courses. Over the past decades, while travel between Iran and the United States has been limited at best, exhibitions of Iranian art in American museums have helped bring visual context

to a broader audience, conveying a more nuanced and complex view of Iran than what is often presented in the news media. Art exhibitions have become a critical nexus between creatives, scholars, and a broader public, extending the field of Iranian studies in the United States in important ways over the past decades.

Notes

This essay was originally written in 2011 as part of an edited volume to mark fifty years of the contributions of the American Institute of Iranian Studies to the field of Iranian Studies. I intended for the essay to show the ways museum exhibitions can be an integral part of the landscape of knowledge production, creating connections between scholars, creatives, and the public. We now reframe this collection as a tribute to Franklin D. Lewis, who helped instigate the project, who served as the President of the American Institute of Iranian Studies for years, and who was a dedicated, productive, and generous scholar of the field. He has left us a model of mentorship, friendship, and collegiality alongside brilliant studies and translations of Persian literature.

1. Eleanor Roosevelt, "My Day," June 3, 1940. From the electronic edition of E. Roosevelt's "My Day" newspaper column for this day, see http://www.gwu.edu/~erpapers/myday/displaydoc.cfm?_y=1940&_f=md055596.
2. "Persian Art."
3. Arthur Upham Pope, as quoted in his *New York Times* obituary from September 4, 1969. Pope and his wife are buried in a mausoleum in Isfahan erected in their honor by Mohammed Reza Shah Pahlavi in recognition of their service to Iranian art.
4. *New York Times* obituary; and. Creswell, Hobson, and Grey, review of *A Survey of Persian Art*.
5. Grabar, "Richard Ettinghausen."
6. "Iranian Art Study."
7. Ettinghausen, "Six Thousand Years."
8. Hillenbrand, "Scramble for Persian Art."
9. "Arthur Pope, 88."
10. Jewell, "Persian Exhibition of Art"; Silver, "Arthur Upham Pope."
11. Ettinghausen, "Six Thousand Years," 110.
12. Shapley, "Great Art of Persia in a Monumental Survey," emphasis mine.
13. Blair, review of *Royal Persian Paintings*.
14. Appardurai and Breckenridge, "Museums Are Good to Think," 688.
15. For an important discussion of the linkage between ancient heritage and modern nationalism, see Timothy Mitchell, "Heritage and Violence."
16. McAlister, "Common Heritage of Mankind."
17. See Kirshenblatt-Gimblett's thoughtful discussion of Oleg Grabar's elucidation of Islamic objects as art in *Destination Culture*, 23–25.
18. Diba, "Embracing Lovers."
19. Cotter, "Dazzling Images."
20. Berger, *Ways of Seeing*.
21. Najmabadi, *Women with Mustaches*, 6.
22. Keddie, *Qajar Iran*. For more information, see Balaghi, review of *Qajar Iran*.
23. Grabar, "Reflections on Qajar Art," 186.
24. Blair, review of *Royal Persian Paintings*.

25. Interview with the author, 2011.
26. Balaghi, "Iranian as Spectator and Spectacle."
27. Chelkowski, "Popular Arts."
28. Chelkowski and Dabashi, *Staging a Revolution*. Dabashi has been pivotal in shaping the study of Iranian visual culture. His book *Close Up* became the standard book on the subject. It was followed by numerous important studies on Iranian art and cinema.
29. Chelkowski and Dabashi, *Staging a Revolution*, 9.
30. Grey, *Picture Is the Window*, 21.
31. Gumpert, "Reflections," 18.
32. For more on Grey's collection of Tanavoli art and her decades-long friendship with the artist, see Balaghi, "Abby Weed Grey."
33. See Balaghi, "Iran as Museum."
34. For more information on the exhibition, including some essays and images, see http://www.nyu.edu/greyart/exhibits/iran/index.html.
35. Balaghi and Gumpert, *Picturing Iran*.
36. See press release for "Between Word and Image" https://greyartmuseum.nyu.edu/exhibition/iranian-art-091802-120702/.
37. Balaghi, "Iranian Visual Arts."
38. Daftari, "Another Modernism," 39–48 and 65–87.
39. Cotter, "Modernism Gets a Revolutionary Makeover."
40. Ebrahamian, "Pictures from a Revolution."
41. Grey Art Gallery, "Iranian Art."
42. "Modernisms" subsequently traveled to the Block Museum of Art at Northwestern University in 2020 and Rollins Museum of Art in 2022.
43. Kelley and Friedlander, *Irangeles*.
44. *Iranian Studies* 31.1 (1998).
45. Naficy, *Accented Cinema*.
46. Several scholars and many art critics have written on Shirin Neshat. Of special note are Milani, *Shirin Neshat*; Dadi, "Shirin Neshat's Photographs"; Dabashi's several articles including "Shirin Neshat"; and Balaghi, "Searching for Tooba." For interesting observations on viewers' responses to seeing these photographs exhibited after September 11, 2001, see Winegar, "Humanity Game."
47. Interview with the author, 2002.
48. Wilson, "Through the Lens."
49. Interview with the author, 2002.
50. Mizota, "Document."
51. Quotes from Komaroff are from an interview with the author, May 2018.
52. See a translation of a 1973 conversation between the poet Esmail Khoi and Ardeshir Mohassess in Neshat and Nodjoumi, *Ardeshir Mohassess*, 31–37.
53. Till Fellrath interview with author, 2011.
54. Yektai quoted in Leila Darab, "Iran Inside Out."
55. Interview with the author, 2011.
56. "Parviz Tanavoli," Davis Museum at Wellesley College, Wellesley, MA, February 10-June 7, 2015; "Monir Shahroudy Farmanfarmaian: Infinite Possibility," Solomon R. Guggenheim Museum, New York, March 13–June 3, 2015; "Shirin Neshat: Facing History," Hirshhorn Museum and Sculpture Garden, Washington, DC, May 18–September 20, 2015.

57. Sebastian Smee, "Iranian Artist Tanavoli."
58. Stella, "Reflection."
59. Armajani as quoted in Tomkins, "Open, Available, Useful."
60. While this essay has focused on some key publications directly related to art exhibitions, some important studies on Iranian art have also been published in recent years, including Grigor, *Contemporary Iranian Art*; Daftari, *Persia Reframed*; and Karimi, *Alternative Iran*.

Bibliography

Appardurai, Arjun, and Carol A. Breckenridge. "Museums Are Good to Think: Heritage on View in India." Pages 685–99 in *Grasping the World: The Idea of the Museum*. Edited by Donald Preziosi and Claire Farago. London: Ashgate, 2004.

"Arthur Pope, 88, Expert on Iran." *New York Times*, September 4, 1969, 47.

Balaghi, Shiva. "Abby Weed Grey and Parviz Tanavoli." Grey Art Museum. December 2008. https://greyartmuseum.nyu.edu/2015/12/2893/.

———. "Iran as Museum and the Artist as Collector: Parviz Tanavoli's Artistic Inspiration." Pages 28–39 [Arabic translation 574–64] in *Parviz Tanavoli*. Edited by Charles Pocock. Dubai: Meem, 2010.

———. "The Iranian as Spectator and Spectacle: Theater and Nationalism in Nineteenth Century Iran." Pages 193–216 in *Social Constructions of Nationalism*. Edited by F. Muge Gocek. Syracuse: Syracuse University Press, 2002.

———. "Iranian Visual Arts in the Century of Machinery, Speed, and the Atom: Rethinking Modernity." Pages 21–38 in *Picturing Iran: Art, Society and Revolution*. Edited by Shiva Balaghi and Lynn Gumpert. London: I. B. Tauris, 2002.

———. Review of *Qajar Iran and the Rise of Reza Khan, 1769–1925*, by Nikki Keddie. *Iranian Studies* 33.1–2 (2000): 257–58.

———. "Searching for Tooba: Reflections on Exile and Art in the Work of Shirin Neshat and Shoja Azari." Pages 97–107 in *1.5 Generation*. Edited by Ellen Harvey. New York: Queens Museum, 2009.

Balaghi, Shiva, and Lynn Gumpert, eds. *Picturing Iran: Art, Society and Revolution*. London: I. B. Tauris, 2002.

Berger, John. *Ways of Seeing*. London: Penguin, 1990.

Blair, Sheila S. Review of *Royal Persian Paintings: The Qajar Epoch, 1785–1925*, edited by Layla Diba. *Iranian Studies* 33.1–2 (2000): 228–331.

Chelkowski, Peter. "Popular Arts: Patronage and Piety." Pages 90–99 in *Royal Persian Paintings: The Qajar Epoch, 1785–1925*. Edited by Layla S. Diba. London: Brooklyn Museum of Art with I. B. Tauris, 1998.

Chelkowski, Peter, and Hamid Dabashi. *Staging a Revolution: The Art of Persuasion in the Islamic Republic of Iran*. New York: New York University Press, 1999.

Cotter, Holland. "Dazzling Images Delineate a World that Never Was." *New York Times*, October 23, 1998, E33.

———. "Modernism Gets a Revolutionary Makeover in Iran." *New York Times*, September 27, 2002, E31.

Creswell, K. A. C, R. L. Hobson, and Basil Grey. Review of *A Survey of Persian Art from Prehistoric Times to the Present*, by Arthur Upham Pope and Phyllis Ackerman. *The Burlington Magazine for Connoisseurs* 77.448 (July 1940): 31–32.

Dabashi, Hamid. *Close Up: Iranian Cinema, Past, Present, and Future*. London: Verso, 2001.

———. "Shirin Neshat: Transcending the Boundaries of an Imaginative Geography." Pages 31–81 in *The Last Word*. Edited by Octavio Zaya. San Sebastian: Museum of Modern Art, 2005.
Dadi, Iftikhar. "Shirin Neshat's Photographs as Postcolonial Allegories." *Signs* 34.1 (2008): 125–50.
Daftari, Fereshteh. "Another Modernism: An Iranian Perspective." Pages 39–88 in *Picturing Iran: Art, Society and Revolution*. Edited by Shiva Balaghi and Lynn Gumpert. London: I. B. Tauris, 2002.
———. *Persia Reframed: Iranian Visions of Modern and Contemporary Art*. London: I. B. Tauris, 2019.
Darab, Leila. "Iran Inside Out." *Tehran Bureau*, June 28, 2009. http://www.pbs.org/wgbh/pages/frontline/tehranbureau/2009/06/iran-inside-out.html.
Diba, Layla S. "Embracing Lovers." Page 157 in *Royal Persian Paintings: The Qajar Epoch, 1785–1925*. Edited by Layla S. Diba. London: Brooklyn Museum of Art with I. B. Tauris, 1998.
Ebrahamian, Babak. "Pictures from a Revolution: The 1979 Uprising." *PAJ: A Journal of Performance and Art* 25.2 (2003): 19–31.
Ettinghausen, Richard. "'Six Thousand Years of Persian Art': The Exhibition of Iranian Art, New York 1940." *Ars Islamica* 7 (1940): 106–17.
Grabar, Oleg. "Reflections on Qajar Art and Its Significance." *Iranian Studies* 34.1–4 (2001): 183–86.
———. "Richard Ettinghausen." *Artibus Asiae* 41.4 (1979): 281–84.
Grey, Abby Weed. *The Picture Is the Window, the Window Is the Picture*. New York: New York University Press, 1983.
Grey Art Gallery. "Iranian Art." https://greyartgallery.nyu.edu/collections/abby-weed-grey-collection/iranian/.
Grigor, Talinn. *Contemporary Iranian Art: From the Street to the Studio*. London: Reaktion, 2014.
Gumpert, Lynn. "Reflections on the Abby Grey Collection." Pages 17–20 in *Picturing Iran: Art, Society and Revolution*. Edited by Shiva Balaghi and Lynn Gumpert. London: I. B. Tauris, 2002.
Hillenbrand, Robert. "The Scramble for Persian Art: Pope and His Rivals." Lecture at the Art Institute of Chicago, September 10, 2010
"Iranian Art Study Issues 3 Volumes." *New York Times*, January 15, 1939, 15.
Jewell, Edward Alden. "Persian Exhibition of Art Is Opened." *New York Times*, April 24, 1940, 20.
Karimi, Pamela. *Alternative Iran: Contemporary Art and Critical Spatial Practice*. Palo Alto: Stanford University Press, 2022.
Keddie, Nikki. *Qajar Iran and the Rise of Reza Khan, 1769–1925*. Costa Mesa, CA: Mazda, 1999.
Kelley, Ron, and Jonathan Friedlander, eds. *Irangeles: Iranians in Los Angeles*. Berkeley: University of California Press, 1993.
Kirshenblatt-Gimblett, Barbara. *Destination Culture: Tourism, Museums, and Heritage*. Berkeley: University of California Press, 1998.
McAlister, Melani. "The Common Heritage of Mankind." *Representations* 54 (1996): 80–103.
Milani, Farzaneh. *Shirin Neshat*. Milan: Charta, 2001.

Mitchell, Timothy. "Heritage and Violence." Pages 179–205 in *Rule of Experts: Egypt, Techno-Politics, Modernity*. Edited by Timothy Mitchell. Berkeley: University of California Press, 2002.

Mizota, Sharon. "'Document: Iranian Americans in L.A.' at the Fowler Museum." Culture Monster (blog). *Los Angeles Times*, July 19, 2010. https://fowler.ucla.edu/exhibitions/document-iranian-americans-in-los-angeles/.

Naficy, Hamid. *An Accented Cinema: Exilic and Diasporic Filmmaking*. Princeton: Princeton University Press, 2001.

Najmabadi, Afsaneh. *Women with Mustaches and Men Without Beards: Gender and Sexual Anxieties of Iranian Modernity*. Berkeley: University of California Press, 2005.

Neshat, Shirin, and Nicky Nodjoumi, eds. *Ardeshir Mohassess: Art and Satire in Iran*. New York: Asia Society, 2008.

"Persian Art." *Time*, May 6, 1940, https://time.com/archive/6763297/art-persian-art/.

Roosevelt, Eleanor. "My Day." June 3, 1940. From the electronic edition of E. Roosevelt's "My Day" Newspaper Columns. https://www2.gwu.edu/~erpapers/myday/displaydocedits.cfm?_y=1940&_f=md055596.

Shapley, John. "The Great Art of Persia in a Monumental Survey." *New York Times*, January 7, 1940, 99.

Silver, Noel. "Arthur Upham Pope." *Encyclopaedia Iranica*. July 20, 2005. https://www.iranicaonline.org/articles/pope-arthur-upham.

Smee, Sebastian. "Iranian Artist Tanavoli in the Spotlight at the Davis Museum." *Boston Globe*, February 21, 2014. https://www.bostonglobe.com/arts/theater-art/2015/02/21/iranian-artist-tanavoli-spotlight-davis-museum/acTLoFJz1SQMvea1XW93JP/story.html.

Stella, Frank. "A Reflection." Page 65 in *Monir Shahroudy Farmanfarmaian: Cosmic Geometry*. Edited by Hans Ulrich Obrist and Karen Marta. Dubai: Damiani, 2011.

Tomkins, Calvin. "Open, Available, Useful." *New Yorker*, March 19, 1990, 71.

Wilson, William. "Through the Lens of Iranian Culture: Two Exhibitions at UCLA's Fowler Museum Enrich Images of these Immigrants in L.A." *Los Angeles Times*, July 2, 1994. https://www.latimes.com/archives/la-xpm-1994-07-02ca-10931-story.html.

Winegar, Jessica. "The Humanity Game: Art, Islam, and the War on Terror." *Anthropological Quarterly* 81.3 (2008): 651–81.

CHAPTER 12

Some American Contributors to Iranian Studies Born Before 1900

D. T. Potts

AMERICAN ARCHAEOLOGICAL AND EPIGRAPHIC RESEARCH in and on ancient Iran is often considered a phenomenon that began in the 1920s and '30s. These were, to be sure, years of great activity. In 1926, the First International Congress on Persian Art (which did not cover pre-Islamic material)[1] was held in Philadelphia, followed two years later by the creation of the American Institute for Persian Art and Archaeology in New York City.[2] Shortly thereafter, excavations were initiated at a host of sites, including Tureng Tepe (University of Pennsylvania Museum and Kansas City Museum); Persepolis, Naqsh-e Rustam, Istakhr, and Tal-e Bakun (Oriental Institute of Chicago); Qasr-i Abu Nasr (Metropolitan Museum of Art); Tepe Hissar, Rayy, Cheshmeh Ali, and Murteza Gerd (University of Pennsylvania Museum); and Bisotun, Tamtama, Khunik, and Gar-e Kamarband / Hotu (University of Pennsylvania Museum). American interest in and scholarship on ancient Iran, however, had begun much earlier. Some of the less well-known American figures in early Iranological scholarship born before 1900 will be treated in this essay. Of these, several possessed genuine scholarly abilities, while others were merely interested facilitators, corresponding with learned societies and academics in Europe and the United States. They are discussed in order of birth as follows:

> Justin Perkins (1805–1869)
> Albert Lewis Holladay (1805–1856)
> Austin Hazard Wright (1811–1865)
> Edward Elbridge Salisbury (1814–1901)
> David Tappan Stoddard (1818–1857)
> Henry Lobdell (1827–1855)
> William Dwight Whitney (1827–1894)
> John Haskell Shedd (1833–1895)
> Isaac Hollister Hall (1837–1896)
> Lawrence Heyworth Mills (1837–1918)
> Joseph Plumb Cochran (1855–1905)

James Elcana Rogers (1856–1938)
Samuel Graham Wilson (1858–1916)
Abraham Valentine Williams Jackson (1862–1937)
William Ambrose Shedd (1865–1918)
Herbert Cushing Tolman (1865–1923)
Ephraim Cutler Shedd (1873–1951)
Edwin Lee Johnson (1874–1947)
Louis Herbert Gray (1875–1955)
Roland Grubb Kent (1877–1953)
Augustus William Ahl (1885–1976)
Alvin Harrison Morton Stonecipher (1888–1981)

Justin Perkins (1805–1869)

In 1829, the Board of Foreign Missions of the Presbyterian Church in the United States sent the Rev. Eli Smith and the Rev. Harrison Gray Otis Dwight from their mission in Turkey to northwestern Iran.[3] Their observations were many and varied, though rarely of an antiquarian nature. One exception concerns the comments they made on Salmas which, they noted, was "mentioned by ancient writers as a town in the Armenian province of Persarmenia. . . . The only remains of antiquity we saw, were two or three cylindrical monuments or towers of an order similar to that at Shamkór [modern Shamkir, Azerbaijan], but much inferior in height. They were constructed of brick, and marked with inscriptions in the Arabic character, betraying a moslem origin."[4] Smith and Dwight recommended the establishment of a mission among the Nestorians around Lake Urmia.[5] In January 1833, the Rev. Justin Perkins was appointed to establish the planned mission.

Perkins was born in West Springfield (now Holyoke), Massachusetts. He entered Amherst College in 1825, graduating in 1829. After teaching at Amherst Academy, he enrolled at Andover Theological Seminary, from which he graduated in 1831.[6] At the time of his invitation to establish the Presbyterian mission at Urmia, Perkins was Tutor in Rhetoric, Logic, and Languages at Amherst College.[7] Having received his instructions on September 8, 1833,[8] Perkins and his wife set sail from Boston two weeks later for Constantinople, arriving on December 21, 1833. There they spent the winter before setting out for Urmia in May 1834.[9] At Maragha, Perkins commented on the tomb of Hülegü: "Its foundations are of stone and its superstructure of brick, about forty feet high and twenty wide,—once a splendid structure, but now yielding to neglect and decay. The tomb itself is even used as a stable, and the tower over it as a dove–cote."[10] Perkins also visited the "scarcely–distinguishable ruins

of the old observatory, erected by Hoolakóo [Hülegü], on a mountaintop near the city, for his celebrated astronomer, Nasser-i-Dîn."[11]

Shortly before Easter on April 19, 1837, Perkins visited Geogtapa, "a large village, four miles distant from the city [Oroomiah or Urmia], inhabited entirely by Nestorians" and considered "the Nestorian metropolis of the province of Ooroomiah."[12] Perkins was attracted by

> one of the largest of those artificial mounds, of which there are many on the plain of Oróomiah, supposed to have been accumulated by the ancient fire-worshippers. These mounds are often partially excavated, for the purpose of obtaining the soil, for manure, as well as stones for building, from the old walls imbedded in them. A few days since, in excavating the side of the hill at Gĕog-tapá, a discovery was made, which has not a little roused the curiosity and speculation of the simple-hearted villagers. The excavator reached a stone tomb, about forty feet below the surface of the hill, in which he found a human skeleton and in its skull, several copper spikes, from four to five inches long. He took out the spikes and carefully replaced the skull in its bed, regarding it as highly sacrilegious to disturb the bones and ashes of the dead. Mar Elias, the bishop resident in that village, presented to me one of the spikes, which he had obtained from the discoverer. A thick coat of verdigris had formed on it, though copper, it is well known, long resists decomposition.... I suggested to them, that the tomb may have been the work of the ancient fire-worshippers, and driving nails into the head, their method of destroying their enemies or their victims.... I referred to the fact stated in Judges 4: 21,—'Then Jael, Heber's wife took a nail of the tent and took a hammer in her hand, and went softly unto him and smote the nail into his temples, and fastened it into the ground; for he was fast asleep and weary; so he died'—and remarked to them that perhaps this Scripture is illustrated by their discovery in the excavation, though the nail of the tent was probably a wooden pin.... A few days ago, our Persian Meerza incidentally stated, that in excavating the side of another mound, which is situated about twelve miles from the one above-mentioned, a few years ago, an earthen pot of silver coins of some European stamp was found; and near that, a large earthen sarcophagus, containing a human skeleton, with nails driven into the skull! Coincidences that may lead to interesting discoveries.[13]

In 1849, Perkins visited the site of Kelishin. He wrote, "On the top of the highest ridge on the route between Ooshnoo [Ushnu] and Ravandooz [Rowanduz], which is called the Pass of *Galeeâ Sheen*, meaning in the Koordish

language, the azure-pillar, is a dark marble pillar, eight or ten feet high, placed on a large pedestal, on which are inscriptions in the cuneiform character. This pillar was visited a few years ago by Major Rawlinson,[14] who copied the inscriptions, and supposes the pillar to commemorate the journey of Alexander, on this route, in his pursuit of Darius."[15]

Perkins's desire to contribute to the post-Enlightenment "republic of letters" is demonstrated by his correspondence with Heinrich Leberecht Fleischer, one of Germany's leading Orientalists and the host of a September 1843 meeting that resulted in the formation of the Deutsche Morgenländische Gesellschaft.[16] The *Zeitschrift der Deutschen Morgenländischen Gesellschaft* published excerpts of letters written by Perkins to Fleischer, giving information on developments then taking place, particularly with regard to Syriac, at the mission in Urmia.[17] Perkins's letter of October 12–17, 1853, gave further details about Qelishin, noting that a complete plaster cast had been made of its inscriptions in 1852 by Nikolai Vladimirovich Khanikoff (Khanykov) (1819–1878), Russian Consul General at Tabriz and "a gentleman of eminent literary and scientific attainments,"[18] who was highly esteemed by the American missionaries at Urmia and "proved himself a sincere and valuable friend to the mission."[19] The cast, however, was lost in transit (presumably en route to Russia). The following summer, Khanikoff obtained a good paper squeeze of the inscriptions, which Perkins seems to have either seen or discussed with Khanikoff, for he described the inscriptions as too damaged to read. Perkins did note, however, that several months earlier the American missionary Dr. Henry Lobdell (see below) discovered a similar "column" (Säule) between Ushnu and Rowanduz close to the Christian village of Sadikan.[20]

Albert Lewis Holladay (1805–1856)

Less well known than Perkins was the Rev. Albert Lewis Holladay. Born in Spottsylvania County, Virginia, he entered the University of Virginia in 1826 and left in 1827 with an MA as one of the first graduates in mathematics.[21] After teaching school in Richmond and Charlottesville, he was elected, at the age of only twenty-seven, to the Chair of Ancient Languages at Hampden–Sidney College in Hampden Sydney (Farmville), Virginia, a liberal arts college founded in 1775.[22] After serving in this capacity for two years, Holladay decided to study theology at Union Seminary in Virginia, and in 1837 he went as a missionary to Urmia, where he arrived on June 6.[23] Holladay worked among the Nestorian community until 1846. In about 1840, he completed a grammar of modern Syriac,[24] which was never published though is referred to in D. T. Stoddard's work (see below) on the same subject, where we read that

Holladay "prepared a very brief, though excellent sketch of the grammar of the Modern Syriac, about the year 1840."[25]

Austin Hazard Wright (1811–1865)

Rev. Austin H. Wright, MD, an 1830 graduate of Dartmouth College, was born in Hartford, Vermont. He later studied theology at the Union Theological Seminary in Prince Edward County, Virginia as well as Syriac, Hebrew, New Testament Greek, and medicine at the University of Virginia in Charlottesville, Virginia.[26] Wright sailed for Turkey on March 9, 1840, and joined the Urmia mission on July 25, 1840.[27] After his arrival, Wright spent three years studying Turkish, Neo-Aramaic (Syriac), and Persian in succession and "is said to have spoken each of the languages . . . with a precision, fluency, and grace, rarely equaled by a foreigner."[28] In July 1854, Wright twice visited Kelishin. His observations, though brief, were nevertheless precise:

> A few days ago, I returned from a journey across the mountains of Koordistan. On the way, both in going and returning, I visited that celebrated pillar, with cuneiform inscriptions, on the top of the mountain between Ooshnu and Ravandooz. The stone is about 2 yards long, 2 feet wide, and 1 foot thick, and is of a dark green color. Hence its name in Koordish, *Kel-e Sheen*, green stone. It stands in an upright position, one end being inserted in a large square stone, partly in the ground, and cut for the purpose. It faces E.S.E. Both sides are covered with inscriptions, the most distinct being on the southern face. I counted 40 lines on oneside, and 42 on the other. My Koordish guides would not allow me to examine this interesting relic of a former age but a few minutes, apprehending an attack of robbers, who infest that locality.
>
> I visited another stone with similar inscriptions near the village of Sidek [Sidekan or Bradost, referring to the Topzawa stele], five or six hours South-West of the one above named. It is of smaller dimensions than the other, and is of a dark grey color. It faces in the same direction. Dr. Grant [Dr. Asahel Grant] supposed there were inscriptions only on the South-East face of the stone, but it is my impression that they existed originally on both sides, and that they have been defaced from the northern side by the ravages of time. I thought that I discovered traces of the letters on that side, though, as I passed the spot at the early dawn, I ought not to be very confident. The stone appeared to be a softer texture than the one on the top of the mountain. These ancient relics carried me back in thought thousands of years, and I felt an inexpressible

desire to read the lesson of history written upon them. An impression of *Kel-e-Sheen* was taken two years ago by a learned Russian gentleman, Mr. Khanikoff of Tiflis, now acting Consul at Tabreez, on porous paper. This is now in the hands of Col. Rawlinson of Bagdad, who, it is hoped, will be able to decipher its meaning.

P.S.—*Kel* is used in Koordish for a *stone set up on end*, as in a graveyard. Hence Kel-e-Sheen means a *green upright stone*.[29]

When W. F. Ainsworth and Hormuzd Rassam were on their way back to Mosul from an excursion to Kurdistan, they met Wright, who was at the time returning to Urmia from Trabzon.[30]

Edward Elbridge Salisbury (1814–1901)

Edward Elbridge Salisbury, who was born in Boston, Massachusetts, was a member of the Class of 1832 at Yale. His student and successor at Yale, E. Washburn Hopkins, characterized the situation in the United States in the early 1840s with respect to Oriental studies, including Iranology, when Salisbury took up his Chair of Arabic and Sanskrit at Yale (1843), as follows: "It was a time when the intellectual activities of the country, in so far as they concerned themselves with the Orient at all, were busied almost exclusively with missionary work abroad and with the wisdom of the Hebrews here. Indian and Arabic literatures were ignored well-nigh completely, and Persian antiquities interested none.... [N]or was there yet, even in Europe, any general recognition on the part of the Universities of the intrinsic value of Hindu and Iranian literatures."[31] On two occasions, Salisbury spent periods studying in Europe, first with Franz Bopp (1791–1867) in Berlin and Baron Antoine Isaac Sylvestre de Sacy (1758–1838) and his student Joseph Héliodore Sagesse Vertu Garcin de Tassy (1794–1878) in Paris, and on the second occasion with Christian Lassen (1800–1876) in Bonn and Eugène Burnouf (1801–1852) in Paris. In addition, when Sylvestre de Sacy's library came up for sale (April 18–28, 1843, and April 6–29, 1846),[32] Salisbury purchased a portion of it, which he later donated to Yale.[33]

As Hopkins noted, "Although Mr. Salisbury's title was 'Professor of Arabic and Sanskrit,' he included in his studies, with his usual breadth of vision, Persian as a close relative of Sanskrit."[34] In 1849, Salisbury published a paper on Old Persian,[35] which although only a summary of the state of the field, "deserves mention particularly because it shows that Mr. Salisbury had already worked his way through Lassen, Burnouf, Rawlinson, and the more recent *Beiträge zur Erklärung der Persischen Keilinschriften* of Adolph Holtzmann,

Die Persischen Keilinschriften [*mit Uebersetzung und Glossar*] of Benfey (1847), and to have known of Oppert's *Lautsystem des Altpersischen* (1848), although, properly speaking, the whole subject lay apart from his official field of research."[36] Hopkins omitted to mention that Salisbury had also worked through Ferdinand Hitzig's *Die Grabinschrift des Darius zu Nakschi Rustam* (1847).[37]

David Tappan Stoddard (1818–1857)

A native of Northampton, Massachusetts, David Tappan Stoddard studied for a year at Williams College before entering Yale. Stoddard showed a keen interest and considerable skill in mechanics and astronomy. In 1837, while still a student, he "constructed from the crude materials, an excellent telescope, which he sold, to gain the means of constructing another upon a much larger scale."[38] In this he was encouraged by Benjamin Silliman, Professor of Chemistry and Natural History, and Denison Olmsted, Professor of Mathematics and Natural Philosophy, who urged him to "pursue my taste in this department," giving him "the privileges of an assistant, so that I have access at all times, to the college observatory, and the philosophical instruments, and am allowed to take observations with an experienced and careful man."[39]

In late February 1836, a letter was distributed at Yale from Dr. John Scudder who, together with Myron Winslow, had that year established a mission at Madras, India.[40] In the space of just a few days Stoddard experienced a spiritual epiphany. He graduated from Yale in 1838, having excelled academically, but although he was tempted to make a career in science, he decided to enter the ministry and began learning German and Hebrew while working as a Greek and Latin Tutor at Marshall College in Mercersburg, Pennsylvania.[41] The following year, he entered Andover Theological Seminary, where he continued with Hebrew, New Testament Greek, and Latin. In 1840, he returned to Yale as a tutor and completed his theological studies at New Haven Seminary. While visiting his eldest brother Solomon Stoddard, Professor of Languages at Middlebury College in September 1842, Stoddard preached in a service attended by Justin Perkins who, without hesitation, asked him to accompany him to Urmia, and after three interviews with the American Board of Commissioners for Foreign Missions in Norwich, Connecticut, his fate was sealed.[42] In the spring of 1843, the Rev. David T. Stoddard and his wife sailed from Boston for Smyrna (Izmir) in company with Dr. and Mrs. Perkins, who were returning to Urmia from a visit to the United States.[43]

In addition to being a devout Christian and committed missionary, Stoddard was a polymath. While at Urmia, he completed a "grammar of modern

Syriac as spoken in Oroomiah and in Koordistan," which was published in the *Journal of the American Oriental Society*.[44] The same volume that contained Stoddard's grammar also included a letter from him dated Urmia, July 8, 1856, in which he requested a review "by a competent person, which should point out its defects, which I am myself sensible are not few." Stoddard also announced that he was working on a study of the Hebrew spoken by the contemporary Jewish population in Iran.[45] Stoddard wrote to a friend, "By the way, do you know that I have made quite a splendid series of observations—more than ten thousand separate observations—on this climate? I have just been putting them in order, ascertaining the average temperature, the average height of the barometer and hygrometer, the prevailing direction of the winds, the amount of rain and melted snow, &c., and I shall forward the article to Professor [Denison] Olmsted for publication."[46] Of this work his biographer observed, "In making these observations, his mechanical invention and skill were put to the test in repairing barometers, thermometers, and other delicate instruments, which had been injured in transportation from the United States."[47] The work was published in 1855.[48] Stoddard may have been inspired by N. V. Khanikoff who, before taking up his post as the Russian Consul General in Tabriz, visited him "in the summer of 1852, to obtain information concerning the elevations and climates of these districts."[49]

Henry Lobdell (1827–1855)

Henry Lobdell was born in Danbury, Connecticut. When he entered Amherst College in 1845, he had already been teaching school and studying medicine since the age of sixteen.[50] Graduating in 1849, he soon went to Yale, where he continued his medical studies, becoming Doctor of Medicine in January 1850. While in New Haven, he also studied Hebrew and theology at the Yale Divinity School.[51] He then left to attend Auburn Theological Seminary in New York City, subsequently studying for short periods at both Andover Theological Seminary and Union Theological Seminary.[52] Upon hearing that the American Board's missions in China and Persia required three physicians, Lobdell wrote to them in July 1851 offering his services.[53] A month later, he was informed that Mosul, Iraq, was in need of his services, and in the same month he was ordained. By November 29, he and his wife were aboard the *Sultana*, bound for Smyrna (Izmir).

In May 1852, the Rev. Henry Lobdell and his wife arrived in Mosul.[54] In June 1853, Lobdell was given permission to travel to Urmia to escape the extreme heat of northern Iraq "for the improvement of his health."[55] On June 23 he noted:

> About half a mile from Sedekan, I discovered in a valley a basalt pillar, four feet high, fourteen inches thick, and twenty-eight inches wide, carved with small cuneiform characters, but very much defaced by the wear of the last two thousand years. I suppose no Frank ever saw it before.* The pillar was half covered up by bushes, but has considerable interest, inasmuch as it gives unmistakable evidence of having been erected by the same hero that set up the famous pillar of Kel-i-Sheen, to which we came on the following day, on the boundary line between Turkey and Persia.

And in his note demarcated *, Lobdell's biographer wrote:

> On his return to Mosul, Dr. L. wrote an account of this pillar to Col Rawlinson, at Baghdad. Col. R. replied that he had described it from reports of the natives some fifteen years ago, in an article on Ecbatana,[56] together with the pillar at Kel-i-Sheen. At a still later date, Oct. 24th, we find this entry in Dr. L's journal: "Since I wrote Col. R., I find in Dr. Grant's [Dr. Asahel Grant] journal a few words on the pillar of which I thought myself the first Frank discoverer. So true it is, 'there is nothing new under the sun.'"[57]

On June 24 he noted:

> After an hour's hard ride, we came to the azure pillar of Kel-i-Sheen on the top of the range, as we crossed into Persia. Here we halted about two hours.... I embraced the opportunity to copy a dozen specimens of the arrow-headed characters on the time-worn pillar to determine to what class they belong, as this alone, it would seem, will settle the question of their age. The stone is a very interesting one, and the inscription has lately been copied by a Russian gentleman [Khanikoff] and by Col. Williams [later General Sir William Fenwick Williams (1800–83)]. It is quite imperfect, though the block is of the hardest kind, and was originally polished like glass.*

And again in the note demarcated * we read, "An account of this journey from Mosul to Kel-i-Sheen was sent by Dr. Lobdell to the American Oriental Society, and only accidental circumstances have prevented its appearing in the journal of the Society. The Corresponding Secretary, Prof. Whitney [William Dwight Whitney (1827–1894), appointed Professor of Sanskrit at Yale in 1854, see below], says: 'It is an interesting and valuable document, and ought not to be withheld from the public.'"[58]

In May 1854, Lobdell was elected a Corresponding Member of the American Oriental Society.[59] Later that year at the Society's semiannual meeting in New Haven (October 18–19), a paper by Lobdell entitled "A Table of Scripture Proper-Names with Their Equivalents in Perso-Kurdish, with an Accompanying Letter on the Character of the Language of the Assyrian Inscriptions," was communicated.[60] After Lobdell had recovered from a serious illness, he traveled with the Rev. Joseph Gallup Cochrane of the Nestorian mission to Salmas en route to Tabriz. There he was able "to visit the sculptured rocks near the boundary, commemorating, as is supposed, some ancient conquest of Persia over her subtile and often formidable enemy, the Koord."[61] Lobdell also visited Maragheh. As his biographer noted, "The Doctor was allured to this out-of-the-way district by the prospect of finding in the monumental inscriptions, which occur at Mar Agha, something of historical or antiquarian interest."[62] The inscriptions in question may have been those adorning the Gunbad-e Surkh (1147 CE). As Lobdell's biographer observed, in addition to "some curiosities in literature"—a list of the Ottoman pashas of Mosul covering the preceding two centuries, "a specimen of Moslem genealogy," and the text of a prayer in Hebrew left by a pilgrim to the tomb of Nahum at Alqosh, circa 50 km north of Mosul—donated to the American Oriental Society, "he sent to the Society ... also coins, cylinders, and other relics of antiquity, which he had collected."[63] Lobdell was only twenty-eight when he died. As Justin Perkins wrote, "His inquiries embraced a very wide range. He was at once theologian and antiquarian, philologist, and naturalist, and most of all, missionary. Had his life been spared, he would have greatly distinguished himself, particularly as an Oriental and antiquarian scholar."[64]

William Dwight Whitney (1827–1894)

William Dwight Whitney was a native of Northampton, Massachusetts, who proceeded to Williams College and had a distinguished career at Yale where, on May 10, 1854, he was elected to a newly established "Professorship of the Sanskrit and its relations to kindred languages, and Sanskrit literature" in the Department of Philosophy and the Arts. In making this appointment, the responsibility for teaching Sanskrit—formerly assumed by Salisbury—was separated from the latter's teaching duties and vested in Whitney, who had been his student. The announcement of courses in philology for the autumn semester of 1854 included the following: "Professor Whitney will give instruction in Sanskrit from Bopp's Grammar and Nalus, or such other text-books as may be agreed upon, and in the rudiments of the Ancient and Modern Persian, and of the Egyptian languages."[65] What was meant here by "Ancient Persian" is not entirely clear, for in his sketch of ancient Iranian languages, it is clear that

Whitney was familiar with both Old Persian (Achaemenid) and Avestan.[66] Given the fact that, in the same semester as the abovementioned course was offered, Whitney read a paper entitled "On the Avesta or the Sacred Scriptures of the Zoroastrian Religion" before the American Oriental Society on October 18, 1854,[67] it is probably safe to surmise that Avestan was meant in this case. Whitney's overview of Avestan, the Avesta, other works of Pahlavi literature, and Zoroastrianism demonstrate that he was well read in all of the contemporary and earlier European literature on topics that fall squarely into the realm of what we would today recognize as Iranology.[68] Interestingly, H. C. Tolman (see below) later worked as Whitney's assistant.[69]

John Haskell Shedd (1833–1895)

John Haskell Shedd, an Ohioan of New England background, was born in Mount Gilead, Ohio. He enrolled at Ohio Wesleyan University (1852–53) before moving to Marietta College, from which he graduated in 1856.[70] Thereafter, he studied theology at Lane Seminary (Cincinnati, Ohio; 1856–58) and Andover Theological Seminary (1858–59). Shortly after marrying Sarah Jane Dawes on July 28, 1859, he was ordained in August 1859.[71] A few months later, Shedd and his wife embarked for Iran to join the mission in Urmia.[72] At the 1871 meeting of the American Oriental Society in New Haven (October 12–13), the directors presented "copies of a circular prepared by a committee appointed by the Directors and sent during the past summer to all American missionaries in Eastern countries, urging on them a continuance and increase of the active and fruitful interest which they have generally taken in the Society, from the time of its first establishment."[73] Shedd enthusiastically embraced the scientific aims of the American Oriental Society, which for the 1871 meeting included an exhibition of a "collection of objects of archaeological interest, brought from the border-lands of Turkey and Persia by Rev. J. H. Shedd, of the Orûmiah mission" and a "reading of Mr. Shedd's letter of explanations respecting them." While some of the objects were from Gawar (modern Yüksekova, Hakkari Province, Turkey), others came from a cave discovered accidentally by a villager at Geogtapa (Gogtapeh) near the village of Urmia during the construction of an oven, when he "struck a large flat stone, which he and his neighbors removed with some difficulty." Beneath this was "a vault, several feet in length and three or four in height." In addition to fragmentary bones and a few ceramic vessels, one of which was spouted ("resembling a teapot"), the tomb contained

> large quantities of beads ... some valuable gold ear-rings and other ornaments; and, most singular of all, at what might have been the head and

feet of the corpse, two copper rings, weighing about six pounds each... of hammered copper, very round, larger in the middle, and with the ends not joining so as to form a complete circle, but having between them a space of the third of an inch. Two other such rings were at the supposed sides of the corpse, and then, running from head to foot on each side, was a line of copper rings, complete circles, and of much smaller size. There were over a hundred of these smaller rings, standing upright side by side, and so close that they were rusted together.[74]

In addition to a notice describing the tomb and its finds at Geogtapa written by his son, Ephraim C. Shedd (see below), the *Journal of the American Oriental Society* contained excerpts from a paper submitted by J. H. Shedd, reporting on "a tour made in March–May, 1870" from Urmia to Hamadan.[75] As Shedd's original paper was apparently "very long and detailed," the Corresponding Secretary read "considerable extracts... with condensed statements of its other principal contents." After some largely ethnographic remarks about the Armenian, Jewish, and other groups living along his route, Shedd noted, "There are localities where the soil is so rich in fragments of silver and gold, coins, and other antiquities, that it is sold by the donkey-load.... The sum of ten or twelve hundred dollars would now buy a very complete and valuable collection of these precious relics."[76] Shedd gave "a detailed account" of the tomb of Esther and Mordecai (which was not read, or at least not printed). On his return, Shedd "visited the remarkable caves of Karaftu, but does not attempt to add anything of consequence to the account of them given by Sir R. K. Porter [Robert Ker Porter]."[77]

Not mentioned in this context were Syriac manuscripts and other specimens of writing acquired by Shedd. These included a parchment or paper scroll (200 × 6 cm) and a second, smaller one (measuring 127 × 7 cm), which are today in Houghton Library, Harvard University. Both of these manuscripts (Syr 159 and 158) are described as collections of charms, such as a "charm of Mar George, accompanied by a picture of the Saint on horseback transfixing a serpent," a "charm of Mar Abd 'Isho' the anchorite, accompanied by a picture," a "charm beginning with John 1.1," and a "charm for one who has some disease."[78] These objects were obtained around 1890–92 as a result of a request by David Gordon Lyon (1852–1935), Hollis Professor of Divinity at Harvard, who wished to acquire material for Harvard's Semitic Museum. Lyon wrote to Shedd on January 13, 1890, while the latter was on leave in the United States "to enquire about obtaining Syriac manuscripts for the collection."[79] Apart from his own desire to expand Harvard's holdings, Lyon was probably actuated by the extracts from Shedd's letters that had been published in 1889 by Isaac Hollister Hall (1837–1896; see below), in which Shedd explained "the effort...

being made by the Missionary College at Oroomia Persia, to obtain a copy of every work still existing among the Nestorians in the Old Syriac language; also to secure valuable ancient manuscripts."[80] The first of Harvard's acquisitions was published by Willis Hatfield Hazard (1866–1950), a graduate of Haverford College (1887) and the General Theological Seminary (1891, PhD 1894) who had presented his results in a paper to the American Oriental Society on April 21, 1892.[81] Eventually, many of the manuscripts acquired by Shedd were sold to Harvard and the Andover Newton Theological School (see below). Robert Dick Wilson (1856–1930), the eminent theologian brother of Samuel Graham Wilson (see below) and student of Eduard Sachau, purchased at least thirteen manuscripts from Shedd, all of which ended up in private collections.[82] Wilson was himself the author of a Syriac teaching manual and grammar.[83]

Isaac Hollister Hall (1837–1896)

Isaac Hollister Hall, who came from Norwalk, Connecticut, was educated at Hamilton College in upstate New York and at Columbia University, where he graduated from the Law School in 1865. Thereafter, he served as a professor of English at the Protestant College in Beirut. In 1884, he was appointed curator of the Department of Sculpture and the Department of Casts at the Metropolitan Museum of Art and served simultaneously as a lecturer in New Testament Greek at Johns Hopkins. According to his obituary in the *New York Times*, "He was considered a great authority on Greek, Phoenician, Himyaritic, and other Oriental inscriptions, and in 1876 discovered in Beyroot, Syria, a Syriac manuscript of the Gospels, Acts, and most of the Epistles."[84] At the time of his death, Hall "possessed at least 26 East Syriac manuscripts, probably all acquired through Shedd."[85] In 1900, twenty-one of these were sold to Harvard by Hall's widow, while a year later five more were sold to the Andover Newton Theological School.[86] Hall published a number of Syriac manuscripts acquired by James E. Rogers (see below) during his tenure in Urmia, though it is not always clear if they came from Urmia and its environs.[87]

Lawrence Heyworth Mills (1837–1918)

Lawrence Heyworth Mills was born in New York City, educated at New York University, and ordained as an Episcopal minister at the Theological Seminary in Fairfax, Virginia. He served the church between 1861 and 1872 before moving to Florence, where he lived until 1877 when he went to Germany. At the request of the great Orientalist James Darmesteter, he took over the translation of the

Gāthas, which appeared as the thirty-first volume in the series Sacred Books of the East. In 1887 at the invitation of Max Müller,[88] he moved to Oxford, where he was active in acquiring for the Bodleian Library what was at that time the earliest known manuscript of the Yasna. In 1898, he became Professor of Zend Philology at Oxford, a position that he held until his death in 1918.[89]

Joseph Plumb Cochran (1855–1905)

Joseph Plumb Cochran was born in Iran, the son of the Rev. and Mrs. Joseph G. Cochran, whose work as missionaries at Urmia had begun in 1848.[90] He grew up at Seer (Seir) approximately six miles from Urmia, becoming a fluent speaker of Persian, Azeri Turkish, Kurdish, and Assyrian (Neo-Aramaic).[91] When he was fifteen, Cochran came to the United States, completing his high school education in Buffalo, New York, and eventually receiving his MD from Bellevue Medical College in New York before working at Kings County Hospital. In 1878, following his marriage to Katharine Hale of Minneapolis, Cochran was appointed missionary in Urmia by the Board of Foreign Missions of the Presbyterian Church in the United States of America.[92] Cochran founded Westminster Hospital in Urmia,[93] and he was "in charge of the medical work of the station" for a quarter of a century.[94] In addition, he served as president of Oroomiah College.[95] Described as "a godly man, who is known in all Persia,"[96] Cochran received "the highest degree that is possible to give to a foreigner" from Nasr ed-Din Shah.[97] "He was a man who loved Persia, a favourite of the Persian people, without regard to religious affiliation, and who gave his life for the social, moral, and spiritual regeneration of all classes," wrote J. G. Wishard, director of the American Presbyterian Hospital in Tehran. "The writer was at the Court when the death of this good man was announced... and he can testify to the manifestation of sorrow expressed on every hand at his untimely demise."[98]

In the autumn of 1881, Cochran visited the site of Rayy. His biographer R. E. Speer described Cochran's visit as follows: "Quite a party of us visited the ruins of ancient Rhei or Rhages, about ten miles out of the city [Tehran]. History tells us that this was the largest city east of Babylon, 500,000 inhabitants lived in it a thousand years ago. Part of the walls of the city stand, and two or three towers, on one of which are Cufic inscriptions."[99]

James Elcana Rogers (1856–1938)

James Elcana Rogers, from Sale Creek, Tennessee, entered Maryville College in Maryville, Tennessee in 1878, where he was also employed (in 1878–79) as

a tutor in French.[100] From 1879 to 1882, he attended Union Theological Seminary in New York City.[101] Ordained in 1882, he joined the Urmia mission in the same year, remaining until 1885.[102] Over a dozen Syriac manuscripts obtained by Rogers were later acquired by Union Theological Seminary.[103]

After leaving the mission, Rogers obtained a PhD at the University of Liège (1886) and later had appointments at Maryville College (1887–90),[104] during part of which time he served as Chairman of the Faculty while holding the Chair of Natural Sciences, French, and German and later the Chair of Ancient and Modern Languages.[105] He also worked at Blackburn University (1893–1907) in Carlinville, Illinois, and Carroll College (1908–38) in Waukesha, Wisconsin.[106]

Samuel Graham Wilson (1858–1916)

Samuel Graham Wilson was born in Indiana, Pennsylvania. After graduating from Princeton (AB 1876, AM 1879), he trained in theology at Western Theological Seminary in Allegheny, Pennsylvania (1876–79) and Princeton Theological Seminary (1879–80). Ordained in the same year, he traveled shortly thereafter to Tabriz, where he served as Principal of the Memorial Theological School.[107] An expert on Baha'i religion and contemporary Islam, Wilson received honorary Doctorates of Divinity from Western University and Grove City College in 1906. In 1895, he published a vivid account of the "ash mounds" of Geogtapa, describing himself as

> greatly attracted to the ash-hills of the fire-worshippers. Of considerable size, associated with an unknown past, they seem appropriate to the place where Zoroaster was born, and where the Emperor Heraclius (A.D. 625) destroyed a magnificent fire-temple, along with the city. I visited ash-hills at Degala, at Geogtapa, and at Sheikhtapa. They have been much excavated, and for centuries the ashes have been used as fertilizers. Coins, earrings, and bracelets of copper and gold, bowls, lamps, and other earthen utensils have been unearthed. Pieces of broken pottery are dug up continually and are lying about. Bones of men and animals are also excavated.[108]

Wilson also noted, "Upon the mountains, near the border of Turkey, is an interesting rock with a cuneiform inscription"[109]—most probably referring to the Kelishin Inscription—suggesting that he visited the site. His brother was the theologian Robert Dick Wilson (see above).

Abraham Valentine Williams Jackson (1862–1937)

Of all the figures described here, Jackson is unquestionably the individual whose scholarly, Iranological reputation stands head and shoulders above the rest. Given the breadth of Jackson's achievements and publications, all of which are well documented, this review will necessarily be only a brief summary.[110]

Abraham Valentine Williams Jackson, known to his friends as "Will," was born and died in New York City, close to Columbia University where he spent his entire career (AB 1883, AM 1884, LHD 1885, PhD 1886, LLD 1904) apart from periods of study in Germany. Jackson was appointed an instructor in Indo-Iranian Languages in 1886, and from 1887 to 1892 he studied Sanskrit and Avestan with Richard Pischel in Halle and Karl Friedrich Geldner in Berlin.[111] In 1895, Columbia reorganized some of its language departments, establishing a Department of Indo-Iranian Languages and Literatures headed by Jackson. He visited Iran on a number of occasions, and although Iranian religion was his pet subject,[112] he published on a wide array of different topics. Early in his career, his publications were almost entirely concerned with the Avesta, but as time went on he began to publish increasingly on Zoroastrianism and, to a lesser extent, Sanskrit literature and India. By 1893, it was said of him by H. C. Tolman (see below) that, "In these recent years there has been such an advancement in this line of scholarship [Iranology] that Sanskrit students have been compelled to surrender this field to specialists among whom in America the name of Dr. A. V. Williams Jackson of Columbia College is conspicuous."[113]

Jackson's visits to Iran (1903 and 1907–8) provided the material for two of his richest works, *Persia Past and Present* and *From Constantinople to the Home of Omar Khayyam*.[114] It is impossible to do justice to the many observations made at sites visited or the multiplicity of topics in which he was interested, ranging from Iran's most ancient past to its state in the early twentieth century. Nevertheless, a perusal of the illustrations published in *Persia Past and Present* reveals an impressive line-up of archaeological sites visited by Jackson, including Salmas, Takht-e Suleiman, the Ganj Nameh inscriptions, Bisotun, Taq-e Bustan, Kangavar, Pasargadae, Naqsh-e Rustam, Persepolis, and Rayy. During his latter journey, which concentrated on northern Iran and the Caucasus, many historically important sites were examined as well, though these tended to be less archaeological in nature than those seen on his earlier visit. Jackson was accompanied on his second journey by his friend Alexander Smith Cochran (1874–1929). An 1896 graduate of Yale, Cochran had inherited a fortune (his family owned one of the largest carpet factories in the world) and

donated money to a wide range of philanthropic causes both in America and in Great Britain. As Jackson wrote, "It was at the Charity Ball in Yonkers, my home on the Hudson, that I chanced to be talking with my friend Alexander Smith Cochran, about the success which the evening had proved despite the furious storm of snow that raged outside with all the violence of early January. Somehow—perhaps recalling snows I had encountered in Iran—our conversation veered to travel in the Orient, and a moment later we had resolved to take a trip together to Persia and Central Asia, starting in the spring."[115] During this trip, Cochran purchased twenty Persian as well as two Arabic and two eastern Turkish manuscripts, which he donated to the Metropolitan Museum of Art in March 1913. As Jackson and A. Yohannan wrote, "All of the codexes are handsomely illuminated and are adorned with beautiful miniatures, the entire collection containing much that is of interest to students of art, literature, and history. A number of the manuscripts are in certain respects unique."[116] Given the fact that the museum at the time possessed only a single Persian manuscript, the significance of Cochran's gift can scarcely be overestimated. The gift included five different manuscripts of Ferdowsi's *Shahnama*, six manuscripts containing some or all of Nizami's works, a volume of Rumi, one of Hafiz, two of Sa'di, and four of Jami.[117] Also included in the collection was a Qur'an transcribed by Temür's grandson, Ibrahim Sultan, that had once been in the possession of the Mughal emperor Aurangzeb.

In 1903, Jackson visited Geogtapa, noting:

> A Christian church, erected by the Nestorians, now crowns the summit of this ancient ash-hill, and the minister, Mr. Morehatch, an Assyrian Christian born near Urumiah, told me that when the workmen were excavating for the foundations of the church they came across an underground chamber built of stone and containing a carved hollow cylinder three or four inches high. The stone vault, he explained, had been filled up in order to make the foundation of the building more secure, and the image had been purchased and sent to America. On my return home I found that this cylindrical bas-relief is now preserved in The Metropolitan Museum of Art in New York City, and that my friend, Dr. William Hayes Ward had given a detailed description of it.... I examined the cylinder a number of times.[118]

Although these observers were all convinced that the mounds in question consisted of pure ash, A. V. Williams Jackson noted:

> It is common, when speaking of this and the other ash-hills around Urumiah, to say that they are composed "entirely of ashes," but from my

examination in the present instance, and my investigations in others, this term is to be taken relatively. I believe therefore that Dr. Ward, even though he had not seen them, was right in his impression that they are composed rather "of clay which has become mixed with ashes and saturated with nitrous salts of organic composition."... There is every reason to assume that these elevations were surmounted by sanctuaries dedicated to the worship of fire, even if we do not agree in every detail with the natives, who unanimously attribute the vast accumulation of ashes to the accretions from the fire-temples, the ashes having been scattered over the hill age after age.[119]

Cuts in one of the mounds visited by Jackson allowed him to examine its stratigraphy. "It consists of soft earth with stratum upon stratum of solid ashes at varying depths and several feet thick," he wrote. "There is little stone in the mass, but in former times some stone buildings stood on top of the hills, and the village of Degalah is built largely from the stones of these.... Potsherds by the hundreds were lying at the bottom and about the mouth of every pit, but I could not learn of a single instance where any inscribed tablet or cylinder had been found among the layers of earth and ashes."[120]

In 1918, Jackson and his wife participated in the American-Persian Relief Commission. The Commission had been established "with the intent of endeavoring to remedy conditions in Persia resulting from famine, pestilence, and war" and "to study the situation and organize relief on a more definite basis and on a larger scale" than that achieved by the American Committee for Relief in the Near East, the successor to the American Committee for Armenian and Syrian Relief.[121] After arriving in Baghdad in September 1918, Jackson's wife "was most glad to meet Miss Bell who is in the Political Office here, and remarkably intelligent. She told Will his 'Persia, Past and Present' had been her constant companion in Persia and she had known it for a long time."[122] After arriving in Tehran, Mrs. Jackson wrote in her letter of December 14, 1918, "The nicest luncheon was given by an uncle of the Shah [Ahmad Shah Qajar], the only other guests, besides ourselves, being his three brothers. It was out in the country at the place I mentioned, called Rei, which was formerly a great city centuries before Christ. This Prince owns the site and gave us each a gold coin, a very old one, which had been dug up there. It was a perfect day, and the mountains were dazzlingly beautiful."[123] The American missionary Arthur C. Boyce, who assisted the Committee in Iran, wrote that "Professor Jackson's scholarship in things Persian and deep sympathy for the Persian people ... greatly enhanced the name of America."[124]

William Ambrose Shedd (1865–1918)

William Ambrose Shedd, son of John Haskell Shedd (see above), was born at Mount Seer near Urmia in 1865. Like his father and younger brother, Ephraim Cutler Shedd (see below), he graduated from Marietta College (1887), after which he spent two years working with his parents in Iran before returning to America to study at Princeton Theological Seminary, from which he graduated in 1892. Directly thereafter, he returned to Iran, where he lived for the rest of his life apart from a furlough in 1902–3, two years recuperating for poor health (1910–12), at which time he was awarded an honorary Doctor of Divinity by his alma mater,[125] and a year (September 1915–16) spent in the United States recuperating from the Ottoman siege of Urmia and attempting to inform the American government of the situation there. Shedd's heroics in defense of the Christian community of Urmia largely overshadow his achievements in studies of Islam and Islam-Christian relations.[126] He himself said, "I have found out long ago that writing and studying have to be subordinate parts of my life, and I try to accept it without grumbling and keep on writing and studying when I can."[127] Nevertheless, the lectures that he delivered in 1902–3 at Princeton Theological Seminary, Auburn Theological Seminary, McCormick Theological Seminary, Presbyterian Theological Seminary (Kentucky), and Chicago Theological Seminary on "Historical Relations of Islam and the Oriental Churches" were published as *Islam and the Oriental Churches*.[128] Less successful was the concordance to the Peshitta, upon which Shedd worked for years. As Prof. Duncan B. MacDonald of the Hartford Theological Seminary noted:

> This was one of the great undertakings of scholarship and its destruction is one of the greatest blows that Semitic scholarship has ever received, and it is to be reckoned among the historic calamities of learning.... [T]his Concordance would have been a basis for any future critical edition of the Peshitta and would have put the lexicography of Syriac on a new footing. In it the glory of the ancient Nestorian community would have been revived in the scholarly labors of its last descendant. And it is in a sense fitting, if also heartbreaking, that this last monument of Nestorian scholarship should have passed away in the destruction of the Nestorian race.... When the war finally broke out, the work was ready for the printer and had been tested and corrected throughout. Dr. Shedd was occupied in reviewing the corrections when he was compelled to stop. The story of the destruction of the MS. is part of the story of the destruction of the Urmia Mission.[129]

After his father's death, William Ambrose Shedd continued acquiring manuscripts as his father had done. In 1905, he sold some to the British Quaker, scholar, and collector James Rendel Harris (1852–1941),[130] who in turn sold about ten of them to the Harvard Semitic Museum.[131]

Herbert Cushing Tolman (1865–1923)

Herbert Cushing Tolman was born in Norwell (at the time South Scituate), Massachusetts. His family moved in 1879 to Hanover, Massachusetts.[132] After attending public school there, Tolman went to Yale (AB 1888), where he studied Sanskrit with William Dwight Whitney (see above) for five years. After graduation, he worked there as a fellow and assistant in Indo-European Languages (1888–91). He received his PhD from the same institution in 1890. Thereafter, he served as Assistant Professor of Sanskrit and Instructor in Latin at the University of Wisconsin (1891–93), Professor of Sanskrit at the University of North Carolina (1893–94), and finally Professor of Greek at Vanderbilt University from 1894 until his death.[133] He studied in Germany on two occasions, once in Berlin (1896) and once in Munich (1905), and received a Doctor of Divinity from the University of Nashville in 1901 as well as an honorary doctorate from Hobart and William Smith Colleges in 1913.[134] Tolman's Iranological publications were generally derivative and more intended as learned summaries than original scholarship. Thus, at the beginning of his *Guide to the Old Persian Inscriptions* he states, "This book does not claim to be a contribution to Iranian subjects," and "My work in the Zend Avesta and in the dialects of Persia has been simply an avocation from my chosen field of Sanskrit."[135] Nevertheless, as he noted in 1892, "The Old Persian language deserves a larger place in American scholarship than it has yet received. Heretofore the work has been left entirely to European scholars."[136] And again in 1893 he wrote, "No book has been published in English containing the grammar, text and vocabulary of all the Old Persian Inscriptions,"[137] a statement that was only partly correct considering the fact that George Bertin's grammar of Old Persian had been published in England in 1888.[138] Tolman's *Ancient Persian Lexicon* shows that he was not only fully aware of European scholarship on Old Persian but also had read the works of G. Hüsing, P. Jensen, F. Bork, and V. Scheil on Elamite which he had used "perhaps with too great caution" given the inadequate understanding of the language at that time, notwithstanding the great increase in texts thanks to the French excavations at Susa.[139] Tolman also reveals that he was in direct correspondence with F. H. Weissbach.[140] His overview of the Bisotun Inscription carefully compared new readings suggested

by King and Campbell Thompson's collation of the texts with earlier statements by Rawlinson and others.[141] In December 27–30, 1912, Tolman delivered a paper entitled "The Grave Relief of King Darius" at the annual meeting of the American Institute of Archaeology. Although it was announced that "The paper will be published in full in a work which the writer is preparing on the Ancient Monuments of Persia,"[142] this work apparently did not appear in Tolman's lifetime. In 1899, Tolman and his Vanderbilt colleague James Henry Stevenson brought out a student's guide to those portion of Herodotus's *Histories* concerned with the ancient empires of Babylonia, Assyria, and Persia, which was based on Johannes Nikel's then recently published study *Herodot und die Keilschriftforschung*.[143] Finally, a paper on Pasargadae, written by Tolman for the second Sanjana memorial volume, appeared posthumously.[144]

Ephraim Cutler Shedd (1873–1951)

Ephraim Cutler Shedd, a son of John Haskell Shedd (see above), was born in Charlotte, North Carolina. Valedictorian of Marietta College in Ohio (1893), which his father had also attended, he received an AM from Princeton Theological Seminary in 1896. He served as an instructor in Latin and Greek at Lewis Academy in Wichita, Kansas, from 1898 to 1900,[145] publishing two manuals for school Latin instruction as well as at least one article combining biblical and Assyriological scholarship and a children's book set in Iran.[146] In 1900, he moved to Rye, New York, where he married and taught Latin and Greek at Heathcote Hall.[147] Eventually, he gave up teaching and became an accountant for the Virginia Shipbuilding Corporation (est. 1917), which constructed merchant vessels during World War I,[148] later settling in Alexandria and Petersburg, Virginia.[149]

In 1888 at the age of sixteen, Ephraim Shedd contributed a note on a poplar tree in Salmas consisting of two separate trunks, which united about three meters off the ground and concerning which he states that "the people hold . . . sacred, saying that if a man sick with fever crowd between the two trunks seven times he will be cured!"[150] In the same year, he wrote to the American scholar William Hayes Ward with a description of a corbel vaulted tomb of unworked stone that had been discovered during the construction of a well intended for use by a new church being constructed on "Geog-tepe Hill."[151] According to Shedd's letter, quoted verbatim by Ward, the diggers at Geogtapa had come upon a room around 19′3″ long (5.87 m) and 7′3″ wide (2.21 m) at the base, tapering to a width of 4′3″ (1.3 m) at the highest preserved point with walls standing up to 7′2″ (2.18 m). The stone blocks from which it was built measured generally 2.5–3.5′ × 1′ (0.74–1.04 × 0.30 m), and the floor had

a flagstone paving. The principal interest of this tomb resided in the fact that it yielded a "cylinder ... of translucent alabaster ... 94 millimeters long, and 59 mm. in diameter" with walls around 6 mm thick. Somewhat mysteriously, Ward noted that, "The entire surface without and within was coated with black paint, or bitumen, of which considerable patches remain."[152] Although Ward published four photographs of this deeply carved object, and the size might suggest it was a cylinder seal, his study identifies it as a "Babylonian cylindrical bas-relief," while his later publication of cylinder seals identifies the object as a "a little cylindrical pyx of alabaster."[153] By the time Ward published his study of this piece, it had entered the collection of the Metropolitan Museum of Art. According to Samuel Graham Wilson (see above), of whom it was said that "few men have toured Northwestern Persia more widely than he,"[154] this object "was purchased from the owner of the village."[155]

One impression of Geogtapa that seems to have struck all Western visitors was the notion that the hills there and at nearby Degala consisted entirely of ash. As Shedd wrote to W. H. Ward:

> Over the entire plain of Urumia are scattered ash-hills of various sizes, to the number, at least, of twenty-five or thirty, and others are found on the plain of Sulduz, south of Urumia, but none to the north, in Salmas. These hills are, in some cases, composed entirely of ashes; in others the ashes have been added to a small natural eminence.... Since the beginning of this century, the inhabitants have used these ashes to fertilize their fields, and a very large amount of broken pottery, and some brick and stone walls, have been continually uncovered, the stone being removed and sold.... Degala Hill is composed entirely of ashes: it is about 100 feet high and 1000 feet long.[156]

Although his date of death is unclear, he was resident in Chicago as late as 1936.[157]

Edwin Lee Johnson (1874–1947)

Edwin Lee Johnson was born in Mount Vernon, Illinois. His family moved to Oxford, Mississippi, where he attended high school, and he graduated from the University of Mississippi in 1894 (AB). He pursued his studies at Vanderbilt with H. C. Tolman, receiving his AM in 1900 and his PhD in 1910. From 1896 to 1898, Johnson taught at Quitman College in Arkansas, and from 1902 to 1904 and from 1904 to 1909 he taught at the Alexander Institute in Jacksonville, Texas. In 1909, he became a fellow and assistant in Greek at Vanderbilt,[158]

later becoming Assistant Professor of Latin and Greek.[159] During this time, Johnson also compiled the *index verborum* accompanying Tolman's cuneiform supplement to his ancient Persian lexicon.[160] In 1935–36, he served as Secretary-Treasurer of the Tennessee Philological Association.[161] Johnson's dissertation was a grammar of Old Persian, which was published in revised form as *Historical Grammar of the Ancient Persian Language* in 1917. One reviewer noted, "In comparison with A. Meillet's *Grammaire du Vieux Perse* [1915], which emphasizes the inflectional forms and the syntax, the distinctive feature of Dr. Johnson's grammar is the historical treatment of the subject. Of especial interest is the chapter on the decipherment of the inscriptions, showing how the determination of the cuneiform characters was brought about by the combined labors of English, French, and German scholars after nearly fifty years of patient, persistent toil."[162] Roland G. Kent compared Johnson's grammar positively in some respects to Meillet's grammar, noting that, "For etymological comparisons and studies, one finds Johnson's work the more usable," while finding that "Johnson's procedure is very extravagant of space, often hiding the ancient Persian needle in an Indo-European or Aryan haystack."[163]

Louis Herbert Gray (1875–1955)

Born in Newark, New Jersey, Louis Herbert Gray received his AB from Princeton in 1896. Thereafter he studied Indo-Iranian philology with A. V. W. Jackson at Columbia, obtaining his AM in 1898 and his PhD in 1900. A linguistic polymath, he published widely on Iranian philology, poetry, and religion.[164] After working as chief cataloger and instructor in Indo-Iranian at Princeton (1900–2), he was employed as an editor (*New International Encyclopaedia, The Jewish Encyclopaedia, Schaff-Herzog Encyclopaedia of Religious Knowledge, Hastings' Dictionary of Religion and Ethics*). After World War I, he served as expert member and advisor on Near Eastern affairs in the American Peace Commission in Paris. Gray was appointed in 1921 to a position in philology at the University of Nebraska, where he remained until 1926 upon accepting a chair at Columbia, where he taught until he retired in 1944.[165] Early in his career he attended many of the most important scholarly meetings in Europe (International Congresses of Orientalists in Rome [1899], Hamburg [1902], and Algiers [1905]; Congress for Comparative Religion in Basel [1904]),[166] and while working for James Hastings he lived in Aberdeen, Scotland. However, despite his great interest in Iranian matters he never visited the country.

Roland Grubb Kent (1877–1953)

Roland Grubb Kent was born in Wilmington, Delaware. At the age of only fifteen, he entered Swarthmore College, graduating in 1895 and obtaining an MA in 1898. He then studied Greek epigraphy, ancient history, and archaeology in Berlin and Munich before spending 1902 at the American School of Classical Studies in Athens. Thereafter he returned to the United States and obtained his PhD at the University of Pennsylvania in 1903, where he continued to hold a series of appointments, including the Harrison Fellow in Classics (1903) as well as Professor of Comparative Philology (1909–42) and Indo-European Linguistics (1942–47) with visiting positions elsewhere throughout his distinguished career.[167] A founding member of the Linguistic Society, which he served faithfully from its inception until his death, Kent was a linguistic polymath, whose *Old Persian: Grammar, Texts, Lexicon* is still widely consulted to this day.[168] Kent published shorter papers on Old Persian,[169] and he also produced reviews of Johnson's *Historical Grammar of the Ancient Persian Language* and Stonecipher's *Greco-Persian Names*.[170]

Augustus William Ahl (1885–1976)

Augustus William (Wilhelm) Ahl, who was born in Germany, immigrated with his parents to the United States. As a young man, he returned to Germany where he studied theology at Breklum Seminary in Breklum, Schleswig-Holstein, Germany, graduating in 1908. He was listed as "Wilhelm Ahl" from "Breklem [sic], Germany," a member of the Middle Class in the Theological Seminary of Susquehanna University.[171] From May 1912 to October 1916, he was pastor of St. John's Lutheran Church in Parkville, Maryland.[172] Meanwhile, he received an AM in 1912 at Susquehanna University, and he earned a PhD under H. C. Tolman at Vanderbilt in 1920.[173] He taught at Thiel College (1922–27) and Susquehanna University, where he was appointed Professor of Greek and Bible in 1927.[174] In 1922, he published a survey of Achaemenid history based principally on the cuneiform evidence, and a decade later delivered a paper on the problem of Cyrus's identity.[175]

Alvin Harrison Morton Stonecipher (1888–1981)

Alvin Harrison Morton Stonecipher was born in Harrison County, Indiana. He received his BA from Vanderbilt University in 1913 and an MA in 1914.[176]

By the time he received his PhD in 1917 for a thesis entitled *Graeco-Persian Proper Names*, his family had moved to Kenton, Tennessee.[177] He served as Professor of Modern Languages at Indiana Central University from 1913 to 1932.[178] In 1918, Stonecipher's revised dissertation on Greco-Persian names appeared.[179] As Roland G. Kent noted in the *American Journal of Philology* with reference to Tolman, the volume "gives still further testimony of the scholarly productivity which one enthusiastic teacher may evoke in a little frequented field of knowledge."[180] In 1962, Stonecipher received an honorary doctorate from Lebanon Valley College,[181] where he had served as a professor of Latin and Dean from 1936 to 1952, later serving as an advisory dean and Chairman of the Department of Foreign Languages as well as a professor of German.[182]

Conclusion

In his classic *Persia Past and Present*, A. V. W. Jackson cited only two works by American writers—Justin Perkins's *A Residence of Eight Years in Persia* of 1843 and Samuel Graham Wilson's 1895 study, *Persian Life and Customs*. That more were not cited, given the number of American missionaries in Iran, is perhaps surprising. After all, virtually every British military officer and diplomat stationed in Iran seems to have written one or more accounts of his travels, often with detailed information on archaeological and historical monuments visited with drawings and photographs. By 1887, moreover, American missionaries were based at Urmia, Tabriz, Hamadan, and Tehran.[183] Many reported on extensive travels, usually on horseback, in areas that are replete with ancient monuments. Nevertheless, if one compares the quantity of notices on antiquarian matters in American accounts to those of British officers and diplomats, the number is insignificant. I think there is, however, a very simple explanation for this. It has nothing to do with their education—most missionaries had excellent linguistic preparation and had received both university as well as seminary educations. Rather, the American missionaries who went to Iran were fiercely dedicated to their aim of bringing religious enlightenment to their flocks. Unlike Rawlinson, who took every opportunity to visit and describe ancient sites, most of the Americans mentioned above seem to have engaged in such recreation only very occasionally. Though they had ample opportunity to visit places of archaeological and historical interest, and undoubtedly did so, their writings show an overriding concern for the welfare of the people to whom they ministered. Only rarely did they allow themselves the luxury of putting their spiritual responsibilities aside and focusing for a brief time on the ancient past of the land in which they labored.

With the exception of Jackson, virtually all of the work in Iran itself reported upon here was conducted by American missionaries. Academic study, on the other hand, grew out of Sanskrit, Avestan and Classical or Indo-European Studies, as pursued by scholars like William Dwight Whitney, Herbert Cushing Tolman, Edward Salisbury and Roland Kent. Although Tolman's achievements were considerable, Jackson must be regarded as the true founder of Iranology in America. The work of these scholars clearly shows that, when the first flush of exploration and excavation by American archaeologists and art historians began in the 1920s, a good deal of preparatory work had already been accomplished at American universities.

Notes

1. Ackerman, *Guide to the Exhibition*, 34.
2. Rizvi, "Art History and the Nation," 48; Frye, "Asia Institute, Bulletin of"; Frye, "Asia Institute."
3. E. Smith, *Researches of the Rev. E. Smith*; Speer and Carter, *Report on India and Persia*, 314.
4. Smith and Dwight, *Missionary Researches in Armenia*, 357.
5. Smith and Dwight, *Missionary Researches in Armenia*, 410.
6. H. M. Perkins, *Life of Rev. Justin Perkins*, 10.
7. Tyler, *History of Amherst College*, 167; J. Perkins, *Residence of Eight Years*, 27.
8. *Nestorians of Persia*, 32.
9. J. Perkins, "Letter from Mr. Perkins," 61; J. Perkins, *Residence of Eight Years*, 34.
10. J. Perkins, *Residence of Eight Years*, 196.
11. J. Perkins, *Residence of Eight Years*, 196.
12. Lathrop, *Memoir of Asahel Grant*, 46.
13. J. Perkins, *Residence of Eight Years*, 339.
14. Rawlinson, "Notes on a Journey."
15. J. Perkins, "Journal of a Tour," 76.
16. Müller, "Memoir," 518.
17. J. Perkins, "Aus Briefen an Prof. Fleischer [1853]"; J. Perkins, "Aus Briefen an Prof. Fleischer [1854]."
18. Tyler, *Memoir of Rev. Henry Lobdell*, 283.
19. Anderson, *History of the Missions*, 2:117.
20. Perkins, "Aus Briefen an Prof. Fleischer [1854]," 602.
21. Johnson, *University Memorial*, 249–50; Hayden, *Genealogy of the Glassell Family*, 371.
22. Hayden, *Genealogy of the Glassell Family*, 371.
23. Grant, *Nestorians*, 7.
24. Grant, *Nestorians*, 154.
25. Stoddard, "Grammar of the Modern Syriac Language," 7.
26. J. Perkins, *Beloved Physician*, 14–15; "Rev. Austin H. Wright," 130.
27. Grant, *Nestorians*, 7.
28. Anderson, *History of the Missions*, 286.
29. Wright "From a Letter from Rev. A. H. Wright."

30. Ainsworth, *Travels and Researches*, 303; for more on Wright's time at the mission, see, for example, J. Perkins, *Missionary Life in Persia*; J. Perkins, *Beloved Physician*.
31. Hopkins *India Old and New*, 3–4.
32. *Bibliothèque de le Baron Sylvestre de Sacy*.
33. Hopkins, *India Old and New*, 18.
34. Hopkins, *India Old and New*, 10.
35. Salisbury, "Identification of the Signs."
36. Hopkins, *India Old and New*, 10–11.
37. Salisbury, "Identification of the Signs," 522.
38. Thompson, *Memoir of Rev. David Tappan Stoddard*, 66.
39. Thompson, *Memoir of Rev. David Tappan Stoddard*, 66.
40. Thompson, *Memoir of Rev. David Tappan Stoddard*, 44, was mistaken when he attributed the letter to William Scudder, one of John Scudder's sons; Waterbury, *Memoir of the Rev. John Scudder*, 116; Franklin, *Ministers of Mercy*, 232.
41. Thompson, *Memoir of Rev. David Tappan Stoddard*, 70.
42. Thompson, *Memoir of Rev. David Tappan Stoddard*, 89.
43. Thompson, *Memoir of Rev. David Tappan Stoddard*, 108.
44. Stoddard, "Grammar of the Modern Syriac Language."
45. Stoddard, "From a Letter from Rev. D. T. Stoddard."
46. Thompson, *Memoir of Rev. David Tappan Stoddard*, 352.
47. Thompson, *Memoir of Rev. David Tappan Stoddard*, 351.
48. Stoddard, "On the Meteorology of Oroomiah."
49. Anderson, *History of the Missions*, 116.
50. Tyler, *Memoir of Rev. Henry Lobdell*, 18.
51. Tyler, *Memoir of Rev. Henry Lobdell*, 67–68.
52. *General Catalogue of the Auburn Theological Seminary*, 212.
53. Tyler, *Memoir of Rev. Henry Lobdell*, 83.
54. Anderson, *History of the Missions*, 86.
55. Anderson, *History of the Missions*, 89.
56. Rawlinson, "Notes on a Journey," 22.
57. Tyler, *Memoir of Rev. Henry Lobdell*, 274.
58. Tyler, *Memoir of Rev. Henry Lobdell*, 276.
59. Tyler, *Memoir of Rev. Henry Lobdell*, 340.
60. "Select Minutes of Meetings," i.
61. Tyler, *Memoir of Rev. Henry Lobdell*, 282.
62. Tyler, *Memoir of Rev. Henry Lobdell*, 283.
63. Tyler, *Memoir of Rev. Henry Lobdell*, 340.
64. Tyler, *Memoir of Rev. Henry Lobdell*, 407.
65. Seymour, "William Dwight Whitney," 280.
66. Whitney, *Language and the Study of Language*, 222–23; Whitney, *Life and Growth of Language*, 185–86.
67. Whitney, "On The Avesta"; see Lanman, "Appendix III," 124.
68. Whitney, *Oriental and Linguistic Studies*, 149–97.
69. Briggs, *Biographical Dictionary*, 648.
70. F. E. Shedd, *Daniel Shed Genealogy*, 536.
71. F. E. Shedd, *Daniel Shed Genealogy*, 536.
72. M. L. Shedd, *Measure of a Man*, 28.
73. "Proceedings at New Haven," xxx.

74. "Proceedings at New Haven," xxxi.
75. J. H. Shedd, "Journal of a Tour," xxxviii.
76. "Proceedings at New Haven," xxxviii.
77. "Proceedings at New Haven," xxxix.
78. Hunter, "Another Scroll Amulet," 163.
79. Coakley, "Manuscripts for Sale," 1.
80. Hall, "American Oriental Society's Proceedings," clxxxiii.
81. Hazard, "Syriac Charm."
82. Coakley, "Manuscripts for Sale," 7.
83. R. D. Wilson, *Introductory Syriac Method*.
84. *The New York Times*, July 3, 1896.
85. Coakley, "Manuscripts for Sale," 6.
86. Coakley, "Manuscripts for Sale," 6n19.
87. For example, Hall, "On Some Syriac Manuscripts"; Hall, "Lives of the Prophets"; Hall, "Extremity of the Romans."
88. *Who's Who 1906*, 1184.
89. "Lawrence Heyworth Mills."
90. Franklin, *Ministers of Mercy*, 96.
91. Yourdshahian, Ghavam, and Ansari, "Life of Dr. Joseph Plumb Cochran," 127.
92. Franklin, *Ministers of Mercy*, 98.
93. Speer, *Hakim Sahib*, 53; Speer and Carter, *Report on India and Persia*, 463.
94. M. L. Shedd, *Measure of a Man*, 77.
95. Daniel, *Modern Persia*, 200.
96. S. G. Wilson, *Persia*, 258.
97. Daniel, *Modern Persia*, 208.
98. Wishard, *Twenty Years in Persia*, 248.
99. Speer, *Hakim Sahib*, 115.
100. *Catalogue of the Officers and Students of Maryville College* (1878); S. T. Wilson, *Century of Maryville College*, 254.
101. Tryon, *Union Theological Seminary*, 51.
102. Malick, *American Mission Press*, 2.
103. Hall, "On Some Syriac Manuscripts."
104. *Catalogue of the Officers and Students of Maryville College* (1888), 4, 32.
105. S. T. Wilson, *Century of Maryville College*, 150, 254.
106. Schlicher, "Reports from the Classical Field," 85; *Carroll College Catalogue*, 5.
107. "Necrological Report," 503.
108. S. G. Wilson, *Persian Life and Customs*, 95–96.
109. S. G. Wilson, *Persian Life and Customs*, 99.
110. For his life, see Perry, "Abraham Valentine Williams Jackson"; for his bibliography, see Haas, "Bibliography of A. V. Williams Jackson."
111. Perry, "Abraham Valentine Williams Jackson," 222.
112. See, for example, A. V. W. Jackson, *Hymn of Zoroaster*; A. V. W. Jackson, *Zoroaster*; A. V. W. Jackson, "Iranische Religion."
113. Tolman, "To the Reader."
114. A. V. W. Jackson, *Persia Past and Present*, 94–95, and A. V. W. Jackson, *From Constantinople*.
115. A. V. W. Jackson, *From Constantinople*, 1.
116. Jackson and Yohannan, *Catalogue of the Collection of Persian Manuscripts*, xvii.

117. Jackson and Yohannan, *Catalogue of the Collection of Persian Manuscripts*, xix–xx.
118. A. V. W. Jackson, *Persia Past and Present*, 94–95.
119. A. V. W. Jackson, *Persia Past and Present*, 92–93.
120. A. V. W. Jackson, *Persia Past and Present*, 91–92.
121. Judson, "American–Persian Relief Expedition," 232.
122. Letter of September 16, 1918; K. Jackson, *Around the World to Persia*, 46–47.
123. K. Jackson, *Around the World to Persia*, 70.
124. Boyce, "Letters from Persia."
125. F. E. Shedd, *Daniel Shed Genealogy*, 675.
126. F. E. Shedd, *Daniel Shed Genealogy*, 676; M. L. Shedd, *Measure of a Man*; W. A. Shedd, "Syrians of Persia and Eastern Turkey."
127. M. L. Shedd, *Measure of a Man*, 124.
128. W. A. Shedd, *Islam and the Oriental Churches*.
129. M. L. Shedd, *Measure of a Man*, 128–30.
130. For his life, see Falcetta, "James Rendel Harris."
131. Coakley, "Manuscripts for Sale," 8n25.
132. *Catalogue of the Officers and Students of Yale College*, 32; Dwelley, and Simmons, *History of the Town of Hanover*, 115.
133. *Catalogue of the Vanderbilt Chapter*, 44; Briggs, *Biographical Dictionary*, 658–59.
134. "In Memoriam."
135. Tolman, *Guide to Old Persian Inscriptions*.
136. See the unpaginated preface to Tolman, *Grammar of the Old Persian Language*.
137. Tolman, *Guide to the Old Persian Inscriptions*.
138. Bertin, *Abridged Grammars*.
139. Tolman, *Ancient Persian Lexicon*, viii.
140. See Tolman, *Cuneiform Supplement*, iii.
141. Tolman, *Behistan Inscription*.
142. "General Meeting of the Archaeological Institute of America," 85–86.
143. Tolman and Stevenson, *Herodotus and the Empires of the East*.
144. Tolman, "Palace Ruins and Cyrus Relief Pasargadae."
145. F. E. Shedd, *Daniel Shed Genealogy*, 536–37.
146. E. C. Shedd, *Word Lists for Livy*; E. C. Shedd, *First Latin Book*; E. C. Shedd, "Servant of Jehovah"; E. C. Shedd, *Our Little Persian Cousin*.
147. *List of Active Members of the National Education Association*, 254.
148. *Moody's Manual of Railroads*, 1221.
149. F. E. Shedd, *Daniel Shed Genealogy*, 536–37.
150. E. C. Shedd, "Tree in Salmas," 189.
151. Ward, "Notes on Oriental Antiquities."
152. Ward, "Notes on Oriental Antiquities," 290.
153. Ward, *Seal Cylinders of Western Asia*, 92.
154. R. E. Speer, "Samuel Graham Wilson," 192.
155. S. G. Wilson, *Persian Life and Customs*, 96.
156. Ward, "Notes on Oriental Antiquities," 286.
157. "List of Members," 612.
158. *Who's Who in Tennessee*, 428–29.
159. *Register of Vanderbilt University for 1921–1922*, 12.

160. Johnson, *Index Verborum*, 1–51.
161. "Current Events," 572.
162. Review of *Historical Grammar*, 504–5.
163. Kent, review of *Historical Grammar*.
164. Gray, *Indo-Iranian Phonology*; Gray, *Hundred Love Songs*; Gray, *Foundations of the Iranian Religions*.
165. Malandra, "Gray, Louis Herbert."
166. "Gray, Louis Herbert."
167. Lane, "Roland Grubb Kent," 2.
168. Kent, *Old Persian Grammar*.
169. Kent, "Studies in the Old Persian Inscriptions"; Kent, "Addendum."
170. Kent, review of *Historical Grammar*; Kent, review of *Graeco-Persian Names*.
171. *Susquehanna Bulletin*, 89.
172. Wentz, *Centennial History*, 253, 275.
173. "Susquehanna Claims Men Prominent"; *The 1930 Lanthorn*, 35.
174. *1930 Lanthorn*, 35. Thiel College was not in Oxford, as erroneously stated by P. Briant, "Milestones in the Development of Achaemenid Historiography," 273n37, but in Greenville, Pennsylvania.
175. Ahl, *Outline of Persian History*; Ahl, "Proceedings."
176. "With the Alumni," 139.
177. *Register of Vanderbilt University for 1917–1918*, 215.
178. *Eighth Annual Catalogue of Indiana Central University*, 10; Hill, "Downright Devotion to the Cause," 167.
179. Stonecipher, *Graeco-Persian Names*.
180. Kent, review of *Graeco-Persian Names*.
181. *Lebanon Valley College Bulletin*.
182. "Lebanon Valley Will Confer Degrees."
183. H. M. Perkins, *Life of Rev. Justin Perkins*, 5–6.

Bibliography

Ackerman, P. *Guide to the Exhibition of Persian Art*. New York: Iranian Institute, 1940.

Ahl, A. W. *Outline of Persian History Based on the Cuneiform Inscriptions*. London: Luzac, 1922.

———. "Proceedings of the Sixty-Fourth Annual Meeting of the American Philological Association: 'Cyrus' in the Light of Recent Research." *Transactions and Proceedings of the American Philological Association* 63 (1932): xli.

Ainsworth, W. F. *Travels and Researches in Asia Minor, Mesopotamia, Chaldea, and Armenia*. Vol. 2. London: Parker, 1842.

Anderson, R. *History of the Missions of the American Board of Commissioners for Foreign Missions to the Oriental Churches*. Vol. 2. Boston: Congregational Publishing Society, 1872.

Bertin, G. *Abridged Grammars of the Languages of the Cuneiform Inscriptions, Containing I.—A Sumero-Akkadian Grammar; II.—An Assyro-Babylonian Grammar; III—A Vannic Grammar; IV.—A Medic Grammar; V.—An Old Persian Grammar*. London: Trübner, 1888.

Bibliothèque de le Baron Sylvestre de Sacy. 2 vols. Paris: A l'Imprimerie Royale, 1842, 1846.

Boyce, A. C. "Letters from Persia." *University Record* 5 (1919): 52.
Briant, P. "Milestones in the Development of Achaemenid Historiography in the Era of Ernst Herzfeld." Pages 263–80 in *Ernst Herzfeld and the Development of Near Eastern Studies, 1900–1950*. Edited by A. Gunter and S. Hauser. Leiden: Brill, 2002.
Briggs, W. W., Jr. *Biographical Dictionary of North American Classicists*. Westport, CT: Greenwood, 1994.
Carroll College Catalogue, 1919–1920. Waukesha, WI: Carroll College, 1920.
Catalogue of the Officers and Students of Maryville College, East Tennessee, for the Academic Year, 1877–78. Maryville, TN: Index Job and News Office, 1878.
Catalogue of the Officers and Students of Maryville College, East Tennessee, for the Year 1887–88. Maryville, TN: Neff, 1888.
Catalogue of the Officers and Students of Yale College, With a Statement of the Course of Instruction in the Various Departments, 1878–79. New Haven, CT: Tuttle, Morehouse & Taylor, 1878.
Catalogue of the Vanderbilt Chapter, Phi Beta Kappa. Nashville: Vanderbilt University, 1906.
Coakley, J. F. "Manuscripts for Sale: Urmia, 1890–2." *Journal of Assyrian Academic Studies* 20.2 (2006): 1–12.
"Current Events." *Classical Journal* 30.9 (1935): 570–80.
Daniel, M. G. *Modern Persia*. Toronto: Henderson, 1898.
Dwelley, J., and J. F. Simmons. *History of the Town of Hanover, Massachusetts, with Family Genealogies*. Town of Hanover, Massachusetts, 1911.
The Eighth Annual Catalogue of Indiana Central University for the Year Ending June 18, 1913, with Announcements for 1913–1914. Indianapolis: Indiana Central University, 1913.
Falcetta, A. "James Rendel Harris: A Life on the Quest." *Quaker Studies* 8.2 (2004): 208–25.
Franklin, J. H. *Ministers of Mercy*. New York: Missionary Education Movement of the United States and Canada, 1919.
Frye, R. N. "Asia Institute." *Encyclopaedia Iranica*. Last updated August 16, 2011. https://www.iranicaonline.org/articles/asia-institute-the-1.
———. "Asia Institute, Bulletin of." *Encyclopaedia Iranica*. Last updated August 16, 2011. https://www.iranicaonline.org/articles/asia-institute-bulletin-of-the.
General Catalogue of the Auburn Theological Seminary, Including the Trustees, Treasurers, Professors, and Alumni, 1883. Auburn, NY: Daily Advertiser and Weekly Journal Printing House, 1883.
"General Meeting of the Archaeological Institute of America, December 27–30, 1912." *American Journal of Archaeology* 17 (1913): 81–94.
Grant, A. *The Nestorians; or the Lost Tribes: Containing Evidence of Their Identity; an Account of Their Manners, Customs, and Ceremonies; Together with Sketches of Travel in Ancient Assyria, Armenia, Media, and Mesopotamia; and Illustrations of Scripture Prophecy*. London: Murray, 1841.
Gray, L. H. *The Foundations of the Iranian Religions*. K. R. Cama Oriental Institute Publications 5. Bombay: Cama Oriental Institute, 1929.
———. *The Hundred Love Songs of Kamal-ad-Din of Isfahan*. New York: Nutt, 1904.
———. *Indo-Iranian Phonology with Special Reference to the Middle and New Indo Iranian Languages*. New York: Columbia University Press, 1902.
"Gray, Louis Herbert." *Who's Who in America, 1908–1909* (1908): 755.

Haas, G. C. O. "Bibliography of A. V. Williams Jackson." *Journal of the American Oriental Society* 58 (1938): 241–57.
Hall, I. "American Oriental Society's Proceedings, Oct. 1889. Scheme for Collecting and Preserving Ancient Syriac Texts at Oroomia." *Journal of the American Oriental Society* 14 (1890): clxxx–clxxxv.
———. "The Extremity of the Romans: And Praise Before the Holy Mysteries: Syriac Texts and Translations." *Journal of the American Oriental Society* 13 (1889): 34–56.
———. "The Lives of the Prophets." *Journal of the Society of Biblical Literature and Exegesis* 7.1 (1887): 28–40.
———. "On Some Syriac Manuscripts Recently Acquired by the Union Theological Seminary, New York." *Journal of the Society of Biblical Literature and Exegesis* 5 (1885): 93–100.
Hayden, H. E. *A Genealogy of the Glassell Family of Scotland and Virginia. Also of the Families of Ball, Brown, Bryan, Conway, Daniel, Ewell, Holladay, Lewis, Littlepage, Moncure, Peyton, Robinson, Scott, Taylor, Walls, and others, of Virginia and Maryland.* Wilkes-Barre, PA: Yordy, 1891.
Hazard, W. H. "A Syriac Charm." *Journal of the American Oriental Society* 15 (1893): 284–96.
Hill, F. *"Downright Devotion to the Cause": A History of the University of Indianapolis and its Legacy of Service.* Indianapolis: University of Indianapolis, 2002.
Hopkins, E. W. *India Old and New with a Memorial Address.* New York: Scribner's; London: Arnold, 1901.
Hunter, E. C. D. "Another Scroll Amulet from Kurdistan." Pages 161–72 in *After Bardaisan: Studies on Continuity and Change in Syriac Christianity in Honour of Professor Han J. W. Drijvers.* Edited by G. J. Reinink and A. C. Klugkist. Orientalia Lovaniensia Analecta 89. Louvain: Peeters, 1999.
"In Memoriam." *Phi Beta Kappa Key* 5.7 (1924): 460–64.
Jackson, A. V. W. *From Constantinople to the Home of Omar Khayyam: Travels in Transcaucasia and Northern Persia for Historic and Literary Research.* New York: Macmillan, 1911.
———. *A Hymn of Zoroaster: Yasna 31, Translated with Comments.* Stuttgart: Kohlhammer, 1888.
———. "Die iranische Religion." Pages 612–710 in vol. 2 of *Grundriss der iranischen Philologie.* Edited by W. Geiger and E. Kuhn. Strassburg: Trübner, 1896–1904.
———. *Persia Past and Present: A Book of Travel and Research.* London: Macmillan, 1906.
———. *Zoroaster, the Prophet of Ancient Iran.* New York: Columbia University Press, 1899.
Jackson, A. V. W., and A. Yohannan. *A Catalogue of the Collection of Persian Manuscripts Including Also Some Turkish and Arabic Presented to the Metropolitan Museum of Art, New York, by Alexander Smith Cochran.* New York: Columbia University Press, 1914.
Jackson, K. *Around the World to Persia: Letters Written While on the Journey as a Member of the American-Persian Relief Commission in 1918.* New York: Privately printed, 1920.
Johnson, E. L. *Historical Grammar of the Ancient Persian Language.* Nashville: Vanderbilt Oriental Series, 1917.

---. "Index Verborum to the Old Persian Inscriptions." Pages 1–51 in H. C. Tolman, *Cuneiform Supplement (Autographed) to the Author's Ancient Persian Lexicon and Texts, with Brief Historical Synopsis of the Language.* Nashville: Vanderbilt Oriental Series, 1910. (Separately paginated from Tolman's text.)

---. *The University Memorial: Biographical Sketches of Alumni of the University of Virginia Who Fell in the Confederate War.* Baltimore: Turnbull Brothers, 1871.

Judson, H. P. "The American–Persian Relief Expedition." *University Record* 5 (1919): 232–38.

Kent, R. G. "Addendum on a Difficult Old Persian Passage." *Journal of the American Oriental Society* 41 (1921): 74–75.

---. "A New Inscription of Xerxes." *Language* 9 (1933): 35–46.

---. *Old Persian: Grammar, Texts, Lexicon.* New Haven: American Oriental Society, 1950.

---. "The Recently Published Old Persian Inscriptions." *Journal of the American Oriental Society* 51 (1931): 189–240.

---. "The Record of Darius's Palace at Susa." *Journal of the American Oriental Society* 53 (1933): 1–23, and "Addendum," 166.

---. Review of *Graeco-Persian Names*, by A. H. M. Stonecipher. *American Journal of Philology* 39 (1918): 333.

---. Review of *Historical Grammar of the Ancient Persian Language*, by E. L. Johnson. Johnson. *American Journal of Philology* 39 (1918): 332.

---. "Studies in the Old Persian Inscriptions." *Journal of the American Oriental Society* 35 (1918): 321–52.

Lane, G. S. "Roland Grubb Kent." *Language* 29 (1953): 1–13.

Lanman, C. R. "Appendix III. Chronological Bibliography of the Writings of William Dwight Whitney." *Journal of the American Oriental Society* 19 (1898): 121–50.

Lathrop, A. C. *Memoir of Asahel Grant, M.D., Missionary to the Nestorians. Compiled, at the Request of his Mother, (Mrs. Rachel Grant,) ... Containing Also, an Appeal to Pious Physicians, by Dr. Grant.* New York: Dodd, 1847.

"Lawrence Heyworth Mills, 1837–1918." *Monist* 38 (1918): 314–16.

Lebanon Valley College Bulletin, 1963–1964 Catalog Supplement. Annville PA: Lebanon Valley College, 1963.

"Lebanon Valley Will Confer Degrees upon Four Distinguished Men." *Lebanon Daily News*, May 16, 1962, 50.

List of Active Members of the National Education Association for the Year Beginning December 31, 1912, and Ending December 31, 1913. Ann Arbor, MI: Published by the Association, 1913.

"List of Members." *Journal of the American Oriental Society* 60 (1940): 589–616.

Malandra, W. W. "Gray, Louis Herbert." *Encyclopaedia Iranica* 11 (2002): 200.

Malick, D. G. *The American Mission Press: A Preliminary Bibliography.* Chicago: ATOUR, 2008.

Moody's Manual of Railroads and Corporation Securities, Twenty-Third Annual Number, Industrial Section (Volume II—K to Z) 1922. New York: Poor's, 1922.

Müller, A. "Memoir of Heinrich Leberecht Fleischer." *Smithsonian Report for 1889* (1892): 507–25.

"Necrological Report. Samuel Graham Wilson." *Princeton Seminary Bulletin* 11.1 (1917): 503–4.

The Nestorians of Persia: A History of the Origin and Progress of that People, and of Missionary Labours Among Them; With an Account of the Nestorian Massacres by the Koords. Philadelphia: American Sunday-School Union, 1848.
The 1930 Lanthorn. Selins Grove, PA: The Junior Class at Susquehanna University, 1929.
Perkins, H. M. *Life of Rev. Justin Perkins, D.D.: Pioneer Missionary to Persia.* Chicago: Women's Presbyterian Board of Missions of the Northwest, 1887.
Perkins, J. "Aus Briefen an Prof. Fleischer. Von Missionar J. Perkins." *Zeitschrift der Deutschen Morgenländischen Gesellschaft* 7 (1853): 572–73.
———. "Aus Briefen an Prof. Fleischer. Von Missionar J. Perkins." *Zeitschrift der Deutschen Morgenländischen Gesellschaft* 8 (1854): 601–2.
———. *The Beloved Physician: A Sermon Occasioned by the Death of the Rev. Austin H. Wright, M.D., Preached to the Families of the Nestorian Mission, at Oroomiah, Persia, Feb. 8th, 1865.* New York: Jenkins, 1865.
———. "Journal of a Tour from Oroomiah to Mosul, Through the Koordish Mountains, and a Visit to the Ruins of Nineveh." *Journal of the American Oriental Society* 2 (1851): 69, 71–119.
———. "Letter from Mr. Perkins, Dated at Erzroom, June 26th, 1834." *Missionary Herald* 31 (1835): 61–62.
———. *Missionary Life in Persia: Being Glimpses at a Quarter of a Century of Labors Among the Nestorian Christians.* Boston: American Tract Society, 1861.
———. *A Residence of Eight Years in Persia, Among the Nestorian Christians; with Notices of the Muhammedans.* Andover: Allen, Morrill & Wardwell, 1843.
Perry, E. D. "Abraham Valentine Williams Jackson." *Journal of the American Oriental Society* 58.2 (1938): 221–24.
"Proceedings at New Haven, Oct. 12th and 13th, 1871." *Journal of the American Oriental Society* 10 (1872–80): xxx–xliv.
Rawlinson, H. C. "Notes on a Journey from Tabríz, Through Persian Kurdistán, to the Ruins of Takhti-Soleïmán, and from Thence by Zenján and Ṭárom, to Gílán, in October and November, 1838; with a Memoir on the Site of the Atropatenian Ecbatana." *Journal of the Royal Geographical Society* 10 (1841): 1–158.
Register of Vanderbilt University for 1917–1918, Announcement for 1918–1919. Nashville: Vanderbilt University, 1918.
Register of Vanderbilt University for 1921–1922, Announcement for 1922–1923. Nashville: Vanderbilt University, 1922.
"Rev. Austin H. Wright, M.D." *Missionary Herald of the American Board* 61.5 (1865): 129–34.
Review of *Historical Grammar of the Ancient Persian Language*, by E. L. Johnson. *The Sewanee Review* 25 (1917): 504–5.
Rizvi, K. "Art History and the Nation: Arthur Upham Pope and the Discourse on 'Persian Art' in the Early Twentieth Century." *Muqarnas* 24 (2007): 45–66.
Salisbury, E. E. "On the Identification of the Signs of the Persian Cuneiform Alphabet." *Journal of the American Oriental Society* 1.4 (1849): 517–58.
Schlicher, J. J. "Reports from the Classical Field." *Classical Journal* 4.2 (1908): 79–87.
"Select Minutes of Meetings of the Society." *Journal of the American Oriental Society* 7 (1855): i–iv.
Seymour, T. D. "William Dwight Whitney." *American Journal of Philology* 15 (1894): 271–98.

Shedd, E. C. *The First Latin Book.* New York: Harrison, 1901.
———. *Our Little Persian Cousin.* Boston: Page, 1909.
———. "The Servant of Jehovah in the Light of the Inscriptions: A World Empire, a World Religion." *Biblical World* 30.6 (1907): 464–68.
———. "A Tree in Salmas." *Swiss Cross: A Monthly Magazine of the Agassiz Association* 3.6 (1888): 188–89.
———. *Word Lists for Livy, Books I, XXI, XXII.* Wichita: Funk, 1900.
Shedd, F. E. *Daniel Shed Genealogy: Ancestry and Descendants of Daniel Shed of Braintree, Massachusetts, 1327–1920.* Vol. 2. Boston: Published for the Shedd Family Association, 1921.
Shedd, J. H. "Journal of a Tour Made in March–May, 1870, from Orûmiah to Hamadan, with Notices of the Antiquities, and of the Existing Races and Religions, of Ancient Media." *Journal of the American Oriental Society* 10 (1872–80): xxxviii–xxxix.
Shedd, M. L. *The Measure of a Man: The Life of William Ambrose Shedd, Missionary to Persia.* New York: Doran, 1922.
Shedd, W. A. *Islam and the Oriental Churches: Their Historical Relations.* New York: Young People's Missionary Movement, 1904.
———. "The Syrians of Persia and Eastern Turkey." *Bulletin of the American Geographical Society* 35.1 (1903): 1–7.
Smith, E. *Researches of the Rev. E. Smith and Rev. H. G. O. Dwight in Armenia: Including a Journey Through Asia Minor, and into Georgia and Persia, with a Visit to the Nestorian and Chaldean Christians of Oormiah and Salmas.* 2 vols. Boston: Crocker, Brewster & Leavitt, 1833.
Smith, E., and H. G. O. Dwight. *Missionary Researches in Armenia: Including a Journey Through Asia Minor, and into Georgia and Persia, with a Visit to the Nestorian and Chaldean Christians of Oormiah and Salmas.* London: Wightman, 1834.
Speer, R. E. *"The Hakim Sahib," The Foreign Doctor: A Biography of Joseph Plumb Cochran, M.D. of Persia.* New York: Revell, 1911.
———. "Samuel Graham Wilson of Persia." *Moslem World* 7.2 (1917): 191–95.
Speer, R. E., and R. Carter. *Report on India and Persia of the Deputation Sent by the Board of Foreign Missions of the Presbyterian Church in the U.S.A. to Visit These Fields in 1921–22.* New York: The Board of Foreign Missions of the Presbyterian Church in the U.S.A., 1922.
Stoddard, D. T. "From a Letter from Rev. D. T. Stoddard, of Orûmiah." *Journal of the American Oriental Society* 5 (1856): 426.
———. "Grammar of the Modern Syriac Language, as Spoken in Oroomiah, Persia, and in Koordistan." *Journal of the American Oriental Society* 5 (1856): 1–182.
———. "On the Meteorology of Oroomiah." *American Journal of Science and Arts* 20 (1855): 254–58.
Stonecipher, A. H. M. *Graeco-Persian Names.* New York: American Book Company, 1918.
The Susquehanna Bulletin (Catalogue Edition) of Susquehanna University, 1907–1908. Selinsgrove, PA: Susquehanna University, 1908.
"Susquehanna Claims Men Prominent as Authors of Merit." *Susquehanna* 35 (March 24, 1929): 1.
Thompson, J. P. *Memoir of Rev. David Tappan Stoddard, Missionary to the Nestorians.* New York: Sheldon, Blakeman, 1858.

Tolman, H. C. *Ancient Persian Lexicon and the Texts of the Achaemenidan Inscriptions Transliterated and Translated with Special Reference to Their Recent Re-Examination*. Nashville: Vanderbilt Oriental Series, 1908.

———. *The Behistan Inscription of King Darius: Translation and Critical Notes to the Persian Text with Special Reference to Recent Re-Examinations of the Rock*. Nashville: Vanderbilt Oriental Series, 1908.

———. *Cuneiform Supplement (Autographed) to the Author's Ancient Persian Lexicon and Texts, with Brief Historical Synopsis of the Language*. Nashville: Vanderbilt Oriental Series, 1910.

———. *Grammar of the Old Persian Language, with the Inscriptions of the Achaemenian Kings and Vocabulary*. Boston: Ginn, 1892.

———. *A Guide to the Old Persian Inscriptions*. New York: American Book Company, 1893.

———. "Palace Ruins and Cyrus Relief Pasargadae." Pages 175–78 in *Indo–Iranian Studies: Being Commemorative Papers Contributed by European, American and Indian Scholars, in Honour of Shams–Ul-Ullema Dastur Darab Peshotan Sanjana*. London: Kegan Paul, Trench & Trübner, 1925.

Tolman, H. C., and J. H. Stevenson. *Herodotus and the Empires of the East Based on Nikel's Herodot und die Keilschriftforschung*. New York: American Book Company, 1899.

Tryon, H. H. *Union Theological Seminary in the City of New York Alumni Catalogue, 1836–1947*. New York: Union Theological Seminary, 1948.

Tyler, W. S. *History of Amherst College During Its First Half Century, 1821–1871*. Springfield, MA: Bryan, 1873.

———. *Memoir of Rev. Henry Lobdell, M.D., Late Missionary of the American Board at Mosul: Including the Early History of the Assyrian Mission*. Boston: American Tract Society, 1859.

Ward, W. H. "Notes on Oriental Antiquities." *American Journal of Archaeology and of the History of the Fine Arts* 6.3 (1890): 286–98.

———. *The Seal Cylinders of Western Asia*. Washington, DC: Carnegie Institution, 1910.

Waterbury, J. B. *Memoir of the Rev. John Scudder, M.D., Thirty-Six Years Missionary in India*. New York: Harper & Brothers, 1870.

Wentz, A. R. *Centennial History of the Evangelical Lutheran Synod of Maryland of the United Lutheran Church in America, 1820–1920*. Harrisburg, PA: Evangelical Press, 1920.

Whitney, W. D. *Language and the Study of Language: Twelve Lectures on the Principles of Linguistic Science*. New York: Scribner's, 1867.

———. *The Life and Growth of Language*. London: King, 1875.

———. "On The Avesta, or The Sacred Scriptures of the Zoroastrian Religion." *Journal of the American Oriental Society* 5 (1855–56): 337–83.

———. *Oriental and Linguistic Studies: The Veda; the Avesta; the Science of Language*. New York: Scribner, Armstrong, 1873.

Who's Who in Tennessee: A Biographical Reference Book of Notable Tennesseans of To-Day. Memphis: Paul & Douglas, 1911.

Who's Who 1906: An Annual Biographical Dictionary. London: Black, 1906.

Wilson, R. D. *Elements of Syriac Grammar by an Inductive Method*. New York: Scribner's Sons, 1891.

———. *Introductory Syriac Method and Manual*. New York: Scribner's, 1891.
Wilson, S. G. *Persian Life and Customs, with Scenes and Incidents of Residence and Travel in the Land of the Lion and the Sun*. Edinburgh: Anderson & Ferrier, 1896.
———. *Persia: Western Mission*. Philadelphia: Presbyterian Board of Publication and Sabbath–School Work, 1896.
Wilson, S. T. *A Century of Maryville College, 1819–1919: A Story of Altruism*. Maryville, TN: Directors of Maryville College, 1916.
Wishard, J. G. *Twenty Years in Persia: A Narrative of Life Under the Last Three Shahs*. New York: Revell, 1908.
"With the Alumni." *Vanderbilt University Quarterly* 15.2 (1915): 129–42.
Wright, A. H. "From a Letter from Rev. A. H. Wright, M.D., of Orûmiah." *Journal of the American Oriental Society* 5 (1856): 262–63.
Yourdshahian, E., F. Ghavam, and M.-H. Ansari. "Life of Dr. Joseph Plumb Cochran, Founder of Iran's First Contemporary Medical College." *Archives of Iranian Medicine* 5.2 (2002): 127–28.

CHAPTER 13

The Study of Ancient Iran in the United States: A History Focusing on Art and Material Culture

Judith A. Lerner

COMPARED TO ITS PURSUIT in Europe and Asia, Iranian studies in the United States is a relatively new discipline. Two interrelated facts account for this: geography and history. The great distances that separate the United States from Europe and Asia mitigated against vibrant scholarly interchange until as recently as the second half of the twentieth century, when intercontinental travel and then the internet made it easier and more efficient to lecture, teach, and attend meetings overseas as well as to share information and respond to communications almost immediately. The relative youth of the United States, with fewer direct intellectual, political, economic, and cultural ties to Iran— the historical "Persia," as it was known before the early twentieth century— also contributed to a dearth of interest in Iranian studies and, specifically, the study of ancient Iran.

In this chapter, I document the growth of ancient Iranian studies in the United States, with an emphasis on the contributions of foreign-born scholars and, except for the "younger" generation of such scholars, I focus on those born before and somewhat after the turn of the twentieth century. I do this because although the general field of ancient Iranian studies in the United States was initiated and developed by American-born scholars (see below), the disciplines of art history and archaeology (in particular the former) were largely developed by those who came from elsewhere seeking opportunity for their scholarly pursuits and, for many, refuge.

The Beginnings and Growth of Ancient Iranian Studies in the United States

As a discipline of higher education in the United States, ancient Iranian studies began with the scholarly works and teaching of the Indo-Iranist scholar Abraham Valentine Williams Jackson (1862–1937). While still an undergraduate at Columbia University, Jackson's interest in comparative philology led to

his study of Sanskrit that in turn led him to Avestan, which was first taught in the United States by the Columbia University Sanskritist Edward Washburn Hopkins (1857–1932). Among his many accomplishments, Jackson produced a grammar of the Avestan language followed by an *Avesta Reader*.[1] Based on his textual studies and travels in India and Persia to understand native Iranian traditions, Jackson wrote his seminal work on Zarathushtra, entitled *Zoroaster: The Prophet of Ancient Iran*,[2] whom he believed to have been a living personage.

Jackson's teaching at Columbia University paved the way for the great Iranist Richard Nelson Frye (1920–2014) as well as for the important Avestan scholar Hanns-Peter Schmidt (1930–2017) to establish Iranian studies programs at Harvard University and at the University of California, Los Angeles, respectively. Harvard's was developed by Frye in the 1950s while UCLA's was created in 1963.[3] Other major American educational institutions followed suit by offering courses and advanced degrees in their Near Eastern or Middle Eastern Languages as well as their Languages and Literature departments and centers for Iranian studies. Most of them focused on "Iranistik"—that is, Persian language and literature. Far fewer, however, focused on ancient Iran and ancient Iranian languages. An exception was the University of Chicago, which since its founding in 1891 had offered courses and degree programs on Assyrian and Semitic languages. In the late 1920s, its Oriental Institute had begun teaching courses on ancient Iran civilization and Iranian languages. Thus, such study was firmly established when the Institute began its excavations at Persepolis in 1931, with its two successive directors (to be discussed later) both being émigrés.

The prior mention of Richard Nelson Frye must be expanded due to his enormous and unique contributions to the study of ancient Iran. American by birth and *Irandoost* by conviction, Frye not only helped found the first Iranian studies program in the United States (Center for Middle Eastern Studies, Harvard) but was also the author of numerous books and articles on the history and languages of Iran and Iranian Central Asia (not to mention other Byzantine, Caucasian, and Ottoman topics). Additionally, he was a remarkable polyglot who published on a variety of Iranian and non-Iranian languages. Less well known among his accomplishments, but especially important to our knowledge of the art and architecture of ancient Iran, are his epigraphic skills as related to seals and sealings. This is demonstrated, for example, by his authoring of chapters and overall editing of *Sasanian Remains from Qasr-i Abu Nasr: Seals, Sealings and Coins*.[4] Also fairly unknown is his 1948 discovery of the sixth-century BCE Achaemenid tomb at Gur-e Dokhtar near Buzpar in southwestern Iran (fig. 13.1).

Other pioneers in Iranian studies in the United States were William S. Haas (1883–1956) and the Indo-Iranianist Bernhard Geiger (1881–1964).

FIGURE 13.1. Gur-e Dokhtar, Buzpar, Fars Province, Iran. Photo: Wikimedia Commons / dynamosquito (CC BY-SA 2.0).

Trained in philosophy and sociology in his native Germany, Haas served as an advisor to the Iranian Ministry of Education before the outbreak of World War II (1934–39). He then immigrated to the United States, where he taught area studies courses to military servicemen and intelligence agents at Arthur Upham Pope's School for Iranian Studies (mentioned below). He is credited in 1949 with preparing the curriculum for Columbia University's Center for Iranian Studies, which was established to focus on social sciences and literature. He then taught and researched Iranian politics and culture at the Center until his death in 1956. His 1946 book, entitled *Iran*,[5] was one of the earliest of its kind in English to provide information to the American public about the country. Geiger was also given a position by Pope at his Asia Institute before going to Columbia University as Visiting Professor of Iranian Studies. His research was mainly philological, centering on Avestan and Zoroastrian studies as well as Middle Persian. Among his many contributions relating to Talmudic-Aramaic words of Iranian origin was his edition of the texts found in the synagogue of Dura-Europos, which were in Parthian as well as in Middle Persian from the brief time when the city was occupied by the forces of the Sasanian ruler Shapur I (ca. 252/53 CE).[6]

Also forced to emigrate from Germany was Walter Bruno Henning (1908–1967), the great scholar of Middle Iranian languages and literature. He went first to London in 1936, where he taught at the School of Oriental Studies.

The United States, however, later gained from his presence when in 1961, for reasons of health, he moved to the University of California, Berkeley and its more salubrious climate.

This part of the narrative would be incomplete without mention of Ehsan Yarshater (1920–2018), who first came to the United States in 1958 as Visiting Associate Professor of Indo-Iranian at Columbia University; this was the first full-time professorship of the Persian language and literature at an American university since World War II. In 1968, Yarshater established the Center for Iranian Studies at Columbia University, serving as its director until 2017. Also in 1968, he was elected Chairman of the Middle East Department, a post he held until 1973. The following year, he founded and managed the ongoing publication of the *Encyclopaedia Iranica* as well as oversaw the Center's active publication program—he himself authoring, translating, and editing numerous scholarly works on Persian history, literature, and language. Among these works are two publications, both initiated in the early 1970s and both invaluable for students and scholars of Iranian history and culture. The first was the *Cambridge History of Iran*, vol. 3, parts 1 and 2: *The Seleucid, Parthian and Sasanian Periods*, which was published in 1983 and for which Yarshater served as editor and contributor. The second of these publications was the annotated, forty-volume English translation of al-Tabarī, *History of Prophets and Kings*, which was published between 1985 and 1999.[7]

With the exception of the Alabama-born Frye, the "transplanted" scholars just cited—many displaced by forces beyond their control—began new chapters in their lives and careers, and in so doing they furthered and enriched ancient Iranian studies in the United States. What was Europe's loss was America's gain. In the years since World War II, scholars of ancient Iran continued to immigrate to the United States, benefiting from the growth in academic opportunity that was due in great part to the earlier wave of émigré scholars and their academic legacy. Such postwar arrivals as Ehsan Yarshater and Hanns-Peter Schmidt have already been mentioned. The Iranian languages and religions scholar Prods Oktor Skjaervø arrived in 1985 from Norway by way of Germany, and in 1991 he became the Aga Khan Professor of Iranian Studies at Harvard, succeeding Richard Frye in that chair (with Skjaervø's retirement in 2015, the position was closed down). After the Iranian Revolution, Iranian historian and Achaemenid-period archaeologist Alireza Shapur Shahbazi (1942–2006) immigrated to the United States, where he served as an editor of the *Encyclopaedia Iranica* and later, until his untimely death, as a professor of history at Eastern Oregon University.

A new generation of Iranian-born philologists and historians who studied in the United States subsequently remained to enrich or build departments of Iranian studies there. Prominent among them are the literary critic and

Shahnama specialist Mahmoud Omidsalar (Jordan Center for Persian Studies Scholar in Residence, University of California, Irvine); the philologist and historian M. Rahim Shayegan (Pourdavoud Center for the Study of the Iranian World, University of California, Los Angeles), who was an early student of Skjaervø; the Iranologist and historian Touraj Daryaee (University of California, Irvine), who was a student of Hanns-Peter Schmidt; and the historian Parvaneh Pourshariati (City University of New York).

The Development of Iranian Art and Archaeology Studies in the United States

In contrast to the study of ancient Iranian history, language, religion, and texts, which, as described above, goes back to the late nineteenth century, the interrelated fields of ancient Iranian art and archaeology are several generations younger. Greatly contributing to their birth were émigré scholars who found a haven in the United States from their homelands, which were threatened and occupied by the Nazis. Indeed, it would not be an exaggeration to state that the flourishing of pre-Islamic (as well as Islamic) cultural studies benefited from the terrible events that overtook all of Europe, and Germany specifically, in the 1930s. As is well known (and alluded to in the boast by Walter Cook, Chairman of the Institute of Fine Arts, New York University, that "Hitler is my best friend; he shakes the tree and I collect the apples"),[8] the United States provided refuge for many of these scholars, both Jewish and non-Jewish, who had to flee Nazism or felt that they could not remain in so horrific an environment. These émigré scholars enabled the growth of art historical and archaeological studies—ancient as well as medieval—by establishing or helping to establish and expand academic as well as museum departments in a number of institutions across the United States. By so doing, they trained a new generation of scholars who, now as senior scholars, have in geometric sequence trained younger entrants to the field.

Much of this could not have happened without the help of Arthur Upham Pope (1881–1969), American educator, author, and tireless promoter of Persian art and architecture as well as the coeditor (with his wife Phyllis Ackerman) of the multivolume and monumental *A Survey of Persian Art: From Prehistoric Times to the Present*, which was first published in 1938.[9] In 1928, Pope founded the American Institute for Persian Art and Archaeology in New York City, which in 1937 became the American Institute for Iranian Art and Archaeology. Beginning in the early 1930s, Pope also offered academic employment to a number of émigrés at his Institute's School for Iranian Studies. Thus, the important German historian of Islamic art Richard Ettinghausen (1906–1979)

joined Pope when he immigrated to New York City before later teaching at the University of Michigan and then at the Institute of Fine Arts of New York University, as well as building the Islamic collection of the Freer Gallery in Washington, DC, into one of the finest in the world.

Also teaching at Pope's Institute in the 1940s was Edith Porada (1912–1994), the doyenne of ancient Near Eastern art history and in particular of pre-Islamic Iranian art. In 1938, Porada arrived in the United States from Austria by way of France. Although Porada's studies in Vienna had included no formal art historical training, she immersed herself in the study and careful analysis of objects. This led her to new and valuable insights into the visual cultures of the ancient Near East: those of Babylonia, Assyria, the Levant, and Cyprus. Her writings about the art of pre-Islamic Iran remain essential to our studies. *The Art of Ancient Iran*, which was published in 1965 in several different languages,[10] may still serve as the basis for art historical research on any period of pre-Islamic Iranian art. Another model work is her 1948 publication of the cylinder seals in the Pierpont Morgan Library Collection (fig. 13.2).[11] Through her focus on the seals of the ancient Near East as well as Iran, Porada trained several generations of art historians now working in both the United States (this author included) and other countries in approaches to the style and iconography of ancient art in all media and that of seals in particular.

Mention must also be made of the Sinologist Otto Mänchen-Helfen (1894–1969), who published in the closely related field of Hunnic history. Born in Vienna, Mänchen-Helfen worked in Moscow and then in Berlin. He returned to Austria when the Nazis came to power, but after the *Anschluss* in 1938 he immigrated to the United States, where he eventually became an influential professor of art at the University of California, Berkeley. In addition to *The World of the Huns: Studies in Their History and Culture* (1973) and other important writings, Mänchen-Helfen was the first non-Russian to travel and report on the then-independent enclave of Tuva in southern Siberia.[12]

As for Iranian archaeology, the German polymath Ernst E. Herzfeld (1879–1948) undoubtedly remains the field's most influential archaeologist, foreign-born or otherwise. Although he resided in the United States only between 1935 and 1944 as a member of the Institute for Advance Study in Princeton, Herzfeld had an enormous impact on Iranian archaeology not only in the United States but in Europe and in Iran itself. Trained in architecture as well as in Assyriology, ancient history, and art history, Herzfeld traveled widely throughout the Middle East, surveying and documenting many ancient sites until World War I. Between 1911 and 1913, he excavated at the Islamic period site of Samarra and also documented pre-Islamic Ctesiphon. His extensive travels in Persia, in part with the great German scholar of Islamic art, Friedrich Sarre (1865–1945), resulted in their monumental *Iranische Felsreliefs*.[13]

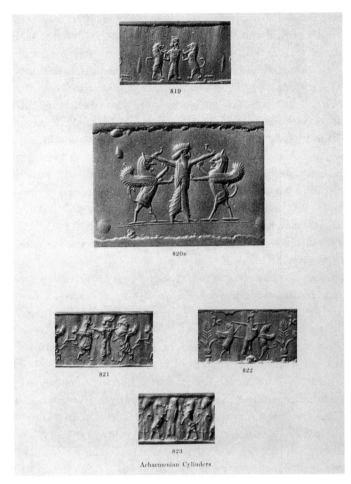

FIGURE 13.2. Photographic plate showing Achaemenid cylinder seal impressions, nos. 819–23. After Edith Porada, *Corpus of Ancient Near Eastern Seals in North American Collections: The Pierpont Morgan Library Collection* (New York: Pantheon Books, 1948).

His other works, such as *Archaeological History of Iran*,[14] *Iran in the Ancient East*,[15] and his publication of the nine volumes of the journal *Archäologische Mitteilungen aus Iran* between 1929 and 1938, contributed a hundredfold to our knowledge of ancient Iran.

But it was in his role between 1931 and 1934 as director of the University of Chicago's Oriental Institute excavations at Persepolis that Herzfeld—even before he immigrated to the United States—contributed most to the field of Iranian archaeology. Not only did his excavations yield sensational new

discoveries, but they also opened new horizons for architectural, artistic, epigraphic, and historical studies not just for scholars in the United States but also for scholars everywhere. Ironically, Herzfeld did not publish much about his Persepolis excavations, and he was replaced by the field archaeologist Erich F. Schmidt (1897–1964), who led the excavations from 1934 until 1939.[16] Schmidt, too, was German-born, but unlike Herzfeld, he was not forced by accident of birth to leave Germany. Instead, he had come to the United States in 1923 at age twenty-six to study at Columbia University. In addition to continuing work at Persepolis, he expanded Herzfeld's earlier excavations at nearby Naqsh-e Rustam and at early Islamic Istakhr, and he conducted soundings at the prehistoric mounds of Tall-i Bākun. Schmidt also excavated in other parts of Iran, including at Tepe Hissar near Damghan (1930–33), Rayy (1934–36), and in Luristan (1935 and 1938), and he importantly published his results. As a pilot, Schmidt also pioneered reconnaissance flights to locate archaeological monuments and sites.[17]

Born in Iran, Ezatollah Negahban (1926–2009) is considered by many to be the father of Iranian modern archaeology. Negahban completed his graduate work at the Oriental Institute of the University of Chicago and then returned to Iran, where he founded the Institute of Archaeology, served as advisor to the Ministry of Culture, and excavated the important sites of Marlik and Haft Tepe, the latter serving as a field school to train Iranian archaeologists.[18] The Oriental Institute's connection with Iranian archaeology, first begun by Ernst Herzfeld and Erich Schmidt, has been continued by the Iranian-born scholar Abbas Alizadeh (b. 1951), a member of Chicago's Iranian Prehistoric Project (and a student of Helen J. Kantor, mentioned below). Through his efforts, Americans were able to resume archaeological work after the Iranian Revolution as members of Iranian teams. In the early 1960s, the Scottish archaeologist David Stronach (1931–2020) continued Herzfeld's work at Cyrus the Great's capital of Pasargadae (1961–63) and excavated pre-Achaemenid Nush-e Jan (1967–68), all the while serving as director of the British Institute of Persian Studies in Tehran (1961–79). After leaving Iran in 1978, Stronach became a professor of Near Eastern Archaeology at the University of California, Berkeley, thereby expanding its program in Iranian art and archaeology.

American-Trained Archaeologists and Art Historians from Related Disciplines

Because archaeology in Iran had been a French monopoly up until 1930, the first generation of American archaeologists who worked in Iran had been trained by anthropologists and prehistorians, and hence they had a more

anthropological and "holistic" approach to excavation and the interpretation of finds (e.g., Erich F. Schmidt obtained his PhD at Columbia under the German-born and trained Franz Boas and began his fieldwork in Arizona under the auspices of the American Museum of Natural History). Several American archaeologists with such training contributed greatly to our understanding of the ancient cultures of Iran. Chief among them are William M. Sumner (1928–2014), Robert H. Dyson Jr. (1927–2020), and C. C. Lamberg-Karlovsky (b. 1937). Sumner discovered the site of Tal-e Malyan in Fars Province, western Iran, and, from 1971 to 1978 under the auspices of the University of Pennsylvania Museum, he directed excavations there. During his initial survey of the region (the Kur River basin) in 1968, Sumner had found fragmentary inscribed bricks that enabled him to identify the site as ancient Anshan, the highland capital of Elam.[19] For over two-and-a-half millennia, Anshan had waxed and waned in political and economic importance (based on textual and archaeological evidence) and by the seventh century had become the homeland of the Achaemenid dynasty under Cyrus I.[20] Dyson directed another University of Pennsylvania Museum excavation, that of the mainly Iron Age site of Hasanlu Tepe in Azerbaijan Province, northwestern Iran.[21] Fieldwork conducted between 1956 and 1977 produced an occupational sequence from the Neolithic of the fifth millennium BCE through a massive destruction at the end of the ninth or early in the eighth century BCE, which was followed by subsequent reoccupations that ended in the Achaemenid and Early Parthian periods.[22] In addition to being a center of commerce and artistic production, Hasanlu was strategically located along trade routes through the Zagros Mountains that connected it with Anatolia and Mesopotamia, thereby linking it with major political and artistic centers of the Near East. C. C. Lamberg-Karlovsky, who immigrated to the United States from Czechoslovakia as a child, directed the Harvard University excavations at Tepe Yahya in Kerman Province located in southeastern Iran from 1966 to 1975. With an occupation span from the late Neolithic period (ca. 5500 BCE) into the early Sasanian (300 CE) period (with some interruptions), Tepe Yahya remains the only long stratigraphic sequence in the region known today.[23] Especially significant is the site's role in international trade during the third millennium BCE, with cultural connections to Mesopotamia to the west and the Indus valley to the east. It was also a production center for stone (chlorite) vessels, elaborately decorated in the "intercultural style," recognized from sites in Sumerian Mesopotamia, islands in the Persian Gulf, the Indus Valley, Uzbekistan, and elsewhere (fig. 13.3).

In nearing the end of this narrative, recognition must be accorded to two art historian-archaeologists who were trained in the art and archaeology of areas west of ancient Iran and who brought this training along with their keen eyes and insights to works of ancient Iranian art and architecture. The first,

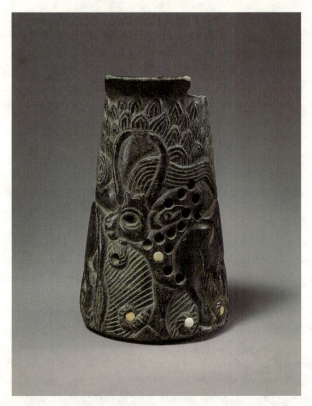

FIGURE 13.3. Vessel with two zebu, 2600–2350 BCE (Early Dynastic II–III). Probably from the Persian Gulf region, Tarut Island (al-Rafiah). Chlorite, calcite inlay, 11.4 × 7 × 7 cm. Gift of Mrs. Constantine Sidamon-Eristoff, 2014 (2014.717). The Metropolitan Museum of Art, New York.

a Chicago-born product of the University of Chicago and lifelong teacher there, is Helen J. Kantor (1919–1993). Kantor has left a lasting legacy through her students and her prolific writing. Like Edith Porada, her interests spanned many parts of the ancient Near East as well as Egypt and the Aegean. Her archaeological fieldwork at Choga Mish in southwestern Iran (1961–78) has added greatly to our awareness and understanding of the cultures of prehistoric and protohistoric southwestern Iran and the beginning of writing.

Study of the classics led Carl Nylander (b. 1932) to Iranian art and archaeology, and in particular those regions bordering the classical world. Indeed, for many classicists Iran (Persia) and its "frontieriality"—along with its perceived and actual historical and cultural "opposition" to the West—engendered their strong interest, which resulted in rewarding scholarship; this is certainly true

in Achaemenid studies and is exemplified by Nylander. After completing his graduate studies and teaching at Uppsala University, this Swedish archaeologist and writer of popular science served as Professor of Classical and Near Eastern Archaeology at Bryn Mawr College from 1970 to 1976 (he then taught in Copenhagen [1977–81] and directed the Swedish Institute in Rome [1979–97]). His research into the stone-working techniques used in Achaemenid architecture and sculpture was the subject of his 1969 dissertation, which dealt with Greek influences on Persian Achaemenid monumental art. The publication of his dissertation as *Ionians in Pasargadae: Studies in Old Persian Architecture* along with subsequent articles led the way for the next generation of art historians to explore the connections and reciprocities between the Hellenic and Roman worlds and the corresponding Persian spheres.[24]

Another archaeologist who came to the study of Iran's pre-Islamic past by way of classical archaeology was Oscar White Muscarella (1931–2022). While still a graduate student and then a member of the Metropolitan Museum of Art's Department of Ancient Near Eastern Art, which he joined in 1964, he participated in excavations at several sites in northwestern Iran, including Hasanlu, Agrab Tepe, Ziwiye, Dinkha Tepe, and Nush-i Jan. Muscarella retired from the Metropolitan Museum in 2009, his tenure there having been fraught as he unceasingly spoke out about unprovenanced acquisitions and condemned many otherwise accepted antiquities as fakes. A prolific writer, his major publications are the catalog of the Metropolitan Museum's ancient Near Eastern bronze and iron artifacts and the "bombshell" book *The Lie Became Great: The Forgery of Ancient Near Eastern Cultures*.[25]

Born in Iran in 1934, the art historian, Guitty Azarpay (d. 2024), came to the United States to study at the University of California, Berkeley. After earning her PhD there, she taught in the Department of Middle Eastern Languages and Cultures (1964–94) and was only the second woman appointed to a tenure-track position in that department. A major contribution to the field of Iranian art and archaeology in its broadest sense, she also pioneered the study of Central Asian art and archaeology in the United States with her 1981 book, *Sogdian Painting: The Pictorial Epic in Oriental Art*, in collaboration with the Russian archaeologists A. M. Belenitskii and Boris I. Marshak.

The last scholar of ancient Iran included here—though by far not least among these luminaries—is Prudence O. Harper (b. 1933), the longtime curator and then head of the Department of Ancient Near Eastern Art at the Metropolitan Museum of Art. As *the* authority on the visual culture of the Sasanian period (241–651 CE), Harper has published extensively and rigorously on a range of Sasanian art, most influentially and abundantly on metalwork. Her major contribution to this field is *Silver Vessels of the Sasanian Period*, vol. 1, *Royal Imagery*. Her 1978 exhibition "The Royal Hunter" was the first museum

exhibition to focus on Sasanian art in the United States, if not in the world.[26] Her volume *In Search of a Cultural Identity: Monuments and Artifacts of the Sasanian Near East, 3rd to 7th Century A.D.* is the result of a lifetime of studying Sasanian material culture.[27] In this book, Harper synthesizes the varied influences on Sasanian culture and formulates a rich definition of it.

Conclusion

As I have endeavored to show, ancient Iranian studies in the United States evolved from academic interest in ancient Indo-Iranian religion and languages. This development and its continuity in great part relied and thrived upon the vital mix of scholars from both the United States and elsewhere. Political and economic fluctuations have changed the nature of this mix, but it remains sizable and diverse, even though universities in the United States no longer are viewed as émigré havens. Despite the more than forty-year hiatus in US-Iran diplomatic relations, many American scholars remain dedicated to the study of ancient Iran's art and archaeology and strive to train a new generation of American students, even in light of current restrictions that have adversely affected participation in archaeological exploration in Iran and firsthand experience of Iran's art and material culture.

Notes

This chapter is based on a paper presented at the international conference, "Iranian Studies in Eurasia: Past, Present and Future," September 22–23, 2016, Russian State University for the Humanities (RSUH) in Moscow and published in 2018. Organized in collaboration with the Moscow International Foundation for Iranian Studies, the aim of the conference was, in the organizers' words, "to develop and to strengthen relations between experts in the field of Iranian Studies and to facilitate research in Iranian Studies in Eurasia." The ultimate goal of the meeting was to establish a "network of experts in Iranian studies in Eurasia." This resulted at the close of the meeting in the founding of the Eurasian Society for Iranian Studies, an international organization that, nevertheless, focuses on European countries, Iran, and the Iranophone nations of Central Asia. The conference was supported by the Embassy of the Islamic Republic of Iran, Moscow; I was the only North American attendee.

1. A. V. W. Jackson, *Phonology, Inflection, Word-Formation*; A. V. W. Jackson, *Avesta Reader*.
2. A. V. W. Jackson, *Zoroaster*.
3. Frye, who received his master and doctoral degrees at Harvard in 1940 and 1946, joined the Harvard faculty in 1948, where he helped to create the university's Center for Middle Eastern Studies. In 1957, he was named its first chair of Iranian Studies, a post he held until his retirement in 1990; see Giudicessi, "Professor Richard N. Frye," and Shahbazi, "Richard Nelson Frye."
4. Frye, *Sasanian Remains*.

5. Haas, *Iran*.
6. Geiger, "Middle Iranian Texts."
7. Yarshater, *Cambridge History of Iran*, and Yarshater, *History of al-Tabari*. An index was added to the set in 2007.
8. Quoted from Panofsky, *Meaning in the Visual Arts*, 332.
9. Pope and Ackermann, *Survey of Persian Art*.
10. Porada, *Art of Ancient Iran*.
11. Porada, *Corpus of Ancient Near Eastern Seals*.
12. First appearing as *Reise ins Asiatische Tuwa* (1931), the English translation was published posthumously as Mänchen-Helfen, *Journey to Tuva*. For further discussion of original publications, see https://en.tuva.asia/194-maenchen.html.
13. Sarre and Herzfeld, *Iranische Felsreliefs*.
14. Herzfeld, *Archaeological History of Iran*.
15. Herzfeld, *Iran in the Ancient East*.
16. For more on Herzfeld and Schmidt at Persepolis, see Matthew W. Stolper in this volume.
17. Schmidt, *Flights over Ancient Cities*.
18. Although mainly known for his work at Neolithic Jarmo in Iraqi Kurdistan on the border with Iran and at Çayönü in southeastern Turkey, Robert J. Braidwood (1907–2003)—a somewhat younger contemporary of Herzfeld and Schmidt at the Oriental Institute—and his wife and collaborator Linda S. Braidwood (1909–2003) were invited to Iran by Negahban and spent a season in Kermanshah, northwestern Iran (1959–60), surveying and test excavating early rock shelters and open sites; see Watson, "Robert John Braidwood."
19. See Abdi, "Maliān." For a bibliography of Malyan publications, including excavation reports and specialized studies, see http://www.penn.museum/sites/MalWebSite/bibliography.html.
20. Hansman, "Anshan."
21. For more on Dyson at Hasanlu, see Christopher P. Thornton, Alessandro Pezzati, and Holly Pittman in this volume.
22. Dyson, "Ḥasanlu Teppe."
23. Potts, "Tepe Yahya."
24. Nylander, *Ionians in Pasargadae*.
25. Muscarella, *Lie Became Great*.
26. Harper, *Royal Hunter*.
27. Harper, *In Search of a Cultural Identity*.

Bibliography

Abdi, Kamyar. "Maliān." *Encyclopaedia Iranica*. Last updated July 20, 2005. http://www.iranicaonline.org/articles/malian.

———. "Oriental Institute of the University of Chicago." *Encyclopaedia Iranica*. Last updated July 20, 2005. http://www.iranicaonline.org/articles/oriental-institute-univ-chicago.

Boyce, Mary, and Gernot Windfuhr. "Introduction." Pages ix–xxiii in *Iranica Varia: Papers in Honor of Professor Ehsan Yarshater*. Edited by D. Amin. Acta Iranica 30. Leiden: Brill, 1990.

Daryaee, Touraj. "The Study of Ancient Iran in the Twentieth Century." *Iranian Studies* 42.4 (2009): 579–89.

Dyson, Robert H., Jr. "Ḥasanlu Teppe." *Encyclopaedia Iranica*. Last updated March 20, 2012. http://www.iranicaonline.org/articles/hasanlu-teppe-i.

Frye, Richard N. "Asia Institute." *Encyclopaedia Iranica*. Last updated August 16, 2011. http://www.iranicaonline.org/articles/asia-institute-the-1.

———, ed. *Sasanian Remains from Qasr-i Abu Nasr: Seals, Sealings, and Coins*. Cambridge: Harvard University Press, 1973.

Geiger, Bernhard. "The Middle Iranian Texts." Pages 283–317 in *The Excavations at Dura-Europos, Conducted by Yale University and the French Academy of Inscriptions and Letters, Final Report 8/1, the Synagogue*. Edited by C. H. Kraeling. New Haven: Yale University Press, 1956.

Giudicessi, Beth. "Professor Richard N. Frye Dies at 94," *Harvard Gazette* (April 4, 2014), http://news.harvard.edu/gazette/story/2014/04/professor-richard-n-frye-dies-at-94/.

Haas, William S. *Iran*. New York: Columbia University Press, 1946.

Haines, Richard C. "Erich F. Schmidt. September 13, 1897-October 3, 1964." *Journal of Near Eastern Studies* 24.3 (1965): 145–48.

Hansman, J. "Anshan." *Encyclopaedia Iranica*. Last updated August 5, 2011. http://www.iranicaonline.org/articles/anshan-elamite-region.

Harper, Prudence O. *In Search of a Cultural Identity: Monuments and Artifacts of the Sasanian Near East, 3rd to 7th Century A.D.* New York: Bibliotheca Persica, 2006.

———. *The Royal Hunter*. New York: Asia House Gallery, 1978.

———. *Silver Vessels of the Sasanian Period*. Vol. 1, *Royal Imagery*. New York: Metropolitan Museum of Art, 1981.

Herzfeld, Ernst E. *Archaeological History of Iran: The Schweich Lectures of the British Academy 1934*. London: Oxford University Press for the British Academy, 1935.

———. *Iran in the Ancient East: Archaeological Studies Presented in the Lowell Lectures at Boston*. London: Oxford University Press, 1941.

Jackson, A. V. W. *Avesta Reader: First Series*. Stuttgart: Kohlhammer, 1893.

———. *Phonology, Inflection, Word-Formation with an Introduction on the Avesta*. Part 1 of *An Avesta Grammar in Comparison with Sanskrit*. Stuttgart: Kohlhammer, 1892.

———. *Zoroaster: The Prophet of Ancient Iran*. New York: Macmillan, 1898.

Kamaly, Hossein. "Haas, William S." *Encyclopaedia Iranica*. Last updated February 26, 2014. http://www.iranicaonline.org/articles/haas-william.

Lerner, Judith A. "Arthur Upham Pope and the Sasanians." Pages 166–229 in *Arthur Upham Pope and a New Survey of Persian Art*. Edited by Yuka Kadoi. Leiden: Brill, 2016.

———. "The Study of Ancient Iran in the United States: A History Focusing on Art and Material Culture." Pages 43–52 in *Иранистка в Евразии: Прошлое, Настоящее, Будущее; Сьорник статей / Iranistik v Evrazii: Proshloe, Nastojashchee, Budshchee; Sbornik statej*. Edited by P. B. Basharin. Moscow: 2018.

Malandra, William W. "Jackson, Abraham Valentine Williams." *Encyclopaedia Iranica*. Last updated August 24, 2012. http://www.iranicaonline.org/articles/jackson-abraham-valentine-williams.

Mänchen-Helfen, Otto. *Journey to Tuva: An Eye-Witness Account of Tannu-Tuva in 1929*. Translated by Alan Leighton. Los Angeles: Ethnographics Press of the University of Southern California, 1992.

———. *The World of the Huns: Studies in Their History and Culture.* Berkeley: University of California Press, 1973.

Muscarella, Oscar White. *Bronze and Iron: Ancient Near Eastern Artifacts in the Metropolitan Museum of Art.* New York: Metropolitan Museum of Art, 1988.

———. *The Lie Became Great: The Forgery of Ancient Near Eastern Cultures.* Groningen: Styx, 2000.

Nylander, Carl. *Ionians in Pasargadae: Studies in Old Persian Architecture.* Acta universitatis Upsaliensis. Uppsala Studies in Ancient Mediterranean and Near Eastern Civilizations 1. Uppsala: Boreus, 1970.

Panofsky, Irwin. *Meaning in the Visual Arts: Papers in and on Art History.* Garden City, NY: Doubleday, 1955.

Pope, Arthur Upham, and Phyllis Ackerman, eds. *A Survey of Persian Art: From Prehistoric Times to the Present.* 6 vols. Oxford: Clarendon, 1938.

Porada, Edith. *The Art of Ancient Iran: Pre-Islamic Cultures.* New York: Crown, 1969.

———. *Corpus of Ancient Near Eastern Seals in North American Collections: The Pierpont Morgan Library Collection.* New York: Pantheon, 1948.

Potts, D. T. "Tepe Yahya." *Encyclopaedia Iranica.* Last updated July 20, 2004. http://www.iranicaonline.org/articles/tepe-yahya.

Sarre, Friederich, and Ernst E. Herzfeld. *Iranische Felsreliefs: Aufnahmen und Untersuchungen von Denkmälern aus Alt- und Mittelpersischer Zeit.* Berlin: Wasmuth, 1910.

Schmidt, Erich F. *Flights over Ancient Cities of Iran.* Chicago: University of Chicago Press, 1940.

Schmitt, Rüdiger. "Geiger, Bernhard." *Encyclopaedia Iranica.* Last updated February 3, 2012. http://www.iranicaonline.org/articles/geiger-bernhard.

Shahbazi A. Sh. "Richard Nelson Frye: An Appreciation." *Bulletin of the Asia Institute* 4 (1990): ix–xiv.

Vanden Berghe, Louis. "Bozpār." *Encyclopaedia Iranica.* Last updated September 30, 2016. http://www.iranicaonline.org/articles/bozpar.

Watson, Patty Jo. "Robert John Braidwood." *Proceedings of the American Philosophical Society* 149.2 (2005): 234–41.

Williams, Bruce. "Helene J. Kantor (1919–1993)." *Journal of the American Research Center in Egypt* 30 (1993): ix–xi.

Yarshater, Ehsan, ed. *Dr. Ehsan Yarshater: An Authorized Web Site.* http://www.perlit.sailorsite.net/yarshater/.

———, ed. *History of al-Tabari.* 40 vols. Albany: State University of New York Press, 1985–99.

———. "Obituary. Professor Richard Nelson Frye (10 January 1920–27 March 2014). A Distinguished Scholar of Iranian Studies." *Iranian Studies* 47.4 (2014): 649–52.

———. *The Seleucid, Parthian and Sasanid Periods.* Vol. 1, parts 1 and 2 of *The Cambridge History of Iran.* Cambridge: Cambridge University Press, 1983.

CHAPTER 14

Sasanian Art Historical and Archaeological Studies in the United States, 1960–2010

Prudence O. Harper

IN THE EARLY 1930S, the French monopoly over archaeological explorations in Iran expired and the Metropolitan Museum of Art in New York City sent an expedition to a site in the south of that country near the modern city of Shiraz. The mound selected in 1932 by the museum was Qasr-i Abu Nasr, where Achaemenid remains still stood on the surface. As the American team soon discovered, the site was not an Achaemenid one but mainly late Sasanian and early Islamic in date and in the course of the next three seasons, ending in 1935, excavations in two rooms in the late Sasanian citadel (a local administrative and commercial center) uncovered large collections of stamped clay sealings.[1] These sealings, some 505 in number, were divided between the Iran Bastan Museum in Tehran and the Metropolitan Museum, where they entered the Department of Near Eastern Art (only in 1957 was a separate Department of Ancient Near Eastern Art established). They joined a group of Sasanian works of art, which included around one hundred Sasanian seals acquired in the late nineteenth and early twentieth centuries and a number of stucco plaques from the German excavations at the Sasanian capital city of Ctesiphon in Iraq, a project to which the Metropolitan Museum had contributed funds for the 1931–32 season.[2] In addition, the museum had acquired in 1934 a Sasanian silver plate, one of the very few to exist at that time in North American collections.[3]

In the 1930s, almost no comprehensive and systematic examination of Sasanian monuments and artifacts existed, although the literature by the end of the nineteenth and beginning of the twentieth centuries included studies of the rock reliefs, silver vessels, and coin and seal collections. Noteworthy among the many publications was Arthur Christensen's masterful reconstruction of the history of Sasanian civilization, *L'Iran sous les Sassanides*, published in Copenhagen in 1936 (a second edition appeared in 1944), a volume that still remains relevant.[4] The history of the early studies in the late nineteenth and early twentieth centuries of Sasanian remains was summarized by Oleg Grabar in 1967 in "An Introduction to the Art of Sasanian Silver," which appeared in

the catalog for an exhibition entitled "Sasanian Silver" that was held at the University of Michigan, Ann Arbor.[5] Grabar stressed at that time the difficulties of working in a field in which no clear definition of the material culture existed and where systematic investigations of different categories of artifacts were lacking. In addition, scholars working in the fields of Late Antique and Islamic studies were more concerned with the Sasanian period in the Near East than specialists in the history of the pre-Islamic Near East, resulting in an unbalanced and often negative presentation of the art of the period.[6]

As we look back in time, it is evident that the situation was rapidly changing by the time of the Michigan exhibition, and the following comments on Sasanian studies in the United States will cover the subsequent decades. After 1967, scholars in the United States had increasing access to materials in Iran, facilitated by the establishment in that year of the American Institute of Iranian Studies. The director of the Tehran Center was able to assist visiting scholars in obtaining residence and research permits and offer useful information on various facilities within Iran. Interest in the culture of Sasanian Iran was also stimulated in North America as a direct result of the subject about which Grabar had written: Sasanian silver vessels. Between the 1950s and '70s, large numbers of these silver vessels appeared for the first time on the antiquities market in Iran and subsequently in Europe, England, and the United States. In the United States, as elsewhere, the vessels entered museum and private collections, which had among their holdings almost no works of art from this period in this precious medium. In order to interpret and date the vessels, all of which lacked a meaningful archaeological context, new attention was directed to different aspects of their production, notably to an accurate appraisal of the techniques used for their construction, analyses of the silver composition, and more detailed stylistic and iconographic studies of the images appearing on them.[7] Technical and art historical reports were included in the subsequent publications of silver vessels in the Metropolitan Museum collection by Prudence O. Harper and Pieter Meyers,[8] in the Hermitage Museum in St. Petersburg by Kamilla V. Trever and Vladimir G. Lukonin (with x-rays and technical information by P. Meyers),[9] and in the Arthur M. Sackler Gallery and the Freer Gallery of Art in Washington, DC, by Ann C. Gunter and Paul Jett.[10]. Another significant group of Sasanian silver vessels was acquired by the Cleveland Museum of Art in the 1960s and published in a number of articles by Dorothy G. Shepherd.[11] Attention was also directed to the much-abbreviated Middle Persian inscriptions appearing on some of the vessels in museum collections. In 1973 at a Sasanian silver conference held at the Metropolitan Museum, Christopher J. Brunner of the Iran Center at Columbia University contributed to the interpretation of these inscriptions by offering a new and corrected reading of the abbreviated weight notations.[12]

The attention given the silver vessels also spread to Sasanian coins,[13] seals, and sealings.[14] In 1978, Brunner catalogued the Sasanian seals in the Metropolitan Museum and in the Moore Collection, at that time on loan to the Metropolitan Museum.[15] Richard N. Frye, Prudence O. Harper, and George C. Miles also published in the first volume of the Harvard Iranian Series the coins and sealings as well as other assorted finds from the Metropolitan Museum's early excavations at Qasr-i Abu Nasr.[16] In 1977, Judith A. Lerner published a monograph on the complicated subject of Christian seals of Sasanian date.[17] Also notable were the successful efforts of Guitty Azarpay (University of California, Berkeley) to acquire and preserve a large collection of over 260 Middle Persian documents comprising economic texts from Iran dating from or just after the Late Sasanian period (between the seventh and ninth century CE) written on parchment, leather, and textiles. Eighty-two of the documents were still sealed with stamped clay sealings. The group, which had appeared on the antiquities market, was finally presented in 2001 and 2002 to the Bancroft Library at the University of California, Berkeley, and arrangements have been made for the publication of the documents by Phillippe Gignoux and Rika Gyselen.[18]

At the Corning Museum of Glass, the collection grew with the acquisition of Sasanian glass vessels from Iran, which appeared in dealers' hands in the 1960s and '70s at about the same time as the silver vessels. In recent decades, scientific studies and analyses by Robert H. Brill at the Corning Museum of Glass have given definition to works in this medium that has complemented the literature on glass written in the early twentieth century.[19]

The study of Sasanian textiles has remained a complex and difficult one in part because of the scarcity of excavated examples, which inevitably leads to questions concerning date and probable places of manufacture and use. In Iran, the Sasanian rock sculptures provide some secure information about late Sasanian textile patterns, notably the late Sasanian monument of Khosrow II (591–628) at Taq-i Bustan studied by Elsie Holmes Peck in a still valuable illustrated article in *Artibus Asiae*.[20] Later Japanese photographic surveys devoted to the sculptures at Taq-i Bustan contributed further to the analysis of the varied and rich patterns on the drapery of the royal and supernatural figures in the large iwan.[21] Another scholar in the United States, Carol Bier, has contributed to the study of Sasanian textiles from the time of her first publication on the subject in *The Royal Hunter* catalog in 1978.[22] Her careful analyses and descriptions of the sophisticated weaving techniques has been accompanied by a skepticism shared by most scholars concerning the Sasanian date and manufacture of many textiles in European church treasuries and museums as well as from old excavations in Egypt.

A group of undecorated and simply decorated textiles unearthed with a late sixth-century coin at Shahr-i Qūmis in Iran is preserved in the Metropolitan

Museum in New York (a supporter of the expedition led by David Stronach).[23] Also in the Metropolitan Museum is an interesting group of post-Sasanian textiles (eighth to tenth century), including a linen caftan with silk borders and a pair of silk leggings with linen feet, from the site of Moshchevaya Balka in the Caucasus, a site excavated by Anna Ierusalimskaja of the Hermitage Museum in St. Petersburg.[24] In spite of these studies and new discoveries, uncertainty still surrounds works of art in this medium. Further technical and art historical investigations of Sasanian textiles are necessary before a convincing Sasanian corpus of material can be identified. As textiles readily decay in the climate of Iran, it is unlikely that meaningful finds will be made as a result of further archaeological endeavors in Iran.

To the research on the silver vessels, coins, seals, glass, and textiles can be added studies of the Parthian and Middle Persian rock-cut Sasanian dynastic inscriptions and Avestan texts.[25] In the United States, a major contributor has been P. Oktor Skjaervø, Aga Khan Professor of Iranian Studies Emeritus at Harvard University. In 1983, Skjaervø published a final edition of the Parthian and Middle Persian inscriptions from the great tower of Narseh (293–302) at Paikuli (Iraq), a monument laboriously documented and published by Ernst Herzfeld in 1924.[26] The photographs, squeezes, and facsimiles made by Herzfeld at the site and kept at the Arthur M. Sackler Museum and the Freer Gallery of Art in Washington, DC, are the primary source for these inscriptions, as the remains at the site have since deteriorated. More recently, Skjaervø's *The Spirit of Zoroastrianism* has appeared with his translations of Zoroastrian texts, offering an insight into Zoroastrian beliefs.[27] James R. Russell, Mashtots Professor of Armenian Studies Emeritus at Harvard University, wrote a volume relevant to the history of the Zoroastrian religion in Iran entitled *Zoroastrianism in Armenia*.[28] His later publication, *Armenian and Iranian Studies*, includes other articles by him on Iranian texts, culture, and religion.[29] A Russian translation by Anahit G. Perikhanian of a late Sasanian law book, *The Book of a Thousand Judgements* (*Mādigān i hazār Dādīstān*) was translated from Russian into English in an edition by Nina Garsoïan of Columbia University in 1997, a monumental publication that has contributed to our understanding of Sasanian administration and history.[30] Another scholar and editor of the *Encyclopaedia Iranica*, Christopher J. Brunner, continues to make important contributions to that publication and to the study of Middle Persian texts.

The wealth of new information produced by these systematic studies of Sasanian monuments and artifacts by scholars in North America, England, Europe, and Asia has not, unfortunately, been supplemented by archaeological investigations in Iran. New excavations and surveys in Iran at Sasanian sites or in Sasanian levels have been regrettably few in number. One positive development has been the publication in recent decades of old excavations,

including a second volume in 1985 on the finds made in the 1930s at Qasr-i Abu Nasr by Donald S. Whitcomb of the University of Chicago.[31] Whitcomb also reexamined and reevaluated the records and finds made by the University of Chicago at Istakhr near Persepolis in the 1930s.[32] Similarly, the seventh- or eighth-century stucco remains found in the mid-1930s in excavations of the University of Pennsylvania at the site of Chal Tarkhan-Eshqabad near Rayy in northern Iran were the subject of a comprehensive study in 1976 by the independent American scholar Deborah Thompson.[33] The original expedition, under the direction of Erich F. Schmidt, then at the University of Pennsylvania, and Assistant Field Director George C. Miles, later head of the American Numismatic Society in New York, was also supported by the Museum of Fine Arts in Boston. Trudy S. Kawami, another independent scholar in the United States, reconsidered the remains, notably the paintings, from the site of Kuh-e Khwaja in northeastern Iran by examining the notebooks, drawings, and photographs of Ernst Herzfeld, who visited the site in 1925, and subsequently published some of his findings in 1941.[34] Herzfeld's archives are largely held by the Arthur M. Sackler Gallery and the Freer Gallery of Art in Washington, DC, and two wall paintings, the only ones to survive from Herzfeld's excavations, were acquired by the Metropolitan Museum in New York in 1945.[35] While some disagreement still exists about the periods of occupation at the site—Parthian, Early and Late Sasanian, and Islamic—Kawami's work is an important contribution. It has been supplemented by Mahmoud Mousavi, who worked at the site from 1990 to 1992 under the aegis of the Office of Iranian Cultural Heritage evaluating serious problems of conservation and restoration, and by Suroor Ghanimati, who concludes on the basis of the architectural and artistic remains that Kuh-e Khwaja served continuously from Late Parthian through Late Sasanian times as a Zoroastrian religious center that was richly decorated with sculptures and murals.[36]

Works on Sasanian remains in Iran include a survey in the 1960s by Robert McC. Adams and Donald P. Hansen at the site of Gunde Shapur in southwestern Iran not far from Susa.[37] A map of the city was drawn up from surface observations in 1963, a particularly fortunate undertaking as the remains of this foundation of Shapur I, in part constructed by Roman prisoner workers, were eventually destroyed, according to the Iranian Cultural Heritage Foundation, as a result of continuous cultivation. Lionel Bier of Brooklyn College made valuable contributions to the study of Sasanian architecture, reexamining palatial remains at Firuzabad, Bishapur, and Sarvistan in a monograph and several articles.[38] Bier demonstrated just how little reliable evidence exists concerning the building plans and methods of construction used in so-called Sasanian structures, some of which he found to be Early Islamic in date. The functions of many Sasanian structures, as questioned by Bier, still remain open to question.

Archaeological fieldwork in Iran by North American and Iranian scholars interested in the Sasanian era has also focused on less spectacular remains. One such example is the site of a Sasanian palace at Tepe Hissar (Damghan) in northeastern Iran. First excavated by Erich F. Schmidt on behalf of the University Museum of the University of Pennsylvania between 1931 and 1933, permission was given by the Iranian Center for Archaeological Research to Robert H. Dyson of the University of Pennsylvania and Maurizio Tosi to return to this site for further exploration.[39] One result of this was a valuable survey in 1976–77 by Kathryn M. Trinkhaus to document Parthian and Sasanian ceramic types on the Damghan plain (northeast Iran).[40] Surveys by Robert McC. Adams, James A. Neely, and R. J. Wenke focused on western Iran and Khuzestan have contributed to our understanding of sociopolitical developments in the region in the Late Sasanian period.[41] The American archaeologist William Sumner, as part of the University of Pennsylvania's Hasanlu Project, led an excavation in southern Iran at Malyan, where a burial of Sasanian date containing a simple silver vessel was uncovered, an interesting discovery since the original context of almost all Sasanian silver vessels found in Iran is unknown.[42] At Shahr-i Qumis in northeast Iran, a team led by John Hansman and David Stronach made an unexpected find of sixth-century Sasanian textiles in an abandoned room that had been reused as a repository for a single body.[43] On the Persian Gulf at Siraf, early levels belonging to the Sasanian period were uncovered during six seasons of excavations begun in 1966 by David Whitehouse, who later became the Director of the Corning Museum of Glass.[44]

Iranian colleagues continue to make important discoveries. Under the auspices of the Iranian Center for Archaeological Research, the Iranian archaeologist Massoud Azarnoush undertook a salvage excavation at Hajiabad in southern Iran. In a rapidly executed, single season just before the Iranian Revolution, he unearthed at the already partly demolished site that comprised rich Early Sasanian remains of a manor house, including stucco sculptures and paintings dated by him from the fourth century and by some other scholars from the fourth to fifth centuries.[45] Azarnoush's report of his 1978 season was completed during a subsequent stay in the United States at the University of Michigan, Ann Arbor, the University of California, Los Angeles, and as a fellow at the Metropolitan Museum of Art in New York and the Smithsonian Institution in Washington, DC, before his return to Iran. In the same years, Azarnoush excavated at the so-called Anahita Temple at Kangavar in western Iran until 1979, work that was continued by Iranian colleagues Mehdi Mehryar and A. Kabiri in the years from 1988 to 2001.[46] Just before his death, Azarnoush reaffirmed his conclusions that the Anahita Temple was largely Late Sasanian in date.[47]

An exciting archaeological salvage project directed by the Iranian archaeologist Mehdi Rahbar is a rescue investigation begun in 1994 of remains at

Bandiyan in northern Khorasan, where the excavation of a fifth-century building identified as a fire temple has uncovered partly destroyed rooms richly decorated with stucco depictions of cult activities as well as battle scenes in which Sasanians and Hephthalites are thought to be represented.[48] Other excavations by Iranian colleagues have been noted in 1997 and 1998 issues of the journal *Iran*, in a May 1999 issue of *Dossiers d'Archéologie*, and in a number of new Iranian periodicals devoted to archaeology: *Name-ye Iran-e Bastan: The International Journal of Ancient Iranian Studies* (initiated in 2001), the *Bulletin of Ancient Iranian History* (in Persian; initiated in 2004), and *Bastan Pazhuhi* (in Persian).

Unique stylistic and iconographical features characterize the works of art found at the sites mentioned above. This fact underscores the need for more archaeological fieldwork in different parts of Iran so that regional trends and variations can be documented. Without further surveys and excavations, any understanding or interpretation of Sasanian cultural developments is necessarily restricted.

Many books on ancient Iran have covered the art and archaeology as well as the socioeconomic history of both the Parthian and Sasanian periods, R. N. Frye of Harvard University being a major contributor.[49] Historical, social, and cultural developments are the subjects of respective volumes by Matthew P. Canepa, Touraj Daryaee, and Prudence O. Harper.[50] Another important scholar, one who regularly contributed to the *Encyclopaedia Iranica* as well as many other publications, was A. Shapur Shahbazi, who was Emeritus Professor of History at Eastern Oregon University before his untimely death in 2006. Probably the most comprehensive and important two initiatives were undertaken by Ehsan Yarshater of the Center for Iranian Studies of Columbia University and later of the *Encyclopaedia Iranica*. The first of these—parts one and two of the third volume of *The Cambridge History of Iran* covering the Seleucid, Parthian and Sasanian periods—was completed in 1983.[51] The second significant initiative associated with Yarshater is the multivolume *Encyclopaedia Iranica*. This international collaborative project, the first fascicle of which appeared in 1982, is still a work in progress.[52] Both publications include articles by North American and foreign scholars on Parthian and Sasanian language and literature, history, society, religion, and art history. The *Encyclopaedia Iranica* is now a primary resource providing bibliographical data as well as information on current developments in the fields of Parthian and Sasanian studies. A review of the publication with attention to the Sasanian headings appeared in *Iranian Studies* 31.[53] In 1987, a new American journal appeared, entitled the *Bulletin of the Asia Institute*, that was edited initially by Carol Altman Bromberg, Richard N. Frye, and Bernard Goldman and published by Wayne State University Press in Detroit. This journal was conceived

as a continuation of the *Bulletin of the American Institute for Persian Art and Archaeology*, which was initiated in 1931 through the efforts of Arthur U. Pope and, with slight changes of name, through the work of successors. It has been published in subsequent years in the United States and Iran by Pahlavi University and finally by Shiraz University in 1978. More recent appearances are the *Journal of Inner Asian Art and Archaeology* edited by L. Russell-Smith (London) and Judith A. Lerner (New York), which includes subjects relating to Parthian and Sasanian material culture in and beyond the borders of Iran, and the *Journal of Persianate Studies* edited by Saïd A. Arjomand (State University of New York, Stony Brook). These publications followed the lead of many newly established British, European, Russian, and Japanese journals including articles on Sasanian Iran, some initiated as far back as the 1960s.

A contribution having important implications for art historians as well as social and economic historians is the 2008 volume *Decline and Fall of the Sasanian Empire* by Parvaneh Pourshariati of Ohio State University.[54] Pourshariati questions the proposal made by Arthur Christensen in 1944 that the Sasanian administration was strongly centralized throughout the period. She argues instead that there is evidence in late Middle Persian, Greek, Syriac, and Armenian sources as well as in the classical Arabic histories that the great Parthian feudal families played a major role in Sasanian Iran through the positions they held and the vast lands they controlled in northern, eastern, and western Sasanian realms. In her opinion, which is well documented in the volume, the Parthian great families played a significant role throughout the Sasanian period in what she believes is more accurately described as a Sasanian-Parthian confederation.

Increasingly, the Sasanian field of study has benefited from modern technological advances. There is now a website for the Sasanian period: "Sasanika: The History and Culture of Sasanians,"[55] edited by Touraj Daryaee and the University of California, Irvine. This is an invaluable resource. The second volume of the Sasanika Series is *Bibliographika Sasanika 1990–1999*, and Sasanika also has agreements with the National Museum of Iran to publish Sasanian seals and sealings in that collection as well as coins and seals in the Museum of Money in Tehran in the future.[56]

The different lines of research described above that were conducted from 1960 to 2010 have been reflected in enlarged displays of Sasanian art in many museums in the United States and abroad, which have been supplemented by periodic special exhibitions. All of these exhibitions have brought this period of Iranian history to public attention. The first exhibit after Grabar's "Sasanian Silver" in 1967 was "The Royal Hunter: Art of the Sasanian Empire," which was curated by Prudence O. Harper in 1978 at the Asia House Gallery for the Asia Society in New York. The catalog, which was written by several scholars,

included and illustrated works of art in many media from American, British, European, and Iranian private and public collections.[57] Another exhibit, entitled "Splendeur des Sassanides," was organized in Brussels fifteen years later by Louis Vanden Berghe, whose work in Iran and at the University of Ghent in Belgium led to many contributions to the field of Sasanian studies. Accompanied by a catalog of essays written by specialists in the field, the exhibition, which included objects made of many different materials drawn from holdings in several countries, focused attention on advances in Sasanian historical and art historical studies.[58] In 2006, Françoise Demange of the Musée du Louvre planned and coordinated the international exhibition "Les perses sassanides: Fastes d'un empire oublié (224–642)" at the Musée Cernuschi in Paris.[59] A subsequent abbreviated form of the exhibit, entitled "Glass, Gilding and Grand Design: Art of Sasanian Iran (224–642)," appeared in the United States at the Asia Society in New York in early 2007.[60] This exhibition drew on major collections of Sasanian art and an international team of scholars contributed to the text of the catalog.

Research in the field of Sasanian studies in this country and abroad has greatly expanded our understanding of the social and economic history and the material culture of the period. Analyses of texts, coins, seals, and sealings are responsible for advances that will lead eventually to a reevaluation and reinterpretation of some of the other material remains, both architectural as well as artifactual. Not surprisingly, the palatial arts of luxury and the centers of Sasanian dynastic power have received more attention than the artifacts of daily life and the smaller settlements scattered around the country of Iran. The result is that we are still far from being able to reconstruct convincingly a broad cultural history of Sasanian Iran. The finds at Hajiabad and Bandian provide evidence of just how varied the cultural remains from different geographical regions in Iran are. While a greater presence of Sasanian artifacts in the collections of museums in the United States has increased an awareness of the artistic and archaeological remains, an expansion in this country of university programs devoted to the different aspects of life and culture in Iran in the Sasanian period is badly needed, if future contributions to an understanding of the wealth and diversity of this period in pre-Islamic Iranian history are to be made by another generation of scholars in the United States.[61]

Notes

1. Brief reports by Walter Hauser, Joseph Upton and Charles K. Wilkinson were first published in the *Bulletin of The Metropolitan Museum of Art* in November 1933, December 1934, and September 1936.

2. The definitive volume on Sasanian stucco from Ctesiphon and other sites is by Kröger, *Sasanidischer Stuckdekor*.

3. Acc. no. 34.33. Harper, "Sasanian Silver Vessels."
4. Christensen, *L'Iran sous les Sassanides*.
5. University of Michigan Museum of Art, *Sasanian Silver*, 19–89. A survey of the studies before the 1960s was given in Grabar's introduction to the exhibit. Notable American contributions were the photographic documentation of Sasanian sites by Schmidt, *Flights over Ancient Cities* and the photographic survey of Sasanian reliefs in the Persepolis region in Schmidt, *Royal Tombs and Other Monuments*.
6. Increasing interest in Sasanian studies is demonstrated by the four panels at the MESA meetings in 2009 organized by P. Pourshariati entitled "Recent Trends in Late Antique Iranian Studies."
7. An early and important study of the gilding on the vessels was by Lechtman, "Ancient Methods of Gilding." Art historical studies of the vessels were facilitated by the publication of commentaries on the dynastic Sasanian rock reliefs accompanied by detailed photographs and drawings made by British scholar Georgina Herrmann (drawings by Rosalind Howell) between 1977 and 1985, a project of the German Archaeological Institute's Tehran Section in the series *Iranische Denkmäler, Iranische Felsreliefs*.
8. Harper and Meyers, *Silver Vessels*.
9. Trever and Lukonin, *Sasanidskoe Serebro*.
10. Gunter and Jett, *Ancient Iranian Metalwork*. See also Chase, "Technical Examination."
11. Shepherd "Sasanian Art in Cleveland"; Shepherd, "Two Silver Rhyta."
12. Brunner, "Middle Persian Inscriptions." In the United States, Europe, and Russia new studies of the inscriptions were made by Livshits and Lukonin, Henning, Harmatta, Frye, and Gignoux: see references in Brunner, "Middle Persian Inscriptions"; see also the bibliography in Harper and Meyers, *Silver Vessels*, 241–50.
13. Göbl, *Sasanidische Numismatik*; more recently see the multivolume international (Paris, Vienna, Berlin) Sasanian coin project, which began publication in 2003 with Alram and Gyselen, *Sylloge Nummorum Sasanidarum*.
14. In 1969, A. D. H. Bivar published a catalogue of the Sasanian seals in the British Museum; see Bivar, *Sassanian Dynasty*. In 1978 and 1993, Phillipe Gignoux and Rika Gyselen published seals and sealings in the Musée du Louvre and the Bibliothèque nationale, and in subsequent years they published a number of private collections of seals and sealings; see bibliography in Gyselen, *Sasanian Seals and Sealings*, and volumes of Res Orientales for the impact of these studies on our understanding of Sasanian administration and society.
15. Brunner, *Sasanian Stamp Seals*, and Brunner, "Sasanian Seals."
16. Frye, *Sasanian Remains*. Another large group of sealings from the German excavations at Takht-i Soleiman was published by Göbl, *Tonbullen*.
17. Lerner, *Christian Seals*; Lerner, "Sacrifice of Isaac Revisited." For other publications of Sasanian Christian seals, see the bibliography in Gyselen, "Sceaux des mages," 149.
18. See Azarpay et al., "Analysis of Writing Materials," and Azarpay et.al., "New Information."
19. Whitehouse, *Sasanian and Post-Sasanian Glass*. Appendix 2 in this volume is by Brill, "Chemical Analyses."
20. Peck, "Representation of Costumes."
21. See both volumes of Fukai and Horiuchi, *Taq-i Bustan*.

22. Bier, "Textiles." See also Bier, "Pattern Power," and Bier, "Sasanian Textiles."
23. Acc. nos. 69.24.29–37. Hansman and Stronach, "Sasanian Repository."
24. Acc. nos. 1996.78.1 (caftan), 1996.78.2a,b (leggings). On this subject, see articles in *Metropolitan Museum Journal* 36 (2001) by Harper, "Man's Caftan"; Kajitani, "Man's Caftan"; and Knauer, "Man's Caftan." Additional textiles from the same location were a gift to the Metropolitan Museum by Jacqueline Simcox in 1999 (acc. nos. 1999.153.34–43).
25. For European contributions, see Back, *Sasanidischen Staatsinschriften*, and the bibliography by Phillipe Gignoux in Gyselen, *Au carrefour des religions*, 11–18.
26. Skjaervø, *Restored Text and Translation*.
27. Skjaervø, *Spirit of Zoroastrianism*. See also Skjaervø, "Karsasp," and Skjaervø, "Kartir." A complete list of Skjaervø's publications appears on his homepage: https://nelc.fas.harvard.edu/files/nelcnew/files/pos_cv_biblio.pdf. See also his *Festschrift* volume: Bromberg, Sims-Williams, and Sims-Williams, *Iranian and Zoroastrian Studies*.
28. Russell, *Zoroastrianism in Armenia*.
29. Russell, *Armenian and Iranian Studies*.
30. Perikhanian and Garsoïan, *Book of a Thousand Judgements*, see especially its introduction, transcription, and translation of the Pahlavi text, including its notes, glossary and indexes. For the work of Christopher J. Brunner, Associate Editor, *Encyclopaedia Iranica*, see Brunner, *Sasanian Stamp Seals*; Brunner, "Sasanian Seals in the Moore Collection"; and entries over the years in *Encyclopaedia Iranica*.
31. Whitcomb, *Before the Roses*.
32. Whitcomb, "City of Istakhr."
33. Thompson, *Stucco from Chal Tarkhan-Eshqabad*.
34. Kawami, "Kuh-e Khwaja," and Kawami, "Ernst Herzfeld."
35. Acc. nos. 45.99.1, 2. The Metropolitan Museum also holds Herzfeld archival materials in the Department of Islamic Art and the Department of Ancient Near Eastern Art. Most of these papers cover material later published by Herzfeld.
36. Mousavi, "Kuh-e Khadjeh." See also Ghanimati, *Kuh-e Khwaja*, and Ghanimati, "New Perspectives."
37. Adams and Hansen, "Archaeological Reconnaissance."
38. Bier, "Sasanian Palaces in Perspective"; Bier, *Sarvistan*; Bier, "Sassanian Palaces and their Influence"; and Bier, "Sarvistan Reconsidered."
39. Schmidt, *Excavations at Tepe Hissar*.
40. Trinkhaus, "Pottery from the Damghan Plain."
41. Adams, "Agriculture and Urban Life"; Neely, "Sasanian and Early Islamic Water-Control"; and Wenke, "Imperial Investments."
42. Balcer, "Excavations at Tal-i Malyan." For two inscribed silver bowls found in a cave at Quri Gal'eh in western Iran, see Akbarzadeh, Daryaee, and Lerner, "Two Recently Discovered Inscribed Sasanian Silver Vessels."
43. See Hansman and Stronach, "Sasanian Repository."
44. See reports by David Whitehouse on the excavations at Siraf in *Iran* between 1968 and 1974, especially Whitehouse and Williamson, "Sasanian Maritime Trade."
45. Azarnoush, *Sasanian Manor House at Hājīābād*.
46. Azarnoush, "Excavations at Kangavar"; Mehryar and Kabiri, *Excavations, Researches, Site Management*.
47. Azarnoush, "New Evidence."

48. Rahbar, "Découverte d'un monument"; Gignoux, "Inscriptions en Moyen-Perse"; Rahbar, "Découverte des panneaux"; Rahbar, "Monument sassanide de Bandian"; Rahbar, "Discovery of a Sasanian Fire Temple"; and Rahbar, "Tower of Silence."
49. See Frye's bibliography in his *Festschrift* in Bromberg et al., *Aspects of Iranian Culture*, xv–xxv.
50. Canepa, *Two Eyes of the Earth*; Daryaee, *Sasanian Iran*; Harper, *In Search of a Cultural Identity*.
51. Yarshater, *Cambridge History of Iran*.
52. The publishers have been, in sequence: Kegan Paul & Routledge; Mazda in Costa Mesa, CA; Bibliotheca Persica Press, New York; and the Encyclopaedia Iranica Foundation, New York. The website is https://www.iranicaonline.org.
53. Amanat and Hanaway, "Review of the *Encyclopaedia Iranica*."
54. Pourshariati, *Decline and Fall*. For a review of this volume, see Daryaee, "Fall of the Sasanian Empire." Rika Gyselen offers a detailed critique of parts of the volume in Gyselen, "Primary Sources." For an earlier opinion by James Howard-Johnston that "a partnership between the royal house and the nobility" was essential for the success of the Sasanian state, see Howard-Johnston, "Two Great Powers."
55. See http://www.humanities.uci.edu/sasanika/.
56. Venetis, Daryaee, and Alinia, *Bibliographika Sasanika*.
57. Harper, *Royal Hunter*.
58. Musées royaux d'Art et d'Histoire, *Splendeur des Sassanides*.
59. Demange, *Perses Sassanides*.
60. Demange, *Glass, Gilding and Grand Design*.
61. I am grateful to Judith A. Lerner for her review of this chapter and her thoughtful suggestions and reminders.

Bibliography

Adams, Robert McC. "Agriculture and Urban Life in Early Southwestern Iran." *Science* 136 (1962): 109–22.

Adams, Robert McC., and Donald P. Hansen. "Archaeological Reconnaissance and Soundings in Jundī Shāhpūr." *Ars Orientalis* 7 (1968): 53–70.

Akbarzadeh, Daryoosh, Touraj Daryaee, and Judith A. Lerner. "Two Recently Discovered Inscribed Sasanian Silver Vessels." *Bulletin of the Asia Institute* 15 (2001): 71–75.

Alram, Michael, and Rika Gyselen, eds. *Sylloge Nummorum Sasanidarum: Paris, Berlin, Wien*. Vienna: Österreiche Akademie der Wissenschaften, 2003.

Amanat, Abbas, and William L. Hanaway, eds. "A Review of the *Encyclopaedia Iranica*." Special issue of *Iranian Studies* 31.3–4 (1998).

Azarnoush, Massoud. "Excavations at Kangavar." *Archaeologische Mitteilungen aus Iran* 14 (1981): 69–94.

———. "New Evidence on the Chronology of the 'Anahita Temple.'" *Iranica Antiqua* 44 (2009): 393–402.

———. *The Sasanian Manor House at Hājīābād, Iran*. Monografie di Mesopotamia 3. Florence: Casa Editrice Le Lettere, 1994.

Azarpay, Guitty, J. G. Barabe, K. A. Martin, and A. S. Teetsov. "Analysis of Writing Materials in Middle Persian Documents." *Bulletin of the Asia Institute* 16 (2002): 181–87.

Azarpay, Guitty, Kathleen Martin, Martin Schwartz, and Dieter Weber. "New Information on the Date and Function of the Berkeley MP Archive." *Bulletin of the Asia Institute* 17 (2003): 17–30.

Back, Michael. *Die sasanidischen Staatsinschriften*. Acta Iranica 18. Leiden: Brill; Tehran: Bibliothèque Pahlavi, 1978.
Balcer, J. M. "Excavations at Tal-i Malyan: Part 2, Parthian and Sasanian Coins and Burials (1976)." *Iran* 16 (1978): 86–92.
Bier, Carol. "Pattern, Power: Textiles and the Transmission of Knowledge." *Textile Society of America Symposium* 9 (2004): 144–53.
———. "Sasanian Textiles." Pages 943–52 in *The Oxford Handbook of Ancient Iran*. Edited by D. T. Potts. Oxford: Oxford University Press, 2013.
———. "Textiles." Pages 119–40 in Prudence O. Harper, *The Royal Hunter: Art of the Sasanian Period*. New York: Asia Society, 1978.
Bier, Lionel. *Sarvistan: A Study in Early Islamic Architecture*. University Park: Pennsylvania State University Press, 1986.
———. "Sarvistan Reconsidered." Pages 43–51 in *Leaving No Stone Unturned: Essays on the Ancient Near East and Egypt in Honor of Donald P. Hansen*. Edited by Erica Ehrenberg. Winona Lake, IN: Eisenbrauns, 2002.
———. "Sasanian Palaces in Perspective." *Archaeology* 35 (1982): 29–36.
———. "The Sasanian Palaces and Their Influence in Early Islam." *Ars Orientalis* 23(1993): 57–66.
Bivar, A. D. H. *The Sassanian Dynasty*. Vol. 2 of *Catalogue of the Western Asiatic Seals in the British Museum: Stamp Seals*. London: British Museum, 1969.
Brill, Robert H. "Chemical Analyses of some Sasanian Glass from Iraq." Pages 65–75 in David Whitehouse, *Sasanian and Post-Sasanian Glass from the Corning Museum of Glass*. Corning, NY: Hudson Hills, 2005.
Bromberg, Carol Altman, Bernard Goldman, Prods Oktor Skjaervø, and A. Sh. Shahbazi, eds. "Aspects of Iranian Culture: In Honor of Richard Nelson Frye." Special issue of *Bulletin of the Asia Institute* 4 (1990).
Bromberg, Carol Altman, Nicholas Sims-Williams, and Ursula Sims-Williams, eds. "Iranian and Zoroastrian Studies in Honor of Prods Oktor Skjaervø." Special issue of *Bulletin of the Asia Institute* 19 (2005).
Brunner, Christopher J. "Middle Persian Inscriptions on Sasanian Silverware." *Metropolitan Museum Journal* 9 (1974): 109–21.
———."Sasanian Seals in the Moore Collection: Motive and Meaning in Some Popular Subjects." *Metropolitan Museum Journal* 14 (1980): 33–50.
———. *Sasanian Stamp Seals in The Metropolitan Museum of Art*. New York: Metropolitan Museum of Art, 1978.
Canepa, Matthew P. *The Two Eyes of the Earth: Art and Ritual of Kingship Between Rome and Sasanian Iran*. Berkeley: University of California Press, 2009.
Chase, W. Thomas. "The Technical Examination of Two Sasanian Silver Plates." *Ars Orientalis* 7 (1968): 75–93.
Christensen, Arthur. *L'Iran sous les Sassanides*. Copenhagen: Munksgaard, 1936.
Daryaee, Touraj. "The Fall of the Sasanian Empire to the Arab Muslims." *Journal of Persianate Studies* 3 (2010): 239–54.
———. *Sasanian Iran (224–651 C.E.): Portrait of a Late Antique Empire*. Costa Mesa, CA: Mazda, 2008.
Demange, F. *Glass, Gilding and Grand Design: Art of Sasanian Iran (224–642)*. New York: Asia Society, 2007.
———. *Les Perses Sassanides: Fastes d'un empire oublié (224–642)*. Paris: Findakly, 2006.

Frye, Richard N., ed. *Sasanian Remains from Qasr-i Abu Nasr: Seals Sealings and Coins*. Harvard Iranian Series 1. Cambridge: Harvard University Press, 1973.
Fukai, Shinji, and K. Horiuchi. *Taq-i Bustan*. 2 vols. The Tokyo University Iraq-Iran Archaeological Expedition 10, 13. Tokyo: University of Tokyo, 1969, 1972.
Ghanimati, Suroor. *Kuh-e Khwaja: A Major Zoroastrian Temple Complex in Sistan*. Berkeley: University of California, 2001.
———. "New Perspectives on the Chronology and Functional Horizons of Kuh-e Khwaja in Sistan." *Iran* 38 (2000): 137–50.
Gignoux, Phillipe. "Les inscriptions en Moyen-Perse de Bandian." *Studia Iranica* 27.2 (1998): 251–58.
Göbl, Robert. *Sasanidische Numismatik*. Braunschweig: Klinkhardt & Biermann, 1968.
———. *Die Tonbullen von Tacht-e Soleiman: Ein Beitrag zur spätsasanidischen Sphragistik*. Berlin: Reimer, 1976.
Gunter Ann C., and Paul Jett. *Ancient Iranian Metalwork in the Arthur M. Sackler Gallery and the Freer Gallery of Art*. Washington, DC: Smithsonian Institution, 1992.
Gyselen, Rika, ed. *Au carrefour des religions: Mélanges offerts à Philippe Gignoux*. Res Orientales 7. Leuven: Peeters, 1995.
———. "Primary Sources and Historiography on the Sasanian Empire." *Studia Iranica* 38 (2009): 163–90.
———. *Sasanian Seals and Sealings in the A. Saeedi Collection*. Acta Iranica 44. Leuven: Peeters, 2007.
———. "Les sceaux des mages de l'Iran Sassanid." Pages 121–50 in *Au carrefour des religions: Mélanges offerts à Philippe Gignoux*. Edited by Rika Gyselen. Res Orientales 7. Leuven: Peeters, 1995.
Hansman, John and David Stronach. "A Sasanian Repository at Shahr-i Qūmis." *Journal of the Royal Asiatic Society* (1970): 142–55.
Harper, Prudence O. *In Search of a Cultural Identity: Monuments and Artifacts of the Sasanian Near East, 3rd to 7th Century A.D.* New York: Bibliotheca Persica, 2006.
———. "A Man's Caftan and Leggings from the North Caucasus of the Eighth to Tenth Century: Introduction." *Metropolitan Museum Journal* 36 (2001): 83–84.
———. *The Royal Hunter: Art of the Sasanian Period*. New York: Asia Society, 1978.
———. "Sasanian Silver Vessels: The Formation and Study of Early Museum Collections." Pages 46–56 in *Mesopotamia and Iran in the Parthian and Sasanian Periods*. Edited by John Curtis. London: British Museum, 2000.
Harper, Prudence O., and Pieter Meyers. *Silver Vessels of the Sasanian Period I: Royal Imagery*. New York: Metropolitan Museum of Art, 1981.
Howard-Johnston, James. "The Two Great Powers in Late Antiquity: A Comparison." Pages 157–226 in *States, Resources and Armies*. Vol. 3 of *The Byzantine and Early Islamic Near East*. Edited by A. Cameron. Princeton, NJ: Darwin, 1995.
Kajitani, Nobuko. "A Man's Caftan and Leggings from the North Caucasus of the Eighth to Tenth Century: A Conservator's Report." *Metropolitan Museum Journal* 36 (2001): 85–124.
Kawami, Trudy S. "Ernst Herzfeld, Kuh-e Khwaja and the Study of Parthian Art." Pages 181–214 in *Ernst Herzfeld and the Development of Near Eastern Studies, 1900–1950*. Edited by Ann C. Gunter and Stefan R. Hauser. Leiden: Brill, 2005.
———. "Kuh-e Khwaja, Iran and Its Wall Paintings: The Records of Ernst Herzfeld." *Metropolitan Museum Journal* 22 (1987): 13–52.

Knauer, Elfriede Regina. "A Man's Caftan and Leggings from the North Caucasus of the Eighth to Tenth Century: A Genealogical Study." *Metropolitan Museum Journal* 36 (2001): 125–54.

Kröger, Jens. *Sasanidischer Stuckdekor*. Baghdader Forschungen 5. Mainz: von Zabern, 1982.

Lechtman, Heather. "Ancient Methods of Gilding. Examples from the Old and New Worlds." Pages 2–30 in *Science and Archaeology*. Edited by Robert H. Brill. Cambridge: MIT Press, 1971.

Lerner, Judith A. *Christian Seals of the Sasanian Period*. Leiden: Nederlands Historisch-Archaeologisch Instituut te Istanbul, 1977.

———. "The Sacrifice of Isaac Revisited: Additional Objects on a Theme in Sasanian Glyptic Art." Pages 39–57 in *Facts and Artefacts in the Islamic World: Festschrift for Jens Kröger on His 65th Birthday*. Edited by Annette Hagedorn and Avinoam Shalem. Leiden: Brill, 2007.

Mehryar, Mehdi, and A. Kabiri. *Excavations, Researches, Site Management and Introduction: The Fourth Archaeological Expedition (from 1998–2001). The Continuation of Investigation in Anahita Temple, Kangavar*. Tehran: Research Institute of the Iranian Cultural Heritage and Tourism Organization, 2004.

Mousavi, Mahmoud. "Kuh-e Khadjeh. Un complexe religieux de l'est iranien." *Dossiers d'Archéologie* 243 (1999): 81–84.

Musées royaux d'Art et d'Histoire. *Splendeur des sassanides: L'empire Perse entre Rome et Chine (224–642)*. Brussels: Musées royaux d'Art et d'Histoire, 1993.

Neely, James A. "Sasanian and Early Islamic Water-Control and Irrigation Systems in the Deh Luran Plain, Iran." Pages 21–42 in *Irrigation's Impact on Society*. Edited by T. E. Downing and McGuire Gibson. Tucson: University of Arizona Press, 1974.

Peck, Elsie H. "The Representation of Costumes at Taq-i Bustan." *Artibus Asiae* 31 (1969): 101–25.

Perikhanian, Anahit G., and Nina Garsoïan, eds. and trans. *The Book of a Thousand Judgements: A Sasanian Law-Book*. Costa Mesa, CA: Mazda, 1997.

Pourshariati, Parvaneh. *Decline and Fall of the Sasanian Empire: The Sasanian-Parthian Confederacy and the Arab Conquest of Iran*. London: I. B. Tauris, 2008.

Rahbar, Mehdi. "Découverte des panneaux de stucs sassanides." *Dossiers d'Archéologie* 243 (1999): 62–65.

———. "Découverte d'un monument d'époque sassanide a Bandian/Dargaz (Nord Khorasan), Fouilles 1994 et 1995." *Studia Iranica* 27.2 (1998): 213–50.

———. "The Discovery of a Sasanian Fire Temple at Bandian, Dargaz." Pages 15–40 in *Current Research in Sasanian Archaeology, Art and History*. Edited by Derek Kennet and Paul Luft. BAR International Series 1810. Oxford: Archaeopress, 2008.

———. "Le monument sassanide de Bandian, Dargaz: Un temple de feu d'après les derniers découvertes 1996–1998." *Studia Iranica* 33.1 (2004): 7–30.

———. "A Tower of Silence of the Sasanian Period at Bandiyan: Some Observations about *Dakhmas* in Zoroastrian Religion." Pages 455–73 in *After Alexander: Central Asia Before Islam*. Edited by Joe Cribb and Georgina Herrmann. Oxford: Oxford University Press, 2007.

Russell, James R. *Armenian and Iranian Studies*. Harvard Armenian Texts and Studies 9. Cambridge: Harvard University Press, 2004.

---. *Zoroastrianism in Armenia*. Harvard Iranian Series 5. Cambridge: Harvard University and National Association for Armenian Studies and Research, 1987.
Schmidt, Erich F. *Flights over Ancient Cities of Iran*. Chicago: University of Chicago Press, 1940.
---. *The Royal Tombs and Other Monuments*. Vol. 3 of *Persepolis*. Oriental Institute Publications 70. Chicago: University of Chicago Press, 1970.
Shepherd, Dorothy G. "Sasanian Art in Cleveland." *Bulletin of the Cleveland Museum of Art* 51 (1964): 66–95.
---. "Two Silver Rhyta." *Bulletin of the Cleveland Museum of Art* 53 (1966): 289–311.
Skjaervø, Prods O. "Karsasp." *Encyclopaedia Iranica*. Last updated April 24, 2012. https://www.iranicaonline.org/articles/karsasp.
---. "Kartir." *Encyclopaedia Iranica*. Last updated April 24, 2012. https://www.iranicaonline.org/articles/kartir.
---. *Restored Text and Translation*. Part 3.1 of *The Sassanian Inscription of Paikuli*. Wiesbaden: Reichert, 1983.
---. *The Spirit of Zoroastrianism*. New Haven: Yale University Press, 2011.
Thompson, Deborah. *Stucco from Chal Tarkhan-Eshqabad near Rayy*. Colt Archaeological Institute Publications. Warminster: Aris & Phillips, 1976.
Trever, Kamilla V., and Vladimir G. Lukonin, *Sasanidskoe Serebro: Sobranie Gosudarstvennogo Ermitazha*. Moscow: Iskusstvo, 1987.
Trinkhaus, Kathryn, M. "Pottery from the Damghan Plain, Iran: Chronology and Variability from the Parthian to the Early Islamic Periods." *Studia Iranica* 15 (1986): 23–88.
University of Michigan Museum of Art. *Sasanian Silver: Late Antique and Early Medieval Arts of Luxury from Iran*. Ann Arbor: University of Michigan Museum of Art, 1967.
Venetis, Evangelos, Touraj Daryaee, and Massoumeh Alinia. *Bibliographika Sasanika: A Bibliographical Guide to Sasanian Iran Volume 1: Years 1990–99*. Sasanika Series 2. Costa Mesa, CA: Mazda, 2009.
Wenke, R. J. "Imperial Investments and Agricultural Developments in Parthian and Sasanian Khuzaestan, 150 B.C. to A.D. 640." *Mesopotamia* 10–11 (1975–76): 31–221.
Whitcomb, Donald S. *Before the Roses and the Nightingales: Excavations at Qasr-i Abu Nasr, Old Shiraz*. New York: Metropolitan Museum of Art, 1985.
---. "The City of Istakhr and the Marvdasht Plain." Pages 363–70 in *Akten des VII internationalen Kongresses für iranische Kunst und Archäologie*. Archaeologische Mitteilungen aus Iran Ergänzungsband 6. Berlin: Reimer, 1979.
Whitehouse, David. *Sasanian and Post-Sasanian Glass in the Corning Museum of Glass*. Corning, NY: Hudson Hills, 2005.
Whitehouse, David, and A. Williamson. "Sasanian Maritime Trade." *Iran* 11 (1973): 29–50.
Yarshater, Ehsan, ed. *The Seleucid, Parthian and Sasanid Periods*. Vol. 1, parts 1 and 2 of *The Cambridge History of Iran*. Cambridge: Cambridge University Press, 1983.

CHAPTER 15

The Nomad Period in Iranian History from the Seljukids Through the Timurids: North American Contributions to the Field, 1980–2010

Beatrice Forbes Manz

IN THIS CHAPTER, I shall examine scholarship on the middle period in the history of Iran, when conquest dynasties from the Eurasian steppe were the dominant power. The period from 1980 to 2010 saw a surge of interest in the later Middle Ages along with an increase in the contributions to this academic discourse by North American scholars and, incidentally, women. By the late 1960s and '70s, much of the groundwork for early Islamic history had been laid, and the central corpus of historical texts was well known. Later Islamic history, however, remained underdeveloped despite the existence of numerous sources. It is not surprising that students entering graduate school in the 1970s gravitated toward a new period of Islamic history that offered both unexplored terrain and a rich source base with which to research it. Mamluk, Ottoman, Mongol, and Timurid history all attracted students. Meanwhile, interest in Iranian history was stimulated in the United States by Peace Corps volunteers returning from Afghanistan and Iran. In this chapter, I will discuss the scholarship produced from the late 1970s on, emphasizing the contribution of US scholars. Due to space constraints, I will limit myself to political, cultural, and social history with only incidental discussion of intellectual and literary studies.

The State of the Field in the 1970s

Several prominent European scholars had worked on Iranian history of the middle periods from the 1950s to the '70s, producing the outline of the narrative history and a number of valuable studies. Scholarship was strongest for the earliest nomad dynasty—the Seljukids—still seen as part of the classical period. The Mongols were less fully covered, and outside the Soviet Union the Timurid dynasty had received little attention except from historians of art.

Students entering graduate school in the 1970s had several new and important works at their disposal. Volume 5 of the *Cambridge History of Iran* on the

Seljukid and Mongol periods appeared in 1968 and for the first time provided a reliable narrative of Iranian history from 1000 to 1350 along with analyses of social and intellectual history.[1] The history of cities gained impetus from the work of Ira Lapidus, who developed his 1964 Harvard dissertation into a highly influential book, *Muslim Cities in the Later Middle Ages*, which was published in 1967.[2] Lapidus examined Mamluk cities, for which sources are more plentiful than they are for Iranian cities. A great advance for the historiography of Iran came with the work of Marshall G. S. Hodgson of the University of Chicago, who died at a tragically young age. His survey of Islamic history, *The Venture of Islam*, was published posthumously in 1974.[3] Its second volume, subtitled *The Expansion of Islam in the Middle Periods*, offered a new and much more positive view of the later Middle Ages, emphasizing the florescence of Iranian culture. Hodgson's analysis of Islamic society, including that of Iran, has remained influential to the present day. Two ideas are of particular importance. Hodgson saw the middle periods as a time of greater militarization of government. Rulers and military were foreign to the subject population and exerted control largely through the domination of cities, in a dynamic which Hodgson named the "*amīr-aʿyān* system." Most administration remained in the hands of urban notables (*aʿyān*) drawn from the local elite, while military matters lay with garrison commanders serving the central government. These two groups collaborated but remained separate in both culture and function.[4] Another contribution by Hodgson is his discussion of decline. While he stressed the dynamism of Iranian culture and society in the middle periods, Hodgson did not deny a decline in agriculture. In assigning a reason for it, however, he rejected earlier explanations centering on the destruction caused by Mongol conquest and rule, pointing out that decline had begun earlier and was a gradual process in which the Mongols were only one of several factors.[5]

From the 1970s Onward

The Seljukid Period

By the 1970s, Turkish and European scholars had established the outlines of Seljukid political and social history.[6] Intellectual history was unsurprisingly quite well developed, given the central importance of several writers of the Seljukid period, but this topic lies outside the scope of this study. The 1970s saw some further development on the topics of social and administrative history. The major North American contribution was Richard Bulliet's 1972 book on the notables of Nishapur, which described sectarian struggles within the cities of Seljukid Khorasan.[7] Along with Bert Fragner's history of Hamadan

published that year, this work is one of a handful of studies of Iranian urban society.[8] Several scholars also examined the workings of the Seljukid *dīwān*. Although the most substantial discussions on this subject have been by Europeans, one important exception to this is the monograph by the American Carla Klausner based on her 1963 Harvard dissertation.[9]

No histories from the Early Seljukid period survive in their original form; this lack of source material, along with fuller existing coverage of the Seljukid dynasty, made the period less attractive to younger scholars of the 1980s and '90s. Few new monographs appeared during these decades. In 1988, Gary Leiser, a historian attached to the US Air Force, published an English translation of the work of Turkish scholar Kafesoğlu with a discussion of the controversy surrounding it.[10] Thus, Kafesoğlu's seminal work became available to scholars who could not read modern Turkish. There was a further gap after this until 2000, which marked a new surge of interest in the Seljukids. That year, Israeli scholar Daphna Ephrat published a book on the *'ulamā'* of Baghdad (based on a Harvard dissertation of 1993), which focuses specifically on that city and on learned society.[11] A translation of Rashīd al-Dīn's history of the Seljukids by K. Allin Luther of the University of Michigan was edited by E. Clifford Bosworth and published in 2001 after Luther's death.[12] From this time on, the Seljukid period received increasing attention, largely from European scholars. Since 2006 particularly, there has been a spate of new monographs on the Seljukids. Omid Safi's 2006 book based on his 2000 Duke University dissertation sets out to revise the earlier understanding of early Seljukid history. He suggests that Seljukid campaigns were more destructive than had been thought and that this aspect of their history was suppressed in the sources written for later Seljukid sultans, which were informed by a deliberately constructed religious ideology and came to dominate Seljukid historiography.[13] Carole Hillenbrand of the University of Edinburgh has written on the Battle of Manzikert of 1071 as a foundation myth. Like Safi, she emphasizes the programmatic nature of the later histories that emphasized religious motivation.[14] Two articles written in 2005 address a different issue by contesting the belief that city populations of the period were politically and militarily passive. Instead, these articles show that urban dwellers were decisive in decisions about whether or not to submit to outside powers and how to defend the city against an attacking army. While these articles deal with Seljukid examples, their importance goes beyond this period.[15]

In 2010, three new books were published in the Routledge series Studies in the History of Iran and Turkey. In his monograph in the series, Aziz Başan offers a history of the Great Seljukids, making available in English the fruits of earlier Turkish historiography, particularly that of the great early twentieth-century historians Kafesoğlu, Köprülü, Osman Turan, and Zeki Velidi Togan.[16]

In *Early Seljūq History: A Reexamination*, Andrew Peacock reopens several questions about the beginning of the Seljukid dynasty. He argues for the continued importance of Turkic imperial tradition and pastoralist lifestyle within the Seljukid dynasty. Thus, he suggests that the Turkmen campaigns in Anatolia were encouraged and overseen by the sultans not only to keep the Turkmens out of the heartland but equally to ensure the availability of good pasture for the armies.[17] Another book appearing in the series is David Durand-Guédy's *Iranian Elites and Turkish Rulers*.[18] As the title implies, the major emphasis of this detailed analytical history of Isfahan under Seljukid rule is on local elites, but it also provides an important discussion of Seljukid policies toward the city. Durand-Guédy demonstrates the political and military importance of regional elites and their involvement in wider politics.

Thus, since the study of the Seljuks regained popularity, there has been an explosion of scholarship and a reexamination of several accepted theories about their rule, most notably their Sunni religiosity. Few of these studies, however, have been undertaken in the United States.

The Mongol Period

For many decades, the basic work on the Mongols in Iran remained that of Bertold Spuler, which was supplemented by the works of Ann K. S. Lambton.[19] In 1960, the Soviet scholar I. P. Petrushevsky published a voluminous study on the agriculture of Iran during the Mongol period, painting a thoroughly bleak picture of devastation and mismanagement.[20] The 1970s brought a fruitful reexamination of Mongol ideology and historiography, opening the way to a more complex understanding of Mongol politics.[21] In this process, the United States has played an important part. The first American scholar to center his work on Mongol Iran was John Masson Smith of the University of California, Berkeley. Beginning with two influential speculative articles on Mongol population and taxation published in the early 1970s, he produced a series of studies focused on logistical and ecological questions.[22] The 1977 University of Washington PhD thesis of Paul Buell, unfortunately never published, introduced new material on the structure of the Mongol Empire, some of it relevant to Iran. This work clarified several aspects of Mongol administration, particularly the creation of joint administrations over agricultural regions in conquered territories.[23] For Iran itself, the geographical work of the German scholar Dorothea Krawulsky published in 1978 provided a valuable base for further research.[24]

In 1987, Thomas Allsen of Trenton State College in New Jersey published his first book, *Mongol Imperialism: The Policies of the Grand Qan Möngke in China, Russia, and the Islamic Lands, 1251–1259*.[25] Having mastered Russian,

Persian, and Chinese, Allsen combined sources from the three largest societies under Mongol rule to show the commonalities among different areas of the empire. What is revolutionary about his book is that it analyzes the Mongol Empire not from the settled periphery but rather from the Mongol center as it demonstrates the logic of Mongol rule. In an important series of articles, Allsen examined Mongol administrative practices and dynastic issues in Iran, the Russian steppe, and China. A particularly important contribution to Iranian history is his demonstration of the Mongol and Chinese origin of Ilkhanid reforms previously ascribed solely to Persian viziers.[26] He also showed that Mongol rulers were active cultural patrons who adopted the elements of sedentary culture most relevant to their concerns. In contrast to most scholarship, which emphasizes Chinese influence on Iran, Allsen's work highlighted the Middle Eastern and particularly Iranian impact on Chinese scholarship.[27]

Other scholars, mostly European, reexamined the internal history of the Mongol Ilkhanate. Despite general agreement that Sufi movements gained impetus during this period, there has been relatively little work on their social and political activities.[28] Much more attention was given to the conversion of Ilkhanid rulers to Islam. In earlier scholarship, the reestablishment of Islam as the official religion by Ghazan Khan (1295–1304) and the reforms ascribed to his vizier Rashīd al-Dīn were considered the major turning point in the history of Mongol rule in Iran, introducing a period of modest recovery. It was the British historian Charles Melville who first questioned Ghazan Khan's central importance, as shown in an article of his from 1990 that argued that by the time of Ghazan's accession a significant proportion of the Mongol elite had already converted.[29] Judith Pfeiffer in a PhD dissertation for the University of Chicago carried the question further, examining the conversion and pro-Islamic policies of the Ilkhan Tegüder Aḥmad (r. 1282–84).[30]

Melville's work, along with that of Thomas Allsen, prompted a reevaluation of Ghazan Khan's reforms and of the role of his vizier, Rashīd al-Dīn. While Ghazan's reforms are still considered important, newer scholarship makes a less sharp distinction between early and late Ilkhanid rule and also treats the claims of Rashīd al-Dīn and other Persian viziers with greater skepticism than we find in earlier analyses.[31] Jean Aubin, in a short but highly influential 1995 monograph, portrayed Ghazan as a follower rather than a leader and went further to suggest that much of the conflict within Ilkhanid Iran was not between Persians and Mongols, but between factions including both groups.[32] In her monograph on Fars under the Mongols, Jean Aubin's student Denise Aigle calls into question both the severity of economic decline in Fars and the primacy of Mongol responsibility.[33]

Much of the earlier research on the economy of Mongol Iran focused on agriculture and emphasized decline. Scholars of the past decades, following

the lead of Hodgson, have set the beginning of this decline earlier and demonstrated the unreliable nature of some sources used to contrast Mongol disaster with earlier florescence.[34] There has been no full study of agriculture in Iran to take the place of Petrushevsky's work. More recent works have focused more on issues of trade and currency, in which the Mongols have a much stronger record. A highly influential book published in 1989 by Janet Abu Lughod of the New School of Social Research gives the Mongols credit for the creation of a world system in trade.[35] Thomas Allsen likewise examined the active part that the Mongol leadership played in commerce both through the formation of trading partnerships and by promoting the production of specialized goods.[36] Of further note are two scholars who have addressed Mongol currency reforms, painting a very favorable picture of Mongol finance. A. P. Martinez has addressed the Gulf trade, bullion, and currency in several articles.[37] Judith Kolbas has contributed a monograph more specifically on Mongol currency in Iran based on her 1992 dissertation at New York University.[38]

Not surprisingly, the Mongol military holds enduring interest, and recent works have examined both the organization and tactics of the Mongol army. In a 1986 article, A. P. Martinez addresses issues of provisioning and pay and also charts the change in the army over time.[39] John Masson Smith has produced a number of studies dealing primarily with numbers, training and logistics.[40] In his 2004 dissertation for the University of Wisconsin, Timothy May examines the Mongol conquest from a military point of view, suggesting that the Mongols conquered regions in waves and kept only part of the territory they conquered on each campaign, so that they did not strain their resources. A monograph based on May's dissertation appeared in 2007.[41]

Mongol attempts to conquer Syria and their failure in that endeavor have been an enduring issue for scholars, who have presented a number of potential explanations. The question was posed quite early by John Masson Smith, who suggested that the defeat of the Mongols was due both to the superior military training of the Mamluk cavalry and to insufficient pasture available for Mongol livestock.[42] The fullest examination of the subject for the early period is the monograph of Israeli scholar Reuven Amitai-Preiss.[43] Here, and in several articles on later campaigns, Amitai-Preiss offers a detailed analysis of manpower, weaponry, and tactics on both sides and emphasizes the importance of morale on the side of the Mamluks.[44] Several articles have also addressed the ideological adjustments undertaken as Mamluk-Mongol conflict changed from opposition between Muslim and non-Muslim powers to rivalry within the Islamic world.[45]

There has been a significant growth of interest in the imperial ideology of the Mongols.[46] Thomas Allsen examined dynastic legitimation under the

Ilkhans, and the mythology developed in Iran around the person of Chinggis Khan has been discussed by Israeli scholar Michal Biran.[47] The fullest analysis of Ilkhanid dynastic ideology in its Mongolian and its Islamic character is found in the 2008 book by Anne F. Broadbridge of the University of Massachusetts.[48] Broadbridge focuses on the rhetoric of superiority used by the Mamluks and the Ilkhans (later the Timurids) in their diplomatic relations. On the other side, the Mongol involvement with Iranian traditions, including the *Shāhnāma* epic, has been explored by historians of art and literature. Art historians have discussed, for example, the reuse of a Sasanian imperial city for the palace of the Ilkhan Abaqa and the creation of illustrated *Shāhnāmas* for imperial legitimation.[49]

The history of art is one of the most active fields of study on the Mongol period, especially in the United States. The Mongols introduced new artistic techniques and influences, presiding over an exceptionally brilliant period that is now receiving its due. There has been a striking increase in dissertations, books, and articles on the art of the Mongol period in Iran. Starting in the 1970s, a number of Harvard students produced dissertations under the supervision of the late Oleg Grabar. The 1972 dissertation of Renata Holod-Tretiak examined the monuments of Yazd from the Mongol and Timurid periods.[50] Marianna Shreve Simpson wrote her dissertation on the earliest *Shāhnāma* manuscripts, and in 1980 Sheila Blair submitted her thesis on the shrine at Natanz; both of these were subsequently published.[51] Sheila Blair has remained an active contributor to the field, writing on both architecture and painting.[52] Major exhibitions have played an important part in furthering interest and publication. An exhibition at the Metropolitan Museum of Art in New York and the Los Angeles County Museum of Art in 2002–3 brought together an extraordinary collection of works from Western Asia, and its catalog contains articles by several of the most distinguished scholars on the period.[53] A symposium organized to coincide with the exhibition in Los Angeles resulted in the publication of a collected volume of essays on both history and art history.[54]

The end of the Ilkhanid dynasty and the rise of successor states became more fully researched during the period discussed here. The reign of Abū Saʿīd, and particularly the role of his powerful emir Choban, was the subject of several studies by Charles Melville.[55] In 2004, John Limbert, formerly of the US Foreign Service, published his book on Shiraz under Injuʾid and Muzaffarid rule based on his Harvard University dissertation of 1974. It is primarily a city portrait, giving the political, social, and intellectual history of the fourteenth century.[56] Two valuable numismatic studies by Stephen Album of California contribute to our understanding of post-Ilkhanid legitimation.[57] The fullest discussion of the end of the Ilkhans and the rise of successor states is the 2007 University of Chicago dissertation on the Jalayirid dynasty (1336–1432) of

western Iran written by Patrick Wing.[58] Much less has been written on eastern Iran during this period. The one full-length monograph dealing with the area is John Masson Smith's 1970 book on the Sarbadarid dynasty (1336–81).[59] Lawrence G. Potter did not publish his 1992 Columbia University dissertation on the Kartid dynasty, though two articles resulted from his research.[60]

There has been a significant advance in our understanding of the social and political history of Iran in the Mongol period. The American contribution was strongest in two areas. The first was analysis of the Mongol Empire as a whole, which was revolutionized by Thomas Allsen, whose work also contributed to our understanding of Iran and its place within the empire. As a group, American scholars have been most active in the history of art in the Mongol period, which has moved from relative obscurity to a central place in Islamic art history.

The Timurid Period

In the United States, the study of the Timurid period developed especially quickly. Up to the 1980s, scholarship on the Timurids was dominated by Soviet scholars, who provided both the narrative and most of the analytical framework on the topic. Western Europeans had examined some aspects of history and published several important primary sources, but no systematic coverage had been attempted.[61] In the history of art, interest among scholars developed much sooner, since the Timurid period was seen as a crucial one for the development of both calligraphy and painting.[62] At the end of the 1960s, students of art history in the United States began to produce dissertations on both painting and architecture. Lisa Golombek at the University of Michigan wrote on the Timurid shrine at Gazurgah in Herat in 1968, Priscilla Soucek finished a dissertation on fourteenth- and fifteenth-century illustrated manuscripts of Nizami at New York University in 1971, and Renata Holod completed a dissertation at Harvard in 1972 on Mongol and Timurid monuments in Yazd, which I mentioned above.[63]

The great Anatolian tribal confederations that coincided with the Timurid dynasty also received attention, though since most of their rule was within Anatolia, only the last years of each dynasty belong to Iranian history.[64] In 1976, John E. Woods of the University of Chicago published his highly influential study of the Aq Qoyunlu, of which the last chapters concern the conquest of Iran and the beginnings of the Safavid confederation.[65] As a discussion of a nomadic tribal confederation, Woods's study has importance well beyond its immediate subject and has been widely cited.

In the 1980s, more young scholars entered the field, including several Americans. Two works on Timurid Khorasan appeared early in the decade,

one published in 1982 on the *Geography* of Ḥāfiẓ-i Abrū by the German scholar Dorothea Krawulsky, and one work on Timurid Herat published in 1983 by Terry Allen based on his Harvard dissertation.[66] A major step forward came with the publication of the sixth volume of the *Cambridge History of Iran* on the Timurid and Safavid periods. In this volume, the narrative history of the Timurids was written for the first time in English along with analyses of social, economic, and cultural history provided by a variety of scholars.[67] Shortly thereafter, two important works on Timurid architecture appeared, one by Bernard O'Kane in 1987 and one by Lisa Golombek of Toronto with Donald Wilber in 1988. Both are notable for their inclusion of epigraphic material and attention to architectural patronage and the social background of the monuments discussed.[68]

In North America, 1989 could be called the year of the Timurids. A rich exhibit of Timurid and Turkmen art appeared at the Sackler Museum of the Smithsonian Institute and the Los Angeles County Museum of Art; its catalog, edited by Thomas W. Lentz and Glenn D. Lowry, brought together the cultural and courtly history of the period.[69] The Middle East Studies Association meeting held at Toronto that year featured a plenary session on the Timurids; these and other conference papers were published by Lisa Golombek and Maria Subtelny.[70] This year was also the date of publication of a study of Tamerlane by Beatrice F. Manz of Tufts University, remarkably enough the first full-length study of the conqueror.[71] It is interesting to note that many of the younger scholars entering the field at this time were trained at Harvard University: Terry Allen, Thomas Lentz, Maria Subtelny, and Beatrice Manz all completed Harvard doctorates in the 1980s.

A much greater event that occurred in 1989 was the fall of the Berlin Wall, presaging the collapse of the Soviet Union and disarray in the USSR Academy of Sciences, which had dominated the study of Central Asia. Thus, just as Western European and North American scholars began to work on the Timurid period, Soviet scholars entered a time of extreme difficulty, particularly in the new republics of Central Asia. The dominance of North American and Western European scholars moved the field to new ideologies, themes, and methodology.

Two collections of articles on the Timurids in the 1990s connected political and cultural history, adding studies of Timurid influence on neighboring and successor dynasties as well as of views of the Timurids by outside powers, including the Europeans.[72] The most detailed study of the early Timurids is Beatrice F. Manz's monograph on the social and political dynamics of Iran during the reign of Shāhrukh (1409–47).[73] The book analyzes the relationship between the Turco-Mongolian ruling group and its subject population,

suggesting that the two were less separate than usually supposed and that the Persians were active both in politics and in the military.

Most scholarly attention focused on the latter part of the Timurid period—particularly the reign of Sulṭān Ḥusayn Bayqara (1470–1506)—one of particular cultural brilliance. Maria Subtelny has explored political and cultural history with an interest in *waqf* endowments and agrarian developments.[74] Her 2007 book *Timurids in Transition* focuses particularly on the development of intensive agriculture in Khorasan during the reign of Ḥusayn-i Bayqara.[75] Two scholars specializing in later history have contributed valuable works on this period. Robert McChesney of New York University has studied the shrine of the Naqshbandi Sufi Khwāja Muḥammad Pārsā, following *waqf* endowment and shrine administration from the late Timurids into the Uzbek period.[76] Stephen Dale of Ohio State University has discussed the Timurid prince Babur, founder of the Mughal or later Timurid dynasty, from a political, ideological, and cultural standpoint.[77]

The Harvard scholar Wheeler Thackston turned his attention to the Timurids in 1989, starting with a translation of sources on cultural history before proceeding during the 1990s to publish translations and some editions of several major histories. These include two central texts for later Timurid history: the memoirs of Babur and the history of Khwāndamīr.[78] More recently, the issues of historiography, ideology, and legitimation have been a concern of many scholars, including those working on the Timurid dynasty. One of the pioneers here is John Woods.[79] On questions of legitimation, further work has also been done Beatrice F. Manz and Anne Broadbridge, whose book has been mentioned above.[80] Several scholars have worked on historiography; a figure of particular interest is the poet and historian of Shāhrukh's period, Sharaf al-Dīn 'Alī Yazdī.[81] Sholeh Quinn of the University of California, Merced has followed the influence of Timurid legitimation in the historiography of the Safavid dynasty.[82]

It was during the Timurid period that the Naqshbandi Sufi order became a major force under the famous shaykh Khwāja Aḥrār, and several other orders likewise rose to prominence. Jo-Ann Gross submitted her doctoral dissertation on Khwāja Aḥrār to New York University in 1982 and followed with several articles using his example to analyze issues connected to Sufi authority.[83] With Asom Urunbaev of Tashkent she published a valuable edition and translation of Khwāja Aḥrār's correspondence that sheds light on his contacts and client network.[84] Other Sufi orders of the Timurid period, particularly the Yasawiyya and Kubrawiyya of Central Asia and eastern Iran, have been the subject of extensive research by Devin DeWeese of Indiana University.[85] Shahzad Bashir of Stanford University has written on several millenarian movements of the

fifteenth century, starting with a doctoral dissertation on the Nurbakhshiyya for Yale University in 1997.[86]

The histories of art and culture have remained active fields in the United States and Canada. Priscilla Soucek and Lisa Golombek, both mentioned above, have continued to publish on the Timurids, adding significantly to our knowledge of courtly life and art.[87] Linda Komaroff began her career as a specialist on Timurid metalwork, the subject of her 1984 dissertation at New York University and a monograph published in 1992.[88] David Roxburgh of Harvard University has written extensively on Timurid art, focusing particularly on the arts of the book.[89] Maria Subtelny's book on Persian gardens uses her research on the Timurids as a major example.[90] A special edition of *Iranian Studies* in 2003, edited by Robert McChesney and Maria Subtelny, focused on the polymath Ḥusayn Wāʿiz Kāshifī, whose works include a treatise on ethics and a *futuwwa* manual.[91] Although Paul Losensky's book on the poet Fighānī and his reception deals primarily with a later period, it also includes the late Timurid literary milieu.[92]

Timurid history remains a thoroughly international field, but the contribution of scholars in North America has been conspicuous. If we look at the scholarship of the past decades, we see that cultural history predominates, especially for the later period, but it is closely attuned to social, political, and economic history. Political and social history, on the other hand, was strongest for the reigns of Temür and Shāhrukh, while the middle period—the reign of Abū Saʿīd—is still largely unexamined.

Conclusion

One can identify a number of major shifts in the scholarly understanding of nomad dynasties in the thirty years between 1980 and 2010. The belief in a rigid separation between nomad and settled roles in government and society began to break down along with the assumption that nomad rulers became knowledgeable cultural patrons only after abandoning their steppe identity. This model was not totally abandoned, but it was challenged by several scholars working on different periods. Thomas Allsen's work on Mongol administration, cultural patronage, and the promotion of artisanal production was decisive in shifting our understanding of these issues. The major exhibits of Mongol and Timurid art alongside the scholarly activity surrounding them provided new insights into the activities of Turco-Mongolian courts. Many scholars began to give credit to nomad rulers for active involvement in civilian as well as military affairs. On the other side, there was a new recognition of the

military importance of the Persian population, particularly in the defense of cities, that was crucial in determining the outcome of regional contests.

The middle periods of Islamic history provide much fuller sources on social history than we have for the earlier period, particularly on the religious classes. There has been a great deal of work on social history, much of it written by American scholars. As I have shown, important studies on Iranian cities and regional history during this period have also been written, and for the Timurid period we have a rich body of literature on the activities of Sufi shaykhs and orders. Given the vastly richer sources available to Mamluk and Ottoman historians, however, it is likely that more Western paradigms will continue to dominate our understanding of medieval Islamic urban society.

The contribution of North American scholars to new understandings of Iranian history has been substantial, especially for the Mongol and Timurid periods. The teaching activities of two major scholars has also been instrumental in providing the impetus to study this period. Martin Dickson of Princeton University concentrated on late medieval Iran and trained a large number of students. Two of Dickson's students, Robert McChesney of New York University and John Woods of the University of Chicago, have in their turn attracted their own enclaves of students, as the number of PhDs from their respective institutions attests. The second of these major scholars is Oleg Grabar, who while teaching at the University of Michigan and later at Harvard University supervised a number of students writing on Mongol and Timurid art, many of whom were mentioned above. From the 1970 to 2010, the number of dissertations on these periods coming from universities across the country continued to grow, and the field has only flourished further in North America in the decade since then.

Notes

1. Boyle, *Cambridge History of Iran*.
2. Lapidus, *Muslim Cities*.
3. Hodgson, *Venture of Islam*.
4. Hodgson, *Venture of Islam*, 2:64–69, 2:391–400.
5. Hodgson, *Venture of Islam*, 2:371–91.
6. The writings of the eminent Turkish scholars Osman Turan and Ibrahim Kafesoğlu were accessible only to those who knew modern Turkish. Among European scholars, the work of Claude Cahen and Ann K. S. Lambton stands out: Cahen, "Malik-nameh"; Cahen, "Turkish Invasion"; Lambton, *Landlord and Peasant*; Lambton, "Aspects of Saljūq-Ghuzz Settlement."
7. Bulliet, *Patricians of Nishapur*.
8. Fragner, *Geschichte der Stadt Hamadān*.
9. Horst, *Staatsverwaltung*; Klausner, *Seljuk Vezirate*; and Klausner, "Seljuk Vezirate."

10. Lambton, *Continuity and Change*, covers both the Mongol and the Seljukid period, constituting a summation of the author's work to that period.
11. Ephrat, *Learned Society*.
12. Rashīd al-Dīn, *History of the Seljuq Turks*. In 2002, D. S. Richards published his translation of the relevant section of the Arab historian Ibn al-Athīr, *Annals of the Saljuq Turks*. The history of Ẓahīr al-Dīn Nīshāpūrī, which served as a source for most later histories, was edited and published by Alexander H. Morton in 2004 in Nīshāpūrī, *Saljūqnāma*.
13. Safi, *Politics of Knowledge*.
14. Hillenbrand, *Turkish Myth*.
15. Durand-Guédy, "Iranians at War"; Paul, "Seljuq Conquest(s)." For a broader argument concerning the later period, see Manz, "Military Manpower."
16. Başan, *Great Seljuqs*.
17. Peacock, *Early Seljūq History*.
18. Durand-Guédy, *Iranian Elites*.
19. Spuler, *Mongolen in Iran*.
20. Petrushevskiĭ, *Zemledelie*.
21. Two particularly crucial contributions were the discussion of the Mongol dynastic code and family bias in Mongol historiography by David Ayalon and Peter Jackson's analysis of sources on the dissolution of the Mongol Empire; see Ayalon, "Great Yāsa of Chingiz Khān"; P. Jackson, "Dissolution of the Mongol Empire."
22. Smith, "Mongol and Nomadic Taxation."
23. Buell, "Tribe, 'Qan' and 'Ulus.'"
24. Krawulsky, *Īrān, das Reich der Īlḫāne*.
25. Allsen, *Mongol Imperialism*.
26. Allsen, "Biography of a Cultural Broker." See also Allsen, "Changing Forms"; Allsen, "Sharing out the Empire"; and Allsen, "Notes on Chinese Titles."
27. Allsen, *Culture and Conquest*.
28. The most extended treatment is Grönke, *Derwische im Vorhof der Macht*.
29. Melville, "Pādshāh-i Islām."
30. Pfeiffer, "Conversion to Islam." See also Pfeiffer, "Reflections on a 'Double Rapprochement.'"
31. See, for example, Morgan, "Mongol or Persian," and Morgan, "Rašīd al-Dīn." See also Lane, *Early Mongol Rule*.
32. Aubin, *Émirs mongols*.
33. Aigle, *Fārs sous la domination mongole*.
34. Lambton, *Continuity and Change*, particularly p. 219.
35. Abu-Lughod, *Before European Hegemony*.
36. Allsen, "Mongolian Princes," and Allsen, *Commodity and Exchange*.
37. See, for example, Martinez, "Ducats and Dinars" (1999) and (2000–2001), and Martinez, "Wealth of Ormus."
38. Kolbas, *Mongols in Iran*.
39. Martinez, "Some Notes on the Īl-Xānid Army."
40. See, for example, Smith, "Nomads on Ponies," and Smith, "Mongol Society."
41. May, "Mechanics of Conquest and Governance," and May, *Mongol Art of War*. See also May, "Training of an Inner Asian Nomad Army."
42. Smith, "'Ayn Jālūt." See also Morgan, "Mongols in Syria."
43. Amitai-Preiss, *Mongols and Mamluks*.

44. See, for example, Amitai-Preiss, "Mongol Occupation of Damascus," and Amitai-Preiss, "Whither the Ilkhanid Army?"

45. See, for example, Melville, "Year of the Elephant," and Aigle, "Légitimité islamique."

46. In a set of studies published in 1989, Dorothea Krawulsky addressed several basic issues, including the term "Ilkhan" and implications of the Mongol embrace of Iran as a geographical and historical entity; see Krawulsky, *Mongolen und Ilkhâne*.

47. Allsen, "Notes on Chinese Titles." See also Amitai-Preiss, "Mongol Imperial Ideology"; Biran, *Chinggis Khan*.

48. Broadbridge, *Kingship and Ideology*.

49. Huff, "Ilkhanid Palace," and Hillenbrand, "Arts of the Book." See also Raby and Fitzherbert, *Court of the Il-khans*.

50. Holod-Tretiak, "Monuments of Yazd."

51. Simpson, "Illustration of an Epic," published under the same title by Garland in 1979; Blair, "Shrine Complex at Natanz," published later as *Ilkhanid Shrine Complex*.

52. See, for example, Blair and Grabar, *Epic Images and Contemporary History*; Blair, "Epigraphic Program of Uljaytu's Tomb"; and Blair, *Compendium of Chronicles*.

53. Komaroff and Carboni, *Legacy of Genghis Khan*.

54. Komaroff, *Beyond the Legacy of Genghis Khan*.

55. Melville, *Fall of Amir Chupan*, and Melville, "Wolf or Shepherd?"

56. Limbert, *Shiraz in the Age of Hafez*, based on Limbert, "Shiraz in the Age of Hafiz."

57. Album, "Studies in Ilkhanid History and Numismatics. I," and Album, "Studies in Ilkhanid History and Numismatics. II."

58. Wing, "Jalayirids and Dynastic State Formation." This has since been published as Wing, *Jalayirids: Dynastic State Formation*.

59. Smith, *History of the Sarbadār Dynasty*. See also Reid, "Jeʾun-i Qurbān Oirat Clan."

60. Potter, "Kart Dynasty of Herat"; Potter, "Sufis and Sultans in Post-Mongol Iran"; and Potter, "Herat Under the Karts."

61. The most prominent scholars were Hans Robert Roemer, Jean Aubin, and Felix Tauer. See, for example, Marwārīd, *Staatsschreiben der Timuridenzeit*; Aubin, *Deux sayyids de Bam*; Naṭanzi, *Extraits*; Shāmī, *Histoire des conquêtes de Tamerlan*, vols. 1 and 2 (vol. 2 contains additions made by Ḥāfi-i Abrū).

62. See, for example, Stchoukine, *Peintures des manuscrits tîmourides*; Robinson, "Bihzad and his School"; and Robinson, "Prince Baysunghur."

63. Golombek, "Timurid Shrine at Gazur Gah," and Soucek, "Illustrated Manuscripts."

64. See particularly Sümer, *Kara Koyunlular*.

65. Woods, *Aqquyunlu* (1976), and the revised and expanded edition of Woods, *Aqquyunlu* (1999).

66. Ḥāfiẓ -i Abrū, *Ḫorāsān zur Timuridenzeit*, and Allen, *Timurid Herat*.

67. Jackson and Lockhart, *Cambridge History of Iran*.

68. O'Kane, *Timurid Architecture in Khurasan*, and Golombek and Wilber, *Timurid Architecture*.

69. Lentz and Lowry, *Timur and the Princely Vision*.

70. Golombek and Subtelny, *Timurid Art and Culture*.

71. Manz, *Rise and Rule of Tamerlane*.

72. Szuppe, *Héritage timouride*, and Bernardini, *Civiltà Timuride*.
73. Manz, *Power, Politics and Religion*. Two important works on the period by European scholars are Nagel, *Timur der Eroberer*, and Ando, *Timuridische Emire*.
74. See, for example, Subtelny, "Centralizing Reform"; Subtelny, "Bābur's Rival Relations"; and Subtelny and Khalidov, "Curriculum of Islamic Higher Learning."
75. Subtelny, *Timurids in Transition*.
76. McChesney, *Waqf in Central Asia*.
77. Dale, *Garden of the Eight Paradises*. Another important study on this period is the book by Maria Szuppe examining changes and continuities within Herat as the city became a battleground between Uzbeks and Safavids; see Szuppe, *Entre Timourides*.
78. Most notably Thackston, *Century of Princes*; Babur, *Baburnama*; Dughlat, *Mirza Haydar Dughlat's Tarikh-i-Rashidi*; and Khwandamir, *Habibu's-siyar*.
79. Woods, "Rise of Tīmūrīd Historiography."
80. Manz, "Mongol History Rewritten"; Broadbridge, *Kingship and Ideology*. Another important work is Bernardini, *Mémoire et propagande*.
81. For example, Binbaş, "Sharaf al-Dīn ʿAlī Yazdī," and Manz, "Johannes Schiltberger." One should also note the work of the late Japanese scholar, Shiro Ando; see Ando, "Timuridische Historiographie."
82. Quinn, *Historical Writing*.
83. Gross, "Khoja Ahrar"; Gross, "Multiple Roles and Perceptions"; and Gross, "Authority and Miraculous Behavior." The German scholars Jürgen Paul and Fritz Meier have written important works on the Naqshbandi. See, for example, Paul, *Politische und soziale Bedeutung*, and Meier, *Meister und Schüler*.
84. Aḥrār, *Letters of Khwāja ʿUbayd Allāh Aḥrār*.
85. See, for example, DeWeese, "Eclipse of the Kubravīyah," and DeWeese, "Mashāʾikh-i Turk and the Khojagān." A short monograph published in 1956 by Jean Aubin was far ahead of its time in examining the role that Sufi shaykhs played in local society. It was followed in 1991 by an article on the Niʿmatullahi order; see Aubin, *Deux sayyids de Bam*, and Aubin, "De Kûhbanân à Bidar."
86. Bashir, *Messianic Hopes and Mystical Visions*, and Bashir, *Fazlallah Astarabadi*.
87. See, for example, Golombek, Mason, and Bailey, *Tamerlane's Tableware*, and Soucek, "Ibrāhīm Sulṭān b. Shāhrukh."
88. Komaroff, *Golden Disk of Heaven*.
89. Roxburgh, *Persian Album*; and, for instance, Roxburgh, "Persian Drawing."
90. Subtelny, *Monde est un jardin*.
91. *Iranian Studies* 36.4 (2003).
92. Losensky, *Welcoming Fighānī*.

Bibliography

Abu-Lughod, Janet L. *Before European Hegemony: The World System, A.D. 1250–1350*. New York: Oxford University Press, 1989.

Aḥrār, ʿUbayd Allāh ibn Maḥmūd. *The Letters of Khwāja ʿUbayd Allāh Aḥrār and His Associates*. Translated by Jo-Ann Gross and A. Urunbaev. Brill's Inner Asian Library 5. Leiden: Brill, 2002.

Aigle, Denise. *Le Fārs sous la domination mongole: Politique et fiscalité, XIIIe–XIVes*. Cahiers de Studia Iranica 31. Paris: Association pour l'avancement des études iraniennes, 2005.

———. "La légitimité islamique des invasions de la Syrie par Ghazan Khan." *Eurasian Studies* 5.1–2 (2006): 5–29.
Album, Stephen. "Studies in Ilkhanid History and Numismatics. I. A Late Ilkhanid Hoard (743/1342)." *Studia Iranica* 13.1 (1984): 49–116.
———. "Studies in Ilkhanid History and Numismatics. II. A Late Ilkhanid Hoard (741/1340)." *Studia Islamica* 14.1 (1985): 43–76.
Allen, Terry. *Timurid Heart*. Beihefte zum Tübinger Atlas des Vorderen Orients. Reihe B, Geisteswissenschaften 56. Wiesbaden: Reichert, 1983.
Allsen, Thomas. "Biography of a Cultural Broker, Bolad Ch'eng-Hsiang in China and Iran." Pages 7–22 in *The Court of the Il-khans, 1290–1340*. Edited by Julian Raby and Teresa Fitzherbert. Oxford: Oxford University Press, 1996.
———. "Changing Forms of Legitimation in Mongol Iran." Pages 223–41 in *Rulers from the Steppe: State Formation and the Eurasian Periphery*. Edited by Gary Seaman and Daniel Marks. Los Angeles: University of Southern California Press, 1991.
———. *Commodity and Exchange in the Mongol Empire: A Cultural History of Islamic Textiles*. Cambridge Studies in Islamic Civilization. Cambridge: Cambridge University Press, 1997.
———. *Culture and Conquest in Mongol Eurasia*. Cambridge Studies in Islamic Civilization. Cambridge: Cambridge University Press, 2001.
———. "Mongolian Princes and Their Merchant Partners, 1200–1260." *Asia Major* 2.2 (1989): 83–126.
———. *Mongol Imperialism: The Policies of the Grand Qan Möngke in China, Russia, and the Islamic Lands, 1251–1259*. Berkeley: University of California Press, 1987.
———. "Notes on Chinese Titles in Mongol Iran." *Mongolian Studies* 14 (1991): 27–39.
———. "Sharing out the Empire: Apportioned Lands Under the Mongols." Pages 72–90 in *Nomads in the Sedentary World*. Edited by A. Wink and A. Khazanov. New York: Routledge, 2001.
Amitai-Preiss, Reuven. "Mongol Imperial Ideology and the Ilkhanid War Against the Mamluks." Pages 57–72 in *The Mongol Empire and Its Legacy*. Edited by Reuven Amitai and David Morgan. Leiden: Brill, 2000.
———. "The Mongol Occupation of Damascus in 1300: A Study of Mamluk Loyalties." Pages 21–42 in *The Mamluks in Egyptian and Syrian Politics and Society*. Edited by Michael Winter and Amalia Levanoni. Leiden: Brill, 2004.
———. *Mongols and Mamluks: The Mamluk-Īlkhānid War, 1260–1281*. Cambridge Studies in Islamic Civilization. Cambridge: Cambridge University Press, 1995.
———. "Whither the Ilkanid Army? Ghazan's First Campaign into Syria (1299–1300)." Pages 221–64 in *Warfare in Inner Asian History, 500–1500*. Edited by Nicola Di Cosmo. Leiden: Brill, 2002.
Ando, Shiro. *Timuridische Emire nach dem Muʿizz al-ansāb: Untersuchung zur Stammesaristokratie Zentralasiens im 14. und 15. Jahrhundert*. Islamkundliche Untersuchungen. Berlin: Schwarz, 1992.
———. "Die timuridische Historiographie II: Šaraf al-Dīn ʿAlī Yazdī." *Studia Iranica* 24.2 (1995): 219–46.
Aubin, Jean. "De Kûhbanân à Bidar: La famille niʾmatullahī." *Studia Iranica* 20.2 (1991): 233–61.

———. *Deux sayyids de Bam au xv. siècle: Contribution à l'histoire de l'Iran timouride*. Akademie der Wissenschaften und der Literatur, Abhandlungen der geistes-und-sozialwissenschaftlichen Klasse 7. Mainz: Akademie der Wissenschaften und der Literatur in Mainz, 1956.

———. *Émirs mongols et vizirs persans dans les remous de l'acculturation*. Cahiers de Studia Iranica 15. Paris: Association pour l'avancement des études iraniennes, 1995.

Ayalon, David. "The Great Yāsa of Chingiz Khān: A Reexamination." Pts. A and B. *Studia Islamica* 33 (1971): 97–140; 34 (1971): 151–80.

Babur. *The Baburnama: Memoirs of Babur, Prince and Emperor*. Translated by W. M. Thackston. Washington, DC: Smithsonian Institution, 1996.

Başan, Aziz. *The Great Seljuqs: A History*. London: Routledge, 2010.

Bashir, Shahzad. *Fazlallah Astarabadi and the Hurufis*. Makers of the Muslim World. Oxford: Oneworld, 2005.

———. *Messianic Hopes and Mystical Visions: The Nūrbakhshīya Between Medieval and Modern Islam*. Studies in Comparative Religion. Columbia: University of South Carolina Press, 2003.

Bernardini, Michele, ed. "La civiltà Timuride come fenomeno internazionale." Special issue of *Oriente Moderno* 76 (1996).

———. *Mémoire et propagande à l'époque timouride*. Cahiers de Studia Iranica 37. Paris: Association pour l'avancement des études iraniennes, 2008.

Binbaş, Ilker Evrim. "Sharaf al-Dīn 'Alī Yazdī (ca. 1370s–1454): Prophecy, Politics and Historiography in late Medieval Islamic History." PhD diss., University of Chicago, 2009.

Biran, Michal. *Chinggis Khan*. Makers of the Muslim World. Oxford: Oneworld, 2007.

Blair, Sheila. *A Compendium of Chronicles: Rashid al-Din's Illustrated History of the World*. The Nasser D. Khalili Collection of Islamic Art 27. Edited by Julian Raby, London: The Nour Foundation in association with Azimuth Editions and Oxford University Press, 1995.

———. "The Epigraphic Program of Uljaytu's Tomb at Sultaniyya: Meaning in Mongol Architecture." *Islamic Art* 2 (1987): 43–96.

———. *The Ilkhanid Shrine Complex at Natanz, Iran*. Harvard Middle East Papers, Center for Middle Eastern Studies. Cambridge: Harvard University, 1986.

———. "The Shrine Complex at Natanz, Iran." PhD diss., Harvard University, 1980.

Blair, Sheila, and Oleg Grabar. *Epic Images and Contemporary History: The Illustrations of the Great Mongol Shahnama*. Chicago: University of Chicago Press, 1980.

Boyle, J. A., ed. *The Saljuq and Mongol Periods*. Vol. 5 of *The Cambridge History of Iran*. Cambridge: Cambridge University Press, 1968.

Broadbridge, Anne F. *Kingship and Ideology in the Islamic and Mongol Worlds*. Cambridge: Cambridge University Press, 2008.

Buell, Paul D. "Tribe, 'Qan' and 'Ulus' in Early Mongol China: Some Prolegomena to Yüan History." PhD diss., University of Washington, 1977.

Bulliet, Richard W. *The Patricians of Nishapur: A Study in Medieval Islamic Social History*. Harvard Middle Eastern Studies 16. Cambridge: Harvard University Press, 1972.

Cahen, Claude. "Le Malik-nameh et l'histoire des origines seljukides." *Oriens* 2 (1949): 31–65.

———. "The Turkish Invasion: The Selchükids." Pages 135–76 in *A History of the Crusades*. Edited by Kenneth Setton. Philadelphia: University of Pennsylvania Press, 1955.

Dale, Stephen Frederic. *The Garden of the Eight Paradises: Bābur and the Culture of Empire in Central Asia, Afghanistan and India (1483–1530)*. Brill's Inner Asian Library 10. Leiden: Brill, 2004.

DeWeese, Devin. "The Eclipse of the Kubravīyah in Central Asia." *Iranian Studies* 21.1–2 (1988): 45–83.

———. "The Mashā'ikh-i Turk and the Khojagān: Rethinking the Links Between the Yasavī and Naqshbandī Sufi Traditions." *Journal of Islamic Studies* 7.2 (1996): 180–207.

Dughlat, Mirza Haydar. *Mirza Haydar Dughlat's Tarikh-i-Rashidi: A History of the Khans of Moghulistan*. Sources of Oriental Languages and Literatures 38. Translated by W. M. Thackston. Cambridge: Harvard University Press, 1996.

Durand-Guédy, David. *Iranian Elites and Turkish Rulers: A History of Iṣfahān in the Saljūq Period*. London: Routledge, 2010.

———. "Iranians at War Under Turkish Domination: The Example of Pre-Mongol Isfahan." *Iranian Studies* 38.4 (2005): 587–606.

Ephrat, Daphna. *A Learned Society in a Period of Transition: The Sunni "Ulama" of Eleventh-Century Baghdad*. SUNY Series in Medieval Middle East History. Albany: State University of New York Press, 2000.

Fragner, Bert G. "Geschichte der Stadt Hamadān und ihrer Umgebung in den ersten sechs Jahrhunderten nach der Hiǧra. Von d. Eroberung durch die Araber bis zum Untergang d. Irāq-Selčuken." PhD diss., University of Vienna, 1972.

Golombek, Lisa. "The Timurid Shrine at Gazur Gah: An Iconographical Interpretation of Architecture." PhD diss., University of Michigan, 1968.

Golombek, Lisa, Robert B. Mason, and Gauvin A. Bailey. *Tamerlane's Tableware: A New Approach to Chinoiserie Ceramics of Fifteenth-and Sixteenth-Century Iran*. Islamic Art and Architecture Series. Costa Mesa, CA: Mazda, 1996.

Golombek, Lisa, and Maria Subtelny. *Timurid Art and Culture: Iran and Central Asia in the Fifteenth Century*. Studies in Islamic Art and Architecture. Leiden: Brill, 1992.

Golombek, Lisa, and Donald Newton Wilber. *The Timurid Architecture of Iran and Turan*. 2 vols. Princeton Monographs in Art and Archaeology 46. Princeton: Princeton University Press, 1988.

Grönke, Monika. *Derwische im Vorhof der Macht: Sozial- und Wirtschaftsgeschichte Nordwestirans im 13. und 14. Jahrhundert*. Freiburger Islamstudien 15. Stuttgart: Steiner, 1993.

Gross, Jo-Ann. "Authority and Miraculous Behavior: Reflections on *Karāmāt* Stories of Khwāja ʿUbayd Allāh Aḥrār." Pages 159–72 in *The Legacy of Mediaeval Persian Sufism*. Edited by Leonard Lewisohn. London: Khanaqahi-Nimatullahi, 1992.

———. "Khoja Ahrar: A Study of the Perceptions of Religious Power and Prestige in the Late Timurid Period." PhD diss., New York University, 1982.

———. "Multiple Roles and Perceptions of a Sufi Shaykh: Symbolic Statements of Political and Religious Authority." Pages 109–21 in *Naqshbandis: Cheminements et situation actuelle d'un ordre mystique musulman*. Edited by Alexandre Popovic, Marc Gaborieau, and Thierry Zarcone. Istanbul: Institut français d'études anatoliennes d'Istanbul, 1990.

Ḥāfiẓ -i Abrū. *Ḫorāsān zur Timuridenzeit nach dem Tārīḫ-e Ḥāfeẓ -e Abrū (verf. 817–23 h.) des Nūrallāh Abdallāh b. Luṭfallāh al-Ḫvāfī genannt Ḥāfeẓ -e Abrū.* 2 vols. Translated by Dorothea Krawulsky. Beihefte zum Tübinger Atlas des Vorderen Orients. Reihe B, Geisteswissenschaften 46. Wiesbaden: Reichert, 1982.

Hillenbrand, Carole. *Turkish Myth and Muslim Symbol: The Battle of Manzikert.* Edinburgh: Edinburgh University Press, 2007.

Hillenbrand, Robert. "The Arts of the Book in Ilkhanid Iran." Pages 134–67 in *The Legacy of Genghis Khan: Courtly Art and Culture in Western Asia, 1256–1353.* Edited by Linda Komaroff and Stefano Carboni. New York: Metropolitan Museum of Art; New Haven: Yale University Press, 2003.

Hodgson, Marshall G. S. *The Venture of Islam: Conscience and History in a World Civilization.* 3 vols. Chicago: University of Chicago Press, 1974.

Holod-Tretiak, Renata. "The Monuments of Yazd, 1300–1450: Architecture, Patronage and Setting." PhD diss., Harvard University, 1972.

Horst, Heribert. *Die Staatsverwaltung der Grosselǧūqen und Khōrazmšāhs, 1038–1231: Eine Untersuchung nach Urkundenformularen der Zeit.* Akademie der Wissenschaften und der Literatur. Veröffentlichungen der Orientalischen Kommission 18. Wiesbaden: Steiner, 1964.

Huff, Dietrich. "The Ilkhanid Palace at Takht-i Sulayman: Excavation Results." Pages 94–110 in *Beyond the Legacy of Genghis Khan.* Edited by L. Komaroff. Leiden: Brill, 2006.

Ibn al-Athīr, ʿIzz al-Dīn. *The Annals of the Saljuq Turks: Selections from al-Kāmil fīʾl-Taʾrīkh of ʿIzz al-Dīn Ibn al-Athīr.* Translated by D. S. Richards. London: Routledge, 2002.

Jackson, Peter. "The Dissolution of the Mongol Empire." *Central Asiatic Journal* 22 (1978): 186–244.

Jackson, Peter, and Laurence Lockhart, eds. *The Timurid and Safavid Periods.* Vol. 6 of *The Cambridge History of Iran.* Cambridge: Cambridge University Press, 1986.

Kafesoğlu, Ibrahim. *A History of the Seljuks: Ibrahim Kafesoğlu's Interpretation and the Resulting Controversy.* Translated by Gary Leiser. Carbondale: Southern Illinois University Press, 1988.

Khalidov, Anas B., and Maria E. Subtelny. "The Curriculum of Islamic Higher Learning in Timurid Iran in Light of the Sunni Revival Under Shāh-Rukh." *Journal of the American Oriental Society* 115.2 (1995): 210–36.

Khwandamir, Ghiyāth al-Dīn ibn Humām al-Dīn. *Habibu's-Siyar.* Translated by W. M. Thackston. Sources of Oriental Languages and Literatures. Cambridge: Harvard University Press, 1994.

Klausner, Carla L. *The Seljuk Vezirate: A Study of Civil Administration, 1055–1194.* Harvard Middle Eastern Monographs 22. Cambridge: Harvard University Press, 1973.

———. "The Seljuk Vezirate: A Study of Civil Administration, 1055–1094." PhD diss., Harvard University, 1963.

Kolbas, Judith G. *The Mongols in Iran: Chingiz Khan to Uljaytu, 1220–1309.* London: Routledge, 2006.

Komaroff, Linda. *Beyond the Legacy of Genghis Khan.* Islamic History and Civilization 64. Leiden: Brill, 2006.

———. *The Golden Disk of Heaven: Metalwork of Timurid Iran.* Persian Art Series 2. Costa Mesa, CA: Mazda, 1992.

Komaroff, Linda, and Stefano Carboni. *The Legacy of Genghis Khan: Courtly Art and Culture in Western Asia, 1256–1353.* New York: Metropolitan Museum of Art; New Haven Yale University Press, 2002.

Krawulsky, Dorothea. *Īrān, das Reich der Īlḫāne: Eine topographische-historische Studie.* Beihefte zum Tübinger Atlas des Vorderen Orients Reihe B, Geisteswissenschaften 17. Wiesbaden: Reichert, 1978.

———. *Mongolen und Ilkhâne—Ideologie und Geschichte: 5 Studien.* Beirut: Verlag für Islamische Studien, 1989.

Lambton, A. K. S. "Aspects of Saljūq-Ghuzz Settlement in Persia." Pages 105–26 in *Islamic Civilization, 950–1150.* Edited by D. S. Richards. Oxford: Cassirer, 1973.

———. *Continuity and Change in Medieval Persia: Aspects of Administrative, Economic, and Social History, 11th–14th Century.* Columbia Lectures on Iranian Studies 2. Albany, NY: Bibliotheca Persica, 1988.

———. *Landlord and Peasant in Persia: A Study of Land Tenure and Land Revenue Administration.* London: Oxford University Press, 1953.

Lane, George. *Early Mongol Rule in Thirteenth-Century Iran: A Persian Renaissance.* Studies in the History of Iran and Turkey. London: Routledge, 2003.

Lapidus, Ira M. *Muslim Cities in the Later Middle Ages.* Harvard Middle Eastern Studies 11. Cambridge: Harvard University Press, 1967.

Lentz, Thomas W., and Glenn D. Lowry. *Timur and the Princely Vision: Persian Art and Culture in the Fifteenth Century.* Los Angeles: Los Angeles County Museum of Art, 1989.

Limbert, John W. *Shiraz in the Age of Hafez: The Glory of a Medieval Persian City.* Seattle: University of Washington Press, 2004.

———. "Shiraz in the Age of Hafiz." PhD diss., Harvard University, 1974.

Losensky, Paul E. *Welcoming Fighānī: Imitation and Poetic Individuality in the Safavid-Mughal Ghazal.* Bibliotheca Iranica Literature Series 5. Costa Mesa, CA: Mazda, 1998.

Manz, Beatrice Forbes. "Johannes Schiltberger and Other Outside Sources on the Timurids." Pages 51–62 in *España y el Oriente islámico entre los siglos XV y XVI: Imperio Otomano, Persia y Asia central: Actas del congreso Università degli Studi di Napoli "l'Orientale" Nápoles 30 de septiembre–2 de octubre de 2004.* Edited by Pablo Martín Asuero and Michele Bernardini. Istanbul: Instituto Cervantes, 2007.

———. "Military Manpower in Late Mongol and Timurid Armies." Pages 43–56 in *L'Héritage timouride Iran—Asie centrale—Inde XVe–XVIIIe siècles.* Edited by Maria Szuppe. Tashkent: Cahiers d'Asie centrale 1997.

———. "Mongol History Rewritten and Relived." *Revue des mondes musulmans et de la Méditerranée* 89/90 (2001): 129–50.

———. *Power, Politics and Religion in Timurid Iran.* Cambridge: Cambridge University Press, 2007.

———. *The Rise and Rule of Tamerlane.* Cambridge Studies in Islamic Civilization. Cambridge: Cambridge University Press, 1989.

Martinez, A. P. "Ducats and Dinars: Currency Manipulations, Paper Money, Arbitrage, the India Bullion Trade, and Monetary-Commercial Policy in the Il-Xanate, 654–94 H./1256-1295 A.D." Pts. 1 and 2. *Archivum Eurasiae Medii Aevi* 10 (1999): 118–206; 11 (2000–2001): 65–139.

———. "Some Notes on the Īl-Xānid Army." *Archivum Eurasiae Medii Aeivi* 7 (1986): 129–242.

———. "The Wealth of Ormus and of Ind: The Levant Trade in Bullion, Intergovernmental Arbitrage, and Currency Manipulations in the Il-Xanate, 704–51/1304–1350." *Archivum Eurasiae Medii Aevi* 9 (1995–97): 123–251.
Marwārīd, ʿAbd-Allāh ibn Muḥammad. *Staatsschreiben der Timuridenzeit: Das Šarafnāmä des ʿAbdallāh Marwārīd in kritischer Auswertung. Persischer Text in Faksimile (Hs. Istanbul Üniversitesi F 87.).* Translated by Hans Robert Roemer. Akademie der Wissenschaften und der Literatur. Veröffentlichungen der Orientalischen Kommission 3. Wiesbaden: Steiner, 1952.
May, Timothy. "The Mechanics of Conquest and Governance: The Rise and Expansion of the Mongol Empire, 1185–1265." PhD diss., University of Wisconsin, 2004.
———. *The Mongol Art of War: Chinggis Khan and the Mongol Military System.* Barnsley: Pen & Sword Military, 2007.
———. "The Training of an Inner Asian Nomad Army in the Pre-Modern Period." *Journal of Military History* 70.3 (2006): 617–35.
McChesney, R. D. *Waqf in Central Asia: Four Hundred Years in the History of a Muslim Shrine, 1480–1889.* Princeton: Princeton University Press, 1991.
Meier, Fritz. *Meister und Schüler im Orden der Naqšbandiyya: Vorgetragen am 10. Februar 1995.* Sitzungsberichte der Heidelberger Akademie der Wissenschaften, Philosophisch-Historische Klasse Jahrg. 1995. Heidelberg: Winter, 1995.
Melville, C. P. *The Fall of Amir Chupan and the Decline of the Ilkhanate, 1327–1337: A Decade of Discord in Mongol Iran.* Bloomington, IN: Indiana University Research Institute for Inner Asian Studies, 1999.
———. "Wolf or Shepherd? Amir Chupan's Attitude to Government." Pages 75–93 in *The Court of the Il-Khans.* Edited by Julian Raby and Teresa Fitzherbert. Oxford Studies in Islamic Art 12. Oxford: Oxford University Press, 1994.
———. "'The Year of the Elephant': Mamluk-Mongol Rivalry in the Hejaz in the Reign of Abū Saʿīd (1317–1335)." *Studia Iranica* 21.2 (1992): 197–214.
Morgan, David. "Mongol or Persian: The Government of Īlkhānid Iran." *Harvard Middle Eastern and Islamic Review* 3.1–2 (1996): 62–76.
———. "The Mongols in Syria, 1260–1300." Pages 231–35 in *Crusade and Settlement: Papers Read at the First Conference of the Society for the Study of the Crusades and the Latin East and Presented to R. C. Smail.* Edited by P. W. Edbury. Cardiff: Cardiff University Press, 1985.
———. "Rašīd al-Dīn and Ġazan Khan." Pages 179–88 in *L'Iran face à la domination mongole.* Edited by Denise Aigle. Tehran: Institut Français de recherche en Iran, 1997.
Nagel, Tilman. *Timur der Eroberer und die islamische Welt des späten Mittelalters.* Munich: Beck, 1993.
Naṭanzī, Muʿin al-Din. *Extraits du Muntakhab al-tavarikh-i Muʿin (Anonyme d'Iskandar).* Edited by Jean Aubin. Tehran: Khayyam, 1957.
Nīshāpūrī, Ẓahīr al-Dīn. *The Saljūqnāma of Ẓahīr al-Dīn Nīshāpūrī: A Critical Text Making Use of the Unique Manuscript in the Library of the Royal Asiatic Society.* Translated by A. H. Morton. Warminster: Gibb Memorial Trust, 2004.
O'Kane, Bernard. *Timurid Architecture in Khurasan.* Islamic Art and Architecture Series 3. Costa Mesa, CA: Mazda, 1987.
Paul, Jürgen. *Die politische und soziale Bedeutung der Naqšbandiyya in Mittelasien im 15. Jahrhundert.* Studien zur Sprache, Geschichte und Kultur des islamischen Orients 13. Berlin: de Gruyter, 1991.

———. "The Seljuq Conquest(s) of Nishapur: A Reappraisal." *Iranian Studies* 38.4 (2005): 575–85.
Peacock, A. C. S. *Early Seljūq History: A New Interpretation.* London: Routledge, 2010.
Petrushevskiĭ, I. P. *Zemledelie i agrarnye otnosheniia v Irane XIII–XIV vekov.* Leningrad: Izd-vo Akademii nauk SSSR, Leningradskoe otd., 1960.
Pfeiffer, Judith. "Conversion to Islam Among the Ilkhans in Muslim Narrative Traditions: The Case of Aḥmad Tegüder." PhD diss., University of Chicago, 2003.
———. "Reflections on a 'Double Rapprochement': Conversion to Islam Among the Mongol Elite During the Early Ilkhanate." Pages 369–89 in *Beyond the Legacy of Genghis Khan.* Edited by Linda Komaroff. Leiden: Brill, 2006.
Potter, Lawrence G. "Herat Under the Karts: Social and Political Forces." Pages 184–207 in *Views from the Edge: Essays in Honor of Richard W. Bulliet.* Edited by Neguin Yavari, Lawrence G. Potter, and Jean-Marc Ran Oppenheim. New York: Columbia University Press, 2004.
———. "The Kart Dynasty of Herat: Religion and Politics in Medieval Iran." PhD diss., Columbia University, 1992.
———. "Sufis and Sultans in Post-Mongol Iran." *Iranian Studies* 59 (1994): 77–102.
Reid, James J. "The Je'un-i Qurbān Oirat Clan in the Fourteenth Century." *Journal of Asian History* 18 (1984): 189–98.
Quinn, Sholeh Alysia. *Historical Writing During the Reign of Shah 'Abbas: Ideology, Imitation, and Legitimacy in Safavid Chronicles.* Salt Lake City: University of Utah Press, 2000.
Raby, Julian, and Teresa Fitzherbert, eds. *The Court of the Il-khans, 1290–1340: The Barakat Trust Conference on Islamic Art and History, St. John's College, Oxford, Saturday, 28 May 1994.* Oxford Studies in Islamic Art 12. Oxford: Oxford University Press 1996.
Rashīd al-Dīn. *The History of the Seljuq Turks from the Jāmi' al-tawārīkh: An Ilkhanid Adaptation of the Saljūq-nāma of Ẓahīr al-Dīn Nīshāpūrī.* Translated by Kenneth A. Luther and Clifford Edmund Bosworth. Richmond: Curzon, 2001.
Robinson, B. W. "Bihzad and his School: The Materials." *Marg* 30.2 (1977): 51–76.
———. "Prince Baysunghur and the Fables of Bidpai." *Oriental Art* 16.1 (1970): 145–54.
Roxburgh, David J. *The Persian Album, 1400–1600: From Dispersal to Collection.* New Haven: Yale University Press, 2005.
———. "Persian Drawing, ca. 1400–1450: Materials and Creative Procedures." *Muqarnas* 19 (2002): 44–77.
Safi, Omid. *The Politics of Knowledge in Premodern Islam: Negotiating Ideology and Religious Inquiry.* Chapel Hill: University of North Carolina Press, 2006.
Shāmī, Niẓām al-Dīn. *Histoire des conquêtes de Tamerlan intitulée Ẓafarnāma par Niẓām al-Dīn Shāmī.* 2 vols. Edited by F. Tauer. Prague: Oriental Institute, 1937, 1956.
Simpson, Marianna Shreve. "The Illustration of an Epic: The Earliest 'Shahnama' Manuscripts." PhD diss., Harvard University, 1978.
———. *The Illustration of an Epic: The Earliest 'Shahnama' Manuscripts.* New York: Garland, 1979.
Smith, John Masson. "Ayn Jālūt: Mamlūk Success or Mongol Failure?" *Harvard Journal of Asiatic Studies* 44.2 (1984): 307–45.

———. *The History of the Sarbadār Dynasty, 1336–1381 A.D. and Its Sources.* The Hague: Mouton, 1970.

———. "Mongol and Nomadic Taxation." *Harvard Journal of Asiatic Studies* 30 (1970): 46–85.

———."Mongol Manpower and Persian Population." *Journal of the Economic and Social History of the Orient* 18.3 (1975): 271–99.

———. "Mongol Society and Military in the Middle East: Antecedents and Adaptations." Pages 249–66 in *War and Society in the Eastern Mediterranean, 7th–15th Centuries.* Edited by Yaacov Lev. Leiden: Brill, 1997.

———. "Nomads on Ponies vs. Slaves on Horses." *Journal of the American Oriental Society* 118 (1998): 154–62.

Soucek, Pricilla. "Ibrāḥīm Sulṭān b. Shāhrukh." Pages 24–41 in *Iran and Iranian Studies: Essays in Honor of Iraj Afshar.* Edited by Kambiz Eslami. Princeton: Zagros, 1998.

———."Illustrated Manuscripts of Nizami's 'Khamseh': 1386–1482." PhD diss., New York University, 1971.

Spuler, Bertold. *Die Mongolen in Iran: Politik, Verwaltung und Kultur der Ilchanzeit 1220–1350.* Iranische Forschungen 1. Leipzig: Hinrichs, 1939.

Stchoukine, Ivan. *Les peintures des manuscrits tîmourides.* Paris: Geuthner, 1954.

Subtelny, Maria E. "Bābur's Rival Relations: A Story of Kinship and Conflict in 15th–16th Century Central Asia." *Der Islam* 66.1 (1989): 102–18.

———. "Centralizing Reform and its Opponents in the Late Timurid Period." *Iranian Studies* 21.1–2 (1988): 123–51.

———. *Le monde est un jardin: Aspects de l'histoire culturelle de l'Iran médiéval.* Cahiers de Studia Iranica 28. Paris: Association pour l'avancement des études iraniennes, 2002.

———. *Timurids in Transition: Turko-Persian Politics and Acculturation in Medieval Iran.* Brill's Inner Asian Library 19. Leiden: Brill, 2007.

Subtelny, Maria E., and Anas B. Khalidov. "The Curriculum of Islamic Higher Learning in Timurid Iran in Light of the Sunni Revival Under Shāh-Rukh." *Journal of the American Oriental Society* 115.2 (1995): 210–36.

Sümer, Faruk. *Kara Koyunlular: Başlangıçtan Cihan-Şah'a kadar.* Ankara: Türk Tarih Kurumu Basimevi, 1967.

Szuppe, Maria. *Entre Timourides, Uzbeks et Safavides: Questions d'histoire politique et sociale de Hérat dans la première moitié du XVIe siècle.* Cahiers de Studia Iranica 12. Paris: Association pour l'avancement des études iraniennes, 1992.

———, ed. *L'Héritage timouride: Iran, Asie centrale, Inde XVe–XVIIIe siècles.* Cahiers d'Asie centrale. Aix-en-Provence: Institut français d'études sur l'Asie centrale, 1997.

Thackston, W. M. *A Century of Princes: Sources on Timurid History and Art.* Cambridge: The Aga Khan Program for Islamic Architecture, 1989.

Wing, Patrick. "The Jalayirids and Dynastic State Formation in the Mongol Ilkhanate." PhD diss., University of Chicago, 2007.

———. *The Jalayirids: Dynastic State Formation in the Mongol Middle East.* Edinburgh: Edinburgh University Press, 2016.

Woods, John E. *The Aqquyunlu: Clan, Confederation, Empire.* Rev. ed. Salt Lake City: University of Utah Press, 1999.

———. *The Aqquyunlu: Clan, Confederation, Empire: A Study in 15th/9th Century Turko-Iranian Politics*. Studies in Middle Eastern History 3. Minneapolis: Bibliotheca Islamica, 1976.

———. "The Rise of Tīmūrīd Historiography." *Journal of Near Eastern Studies* 46.2 (1987): 81–108.

———. "Timur's Genealogy." Pages 85–126 in *Intellectual Studies on Islam: Essays Written in Honor of Martin B. Dickson*. Edited by Michael Mazzaoui and Vera B. Moreen. Salt Lake City: University of Utah Press, 1990.

CHAPTER 16

Development of Persian Language Studies in the United States

Franklin D. Lewis

IRANIAN STUDIES AND THE LEARNING of Persian was established much later in the United States than in Europe, after Persian had become a requirement for British civil service in India, after the Raj had replaced Company rule, and after Britain had grown alarmed about possible French or Russian designs on the flank of the British Raj in Afghanistan and Persia. But Persian literature nevertheless had its impact on American authors and transcendentalist thought; through Montesquieu's *Lettres persanes* of 1721 and Voltaire's fascination with Zoroastrianism the idea of Persia became a staple of discussion for Enlightenment thinkers.[1] In the nineteenth century, Persian Sufism, or what was seen as "pantheism,"[2] as well as reform movements like Babism and Baha'ism held the attention of many thinkers, while the various missions of the church in Persian-speaking lands brought many Europeans and Americans in contact with Persian speakers. Perhaps most importantly, European Romanticism was suffused with Persian (or "oriental") poetic inspiration that was not only read on the page but sung in the form of *Lieder* around parlor pianos in America and Europe. Persian poetry specifically, though cast in the larger framework of oriental literature, helped shaped Goethe's ideas of *Weltliteratur* (*West-östlicher Divan* written between 1814 and 1819), Friedrich Max Müller's *Sacred Books of the East* (written between 1879 and 1910), and collections of classic literature produced in the United States. After the discovery of oil, especially during the Cold War, and in the wake of the Iranian Revolution, the geopolitical significance of Iran has compelled both journalistic and scholarly attention. For the generations of Americans born since the Iranian Revolution, it may be difficult to imagine a world in which few people in the academy saw the need to study Iran and almost no professors knew Persian.

Italian missionaries, diplomats, and scholars had been working with Persian texts from at least the fourteenth century. The collaborative work of Persian-speaking Christians and Italian scholars led to perhaps the earliest adaptation of a Persian literary text in a European language, *Peregrinaggio di tre giovani figliuoli del re di Serendippo* (1557), which was rendered by an Armenian from

Tabriz named Cristoforo Armeno, who came to Venice in 1554 with the help of an Italian friend.[3] There were other Persian-speaking informants from Iran who assisted European orientalists with editions and translations of Persian works; these included Don Juan of Persia, Uruch Beg (1560–1604), and Hakkwirdi (Ḥaqqverdi), who accompanied Adam Olearius (1599–1671) from Persia to Gottorp and took up residence there, helping him to translate Saʿdi's *Golestān*, a text that was much admired by scholars of Enlightenment-era Europe and which constituted the first literary text in Persian to be read by Persian-language students after learning the grammar in India, Britain, and elsewhere during the nineteenth and into the twentieth century. University chairs for the study and promulgation of knowledge of the Persian language and Persia of the Islamic period had been established in the nineteenth century in Holland, Great Britain, France, Austria, Germany, Poland, and Russia. According to Gernot Windfuhr, the grammar and lexicon of modern Persian was "first studied in the 11th century by Iranians, who were later joined by Turkish and then by Indian and other Muslim scholars, and finally, since the 17th century, by western scholars. The two main paradigms with which Persian grammar has been studied and described are the 'Muslim / Near Eastern' and the 'Western' paradigm. (A third paradigm, that of Indian [Sanskrit] grammar, is said to have been applied in some grammars of Persian written in India during the time of Akbar.)"[4]

Windfuhr traces the origins of the "Muslim / Near Eastern" paradigm for the study of Persian to Avicenna's abstract and philosophical approach, followed by the efforts of lexicographers, rhetoricians and phoneticians writing in Persian. But some authors composed works on Persian grammar in Arabic, including Abū Ḥayyān Naḥwī (1256–1344; his very name advertises his professional concerns with syntax and grammar), who wrote a now lost work titled *Manṭiq al-khurs fī lisān al-furs* (Communication of the mute [i.e., non-Arabic speakers] in the Persian tongue). To the same period belongs *Kitāb ḥilyat al-insān fī ḥalbat al-lisān* (The adornments of mankind in the arena of language) of Jamāl al-Dīn Ibn al-Muḥannā, who treats comparatively the four languages of power and knowledge of the day: Arabic, Mongolian, Turkish, and Persian. But because of the literary prestige of Persian outside the areas where it was natively spoken, Ottoman scholars in Anatolia and Mughal scholars in India contributed treatises and manuals of Persian grammar as well as dictionaries.[5] In 1841, Mirza Mohammad Ibrahim, professor of Arabic and Persian at the East India Company's College in Haileybury, produced the first grammar of Persian written in English by an Iranian Persian speaker undertaking "to communicate the elements of Persian Grammar to English Students, in an English dress" and "to teach *the Persian of Persians*;—not the Persian only of *books*."[6] Heinrich Leberecht Fleischer (1801–1888), a professor of Oriental

Languages at Leipzig (and a student of Sylvestre de Sacy, 1758–1838) soon adapted and expanded on Ibrahim's grammar format in German.[7] The book that sparked interest in England for learning Persian, Sir William Jones's *Persian Grammar*, was originally published in 1771 and was translated by Jones himself into French in 1772. The title page of both the English and the French versions contains a line from Hafez as well as a Persian version of the book's name, following Persian book-naming style, in Persian typescript: *Ketāb-e Šekarestān dar naḥvi-ye zabān-e pārsi* (Fields of sugarcane in the grammar of Persian) by Jones of Oxford (*Yunes-e Uksfordi*).[8] Jones credits "a foreign nobleman" for his knowledge of and enthusiasm for Persian, but this was likely the Polish Count Reviczky and not an Iranian or an Indian. However, when Professor Samuel Lee published a revised and improved edition of Jones's grammar in 1828, his own command of Persian was informed by consultation in 1818–19 with one of the first Iranian students and scholars in Britain, Mirzā Ṣāleḥ Shirāzi, whom Lee obliquely thanks as one of the "intelligent and learned Persians whom I have had the opportunity to consult" in his preface.[9] The "western" tradition of Persian grammars was thus partially informed—despite a strong British orientation to Indo-Persian—by an Iranian understanding of Persian as a modern spoken language.[10]

Yet, like Mirza Mohammad Ibrahim's grammar, modern Persian grammars produced for use in schools inside Iran by native and nonnative speakers of Persian generally took European grammars of Persian as their exemplars, assuming standard literary Persian as the target register to be emulated. Naturally enough in an age concerned with the spread of literacy and the standardization of "national" language usage, though colloquial Persian was the living language natively spoken in many homes and on the street, it was not the standard language in which pupils would be asked to write compositions or could expect to read books. Persian was also not the native language of all Iranians (a significant percentage of whom natively spoke Azeri Turkish, Kurdish, Lori, Baluchi, Arabic, etc.) but the language of prestige and of national unity. Although a Persian grammar was not introduced into the Dar al-Fonun curriculum until 1914, in the era before comprehensive state-run schools a book published by Mirzā Qarib proudly proclaiming to follow European methods gained wide acceptance.[11] Decades later, four professors of Persian at the University of Tehran built upon Qarib's work and redesigned this grammar of Persian for students in the first and second year of Iranian high schools, which was adopted into the Iranian school curriculum as the "Persian Grammar of the Five Professors."[12]

As for "the 'western' paradigm" for Persian grammatical study, religious or economic motivations drove the earlier European interest in Persian with literary or linguistic motivations following. In the seventeenth century,

a handful of grammars of Persian were published in various European languages, several of them written by individuals who had visited or lived in Iran and described the language from firsthand practical experience.[13] By the end of the nineteenth century, a large number of Persian grammars had been produced in European languages,[14] though most of the plentiful English-language grammars of Persian were based upon "colonial" Persian, which was used in South Asia primarily for literate and elite composition of texts but not for spoken communication.[15] Anglophone scholarship initially depended on the grammars of Persian written in the prefaces of Persian dictionaries or literary anthologies compiled in India in the sixteenth through seventeenth centuries, a fact which Aleksander Chodzko, the Polish Slavist, Iranologist, diplomat, and professor at Collège de France, already noted in 1852, declaring this situation "intolerable for a grammar of the *Persian* language in the nineteenth century."[16] Knowing that this statement came from someone who had spent time in northern Iran and knew how native speakers employed the language for everyday purposes, we may understand his sense of frustration. At the same time, it is worth acknowledging that the textual command of Persian gained by some British civil servants and military officers in India derived from grammars of Persian based on its Indo-Persian context.

Ignoring these learners' textbooks and bracketing the considerable contribution of Russian and Czech scholars, which by and large did not impact the trends in Western European grammars of Persian before World War II, we may note that some scholars conceived and presented Persian grammar in a more theoretical and linguistic framework, in which category we may include Lumsden's descriptive-interpretive approach (1810), Paul Horn's historical-comparative method (1895–1904) in his "Neupersische Schriftsprache" included in the *Grundriss der Iranischen Philologie*, the inclusive coverage of different varieties of Persian by Philott (1919), and the historical approach by Jensen (1931).[17]

Birth of American Cultural and Educational Involvement in Persia

Before the Pilgrims landed at Plymouth Rock, an Armenian, possibly from Persia, lived briefly in Virginia. Called variously Martin the Armenian, Martin Ye Armenia, or John Martin the Persian, he arrived at the Jamestown settlement, perhaps as a servant of Governor George Yeardley, in 1618 or 1619. After living in America for four or five years, Martin acquired British citizenship in 1623, enabling him to become a member of the standing committee of the Virginia Company of London and to return to London. Clearly, he must have

known at least some English, but the epithet "the Persian" suggests he would have been a Safavid subject or at least knew how to speak Persian. In 1653, a further two Armenians, both of whom came from Turkey, were brought by Edward Diggs of the Colony of Virginia, apparently because of their skill with raising silk worms.[18]

There were a few Americans who traveled to Persian-speaking countries early on as well as a few Iranians who came to the United States in the nineteenth century. There was Josiah Harlan (1799–1871), a lapsed Quaker from Pennsylvania who lived a life of adventure to match any gunslinger in the Wild West. Harlan was employed by the East India Company as an assistant surgeon (though with no experience in medicine) and served in the First Burmese war, but in northern India he began working as a covert agent for Shah Shojā al-Molk, the deposed king of Afghanistan, in 1826. Harlan knew of Shah Shojā al-Molk because Mountstuart Elphinstone had been sent on a mission by the British government and concluded a treaty with him in 1809, fearing that Napoleon, after his invasion of Egypt, might turn French attention on India through Afghanistan. Harlan was much taken with Elphinstone's *An Account of the Kingdom of Caubul and Its Dependencies in Persia, Tartary and India*,[19] which propelled him to visit the area for himself. Harlan arrived in Kabul disguised as a dervish in 1828, eventually becoming involved with Maharajah Ranjit Singh in Lahore and then Amir Dost Mohammed in Kabul, for whom he trained Afghan troops in Anglo-American military tactics. It is not clear from his account whether the extensive and insightful details he produces in his book come through a mastery of Pushto or Persian,[20] but he did come to command an army and to receive a treaty appointing him hereditary commander (or Nawaub) of Khoorum by the prince of Ghoree.[21] For a short while in 1838–39, he held territory near Balkh but was chased out by the British invasion of Afghanistan and returned to the United States in 1841 to live in San Francisco.

As it happens, San Francisco was the city where Hajj Sayyāh became the first Iranian to become a naturalized US citizen , on May 26, 1875, as registered by the Court of the Twelfth Judicial District of the State of California.[22] But the intellectual impulse to study Persian as a scholarly endeavor came rather through Ralph Waldo Emerson, whose English translations from German translations of Persian poems introduced American readers to Sa'di, Hafez, and others. In his topical notebooks, Emerson mentions a large number of Orientalists who were responsible in various measure for Western knowledge about Persia (Emerson would not have known the land as "Iran," a name which came into general European usage only after Reza Shah's 1935 edict): Adam Olearius (Ölschläger, 1599–1671); Georgius Gentius, who made a Latin translation of the *Gulistān* in 1651; Barthélémy d'Herbelot (1625–1695), whose *Bibliothèque orientale* was a major Enlightenment-era reference work;

Jean Chardin (1643–1713), who recounted his ventures in his *Travels in Persia, 1673–1677*. These were, of course, all European scholars, but they were often supported in their work by Persian or Indian informants, some of whose names are known to us.

By 1990, there were only some 637,600 Iranians living in diaspora, according to the count given in the official censuses of the United States, Canada, West Germany, Sweden, Great Britain, France, Norway, Australia, Israel, and Japan. Nearly half of this total (285,000) resettled in the United States,[23] but of the Iranians living in the United States in 1990, more than 83 percent had come to the United States since 1975, and less than 1 percent had come here prior to 1950.[24] Indeed, the number of Iranians who came to the United States in the nineteenth century seems to have been miniscule; statistics suggest that only 130 Iranians are known to have set foot in the United States before 1900.[25] And from 1925 to 1950, US immigration records attest only 1,816 Iranians having been cumulatively admitted to the United States as permanent residents. Although the following decade saw a significant increase, with the number of Iranian immigrants living in the United States nearly doubling in ten years, it was still an almost invisible minority, standing at 3,388.[26] One might therefore assume that there cannot have been much informal person-to-person teaching of Persian to Americans during this period. Moreover, the US Senate seems to have been relatively little concerned with Persia in comparison to other places in the Middle East until the mid-1970s, at least as reflected in the documents it published on the Middle East in 1969 and 1975.[27]

The American missionary-educational-philanthropic interaction with the Middle East began about two hundred years ago and led to the establishment of Roberts College in 1863 in Turkey; the Syrian Protestant College (eventually the American University of Beirut) in 1866, and the American University of Cairo (1919), all of which received US government financial assistance after World War II.[28] The Middle East Institute was created in 1946 as a think tank on issues concerning the Middle East. This was before many US universities had modern Middle Eastern Studies programs. An effort to grow university training in the field of Middle Eastern Studies was undertaken by the government with the passage of the National Defense Education Act in 1958, leading to the creation of a dozen National Resource Centers on the Middle East alongside other area studies centers, which both encouraged American students to study the field (and to travel to the Middle East) and brought Middle Eastern scholars to the United States.[29] We cannot know if the natural development of political, commercial, and cultural contacts would have in any case led to the same result, but by 1978 there were an estimated 100,000 students from the Middle East in the United States—the single largest nationality among foreign students being Iranians—and almost 90,000 Americans were

living in the Middle East.[30] Meanwhile, the Franklin Books Program, which was launched in 1952, distributed on a nonprofit basis in excess of 30 million copies of American books that had been translated into various languages, while the United States Information Agency also helped to set up circulating public libraries in many Middle Eastern cities.[31]

Grammars

Sir William Jones published the first English-language grammar of Persian in 1771, and none of the grammars published since has been as popular or successful. By 1828, it had gone through nine English editions and a French translation, and gentlemen in the eighteenth and nineteenth centuries spoke about rushing home to read more of it as one might for a suspense novel. In the preface, Jones offers three reasons for writing a grammar and, by extension, for learning Persian: (1) employees of the East India Company would need a grammar to help them learn Persian, because Indian princes use the language in their correspondence; (2) perhaps closer to Jones's heart, Persian literature could invigorate the somewhat lackluster state in which British literature of the neo-classical era found itself—he surely had in mind poems such as "The Persian Song of Hafiz," which Jones himself provides in translation; and (3) with a knowledge of Persian under their belts, European scholars might translate works heretofore unknown in English and thereby fortify their intellectual and cultural heritage.[32]

Two of three of these justifications seem to be more abstract than applied concerns and would not likely lead to gainful employment. To be sure, an educated English speaker might find a reading knowledge of Persian quite helpful while working in India. Even so, Jones did not think of the grammar he wrote as an end in itself but merely a means to an ends; the process of language study held little interest for him as an intellectual activity, and since Persian in the subcontinent was a literary language and not a spoken one, he needed not concern himself with spoken proficiency: "You may observe, that I have omitted [references to learning] their languages, the diversity and difficulty of which are a sad obstacle to the progress of useful knowledge; but I have ever considered languages as the mere instruments of real learning, and think them improperly confounded with learning itself: the attainment of them is, however, indispensably necessary."[33]

Despite the popularity of Jones's *Persian Grammar* and the craze it helped engender in Europe (not just in England) for Persian poetry, modern critics would find it lacking in many respects, as Garland Cannon points out, especially regarding the use of Persian as an everyday tool of communication. But

a classicist orientation to Persian dominated not just British but European scholarship more generally, which was concerned primarily with Persian as a transnational literary language, one in which court records and dynastic chronicles had been written down across a wide region. Persian's reputation among the European Romantics for its literary heritage even inflected the study of the language in the Middle East; in Egypt, Persian teaching was undertaken by Egyptians, who trained in programs of Oriental studies in Europe and were infused with the same admiration for the Persian literary tradition. Although Zaydān Badrān al-Miṣrī published a grammar of Persian in 1938 to celebrate the marriage of Princess Fawziyya of Egypt with the Shah of Iran entitled *al-Tuḥfa al-Fawziyya fī taʿālīm al Fārisiyya* (The Fawziyya masterpiece in teaching Persian),[34] the textbook that gained wider usage came out just after the Germans were driven out of Egypt by Ibrahim Amin al-Shawarby, who had also translated Hafez. Al-Shawarby's *al-Qawāʾid al-asāsiyya li-dirāsat al-Fārisiyya*,[35] taught by himself at Ibrahim Pasha (now Ain Shams) University and continually refined on the basis of classroom experience, was the standard text in Egypt for a couple of decades.[36]

Of course, there were some British individuals who spent time in Iran and learned to speak modern Persian well, especially during World War II when the Allied Powers deposed Reza Shah and occupied parts of the country (an experience elegantly if fictionally depicted in Simin Dāneshvar's novel *Savushun*). There was the Quaker imprisoned during World War I as a conscientious objector and poet of Ezra Pound's circle, Basil Bunting, who learned Persian and translated many Persian poems, as a result of which he was sent to work for British Military Intelligence in Iran and at the British Embassy in Tehran during World War II. He then became a correspondent in Tehran for the *Times of London* and married there an Iranian citizen of Kurdish-Armenian background named Sima Alladian. Eventually, Bunting was found to be making intelligence reports for the Anglo-Iranian Oil Company, and he was expelled from the country in May 1952 by Mohammad Mossadegh, after which he returned to his native Newcastle. Laurence Paul Elwell-Sutton (1912–1984) went to work for the Anglo-Iranian Oil Company in Abadan from 1935 to 1938, and after serving in the BBC's Overseas Service during the outset of World War II he went back to the British Embassy in Tehran as the Press Attaché for Broadcasting from 1943 to 1947. He taught at the University of Michigan in 1950 but joined the faculty at Edinburgh University from 1952 until his retirement in 1982,[37] during which time he produced two grammars of Persian, one for formal Persian and the other for spoken Iranian Persian. Of the concentration on the modern language of Iran in L. P. Elwell-Sutton's 1963 *Elementary Persian Grammar*, G. M. Meredith-Owens notes appreciatively in his review of the book how far we have come from the days when Tisdall's Persian grammar

was the only game in town, and he celebrates the book's focus on the modern language of Iran, in contrast to Ann Lambton's grammar.[38]

Although Lambton knew how to speak Persian, had lived for a time in Iran, and did not view the language as exclusively a classical literary one, her *Persian Grammar* constituted something of a whipping boy for reviewers (as indeed, most grammar course books do).[39] Indeed, if employed as a course text in an American classroom, it suffers from several problems, as noted by Sidney Glazer, a consultant to the Near East collection of the Library of Congress in his review in the *Middle East Journal*, which catered to an American diplomatic and government policy audience.[40] While praising elements that could prove helpful to individuals trying to speak Persian in Iran (a chart of intonation patterns, information about the Iranian calendar and public holidays, polite formulas of discussion), Glazer nevertheless found it "defective in the basic components of textbook construction," citing too many rules and exceptions per lesson, too few exercises, never-uttered sentence examples (such as "The wolf is hard and strong and withal one of the cleverest animals"), an over-reliance on rare or classical constructions, an index deficient in details, and "poor organization."[41] Glazer becomes particularly exercised that the glossary traditionally included with a language grammar book has been relegated to a separate volume (thus increasing the expense to students) while providing far more vocabulary than needed to go through the exercises yet not enough of a lexicon to read a newspaper. We may join in the general disappointment over the accompanying *Persian Vocabulary* volume (Frye estimates that it contains 6,000 Persian entries and 5,500 English entries but is not based on any word-frequency count),[42] but Glazer overlooks several virtues of her *Persian Grammar* that I, as a student trained with a more classroom-oriented book (Windfuhr and Tehranissa), found very useful—such as the section on Arabic grammar and the ability to easily find things when consulting it as a reference grammar. Richard Frye in 1955 mentions that students of Persian had not objected to the classroom use of Lambton's grammar (which he therefore planned to keep on using), though Frye agreed that her *Vocabulary* (and also Boyle's dictionary) was wanting.[43] Lambton herself did not apply her method gently; David Morgan suggests that those who took Persian with her might form a survivors' club, whereas M. E. Yapp indicates she once reduced a Major in the British Army to tears.[44] Included in her grammar is a selection of excerpts from Persian texts, for student practice. Farshid Delshad gives some examples of anthologies of Persian texts included in other grammars, among which are: Duncan Forbes, *A Grammar of the Persian Language*; Carl Salemann and Valentin Shukovski, *Persische Grammatik mit Literatur, Chrestomathie und Glossar*; and W. St. Clair Towers Tisdall (with Zia Missaghi), *Modern Persian Conversation-Grammar*.[45] Further to be mentioned are Amir Abbas

Haidari, *A Modern Persian Reader*, and Hassan Kamshad, *A Modern Persian Prose Reader*.

On the other hand, the new and so-called conversational method of language teaching—a patented method developed by Drs. Thomas William Gaspey, Emil Otto, and Karl Marquard Sauer—aimed at helping the foreign language learner gain practical command of a language such that she or he would be able to listen to and speak with a native, enjoyed commercial success from the late nineteenth century. It appealed in particular to missionaries, who had to be able to speak with the local population they hope to evangelize. V. H. Hagopian, an Armenian subject of the Ottoman Empire, taught at the Anatolia College in Merzifon, a school established in 1886 by American missionaries under the direction of the American Board of Commissioners for Foreign Missions. He applied the Gaspey-Otto-Sauer conversational method in the language-learning book he designed for English speakers wishing to learn Ottoman Turkish.[46] He apparently had subjects of the British Commonwealth in mind as the primary readers, and he remonstrated with them for not taking as much interest in conversation with the people of Turkey as the Americans (who were employing him) had done.[47]

Of course, many a British officer, civil servant, or academic throughout the nineteenth and into the twentieth century wrote grammars of Persian using English as the medium of instruction. One might assume that the language manuals published by Persianists in the United Kingdom or India would have been perfectly acceptable for North Americans wanting to pursue the study of Persian. But in the American case, it was neither academics nor civil servants who had need of learning Persian, nor were Americans interested in the written Persian of India. Instead, it was American missionaries who pioneered the study of Persian in the United States in the nineteenth century decades before it took root in the academy, and they needed to learn how to converse with Iranians. It was a British scholar and missionary, Reverend William St. Clair Tisdall (1859–1928), who wrote just the book for them. Rev. Tisdall had spent some time in the Punjab and in India before going to Iran as the Secretary of the Church of England's Church Missionary Society post in Isfahan. He had also already published two books in Trübner's Collection of Simplified Grammars of the Asiatic and European Languages—*A Simplified Grammar and Reading Book of the Panjabi Language* and *A Simplified Grammar of the Gujarātī Language*—and so was asked to write a grammar for Persian by Julius Groos following the new Gaspey-Otto-Sauer conversational method.[48] Tisdall did so in 1902, observing as follows in the preface:

> Persian, the Italian of the East, has long been recognized as one of the most euphonious, expressive and important of Oriental languages.

Unfortunately, however, to most Englishmen who have spent any time in India, Persian is known only in its antique form and pronunciation, which are still in large measure retained on the Afghan frontier and in other parts of India. This prevents the student from being intelligible to the natives of Persia, should he for any reason find it desirable to visit that country. The writer's own experience enables him to speak with some little authority on this subject. Having studied and learnt to speak Persian in the Panjab, he found, on endeavouring to enter into conversation with Shirazis in Bombay, that he was almost if not quite unintelligible to them, since many of the words, phrases and idioms he had learnt from the pages of Saʿdi and other classical Persian authors have become obsolete and have been superseded by others in the modern language as spoken in Persia itself. It was as if a foreigner, having discovered some corner of the world in which English was still spoken by the learned, just as it occurs in the Elizabethan writers and with the pronunciation of that distant day, had learnt the language from them and then tried to converse with the English people of to-day. His conversation would seem at once stilted and vulgar, and it would amuse everyone with whom he came in contact.

The Civil and Military authorities in England and India now, however, seem to have begun to grasp the fact that Indian Persian is somewhat like what the French of "Stratford atte Bowe" was in olden times, and to feel the desirability of favouring the study of the language as actually spoken in Persia itself.[49]

Tisdall quite rightly notes the different needs of Persian learners in India and Persian learners in Persia, though perhaps he also omits or did not realize that the pronunciation of Persian words he had learned in India, combined with his own English accent, probably impeded his efforts at comprehensibility as much as or more than following the language of Saʿdi's *Golestān* did. But Tisdall must have acquired a good knowledge of the common spoken Persian of Iran during his seven years of residence in Isfahan,[50] and he had the help of a native informant there, Āqā Mirzā Asad Allāh. The reading selections came from *Ṣad ḥekāyat* and Nāṣer al-Din Shāh's diary of his third trip to Europe. There were also personal letters, with the correspondents' names removed, scattered through the text and reproduced in the original handscript. The book seems to have enjoyed some currency, having been reprinted in 1923 by Groos with the same London, New York, and Boston outlets, and again in 1943 fifteen years after the death of Tisdall by new publishers (F. Ungar in New York with P. D. and I. Perkins in South Pasadena, California acting as "western distributors").[51] Ungar Publishing brought out an updated version "with new reading

lessons and Persian letters selected by Zia Missaghi" in 1959 and with more printings coming out in 1961 (for $6.50 and $1.50 for the Key volume) and 1982.

With the discovery of oil in Iran and the construction of a refinery at Abadan by the Anglo-Iranian Oil Company, the British staff resident in Iran or conducting business there found it useful to speak at least a modicum of colloquial Persian. The Anglo-Iranian Oil Company began circulating a booklet that would quickly acquaint its employees with the basics of spoken Persian, using only Roman characters and thus dispensing with any need of learning to read in the Persian script. Cecil Lorraine Hawker's *Simple Colloquial Persian* was published first in 1931 and went through a new printing almost every year for a decade.[52] Minorsky, in his review of the pamphlet in the Bulletin of the School of Oriental and African Studies, maintains that spoken Persian has a very regular grammar, the basic rules of which can be explained in three hours. Minorsky praises Hawker's approach to transcribing the modern Iranian pronunciation of words and his selection of a lexicon of about 1,500 practical words, but ultimately finds the work riddled with inconsistencies and errors, though he seems to prefer it for the purpose of learning spoken Persian over Phillot's *Higher Persian Grammar* and Tisdall.[53] In 1959, a second edition of the work was brought out, apparently by a relative of the original author E. M. N. Hawker, who also published a much longer book that also went through many reprints, teaching the script in addition to the spoken language.[54]

But it was during World War II and after that the American government put Iran on the wider mental map of Americans. The US government orientation toward Persian differed from the interests of the British Raj and earlier Company rule in India, in that the common spoken language of Iran was more important than the language of literature or of the courts. The US government took an interest in Iran itself alongside the contemporary twentieth-century political and economic objectives it had with respect to Iran. Textbooks produced in the United States for American learners of Persian in the 1960s therefore adopted an approach that Windfuhr describes as "structuralistically oriented,"[55] which proceeded incrementally by the "build-up" method of introducing in each lesson a list of words, which were then turned into a complete sentence and then deployed in a conversation taking the "(educated) colloquial style of Persian" as the target register of the language.[56]

Despite the general dogma of the "Oral Method" that dominated thinking in the postwar United States—essentially that grammar (the purported focus of the "classical" method) could be dispensed with and the student immersed in conversational practice, so that through the observation and implementation of paradigms, he could masterfully learn in a hands-on way to speak a foreign language—not everyone accepted that teaching of grammar frittered

away class time and did not lead in the end to any practical ability in the language (if the student needed to become proficient in the spoken language, after completing study in the classical method, she or he might then go to the region and pick up the spoken language on the street). The assumption here was that the spoken language could be picked up on the street, as a child does her native language, but that the literate and educated register level of language could be learned only in a classroom, whether by a child or an adult. M. Varasteh, writing at the University of Michigan—where many of the textbooks for Middle Eastern languages would be developed in the 1950s and '60s—argued that the pendulum swings back and forth on a question like this and predicted it would take a while before zealous proponents of the oral method found their way to a medial position. According to Varasteh, presentation of grammar in the classroom, if agreeably done, was not only helpful but essential. The degree to which grammar, which should of course always be taught in streamlined and engaging ways, must feature in the classroom depended in part on whether the language being learned was an analytical or a synthetic language, and whether the language(s) already known by the language learner were analytical or synthetic.

United States Government and Nongovernment Programs

Until World War II, the US government did not much concern itself with making provisions for diplomatic personnel to learn foreign languages. This began to change during the war itself and especially as Cold War flashpoints heated up. The experience of the war also convinced American policy makers of the need to cultivate knowledge among government officials and private citizens that could inform US policy. This gradually led to the support and encouragement of the development of area studies programs in the universities. The Foreign Service Institute (FSI) was proposed in 1946 as "an in-service, graduate-level training institute for State Department employees and others in the Foreign Service." It began operating under Secretary of State George Marshall in 1947 with thirteen languages and a dozen or so professional and technology courses. The instructional orientation was intended to reflect "new global trends and the knowledge and skills required to practice effective diplomacy."[57] Under the auspices of M. J. Dresden (and associates), as revised in the School of Languages Foreign Service Institute, the US Department of State published *A Reader in Modern Persian* (New York: American Council of Learned Societies, 1958) in the Program in Oriental Languages Publications Series. Dresden had originally prepared these language-teaching materials with the assistance of Sadreddin Musavi of the University of Pennsylvania for

the United States Air Force Institute of Technology in 1952–53 with limited distribution within the military. In 1957, it was reproduced as a training document by the Foreign Service Institute. The preface of the volume offers the hope that the book could be "of some use to individuals wishing to study written Persian either on their own or with but little professional guidance." It recommends that in order to learn the script, students should consult Herbert H. Paper and Mohammad Ali Jazayery, *The Writing System of Modern Persian* (Washington, DC: American Council of Learned Societies, 1955). This book gives multiple forms of the material: English translation, typewritten Persian, handwritten Persian, and Romanized transcription. Paper, Jazayery, and Massud Farzan produced another set of books, similarly titled *A Modern Persian Reader*, at the University of Michigan in 1962 comprising three volumes: *Elementary* (as an aid to students with approximately two semesters of semi-intensive work), *Intermediate*, and *Advanced*.

A basic course in spoken Persian was created by the Foreign Service Institute in the 1950s that was meant to be taught by a tutor, though it seems to have been accompanied by an LP record or tape. It is ascribed to Serge Obolensky, Kambiz Yazdan Panah, and Fereidoun Khaje Nouri under the title *Persian Basic Course Units 1–12*.[58] It was republished by permission of the Foreign Service Institute. The book teaches the spoken Persian of Tehran, meaning the educated colloquial language. The conception of language learning in this book is highly communicative, with a focus on dialogues almost to the exclusion of reading (considered an impediment to quickly learning to speak the language). Howard E. Sollenberger, the Dean of the School of Languages and Area Studies of the Foreign Service Institute, wrote in a preface to the volume:

> This course is the first step toward learning the Persian language. All of the lessons are in the spoken language. They represent Persian as illustrated by conversations based on everyday situations. After a thorough grounding in pronunciation and in basic grammatical features, the student should learn the writing system of Persian. Since Persian is not written in the ordinary spoken style (just as English is not), another style of speech must be learned for reading. Some of the basic differences between the ordinary spoken style and the written or formal style are explained in this Unit and in Unit 2. Reading may be begun very early, but learning to read should not keep the student from the primary goal of learning the language. Progress in the language may be hindered by trying to read too soon.
>
> Some obvious facts concerning any language must be kept in mind by the learner. In the first place, there is no one correct way of speaking Persian or any other language. Minor differences of pronunciation,

form, vocabulary and usage are found among speakers of the standard language. The student should expect these and follow the usage of his tutor. If the tutor's normal speech varies from that in the book, his or her manner of speaking should be followed.[59]

This direct method depends almost entirely on imitation of the native-speaker instructor (or "tutor"): "The best way to learn any language is to listen to a native speaker of that language and then imitate exactly what he says. This course is designed to help you to imitate intelligently and efficiently."[60] After World War II, the Civil Service Commission was tasked to take an inventory of government employees and the various foreign languages they possessed as well as their level of expertise. There was no proficiency test available to do that in a systematic way; employees had simply been self-reporting or submitting the grades they had earned in language courses. Dr. Henry Lee Smith, the Dean of the Foreign Service Institute, began to develop a test that was administered in 1955 across languages to all Foreign Service officers. It turned out that fewer than half of them had language skills at a level deemed useful to the service. By 1958, a more sophisticated scale and systematized oral interview process, which was administered by testers trained by the FSI Testing Unit, produced more reliably standardized assessments, which continued to evolve, incorporating assessments of four discreet skills: speaking, listening, reading, and writing. This testing regimen was also used to assess the language level of Peace Corps volunteers in the 1960s. By 1985, the Interagency Language Roundtable (ILR) had developed and implemented official Government Language Skill Level Descriptions across government agencies. Informed by the ILR Skill Level Descriptions, the American Council on the Teaching of Foreign Languages (ACTFL), which was established in 1967, developed its own proficiency guidelines in the 1980s and trained individuals to conduct Oral Proficiency Interview (OPI) assessments according to ACTFL standards for each language.[61]

As Winfrid Lehmann writes in *Persian Studies in North America*, when Mohammad Ali Jazayery came to the United States in the 1950s, where he earned a PhD in linguistics at the University of Texas at Austin, "Persian was taught only irregularly, to supplement programs in Indo-Iranian or Indo-European studies," that is primarily within the constellation of ancient, or at least pre-Islamic studies.[62] In 1972, Jazayery surveyed the field of Persian instruction in the United States in an article for the *Middle East Studies Bulletin*. This article presents the results of an actual survey sent out to twenty-eight North American colleges and universities in June 1971 that were teaching Persian, collecting background information about the Persian program, including the program's objectives, degrees awarded, teaching staff, and teaching

methods and materials.⁶³ This indicated that about twenty institutions offered Persian instruction at some level, a number about five times greater than a decade prior. In addition to the Defense Language Institute, the Foreign Service Institute (which only served a small and select group of students), and the Peace Corps, these institutions were the University of Arizona; University of California, Berkeley; University of California, Los Angeles; University of Michigan; University of Minnesota; University of Maryland; University of Texas at Austin; University of Toronto; University of Utah; University of Washington; University of Chicago; Portland State University; SUNY Binghamton (but via self-instruction); New York University; University of Pennsylvania; Columbia University; Harvard University; Princeton University; and McGill University. Most of these programs had undergraduate classes, and some also offered more advanced graduate-level courses. About fifteen of the university programs made it possible to obtain one or more degrees in Persian (BA, MA, or PhD). Many also offered a Persian literature in translation survey course, which could draw larger enrollments and sometimes entice students to take a subsequent Persian language course.⁶⁴ More recently, beginning in 1990 the Department of Education created through the Title VI program a series of sixteen National Foreign Language Resource Centers (NFLRC) that, among many other languages, offer support for Persian acquisition. This is a congressionally funded program that supports universities that train individuals in foreign language competence and expertise by creating teaching and learning materials, professional development for language teachers, and research into foreign language learning.⁶⁵ Also nationally funded and established by the United States Department of State, the Critical Language Scholarship (CLS) program offers overseas foreign language instruction in the so-called critical languages, including Persian (taught in Tajikistan).⁶⁶ These programs are open to US university (undergraduate and graduate) students. The list of American universities now teaching Persian is extensive.

Some Challenges of Persian Language Pedagogy in the United States

Persian speakers number perhaps some eighty to ninety million persons worldwide. While this number is concentrated geographically in the three countries of Iran, Afghanistan, and Tajikistan, an estimated five million or more speakers comprise mostly Iranian and Afghan émigrés living in diaspora. The nomenclature used in the various countries to describe the respective national varieties of this language—*Fārsi* (فارسی) in Iran, *Darī* (دری) in Afghanistan, *Tojiki* (Тоҷикӣ) in Tajikistan—do tend to reflect broad

dialectical differences, though the dialectical borders do not neatly map to the national borders. Despite this synchronic variation in spoken Persian, literate speakers of Persian from across the entire transnational region where Persian is spoken are able to communicate without significant impediments (as would Scottish, American, and Australian speakers of English). As speech becomes more rural or less governed by the model of written Persian, the dialects eventually do become more difficult for cross-communication; many are recognized as separate Iranian languages (e.g., Gilaki, Lori, Tati) distinct from Persian. However, with the exception of Kurdish and Baluchi, these languages do not have their own written literature, and Persian remains the privileged mode of culture and communication.

The regional varieties of Persian are virtually negligible in the Persian literary register, particularly as far as written poetry is concerned—such that the Persian poetry of Iran, Afghanistan, and Tajikistan use the same idiom, although in the case of Tajikistan the script is different. The Soviet Republic of Tajikistan rejected the Arabic script in 1926 in favor first of the Roman script but then began using the Cyrillic script in 1941 as the sole means of writing Persian in that country. This orthographic divide, coupled with the imposed isolation of Tajikistan during the Soviet period, accelerated changes that were already taking place in the Persian of Central Asia in the premodern period, making supplemental training necessary for students who have mastered Persian as it is used in Afghanistan or Iran to proceed to reading Tajik Persian (the first comprehensive grammar of Tajik Persian written in English was published only in 2005).

The great majority of university courses in Persian adopt the educated speech of Tehran as the standard spoken variety of Persian for students to emulate. Of course, teachers of other languages whose speech communities are geographically dispersed over noncontiguous areas (such as English, Spanish, French, etc.) or are divided by two distinct alphabets and religious affiliations (e.g., Hindi-Urdu, Serbo-Croatian) must make a similar choice about which standard variety of the language to model in the classroom. However, since Persian, like Arabic, also exhibits a high degree of diglossia, Persian teachers must in addition to deciding on a regional standard also design their classes with specific objectives in mind about which register—modern conversational Persian or the modern written language—to take as their focus. These two very distinct registers of language exist side by side and are both encountered on a daily basis. Newspapers, books, and news broadcasts feature the literary register of Persian, but this is rarely used in normal social interactions, where conversational Persian is used.

As one might expect, literary or standard written Persian is the variety favored in all the educational systems of the Persian-speaking countries

themselves. Likewise, from the time when professorships of Persian were set up in European universities in the 1600s and 1700s, Persian was understood in the Western academy primarily as a classical literary language, a perception that did not really start changing until the late 1960s. Consequently, most instructional materials have been based upon the assumption that Persian learners needed to read the language but did not necessarily need to speak it. As proficiency-based language instruction methods became paradigmatic in the 1980s and '90s, the pedagogical problem diglossia presents for the language acquisition classroom has been receiving increased attention, and course materials are now being created with this in mind.

Though the spoken varieties of Persian have almost certainly existed alongside the written language for centuries, spoken Persian is nevertheless perceived as a degenerate form of the written classical language. As such, there has been strong resistance to representing spoken Persian in the Arabic script, making it somewhat awkward to develop instructional materials to teach the spoken variety. Although spoken Persian has recently appeared in the dialogue portions of a few novels (to represent characters' natural speech), and seems destined to eventually break into standard print formats, most existing grammars of spoken or colloquial Persian use the Latin alphabet to represent conversational Persian. This conversational register of language exhibits systematic differences of phonology, lexicon, inflection, and even syntax from the written (standard) register; they are distinct enough that students who learn only the written standard will not clearly follow even simple conversations. This problem is less pronounced in Tajik Persian, where Soviet ideology has promoted the idiom of the people, and where the short vowels are represented in the alphabet.

In addition to the challenge that diglossia poses in the classroom, the student population in most Persian language classrooms in the United States since the 1990s has consisted of a mixture of absolute novices in the language along with heritage learners (i.e., the children of Iranian émigrés) who, though typically unlettered or illiterate in Persian, already come to class with some degree of competence in colloquial Persian. The resulting inequality of levels in the first- and second-year classes of Persian can make it especially difficult to pace the class and create a workable dynamic. Often times, the nonheritage students can feel intimidated or frustrated at the pace of their progress, since it has not been possible for American universities to run overseas language programs in any Persian-speaking country since 1979 due to the political circumstances. Except for the program run by the American Institute of Iranian Studies and some individual initiatives, for the last two and a half decades Persian learners who happen to be US citizens have been mostly deprived of the opportunity to hone their spoken proficiency of Persian in an immersion setting. This, of course, complicates the Persian language teacher's task.

The situation of diglossia, the shift to spoken proficiency as a major goal in language teaching, the presence of large numbers of heritage learners in Persian language classrooms, and the comparatively small market for Persian language textbooks have all made it difficult to develop and keep in print excellent course materials. Persian teachers typically must mix and match materials from the existing textbooks and materials, and they must supplement these liberally with instructional materials they develop on their own (explanations, exercises, dialogues, tests, audio-visual content, etc.). Consequently, much is demanded of Persian teachers in building a curriculum and structuring courses to sustain programs at individual universities, often in conditions where they must also teach nonlanguage classes. Since many university programs underfund their language instruction programs or restrict the number of years an individual can be consecutively reappointed to a one-year position, there are often no guarantees that excellent language teachers will be rewarded or recognized for their labor. The American Association of Teachers of Persian is beginning to provide some support network, but there is not as much outside professional support for the teaching of Persian as there may be in the case of some languages.

Notes

1. See Firby, *European Travellers*; Rose, *Image of Zoroaster*; Stausberg, *Faszination Zarathushtra*; and also Stausberg, "Zoroaster vi."
2. Tholuck, *Ssufismus*.
3. Piemontese, "Emergence of Persian Grammar," citing p. 401; Casari, "Italy xi," 2. The adaptation is from Amir Khosrow's *Hašt behešt*, which was written about 1301, but probably also draws on his exemplar, Neẓāmi's *Haft paykar* (ca. 1197), and a later treatment by Hātefi called *Haft manẓar* (ca. 1492). On Cristoforo Armeno, see Melfi, *Dizionario Biografico degli Italiani*.
4. Windfuhr, *Persian Grammar*, 9.
5. Windfuhr, *Persian Grammar*, 10–12.
6. Ibraheem, *Grammar of the Persian Language*, ii and iv. Ibraheem (later spelled Ibrahim) learned English in the United Kingdom by reverse engineering the elementary grammars of Persian written by English Orientalists. After fourteen years of studying English, he worked to improve upon the "existing system of teaching" Persian, specifically so that "a more idiomatic and living character might be given," because the existing materials are "wholly insufficient for the purpose of imparting to the learner any competent knowledge of its *colloquial phraseology* and *idiom*, its *peculiar turns of expression*, and its *various refinements* and *niceties of diction*," since few of the European authors of the existing Persian grammars "have ever even visited the people whose language they undertake to teach; and none ... have possessed, or could have the means of acquiring, a complete mastery of it, in all its various uses, *literary, technical*, and *colloquial*" (iii). See also Fisher, "Persian Professor in Britain," who notes on 28 that the Haileybury administration was asked by Sir Gore Ouseley to hire Mirza Ibrahim. While the administration recognized his superior Persian, they found him less than perfectly suited to the task of training young Britons for service in India, since he knew no Hindustani and because his Persian, though it be of "utmost purity and

correctness," differed from the Persian taught at Haileybury and was not the Persian used in India.

7. Fleischer, *Grammatik*, clearly credits Ibrahim. It was republished in 1875. Windfuhr, *Persian Grammar*, 15, notes that a German translation of Ibrahim's Persian grammar had already been published even before Fleischer's reworking.

8. Jones, *Grammar of the Persian Language*, xvi–xvii, and the French edition, *Grammaire persanne*, xix–xx. Jones also credits Dr. Hunt, a professor at Oxford, for his assistance.

9. Jones, *Grammar of the Persian Language, with Considerable Additions*, xix. For the establishment of Mirzā Ṣāleḥ Širāzi as one of these Persian gentlemen upon whom Lee relies, see Green, "Madrasas of Oxford."

10. Following Lee's example, Garcin de Tassy set about revising the French version of Jones's Persian grammar. He had intended to write an entirely new grammar, but apparently felt that Lee sufficiently addressed the perceived deficiencies of Jones's work, and so he settled upon a translation of Lee's revision of Jones. De Tassy, however, explicitly adopts Indo-Persian pronunciation over contemporary Iranian pronunciation of Persian words, arguing that the pronunciation in India is closer to classical Persian, whereas in Persia, owing to the vulgarization of the language at the hands (or tongues) of various Turkic dynasties, pronunciation has been altered. For de Tassy, as for many Western scholars, the literary register of Persian that spread in Anatolia and in India (de Tassy extends its influence into Syria, Egypt, and North Africa as well, with Persian books being printed in Constantinople and at Bulāq in Egypt), and which is the language of learning of Muslims in India, far exceeded in importance the spoken language of Persia, thus neutralizing the need to consult native Persian speakers for purposes of language instruction. See de Tassy, *Grammaire Persane de Sir William Jones*, iii–iv.

11. It claims to be directed at third- and fourth-year students, presumably at the primary level. Ṣadiq, "Mirzā ʿAbd-al ʿAẓim Khān Qarib," gives these publication details: Mirzā ʿAbd al-ʿAẓim Qarib-e Garakāni, *Dastur-e zabān be oṣul-e alsene-ye maghrebzamin* (Grammar [of Persian] after the method of Western languages) (Tehran, 1911), as cited by Windfuhr, *Persian Grammar*, 22.

12. The Five Professors were ʿAbd al-ʿAẓim Qarib, Moḥammad Taqi Bahār (who had died before publication), Badiʿ al-Zamān Foruzānfar, Jalāl Homāʾi, and Rashid Yāsemi.

13. Windfuhr, *Persian Grammar*, 13–14.

14. See the list given in Windfuhr, *Persian Grammar*, 24, who speaks of "a virtually never-ending 'deluge' of grammars since 1800."

15. Windfuhr, *Persian Grammar*, 14.

16. Windfuhr, *Persian Grammar*, 14–15, with the quotation from Chodzko on p. 15: "Tout celà est intolerable dans une grammaire *persane* du XIXe siècle."

17. Windfuhr, *Persian Grammar*, 15–20. Lumsden, *Grammar of the Persian Language*; Horn, "Neupersische Schriftsprache"; Phillott, *Higher Persian Grammar*; and Jensen, *Neupersische Grammatik*.

18. Malcolm, *Armenians in America*, 51–57, and Mirak, *Torn Between Two Lands*, 35–36. See also the information on the Historic Jamestown website at https://historicjamestowne.org/september-2018/ and https://historicjamestowne.org/history/history-of-jamestown/first-settlers/. On sericulture and King James I's abiding interest in it along with his fond desire to have silk worms produced in Virginia, see Hatch, "Mulberry Trees and Silkworms." See especially 14, which indicates that in May

1621, Sir Edwin Sandys stated in the House of Commons in London that he hoped for as good silk in Virginia as was made in Persia.

19. Elphinstone, *Account of the Kingdom of Caubul*.
20. Harlan, *Memoir of India and Avghanistaun*. Keenly interested in flora and fauna and the characteristics of individuals, he rarely discusses language, though see Ross, *Central Asia*, 65.
21. Ross, *Central Asia*, 144.
22. United States Department of State, *Despatches from United States Ministers*.
23. Bozorgmehr, "From Iranian Studies to Studies of Iranians," quoting p. 5. For more in the Iranian American diaspora in the United States, see the chapter by Mehdi Bozorgmehr in this volume.
24. Bozorgmehr, "From Iranian Studies to Studies of Iranians," 9.
25. Bozorgmehr, "From Iranian Studies to Studies of Iranians," 6, citing the entry "Iranian" from the *Harvard Encyclopaedia of American Ethnic Groups* by John Lorentz and John Wertime.
26. Bozorgmehr, "From Iranian Studies to Studies of Iranians," 6.
27. United States Senate, Committee on Foreign Relations, *Select Chronology and Background Documents*, with a revised edition published in 1969, and a second revised edition in 1975.
28. Middle East Institute, *American Interests in the Middle East*, 15.
29. Middle East Institute, *American Interests in the Middle East*, 15.
30. Harold H. Saunders, Assistant Secretary for Near Eastern and South Asian Affairs, in a statement made before the Subcommittee on Europe and the Middle East of the House International Relations Committee, June 12, 1978. See Saunders, *Annual Review of U.S. Middle East Policy*, 7.
31. Middle East Institute, *American Interests in the Middle East*, 15–16.
32. Cannon, "Sir William Jones's Persian Linguistics," quoting p. 265.
33. From a 1784 piece by William Jones, "A Discourse on the Institution of a Society," cited in Cannon, "Sir William Jones's Persian Linguistics," 263.
34. al-Miṣrī, *al-Tuḥfa al-Fawziyya*.
35. al-Shawarby, *al-Qawāʾid al-asāsiyya li-dirāsat*.
36. Hammad, "From Orientalism to Khomeinism," especially 35–36 and the bibliography.
37. Hillenbrand, "Obituary," and Bosworth, "Professor L. P. Elwell-Sutton."
38. Meredith-Owens, review of *Elementary Persian Grammar*.
39. Lambton, *Persian Grammar*.
40. Glazer, review of *Persian Grammar*.
41. Additional exercises were added in a separate publication more than a decade later; see Lambton, *Key to Persian Grammar*.
42. Frye, review of *Persian Vocabulary*, quoting p. 249. Writing a review of it several years later, Levy, review of *Persian Vocabulary*, tries to find reasons to like it.
43. Frye, review of *Persian Vocabulary*, 251. Her student, Chelkowski, "In Memoriam," 142, explains that Lambton's *Vocabulary* was in part geared toward the needs for a modern lexicon that British diplomats or military officers in Iran might find useful, although we may note that by the time it came out in 1954, the British were being replaced by American technical advisers.
44. Morgan, "Ann K. S. Lambton," specifically p. 103; Chelkowski, "In Memoriam," 142.

45. Delshad, *Persische Chrestomathie*. See also Mörth, review of *Persische Chrestomathie*.

46. Julius Groos bought the rights to the conversational "Method Gaspey–Otto–Sauer" and commissioned a whole host of foreign language learning texts, which were published in Heidelberg from the late nineteenth through the early twentieth century. Groos maintained publishing and distribution outlets in London, New York, and Boston, which published not only conversation grammars with many exercises and drills for the learner to undertake but also a second "Key" volume for each language containing the answers to the exercises.

47. Hagopian, *Ottoman-Turkish Conversation-Grammar*, iv–v. The Anatolian College where Hagopian taught was established in 1886 and continued to function until World War I temporarily closed its doors. In 1924, after the population exchange with Greece, the college moved to Thessaloniki, where it continues to function (see https://anatolia.edu.gr/en/about/history). Already more than a decade earlier, a conversation grammar for Turkish following the Gaspey-Otto-Sauer method had been published in German; see Jehlitschka, *Türkische Konversations-Grammatik*.

48. Tisdall, *Simplified Grammar and Reading Book of the Panjabi Language*; Tisdall, *Simplified Grammar of the Gujarātī Language*. Tisdall later also published a grammar of Hindustani (the Hindi-Urdu language of north India) in the same conversational-grammar series with Groos in 1911, so we may suspect that the Persian grammar he authored for the same series must have sold at least tolerably well during the intervening years.

49. Tisdall, *Modern Persian Conversation-Grammar*, iii.

50. Though the remarks he gives in Tisdall, *Modern Persian Conversation-Grammar*, iv n1, do not increase one's confidence in his intimacy with the modern idiomatic spoken Persian of Iran.

51. Apparently by this date, Julius Groos's proprietary rights for the Gaspey-Otto-Sauer method had lapsed, and other publishers could take on the book. Frederick Ungar ran a publishing company from 105 E. 24th Street in New York City along with Leo Herland in the Foreign Language Department, publishing nonfiction works, reference books, bilingual dictionaries, technical or college textbooks, and foreign language texts. P. D. and Ione Perkins distributed books "from Near, Middle and Far East, and Pacific Islands" from PO Box 167 in South Pasadena, California, along with a "Display Room" at 1603 Hope Street in South Pasadena.

52. Hawker, *Simple Colloquial Persian*.

53. Minorsky, review of *Simple Colloquial Persian*, 261. The work that Minorsky recommends, seemingly above all others, is Rosen, *Modern Persian Colloquial Grammar*.

54. Hawker, *Written and Spoken Persian*.

55. He singles out Hodge, *Spoken Persian*, and Obolensky, Panah, and Nouri, *Persian Basic Course*.

56. Windfuhr, *Persian Grammar*, 16–17.

57. From the "FSI History" webpage at https://www.state.gov/the-foreign-service-institutes-history/.

58. Obolensky, Panah, and Nouri, *Persian Basic Course*.

59. Sollenberger, "Introduction," 1.3.

60. Sollenberger, "Introduction," 1.3.

61. See the "History of the ILR Scale" webpage at the Interagency Language Roundtable webpage: https://www.govtilr.org/Skills/IRL%20Scale%20History.htm.

62. Lehmann, "Foreword," xi.
63. Jazayery, "State of the Art."
64. Jazayery, "State of the Art," 11.
65. See the NFLRC webpage: http://www.nflrc.org/#find.
66. See https://clscholarship.org/ and also https://en.wikipedia.org/wiki/Critical_Language_Scholarship_Program.

Bibliography

Bosworth, C. Edmund. "Professor L. P. Elwell-Sutton, B.A." *Iran* 23 (1985): iii–iv.
Bozorgmehr, Mehdi. "From Iranian Studies to Studies of Iranians in the United States." *Iranian Studies* 31.1 (1998): 5–30.
Cannon, Garland. "Sir William Jones's Persian Linguistics." *Journal of the American Oriental Society* 78.4 (1958): 262–73.
Casari, Mario. "Italy xi. Translations of Persian Works into Italian." *Encyclopaedia Iranica*. Last updated April 5, 2012. http://www.iranicaonline.org/articles/italy-xi-translations-of-persian-works-into-italian-2.
Chelkowski, Peter. "In Memoriam: Professor Ann K. S. Lambton (8 February 1912–19 July 2008)." *Iranian Studies* 42.1 (2009): 139–43.
Delshad, Farshid. *Persische Chrestomathie klassischer und moderner Prosawerke vom 10. bis zum 21. Jahrhundert. Mit Autorenbiographien, Annotationen und Glossar*. Wiesbaden: Harrassowitz, 2007.
De Tassy, Garcin, ed. and trans. *Grammaire Persane de Sir William Jones, seconde édition française, revue, corrigée et augmentée*. Paris: L'Imprimerie Royale, 1845.
Elphinstone, Mountstuart. *An Account of the Kingdom of Caubul and Its Dependencies in Persia, Tartary and India*. London: Longman, Hurst, Rees, Orme, Brown & Murray, 1815.
Firby, Nora Kathleen. *European Travellers and Their Perceptions of Zoroastrians in the 17th and 18th Centuries*. Berlin: Reimer, 1988.
Fisher, Michael H. "Persian Professor in Britain: Mirza Muhammad Ibrahim at the East India Company's College, 1826–1844." *Comparative Studies of South Asia, Africa and the Middle East* 21.1–2 (2001): 24–32.
Fleischer, H. L. *Grammatik der lebenden Persischen Sprache*. Leipzig: Brockhaus & Avenarius, 1847.
Forbes, Duncan. *A Grammar of the Persian Language: To Which Is Added, A Selection of Easy Extracts for Reading*. London: Allen, 1876.
Frye, Richard. Review of *Persian Vocabulary*, by A. K. S. Lambton. *Harvard Journal of Asiatic Studies* 18.1–2 (1955): 249–51.
Glazer, Sidney. Review of *Persian Grammar*, by A. K. S. Lambton. *Middle East Journal* 8.3 (1954): 351–52.
Green, Nile. "The Madrasas of Oxford: Iranian Interactions with the English Universities in the Early Nineteenth Century." *Iranian Studies* 44.6 (2011): 807–29.
Hagopian, V. H. *Ottoman-Turkish Conversation-Grammar: A Practical Method of Learning the Ottoman-Turkish Language*. Heidelberg: Groos, 1907.
Haidari, Amor Abbas. *A Modern Persian Reader*. London: University of London School of Oriental and African Studies, 1975.
Hammad, Hannan. "From Orientalism to Khomeinism: A Century of Persian Studies in Egypt." *Alif: Journal of Comparative Poetics* 35 (2015): 32–51.
Harlan, Josiah. *A Memoir of India and Avghanistaun*. Philadelphia: Dobson, 1942.

Hatch, Charles E., Jr. "Mulberry Trees and Silkworms: Sericulture in Early Virginia." *Virginia Magazine of History and Biography* 65.1 (1957): 3–61.
Hawker, C. L. *Simple Colloquial Persian*. 5th ed. London: Longmans, Green, 1937.
Hawker, E. M. N. *Written and Spoken Persian*. London: Longmans, Green, 1941.
Hillenbrand, Carole. "Obituary: Professor L. P. Elwell-Sutton (1912–84)." *British Society for Middle Eastern Studies Bulletin* 11.2 (1984): 212–13.
Hodge, C. T. *Spoken Persian*. Washington, DC: Modern Language Association of America, 1960.
Horn, Paul. "Neupersische Schriftsprache." Pages 1–200 in vol. 1 of *Grundriss der Iranischen Philologie*. Edited by W. Geiger and E. Kuhn. Strassburg: Trübner, 1898.
Ibraheem, Meerza Mohammad. *A Grammar of the Persian Language: To Which Are Subjoined Several Dialogues; With an Alphabetical List of the English and Persian Terms of Grammar, and an Appendix on the Use of Arabic Words*. London: Allen, 1841.
Jazayery, M. A. "State of the Art XI: Persian Language Instruction." *Middle East Studies Association Bulletin* 6.1 (1972): 9–29.
Jehlitschka, Henry. *Türkische Konversations-Grammatik: Mit einem Anhang von Schrifttafeln in türkischer Kursivschrift nebst Anleitung*. Heidelberg: Groos, 1895.
Jensen, Hans. *Neupersische Grammatik, mit Berücksichtigung der historischen Entwicklung*. Indogermanische Bibliothek 1.1.22. Heidelberg: Winter, 1931.
Jones, William. *Grammaire persanne*. London: Cadell, 1772.
———. *A Grammar of the Persian Language*. London: Richardson, 1771.
———. *A Grammar of the Persian Language, with Considerable Additions and Improvements*. 9th ed. Edited by Samuel Lee. London: Nicol, 1828.
Kamshad, Hassan. *A Modern Persian Prose Reader*. Cambridge: Cambridge University Press, 1968.
Lambton, A. K. S. *Key to Persian Grammar, with Additional Exercises*. Cambridge: Cambridge University Press, 1967.
———. *Persian Grammar*. New York: Cambridge University Press, 1953.
Lehmann, W. "Foreword." Pages xi–xiv in *Persian Studies in North America: Studies in Honor of Mohammad Ali Jazayery*. Edited by Mehdi Marashi. Bethesda, MD: Iranbooks, 1994.
Levy, Reuben. Review of *Persian Vocabulary*, by A. K. S. Lambton. *Bulletin of the School of Oriental and African Studies* 25 (1962): 413–14.
Lumsden, Matthew. *Grammar of the Persian Language: Comprising a Portion of the Elements of Arabic Inflexion, Together with Some Observations on the Structure of Either Language Considered with Reference to the Principles of General Grammar*. 2 vols. Calcutta: Watley, 1810.
Malcolm, M. Vartan. *The Armenians in America*. Boston: Pilgrim Press, 1919.
Melfi, Eduardo. *Dizionario Biografico degli Italiani* 31 (1985). http://www.treccani.it/enciclopedia/cristoforo-armeno_(Dizionario-Biografico)/.
Meredith-Owens, G. M. Review of *Elementary Persian Grammar*, by L. P. Elwell-Sutton. *Journal of the Royal Asiatic Society of Great Britain and Ireland* 3.4 (1964): 141–42.
Middle East Institute. *American Interests in the Middle East*. Washington, DC: Middle East Institute, 1969.
Minorsky, Vladimir. Review of *Simple Colloquial Persian*, by C. L. Hawker. *Bulletin of the School of Oriental Studies* 10.1 (1939): 261–63.

Mirak, Robert. *Torn Between Two Lands: Armenians in America, 1890 to World War I.* Cambridge: Harvard University Press, 1983.

Miṣrī, Zaydān Badrān al-. *Al-Tuḥfa al-Fawziyya fī taʿālīm al Fārisiyya.* Cairo: Dār al-Maʿārif, 1938.

Morgan, David. "Ann K. S. Lambton (1912—2008) and Persian Studies." *Journal of the Royal Asiatic Society* 21.1 (2011): 99–109.

Mörth, Karlheinz. Review of *Persische Chrestomathie klassischer und moderner Prosawerke vom 10. bis zum 21. Jahrhundert. Mit Autorenbiographien, Annotationen und Glossar,* by Farshid Delshad. *Wiener Zeitschrift für die Kunde des Morgenlandes* 99 (2009): 477–80.

Obolensky, Serge, Kambiz Yazdan Panah, and Fereidoun Khaje Nouri. *Persian Basic Course Units 1–12.* Washington, DC: Modern Language Association of America, 1963.

Phillott, Douglas Craven. *Higher Persian Grammar for the Use of the Calcutta University, Showing Differences Between Afghan and Modern Persian with Notes on Rhetoric.* Calcutta: University Press, 1919.

Piemontese, Angelo Michele. "The Emergence of Persian Grammar and Lexicography in Rome." *Rivista degli studi orientali* 83.1–4 (2010): 399–415.

Qarib, Abd al-ʿAẓim, Moḥammad Taqi Bahār, Badiʿ al-Zamān Foruzānfar, Jalāl Homāʾi, and Rashid Yāsemi. *Dastur-e zabān-i Fārsi: Barā-ye sāl-e avval va dovvom-e dabirestān-hā.* Tehran: Ketābkhāna-ye Markazi, 1955.

Rose, Jenny. *The Image of Zoroaster. The Persian Mage Through European Eyes.* New York: Bibliotheca Persica, 2000.

Rosen, F. *Modern Persian Colloquial Grammar.* London: Luzac, 1898.

Ross, Frank E., ed. *Central Asia: Personal Narrative General Josiah Harlan, 1823–41.* London: Luzac, 1939.

Sadiq, ʿIsā. "Mirzā ʿAbd-al ʿAẓim Khän Qarib va āghāz-e tadris-e zabän-e Färsi dar Dār al-Fonun." *Majalla-ye Dāneškada-ye Adabiyāt-e Tehran* 13.4 (1966): 17–20.

Salemann, Carl and Valentin Shukovski. *Persische Grammatik mit Literatur, Chrestomathie und Glossar.* Berlin: Eichler, 1889.

Saunders, Harold H. *Annual Review of U.S. Middle East Policy, June 12, 1978.* Washington, DC: United States Department of State, 1978.

Shawarby, Ibrahim Amin al-. *Al-Qawāʾid al-asāsiyya li-dirāsat al-Fārisiyya.* Cairo: Maktabat al-Anglo al-Miṣriyya, 1943.

Sollenberger, Howard E. "Introduction: The Persian Language." Pages 1.1–1.6 in Serge Oblensky, Kambiz Yazdan Panah, and Fereidoun Khaje Nouri, *Persian Basic Course Units 1–12.* Washington, DC: Center for Applied Linguistics of the Modern Language Association of America, 1963.

Stausberg, Michael. *Faszination Zarathushtra: Zoroaster und die europäische Religionsgeschichte der Frühen Neuzeit.* 2 vols. Berlin: de Gruyter, 1998.

———. "Zoroaster vi. As Perceived in Western Europe." *Encyclopaedia Iranica.* Last updated July 20, 2005. http://www.iranicaonline.org/articles/zoroaster-perceived-in-europe.

Tholuck, F. A. D. *Ssufismus sive Theosophia Persarum Pantheistica quam e mss. Bibliothecae Regiae Berolinensis Persicis, Arabicis, Turcisis.* Berlin: Duemmleri, 1821.

Tisdall, W. St. Clair. *Modern Persian Conversation-Grammar, with New Reading Lesson and Persian Letters Selected by Zia Missaghi.* New York: Ungar, 1959.

———. *Modern Persian Conversation-Grammar: With Reading Lessons, English-Persian Vocabulary and Persian Letters; Method Gaspey-Otto-Sauer*. Heidelberg: Groos, 1902.

———. *A Simplified Grammar and Reading Book of the Panjabi Language*. London: Trübner, 1889.

———. *A Simplified Grammar of the Gujarātī Language*. London: Trübner, 1892.

United States Department of State. *Despatches from United States Ministers to Persia, 1883–1906*. No. 18. Washington, DC: National Archives and Records Service, General Services Administration, 1961.

United States Senate, Committee on Foreign Relations. *A Select Chronology and Background Documents Relating to the Middle East*. Washington, DC: United States Government Printing Office, 1967.

Windfuhr, Gernot. *Persian Grammar: History and State of Its Study*. The Hague: Mouton, 1979.

CHAPTER 17

Persianate Islamic Studies in American Universities

Carl W. Ernst

ISLAMIC STUDIES AS AN ACADEMIC FIELD has been pursued within American universities for over a century, a disciple initially pursued within the framework of Orientalism and the philological study of Arabic texts. That tendency, still visible in departments of Near Eastern Languages and Civilizations, has been balanced since the 1950s by the more contemporary focus of area studies as found in centers for Middle East studies, many of them supported by the US Department of Education's Title VI Program. More recently, Islamic studies has increasingly found a place in academic departments of religious studies, which are extremely widespread in American colleges and universities.[1] Islamic studies as a field has outgrown its Orientalist roots and has embraced interdisciplinary perspectives on the humanities and social sciences to communicate its conclusions more widely.

How does Iran relate to the study of Islam? Given the prominence of the 1978–79 Iranian Revolution and the establishment of the Islamic Republic of Iran, it may seem obvious today that Iran must play a key role in Islamic studies. But that is not always the case. In the approximately two dozen American PhD programs in religious studies that feature the study of Islam, only a couple have a major emphasis on Persian language or Islam in Iranian cultural regions; it is far more common for universities to focus exclusively on Arabic as the *sine qua non* of the study of Islam.[2] Indeed, from the perspective of religious studies it could be problematic to assert that there is a field of Iranian Islamic studies. Iran, for one thing, is not an analytic category but a cultural symbol, which has been powerfully deployed in nationalist politics, particularly since the 1930s, although with quite different emphases under the Pahlavi dynasty and the Islamic Republic. While it may be the case that modern nation-states have been very effective in defining religion on their own terms (and contemporary Iran is no exception to this rule), adopting such a nationalist perspective would amount to essentialism by asserting the existence of an unchanging Iranian identity in all historical periods. From another perspective, Islam has been excluded from the purview of "Iranian religions" by scholars of ancient

Iran, who restrict the category to ancient Iranian religions, especially Zoroastrianism.[3] From the 1960s through the 1980s, data indicates that Islamic studies (and religious studies in general) was the focus of fewer than 5 percent of American scholars in the field of Iranian Studies.[4] And since the Iranian Revolution, modern scholarship on Iran has been disproportionately focused on contemporary history to the exclusion of premodern Islamic culture in Persia, even while the field of Iranian studies has seen a relative decline in strength overall.

Nevertheless, there are reasons to say that American scholars have made important contributions to Islamic studies in relation to the larger sphere of what Marshall Hodgson (d. 1968) called "Persianate" culture. Hodgson, a professor of Islamic studies and a world historian at the University of Chicago in the 1950s and '60s, introduced this neologism, a parallel to his famous coinage "Islamicate," to describe the "Persianate flowering" that took place in the Safavid, Mughal, and Ottoman empires.[5] He also offered strong readings of Persianate culture throughout the earlier periods of Islamic civilization that still repay attention. Hodgson's early research included a brilliant study of Isma'ili Shi'ism, and his comprehensive history of Islamic civilization, *The Venture of Islam*, set a benchmark for the understanding of the role of Persian language and culture in terms of the Islamic framework.[6] It was a tribute to Hodgson that the Association for the Study of Persianate Societies, with its attendant *Journal of Persianate Studies*, was established as an international academic organization in 2002, drawing attention to Persianate culture not only in Iran but also in the Ottoman, Central Asian, and South Asian regions.[7] Another pioneer in this regard was the well-known American specialist in Iranian Studies, Richard Frye, who was appointed Professor of Iranian History and Languages at Harvard University in 1948. In his early signature publication *The Heritage of Persia*, Frye emphasized the critical role of Iran for early Islamic history by speaking, somewhat counterintuitively, of the "Persian conquest of Islam."[8] Frye also spoke of the "Iranicization of Islam" as a recognizable historical process, which he understood from a historical and philological perspective.[9] In particular, Frye drew attention to the importance of the city chronicles of Central Asia and Khurasan, which were essentially local histories of Muslim scholars, as important resources for understanding the cultural deployment of Islam in Iranian regions.

At roughly the same time, the work of French scholar Henry Corbin (1903–78) began to have an impact on American scholars, including Hodgson. Corbin seems to have been more influential in America than other Europeans, such as the Italian Iranist Alessandro Bausani.[10] Drawn chiefly by his interest in philosophy, Corbin had become attracted to the illuminationist philosopher Suhrawardi (d. 1191), whose Arabic and Persian writings he introduced to

European audiences. In an extensive series of publications, including numerous text editions published in the Bibliothèque Iranienne series for the Institut Français de Recherche en Iran, Corbin explored numerous examples of esoteric and mystical thought, mostly from Iranian Sufi and Shi'i traditions; he cited these materials as incontrovertible evidence that Islam had to be understood from more than an Arabocentric perspective.[11] Indeed, he insisted that there were deep cultural continuities that connected the Mazdean legacy of ancient Persia with Iranian Islam, though Corbin made this argument as a phenomenologist rather than as a historian.[12] In North America, a project headed by Charles Adams at McGill University aimed at producing an English translation of Corbin's four-volume anthology *En Islam iranien*, but it was never completed. In addition, Iranian-American scholar Seyyed Hossein Nasr, a specialist in Islamic philosophy, comparative religion, and the history of science, collaborated with Corbin in publications and in lectures at the University of Tehran over a number of years before returning to the United States after the 1979 Revolution.[13] Despite the popularity of Corbin's writings in English translation, his work also drew criticism. One such expression was a 1980 critical review by Hamid Algar, a British-born scholar who taught at the University of California, Berkeley. Although Algar recognized Corbin's contributions, he faulted him for ignoring Islamic law and theology, and he dismissed Corbin's interest in ancient Persia, flatly declaring, "There is no substantial pre-Islamic substratum in the mainstream religious history of Islamic Iran."[14] Algar also derided Corbin's fascination with Suhrawardi (along with Louis Massignon's obsession with the Sufi martyr Hallaj) as an eccentric preoccupation with a figure whose marginality was demonstrated by the fact that he was executed—an assumption that rings oddly in light of the history of martyrdom in Shi'ism. Some years later, another American scholar, Stephen Wasserstrom, criticized Corbin in a study of modern esoteric interpretations of religion by scholars including Gershom Scholem and Mircea Eliade. Wasserstrom accused Corbin of fascist and anti-Semitic tendencies and, going farther than Algar, charged him with complicity in support of the regime of Mohammed Reza Shah, whose "Aryan" policies would have benefited from Corbin's theories regarding ancient Iran.[15] Corbin's defenders have pointed out serious flaws and distortions in the respective critiques of Algar and Wasserstrom.[16] From the viewpoint of Islamic studies, it is striking that the debate over Corbin is colored both by the question of the Persian character of Islam (as an a priori given rather than a historical conclusion) and by the politics of modern Iranian nationalism, both before and after the Iranian Revolution.

In light of this dispute, it is instructive to see that Algar maintained the same argument in his erudite and detailed *Encyclopaedia Iranica* article (completed in 2006) on "Islam in Iran," which is divided into three sections: (1) the advent

of Islam in Iran, (2) the Mongol-Timurid period, and (3) Shi'ism in Iran since the Safavids.[17] Here again, Algar specifically rejects Corbin's concept of "Iranian Islam" at any time before the Safavid era. His article generally treats the Iranian Revolution of 1978–79 as the genuine religious expression of the will of the Iranian people, and it features Ayatollah Ruhollah Khomeini prominently as a protagonist (Algar has translated Khomeini's writings into English).[18] The prescriptive tone of the article, which treats established Twelver Shi'ism as authoritative, is evident from its regular description of competing religious movements as "fantastic and decadent" (Horufis), "deviant" (early Safavids), and "marginal" (Zaydis, Isma'ilis, Naqshbandis). Indeed, it appears that the editors of the *Encyclopaedia Iranica* felt the need for more diverse perspectives on this topic, since they have now commissioned an additional fourteen sections of "Islam in Iran" under two separate headings: "Messianism and Millenarianism in Islam" and "Islamic Political Movements."[19] These added materials both address sectarian manifestations of Islam (including some that drew upon pre-Islamic Persia) and problematize nationalistic framings of religion.

In a larger historical sense, the Iranian cultural region has never been separate from the prophetic and scriptural religions of the Near East. It was for this reason that Hodgson referred to Irano-Semitic cultural traditions. This complex interaction clearly continued in Islamic Iran, as recent publications by American scholars have shown. Travis Zadeh has demonstrated the pervasive role the use of the New Persian language (in Arabic script) played in the dissemination of Islamic ritual praxis, religious conversion, and exegesis of the Qur'an.[20] Fine-grained historical research has demonstrated how Zoroastrian and Islamic apocalyptic literatures mutually reinforced each other using the language of prophecy. As Jamsheed Choksy has argued, in the conversion of Iran to Islam, "the majority of Zoroastrians did not simply assimilate Islamic mores; upon entering the Muslim community, they embraced and then modified both Islam and its behavioral norms."[21] Likewise, Richard Bulliet has demonstrated, through close analysis of early biographies of Iranian Muslim scholars, how "Iran played a unique and crucial role in the origination and diffusion of institutions that eventually contributed to the centripetal tendency of later Islamic civilization."[22] In an important study of the Iranian messianic movements that led up to the establishment of the Safavid dynasty, Kathryn Babayan has persuasively argued for the persistence of Persianate themes of cyclical time and divine incarnation in the millenarian tendencies that were dismissed as heretical exaggerators (*ghulat*) by the guardians of both Sunni and Shi'i authority. What is especially remarkable is the way in which the triumphal Safavid clerical establishment erased as far as possible the historical traces of the Qizilbash and Nuqtavi cosmologies and histories, which

had persistently sought to return to a pre-Islamic Iranian past. "Ironically," she observes, "just as the Safavis attempt a rationalization of religion, they come to reject the very language with which they led a successful revolution in early modern Iran."[23] In short, despite the theological and ideological claims of current orthodoxies, there are good historical reasons for regarding Persianate Islamic studies as a coherent subject for investigation.

With these preliminary remarks in mind, the remainder of this essay will be devoted to a brief sketch of some of the principal monographic contributions of American scholarship to Persianate Islamic studies, emphasizing religious studies approaches with additional attention to historical studies (the study of Islamic philosophy is beyond the scope of this sketch). This body of scholarship can be loosely divided into the following categories: (1) Islamic religious scholars in general, (2) Shi'ism, (3) Sufism, (4) Persianate sectarian movements, and (5) Islam in contemporary Iran, including the 1978–79 Iranian Revolution. This classification reflects the scholarly literature that is currently available on Persianate Islam, although one can imagine expanding the scope of research to other topics, particularly in the social sciences. It is unfortunate that we lack a significant body of ethnographic study of religious practice in Iran, because of the political barriers that prevent American anthropologists from conducting research there; the studies of women's religious practice in prerevolutionary Shiraz by Anne Betteridge of the University of Arizona provide an example of the possibilities.[24] Other valuable examples of ethnographies dealing with gender are Shahla Haeri's work on temporary marriage and Niloofar Haeri's study of women and prayer.[25] Likewise, there are excellent prospects for developing the topic of religion and visual culture in Persianate Islam, as one can see in the perceptive studies by Christiane Gruber of Indiana University, focusing on illustrated versions of the Prophet Muhammad's ascension narratives as well as on postrevolutionary poster art.[26] In terms of scope, while one could make a case for looking more broadly at Persianate Islam in South Asia (or even the Ottoman Empire), for reasons of space such efforts must be deferred to another occasion. Nevertheless, the prominence of Iran in all these themes of Islamic religion underlines how challenging it is to separate Iran from its historical connections with other regions.

Islamic Religious Scholars and the State

It is widely recognized that religious scholars (*'ulamā'*) have played an important institutional role in Islamic intellectual and religious history. They have worked at times in collaboration with political power and at other times in opposition. Giving a location to institutions of Islamic religious scholarship

inevitably raises the question of the relationship of religious scholars to the state. Mention has already been made of Richard Bulliet's 1994 essay on Iran in the formation of early Islamic institutions. Bulliet, a professor of history at Columbia University since 1978, had earlier written an important analysis of biographies of Iranian Muslim scholars in the well-known study entitled *The Patricians of Nishapur* as well as a provocative interpretation of the process of conversion to Islam in Iran.[27] Bulliet's analysis explored the roles of elite families in Nishapur who supplied leading jurists for the competing Hanafi and Shafi'i legal schools, which came to dominate the politics of the region.

Other social and intellectual historians also explored the landscape of early Islamic religious history. Roy Mottahedeh of Harvard University made an important contribution to the understanding of the Buyid period in his *Loyalty and Leadership in an Early Islamic Society*, which explored the dynamics of social cohesion in postcaliphal Iran and Iraq, including some insightful comments on leadership among religious scholars.[28] Mottahedeh also wrote an evocative depiction of the religious and intellectual life of Iran over the centuries in *The Mantle of the Prophet*.[29] This volume engagingly presented two different intertwined narratives in alternating chapters: the first narrative depicted the life of a contemporary Iranian religious intellectual (known under the pseudonym 'Ali Hashemi) on the brink of the Iranian Revolution, while the second provided skillful historical summations of the major philosophical and religious tendencies that have been prevalent in Iran over the last millennium. The result was a highly readable presentation that was successful precisely because it interwove the personal biography of a believable Iranian scholar with the intellectual and religious history and the contemporary reality of Iran.

Several decades later, Omid Safi contributed an important study of Islamic religious scholars during the Saljuq era, describing the creation of religious orthodoxy as the imposition of political loyalty. In the process, Safi explores in detail the religious and political perspectives of al-Ghazali and the nascent Sufi movement, as exemplified by Abu Sa'id ibn Abi al-Khayr and 'Ayn al-Qudat Hamadani, at a time when Persian was emerging as a potent language of scholarship and poetry alongside Arabic.[30]

Shi'ism

Shi'ism, the movement or faction within Islam advocating the religious authority of 'Ali ibn Abi Talib and his descendants, has played a dramatic part in Islamic history, though it remains a minority tradition today (except in Iraq, Iran, and Lebanon, where Shi'is constitute a majority of Muslims). Within the

field of Islamic studies, it is probably safe to say that Shi'ism has been relatively downplayed, in part because early Orientalists tended to adopt the perspective of their mostly Sunni sources, according to which Shi'ism was to be rejected as a heresy. The remarks that follow refer to Twelver or Imami Shi'ism, on which a significant amount of research has been done by American scholars.

In terms of locations, it might be observed that Shi'ism is not firmly connected to Iran, since the majority of the Imams of Twelver Shi'ism are commemorated by shrines that lie outside of Iran, and significant Shi'i populations reside elsewhere, for instance in Lebanon and South Asia. But it is also the case that important early narratives connected the Shi'i Imams to Persia, by reporting the marriage of Shahbanu, daughter of the last Sasanian shah, to Imam Husayn. And while only one of the Imams is represented by a tomb within the boundaries of modern Iran (the eighth Imam Reza in Mashhad), countless other Iranian shrines commemorate the descendants of the Imams. Numerous messianic movements over the centuries have drawn upon both the symbolism of ancient Persia and the charisma of Shi'i Islam. And since the triumph of the Safavid movement in the early sixteenth century, Shi'ism has been more or less enforced as the state religion of Persia to the present day. Therefore, it is no surprise to see significant scholarly effort aimed at understanding the dynamics of Iranian Shi'ism, although it is striking to see how the impact of the recent Iranian Revolution tends to color the perception of earlier phases of Persian Shi'ism. A useful corrective to those particular Orientalist blinkers is the comparative approach to sacred kingship, as demonstrated by A. Azfar Moin in his juxtaposition of messianic visions of empire in Mughal India and Safavid Iran.[31]

Some American scholars have devoted their attention to the formative period of Shi'ism, when Iran was host to an important center of Shi'i scholarship in the city of Qum. Hossein Modarressi, an Iranian scholar who taught for many years at Princeton University, explored the debates over the authority of the Imams, particularly in the crucial period following the death of the eleventh Imam, Hasan al-'Askari, in 874.[32] Likewise, Andrew Newman (trained at the University of California, Los Angeles though now teaching at the University of Edinburgh) investigated the formation of the Shi'i canonical collections of the hadith sayings of the Imams.[33] And Maria Dakake has focused on the development of religious identity and spiritual charisma in early Shi'ism.[34]

Other scholars have studied the history of Shi'ism in Iran in later historical periods and over the long term. Such is the case with sociologist Saïd Amir Arjomand of the State University of New York at Stony Brook. His classic synthesis, *The Shadow of God and the Hidden Imam*, provides a persuasive and comprehensive overview of the interplay of religion and politics and the establishment of Shi'ism, particularly during the Safavid and Qajar periods.[35]

Michel Mazzaoui, who taught history at the University of Utah, has examined the process by which the Safavid movement came to power in Iran.[36] Abbas Amanat of Yale University has drawn attention in a series of articles to the long-term significance of apocalyptic and millennial thought in Iranian Shiʻism.[37] Hamid Algar's earlier contribution was his 1969 analysis of the role of Shiʻi religious scholars in their relationship to the Qajar state, particularly during the nineteenth century.[38] Juan Cole, Professor of History at the University of Michigan, has addressed the location of Shiʻism in terms of its early modern national and cultural contexts, ranging from India to Iraq, Iran, and Lebanon. His scholarship has been particularly rich in drawing upon the writings of Shiʻi scholars of various theological schools, and in establishing the relationship between North Indian Shiʻism and the traditional scholarly centers in Iran and Iraq.[39] Another recent synthesis comes from the pen of Hamid Dabashi, Professor of Iranian Studies and Comparative Literature at Columbia University, who makes the argument that (particularly in Iran) Shiʻism "is morally triumphant when it is politically defiant, and that it morally fails when it politically succeeds."[40]

Sufism

The study of Sufism or Islamic mysticism has been well developed as a subfield in Islamic Studies, having played a significant role in early Orientalist approaches to Islam since the late eighteenth century. The importance of Sufi studies as a field of scholarly research was recently recognized by the formation of the Islamic Mysticism Group in 2003 as an academic unit of the American Academy of Religion. Among scholars based in the United States, perhaps the most influential was German-born Islamicist Annemarie Schimmel (d. 2003), who taught at Harvard University for many years. Her *Mystical Dimensions of Islam* has been a standard handbook on the subject for decades.[41] Although she had broad interests in Arabic, Turkish, and South Asian sources of Sufism, she also had a special focus on Sufism in Persian poetry, particularly the poetry of Rumi.[42] A number of American scholars have followed in Schimmel's footsteps in exploring the Persian Sufi tradition, often through the production of new translations of Persian Sufi texts. William Chittick, a professor at the State University of New York at Stony Brook, prepared an anthology of translations from Rumi that is organized by the subject as well as translations of the mystical writings of Fakhr al-Din ʻIraqi, ʻAbd al-Rahman Jami, and Shams-i Tabrizi.[43] Franklin D. Lewis, who taught at the University of Chicago, wrote a comprehensive biography of Rumi and his Sufi circle and also translated selections of Rumi's poetry as well as a hagiography devoted to the early

Sufi saint, Ahmad-i Jam.[44] Rumi's poetry is the subject of an important literary analysis by Fatemeh Keshavarz of the University of Maryland, and his teachings on prophecy have been studied by John Renard of St. Louis University.[45] Paul Losensky of Indiana University has contributed an important translation of the classic Persian collection of Sufi biographies by 'Attar.[46] Also noteworthy for their Sufi content are the elegant literary translations of the poetry of 'Attar and Hafiz by Dick Davis, a British-born poet who served as a professor of Persian at Ohio State University.[47] Several introductory works and anthologies include useful materials on Persian Sufism. These include introductions to Sufism by William Chittick and myself along with a series of textbooks and anthologies on Islamic spirituality and sainthood compiled by John Renard.[48]

Persian Sufism received special emphasis in a series of international conferences on the subject that resulted in the publication of a three-volume set entitled *The Heritage of Sufism*, which was edited by Leonard Lewisohn, an American scholar who taught at the University of Exeter.[49] This collection of richly researched articles, many by American scholars, opens up new perspectives on key topics and important figures in the history of Persian Sufism, although Lewisohn in introducing these studies enthusiastically overstated the historic confrontation between Sufism and "fundamentalist Islam" to the extent of subscribing to "an innate predisposition to mysticism in the Persian psyche."[50] Lewisohn added to this dossier by editing two subsequent volumes of essays on Sufism in connection with the writings of 'Attar and Hafiz as well as authoring a detailed analysis of the mysticism of Mahmud Shabistari, author of the *Gulshan-i Raz*.[51]

Other scholars have produced original research on neglected topics and figures in the early history of Sufism. This includes a study of the formation of early Sufism by Ahmet Karamustafa, a professor at the University of Maryland, as well as an analysis of Sufi biographical literature and a study of Rumi's teachings by Jawid Mojaddedi, now of Tufts University; the latter is also producing a complete new translation of Rumi's *Masnavi* in rhyming couplets.[52] Firoozeh Papan-Matin has authored a recent reflective meditation on the Sufi teachings of 'Ayn al-Qudat Hamadani (d. 1131), who is also the subject of a lengthy and somewhat idiosyncratic monograph by Hamid Dabashi.[53] I have examined the concept of sainthood in the writings of Ruzbihan Baqli (d. 1209) and translated his visionary autobiography.[54] A biographical study of the Kubrawi master 'Ala al-Dawla Simnani (d. 1336) was produced by Jamal Elias of the University of Pennsylvania.[55] The topic of embodied religious practice in Persianate Sufism has likewise been addressed by Shahzad Bashir.[56]

Despite the progress that has been made in this field through the studies just mentioned, it must be admitted that there are still major figures and topics in the history of Persian Sufism that have scarcely been discussed in modern

American scholarship, so there are many topics waiting for investigation. This observation holds true particularly for later periods of history, especially with the suppression of many Sunni Sufi orders in Iran after the rise of the Safavids. But it is also remarkable how little scholarship has been done on history of Persian Sufism since the nineteenth century. In this respect, the study of Persian Sufism has continued to reflect the classicist bias of Orientalist scholarship.[57]

Persianate Sectarian Movements

As previously mentioned, scholars such as Kathryn Babayan have made a persuasive case for the persistence of Persianate trends in the messianic and millenarian movements that have periodically resurfaced throughout Iranian history. Shahzad Bashir has devoted two studies to the analysis of the messianic career of Muhammad Nurbakhsh (d. 1464) as well as the Hurufi movement and its founder Fazl Allah Astarabadi (d. 1394).[58] After the end of the Safavid dynasty and under the Qajars, messianic hopes once again came to the fore in the Shaykhi school of thought and full-blown emerged in the Babi movement and eventually the Baha'i faith, which went beyond the boundaries of nineteenth-century Shi'ism. Several American scholars, including Mangol Bayat, Abbas Amanat, and Juan Cole, have contributed important historical studies of the origins and historical development of these later messianic tendencies in the context of nineteenth-century Persia.[59]

Islam in Modern Iran

Finally, one may return to the question of the role of religion in Iran since the turn of the twentieth century, a period that tends to be dominated by the Revolution of 1978–79 and the establishment of the Islamic Republic of Iran. In a way, this subject represents the contemporary extension of the first topic outlined above under the header "Islamic Religious Scholars and the State." But the transformations that have occurred since the Revolution, after the installation of an Islamic government under the supervision of Ayatollah Khomeini, have so drastically changed the basic structure of this relationship that it is arguably a completely different situation. There is an enormous amount of literature that has been published on the religion in contemporary Iran, mostly from political and historical perspectives. One of the leading contributors to this field of study has been Nikki Keddie, for many years a professor of history at the University of California, Los Angeles, who has published extensively on the religion and politics of modern Iran.[60] A number of scholars, such as

Hamid Dabashi and Michael Fischer, have looked for the ideological roots of the Iranian Revolution in modern Shi'i religious thought.[61] Yet, as Charles Kurzman has pointed out, there is an interesting fallacy in much of the literature that attempts to explain the causes of something as chaotic as a revolution, insofar as such explanations amount to retroactive predictions—although few social scientists would claim to be able to predict future events.[62] I will not attempt to describe here all of the American scholarly writing about the Iranian Revolution and its aftermath, which frequently focuses on the Iranian government's use of religious authority as the main locus of research, although one can point to a number of Iranian-American scholars who have recently made valuable social science contributions on the subject of the tangled relationship between Iranian thinkers and the ideologies of modernity.[63] Yet, the assumption that one can speak of an "Iranian Islam," as noted above, is deeply problematic. Studies that are dominated by the contested issue of Iranian identity, in the absence of a critical theorization of the concept of religion, will not clearly fall into the field of religious studies. But a couple of final comments may be added at this point. First is the striking presence in American universities of dissenting Iranian religious thinkers, such as Abdolkarim Soroush and Mohsen Kadivar. Their articulation of a critique of the current Iranian regime draws upon key religious resources of Persianate Islam, but it is increasingly expressed in the language of the American academy.[64] Second is the religious debate in Iran, which goes on in the seminaries and is easily viewed in their Internet publications. This is a debate that draws upon not only Shi'i authoritative tradition but also contemporary critical thinkers from Europe and America.[65] The story of contemporary Persianate Islam is obviously still unfolding, and the complexity of its development deserves serious treatment.

The foregoing sketch of American scholarship on Persianate Islamic studies is only a broad outline, but I hope that this summary provides sufficient evidence both that Persianate Islam is a coherent field of study, and that American scholars have made important contributions to its development. While it would be possible to make a case for many other regions of Islamic civilization as appropriate rubrics for separate investigation, nevertheless there is something compelling about the Persianate cultural sphere that makes it arguably a priority field for any comprehensive program in Islamic studies.

Notes

I would like to thank Charles Kurzman, Matthew Lynch, and Tehseen Thaver for their helpful comments on this article.

1. For overviews of the field of Islamic studies, see Ernst and Martin, "Toward a Post-Orientalist Approach," and Kurzman and Ernst, "Islamic Studies in US Universities."

2. The two American PhD programs that emphasize Persian in Islamic studies are those of Yale University and the University of North Carolina at Chapel Hill. For a list of PhD programs in religious studies that include the study of Islam as a specialty, see https://carlwernst.web.unc.edu/home/phdprograms-html.
3. Gnoli, "Iranian Religions."
4. See Ahmad Ashraf in this volume.
5. Hodgson, *Gunpowder Empires*, 46–52. See also Lawrence, "Islamicate Civilization."
6. Hodgson, *Order of Assassins*, and the 2005 reprint edition. It is instructive to contrast this sophisticated and nuanced interpretation of Ismaʿilism as a religious movement with the crude and conspiratorial sensationalism of B. Lewis, *Assassins*; the 2002 reprint of this work by Basic Books advertises it as an "authoritative account of history's first terrorists . . . [which] sheds new light on the fanatic mind."
7. Arjomand, "From the Editor."
8. Frye, *Heritage of Persia*. For a complete bibliography, see Frye's website at http://www.richardfrye.org.
9. Frye, "Iranicization of Islam." Elsewhere in Frye, *Islamic Iran and Central Asia*, Judith A. Lerner also discusses Frye's contributions to Iranian Studies.
10. Bausani, *Religion in Iran*.
11. An extensive website dedicated to Henry Corbin and his writings is available at http://henrycorbinproject.blogspot.com.
12. Corbin, *Spiritual Body and Celestial Earth*.
13. For Seyyed Hossein Nasr's many scholarly publications, see the website devoted to his work at http://www.nasrfoundation.org. On the Perennial Philosophy espoused by Nasr, and its background in the counter-enlightenment movement of Catholic traditionalism, see Ernst, "Traditionalism."
14. Algar, "Study of Islam," citing p. 89. The tone of this review may be gauged from its final comment: "His enterprise was a rarefied and idiosyncratic form of spiritual colonialism" (p. 91).
15. Wasserstrom, *Religion After Religion*.
16. Subtelny, "History and Religion," and Pierry Lory, "Note sur l'ouvrage *Religion After Religion*."
17. Algar, "Islam in Iran" (Iran, ix, Religions in Iran, 2.1).
18. Khomeini, *Islam and Revolution*. See also Algar, *Roots of the Islamic Revolution*.
19. See the various articles in *Encyclopaedia Iranica* under the category "Islam in Iran."
20. Zadeh, *Vernacular Qurʾan*.
21. Choksy, *Conflict and Cooperation*, 141.
22. Bulliet, *Islam*, 11.
23. Babayan, *Mystics, Monarchs, and Messiahs*, xix. Compare contemporary Iranian clerics' dismissal of the "fictions" of the martyrological text *Rawzat al-shuhadaʾ* by Husayn Waʿiz Kashifi, despite its centrality in Shiʿi tradition, and Ruffle, *Gender*, 147–49, 153, 156.
24. Betteridge, "Muslim Women," and Betteridge "Specialists in Miraculous Action."
25. Haeri, *Law of Desire*, and Haeri, *Say What Your Longing Heart Desires*.
26. Gruber, *Ilkhanid Book of Ascension*; Gruber, *Timurid Book of Ascension*; Gruber, "Media/ting Conflict"; and Gruber, "Jerusalem."

27. Bulliet, *Patricians of Nishapur*, and Bulliet, *Conversion to Islam*. Bulliet's other publications are listed at http://www.columbia.edu/~rwb3/Bulliet/Richard _W._Bulliet.html.
28. Mottahedeh, *Loyalty and Leadership*, especially 135–50.
29. Mottahedeh, *Mantle of the Prophet*. For a complete list of Mottahedeh's publications, see https://scholar.harvard.edu/mottahedeh/publications.
30. Safi, *Politics of Knowledge*.
31. Moin, *Millennial Sovereign*.
32. Modarressi, *Crisis and Consolidation*. For a list of Modarressi's publications in English and Persian, see https://nes.princeton.edu/people/hossein-modarressi.
33. Newman, *Formative Period*.
34. Dakake, *Charismatic Community*.
35. Arjomand, *Shadow of God*. For a list of Arjomand's publications, see his website at http://www.stonybrook.edu/commcms/sociology/people/faculty/arjomand.html.
36. Mazzaoui, *Origins of the Ṣafawids*.
37. Amanat, *Apocalyptic Islam*.
38. Algar, *Religion and State in Iran*.
39. Cole, *Sacred Space and Holy War*. Cole's publications can be consulted on his website at http://www-personal.umich.edu/~jrcole/index/indexa.htm.
40. Dabashi, *Shiʿism*, xvi. Dabashi's publications are listed on his website at http://www.hamiddabashi.com.
41. Schimmel, *Mystical Dimensions of Islam*. See also Waghmar and Chaghatai, *Bibliography*.
42. Schimmel, *Triumphal Sun*; Schimmel, *Rumi's World*; and Schimmel, *As Through a Veil*.
43. Chittick, *Sufi Path of Love*; ʿIraqi, *Divine Flashes*; Chittick, *Faith and Practice of Islam*; Murata, *Gleams*; Shams al-Din Tabrizi, *Me and Rumi*.
44. F. Lewis, *Rumi: Past and Present*; F. Lewis, *Rumi: Swallowing the Sun*; and F. Lewis, *Colossal Elephant and His Spiritual Feats*.
45. Keshavarz, *Reading Mystical Lyric*, and Renard, *All the King's Falcons*.
46. ʿAṭṭār, *Farid ad-Din ʿAṭṭār's Memorial of God's Friends*.
47. ʿAṭṭār, *Conference of the Birds*, and Davis, *Faces of Love*.
48. Chittick, *Sufism*; Ernst, *Shambhala Guide to Sufism* (reprinted as *Sufism: An Introduction*); Ernst, *Teachings of Sufism*; Renard, *Seven Doors to Islam*; Renard, *Windows on the House of Islam*; Renard, *Friends of God*; and Renard, *Tales of God's Friends*.
49. Lewisohn, *Heritage of Sufism*. Volumes 1 and 2 of this collection were originally published in 1993 and 1992 by the diasporic Nimatollahi Sufi order (Khaniqahi Nimatullahi Publications) directed by Dr. Javad Nurbakhsh.
50. Lewisohn, "Overview," quoting pp. 1, 37.
51. Lewisohn, *ʿAṭṭār and the Persian Sufi Tradition*; Lewisohn, *Hafiz and the Religion of Love*; and Lewisohn, *Beyond Faith and Infidelity*.
52. Karamustafa, *Sufism*; Mojaddedi, *Biographical Tradition in Sufism*; Mojaddedi, *Beyond Dogma*; and Rumi, *Masnavi*.
53. Papan-Matin, *Beyond Death*; Dabashi, *Truth and Narrative*.
54. Ernst, *Ruzbihan Baqli*; Ruzbihan Baqli, *Unveiling of Secrets*.
55. Elias, *Throne Carrier of God*.
56. Bashir, *Sufi Bodies*.

57. One of the few studies of modern Persian Sufism is the two-part study by Leonard Lewisohn, "Introduction to the History of Modern Persian Sufism, I" and "Introduction to the History of Modern Persian Sufism, II." A rare translation of a modern Persian mystical text is Elâhi, *Knowing the Spirit*.

58. Bashir, *Messianic Hopes*, and Bashir, *Fazlallah Astarabadi*.

59. Bayat, *Mysticism and Dissent*; Amanat, *Resurrection and Renewal*; and Cole, *Modernity and the Millennium*. See also the comparative study of Buck, *Paradise and Paradigm*.

60. The publications of Nikki Keddie are listed on her website at http://www.sscnet.ucla.edu/history/keddie/.

61. Dabashi, *Theology of Discontent*, and Fischer, *Iran*.

62. Kurzman, *Unthinkable Revolution in Iran*.

63. The writings of scholars such as Mehrzad Boroujerdi, H. E. Chehabi, Behrooz Ghamari-Tabrizi, Ali Mirsepassi, Mansoor Moaddel, Farhang Rajaee, and Farzin Vahdat provide a range of analyses of Islam and modernity in Iran.

64. See the website of Abdulkarim Soroush at http://drsoroush.com/en/publications/, and that of Mohsen Kadivar at https://english.kadivar.com.

65. Foody, "Thinking Islam."

Bibliography

Algar, Hamid. "Iran, ix, Religions in Iran, 2.0–2.3: Islam in Iran." *Encyclopaedia Iranica*. Last updated March 30, 2012. http://www.iranicaonline.org/articles/iran-ix2-islam-in-iran.

———. *Religion and State in Iran, 1785–1906: The Role of the Ulama in the Qajar Period*. Berkeley: University of California Press, 1969.

———. *Roots of the Islamic Revolution in Iran: Four Lectures*. Oneonta, NY: Islamic Publications International, 2001.

———. "The Study of Islam: The Work of Henry Corbin." *Religious Studies Review* 6.2 (1980): 85–91.

Amanat, Abbas. *Apocalyptic Islam and Iranian Shi'ism*. New York: I. B. Tauris, 2009.

———. *Resurrection and Renewal: The Making of the Babi Movement in Iran, 1844–1850*. Ithaca: Cornell University Press, 1989.

Arjomand, Said Amir. "From the Editor: Defining Persianate Studies." *Journal of Persianate Studies* 1 (2008): 1–4.

———. *The Shadow of God and the Hidden Imam: Religion, Political Order, and Societal Change in Shi'ite Iran from the Beginning to 1890*. Publications of the Center for Middle Eastern Studies 17. Chicago: University of Chicago Press, 1984.

'Aṭṭār, Farīd al-Dīn. *The Conference of the Birds*. Translated by Dick Davis and Afkham Darbandi. New York: Penguin, 1984.

———. *Farid ad-Din 'Attār's Memorial of God's Friends: Lives and Sayings of Sufis*. Translated by Paul Losensky. New York: Paulist, 2009.

Babayan, Kathryn. *Mystics, Monarchs, and Messiahs: Cultural Landscapes of Early Modern Iran*. Cambridge: Harvard University Press, 2002.

Bashir, Shahzad. *Fazlallah Astarabadi and the Hurufis*. Oxford: Oneworld, 2005.

———. *Messianic Hopes and Mystical Visions: The Nūrbakhshīya Between Medieval and Modern Islam*. Columbia: University of South Carolina Press, 2003.

———. *Sufi Bodies: Religion and Society in Medieval Islam*. New York: Columbia University Press, 2011.

Bausani, Alessandro. *Religion in Iran: From Zoroaster to Baha'ullah*. Studies in the Bábí and Bahá'í Religions 11. New York: Bibliotheca Persica, 2000.
Bayat, Mangol. *Mysticism and Dissent: Socioreligious Thought in Qajar Iran*. Syracuse: Syracuse University Press, 1982.
Betteridge, Anne. "Muslim Women and Shrines in Shiraz." Pages 276–91 in *Everyday Life in the Muslim Middle East*. 2nd ed. Edited by Donna Lee Bowen and Evelyn A. Early. Bloomington: Indiana University Press, 2002.
———. "Specialists in Miraculous Action: Some Shrines in Shiraz." Pages 189–210 in *Sacred Journeys: The Anthropology of Pilgrimage*. Edited by Alan Morinis. Westport, CT: Greenwood, 1992.
Buck, Christopher. *Paradise and Paradigm: Key Symbols in Persian Christianity and the Bahá'í Faith*. Albany: State University of New York, 1999.
Bulliet, Richard W. *Conversion to Islam in the Medieval Period: An Essay in Quantitative History*. Cambridge: Harvard University Press, 1979.
———. *Islam: The View from the Edge*. New York: Columbia University Press, 1994.
———. *The Patricians of Nishapur: A Study in Medieval Islamic Social History*. Harvard Middle Eastern Studies 16. Cambridge: Harvard University Press, 1972.
Chittick, William. *Faith and Practice of Islam: Three Thirteenth Century Sufi Texts*. Albany: State University of New York Press, 1992.
———. *The Sufi Path of Love: The Spiritual Teachings of Rumi*. Albany: State University of New York Press, 1983.
———. *Sufism: A Short Introduction*. Oxford: Oneworld, 2000.
Choksy, Jamsheed K. *Conflict and Cooperation: Zoroastrian Subalterns and Muslim Elites in Medieval Iranian Society*. New York: Columbia University Press, 1997.
Cole, Juan Ricardo. *Modernity and the Millennium: The Genesis of the Baha'i Faith in the Nineteenth-Century Middle East*. New York: Columbia University Press, 1998.
———. *Sacred Space and Holy War: The Politics, Culture and History of Shi'ite Islam*. London: I. B. Tauris, 2002.
Corbin, Henry. *Spiritual Body and Celestial Earth: From Mazdean Iran to Shi'ite Iran*. Translated by Nancy Pearson. Bollingen Series 91. Princeton: Princeton University Press, 1977.
Dabashi, Hamid. *Shi'ism: A Religion of Protest*. Cambridge: Belknap Press of Harvard University Press, 2011.
———. *Theology of Discontent: The Ideological Foundation of the Islamic Revolution in Iran*. New Brunswick, NJ: Transaction, 2006.
———. *Truth and Narrative: The Untimely Thoughts of 'Ayn al-Quḍāt al Hamadhānī*. Richmond: Curzon, 1999.
Dakake, Maria Massi. *The Charismatic Community: Shi'ite Identity in Early Islam*. Albany: State University of New York Press, 2007.
Davis, Dick, trans. *Faces of Love: Hafez and the Poets of Shiraz*. Waldorf, MD: Mage, 2012.
Elâhi, Nûr Alî-Shâh. *Knowing the Spirit*. Translated by James Winston Morris. Albany: State University of New York Press, 2007.
Elias, Jamal J. *The Throne Carrier of God: The Life and Thought of 'Alā' ad-Dawla as-Simnānī*. Albany: State University of New York Press, 1995.
Ernst, Carl W. *Ruzbihan Baqli: Mystical Experience and the Rhetoric of Sainthood in Persian Sufism*. London: Curzon, 1996.
———. *The Shambhala Guide to Sufism*. Boston: Shambhala, 1997. Repr., *Sufism: An Introduction to the Mystical Tradition of Islam*. Boston: Shambhala, 2011.

———. *Teachings of Sufism*. Boston: Shambhala, 1999.

———. "Traditionalism, the Perennial Philosophy, and Islamic Studies: Review Article." *Middle East Studies Association Bulletin* 28.2 (1994): 176–81.

Ernst, Carl W., and Richard C. Martin. "Toward a Post-Orientalist Approach to Islamic Religious Studies." Pages 1–22 in *Rethinking Islamic Studies: From Orientalism to Cosmopolitanism*. Edited by Carl W. Ernst and Richard C. Martin. Columbia: University of South Carolina Press, 2010.

Fischer, Michael M. J. *Iran: From Religious Dispute to Revolution*. Madison: University of Wisconsin Press, 2003.

Foody, Kathleen M. "Thinking Islam: Islamic Scholars, Tradition, and the State in the Islamic Republic of Iran." PhD diss., University of North Carolina at Chapel Hill, 2012.

Frye, Richard Nelson. *The Heritage of Persia*. Cleveland: World Publishing Company, 1963.

———. "The Iranicization of Islam." Paper presented at the University of Chicago as the annual Marshall Hodgson Memorial Lecture, May 1978. Reproduced in Frye, *Islamic Iran and Central Asia*, part IX, 1–7.

———. *Islamic Iran and Central Asia: 7th–12th Centuries*. London: Variorum, 1979.

Gnoli, Gherardo. "Iranian Religions." Page 277 in vol. 7 of *The Encyclopaedia of Religion*. Edited by Mircea Eliade. New York, Macmillan, 1987.

Gruber, Christiane. *The Ilkhanid Book of Ascension: A Persian-Sunni Devotional Tale*. London: I. B. Tauris, 2010.

———. "Jerusalem in the Visual Propaganda of Post-Revolutionary Iran." Pages 168–97 in *Jerusalem: Idea and Reality*. Edited by Suleiman Mourad and Tamar Mayer. London: Routledge, 2008.

———. "Media/ting Conflict: Iranian Posters from the Iran-Iraq War, 1980–88." Pages 710–15 in *Crossing Cultures: Conflict, Migration. Convergence. Proceedings of the 32nd Congress of the International Committee of the History of Art*. Edited by Jaynie Anderson. Melbourne: Melbourne University Press, 2009.

———. *The Timurid Book of Ascension (Miʿrajnama): A Study of Text and Image in a Pan-Asian Context*. Valencia: Patrimonio Ediciones, 2008.

Haeri, Niloofar. *Say What Your Longing Heart Desires: Women, Prayer, and Poetry in Iran*. Stanford: Stanford University Press, 2021.

Haeri, Shahla. *Law of Desire: Temporary Marriage in Shiʿi Iran*. Syracuse: Syracuse University Press, 1989.

Hodgson, Marshall G. S. *The Gunpowder Empires and Modern Times*. Vol. 3 of *The Venture of Islam*. Chicago: University of Chicago Press, 1968.

———. *The Order of Assassins: The Struggle of the Early Nizârî Ismâʿîlîs Against the Islamic World*. The Hague: Mouton, 1955. Repr., *The Secret Order of Assassins*. Philadelphia: University of Pennsylvania Press, 2005.

ʿIraqi, Fakhr al-Din. *Divine Flashes*. Translated by William Chittick and Peter Lamborn Wilson. New York: Paulist, 1982.

Karamustafa, Ahmet T. *Sufism: The Formative Period*. Berkeley: University of California Press, 2007.

Keshavarz, Fatemeh. *Reading Mystical Lyric: The Case of Jalal al-Din Rumi*. Columbia: University of South Carolina Press, 1998.

Khomeini, Ruhollah. *Islam and Revolution: Writings and Declarations of Imam Khomeini*. Translated by Hamid Algar. Berkeley: Mizan, 1981.

Kurzman, Charles. *The Unthinkable Revolution in Iran*. Cambridge: Harvard University Press, 2005.
Kurzman, Charles, and Carl W. Ernst. "Islamic Studies in US Universities." *Review of Middle East Studies* 46.1 (2012): 24–46.
Lawrence, Bruce B. "Islamicate Civilization: The View from Asia." Pages 61–74 in *Teaching Islam*. Edited by Brannon M. Wheeler. American Academy of Religion Teaching Religious Studies Series. New York: Oxford, 2003.
Lewis, Bernard. *The Assassins: A Radical Sect in Islam*. London: Weidenfeld & Nicholson, 1967.
Lewis, Franklin. *The Colossal Elephant and His Spiritual Feats: Shaykh Ahmad-e Jām: The Life and Legend of a Popular Sufi Saint of 12th-Century Iran*. Costa Mesa, CA: Mazda, 2004.
———. *Rumi: Past and Present, East and West. The Life, Teaching and Poetry of Jalal al-Din Rumi*. Oxford: Oneworld, 2000.
———. *Rumi: Swallowing the Sun—Poems from the Persian*. Oxford: Oneworld, 2008.
Lewisohn, Leonard, ed. *ʿAṭṭār and the Persian Sufi Tradition: The Art of Spiritual Flight*. London: I. B. Tauris, 2006.
———. *Beyond Faith and Infidelity: The Sufi Poetry and Teachings of Mahmud Shabistari*. Richmond: Curzon, 1995.
———, ed. *Hafiz and the Religion of Love in Classical Persian Poetry*. London: I. B. Tauris, 2010.
———, ed. *The Heritage of Sufism*. 3 vols. Oxford: Oneworld, 1999.
———. "An Introduction to the History of Modern Persian Sufism, I: The Niʿmatullahi Order." *Bulletin of the School of Oriental and African Studies* 61.3 (1998): 437–64.
———. "An Introduction to the History of Modern Persian Sufism, II: A Socio-Cultural Profile of Sufism from Dhahabi Revival to Present Day." *Bulletin of the School of Oriental and African Studies* 62.1 (1999): 36–59.
———. "Overview." Pages 11–43 in *The Legacy of Medieval Persian Sufism, 1150–1500*. Vol. 2 of *The Heritage of Sufism*. Edited by Leonard Lewisohn. Oxford: Oneworld, 1999.
Lory, Pierre. "Note sur l'ouvrage *Religion After Religion—Gershom Scholem, Mircea Eliade and Henry Corbin at Eranos*." *Archaeus* 9 (2005): 107–13.
Mazzaoui, Michel M. *The Origins of the Ṣafawids: Šīʿism, Ṣūfism, and the Ġulāt*. Freiburger Islamstudien 3. Wiesbaden: Steiner, 1972.
Modarressi, Hossein. *Crisis and Consolidation in the Formative Period of Shiʿite Islam: Abu Jaʾfar ibn Qiba al-Razi and His Contribution to Imamite Shiʿite Thought*. Princeton: Darwin, 1993.
Moin, A. Azfar. *The Millennial Sovereign: Sacred Kingship and Sainthood in Islam*. New York: Columbia University Press, 2012.
Mojaddedi, Jawid Ahmad. *Beyond Dogma: Rumi's Teachings on Friendship with God and Early Sufi Theories*. Oxford: Oxford University Press, 2012.
———. *The Biographical Tradition in Sufism: The Ṭabaqāt Genre from al-Sulamī to Jāmī*. Richmond: Curzon, 2001.
Mottahedeh, Roy P. *Loyalty and Leadership in an Early Islamic Society*. Princeton Studies on the Near East. Princeton: Princeton University Press, 1980.

———. *The Mantle of the Prophet*. New York: Simon & Schuster, 1985.
Murata, Sachiko. *Chinese Gleams of Sufi Light: Wang Tai-yu's Great Learning of the Pure and Real and Liu Chih's Displaying the Concealment of the Real Realm*. Albany: State University of New York Press, 2000.
Newman, Andrew J. *The Formative Period of Twelver Shīʿism: Ḥadīth as Discourse Between Qum and Baghdad*. Culture and Civilization in the Middle East. Richmond: Curzon, 2000.
Papan-Matin, Firoozeh. *Beyond Death: The Mystical Teachings of ʿAyn al-Quḍāt al Hamadhānī*. Leiden: Brill, 2010.
Renard, John. *All the King's Falcons: Rumi on Prophets and Revelation*. Albany: State University of New York Press, 1994.
———. *Friends of God: Islamic Images of Piety, Commitment, and Servanthood*. Berkeley: University of California Press, 2008.
———. *Seven Doors to Islam: Spirituality and the Religious Life of Muslims*. Berkeley: University of California Press, 1996.
———. *Tales of God's Friends: Islamic Hagiography in Translation*. Berkeley: University of California Press, 2009.
———. *Windows on the House of Islam: Muslim Sources on Spirituality and Religious Life*. Berkeley: University of California Press, 1998.
Ruffle, Karen G. *Gender, Sainthood, and Everyday Practice in South Asian Shiʿism*. Chapel Hill: University of North Carolina Press, 2011.
Rumi, Jalal al-Din. *The Masnavi*. Translated by Jawid Mojaddedi. Oxford World's Classics. Oxford: Oxford University Press, 2004–8.
Ruzbihan Baqli. *The Unveiling of Secrets: Diary of a Sufi Master*. Translated by Carl W. Ernst. Chapel Hill: Parvardigar, 1997.
Safi, Omid. *The Politics of Knowledge in Premodern Islam: Negotiating Ideology and Religious Inquiry*. Islamic Civilization and Muslim Networks. Chapel Hill: University of North Carolina Press, 2006.
Schimmel, Annemarie. *As Through a Veil: Mystical Poetry in Islam*. New York: Columbia University Press, 1982.
———. *Mystical Dimensions of Islam*. Chapel Hill: University of North Carolina Press, 1975.
———. *Rumi's World: The Life and Work of the Great Sufi Poet*. Boston: Shambhala, 2001.
———. *The Triumphal Sun: A Study of the Works of Jalaloddin Rumi*. London: Fine Books, 1978.
Shams al-Din Tabrizi. *Me and Rumi: The Autobiography of Shams-i Tabrizi*. Translated by William Chittick. Louisville, KY: Fons Vitae, 2004.
Subtelny, Maria E. "History and Religion: The Fallacy of Metaphysical Questions. A Review Article." *Iranian Studies* 36.1 (2003): 91–101.
Waghmar, Burzine, and M. Ikram Chaghatai. *Bibliography of the Works of the Scholar-Hermit Prof. Dr. Annemarie Schimmel: 1943 to 2003*. Lahore: Iqbal Academy, 2004.
Wasserstrom, Steven M. *Religion After Religion: Gershom Scholem, Mircea Eliade, and Henry Corbin at Eranos*. Princeton: Princeton University Press, 1999.
Zadeh, Travis. *The Vernacular Qur'an: Translation and the Rise of Persian Exegesis*. Institute of Ismaili Studies Qur'anic Study Series 7. Oxford: Oxford University Press, 2012.

Websites of Individual Scholars
Arjomand, Said Amir: http://www.stonybrook.edu/commcms/sociology/people/faculty/arjomand.html.
Bulliet, Richard W.: http://www.columbia.edu/~rwb3/Bulliet/Richard_W._Bulliet.html.
Cole, Juan Ricardo: http://www-personal.umich.edu/~jrcole/index/indexa.htm.
Corbin, Henry: http://henrycorbinproject.blogspot.com.
Dabashi, Hamid: http://www.hamiddabashi.com.
Frye, Richard Nelson: http://www.richardfrye.org.
Kadivar, Mohsen: https://english.kadivar.com.
Keddie, Nikki: http://www.sscnet.ucla.edu/history/keddie/.
Modarressi, Hossein: https://nes.princeton.edu/people/hossein-modarressi/.
Mottahedeh, Roy P.: https://scholar.harvard.edu/mottahedeh/publications/.
Nasr, Seyyed Hossein: http://www.nasrfoundation.org.
Soroush, Abdulkarim: http://drsoroush.com/en/publications/.

CHAPTER 18

First- and Second-Generation Iranian Americans

Mehdi Bozorgmehr

Introduction and Overview of Sources

The purpose of this chapter is to present a review of the social science literature on Iranian Americans. To this end, I utilize a wide range of sources and organize the material thematically. Major themes include patterns of immigration and exile characteristics, pioneering works on Iranian immigrants, population size and settlement patterns, education and occupation, gender and family, ethnic identity and community, discrimination and prejudice, and the second generation. The paper goes beyond a synthesis of existing scholarly literature to present data on immigration patterns as well as demographic and socioeconomic characteristics of Iranian Americans. I will also point out overlooked topics and areas for further research as needed.

To address these issues, I draw on a variety of sources that provide reliable information on Iranian Americans, including academic research and scholarly publications, survey data collected by the United States government, and other nongovernmental surveys and polls. Very few researchers have taken advantage of the large amount of data made available by the US Immigration and Naturalization Service (INS), which is now under the auspices of the Department of Homeland Security (DHS), and the US Census Bureau's decennial census and annual American Community Survey (ACS). Immigration data are drawn from the INS Statistical Yearbooks, many of which are now readily available online. The comprehensive INS/DHS data on foreign nationals legally admitted into the United States make it possible to look at patterns and trends of immigration over time for each specific country. The INS category of "immigrants admitted," used later in this chapter, includes both "new arrivals" and "adjusters" (those who were already in the United States under a different status but subsequently became "lawful permanent residents" (LPRs or Green Card holders). In the case of Iranians, although some had immigrant status upon arrival, most were admitted as nonimmigrants—students before the Iranian Revolution and exiles who came as visitors afterward—and subsequently

had their status adjusted to LPRs. Following the Iranian Revolution in the 1980s, refugee and asylee status became the most common means of obtaining permanent residence among Iranian immigrants.[1]

The US Census Bureau conducts the American Community Survey (ACS) every year and a full census of the population every ten years. The ACS is a survey that is sent out to a sample of the US population, with approximately one in every thirty-eight households asked to participate. The data are weighted to be nationally representative, meaning that individual responses are assigned a weight based on the prevalence of their characteristics (for example, ethnic or racial group) in the US population overall. This results in a demographic breakdown that reflects the US population. While "Iranian" is not offered as a race category in the short-form census, it is possible to identify Iranian Americans using the ancestry data collected in the ACS and in the long-form censuses from prior years. A question about ancestry was originally introduced in the 1980 census and repeated in the 1990 and 2000 censuses. The question, asked about all household members, was phrased as: "What is this person's ancestry or ethnic origin?" The census gave a list of examples (e.g., Lebanese, Italian) below the question for clarification and allowed up to two responses. The question was included in the long-form census questionnaire and was sent to one out of every six households on a random sample basis. The ACS was fully implemented in 2005 as a replacement for many of the questions previously asked using the long-form decennial census.[2] As a result, data are available on a nationally representative sample of Iranian Americans from 1980 to the present. To increase the sample size, this paper uses data from the three-year merged ACS to analyze the demographic and socioeconomic characteristics of the Iranian American population. I also use data from older decennial censuses to look at trends over time. In addition, where appropriate, the paper draws on data from other sources, such as surveys conducted by researchers and polls taken by community organizations and policy groups.

Patterns of Immigration and Immigrant or Exile Characteristics

Large-scale Iranian immigration to the United States is part of the contemporary post-1965 immigration wave. In the first quarter of the twentieth century, the INS did not even report data for Iranian arrivals to the United States. In the second quarter (1925–50), Iranian immigration remained negligible, and fewer than 2,000 Iranians were admitted to the United States as immigrants. In the second half of the twentieth century, the number of immigrants admitted from Iran increased dramatically to 215,000 during the years 1950–2000. The number of Iranian immigrants more than doubled from around 25,000 from 1975

to 1979, which covers the Iranian Revolution of 1978–79, to nearly 57,000 from 1980 to 1984. The figure significantly increased again to around 84,000 during the subsequent period of 1990–94. The numbers of Iranian immigrants admitted to the United States dropped considerably in the last decade of the twentieth century (about 45,000 in the 1995–99 period) and fluctuated in the first decade of the twenty-first (nearly 50,000 in 2000–2004 and 71,000 in 2005–9).[3]

Iranian immigration is often divided by scholars into two waves: pre- and post-Iranian Revolution (1978–79). Since the causes of migration shifted drastically between these two periods, the two waves were made up of different types of migrants. The first wave mainly consisted of college students and some economic migrants, whereas exiles and political refugees made up the bulk of the second wave. Mohammad Reza Shah's industrialization drive, which began in the 1960s and was spurred on by rising oil revenues in the early to mid-1970s, increased the demand for educated and skilled workers in Iran. However, the Iranian higher education infrastructure at the time could not meet the demands of an increasingly large pool of high school graduates. Thus, overseas education became the only viable option for obtaining the necessary skills for employment in rapidly industrializing Iran. Although Iranian students went abroad to several countries in pursuit of higher education, their favored destination was the United States. In the mid-1970s, about half of Iranian students abroad were studying in the United States. This was partially because English was the main foreign language taught in Iranian high schools, combined with there being far more universities in America than in any other English-speaking country, which increased students' chances of admission. American universities also offered state-of-the-art technical education in fields such as engineering, which were in high demand in industrializing Iran. In the peak year of 1980, with over 50,000 Iranian students studying at American colleges and universities, Iranians made up the largest foreign student population in the United States. At that time, one out of every six foreign students in the country was from Iran.[4] In due course, many Iranian students had their status adjusted to permanent residence after being admitted to the United States on F1 student visas.[5]

During and after the Iranian Revolution, the vast majority of Iranians who emigrated were exiles and political refugees. The early wave of Iranian exiles consisted of members of the elite and other educated and secular Muslim segments of Iranian society. Subsequent waves of political refugees from Iran have come from more modest backgrounds but are still vastly different from impoverished refugees who arrive with "only the shirts on their backs," given that obtaining a US visa from Iran has historically required substantial resources. Before the seizure of the American Embassy in Iran in 1979, obtaining a US

visa was relatively easy. Since then, however, because the US Embassy in Tehran has never reopened, Iranians have had to go to a third country to receive a US visa. Not only is there no US Embassy in Iran, but since the two countries no longer have diplomatic relations, there is also no Iranian Embassy in the United States. In lieu of an embassy, the Iranian Interests Section operates under the Embassy of Pakistan in Washington, DC. My analysis of the Interests Section data from 1996 to 2004 shows that over 130,000 Iranian Americans contacted them for passport-related services during that time, indicating a relatively high frequency of visiting Iran.

In more recent years, the difficulties of immigration from Iran to the United States have been even further exacerbated by a weakened Iranian economy and a highly unfavorable and rapidly deteriorating exchange rate between American and Iranian currency, mainly due to US sanctions. Moreover, increased restrictions imposed by the United States on Middle Easterners after the terrorist attacks on September 11, 2001, and, in 2017, by the Trump administration have made it even more difficult for Iranians to immigrate to the country. Indeed, one can further divide the postrevolutionary wave of Iranian immigration into pre- and post-9/11 phases.[6] If we disaggregate the number of immigrants admitted from Iran into "new arrivals" and "adjusters," the data show that the new arrivals dropped off considerably in the years following September 11, 2001, and after the Trump "Muslim Ban." Therefore, upswings in the total number of immigrants admitted after the World Trade Center attack are not due to new arrivals but rather to adjusters who were already in the United States.

Early research on the exile and immigrant aspects of Iranians originally relied on the imperfect 1980 US census data, which did not contain any information on motivation for leaving the homeland and reported data for five-year categories (this was changed to three years in the 1990 census). Nevertheless, the 1980 census data on Iranians were available but not utilized.[7] Using the 1980 census data to compare the 1975–80 and pre-1975 cohorts of Iranians in the Los Angeles region, Georges Sabagh and I detected that the most recent Iranian cohort contained a higher proportion of minorities (e.g., Armenians) and was more balanced in age and sex (indirect evidence of family migration). Contrary to theoretical expectations, this cohort did not have more human capital (education) than the pre-1975 cohort, because the former contained many college students.[8]

We explored the distinctions between immigrants and exiles further by using the much more appropriate survey of Iranians in Los Angeles, which we conducted in the late 1980s.[9] Based on motivations for leaving Iran, most Iranians who came to the United States before the Iranian Revolution could be classified as migrants (i.e., left for economic or educational purposes), whereas those who came after the revolution were found to be exiles or political

refugees (i.e., left due to fear of persecution). This sociological classification was independent of legal immigration status since, unlike some other refugee groups, Iranians were not granted refugee status categorically. On the basis of their motivation or main reason for leaving Iran, fewer than half (43 percent) of the Iranians surveyed in Los Angeles were classified as exiles or political refugees, and over half (57 percent) were classified as immigrants.[10] This critical finding indicates that the categorical labeling of all postrevolutionary Iranians as exiles is misleading both in scholarly works and in popular culture.

Moreover, we found significant differences in the demographic and socioeconomic characteristics of Iranian exiles/refugees and immigrants, which invariably affected their subsequent adaptation to American society. Compared to immigrants, exiles/refugees were more likely to have migrated with their family members, to intend to return to Iran, and to include more members of the persecuted religious minorities in Iran (especially Baha'is and Jews). The often-exaggerated stories that circulate in the Iranian community about the drastically downward occupational mobility of exiles are misleading. The results of our survey of Iranians in Los Angeles clearly show that exiles had more difficulty than immigrants in transferring their occupations from Iran to the United States. However, both groups shared the same concerns about the lack of availability of capital and incompatibility of qualifications between the Iranian and American labor markets. Furthermore, despite their perceived downward mobility, exiles were not more likely to be dissatisfied with their current jobs and incomes than immigrants.[11]

In addition to trying social and economic adjustment issues, exiles also faced cultural and psychological problems. These problems loomed even larger for a relatively economically well-off group like Iranians. Using cultural theory, Naficy's important research on Iranian television in Los Angeles documented the preoccupation of Iranians with their homeland.[12] With the obvious exception of Hispanic programming, Iranian immigrants produced more programs than any other ethnic group in Los Angeles over the course of the 1980s (many Asian programs were produced overseas).[13] This is quite remarkable given that the Iranian population was at the bottom of the list of the top ten largest foreign-born groups in the Los Angeles region at the time. Ironically, a preoccupation with Iran resulted in a neglect of empirical research on the Iranian community itself in exile.

Pioneering Works on Iranian Immigrants

Paralleling their migration patterns, research and writings on Iranians in the United States can also be divided into pre- and postrevolutionary waves. The

Iranian Revolution ushered a large influx of Iranians into the United States, making studies of this group more significant than they had been before, when Iranians for the most part consisted of temporary visitors (i.e., students, tourists). Before the revolution, Iranian students majored in engineering more than in any other academic field of study.[14] After the revolution, more Iranian students (including this author) began turning their attention to the humanities and social sciences in order to grapple with what had happened in their homeland. However, given the postrevolutionary turmoil, it was not feasible for the majority of these graduate students to return to Iran to conduct research for their dissertations. Under the circumstances, they turned their attention to Iranian exiles and immigrants in the United States as viable alternative subjects for research, especially since they were virtually unstudied at the time. As a rule, immigrant scholars are the first to take an interest in their own group, and the fact that Iranians comprised the largest foreign-student population in the United States in 1980 meant that there was a large pool of candidates to study this immigrant group.[15]

Very little had been published about Iranians in the United States before the Iranian Revolution. As noted above, the Iranian population at the time consisted mainly of college and university students, some of whom had remained in the United States after completing their studies. Therefore, early research focused on Iranian students and the migration of professionals (mostly engineers and physicians) as an example of the phenomenon known as brain drain. In the first half of the 1970s, physicians accounted for about one-third of the Iranian professionals admitted to the United States.[16] Although many dissertations were written on this population, often by Iranian students themselves, these dissertations mostly remain unpublished.

The first article about Iranians in the United States appeared in the *Harvard Encyclopedia of American Ethnic Groups* in 1980.[17] Iran historians Lorentz and Wertime produced an insightful article about this population, despite the limited availability of research material to cover all the topics typically discussed in an encyclopedia entry. Ansari's early dissertation was published in 1988 as the first English-language book on Iranians in the United States.[18]

The second, postrevolutionary wave of Iranian immigration initially spurred a new trend in research on Iranians in the United States. To a large extent, the geographical concentration of Iranians determined where this research was conducted. Consequently, the bulk of research and writings in the late 1980s and early '90s was about Iranians in California and, more specifically, Los Angeles, where the largest concentrations of Iranians in the United States still reside. Kelley and Friedlander compiled an impressive and collectible illustrated book, containing 159 photos accompanied by extensive text written by contributors engaged in research on Iranians in Los Angeles.[19]

Another edited volume dealt with Iranian immigrants and refugees more generally, but four chapters (8–10 and 13) focused on Iranians in the United States.[20] Hamid Naficy's innovative dissertation was also published as a book and dealt with Iranian exile television and popular culture in Los Angeles as a means of recreating Iranian identity and culture.[21]

Population Size and Settlement Patterns

As mentioned above, this chapter makes use of data collected by the US Census Bureau, specifically the ACS, which is administered to a representative sample of the population each year. Our previous analyses of the ACS one-year (2012) and ACS three-year (2009–11) files shed light on the scope and distribution of Iranians across the country. The US Census counted 121,900 Iranians in 1980, 225,936 in 1990, 336,935 in 2000, and 470,341 in 2010. The 2010 population size reveals an increase of about 40 percent since 2000 and is almost four times the population size of Iranians in the United States in 1980. Iranian American community members often claim that there are far more Iranians in the United States, with some estimates exceeding one or even two million. However, the consistent findings of the census from 1980 to 2010 suggest that the US Census population estimates may well be accurate. It is safe to say that there are about half a million Iranians currently living in the United States.

In terms of geographical distribution and settlement patterns, Iranians are highly concentrated in relatively few areas of the country, with the overwhelmingly largest proportion residing in California. Indeed, California is home to close to half of all Iranian Americans (47.9 percent) and is distantly followed by Texas (7.0 percent) and New York (6.5 percent). A large percentage of Iranians are also found in the combined states of Maryland, Virginia, and Washington, DC (8.1 percent). There are virtually no Iranian Americans in the central northwest area of the country (e.g., Montana, North Dakota, South Dakota) or in the far northeast region (e.g., Maine, New Hampshire).

Iranians have congregated in major cities and metropolitan regions. The Los Angeles–Long Beach metropolitan area in California alone is home to approximately one quarter of all Iranian Americans. Another 9.7 percent live in the San Francisco Bay metropolitan area, 8.0 percent live in other metropolitan areas of California, and 7.1 percent live in the New York City–Northeastern New Jersey metropolitan area. Other heavily populated metropolitan areas were in Texas (6.8 percent), including Austin, Dallas–Fort Worth, Houston–Brazoria, and San Antonio. The Washington, DC metropolitan area also comprises 5.7 percent of the population. An analysis of the ACS merged data on the geographical distribution of first- versus second-generation Iranians suggests

that the latter may be moving away from these metropolitan centers with high Iranian American concentrations.

Education and Occupation

Quantitative analyses have repeatedly found that Iranians have some of the highest levels of education among ethnic groups in the United States and have higher average incomes than the US population overall. Even more significantly, research has shown that Iranian income levels are comparable to, or higher than, those of the native-born white population (the segment of the US population that is traditionally most advantaged in the labor market).[22] The ACS merged data confirm these prior findings: 63.5 percent of Iranian American males and 52.8 percent of Iranian American females had a bachelor of arts or higher degree. For the native-born white population, the comparable percentages are 31.8 percent for males and 30.2 percent for females, meaning that the percentages of Iranians with a BA or higher degree were almost double for males and significantly higher for females as well. Looking at education levels above a BA, 33.4 percent of males and 21.9 percent of females had a master's or doctoral degree. There were notable differences in the gender gap between first-generation and second-generation Iranians. While females in the first generation had lower levels of education than males (47.2 percent with a BA or higher degree compared to 63.4 percent), the relationship was markedly different for the second generation. Among second-generation Iranian Americans, 71.8 percent of females have a BA or higher compared to 63.7 percent of males. Given that the percentage for males is basically the same across both generations, the trend was clearly due to a substantial increase in the educational attainment of second-generation female Iranian Americans.[23]

Average income levels are also very high among Iranian Americans. The mean income for employed working-age males was about $78,000 (median: $55,000) and about $53,000 for employed working-age females (median: $36,000). As discussed below, major driving factors behind these high incomes were the entrepreneurial and professional occupations they held. Iranian Americans have a relatively high rate of self-employment—close to 21 percent of the employed population was self-employed—that is more than double the percentage of the overall US population (9.8 percent). The most common occupations for Iranian Americans fell into the categories "Sales and Related Occupations" (16.4 percent) and "Management, Business, and Financial Occupations" (19.5 percent). Other large categories were "Education, Legal, Community Service, Arts, and Media Occupations" (13.7 percent) and "Service Occupations" (9.2 percent). Very small percentages of

Iranian Americans were in "Production, Transportation, and Material Moving Occupations" (5.1 percent) and "Natural Resources, Construction, and Maintenance Occupations" (4.5 percent).

These data underscore the fact that Iranians are unusual even among their contemporary (post-1965) immigrants to the United States, in that they consist of both entrepreneurs and professionals. Some groups, such as Asian Indians, typify immigrant professionals, whereas others (e.g., Koreans) are typically immigrant entrepreneurs. The unique historical circumstances of Iranian migration to the United States, combined with its composition of mostly former college students and elite exiles as well as ethnoreligious "middleman minorities," have resulted in a peculiar mix of professionals and entrepreneurs. Iranians ranked third in terms of educational attainment and percentage in professional specialty occupations after Asian Indians and Taiwanese. They also ranked third in rates of self-employment after Koreans and Greeks in the United States in 1990.[24] These two paths of economic adaptation are widely regarded as keys to the economic success of immigrants. In our study, we found this to be due in part to Iranian Americans' heavy concentration in self-employed and professional occupations.[25] Yet, based on an analysis of the 1990 US census, we also found that Iranians suffered an earnings disadvantage in Los Angeles when educational levels were taken into consideration.

While the quantitative research to date tells a compelling story of Iranian American success, few studies have analyzed stratification within the Iranian American population or have examined those Iranian Americans who have struggled in the labor market. Despite resounding success in the labor market coupled with high earnings for the group as a whole, 13.2 percent of Iranian Americans were below the federal poverty line, a roughly similar percentage to the US population overall (15.3 percent). Little is known about these individuals and their experiences. There is clear opportunity for future research in this area, especially since the newest wave of Iranian immigrants is not as selective as the old ones.

Self-employment is one of the most debated issues in the immigration literature—for example, the explanation for why some groups, such as Koreans and Iranians, have very high rates of self-employment in comparison to many other groups. Der-Martirosian's quantitatively-sophisticated research showed that the main statistically significant sources of Iranian entrepreneurship among men were previous experience of self-employment in Iran, belonging to a religious minority group in Iran (especially being Jewish), and utilizing economic networks in Los Angeles (i.e., for employee or customer relations, transportation to work, and discounts on merchandise and services).[26] Consistently, she documented empirically that Iranian immigrants who relied on family and co-ethnic ties (i.e., social capital) were more likely to find jobs

within the first year of their arrival in the United States, had higher incomes, and reported higher levels of job satisfaction than those who did not.

More specifically, Der-Martirosian's book explored the economic integration of Iranian immigrants with a focus on the role of social networks. Economic performance was conceptualized in two stages: the initial settlement stage and the long-term settled stage. She measured social capital in terms of the extent to which immigrants had access to and were embedded in economic networks. Her general hypothesis was that economic embeddedness affects how well immigrants perform in the labor market. She defined immigrants' economic embeddedness in terms of the extent to which they utilized kinship and co-ethnic ties to receive and give economic help. During the initial phase, the Iranian immigrants who relied on network ties mainly depended on family members. Family ties often accelerated the job search but did not guarantee access to better paying or more prestigious jobs. Results indicated that Iranian refugees and asylees were the most disadvantaged group during the initial settlement phase.

High educational background, entrepreneurial experience, and the ability to mobilize social networks were all found to contribute to the economic integration of Iranian immigrants in Los Angeles. For the four economic outcome measures—length of time spent looking for initial employment in the United States, shift in occupational status, income, and self-employment—network effects were found to be the most significant determinants. The social capital embedded in kinship and co-ethnic ties significantly affected Iranian immigrants' economic experience in Los Angeles. Economic embeddedness was also found to increase the odds of being self-employed, controlling for all other related variables. In addition to economic embeddedness, premigration self-employment increased the probability of postmigration self-employment in the United States. Although this may appear to be obvious, it is an important finding because premigration data are often not collected and analyzed in immigrant entrepreneurship studies. Compared with Armenians, Baha'is, and Muslims, Jewish Iranians had the highest self-employment rate, controlling for other variables. This significant subgroup effect shows the importance of cultural explanations for immigrant entrepreneurship.[27]

What is most distinctive about Iranian businesses is that, like their residences, they are not geographically concentrated. Iranians do not have what sociologists call an "ethnic enclave economy"—that is, a spatial clustering of enterprises. There is no "Little Tehran" or "Irantown" anywhere in Los Angeles, although the area below Westwood Village comes closest to exemplifying this type of ethnic enclave phenomenon. Iranians proudly use the term "Tehrangeles" to boast about the group's ubiquitous presence throughout the city. On the whole, Iranian businesses are concentrated in different parts of

Los Angeles County, such as Armenian ones in Glendale and others in the San Fernando Valley. Moreover, although many Iranians are self-employed, few Iranian-owned businesses employ co-ethnic workers, another criterion for an ethnic enclave economy.[28] This is mainly due to the selectivity of Iranian migration, resulting in the unavailability of a large working-class pool that could potentially be employed in these businesses as well as the increasingly substantial resources required to emigrate from Iran.

Despite their very high self-employment rate, one major explanation for why there is no Iranian ethnic enclave economy in Los Angeles is the diverse ethnoreligious composition of this immigrant group. Iranians have an ethnic economy but no ethnic enclave economy. An ethnic economy consists of business owners and their co-ethnic employees. Iranians had created not one but several ethnic economies in Los Angeles due to "internal ethnicity."[29] Each Iranian ethnoreligious group operated its own ethnic economy (e.g., Armenian-Iranian ethnic economy) rather than an all-encompassing Iranian ethnic economy. With the exception of Armenians, Iranian business owners were more likely to have Iranian coreligionist partners or co-owners. Armenians often turned to non-Iranian coreligionists because of linguistic commonality. Except for Baha'is, Iranian employers with paid employees were also more likely to hire an Iranian coreligionist than other Iranians. Iranian Jews employed roughly the same proportion of non-Jewish workers as Jewish Iranians partly because, as the most entrepreneurial Iranian subgroup, they were short on employees. The causes for these preferences are numerous: reliance on family members, previous business ties (often forged in Iran), mutual trust, and, conversely, mistrust of outsiders.[30]

Surprisingly, little research has been conducted on Iranian ethnic economies in other major areas of Iranian settlement in the United States (e.g., Washington, DC, and New York), despite an apparently high level of participation in business. The main exception is Mobasher's study of Iranian ethnic economy in the Dallas–Fort Worth metropolitan area.[31] Unlike Los Angeles, where large segments of the Iranian community consist of former middleman minorities such as Jews and Armenians, the Iranian population in Texas is by and large Muslim. Consequently, unlike the Los Angeles ethnoreligious minority groups that were already entrepreneurial in Iran, the Muslim Iranian Texans, who mostly came here as students, have turned to entrepreneurship here in the United States due to a lack of opportunity in the labor market commensurate with their education and skills.[32] Therefore, the disadvantage model of entrepreneurship is more applicable to Muslim Iranians in Texas and, conversely, the cultural explanation is more applicable to the experience of Iranian ethnoreligious minorities in Los Angeles.

Gender and Family

Survey data from the US census and the survey of Iranians in Los Angeles have documented a relatively low labor force participation (LFP) rate among first-generation (immigrant) Iranian women. This LFP rate may have been a function of several factors. First and foremost, given the very low rate of female employment in prerevolutionary Iran, many women did not work for pay before migration and continued to be out of the labor force after settlement in the United States. However, it is important to note that this trend has declined with the passage of time, especially for the US-born second generation. Second, for some women, remaining out of the work force was a family strategy to ensure that their children received the proper parental attention in their upbringing, especially since self-employment forced many Iranian businessmen to spend long hours at work. In the absence of the live-in extended family members and maids available in Iran, the burden of child-rearing and home maintenance fell largely on the shoulders of Iranian women. Although some women found work that was compatible with these family responsibilities, others did not have to.

However, Iranian immigrant women's low LFP rate may be masking certain types of informal employment. Some scholars have argued that Iranian immigrant women's entrepreneurial activity is often tied to the home and that there is no clear distinction between the domestic and the public spheres in the way that there is for men. Iranian women have often combined paying social calls to one another's homes, a cultural carryover from Iran, with transacting business. In this way, Iranian women who are not formally employed can still be engaged in female-dominated occupations in an informal economy. Such women often operate their businesses out of the home, since their work needs to be compatible with childcare and other family responsibilities.[33] Focusing on Iranian women's entrepreneurial activities, important research by Dallalfar in California has documented their active role in family-run and home-operated businesses, contrary to the general perception of Iranian women as economically dependent. However, Dallalfar further argues that husbands, and even wives themselves, did not perceive women's economic activity as their primary role. Rather, they considered their primary role to be that of housewife or mother. This could have potentially contributed to underreporting female employment by heads of household. Moreover, since some women were engaged in the informal economy, in which many of the transactions are in cash, it further contributed to the underreporting of their economic activity.[34] Similarly, Mobasher states that a conspicuous characteristic of Iranian immigrant families was the participation of women either as self-employed, active employees of small family businesses or as wage earners.[35]

Tohidi has further analyzed the implications of women's employment in the general labor market on gender relations, such as women feeling guilty for not spending time with children, family disintegration, and rising incidence of divorce. Her insightful research shows that Iranian immigrant women have more egalitarian views of marital relationships than their male counterparts.[36]

Divorce has become a serious problem in the Iranian community. Contrary to conventional wisdom, Iran had one of the highest divorce rates of all Muslim countries until the 1960s. Although it declined after the introduction of improved family laws in 1963, it climbed again in the late 1980s. In the United States, most of the divorces among Iranians are initiated by Iranian women for reasons such as absence of love, incompatibility, mistreatment, and marrying too young.[37]

Gender and sex roles, more generally, have received considerable research attention.[38] While Iranian men appear to be more acculturated than Iranian women, they nonetheless cling to traditional values regarding the role of women, whereas women have more modern outlooks on this issue.[39] In a series of noteworthy articles based on a random sample of nearly five-hundred Iran-born students at the University of California, Los Angeles, Hanassab compared the attitudes of young Muslim and Jewish Iranians in Los Angeles toward intramarriage versus intermarriage.[40] She found that Muslim attitudes were more open to intermarriage than those of Jews, and the attitudes of males were more liberal than those of females in both groups. Acculturation, religiosity, attitudes toward dating, and gender were all determinants of attitudes toward mate selection. Young Iranian women especially were caught between the traditional values of their parents, favoring arranged marriages, and the liberal values of American society.[41] Such conflicts arose because parents did not grant their offspring total freedom in mate selection. The significance of this study is that it gauged the possibility of intermarriage and subsequent assimilation, though attitudes and behavior did not necessarily match.

More recently, we used quantitative data to analyze educational and employment differences between first- and second-generation Iranian Americans. Our research shows that the second generation had lower rates of self-employment than the first generation, corroborating the general trend among other entrepreneurial groups such as Koreans in the United States. Some of our most notable findings dealt with gender. Second-generation females were found to have attained higher education levels than males, and their incomes, while still much lower, were found to be catching up to those of their male counterparts. Similarly, LFP rates for second-generation females were higher than LFP rates for first-generation females, indicating that many more second-generation females were entering the labor force.[42]

Ethnic Identity and Community

Research on Iranians has led to the coining of the new sociological concept, *internal ethnicity*, which refers to the presence of subgroups within a larger immigrant group.[43] Iranians in major immigrant cities are heterogeneous in terms of their ethnoreligious background. In Los Angeles, they include Muslims as well as sizeable numbers of ethnoreligious minorities from Iran (Armenians, Assyrians, Baha'is, Jews, Zoroastrians). In New York, the major groups tend to be Muslims and Jews. In other metropolitan areas, Muslims seem to predominate.

Internal ethnicity gives Iranians more options for ethnic identity and group affiliation and defines the parameters of ethnic groups and boundaries. Survey research among Iranian immigrants in Los Angeles has shown that internal ethnicity plays a stronger role for Iranians than an all-encompassing Iranian ethnicity. That is, Armenian, Baha'i, Jewish, and Muslim Iranians in Los Angeles associate with their Iranian coreligionists more than they do with other Iranians. Moreover, Armenian and Jewish Iranians have retained their ethnicity more than Baha'i and Muslim subgroups. The Baha'i exceptionalism was in part attributable to their universalistic and integrationist worldview. As a generalization, the Iranian subgroups that were minorities in Iran were less assimilated than the Muslim Iranians in Los Angeles.[44] This was mainly because these subgroups were already minorities in Iran, whereas the Muslims had become a minority in the United States for the first time. Since Iranian Muslims in Los Angeles were highly secular—itself a function of their premigration religiosity—religion did not serve as a major force against the pressures of assimilation.[45]

The view from New York has been slightly different. There was initially some conflict between Iranian Jews, who settled in the affluent suburb of Great Neck in Long Island after the Iranian Revolution, and American Jews mostly over cultural differences, reducing the possibility of Iranian integration into the American Jewish community. As a result, most Iranians in Great Neck did not initially mix with other Jews. Internal ethnicity further divides Iranian Jews in New York City into Mashhadis (originating in the city of Mashhad), and Jews from other parts of Iran (e.g., Tehranis). In the New York City area, there are many Mashhadi Jews, whose unusual history of persecution has encouraged subgroup solidarity. Heavy early concentration in a few entrepreneurial occupations (jewelry, carpets, and the garment trade), primarily in Midtown Manhattan, further contributed to their group solidarity.[46]

Ethnic and religious identity is a particularly complex issue for Iranians. There is more research on this topic among Iranian Jews than other subgroups, especially in Los Angeles and New York. "Tricultural conflict," a term coined

by an Iranian-Jewish respondent, refers to striking a delicate balance between Jewish, Iranian, and American identities. The Jewish component of identity seems to be the strongest for this group. Iranians, especially the youth, outwardly look very Americanized but inwardly are very Persian. Young Iranian Jews reported a desire to maintain their Persian values. They believed their Jewish identity has helped them make the transition into American society. As early as the 1990s, Iranian Jews began realizing that returning to Iran was no longer an option. As a result, young Iranian Jews hoped to integrate into the American Jewish community, thereby moving away from their Iranian identity. They also felt that their period of insularity from American Jews was over. Loss of Persian culture (e.g., speaking Persian, reading Persian poetry) became of secondary importance, as long as they could maintain the family values of Persian culture, which were inseparable from Jewish culture.[47]

Mobasher's research in Texas provides another look at Iranian-American ethnic identity more generally. His work is exceptional in its focus on the role of historical context. He emphasizes the importance of taking both the host society and the sending country into account and of looking at the role of political events and the relationship between the two governments. Iranians who were forced into exile experienced the trauma caused by the revolution and its consequences, yet at the same time they have had to deal with discrimination and scapegoating in the United States after the Iran Hostage Crisis and September 11. Mobasher argues that Iranian immigrants in the United States have dealt with the simultaneous loss of home and exclusion by the host society.[48] To illustrate these points, he used a multimethod approach that drew from extensive field work (interviews, life histories, and participant observation) in Texas as well as quantitative data on Iranian Americans from the INS and the US Census Bureau. *Iranians in Texas* serves as a model for a community study, since it covers a wide range of topics such as politics, gender and family, and ethnic identity.

Mobasher's book addresses the contentious political relationship between the United States and Iran, distorted media images and stereotypes of Iranians, and the profiling and discriminatory policies during the Iran Hostage Crisis and, later, after September 11. The burgeoning post-9/11 literature mostly concerns Arabs and Muslims, so this book fills an important gap in knowledge about the distinctive experience of Iranians. Furthermore, it demonstrates how US immigration policies combined with the negative media images of Iranians and Muslims have hindered Iranian ethnic and political identity formation in the United States, thus negatively affecting the attitudes of many Iranians toward the US government and Americans in general. For example, Mobasher shows how Iranian Americans managed stigma by avoiding speaking Persian in public places, by hiding the fact that they are from Iran, or simply by calling themselves "Persian" rather than Iranian.

Mostofi, on the other hand, treats Iranian-American identity as a combination of American values and Iranian cultural traditions, including the family.[49] She suggests that Iranian Americans have been successful in maintaining their ethnic identity among family and friends while at the same time participating in American civil society and publicly exhibiting their American-ness. Her argument is based on a study of Iranian professionals in Southern California shortly after September 11, 2001. In understanding the ethnic identity of this population, it is important to remember that most upper- and middle-class Iranian Americans were already somewhat Westernized in Iran even before coming to the United States.

Although there are few Iranians in smaller cities and rural areas in the United States, it is not surprising to find some in most college towns given their origins as foreign college students. Gilanshah's interesting research concerned Iranians in the Minneapolis–St. Paul area. Numbering around 1,000 to 1,500 in the 1980s, these Iranians were mostly Muslims and full-time undergraduates. She detected a potential for the emergence of an Iranian community through a merger of the Iranian student colony with the nonstudent Iranian community. Her subsequent research on this population during 1983–89 revealed the presence of an Iranian community in the Twin Cities brought about by the transformation of the student population into an older, married, professional population.[50]

Chaichian perceptively examined the Iranian community in Iowa City, a moderate-sized university setting. In 1990, there were fewer than eight hundred Iranians in Iowa City. Despite such a small number, they formed the Iranian Cultural Association of Iowa. These Iranians were fluent in English and very highly educated, as reflected in their highly skilled professional status (mostly doctors, dentists, computer scientists, and engineers). Contrary to the national trend, however, their self-employment rate was quite low. Despite these characteristics, which were generally conducive to assimilation, Iranians in Iowa City preserved their ethnicity and cultural heritage (e.g., virtually all of the sampled population celebrated Now Ruz or the Persian New Year). However, Iranian ethnicity in this setting was not merely symbolic (i.e., turning to its roots once a year). When it came to ethnic identity, only one person self-identified as American, while two-thirds of the sample studied considered themselves to be Iranian, and another one-third self-identified as Iranian American.[51]

For Iranians as a whole, however, the main source of Iranian ethnicity is becoming increasingly symbolic (recreational) as opposed to instrumental (behavioral). There is a stark contrast between the preoccupation of the first-generation exiles with homeland, retarding their integration, and the apolitical character and relatively rapid assimilation of the second generation.

Ethnic associations emerge to address special needs of immigrant communities and to ease immigrants into American society. What is distinctive about Iranians, though to some extent less so for minorities from Iran, is the relatively low development of grassroots community-based organizations (CBOs) and, when present, their minimal role in immigrants' lives. Compared to other new entrepreneurial and professional immigrant groups, such as Koreans and Asian Indians, Iranians have relatively few ethnic associations or organizations. Moreover, most of the Iranian organizations are cultural and professional in nature as opposed to being grassroots and advocacy-oriented groups.

The striking shortage of CBOs among Iranians has mostly to do with this group's class resources (education, knowledge of English, occupational skills), which obviate the need for collectivism or mutual assistance. Few Iranian associations are set up with these objectives in mind. For instance, about two-thirds of the nascent Iranian organizations in Washington, DC, did not assist Iranian newcomers in America.[52] The goal of the majority of these associations was the preservation of Iranian culture. Few of them had the objective of mutual assistance and helping other Iranians. Nor did these associations play a critical role in any aspect of Iranians' lives.[53]

This picture has changed somewhat over time, as Iranians have come to see America as home and grown roots in this country. In spite of their many contributions to American society and the US economy, Iranians, like other Middle Easterners, have borne the brunt of discriminatory governmental initiatives and societal prejudice in the post-9/11 and Trump eras. Not surprisingly, Iranian Americans have mobilized and established a handful of organizations in response to the backlash.[54] One of the most prominent of these is the Public Affairs Alliance of Iranian Americans (PAAIA), a nonprofit membership organization.[55] Not only does PAAIA engage in advocacy on behalf of Iranians, it also conducts yearly national opinion surveys of Iranian Americans to learn about their attitudes and views of current events, politics, and other topics of interest. While these surveys are not as methodologically rigorous as the ACS, they provide unique data unavailable elsewhere on other aspects of the Iranian-American experience. According to a national public opinion survey of Iranian Americans conducted in 2014, the vast majority of Iranian Americans still had family in Iran. Of these, more than half communicated with those family members regularly.[56] About a quarter of the respondents said that they also traveled to Iran once every two or three years. These indicators of transnationalism, which can be simply defined as regular and sustained contact with the homeland, persist among Iranians in the United States despite their primarily exile status. Over half of the sampled population believed that it is important for more Iranian Americans to run for office

and become elected officials so as to better represent the population in government. This speaks to the growing political incorporation of the Iranian-American community, an important and topical issue that badly needs to be researched.

Discrimination and Prejudice

There are very few social problems associated with Iranian immigrants, yet discrimination and prejudice afflict them perhaps more than many other similarly high-status immigrant groups. This is mostly provoked by the actions of the Iranian regime rather than by Iranian immigrants themselves. Anti-American sentiments in Iran started during the Iranian Revolution and the Iran Hostage Crisis, and such sentiments have continued unabated to this day in conservative circles in Iran. In the newest round of the US-Iran conflict, there have been widespread allegations that the Iranian government is acquiring the raw materials and technology to build nuclear weapons, which has reinvigorated the ongoing diplomatic friction between the two countries.

The Iran Hostage Crisis occurred during 1979–81 when fifty-two Americans at the US Embassy in Tehran were held hostage for 444 days. In November 1979, shortly after the seizure of the embassy in Tehran, President Carter directed the US Attorney General to instruct all Iranian foreign students to report to the INS for registration. Each student, including this author, was required to provide proof of full-time school enrollment and a passport with a valid visa. Iranians who were out of legal status and in violation of their visas were subject to deportation. The hostage crisis prompted a presidential order referred to as the "Iranian Control Program." The program screened, on a case-by-case basis, almost 57,000 Iranian students, the single largest group of foreign students, to make sure that they were in the United States legally. After holding a total of 7,177 deportation hearings, 3,088 students were ordered to leave the United States, and the departure of 445 was verified.[57] The program was not aimed at students only and effectively prohibited the entry of most Iranians into the United States.

Several Iranian students sued the US Government to have the presidential decree overturned. They cited protection of personal rights under the Fifth Amendment to the Constitution and argued that the US Government had unfairly singled out Iranians. In its defense, the government argued that the regulation served "overriding national interests." In 1979, a federal appeals court ruled in favor of the Carter administration, stating that it had the right to screen and deport Iranian illegals who did not report to immigration officials. Shortly after, the Court of Appeals in Washington, DC, overturned this

decision, finding that there was a dubious connection between protecting the lives of American hostages in Iran and singling out Iranians for registration with the INS. Rather, the court argued that the regulation seemed to mainly serve the psychological purpose of appeasing the American public's demand that the United States take action in response to the Iranian Hostage Crisis. When the government appealed, the US Court of Appeals for the DC Circuit Court reversed the lower court's order, noting that the Immigration and Nationality Act had given the Attorney General sufficiently broad authority to screen aliens of certain nationalities.[58]

Ironically, the Iranian Hostage Crisis coincided with a massive influx of Iranian exiles into the United States. Although fewer than one thousand Iranians were actually deported, government policy unfairly targeted and scapegoated Iranian immigrants. Iranian Americans have experienced tensions with the host society every time that conflict has broken out between Iran and the United States ever since. Furthermore, after the World Trade Center attack, Iranians were singled out in the National Security Entry-Exit Registration System (NSEERS) with its provision of special registration. After President George W. Bush designated the Islamic Republic of Iran as part of the "Axis of Evil" in his 2002 State of the Union address, individuals bearing Iranian passports were denied visa issuance and subjected to special registration, even though Iran and Iranians had nothing to do with September 11. Special registration resulted in the arrest and detention in Los Angeles of several hundred Iranians deemed in violation of their visas. In response, Iranians staged one of their largest-ever demonstrations outside the Federal Building in the Westwood area of Los Angeles in 2002.[59] Targeting Iranians reached its apex during President Trump's "Muslim Ban," subsequently redirecting migration from the United States to Canada. As a result, in a nod to "Tehrangeles," Canada now has its own "Tehranto" in Toronto, Ontario.

A small but notable body of quantitative research has attempted to analyze discrimination toward Iranian Americans and other Middle Eastern groups, especially in terms of discrimination in the labor market. The survey of Iranians in Los Angeles in the late 1980s showed that 20 percent of the respondents experienced discrimination in finding a job and getting promoted. The perception of prejudice, however, was much higher than experienced discrimination (50 percent). More recent studies on labor market discrimination have compared the employment and earnings of Iranian Americans and other Middle Easterners pre- and post-9/11. These studies have on the whole found some level of discrimination, but specific findings have been mixed concerning the extent of discrimination and the enduring effect of discrimination several years after the September 11 attacks. The consensus of the research seems to be that Iranian Americans and other Middle Eastern groups experienced some

discrimination in earnings directly following September 11, but that the effect seemed to have faded after a few years. The experience of discrimination was felt most by young men, the demographic group most similar to the individuals that carried out the September 11 attacks.[60]

Discrimination against Iranian Americans has been largely based on a societal perception linking Iran with Islamic fundamentalism and state-sponsored terrorism. For example, Iranian exiles who fled to the United States during and after the Iranian Revolution faced targeting and scapegoating despite their exile status, which itself reflected their disapproval of and opposition to the newly established Islamic Republic of Iran. Furthermore, the perception of Iranian immigrants and exiles as Islamic fundamentalists is made even more ironic by the fact that many Iranians in the United States are not even Muslim. In fact, religious minorities such as Christians (mostly Armenians and Assyrians), Baha'is, Jews, and Zoroastrians are overrepresented among the Iranian population in the United States.

Besides PAAIA, which was mentioned above, and its Iranian American Political Action Committee (IAPAC), two other Iranian American organizations became particularly active after September 11 in defending the civil rights of Iranians in the United States: the National Iranian American Council (NIAC) and the Iranian American Bar Association (IABA). While the latter was established before September 11, 2001, its programs and activities took off afterward. In 2004, IABA published an important report on the implementation of the special registration program. This report detailed the abuse and violation of the rights of thirty-four Iranians who were detained.[61] Iranian Americans have come to realize that the strategy of passing as non-Iranians or disassociating themselves from the Iranian regime does not protect them against hostility in the United States.

The Second Generation

By definition, first-generation immigrants include those who were born abroad and immigrated to the United States at age thirteen or older. The second generation consists of those who have at least one foreign-born parent and who were themselves either born in the United States or immigrated at age twelve or younger.[62] Most research on Iranian youth has concerned the population born in Iran and who immigrated to the United States at a young age. Since many of these children fall under the age of thirteen, they make up what immigration scholars have called the 1.5 generation. Despite the burgeoning social science literature on the second generation in the United States in general, there are only a handful of such works on second-generation Iranian

Americans. In this last section, I review the key findings of relevant existing studies on the educational and occupational trajectories, as well as the ethnic identity, of second-generation Iranians.

Although there is a dearth of research about the academic performance of Iranian students, the consensus is that Iranian-American youth do well in school. Higgins conducted a pioneering study of the academic performance of Iranian youth in Northern California, as measured by grade point averages, to assess adjustment and success in American schools. For this study, thirty-two adolescents were interviewed, and separate supplemental interviews were conducted with at least one of their parents. Although parents had high expectations for their children's education, Higgins found little evidence of tension and stress between immigrant parents and their adolescent children, since there was mutual agreement on expectations to achieve and excel. Parental anxiety, when it existed, was mostly caused by their children not performing well enough academically in high school. Ironically, and consistent with findings on other groups, the second-generation students who had the most difficulty academically had assimilated to the cultural norms of their American peers often against the wishes of their parents. On the other hand, those who had not become assimilated (i.e., who knew their ethnic language and had co-ethnic peers), were more successful academically.[63]

In another study of education among Iranian-American youth, Hoffman meticulously examined a secondary school in Los Angeles with a large population of Iranian students. She found that the school fell short of acknowledging these students' national origin, especially in the aftermath of conflict with Iran, by neither recognizing Iranian national holidays nor including the Persian language. What was worse, Iranians were collectively viewed negatively by the teachers, although the problem was not a lack of academic ambition or poor performance. The problem mostly centered on these students' perceived lack of respect for the school's rules and regulations. Iranians resisted the implicit educational mission of the school (i.e., to inculcate a commitment to American culture) and steadfastly maintained their affiliation with Iran. They devised various modes of resistance to overcome what they perceived as the school's preoccupation with rules and regulations. The teachers, in turn, perceived these actions as bypassing the rules. As one student put it to other Iranians: "This is America. Speak Persian!"[64] These problems escalated to the point that teachers became concerned that Iranian students' actions were provoking anti-Iranian racism among other students, predominantly those of a Latino background but also those identifying as African Americans.

As these students have by now come of age, researchers should turn their attention to the educational attainment and occupational achievement of the second generation. Given the high levels of education, professional specialty,

and entrepreneurship of Iranian immigrant parents, it would be very interesting to examine the extent of intergenerational mobility among this population. The scholarly consensus is that children of middle-class (entrepreneurial and professional) immigrants start their education with an advantage and are likely to move into professional careers.[65] While it is common for immigrant parents to emphasize the importance of education, those with high levels of human capital (education, occupation, and skills) can more easily transfer those advantages to their children. Additionally, the direct and indirect pressures of family and community push the second generation toward higher education and the pursuit of prestigious professional occupations. Iranian parents tend to be very involved in their children's education because they see education as the road to success and prestige. The second generation internalizes these values and becomes very motivated to excel in school and to choose professional occupations likely to earn them respect in the Iranian community. As documented above, Iranian parents are often both college educated, the most important determinant of children's educational attainment. Moreover, the fathers usually have high earnings, giving the mothers the flexibility to stay at home to supervise their children's upbringing as a family strategy. The combination of parental educational and financial resources allows them to be more involved in their children's lives as well as to afford quality education and oversight of academic performance.

Generally, second-generation youth from most immigrant groups view education as a way to repay parental sacrifices associated with immigration to a new land. Moreover, middle-class immigrant parents' initial struggles to regain their premigration status can further serve as motivation for children to strive and succeed. This is especially true for skilled and educated foreign-born exiles like Iranians, who, at least initially, often experience more downward mobility than economic migrants.

In her novel book, Shavarini describes a qualitative study she conducted of a religiously diverse sample of thirty undergraduate Iranian students in New England and New York. She focused on factors that influenced their educational achievement. Her key findings were that parental education, employment, and income were strong predictors of children's academic achievement. While both fathers and mothers had high levels of education, fathers more often held high-status jobs. Parents were very involved in their children's schooling and pressured them to do well. They socialized their children accordingly and expected them to pursue higher education, particularly in the fields of math and science. Parents also encouraged children to improve their English in order to do well in school. In turn, the second generation perceived education as a way to advance socioeconomically, garner respect, and even dispel the "terrorist" image associated with Iranians.[66]

Bozorgmehr, Miller, and Hanassab conducted a study that examined educational goals and occupational aspirations of second-generation Iranians. Based on interviews with a diverse sample of thirty-eight second-generation Iranian undergraduate students at a university in Los Angeles, they explored the role of parents and the Iranian ethnic community in the second generation's choices of educational majors and occupations. They documented a strong proclivity toward high levels of educational and occupational attainment. Regardless of academic major, the vast majority of the respondents aimed to obtain advanced degrees in professional fields in order to become doctors, dentists, and lawyers.[67]

Contrary to the tenets of assimilation theory, which holds that immigrants and their descendants must abandon their cultural heritage to move up the economic ladder, the consensus from current research on the second generation is that educational and occupational achievement need not come at the expense of ethnic identity and ethnic attachment. Successful integration often depends on ties to the family and ethnic community because they offer valuable support and resources, even in the absence of parental human capital.[68] Studies on Iranian-American youth seem to indicate that many maintain their ethnic identities while making significant academic progress.[69]

In general, intermarriage is the litmus test of assimilation, which is defined by Alba and Nee as the blurring of ethnic boundaries among groups.[70] This is especially true in the second generation and beyond. Early studies on Iranians focused on dating preferences of the youth and spousal preferences of their immigrant parents. However, attitude is not a perfect predictor of behavior, especially when it comes to marriage. As this population has come of age, research is now needed on endogamy (intramarriage) and exogamy (intermarriage) to ascertain the extent of intermarriage among second-generation Iranians as a whole and its ethnoreligious subgroups. In general, Iranian Muslims, including the second generation, have been more open to intermarriage than are ethnoreligious minorities (e.g., Armenians and Jews) from Iran.[71] Thus, they are more likely to follow the traditional assimilationist path into mainstream American society. One study showed different attitudes toward intermarriage for young Muslim and Jewish Iranians in Los Angeles.[72] Reflecting a more Americanized attitude, Muslims were more open to intermarriage than Jews. Regardless of religion, young Iranian women, more than their male counterparts, were caught between the traditional values of their parents, who favored arranged marriages, and the liberal values of American society. In such cases, conflicts arose because parents did not grant their offspring total freedom in mate selection.[73]

Although there is still very little research on the ethnicity and ethnic identity of second-generation Iranians, preliminary results of a sample survey by Mahdi showed that about half of 1.5- and second-generation Iranians identified

themselves as Iranian American, another one-third as Iranian, and only 10 percent as American. Unsurprisingly, identification with Iranian ethnicity was stronger in areas of high Iranian concentration (e.g., California). Therefore, regionally focused studies are needed to assess the ethnic identities of the second-generation Iranians and the direction of ethnic change among this segment of the population. The study by Bozorgmehr, Miller, and Hanassab mentioned above also found a strong attachment to being Iranian, regardless of the religious background of the second-generation respondents (mostly Muslim and Jewish). Remarkably, only one out of thirty-eight respondents reported an "American only" ethnic identity.[74]

In her timely doctoral dissertation, Komaie examines self-identification among 1.5- and second-generation Iranians in Southern California based on fifty-one in-depth interviews.[75] The findings suggest that tense US-Iran relations influence the way the members of the second generation self-identify. As was the case for Iranian exiles who arrived after the Iranian Revolution, the second generation has also been likely to assert a Persian identity that de-emphasizes association with the Islamic Republic of Iran in the post-9/11 era. Similarly, Mobasher develops a typology of the contested and problematic ethnic identity issues faced by second-generation Iranian Americans.[76] While Mobasher is somewhat pessimistic about the identity retention of second-generation Iranians, Maghbouleh on the other hand has argued that certain activities, such as participation in summer camps organized by and for the Iranian youth, provide the context for reaffirming Iranian national identity.[77]

The fate of the second generation is not simply an academic issue, as the future of the Iranian American community is at stake. If second-generation Iranian subgroups identify more with their ethnoreligious background (e.g., Armenian, Jewish) than with being Iranian, it could result in further fragmentation of the community. Because Iranian ethnoreligious subgroups are concentrated in large metropolitan areas, often with sizable non-Iranian coreligionist populations (e.g., Jews in Los Angeles and New York), Iranian subgroups are vulnerable to integration into the wider coreligionist group and the mainstream. The Iranian population is not large enough to offset such a loss. Nor is Iranian immigration substantial enough to replenish this population. Naficy has argued that Iranian popular culture in exile transcends internal ethnicity and cuts across all subgroups by serving the needs of at least the Persian-speaking Iranians (Baha'is, Muslims, Jews, etc.).[78] While this may be true for first-generation immigrants, it is unlikely that Iranian popular culture will have the same effect on the second generation, as this group is far more exposed to American popular culture. It certainly will not be a factor for second-generation Christian Armenian and Assyrian Americans of Iranian

ancestry, who have little knowledge of Persian. Technological change may forge greater communication among Iranians in the United States, as shown by the nascent Iranian cyber community,[79] but it does not seem that this alone will be enough to retard assimilation. US-born Iranians have increasingly been attending universities and entering the labor market, getting married and raising children while still negotiating their ethnicity, identity, and place in American society in the shadow of the strained US-Iran relationship.

Notes
The analysis of the American Community Survey data on Iranian Americans was made possible by a grant from the American Institute for Iranian Studies. I thank Diana Strumbos for her help with data analysis and Terese Lyons and Sarah Tosh for their indispensable assistance in preparing the chapter.
1. Bozorgmehr, "Iranians" (1996).
2. United States Census Bureau, *Design and Methodology*.
3. Bozorgmehr, "Iranians" (1997).
4. Bozorgmehr and Sabagh, "High Status Immigrants."
5. Bozorgmehr, "Iran."
6. See also Public Affairs Alliance of Iranian Americans, *Iranian Americans*.
7. For an early exception, see Momeni, "Size and Distribution."
8. Sabagh and Bozorgmehr, "Are the Characteristics of Exiles Different."
9. Bozorgmehr and Sabagh, "Survey Research."
10. Bozorgmehr and Sabagh, "Iranian Exiles."
11. Bozorgmehr and Sabagh, "Iranian Exiles."
12. Naficy, "Identity Politics."
13. Naficy, *Making of Exile Cultures*.
14. Askari, Cummings, and Izbudak, "Iran's Migration."
15. Bozorgmehr and Sabagh, "High Status Immigrants."
16. Askari, Cummings, and Izbudak, "Iran's Migration," table 16.
17. Lorentz and Wertime, "Iranians."
18. Ansari, *Iranian Immigrants*. See also Ansari, "Community in Process."
19. Kelley and Friedlander, *Irangeles*.
20. Fathi, *Iranian Exiles and Refugees*.
21. Naficy, *Making of Exile Cultures*.
22. Bozorgmehr, "Iran."
23. Bozorgmehr and Douglas, "Success(ion)."
24. Portes and Rumbaut, *Immigrant America*, tables 4, 7, and 9.
25. Bozorgmehr, Der-Martirosian, and Sabagh, "Middle Easterners."
26. Der-Martirosian, *Iranian Immigrants in Los Angeles*.
27. Der-Martirosian, *Iranian Immigrants in Los Angeles*.
28. Light et al., "Beyond the Ethnic Enclave Economy."
29. Bozorgmehr, "Internal Ethnicity."
30. Light et al., "Internal Ethnicity in the Ethnic Economy."
31. Mobasher, "Iranian Ethnic Economy in the United States."
32. Mobasher, *Iranians in Texas*.
33. Dallalfar, "Iranian Women as Immigrant Entrepreneurs."

34. Dallalfar, "Iranian Ethnic Economy in Los Angeles." Similar arguments are made in Moallem, "Ethnic Entrepreneurship."
35. Mobasher, "Iranian Ethnic Economy in the United States."
36. Tohidi, "Iranian Women and Gender Relations."
37. Tohidi, "Iranian Women and Gender Relations."
38. In addition to the studies discussed, see Hanassab, "Sexuality."
39. Ghaffarian, "Acculturation of Iranians in the United States."
40. Hanassab and Tidwell, "Intramarriage and Intermarriage."
41. Hanassab and Tidwell, "Cross-Cultural Perspective."
42. Bozorgmehr and Douglas, "Success(ion)."
43. Bozorgmehr, "Internal Ethnicity."
44. Bozorgmehr, "Internal Ethnicity."
45. Sabagh and Bozorgmehr, "Secular Immigrants."
46. Ungar, "We Know Who We Are." For more information on New York's Mashhadi community, see Nissimi, "From Mashhad to New York."
47. Feher, "From the Rivers of Babylon."
48. Mobasher, *Iranians in Texas*.
49. Mostofi, "Who We Are."
50. Gilanshah, "Formation of Iranian Community."
51. Chaichian, "First Generation Iranian Immigrants."
52. There were thirty-seven Iranian associations in the Washington metropolitan area in 1987.
53. BiParva, "Ethnic Organizations."
54. Bakalian and Bozorgmehr. *Backlash 9/11*.
55. Public Affairs Alliance of Iranian Americans, *Iranian Americans*.
56. Public Affairs Alliance of Iranian Americans, *National Public Opinion Survey*.
57. Bozorgmehr, "Does Host Hostility Create Ethnic Solidarity?"
58. Bozorgmehr, "Iran."
59. Bakalian and Bozorgmehr. *Backlash 9/11*.
60. Bakalian and Bozorgmehr. *Backlash 9/11*.
61. Iranian American Bar Association, *Review of the Treatment of Iranian Nationals*.
62. Portes and Rumbaut, *Immigrant America*.
63. Higgins, "Intergenerational Stress."
64. Hoffman, "Cross-Cultural Adaptation and Learning."
65. Portes and Rumbaut, "Forging of a New America."
66. Shavarini, *Educating Immigrants*.
67. Bozorgmehr, Miller, and Hanassab, "Goals and Aspirations."
68. Portes and Rumbaut, *Immigrant America*.
69. Mahdi, "Ethnic Identity."
70. Alba and Nee, *Remaking the American Mainstream*.
71. Bozorgmehr, "Internal Ethnicity."
72. Hanassab and Tidwell, "Intramarriage and Intermarriage."
73. Hanassab, "Sexuality."
74. Bozorgmehr, Miller, and Hanassab, "Goals and Aspirations."
75. Komaie, "Persian Veil."
76. Mobasher, "Cultural Trauma."
77. Maghbouleh, "*Ta'arof* Tournament."
78. Naficy, *Making of Exile Cultures*.

79. Nazeri, "Imagined Cyber Communities," 158–64.

Bibliography

Alba, Richard, and Victor Nee. *Remaking the American Mainstream: Assimilation and Contemporary Immigration*. Cambridge: Harvard University Press, 2003.

Ansari, Abdoulmaboud. "A Community in Progress: The First Generation of the Iranian Professional Middle-Class Immigrants in the United States." *International Review of Modern Sociology* 7 (1977): 85–101.

———. *Iranian Immigrants in the United States: A Case Study of Dual Marginality*. Millwood, NY: Associated Faculty, 1988.

Askari, Hossein, John T. Cummings, and Mehmet Izbudak. "Iran's Migration of Skilled Labor to the United States." *Iranian Studies* 10 (1977): 3–39.

Bakalian, Anny, and Mehdi Bozorgmehr. *Backlash 9/11: Middle Eastern and Muslim Americans Respond*. Berkeley: University of California Press, 2009.

BiParva, Ebrahim. "Ethnic Organizations: Integration and Assimilation vs. Segregation and Cultural Preservation with Specific Reference to the Iranians in the Washington, DC Metropolitan Area." *Journal of Third World Studies* 11 (1994): 369–404.

Bozorgmehr, Mehdi. "Does Host Hostility Create Ethnic Solidarity? The Experience of Iranians in the United States." *Bulletin of the Royal Institute for Inter-Faith Studies* 2 (2000): 159–78.

———. "Internal Ethnicity: Iranians in Los Angeles." *Sociological Perspectives* 40 (1997): 387–408.

———. "Iran." Pages 469–78 in *The New Americans: A Guide to Immigration Since 1965*. Edited by Mary Waters, Reed Ueda, and Helen Marrow. Cambridge: Harvard University Press 2007.

———. "Iranians." Pages 213–31 in *Refugees in America in the 1990s: A Reference Handbook*. Edited by David W. Haines. Westport, CT: Greenwood, 1996.

———. "Iranians." Pages 442–48 in *Encyclopedia of American Immigrant Culture*. Edited by David Levinson. New York: MacMillan, 1997.

Bozorgmehr, Mehdi, Claudia Der-Martirosian, and Georges Sabagh. "Middle Easterners: A New Kind of Immigrant." Pages 345–78 in *Ethnic Los Angeles*. Edited by Roger Waldinger and Mehdi Bozorgmehr. New York: Russell Sage, 1996.

Bozorgmehr, Mehdi, and Daniel Douglas. "Success(ion): Second-Generation Iranian Americans." *Iranian Studies* 43 (2010): 3–24.

Bozorgmehr, Mehdi, Elizabeth Miller, and Shideh Hanassab. "Goals and Aspirations of Second Generation Iranian Americans in the Context of Cultural Expectations." Unpublished paper, 2014.

Bozorgmehr, Mehdi, and Georges Sabagh. "High Status Immigrants: A Statistical Profile of Iranians in the United States." *Iranian Studies* 21.3–4 (1988): 5–36.

———. "Iranian Exiles and Immigrants in Los Angeles." Pages 121–44 in *Iranian Exiles and Immigrants Since Khomeini*. Edited by Asghar Fathi. Costa Mesa, CA: Mazda, 1991.

———. "Survey Research Among Middle Eastern Immigrants in the U.S.: Iranians in Los Angeles." *Middle East Studies Association Bulletin* 23 (1989): 23–34.

Chaichian, Mohammad. "First Generation Iranian Immigrants and the Question of Cultural Identity: The Case of Iowa." *International Migration Review* 31.3 (1997): 612–27.

Dallalfar, Arlene. "The Iranian Ethnic Economy in Los Angeles: Gender and Entrepreneurship." Pages 107–28 in *Family and Gender Among American Muslims*. Edited by Barbara Aswad and Barbara Bilge. Philadelphia: Temple University Press, 1996.

———. "Iranian Women as Immigrant Entrepreneurs." *Gender and Society* 8 (1994): 541–61.

Der-Martirosian, Claudia. *Iranian Immigrants in Los Angeles: The Role of Networks and Economic Integration*. New York: LFB Scholarly Publishing, 2008.

Fathi, Asghar, ed. *Iranian Exiles and Immigrants Since Khomeini*. Costa Mesa, CA: Mazda, 1991.

Feher, Shoshanah. "From the Rivers of Babylon to the Valleys of Los Angeles: The Exodus and Adaptation of Iranian Jews." Pages 71–94 in *Gatherings in Diaspora*. Edited by R. Stephen Warner and Judith G. Wittner. Philadelphia: Temple University Press, 1998.

Ghaffarian, Shireen. "The Acculturation of Iranians in the United States." *Journal of Social Psychology* 127 (1987): 565–71.

Gilanshah, Farah. "The Formation of Iranian Community in the Twin Cities from 1983–89." *Wisconsin Sociologist* 27 (1990): 11–17.

Hanassab, Shideh. "Sexuality, Dating, and Double Standards: Young Iranian Immigrants in Los Angeles." *Iranian Studies* 31.1 (1998): 65–76.

Hanassab, Shideh, and Romeria Tidwell. "Cross-Cultural Perspective on Dating Relationships of Young Iranian Women: A Pilot Study." *Counseling Psychology Quarterly* 6 (1989): 281–89.

———. "Intramarriage and Intermarriage: Young Iranians in Los Angeles." *International Journal of Intercultural Relations* 22.4 (1998): 395–408.

Higgins, Patricia. "Intergenerational Stress: Parents and Adolescents in Iranian Immigrant Families." Pages 189–213 in vol. 5 of *Beyond Boundaries: Selected Papers on Refugees and Immigrants*. Edited by Diane Baxter and Ruth Krulfeld. American Anthropological Association, Arlington: 1997.

Hoffman, Diane M. "Cross-Cultural Adaptation and Learning: Iranians and Americans at School." Pages 163–80 in *School and Society: Learning Content Through Culture*. Edited by Henry T. Touba and Concha Delgado-Gaitan. New York: Praeger, 1988.

Iranian American Bar Association. *A Review of the Treatment of Iranian Nationals by the INS in Connection with the Implementation of NSEERS Special Registration Program*. Washington, DC: IABA, 2004.

Kelley, Ron, Jonathan Friedlander, and Anita Colby, eds. *Irangeles: Iranians in Los Angeles*. Berkeley: University of California Press, 1993.

Komaie, Golnaz. "The Persian Veil: Ethnic and Racial Self-identification Among the Adult Children of Iranian Immigrants in Southern California." PhD diss., University of California, Irvine, 2009.

Light, Ivan, Georges Sabagh, Mehdi Bozorgmehr, and Claudia Der-Martirosian. "Beyond the Ethnic Enclave Economy." *Social Problems* 41 (1994): 65–80.

———. "Internal Ethnicity in the Ethnic Economy." *Ethnic and Racial Studies* 16 (1993): 581–97.

Lorentz, John H., and John T. Wertime. "Iranians." Pages 521–24 in *Harvard Encyclopedia of American Ethnic Groups*. Edited by Stephen Thernstrom. Cambridge: Harvard University Press, 1980.

Maghbouleh, Neda. "The *Ta'arof* Tournament: Cultural Performances of Ethno-National Identity at a Diasporic Summer Camp." *Ethnic and Racial Studies* 36.5 (2013): 818–37.

Mahdi, Ali Akbar. "Ethnic Identity Among Second-Generation Iranians in the United States." *Iranian Studies* 31.1 (1998): 77–95.

Moallem, Mino. "Ethnic Entrepreneurship and Gender Relations Among Iranians in Montreal, Quebec, Canada." Pages 180–202 in *Iranian Refugees and Exiles Since Khomeini*. Edited by Asghar Fathi. Costa Mesa, CA: Mazda, 1991.

Mobasher, Mohsen. "Cultural Trauma and Ethnic Identity Formation Among Iranian Immigrants in the United States." *American Behavioral Scientist* 50 (2006): 100–17.

———. "The Iranian Ethnic Economy in the United States." Pages 228–48 in *The Handbook of Research on Ethnic Minority Entrepreneurship*. Edited by Léo-Paul Dana. Cheltenham: Elgar, 2007.

———. *Iranians in Texas: Migration, Politics, and Ethnic Identity*. Austin: University of Texas Press, 2012.

Momeni, Jamshid. "Size and Distribution of Iranian Ethnic Group in the United States." *Iran Nameh* 2 (1980): 17–21.

Mostofi, Nilou. "Who We Are: The Perplexity of Iranian-American Identity." *Sociological Quarterly* 44.4 (2003): 681–703.

Naficy, Hamid. "Identity Politics and Iranian Exile Music Videos." *Iranian Studies* 31.1 (1998): 51–64.

———. *The Making of Exile Cultures: Iranian Television in Los Angeles*. Minneapolis: University of Minnesota Press, 1993.

Nazeri, Haleh. "Imagined Cyber Communities, Iranians and the Internet." *Middle East Studies Association Bulletin* 30.2 (1996): 158–64.

Nissimi, Hilda. "From Mashhad to New York: Family and Gender Roles in the Mashhadi Immigrant Community." *American Jewish History* 93.3 (2007): 303–28.

Portes, Alejandro, and Ruben Rumbaut. "The Forging of a New America: Lessons for Theory and Policy." Pages 301–17 in *Ethnicities: Children of Immigrants in America*. Edited by Ruben Rumbaut and Alejandro Portes. Berkeley: University of California Press, 2001.

———. *Immigrant America: A Portrait*. 3rd ed. Berkeley: University of California Press, 2006.

Public Affairs Alliance of Iranian Americans. *Iranian Americans: Immigration and Assimilation*. Washington, DC: PAAIA, 2014.

———. *2014 National Public Opinion Survey of Iranian Americans*. Washington, DC: PAAIA, 2014.

Sabagh, Georges, and Mehdi Bozorgmehr. "Are the Characteristics of Exiles Different from Immigrants? The Case of Iranians in Los Angeles." *Sociology and Social Research* 71 (1987): 77–84.

———. "Secular Immigrants: Ethnicity and Religiosity Among Iranian Muslims in Los Angeles." Pages 445–73 in *The Muslim Communities of North America*. Edited by Yvonne Y. Haddad and Jane I. Smith. Albany: State University of New York Press, 1994.

Shavarini, Mitra. *Educating Immigrants: Experiences of Second-Generation Iranians*. New York: LFB Scholarly Publishing: 2004.

Tohidi, Nayereh. "Iranian Women and Gender Relations in Los Angeles." Pages 175–217 in *Irangeles: Iranians in Los Angeles*. Edited by Ron Kelley, Johnathan Friedlander, and Anita Colby. Los Angeles: University of California Press, 1993.

Ungar, Sanford. "We Know Who We Are: The Mashadi." Pages 304–30 in *Fresh Blood: The New American Immigrants*. Edited by Sanford Ungar. New York: Simon & Schuster, 1995.

United States Census Bureau. *Design and Methodology: American Community Survey*. Washington, DC: US Government Printing Office, 2009.

CONTRIBUTORS

Ahmad Ashraf served as the Managing Editor of the *Encyclopaedia Iranica* and Codirector of its project at Columbia University for over two decades. He has taught sociology and social history of Iran at the University of Pennsylvania, Columbia University, Princeton University, and the University of Tehran, and has authored books and articles on Iranian studies. He served as President of the Association for Iranian Studies and as member of the editorial boards of the periodicals *Iranian Studies, Politics, Culture and Society*, and *Iran Nameh*.

Shiva Balaghi specializes in the visual culture of the Middle East and its diasporas. She is Academic Coordinator of the Area Global Initiative at the University of California, Santa Barbara. Previously, she served as Senior Advisor to the President of the American University in Cairo for Arts and Cultural Programs and taught at New York University and Brown University. She has written on Iranian art and curated numerous art exhibitions in the United States, Europe, and the Middle East.

Mehdi Bozorgmehr is Professor Emeritus of Sociology at City College and the Graduate Center, City University of New York. He specializes in international migration with a focus on the Middle Eastern–American experience, particularly the Iranian-American ethnic group. He has published widely in this field, including three books, most recently *Growing Up Muslim in Europe and the United States*.

Elton L. Daniel taught Middle Eastern and Islamic History at the University of Hawaii. He has authored, coauthored, or edited several books, including *The Political and Social History of Khurasan Under Abbasid Rule*; *A Shiʻite Pilgrimage to Mecca*; *Qajar Society and Culture*; and *The History of Iran*. He has

served as Editor-in-Chief of the *Encyclopaedia Iranica* and Series Editor for *A History of Persian Literature*.

Erica Ehrenberg studies intercivilizational contacts, particularly in the early Persian period. She has excavated in the Aegean, Iraq, Syria, and Yemen, and has held fellowships at the Metropolitan Museum of Art, the National Gallery of Art, and the German Archaeological Institute. Serving as Director of the American Institute of Iranian Studies since 2001, she has lectured internationally on cross-cultural dialogue and collaborated on projects in the United States, Iran, Tajikistan, Afghanistan, and Pakistan.

Carl W. Ernst is a specialist in Islamic Studies with a focus on West and South Asia. He has received research fellowships from the Fulbright Program, the National Endowment for the Humanities, and the John Simon Guggenheim Foundation, and has been elected a Fellow of the American Academy of Arts and Sciences. On the faculty of the Department of Religious Studies at the University of North Carolina at Chapel Hill from 1992 to 2022, he is now William R. Kenan Jr. Distinguished Professor Emeritus.

Stephen C. Fairbanks first traveled to Iran in 1964 as a member of the Peace Corps to teach English in Shahrud, and from 1968 to 1972 he taught history at the Iranzamin Tehran International School. He received a PhD in Near Eastern Studies from the University of Michigan in 1977 and then returned to Iran, where he served as Director of the Tehran Center of the American Institute of Iranian Studies until 1979. Since that time, he has served as an Iran policy analyst and consultant for media and governmental agencies.

Prudence O. Harper is Curator Emerita in the Department of Ancient Near Eastern Art of the Metropolitan Museum of Art and previously served as Curator and Head of the department. She is a Fellow of the American Academy of Arts and Sciences and a Member of the American Philosophical Society. Her publications include an essay in *Sasanian Remains from Qasr-i Abu Nasr* (edited by R. N. Frye); *The Royal Hunter; Silver Vessels of the Sasanian Period I: Royal Imagery* (with P. Meyers); and *In Search of a Cultural Identity: Monuments and Artifacts of the Sasanian Near East 3rd to 7th Century A.D.*

Linda Komaroff is the Curator and Department Head of the Art of the Middle East Department of the Los Angeles County Museum of Art, where she has helped to double the size of the museum's collection of Islamic art. In 2006, she began to acquire and exhibit contemporary art of the Middle East, placing LACMA's collection at the forefront of American museums. Through her

acquisitions, installations, and exhibitions, she has been especially concerned with challenging an American audience's perceptions of Iranian art and culture and with demonstrating the deep connection between past and present.

Judith A. Lerner is a Research Associate at the Institute for the Study of the Ancient World, New York University. She specializes in the history and visual culture of Iran and Central Asia, from the Achaemenid into the early Islamic period. She has published on the glyptic art of Iran, Bactria, and Sogdiana as well as on the artistic and cultural interchanges along the "Silk Roads." Living in Iran in the late 1970s inspired her publications on the revival of pre-Islamic motifs in nineteenth- and early twentieth-century Persian art. She is coeditor of the series Inner and Central Asian Art and Archaeology.

Franklin D. Lewis (d. 2022) was Associate Professor of Persian Language and Literature and Chair of the Department of Near Eastern Languages and Civilizations at the University of Chicago. His landmark book *Rumi: Past and Present, East and West; The Life and Teachings of Jalāl al-Din Rumi* reassesses all previous research on this Sufi poet and has been translated into Persian, Arabic, Turkish, and Danish. He was also a translator of classical poetry and modern poetry and fiction. Particularly noteworthy are his translations of ghazals by Rumi, *Swallowing the Sun*, and Zoya Pirzad's novel *Things We Left Unsaid*.

Beatrice Forbes Manz is Professor Emerita of History at Tufts University. She is the author of *The Rise and Rule of Tamerlane; Power, Politics and Religion in Timurid Iran*; and *Nomads in the Middle East*. She has also written numerous articles on ideology, historiography, and political practice in the Mongol and Timurid periods. Her current research project is a study of the Mongol conquest of Iran.

Alessandro Pezzati joined the staff of the Penn Museum Archives in 1987 and has led the archives since 2001. He curated the exhibition "Adventures in Photography" in 2002 and produced a catalog / companion book *Photographic Explorations* highlighting the photo collection of the Penn Museum Archives. He has cocurated two additional exhibitions and has written numerous articles for the Penn Museum's magazine, *Expedition*, about the history of the museum.

Holly Pittman is Bok Family Professor in the Humanities and Professor of Art History at the University of Pennsylvania and also a curator in the Near East section of the Penn Museum. She worked in Iran from 1976 to 1978 at Tal-i Malyan (ancient Anshan) and at Konar Sandal South from 2001 to 2008. She has published widely on the art of the Bronze Age of Iran.

Contributors

D. T. Potts is Professor of Ancient Near Eastern Archaeology and History at the Institute for the Ancient World, New York University. He is a Consulting Editor for the *Encyclopaedia Iranica* and the author of several books, including *The Archaeology of Elam: Formation and Transformation of an Ancient Iranian State*; *Excavations at Tepe Yahya, 1967–1975: The Third Millennium*; *Nomadism in Iran: From Antiquity to the Modern Era*; *Persia Portrayed: Portraits of Envoys, 1600–1842*; and *Agreeable News from Persia: Iran in the Colonial and Early Republican American Press, 1712–1848*.

Richard L. Spees served as the General Counsel of the Council of American Overseas Research Centers (CAORC) starting in 1986. He was also the part-time Executive Director of CAORC from 2017 to 2023. He is an attorney with the law firm Akerman LLP, where he represents public entities such as cities and counties, educational institutions, nonprofits, and trade associations before the US Congress and federal agencies. He has written a humorous novel about the lobbying world entitled *Capitol Gains*.

Matthew W. Stolper is the John A. Wilson Professor Emeritus at the Institute for the Study of Ancient Cultures, Department of Near Eastern Languages and Civilizations, and Classics (Program in the Ancient Mediterranean World) at the University of Chicago. Most of his research and publications have centered on the languages, texts, and history of Achaemenid and pre-Achaemenid Iran and Achaemenid Babylonia. Since 2006, he has directed the Persepolis Fortification Archive Project at the Oriental Institute / Institute for the Study of Ancient Cultures.

Keyvan Tabari, who has long promoted the study of Iran at American universities, taught at the University of Tehran, Colby College, and the University of Colorado. He holds both a PhD and JD. Since 1974, he has practiced law in the United States with a few years also practicing as an international lawyer in Iran. Among his publications is *The Rule of Law and the Politics of Reform in Post-Revolutionary Iran*. Tabari was instrumental in the establishment of the Tehran Center of the American Institute of Iranian Studies, when he served as Director General of International Relations at Pahlavi Iran's Ministry of Science and Higher Education.

Christopher P. Thornton is Director of the Division of Research Programs at the National Endowment for the Humanities, a Consulting Scholar of the Penn Museum, and Director Emeritus of the Bat Archaeological Project in the Sultanate of Oman. He has published widely on the archaeology of Iran from the Neolithic era to the Iron Age.

INDEX

1876 Centennial Exhibition (Philadelphia), 119
1893 Columbian Exposition (Chicago), 120, 136n82
1926 Sesquicentennial International Exposition (Philadelphia), 121
9/11. *See* World Trade Center attack

Abdi, Kamyar, 33
Abu Lughod, Janet, 237
Academy of Sciences of the Republic of Tajikistan, 27
Achemenet, 104
Ackerman, Phyllis, 133n30, 141, 205
Adamec, Ludwig, 17
Adams, Charles, 284
Adams, Robert McCormack (Bob), 42–43, 109, 220–21
Afshar, Iraj, 17–18, 21
Afsoonagain, Afsoon, 154
Ağa-Oğlu, Mehmet, 130, 134n41
agriculture, 233, 235–37, 241
Ahl, Augustus William, 165, 187
Aigle, Denise, 236
Ainsworth, W. F., 169
Album, Stephen, 238
Algar, Hamid, 284–85, 289
Alizadeh, Abbas, 100, 208
Allen, Terry, 240
Allsen, Thomas, 235–37, 239, 242
Altman, Benjamin, 126
Amanat, Abbas, 289, 291

American Academy of Arts and Sciences (AAAS), 42–43
American Board of Commissioners for Foreign Missions, 170, 265
American Committee for Armenian and Syrian Relief, 181. *See also* American Committee for Relief in the Near East
American Committee for Relief in the Near East, 181. *See also* American Committee for Armenian and Syrian Relief
American Council of Learned Societies, 62, 268–69
American Council on the Teaching of Foreign Languages (ACTFL), 270
American Institute for Iranian Art and Archaeology, 48, 205. *See also* American Institute for Persian Art and Archaeology and Asia Institute
American Institute for Persian Art and Archaeology, 48, 90, 205. *See also* American Institute for Iranian Art and Archaeology and Asia Institute
American Institute of Afghanistan Studies (AIAS), 32
American Institute of Archaeology, 184
American Institute of Indian Studies (AIIS), 32
American Institute of Iranian Studies (AIIrS), 1–2, 5–12, 14–15, 24–27, 30–34, 41–44, 51, 54, 76, 150, 217, 273

Index

American Institute of Pakistan Studies (AIPS), 32
American Museum of Natural History, 73, 209
American Oriental Society, 5, 171–74, 176
American Peace Commission, 186
American Research Center in Egypt (ARCE), 44, 51
American Research Institute of Turkey, 51
American School of Classical Studies, 42, 187
American Society of Overseas Research (ASOR), 31
American-Persian Relief Commission, 181
Amitai-Preiss, Reuven, 237
Anatolia College, 265
Andover Newton Theological School, 176
Andrew W. Mellon Foundation, 42, 44, 110n89
Anjoman-e Tarikh (Historical Society), 54
anthropology, 27, 46, 50, 52–53, 57, 60, 69, 73, 80, 152, 208–9, 286
anti-Americanism, 21, 318
Antiquities Law of, 1930, 47, 87, 89, 101
Appardurai, Arjun, 143
Archaeological Institute of America, 9, 51, 77
Archaeological Legacy Institute, 31
Archaeological Research Center of Iran, 121
archaeology, 2–3, 7, 14, 16–17, 19, 22, 27, 29–30, 33, 46–54, 57, 60, 62, 69, 72–78, 80, 86–89, 94–95, 97, 101, 106n5, 118, 120, 131, 164, 174, 179, 187–89, 201, 205–12, 216–17, 219, 221–22, 224
architecture, 27, 29–30, 64, 88, 95, 97, 128, 136n89, 157–58, 202, 205–6, 208–9, 211, 220, 224, 238–40
area studies, 50, 60, 203, 261, 268, 269, 282
Arjomand, Saïd A., 223, 288, 294n35
Armajani, Siah, 148–49, 154, 158
Armand Hammer Museum, 145
Arndt, Richard, 6, 10

art history, 2–3, 29–30, 46–50, 52–53, 60, 62, 79, 102, 122, 130, 141–47, 150, 155, 189, 201, 205–6, 208–9, 211, 216–17, 219, 222–24, 225n7, 238–39
carpets, 29, 31, 47, 119, 124–26, 128–29, 135n74, 179, 131–32n6, 132n8, 141, 144, 314
ceramics, 92, 119–21, 124–26, 128–30, 133n22, 149, 174, 221
coins, 216, 218, 225n13
glass, 79, 124, 218, 224
painting, 123, 125–26, 128–30, 141, 145–47, 149, 155–56, 185, 220–21
sculpture, 88, 149, 156, 158, 211, 218, 220–21
seals, 100, 103–4, 185, 207, 216
silk, 17, 219, 260
silver, 88, 90, 144, 166, 175, 211, 216, 217, 218, 219, 221, 223, 226n42
textiles, 31, 119, 124, 129–30, 143–44, 218–19, 221
Art Institute of Chicago, 119, 130
Arthur M. Sackler Gallery, 32, 123–24, 126, 135n65, 217, 219–20, 240
Asia House Gallery, 223
Asia Institute, 48, 203. See also American Institute for Persian Art and Archaeology and American Institute for Iranian Art and Archaeology
Asia Society, 32, 124, 150–51, 155, 223–24
Association for Iranian Studies (AIS), 11–12, 31, 51, 54. See also Society for Iranian Studies
Association for the Study of Persianate Societies (ASPS), 31, 283
Aubin, Jean, 236, 245n61, 246n85
Auburn Theological Seminary, 171, 182
Auburn University, 55
Azari, Shoja, 154
Azarnoush, Massoud, 221
Azarpay, Guitty, 211, 218

Babayan, Kathryn, 285, 291
Bancroft Library, 218
Banuazizi, Ali, 54
Bardaouil, Sam, 155
Başan, Aziz, 234
Bashir, Shahzad, 241, 290–91

Bauer, Janet, 16, 18
Bayat, Mangol, 291
Beck, Lois, 21
Beeman, William, 17
Belenitskii, A. M., 211
Bell, Gertrude, 34, 101, 181
Berman, Judith, 16
Bertin, George, 183
Betteridge, Anne, 9, 286
Bier, Carol, 218
Bier, Lionel, 220
Biran, Michal, 238
Blackburn University, 178
Blair, Sheila, 143, 147, 238
Board of Foreign Missions of the Presbyterian Church in the United States of America, 165, 177
Boas, Franz, 73, 209
Bopp, Franz, 169, 173
Bork, F., 183
Boston College, 55
Bosworth, E. Clifford, 234
botany, 61, 79
Bowman, Raymond A., 99, 102, 105
Boyce, Arthur C., 181
Bozorgmehr, Mehdi, 151, 323–24
Braidwood, Linda S., 213
Braidwood, Robert J., 75, 98, 109n59, 213n18
Breasted, James Henry, 47, 72, 86–90, 94–96, 98–99, 102, 105, 106n5, 109n65
Breckenridge, Carol A., 143
Brill, Robert H., 218
British Institute of Persian Studies, 18, 77, 208
British Library, 123
British Museum, 31, 225n14
Broad Contemporary Art Museum, 154
Broadbridge, Anne F., 238, 241
Bromberg, Carol Altman, 222
Bronstein, Leo, 48
Brooklyn College, 220
Brooklyn Museum, 124, 128, 144, 146–47
Brookshaw, Dominic, 41
Brown University, 55, 141
Browne, E. G., 64
Bruce, Gregory Maxwell, 33

Brunei Gallery, 146
Brunner, Christopher J., 217, 218, 219, 226n30
Bryn Mawr College, 9, 51, 211
Buell, Paul, 235
Bulliet, Richard, 18, 233, 285, 287, 294
Burlington House, 122
Burnouf, Eugène, 169

California State University, 16
calligraphy, 29–30, 121, 150, 239
Cambridge History of Iran, 204, 222, 232, 240
Cameron, George G., 48–49, 93, 96–98, 107n20
Canby, Sheila, 144
Canepa, Matthew P., 222
Carnegie Corporation of New York, 44
Carroll College, 178
Carter administration, 20, 318
Carter, Elizabeth, 70
Center for Iranian Studies (Columbia), 51, 55, 61, 63, 65, 203–4, 222
Center for Middle Eastern Landscapes (CAMEL), 105
Center for Middle Eastern Studies (Harvard), 202, 212n3
Chaichian, Mohammad, 316
Chardin, Jean, 261
Cheekwood Botanical Gardens, 158
Chelkowski, Peter, 147, 149, 276n43
Chelsea Museum of Art, 155
Cheshmeh Ali, 73, 75, 78, 164
Chittick, William, 289, 290
Choksy, Jamsheed, 285
Christensen, Arthur, 216, 223
Cifarelli, Megan, 79
cinema, 2, 32, 151, 160n28. *See also* film
City University of New York, 16, 205
Civil Service Commission, 270
Clark, James D., 26–27
Cleveland Museum of Art, 9, 51, 130, 134n46, 217
Clinton, Jerome W., 8, 35, 51
Cochran, Alexander Smith, 179–80
Cochran, Joseph Plumb, 164, 177
Cochrane, Joseph Gallup, 173
Cold War, 46, 256, 268

Index 337

Cole, Juan, 289, 291
Columbia University, 5, 9–12, 31, 46, 49–51, 55–57, 60–63, 65, 73, 147, 176, 179, 186, 201–4, 208–9, 217, 219, 222, 239, 271, 287, 289
communism, 11, 13
Coon, Carleton S., 70, 75–76, 78, 80
Corbin, Henry, 283, 284–85, 293
Cornell University, 157
Corning Museum of Glass, 218, 221
Cotter, Holland, 144–45, 150
Council of American Overseas Research Centers (CAORC), 2, 8, 25, 27, 42–45
Council on Foreign Relations, 12
Critical Language Scholarship (CLS), 44, 271. *See also* National Security Language Initiative
cultural heritage, 42, 44, 57, 80, 102, 151, 220, 262, 316, 323

d'Herbelot, Barthélémy, 260
Dabashi, Hamid, 147, 160n28, 289–90, 292, 294n40
Daftari, Fereshteh, 149–50
Dakake, Maria, 288
Dale, Stephen, 241
Dallalfar, Arlene, 312
Damghani, Mahdavi, 31
Danti, Michael, 79
Darbandi, Afkham, 34
Darmesteter, James, 176
Dartmouth College, 55, 168
Daryaee, Touraj, 205, 222–23
Davis Museum, 156–57
Davis, Clare, 158
Davis, Dick, 34, 39–41, 290
Davis, Edward W., 8, 51
De Bruijn, Cornelis, 88
Defense Language Institute, 271
Dehkhoda Institute, 26
Delitzsch, Friedrich, 90
Demange, Françoise, 224
Demotte Gallery, 143
Demotte, Georges, 130
Detroit Institute of Arts, 130
Deutsche Morgenländische Gesellschaft, 167

DeWeese, Devin, 241
Diba, Layla, 144–47, 150
Dibble, Harold, 78
Dickson, Martin, 243
Diggs, Edward, 260
Dimand, M., 47
diplomatic history, 28, 29, 61, 238
Doris Duke Foundation for Islamic Art, 130
Dresden, M. J., 268
Dubensky, Boris, 92
Duke University, 11, 55, 234
Dumbarton Oaks, 42, 143
Durand-Guédy, David, 235
Dwight, Harrison Gray Otis, 165
Dyson, Robert H., Jr., 5, 8, 70, 75–78, 80, 209, 221

Eastern Oregon University, 204, 222
Ebrahamian, Babak, 150
economics
 as a factor in the development of the field, 86–87, 201, 212, 258, 267, 303–4
 as an area of study, 17, 28, 50, 52, 54, 60, 151, 209, 218, 223–24, 236, 240, 242, 305, 309–10, 312, 322–23
Ehsan Yarshater Center for Iranian Studies, 63, 65
Ekhtiar, Maryam, 145
Elias, Jamal, 290
Elmore, Douglas, 16
Elwell-Sutton, Laurence Paul, 263
Emerson, Ralph Waldo, 64, 260
Encycloaedia Iranica (*EIr*), 2, 55, 60, 61, 62, 63, 65, 204, 219, 222, 284, 285
Ephrat, Daphna, 234
Eṣṭak̲r. *See* Istakhr
Ethé, Hermann, 64
ethnography, 175, 286
ethnology, 77–78, 136n75
ethnomusicology, 29, 52
Ettehadieh, Mansoureh, 33
Ettinghausen, Richard, 48, 122–23, 133n28, 134nn44–45, 141–43, 205

Fairbanks, Stephen, 2, 8, 51
Farrand, William, 16
Farzan, Massud, 269

Farzaneh, Mateo Mohammad, 33
Fellrath, Till, 155
Filizadeh, Siamak, 32, 154
film, 31, 32, 64, 149, 154, 157. *See also* cinema
Fioretta, Ann, 16
First International Iranian Festival of Popular Traditions, 54
Fischer, Michael, 292
Fleischer, Heinrich Leberecht, 167, 257, 275n7
Fogg Museum, 123, 132n12. *See also* Harvard Art Museum
folklore, 36, 60
Forbes, Duncan, 264
Ford Foundation, 6, 7, 44
Foreign Service Institute (FSI), 268–71
Foruzānfar, B., 64, 275n12
Fouchécour, Charles-Henri de, 18
Fowler Museum, 151–52
Fragner, Bert, 18, 233
Freer Gallery of Art, 32, 120, 123, 126, 135, 206, 217, 219–20. *See also* Arthur M. Sackler Gallery
Freer, Charles Lang, 47, 120, 126–27, 132n16
Friedlander, Jonathan, 151, 306
Frye, Richard Nelson, 5, 49–50, 202, 204, 212n3, 218, 222, 225n12, 227n49, 264, 283
Fulbright Commission, 6, 19, 41
Fulbright Scholar Program, 44

Garrison, Mark B., 100
Garsoïan, Nina, 219
Gaspey, Thomas William, 265, 277nn46–47, 277n51
Geiger, Bernhard, 48, 202–3
Geldner, Karl Friedrich, 46, 179
Gentius, Georgius, 260
geography, 2, 52, 60, 80, 99, 201, 224, 235, 240, 306–7
George Washington University, 55
George, James, 16
Getty Foundation, 44, 110n89
Getty Grant Program, 62
Getty, J. Paul, 126, 129
Ghandriz, Mansour, 149

Ghanimati, Suroor, 220
Ghanoonparvar, Mohammad, 37–38, 41
Ghirshman, Roman, 75
Gholami, Akram, 79
Gignoux, Phillippe, 218, 225n14
Gilanshah, Farh, 316
Gill University, 271, 284
Godard, André, 90
Goelet, John, 128
Goethe Institute, 18
Goldman, Bernard, 222
Golombek, Lisa, 239–40, 242
Grabar, Oleg, 49, 146, 149, 216–17, 223, 225n5, 238, 243
Grant, Asahel, 168, 172
Gray, Louis Herbert, 46, 49, 165, 186
Green, Jerrold, 17, 19
Gregg, Michael, 78
Grey Art Gallery, 33, 148–50
Grey, Abby Weed, 148–50
Grigorian, Marcos, 148–49
Groos, Julius, 265–66, 277n46, 277n48
Gross, Jo-Ann, 241
Gruber, Christiane, 286
Grunebaum, Gustave von, 48
Guggenheim Museum, 156–57
Gumpert, Lynn, 148–49
Gunter, Ann C., 217
Gürsan-Salzmann, Ayse, 78
Gyselen, Rika, 218, 225n14

Haas, William S., 202–3
Haeri, Niloofar, 286
Haeri, Shahla, 286
Hagopian, V. H., 265, 277n47
Haidari, Amir Abbas, 264–65
Hall, Isaac Hollister, 164, 175–76
Hallock, Richard, 96, 99–100, 102, 104–5
Hamlin, Chris, 17, 21
Hampden-Sidney College, 167
Hanassab, Shideh, 313, 323–24
Hanaway, William L., 8, 24–25, 43
Hansen, Donald P., 109n59, 220
Hansman, John, 221
Harlan, Josiah, 260
Harper, Prudence O., 3, 8, 211–12, 217–18, 222–23
Harris, James Rendel, 183

Index

Harvard Art Museum, 123, 128, 132n12. *See also* Fogg Museum
Harvard Semitic Museum, 175, 183
Harvard University, 5, 9, 12, 17, 49–51, 56–57, 75, 119, 132n12, 175–76, 202, 204, 209, 212n3, 219, 222, 233–34, 238–43, 271, 283, 287, 289
Hasanlu Tepe, 75, 209
Hastings, James, 186
Hauser, William, 47
Havemeyer, H. O., 119
Hawker, Cecil Lorraine, 267
Hawker, E. M. N., 267
Hazard, Willis Hatfield, 176
Heeramaneck, Nasli M., 122, 126
Hegland, Mary E., 17
Henning, Walter Bruno, 50, 203
Hermitage Museum, 147, 217, 219
Herzfeld, Ernst E., 47, 72, 74, 87–91, 95–100, 102, 106n5, 107n20, 109nn64–65, 206–8, 213n18, 219–20, 226n35
Higgins, Patricia J., 40, 321
Higher Education Act, 44, 50
Hillenbrand, Carole, 234
Hillenbrand, Robert, 142
Hirshhorn Museum and Sculpture Garden, 156–57
history, 1–3, 16–18, 21, 27–29, 33, 46–50, 52–55, 60–61, 64–66, 68, 86, 88, 94, 99, 122, 126, 145–48, 151, 154–55, 157, 169, 177, 180, 187, 202, 204–6, 216–17, 219, 222–24, 232–36, 238–43, 283–84, 286–91, 306
Hitzig, Ferdinand, 170
Hodgson, Marshall G. S., 233, 237, 283, 285
Hoffman, Diane M., 321
Holbrook, Victoria Rowe, 17
Holladay, Albert Lewis, 164, 167–68
Holod-Tretiak, Renata, 78, 238–39
Holtzmann, Adolph, 169
Homa Gallery, 154
Hooglund, Eric, 17
Hopkins, Edward Washburn, 169–70, 202
Horne, Lee, 17, 20
hostage crisis, 51, 62, 157, 315, 318–19

Houghton Library, 175
Houghton, Arthur, 123
Hourcade, Bernard, 18, 22
Hurewitz, J. C., 5–6, 10–13
Hüsing, G., 183

Ierusalimskaja, Anna, 219
Ilchman, Alice, 43
Inalcik, Halil, 17
Indiana Central University, 188
Indiana University, 3, 241, 286, 290
Institut Français de Recherche en Iran (French Institute), 18, 22, 284
Institute for Advanced Studies, 95
Institute for International Exchange, 44
Institute for the Study of Ancient Cultures, West Asia & North Africa, 2, 47, 72, 86, 89, 91–93, 103–4. *See also* Oriental Institute
Institute of Fine Arts (New York University), 9, 51, 145, 205–6
Institute of Iranian Art and Archaeology, 123
Institute of Museum and Library Services, 44
Interagency Language Roundtable (ILR), 270
International Alliance for the Protection of Heritage in Conflict Areas (ALIPH), 44
International Center for Persian Studies. *See* Dehkhoda Institute
International Institute for Education (IIE), 41
International Society for Iranian Culture, 31–32
International Union of Academies, 62–63
interwar period, 47, 87–88, 122
Iran America Society, 6, 19, 34, 148
Iran Bastan Museum, 22, 134n46, 216
Iran Heritage Foundation, 31, 110n89
Iran-America Society, 6, 19, 148
Iran-Iraq War, 2, 147
Iranian Academy of Arts and Sciences, 17, 32
Iranian American Bar Association (IABA), 320

Iranian American Political Action Committee (IAPAC), 320
Iranian Center for Archaeological Research, 221
Iranian Cultural Heritage Foundation, 220
Iranian Ministry of Culture, 26, 32
Iranian National Museum, 90
Iranian Revolution, 2, 7, 12, 14, 17–18, 20–22, 28, 32, 50–51, 55, 57, 62, 77–78, 100, 147, 149–50, 155, 157, 204, 208, 221, 256, 282–88, 291–92, 301–4, 306, 314–15, 318, 320, 324
Iranian Student Organization, 11
Isfahan, 17, 54, 66, 121, 130, 159, 235, 265, 266
Istakhr, 72, 75, 91, 95, 100, 164, 208, 220

Jackson, Abraham Valentine Williams, 46, 49, 165, 179–81, 186, 188–89, 201–2
Jaleh Square massacre, 19
Jayne, Horace, 69, 72–74
Jazayery, Mohammad Ali, 269–70
Jensen, P., 183
Jett, Paul, 217
Johns Hopkins University, 11, 55, 176
Johnson, Edwin Lee, 165, 185–87
Jones, William, 39, 64, 258, 262, 275n10

Kabiri, A., 221
Kadivar, Mohsen, 292
Kaempfer, Engelbert, 88
Kafesoğlu, Ibrahim, 234, 243n6
Kamshad, Hassan, 265
Kansas City Museum, 73, 164. *See also* Nelson-Atkins Museum of Fine Arts
Kantor, Helene J., 16, 104, 109n59, 208, 210
Karamustafa, Ahmet, 290
Karimi, Pamela, 33
Kawami, Trudy S., 220
Keddie, Nikki, 17, 21, 145, 146, 291, 295n60
Kelekian, Dikran, 119–20, 122, 133n21
Kelley, Ron, 151, 306
Kent, Roland Grubb, 47, 98, 107n20, 165, 186–89

Kenyon, Kathleen, 75
Kerman University, 18
Keshavarz, Fatemeh, 290
Keshavjee, Rafique, 17–18
Kevorkian, Hagop, 50, 120, 122, 132n20, 133n22, 143
Khalidi, Omar, 33
Khanikoff (Khanykov), Nikolai Vladimirovich, 167, 169, 171, 172
Khatami, Mohammad, 25
Khomeini, Ayatollah Ruhollah, 11, 13, 285, 291
Kidder, A. V., 73
Kintner, Watson, 70
Klausner, Carla, 234
Kolbas, Judith, 237
Komaie, Golnaz, 324
Komaroff, Linda, 2, 154, 242
Kraeling, Carl, 96, 105
Kraft, Joseph, 20
Krawulsky, Dorothea, 235, 240, 245n46
Krefter, Friedrich, 88, 90, 95, 97, 107n18
Kroll, Stephan, 79

Lamberg-Karlovsky, C. C., 209
Lambton, Ann K. S., 18, 235, 243n6, 264, 276n43
Lane, Mary Ellen, 43–44
Langsdorff, Alexander, 90
language, 1–3, 18, 25–27, 30–31, 34, 36–39, 44–50, 52–57, 66–67, 95, 99, 102, 167, 173, 176, 179, 183, 186–87, 202, 204–5, 222, 256–59, 262–74, 282–83, 285–87, 292, 303, 321
Arabic, 27, 49, 60, 165, 169, 180, 257–58, 264, 272–73, 282–83, 285, 287, 289
Aramaic, 99, 101–5, 203
Armenian, 223
Babylonian, 98, 102
Baluchi, 30, 258, 272
Egyptian, 102, 173
Elamite, 91, 97–99, 101–5, 183
Farsi, 1, 271
Gilaki, 67, 272
Greek, 30, 39, 87, 91, 99, 102, 223
Kurdish, 67, 173, 177, 258, 272
Lori, 67, 258, 272

language (*continued*)
 Middle Persian, 67, 91, 96, 203, 217–19, 223
 New Persian, 66, 285
 Old Iranian, 30, 46, 97
 Old Persian, 47, 87, 98, 102–3, 169, 174, 183, 186–87
 Parthian, 39, 91, 203, 219, 222
 Syriac (Neo-Aramaic), 30, 167, 168, 171, 175, 176, 177, 178, 182, 223
 Tati, 67, 272
 Turkish, 49, 60, 168, 177, 180, 234, 257–58, 265, 289
Lapidus, Ira, 233
Lassen, Christian, 169
Lay, Douglas, 16
Lehr, Rachel, 35
Leiser, Gary, 234
Lentz, Thomas W., 240
Lerner, Judith A., 3, 218, 223
Levine, Louis, 16
Lewis, David, 99
Lewis, Franklin D., 3, 8, 289
Lewisohn, Leonard, 290
Library of Congress, 21–22, 32, 44, 264
Limbert, John, 238
Lins, Andrew, 18
literature, 1–3, 12, 18, 21, 27–30, 33–35, 37–41, 46, 49–50, 52–55, 60, 64–68, 169, 173–74, 179–80, 202–4, 216, 218, 222, 232, 238, 242–43, 256–59, 262–64, 267, 271–73, 286, 290–92
 drama, 66, 67, 68
 fiction, 40, 66, 67, 68, 263
 poetry, 17–18, 29–30, 34–41, 64–68, 156, 158, 186, 241–42, 256, 262, 272, 287, 289, 290, 315
Lobdell, Henry, 164, 167, 171–73
Lois Roth Foundation, 34
Loon, Maurits van, 100
Lorentz, John H., 306
Los Angeles County Museum of Art (LACMA), 32, 122–24, 126, 128–29, 134n46, 134n46, 154, 238, 240
Losensky, Paul, 3, 26, 242, 290
Louvre, Musée de, 224, 225n14, 155
Lowry, Glenn D., 240
Lukonin, Vladimir G., 217

Luristan, 74, 94, 100, 208
Luther, K. Allin, 7–8, 18, 20–21, 234

Macalester College, 148
MacKinnon, Colin R., 8, 16, 51
Madelung, Wilferd, 18
Madjidzadeh, Yousef, 79
Maghbouleh, Neda, 324
Mahdi, Ali Akhbar, 323
Malek, Amy, 152
Mänchen-Helfen, Otto, 206
Manz, Beatrice Forbes, 3, 8, 17, 240–41
Marietta College, 174, 182, 184
Marlik, 78, 208
Marshak, Boris I., 211
Martinez, A. P., 237
Massignon, Louis, 284
Matney, Timothy, 78
May, Timothy, 237
Mazzaoui, Michel, 289
McAlister, Melani, 144
McChesney, Robert, 241–43
McCown, Donald, 98
Mehryar, Mehdi, 221
Meillet, A., 186
Meisami, Julie, 35
Melkanin, Sirak, 148
Melville, Charles, 236, 238
Metropolitan Museum of Art, 5, 9, 31–32, 47, 51, 53, 119, 121, 123–26, 134n40, 134n48, 158, 164, 176, 180, 185, 210–11, 216–21, 238
Meyer, Eduard, 90
Meyers, Pieter, 217
Michelsen, Leslee, 78
Middle East Institute, 261
Middle East Studies Association (MESA), 23, 31, 225n6, 240
Milani, Farzaneh, 36–37
Miles, George C., 100, 218, 220
Miller, Elizabeth, 323–24
Miller, Naomi F., 33, 79
Mills, Lawrence Heyworth, 164, 176
Minassian, Kirkor, 135–36n74, 143
Minneapolis School of Art, 148
Minnesota College of Art and Design, 156
Missaghi, Zia, 264, 267
Mitchell, Timothy, 148

Index

Mobasher, Mohsen, 311–12, 315, 324
Modarressi, Hossein, 288, 294n32
Mohaghegh, Jason Bahbak, 40
Mohassess, Ardeshir, 154–55
Moin, A. Azfar, 288
Mojaddedi, Jawid, 36, 290
Momayez, Morteza, 149
Monge, Janet, 79
Moore Collection, 218
Moore, Edward C., 119
Moore, William H., Mrs., 87
Mostofi, Nilou, 316
Mottahedeh, Roy, 18, 287, 294n29
Mousavi, Mahmoud, 220
Müller, Max, 177, 256
Musavi, Sadreddin, 268
Muscarella, Oscar White, 211
Musée Cernuschi, 224
Museo Poldi Pezzoli (Milan), 124
Museum Applied Science Center for Archaeology (MASCA), 78
Museum of Fine Arts Boston, 9, 47–48, 51, 90, 94, 119, 121, 128, 131n3, 132n12, 133n23, 134n46, 135n58, 143, 220
music, 17, 29, 61

Naficy, Hamid, 151, 324
Najmabadi, Afsaneh, 145
Naqš-e Rostam. *See* Naqsh-e Rustam
Naqsh-e Rustam, 91, 95, 97, 164, 179, 208
Nasli M. Heeramaneck Collection, 126
Nasr, Seyyed Hossein, 284, 293n13
National Conservatory of Iran, 17
National Defense Education Act of, 1958, 50, 261
National Endowment for the Humanities (NEH), 7, 20, 44, 62, 110n89, 145
National Foundation of the Arts and the Humanities, 6
National Gallery of Art (Washington, DC), 123
National Geographic Society, 72, 110n89
National Iranian American Council (NIAC), 320
National Museum of Iran, 121, 223
National Security Language Initiative (NSLI), 44. *See also* Critical Language Scholarship Program

nationalism, 29, 66, 143, 284
Neely, James A., 221
Negahban, Ezatollah, 78, 79, 208, 213n18
Negarestan Museum, 145
Nelson-Atkins Museum of Fine Arts, 73, 134n46. *See also* Kansas City Museum
Neshat, Shirin, 151–53, 155–57
New School of Social Research, 18, 237
New York University, 9, 33, 51, 148–49, 176, 205–6, 237, 239, 241–43, 271
Newman, Andrew, 288
Nishapur, 47, 121, 123, 125, 233, 287
Norma Jean Calderwood Collection, 129
Nouri, Fereidoun Khaje, 269
Nyerges, A. Andre, 17
Nylander, Carl, 210–11

O'Kane, Bernard, 240
Obolensky, Serge, 269
Office of Iranian Cultural Heritage, 220
Ohio State University, 16, 223, 241, 290
oil, 2, 27, 48, 256, 263, 267, 303
Olearius, Adam, 257, 260
Olmstead, Albert T., 48, 97, 100
Olson, Kyle, 80
Olszewski, Deborah, 78
Omidsalar, Mahmoud, 205
On-Line Cultural and Historical Research Environment (OCHRE), 104
Ono, Morio, 18, 22
Oriental Institute, 2, 9, 16, 32, 47–48, 53, 72, 74–75, 78, 86–90, 94–98, 101–2, 104–5, 106n5, 109n59, 109n65, 164, 202, 207–8, 213n18. *See also* Institute for the Study of Ancient Cultures, West Asia & North Africa
Otto, Emil, 265, 277nn46–47, 277n51
Oxford University, 95, 99, 177, 258, 275n8

Pahlavi, Mohammed Reza Shah, 11, 12, 159n3
Pahlavi University, 223
Panah, Kambiz Yazdan, 269
Papan-Matin, Firoozeh, 290
Paper, Hebert H., 269
Paris Nanterre University, 105

Parsons School of Design, 157
Pasargadae, 179, 184, 208
Peace Corps, 232, 270–71
Peacock, Andrew, 235
Peck, Elsie Holmes, 218
Penn Museum. *See* University of Pennsylvania Museum of Archaeology and Anthropology
Pennsylvania Museum and School of Industrial Art. *See* Philadelphia Museum of Art
Perikhanian, Anahit G., 219
Perkins, Justin, 164–67, 170, 173
Perry, John R., 35
Persepolis, 47, 48, 225n5
Persepolis excavations, 74–75, 87–106, 164, 179, 202, 207–8, 220
Persepolis Fortification Archive, 98, 99, 101, 102, 103, 104, 110n89
Persian Arts Festival, 33
Persian Heritage Foundation, 55, 63, 65
Peterson, David, 8, 51
Petrushevsky, I. P., 235, 237
Pfeiffer, Judith, 236
Philadelphia Museum of Art, 47, 119, 121, 129
philology, 3, 46, 86, 94, 96–97, 173, 177, 186–87, 201, 203–4, 282–83
philosophy, 27–28, 38, 60, 141, 149, 152, 158, 170, 173, 203, 257, 283–84, 286–87
Pierpont Morgan Library Collection, 206–7
Pilaram, Farmaraz, 149
Piran, Simin, 79
Pischel, Richard, 179
Pittman, Holly, 2, 79
Poebel, Arno, 96, 98
political science, 27, 46, 50, 52, 55, 61, 155
Pope, Arthur Upham, 48, 72–73, 90, 106n5, 121–23, 128, 130–31, 133n30, 133n33, 134nn40–41, 136n84, 141–43, 159n3, 203, 205–6, 223
Porada, Edith, 8, 206, 210
Porter, Robert Ker, 175
postwar period, 87, 96, 204, 267
Potter, Lawrence G., 239
Pourshariati, Parvaneh, 205, 223, 225n6

Princeton Theological Seminary, 178, 182, 184
Princeton University, 9, 48, 51, 56–57, 178, 186, 243, 271, 288
Public Affairs Alliance of Iranian Americans (PAAIA), 317, 320

Qasr-i Abu Nasr, 47, 164, 216, 218, 220
Quinn, Sholeh, 241

Rahbar, Mehdi, 221
Rahmanian, Hamid, 34
Rainey, Froelich, 75, 77
Rassam, Hormuzd, 169
Rayy, 47, 73, 75, 78, 90, 94, 100, 120, 133n22, 133n24, 164, 177, 179, 208, 220
Redding, Richard, 16
religion, 2–3, 21, 27–28, 30, 46–47, 50, 53, 60, 99, 174, 178–79, 186, 204–5, 212, 219, 222, 236, 282–86, 288–89, 291–92, 314, 323
 Baha'i, 178, 256, 291, 305, 310–11, 314, 320, 324
 Christianity, 30, 167, 180, 182, 218, 320, 324
 Islam, 1–3, 18, 21, 28–32, 46–48, 50, 52–55, 60, 64–65, 78, 91–92, 100, 118–20, 122–24, 126, 128–30, 142, 146, 151, 154, 157, 178, 182, 205–6, 208, 216–17, 220, 232–33, 236–39, 243, 257, 282–92, 293n2, 295n63, 320, 324
 Judaism, 67, 171, 175, 305, 309–11, 313–15, 320, 323–24
 mysticism, 30, 36, 60, 66, 284, 289, 290
 Sufism, 28–29, 34, 236, 241, 243, 246n85, 256, 284, 286–87, 289–91, 295n57
 Zoroastrianism, 28, 67, 174, 179, 203, 219–20, 256, 283, 285, 314, 320
Renard, John, 290
Rice University, 55
Ripley, S. Dillon, 43
Rockefeller, John D., Mrs., 143
Rogers, James Elcana, 165, 176–78
Root, Margaret Cool, 100
Ross, Denman W., 119, 128, 132n12
Rostovtzeff, Michael, 72

Roth, Lois, 4, 6, 34, 40–41
Roxburgh, David, 242
Royal Asiatic Society, 95, 102
Royal Ontario Museum, 16, 53
Rumi, 36, 64, 180, 289
Russell-Smith, L., 223
Russell, James R., 219
Rypka, Jan, 64

Sacy, Antoine Isaac Sylvestre de, 169, 258
Sadr, Behjat, 149
Sadri, Ahmad, 34
Safa, Dh., 64
Safa, Kaveh, 36–37
Saffari, Bijan, 148
Safi, Omid, 234, 287
Salemann, Carl, 264
Salisbury, Edward Elbridge, 164, 169–70, 173, 189
Sarah Lawrence College, 43
Sarre, Friedrich, 206
Sauer, Karl Marquard, 265, 277nn46–47, 277n51
Savory, Roger, 18
Scheil, V., 183
Schimmel, Annemarie, 289
Schmidt, Erich F., 47–48, 70, 72–74, 78, 80, 90–92, 94–95, 97–98, 100, 105, 108n48, 108n57, 120, 133n24, 208–9, 213n18, 220–21
Schmidt, Hanns-Peter, 202, 204–5
Schmidt, Mary Ellen Warden, 92
School of Asiatic Studies, 48
School of Oriental and African Studies, University of London, 146, 203, 267
Sciolino, Elaine, 20
Semsar, Mehmet, 48
Sepehri, Sohrab, 37, 148–49
September 11, 2001. *See* World Trade Center attack
Sevrugin, Antoin, 32
Shabani-Jadidi, Pouneh, 40
Shahbazi, Alireza Shapur, 204, 222
Shapley, John, 143
Sharma, Sunil, 33
Shashahani, Soheila, 18
Shavarini, Mitra, 322
Shaybani, Manuchehr, 148

Shayegan, M. Rahim, 205
Shedd, Ephraim Cutler, 165, 175, 182, 184–85
Shedd, John Haskell, 164, 174–76, 182, 184
Shedd, William Ambrose, 165, 182–83
Shepherd, Dorothy G., 217
Shiraz, 16, 17, 18, 40, 47, 48, 216, 238, 286
Shiraz Arts Festival, 17, 32, 151
Shiraz University, 48, 223
Shukovski, Valentin, 264
Simpson, Marianna Shreve, 238
Skjaervø, Prods Oktor, 204–5, 219, 226n27
Smee, Sebastian, 156
Smith, Eli, 165
Smith, Henry Lee, 270
Smith, John Masson, 235, 237, 239
Smithsonian Institution, 8, 42, 43, 47, 53, 120, 127, 221, 240
Society for Iranian Studies (SIS), 11, 51, 54, 212. *See also* Association for Iranian Studies
Society of Professors of Persian Language and Literature, 18
sociolinguistics, 71
sociology, 3, 27, 50, 52, 57, 203, 288, 305, 310, 314
Soroush, Abdolkarim, 292
Soucek, Priscilla, 239, 242
Spooner, Brian, 8, 17, 21, 26, 43, 77–78
Sprengling, Martin, 48, 96–97, 107n23, 108n57
Spuler, Bertold, 18, 235
Squires, Geoffrey, 39, 41
Sreberny, Annabelle, 18
St. Louis University, 290
Stanford University, 16, 241
State University of New York at Binghamton, 271
State University of New York at Stony Brook, 288–89
Steele, Sterlyn B., 6
Stevenson, James Henry, 184
Stoddard, David Tappan, 164, 167, 170–71
Stonecipher, Alvin Harrison Morton, 165, 187–88

346 Index

Stronach, David, 18, 22, 208, 219, 221
Subtelny, Maria, 240–42
Sullivan, William, 16, 20
Sumner, William M., 209, 221
Sumner, William M., 7–8, 16, 18, 33, 51, 70, 76
Sung, Victoria, 158
Swedish Institute in Rome, 211

Tabari, Keyvan, 6
Tabatabai, Sassan, 41
Tal-e Bakun, 164
Tal-e Malyan, 16, 76, 209
Tanavoli, Parviz, 148–49, 156
Tassy, Joseph Héliodore Sagesse Vertu Garcin de, 169, 275n10
Tehran Center, 2, 5–8, 14–15, 17–25, 33, 41, 51–52, 76, 217
Tehran University, 7, 17, 19–22
Tepe Hissar, 72, 73, 76, 78, 80, 164, 208, 221
Textile Museum (Washington, DC), 31, 143
Thackston, Wheeler, 241
Thompson, Campbell, 184
Thompson, Deborah, 220
Thompson, William Boyce, Mrs., 73, 80n11
Thornton, Christopher P., 78, 80
Tisdall, William St. Clair Towers, 263–67, 277n48, 277n50
Togan, Zeki Velidi, 234
Tohidi, Nayereh, 151, 313
Tolman, Herbert Cushing, 165, 174, 179, 183–89
Tosi, Maurizio, 221
translation, 30, 34–41, 55, 63–64, 67, 98, 104, 152, 176, 204, 219, 234, 241, 244n12, 257–58, 260, 262–63, 269, 271, 275n7, 275n10, 284–85, 289–90, 295n57
Trenton State College, 235
Trever, Kamilla V., 217
Trinkhaus, Kathryn M., 221
Tufts University, 240, 290
Turan, Osman, 234, 243n6
Tureng Tepe, 72–73, 80, 164

United States Air Force Institute of Technology, 269
United States Information Agency (USIA), 20, 26, 44, 262
United States International Communications Agency (USICA), 7, 20
Universal Galleries, 148
University Museum (University of Pennsylvania), 9, 47–48, 51, 53, 69, 106n5, 133n23, 221. *See also* University of Pennsylvania Museum of Archaeology and Anthropology
University of Arizona, 51, 56, 271, 286
University of Berlin, 47, 87, 90
University of California, Berkeley, 9, 50–51, 57, 141, 204, 206, 208, 211, 218, 235, 271, 284
University of California, Irvine, 205, 223
University of California, Los Angeles (UCLA), 9, 17, 51, 56–57, 65, 145, 151–52, 202, 205, 221, 271, 288, 291, 313
University of California, Merced, 241
University of California, Santa Barbara, 55
University of Chicago, 2, 9, 17, 19, 32, 47–49, 51, 72, 86, 89–93, 96–97, 101, 103–4, 202, 208, 210, 220, 233, 236, 238–39, 243, 271, 283, 289
University of Connecticut, 55
University of Edinburgh, 234, 288
University of Exeter, 290
University of Frankfurt, 122
University of Ghent, 224
University of Illinois, 56
University of Maryland, 271, 290
University of Massachusetts, 238
University of Michigan, 9, 16, 22–23, 48–49, 51, 56, 206, 217, 221, 234, 239, 243, 263, 268–69, 271, 289
University of Minnesota, 55, 271
University of Nebraska, 31, 186
University of North Carolina, 16, 31, 183, 293n2
University of Pennsylvania, 2, 9, 16–17, 47, 51, 75, 79, 187, 220–21, 268, 271, 290
University of Pennsylvania Museum of Archaeology and Anthropology

(UPM), 2, 9, 33, 51, 69–80, 90, 94, 164, 209. *See also* University Museum (University of Pennsylvania)
University of Pittsburgh, 9, 51
University of Santa Barbara, 31
University of Southern California, 104
University of Tehran, 26, 78–79, 155, 258, 284
University of Texas at Austin, 51, 270–71
University of Toronto, 56–57, 240, 271
University of Utah, 9, 51, 56, 271, 289
University of Virginia, 9, 51, 56, 167–68
University of Washington, 57, 235, 271
University of Wisconsin, 55, 183, 237
Upton, Joseph, 47
Urunbaev, Asom, 241
USSR Academy of Sciences, 240

Valentiner, William, 130
Vanden Berghe, Louis, 224
Vanderbilt University, 183–85, 187
Varasteh, M., 268
Victoria and Albert Museum, 120

Walker Art Center, 158
Walters Art Gallery, 119, 129
Walters, Henry, 119
Ward, Lauriston, 75
Ward, William Hayes, 180, 181, 184, 185
Wasserstrom, Stephen, 284
Waters, Edward Austin, 70
Weissbach, F. H., 183
Weisskopf, Sally, 17
Welch, Stuart Cary, 128
Wenke, R. J., 221
Wertime, John T., 306
Whitcomb, Donald S., 100, 220
Whitehouse, David, 221

Whitley, Andrew, 20
Whitney, William Dwight, 164, 172–74, 183, 189
Wilber, Donald Newton, 240
Wilkinson, Charles K., 5, 47
Williams, William Fenwick, 172
Wilson, John A., 89–90, 94
Wilson, Robert Dick, 176, 178
Wilson, Samuel Graham, 165, 176, 178, 185, 188
Wing, Patrick, 239
Winterthur Museum, 18
Wolpe, Sholeh, 38
Woods, John E., 239, 241, 243
Works Progress Administration, 104
World Trade Center attack, 160n46, 304, 315–17, 319–20, 324
World War I, 73, 96, 184, 186, 206, 263, 277n47
World War II, 42, 46, 48, 75, 94–96, 108n48, 122, 156, 203–4, 259, 261, 263, 267–68, 270
Wright, Austin Hazard, 164, 168–69
Wulsin, Frederick, 47, 69–70, 72–73, 80, 73
Wulsin, Janet, 72
Wulsin, Susanne, 69

Yaktai, Darius, 155
Yale University, 12, 31, 54, 56, 169–73, 179, 183, 242, 289, 293n2
Yarshater, Ehsan, 2, 5–6, 50–51, 55, 63, 204, 222
Yohannan, A., 180
Young, T. Cuyler, Jr., 8, 49, 52

Zonis, Marvin, 8, 12, 21
zoology, 61